P9-CFU-644

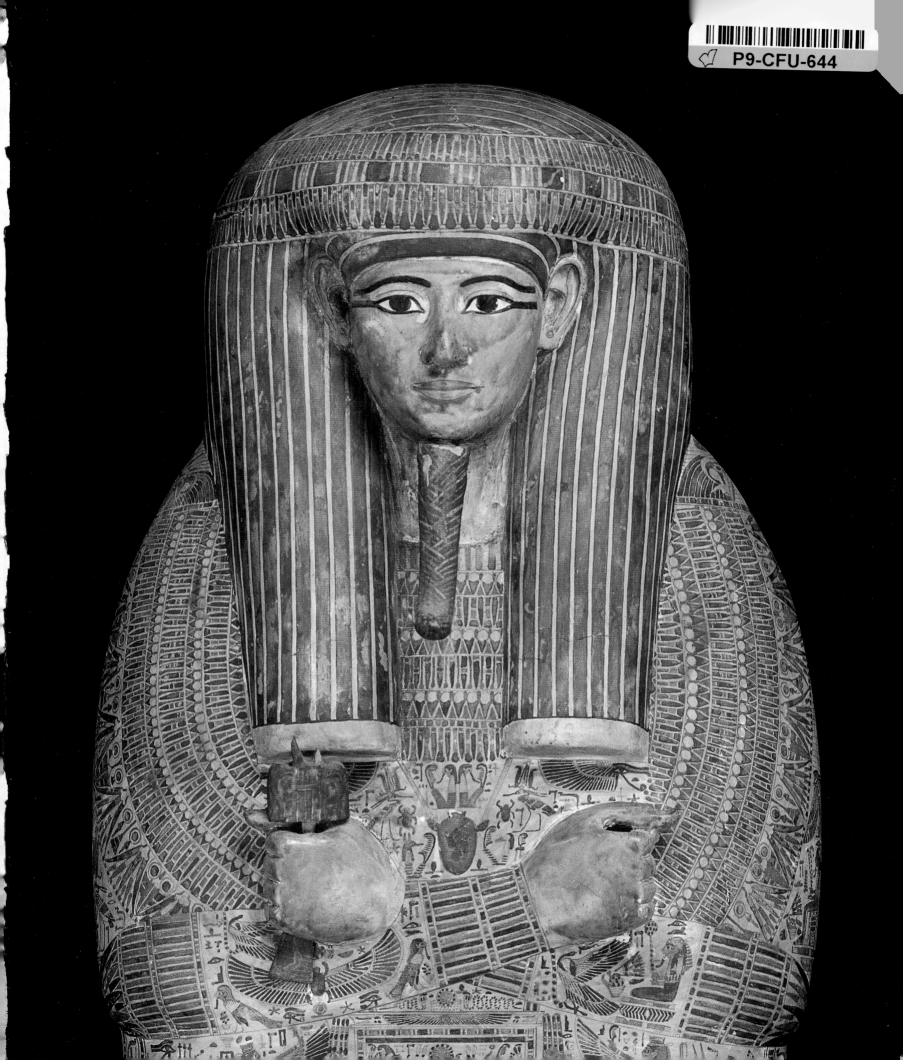

I am pleased to extend my warmest thanks to the Arab Republic of Egypt for its generous and important loan of antiquities to the American people.

This collection, *The Quest for Immortality: Treasures of Ancient Egypt*, examines a unique time in the history of ancient Egypt. Those who tour the exhibition will learn about Egypt by exploring belief systems and practices of its ancient rulers. Such opportunities for historical and cultural study are vital today, as we strive for a better understanding of the beliefs and customs of other nations.

The Quest for Immortality allows a new generation of Americans to see firsthand the treasures of Egypt. I encourage visitors of all ages to enjoy this momentous exhibition, which communicates the generosity of Egypt and celebrates our ongoing efforts to share ideas and learn more about our respective countries.

Laura and I send our best wishes for a memorable exhibition.

George W. Bush
President
United States of America

On behalf of the people of the Arab Republic of Egypt, I am delighted to convey a sincere welcome to the many visitors from the United States who will have an opportunity to enjoy *The Quest for Immortality: Treasures of Ancient Egypt.*

Each succeeding civilization has viewed the majesty of pharaonic Egypt through the prism of its own times. The Greek Ptolemies, the Romans Julius Caesar and Mark Anthony, French Emperor Napoléon Bonaparte, and British Admiral Horatio Nelson all had their personal views informed by their own cultural backgrounds. So it was with the early founders of the American republic.

When the leaders of the United States sought to honor first president George Washington after his death in 1799, they ultimately determined that a fitting monument would be a 555-foot-tall Egyptian-style obelisk, representing the virtues of loftiness, durability, and purity. In fact, the architect of the Washington Monument, Robert Mills, had originally proposed a great 680-foot-tall Egyptian pyramid, with four 350-foot obelisks at its corners! In any event, the more modest plan for the present Washington Monument by Robert Mills was carried out and is now recognized around the world as part of the capital's landscape.

A less well-known tribute is architect Benjamin Latrobe's proposal for an Egyptian-style library in 1808 as the "Library of Congress." Sadly, Latrobe's beautiful design was never implemented, but the drawings remain as a record.

It is a happy coincidence that *The Quest for Immortality* opens at the National Gallery of Art in Washington, located halfway between the Washington Monument and the United States Capitol, within months of the grand opening of the Bibliotheca Alexandrina, a revival of the national library in Alexandria on the site of the ancient structure that disappeared sixteen hundred years ago. We hope that many Americans will come and visit this historical institution, as well as our numerous other monuments.

I hope that a new generation of North Americans discover through *The Quest for Immortality* the wonder and awe, the legacy of art and learning, of ancient Egypt. Most of all, I hope you enjoy the exhibition.

Mohamed Hosny Mubarak
President
Arab Republic of Egypt

The golden orange of the setting sun, just before it slips under the western horizon, emblazons the pyramids, the symbols from which many have taken comfort over the millennia. The pyramids and the magnificent stone monuments of Egypt are nearly eternal. Although the noble mummies disappeared from inside the great tombs, these ancient ruins, with the Sphinx at the vanguard, serve as beacons to souls seeking to find the poetry of life.

Egypt sends exhibitions of its pharaonic masterpieces all over the world because we believe that these monuments belong to everyone. The last major exhibition sent from the Egyptian Museum in Cairo to the United States was *Ramesses the Great*. Exhibitions like these are a wonderful opportunity to better understand the achievements of the ancient Egyptians in art and technology. In my public lectures around the world, I see love of ancient Egypt in the hearts of all. I hope that many people will come to visit ancient and modern Egypt, see the marvelous monuments all over our country, experience the magic, and receive a warm welcome from us, the Egyptians.

The Quest for Immortality is a new exhibition that will tour many cities in North America after opening at the National Gallery of Art in Washington, DC. It contains some of the most beautiful artifacts from the Egyptian Museum in Cairo and the Luxor Museum. An exact replica of the tomb of our great king Thutmose III (the "Napoleon of ancient Egypt") is a spectacular reminder of the ancient Egyptian belief in the resurrection of the soul. Here, we might imagine, we are in the Valley of the Kings, listening to the wind whisper through this world and into the next, anticipating, as Thutmose III must have, the great adventure beyond mortal existence.

This exhibition shows us some of the things that pharaohs expected to use in their eternal life. It explains traditional religious writings in several texts on the afterlife, which were used to decorate the kings' tombs and had a common theme of the mighty journey of the sun god Re, depicted as a ram-headed human carrying the sun's disk on his head. The deceased pharaoh was thought to journey on the boat of Re as he passed through the twelve regions of the underworld, bringing light to the inhabitants there. The rebirth of the sun on the eastern horizon in the morning was taken as assurance that the king would also be reborn into another existence.

Our passage through the tomb of Thutmose III and the galleries of this exhibition is an unforgettable journey into the ancient Egyptian's vision of the afterlife. In our hearts we always hope that we can learn those secrets and have eternal life. In our minds, we know that this is not possible. But perhaps, through *The Quest for Immortality*, we can recapture a sense of ancient Egypt. Egypt always calls us back to find the beauty and peace that are the gifts of the gods.

Zahi Hawass

Zahi Hawass
Supreme Council of Antiquities
Cairo

The Quest for Immortality

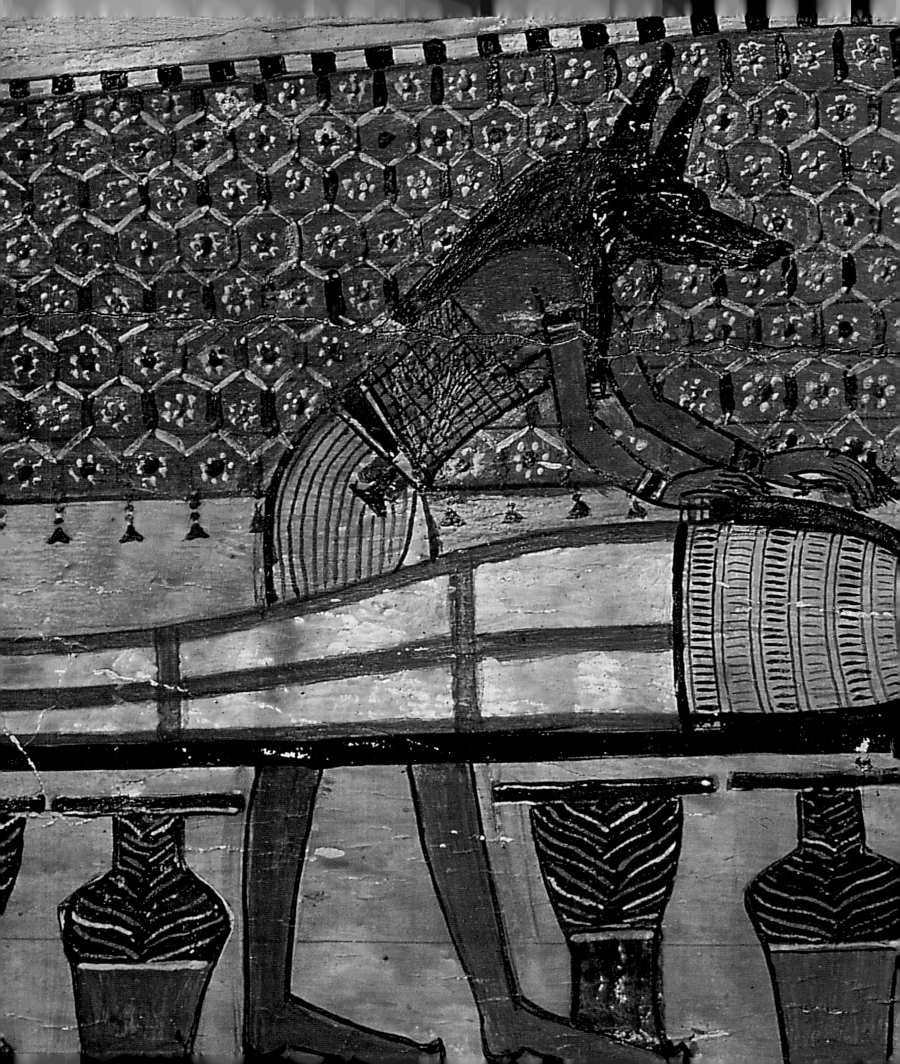

The Quest for Immortality

Treasures of Ancient Egypt

Erik Hornung and
Betsy M. Bryan, editors

Contributions by Theodor
Abt, Betsy M. Bryan,
Terence DuQuesne, Fayza
Haikal, and Erik Hornung

National Gallery of Art,
Washington, and
United Exhibits Group,
Copenhagen

The exhibition is organized by United Exhibits Group, Copenhagen, and the National Gallery of Art, Washington, in association with the Supreme Council of Antiquities, Cairo.

The exhibition travels to museums throughout North America between 2002 and 2007.

Exhibition dates
National Gallery of Art, Washington, June 30–October 14, 2002; Museum of Science, Boston, November 20, 2002–March 30, 2003; Kimbell Art Museum, Fort Worth, May 4–September 14, 2003; New Orleans Museum of Art, October 19, 2003–February 25, 2004; Milwaukee Public Museum, March 28–August 8, 2004; Denver Museum of Nature and Science, September 12, 2004–January 23, 2005; Guggenheim Hermitage Museum, Las Vegas, March 7–July 31, 2005; The Dayton Art Institute, September I, 2005 - January 3, 2006; Frist Center for the Visual Arts, Nashville, June 8–October 8, 2006; Portland Art Museum, Portland, Oregon, November 5, 2006–March 4, 2007; The Museum of Fine Arts, Houston, September 2–December 31, 2007

Copyright © 2002 Board of Trustees, National Gallery of Art, Washington, and United Exhibits Group. All rights reserved. This book may not be reproduced, in whole or in part (beyond that copying permitted by Sections 107 and 108 of the U.S. Copyright Law and except by reviewers from the public press), without written permission from the publishers.

The book was produced by the Publishing Office, National Gallery of Art.

Judy Metro, *Editor in Chief*

Karen Sagstetter, *Senior Editor*

Wendy Schleicher Smith, *Designer*

Chris Vogel, *Production Manager*

Production assistance by Nancy Van Meter. Typeset in Chaparral and Interstate by Duke & Company, Devon, PA. Pre-press and printing on DacoStern, 150 gsm by GZD, Germany.

Library of Congress Cataloguing-in-Publication Data

Hornung, Erik.
The quest for immortality: treasures of ancient Egypt / Erik Hornung, Betsy M. Bryan.

 p. cm.

Catologue of an exhibition at the National Gallery of Art. Includes bibliographical references and index.

1. Art, Ancient—Egypt. 2. Art, Egyptian. I. Bryan, Betsy Morell. II. National Gallery of Art (U.S.) III. Title.

N5350 .H67 2002
709' .32'074753—dc21 2002018847

ISBN 3-7913-2735-6 (alk. cloth)
ISBN 0-89468-303-9 (alk. paper)

The clothbound edition is published by the National Gallery of Art and United Exhibits Group in association with Prestel Publishers, Munich, London, and New York.

Prestel-Verlag
Mandlstrasse 26
D-80802 Munich
Tel: (89) 38.17.09.50
Fax: (89) 38.17.09.35
www.prestel.de

4 Bloomsbury Place
London, WCIA 2QA
Tel: (020) 7323.5004
Fax: (020) 7636.8004

175 Fifth Avenue, Suite 402
New York, NY 10010
Tel: (212) 995.2720
Fax: (212) 995.2733
www.prestel.com

10 9 8 7 6 5 4 3

Cover: (front) *Osiris resurrecting,* cat. 85; (back) *Canopic chest of Queen Nedjmet,* cat. 75

Interior details: (Presidential forewords) *Anthropoid Coffin of Paduamen,* cat. 73; (pp. ii–iii) *Sarcophagus of Khonsu,* cat. 68; (p. viii) *Sphinx of Thutmose III,* cat. 3; (p. xvi) *Statue of Isis,* cat. 79; (pp. 4, 6–7) *Offering table of Thutmose III,* cat. 6; (pp. 24, 26–27) *Gold pectoral with solar boat,* cat. 48; (pp. 52, 54–55) Ushebti *box of Djed-Maat-iuesankh,* cat. 104; (pp. 241–243) View inside life-size facsimile of tomb of Thutmose III (1479–1425 BCE)

vi

Forewords

Director, National Gallery of Art
President, United Exhibits Group

ix

Acknowledgments

xi

Prologue

xv

Map

1

Introduction: The
Quest for Immortality

Betsy M. Bryan

4

Thutmose III
and the Glory of the
New Kingdom

Fayza Haikal

24

Exploring the Beyond

The Tomb of a Pharaoh
The Amduat
The Litany of Re

Erik Hornung

52

Art for the Afterlife

Betsy M. Bryan

74

Catalogue

The King and Society in the
New Kingdom (1–16)

The Royal Tomb (17–51)

The Tomb of a Noble (52–75)

Realm of the Gods and the
Amduat (76–107)

214

Facing the Gods:
Selected Guide

Terence DuQuesne

221

Chronology of
Ancient Egypt

224

Glossary

227

Bibliography

234

Index

240

Illustration Credits

241

Epilogue

Theodor Abt

• Some twenty-five years ago the National Gallery of Art was pleased to introduce the exhibition of *The Treasures of Tutankhamun* to North America. Since then only one exhibition consisting entirely of objects coming from Egypt — *Ramesses the Great* — has visited our shores. At this time we are excited to welcome a new exhibition of Egyptian art, a perfect successor to the great *Tut*, and we are grateful to the Supreme Council of Antiquities, Cairo, and United Exhibits Group, Copenhagen, for crucial collaboration in preparing the exhibition. *The Quest for Immortality: Treasures of Ancient Egypt* combines aesthetically fine objects of Egyptian art with a fascinating glimpse into what the ancient Egyptians believed would occur in the world to which they journeyed after death. The remarkable tomb preparations undertaken by those ancient peoples begin to make sense as we comprehend their hope in the sun god and his victory each night over darkness and evil.

When we visit the pyramids or the tombs in the Valley of the Kings, we are impressed by the grandeur of these monuments, but as the story of ancient Egyptian funerary religion unfolds, we see the confident accomplishments of this great early civilization as the product of a culture like our own — full of faith and fear. The remarkable gifts of the Nile Valley, with its annual flood and unparalleled fertility, encouraged the Egyptians to believe that order could be created and maintained while intermittent famine, destruction, and disease reminded the population that order was neither automatic nor continuous. Only the action of the gods could ensure the harmony of the world; those who created it were also responsible

for its continuation. In *The Quest for Immortality* we see sculpture, sarcophagi, and reliefs — objects that facilitated communication with deities, kings, and other intermediaries — made in the hope of guaranteeing an eternal and organized world. Religion and magic enabled people to partake of the gods' daily encounters with chaos and to attain for themselves a home in the afterworld. As we gaze with awe at the gold funerary masks of these kings and aristocrats who have not walked the earth for three thousand years, we see that the artifacts preserve not only the faith of these ancient peoples, but the hope we all have for the continuation of civilization.

The great tombs in the Valley of the Kings are carved in rock, sculpted, and painted with depictions of the Egyptian conception of the afterworld. Visitors pour into the monuments daily and experience firsthand the beauty of the sites, as they have for more than two thousand years. But these inspiring tombs are now threatened by the attention and by the changing natural environment in southern Egypt. We hope that all who visit *The Quest for Immortality* appreciate the generosity of the Egyptian government in lending these treasures to the United States and see in this gesture their belief that today's world must maintain the legacy of this great civilization.

Earl A. Powell III
Director, National Gallery of Art

vi

• *The Quest for Immortality: Treasures of Ancient Egypt* presents the largest collection of objects ever to leave Egypt for a single North American exhibition. Highlighting masterpieces from the Egyptian Museum in Cairo, the Luxor Museum, and other collections in Egypt, the exhibition includes several works that have not been on display in public before and many that have never been shown outside Egypt.

At the core of the exhibition is a reconstruction of the sarcophagus chamber in the tomb of Thutmose III (1479–1425 BCE). On the original walls of this chamber appeared for the first time the complete text of the Amduat, the oldest Book of the Netherworld. The walls are replicated here, allowing visitors to track the sun god Re on his nocturnal journey and to gain insight into the burial of a pharaoh and the journey of the deceased through the twelve hours of the night. The exhibition affords visitors a truly unique opportunity to learn about the religion and burial customs of the ancient Eygptians through the treasures, tomb decorations, and artifacts they left behind.

The exhibition has been made possible by the wonderful cooperation and support of His Excellency Ambassador Nabil Fahmy; the Egyptian Minister of Culture, His Excellency Farouk Hosni; and the Supreme Council of Antiquities in Cairo, formerly headed by Gaballa A. Gaballa. The concept for the exhibition was inspired by years of preparatory work by the Swiss-based Society of the Friends of the Royal Tombs of Egypt, which together with its Egyptian sister society, is dedicated to preserving the endangered royal tombs of Egypt and to making the values of the pharaonic culture accessible to a wide public.

The successful merging of creative and planning skills brought to the project by the scientific committee of United Exhibits Group has also been vital to accomplishing the goals of this exhibition. We extend our gratitude to the members of that committee, headed by Erik Hornung, professor emeritus of Egyptology at the University of Basel; Dr. Theodor Abt of the Federal Institute of Technology in Zurich; Fayza Haikal, professor of Egyptology at the American University in Cairo; and Betsy M. Bryan, professor of Egyptian art and archaeology at Johns Hopkins University in Baltimore, Maryland.

The successful realization of the project in North America is due in large part to the expert and willing cooperation of the National Gallery of Art in Washington, under the leadership of its director, Earl A. Powell III. *The Quest for Immortality* travels to several museums in North America prior to an extended tour in Europe. It is our hope that visitors on both continents experience the enormous scope and power of this ancient but not lost civilization.

Teit Ritzau
President, United Exhibits Group

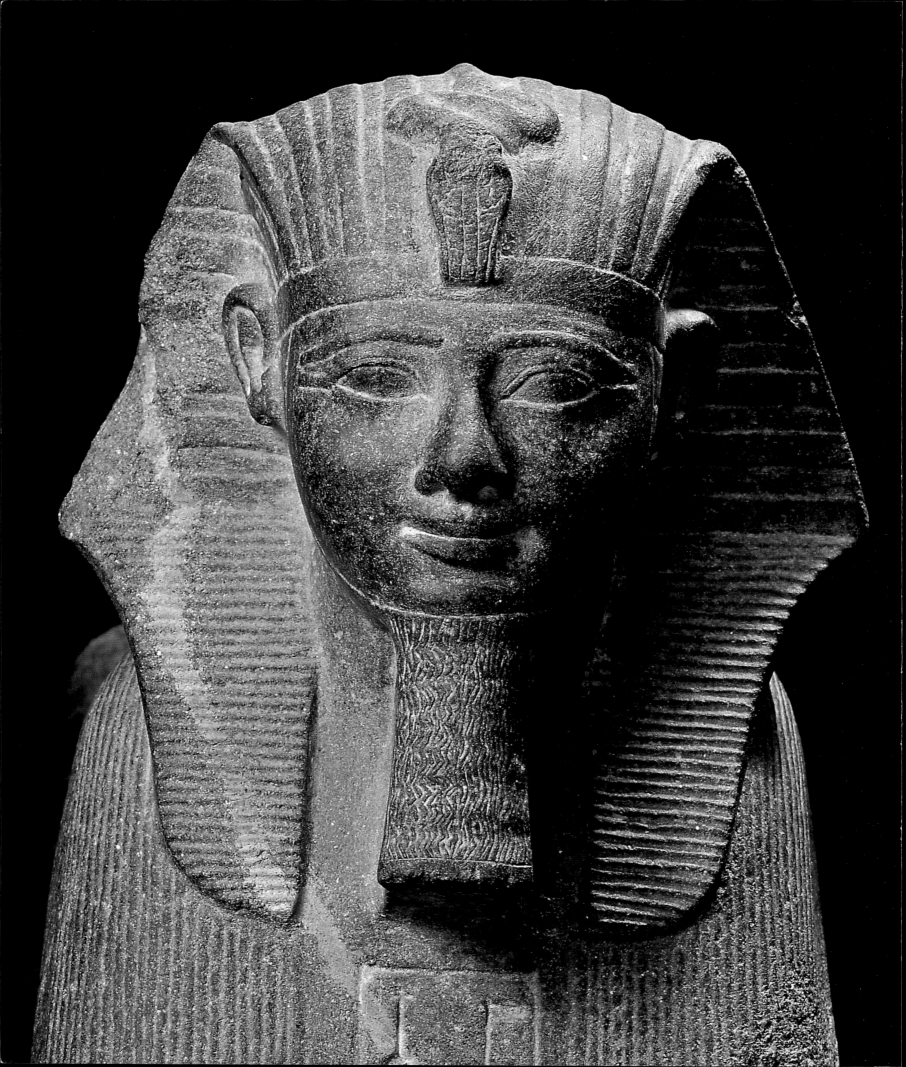

Acknowledgments

• We are grateful to so many people who have helped bring this exhibition and catalogue together in a very brief time. Foremost, our thanks go to those who have worked on the project from its beginnings, including Fayza Haikal of the American University in Cairo and Theodor Abt of the Federal Institute of Technology in Zurich, and of course Teit Ritzau, president of United Exhibits Group. Gaballa A. Gaballa, former secretary general of the Supreme Council of Antiquities in Cairo, has been supportive all along and took his valuable time to see that the exhibition was successfully completed. Dr. Sabry Abdel Aziz, general director of Upper Egyptian Monuments, was extremely supportive of the project, as was Dr. Mohamed el Bialy, general director for Luxor Monuments, West Bank, and Ibrahim Soliman, director of monuments for the Valley of the Kings. We thank also the entire staff of the Egyptian Museum in Cairo, especially Dr. Mamdouh El-Damaty, general director; Adel Mahmoud, curator of New Kingdom art; and Dr. Nadia Ibrahim Lokma, general director of conservation, and her staff. Without their help and that of all the curators and conservators, this exhibition would not have been possible. Every time we needed something, they willingly took their time to help. In Washington, the exhibition would not have taken shape without the full energy and support of the National Gallery of Art and its director, Earl A. Powell III.

We also thank those who wrote entries for the book on a pressured timetable: James Allen, Metropolitan Museum of Art; Lawrence M. Berman, Museum of Fine Arts, Boston; Mamdouh El-Damaty, Egyptian Museum, Cairo; Terence DuQuesne, London; Richard Fazzini, Brooklyn Museum of Art; Rita E. Freed, Museum of Fine Arts, Boston; Richard Jasnow, Johns Hopkins University; Adel Mahmoud, Egyptian Museum, Cairo; Ibrahim El-Nawawy, Supreme Council of Antiquities, Cairo; Ann Macy Roth, Howard University; Edna R. Russman, Brooklyn Museum of Art; Emily Teeter, Oriental Institute Museum, University of Chicago. In addition we thank the members of Betsy Bryan's seminar who wrote entries for the volume: Fatma Ismail, Tammy Krygier, Yasmin El Shazly, Elaine Sullivan, and Elizabeth A. Waraksa.

A special thanks goes to David Roscoe, translator of Erik Hornung's essay, and to James VanRensselaer, photographer for Johns Hopkins University's Homewood Campus, who traveled to Egypt to reshoot nearly thirty objects on a tight deadline. Owing to his generosity and talent, and to the special courier skills of Daniel Shay at the National Gallery, we have a complete catalogue of fine photographs.

In Cairo the staff of the American Research Center in Egypt greatly assisted us with various arrangements and handled communications between the National Gallery of Art and the Supreme Council of Antiquities. We are particularly grateful to Robert Springborg and Amira Khattab. Our colleagues at other institutions have been highly supportive. They include Nancy Thomas at the Los Angeles County Museum of Art and Kenneth Bohač at the Cleveland Museum of Art. We thank Dorothea Arnold, director of the the department of Egyptian art at the Metropolitan Museum of Art, who kindly offered help in securing photographs from a vast archive. Kent Weeks provided assistance in accessing both plans and photographs of monuments from Thebes. Edwin Brock kindly replied to queries we had early on regarding royal sarcophagi.

The staff at United Exhibits Group in Copenhagen has been especially helpful to us. Our thanks go to Factum arte, for design and implementation of the production of the tomb; Cortina Productions, for interactive touchscreen exhibits; J. D. Dallet for photography; Katrine Møllehave, for design of original concept; Claus Frimand, vice president, and Ditte Højriis, project coordinator, for project coordination and management; Troels Askerud and Claus Kongsted, for legal and financial advice; and Søren Løvenlund, chairman of United Exhibits Group. Part of this project was financed with the support of Eksport Kredit Fonden, Denmark.

At the National Gallery of Art we are grateful to Elizabeth A. Croog, secretary and general counsel; Nancy Breuer, associate general counsel; and James Duff, treasurer, for their wise deliberation on all agreements related to the exhibition. For their expert coordination and administration of all exhibition matters, we thank D. Dodge Thompson, chief of exhibitions; Jennifer Cipriano, exhibition officer; and their assistant Jennifer Bumba-Kongo. We are grateful to Susan M. Arensberg, head of exhibition programs, and Mark Leithauser, chief of design, for their early involvement and good advice on the selection and installation of the works; to Gordon Anson, head of exhibition production; Donna Kirk, exhibition designer; and Bill Bowser, production coordinator; for the installation design; and to Carroll Moore, film producer; Lynn Matheny, assistant curator; and Kelly Swain, research assistant; for creating a film for the exhibition. For knowledge and guidance in the delicate matter of packing and shipping the objects, we thank Sally Freitag, chief registrar; Michelle Fondas, registrar for exhibitions; Merv Richard, head of loans and exhibitions conservation; and Bethann Heinbaugh, conservation technician. Bob Grove, digital imaging coordinator, aided in the quick distribution of images for the exhibition. For her fundraising efforts, we thank Chris Myers, chief of corporate relations. Deborah Ziska, chief press and public information officer, and Domenic Morea, publicist, lent their enthusiasm and media skills to the promotion of this exhibition.

Many people on the Gallery's fine editorial staff led by Judy Metro worked with speed and grace to produce this book. Our thanks go especially to Karen Sagstetter, senior editor, for coordinating the editorial side and to designer Wendy Schleicher Smith for giving an elegant form and readability to the book. Other members of the team include Chris Vogel, Margaret Bauer, Sara Sanders-Buell, Mariah Shay, Amanda Mister, and freelancers Jane McAllister, Fran Kianka, and Michele Callaghan. Special thanks go to Kathlyn Cooney and Tammy Krygier, whose research, writing, and knowledge of many things Egyptian were invaluable to the entire team.

To all of those who have helped bring our project to its successful completion, we extend our deepest gratitude.

Erik Hornung and Betsy M. Bryan

• From earliest times the ancient Egyptians denied the physical impermanence of life. They formulated a remarkably complex set of religious beliefs and funneled vast material resources into the quest for immortality. While Egyptian civilization underwent many cultural changes over the course of its nearly three-thousand-year history, the pursuit of life after death endured. This volume focuses on the understanding of the afterlife in the period from the New Kingdom (1550–1069 BCE) through the Late Period (664–332 BCE). The New Kingdom marked the beginning of an era of great wealth, power, and stability for Egypt and was accompanied by a burst of cultural activity. Much of this activity was devoted to the quest for eternal life and was focused in the capital Thebes (modern-day Luxor), located along the banks of the Nile in Upper Egypt. The works of art illustrated in this book—statues, jewelry, painted coffins, and other furnishings for the tomb—are evidence of this pursuit. They come from the Egyptian Museum in Cairo, the Luxor Museum, and the sites of Tanis and Deir el-Bahari.

In ancient Egypt, religion and politics were inextricably linked. Egyptian kingship was associated with solar power, which may be understood as an attempt to immortalize the royal office. A sphinx representing the likeness of the pharaoh Thutmose III (1479–1425 BCE) visualizes this connection, for the sphinx was a symbolic manifestation of the sun god Re (cat. 3). The sphinx's links to the sun were owed, in part, to the fact that lions in ancient Egypt inhabited the desert margins and were believed to be guardians of the horizon, and therefore of the sun.

The bond between the sun and the pharaoh is an idea almost as old as Egypt itself. The Great Pyramids of Giza, built some forty-five hundred years ago, are themselves symbols of the sun, representative not only of its rays as they hit the earth but also of a sacred pyramidal stone in Re's sacred temple in Heliopolis. By the time of the New Kingdom, pharaohs were no longer buried in monumental pyramids, but rather in elaborate tombs beneath a pyramidal-shaped mountain at a site in western Thebes. Known today as the Valley of the Kings, this desert valley on the west bank of the Nile was the royal burial ground for more than six hundred years, until the Twenty-first Dynasty (1069–945 BCE), when the Tanis temple complex in the north of Egypt became the new site for royal tombs. Despite the relocation of the royal tombs to the north (a result of political upheaval in Egypt), the pharaoh's solar associations persisted. The royal tombs at Tanis, found intact in 1939, represent the most important archaeological find since the discovery of Tutankhamun's tomb in the Valley of the Kings in 1922–23. However, because the excavation occurred at the outset of World War II, it went largely ignored by the Western public. A resplendent gold mask and jewelry (cats. 43 and 47) are among objects found in the Tanis tombs.

Egyptian religion, as well as the authority of the king, rested on the concept of *maat,* translated as "truth," "justice," or "natural order." *Maat* was personified as a goddess with a feather on her head, or sometimes seen simply as the hieroglyphic "feather of truth" (cat. 88). The order instilled by *maat* governed the universe, causing the sun to rise and set every day, the Nile to flood its banks and deposit new layers of nourishing soil every year, and the dead to be reborn in the next world. Egyptian religion, in its essence, was an examination of these cycles of death and rebirth.

For the Egyptians, the cycles were not merely guaranteed natural occurrences; the sun did not simply set and rise again twelve hours later undeterred. Rather, the setting sun signaled the death of the sun god Re and his descent into the nocturnal realm of the underworld. There, a host of protective deities helped him overcome a series of dangers that impeded his progress along the path toward rebirth as the rising sun at dawn. Descriptions of the sun god's nightly journey are inscribed on the walls of royal tombs and on the objects contained within. The inscriptions serve as a guidebook for the pharaoh's own journey toward rejuvenation, as ancient Egyptians believed that in the afterlife kings became one with the sun god, with whom they were reborn at sunrise. Without such assistance, the sun god's resurrection was impossible. The Egyptians, similarly, did not view their own rebirth in the next world as an absolute given; magic, force of will, morality, and obscure knowledge enabled human resurrection. Elaborate rituals and ceremonial objects were thus designed to provide the deceased with the essentials to reach the afterlife.

The dangers faced by the sun god Re during his nocturnal voyage were believed to be the same faced by all Egyptians upon death, regardless of class. But if the underworld journey was a perilous one for both the king and his subjects, it also was full of possibility, with the potential for resurrection and immortality at its end. Funerary rituals associated with mummification and burial may be understood as multiple layers of protection, aiding the deceased during the treacherous journey toward afterlife. The body was protected by physical coverings, amulets, and magical deities that together preserved the body and provided the deceased with the knowledge required to achieve resurrection. These protective layers also ensured safety for the *ba*—loosely translated as the soul and personality of the deceased.

The process of mummification, which prevented the body from fully decomposing, functioned as the first protective layer. The deceased's organs were removed from the body, dried in natron salts, wrapped in bandages, and placed in jars with lids depicting guardian deities. The body was similarly dessicated in natron, treated with oils, and then carefully swathed in linen. The wrapping of the body associated the deceased with Osiris, the ruler of the netherworld (cat. 78). The myth of Osiris told of his murder and the dismemberment of his body, which was subsequently collected in its parts, wrapped together, and reborn with divine assistance. To be resurrected, a dead Egyptian—commoner or king—needed to imitate the form of Osiris. Once mummified, the deceased was called "Osiris," and it was expected that he or she then would be reborn in the same magical fashion. An unusual image of the moment of re-awakening is depicted in a mummiform figure that simultaneously represents Osiris and the deceased in his form (cat. 85). The figure has just rolled over from its back and is becoming alert, lifting up his head, and awakening to new life.

The mummies of royalty and nobles were outfitted in elaborate attire that may have included beaded clothing, jewelry, finger and toe covers, and masks. The dressed body was then placed in its magically protective container, the coffin. Depending upon the deceased's status and wealth, the coffin may have then been placed into a series of nesting coffins (cat. 73), which, for the privileged, were set in a massive sarcophagus that rested in the tomb's burial chamber (cat. 100).

Within the tombs, Egyptians placed objects that would assist the deceased in their next life. Many royal tombs contained painted wooden boats such as the one buried with Amenhotep II (1427–1400 BCE; cat. 1). Modeled after royal barges that ferried kings along the Nile in life, such ship models were believed to be the kings' magical transport through the waters of the netherworld. Many of the items discovered in burial chambers were divine objects—statues of gods and goddesses, sacred

funerary texts, and beautiful jewelry with religious iconography, such as the pectoral of King Psusennes I. Placed over the chest of the deceased, the pectoral depicts goddesses protecting a winged scarab beetle, the symbol of the rising sun (cat. 47). The Egyptians believed that by representing deities in tomb chambers, their divine magic and knowledge would accompany the deceased in the journey toward rebirth.

The afterlife was understood as an actual physical existence requiring sustenance. Tomb furnishings, therefore, included a variety of basic provisions, such as clothing, furniture, toiletries, and offerings of food and drink. These everyday objects in Egyptian tombs inform us as much about ancient life as about the Egyptian understanding of death. The frequent decoration of these functional objects with gods and goddesses and sacred texts, for example, indicates that religion was not a distinct realm but instead permeated all aspects of Egyptian society. The chair of Sit-Amun, for example, made for the daughter of King Amenhotep III, is adorned with images of the leonine god Bes and the hippopotamus goddess Taweret— domestic deities who protected women and children (cat. 39).

If the afterlife was considered an actual physical place, it was also one where there was real work to be done. Recognizing this need but not wanting deceased pharaohs and nobles to be burdened with such labor, the Egyptians provided servants for the deceased in the form of small statues known as *ushebti*s (cats. 35, 59, 61). Often equipped with tiny hoes and other tools, *ushebti*s were prepared to perform the agricultural and building activities in the underworld. It was not uncommon to find hundreds of these figures in a single burial chamber — as many as one for every day of the year.

An important component of Egyptian religion is its tradition of funerary literature. The earliest known collection of religious spells, called the Pyramid Texts, dates to 2350 BCE at the time of the Old Kingdom. Over the course of the next centuries, a succession of new funerary texts slowly shaped the course of Egyptian religion. The New Kingdom, however, witnessed an explosion of such funerary texts, collectively referred to as the Books of the Netherworld. More coherent than their predecessors, these books offered the earliest systematic explanation of Egyptian religion. The most important of the texts are popularly known as the Book of the Dead and the Amduat (the latter meaning "that which is in the netherworld").

Those who could afford it commissioned personalized versions of the Book of the Dead to be inscribed on coffins, sarcophagi, *ushebti*s, and other objects for the tomb. The text contained nearly two hundred magical spells and cryptic knowledge that prepared the deceased for the challenges in the underworld. For example, the coffin of the nobleman Paduamen (cat. 73) includes many texts and vignettes from a spell designed to protect the body. The coffin lid depicts Nut, the sky goddess and mother of the sun god, her wings protectively outstretched on the abdomen of the deceased.

While the Book of the Dead was available to all Egyptians, the Amduat was reserved for the pharaoh and a few select nobles. The earliest known complete copy of the Amduat is found in the tomb of Thutmose III in the Valley of the Kings. The text describes in minute detail the geographical layout of the netherworld and the events that transpire in each of the twelve hours of the sun's nocturnal journey — believed to be the pharaoh's journey as well — from sunset and death to sunrise and rebirth. Painted onto the walls of Thutmose III's burial chamber in simple, cursive red and black lines that mimic writing on papyrus, the text guides the deceased through the netherworld.

Describing its various regions, depicting in images and hieroglyphic text all of the perils that must be faced, the Amduat provided the knowledge required to pass through unscathed. Hour by hour all deities, demons, and enemies are drawn and named, for to know the name of something is to harness its power.

The realm of the afterworld was inhabited by hundreds of gods and goddesses who assisted the deceased in the journey toward resurrection. While Osiris reigned as the ruler of the netherworld, all of the other deities worked together to protect the deceased and to aid in the quest for immortality. The deities were represented as humans, animals, and often both, with many gods taking the form of the inhabitants of the Nile Valley. For instance, the Egyptians worshiped the falcon god Horus, master of the sky and the embodiment of kingship; the crocodile god Sobek, connected with fertility and water; and the lioness goddess Sakhmet, who controlled the fortunes of war and pestilence. The goddess Hathor, believed to be the mother goddess, is represented as a cow or as a woman with cow horns. She is closely linked to another of the most powerful female deities, the goddess Isis, who in fact often wears Hathor's cow horns. Amidst this animal imagery, it is important to remember that what the Egyptians venerated was not the animals themselves but the powers associated with them.

The jackal Anubis, who oversaw embalming and guarded the body, was frequently depicted on funerary objects such as canopic chests — boxes that enclosed the four jars containing the mummy's extracted organs. A sculpted Anubis figure lies on top of a canopic chest, clearly marking his territory and domain (cat. 75). His image and power are reinforced by the painted Anubis (here depicted as a human body with a jackal head) rendered on the front of the chest.

Multiple manifestations of individual gods were common and indicative of the complex nature of Egyptian religion. In the case of Re, as many as seventy-five manifestations are known. A pectoral found in the tomb of Psusennes I (1039–991 BCE) in Tanis depicts several of these representations, including a winged sun disk, a motif repeated near the bottom of the pectoral, where a row of red carnelian disks signify the movement of the red solar disk (cat. 47). The sun god is also depicted in the central oval where a lapis-lazuli scarab, the morning manifestation of the sun god, is found. Further solar connections are seen in the use of gold, known generally as the "flesh of the gods," but with particular ties to the luminous sun. By including these many representations of Re in his tomb, the king associated himself with the sun's miraculous death and rebirth every day, thus providing himself with the same regenerative and protective powers for his own resurrection. As in many of the objects in this catalogue, the careful craftsmanship, detailed iconography, and rich materials of this pectoral remind us of the supreme importance of the quest for immortality in ancient Egypt.

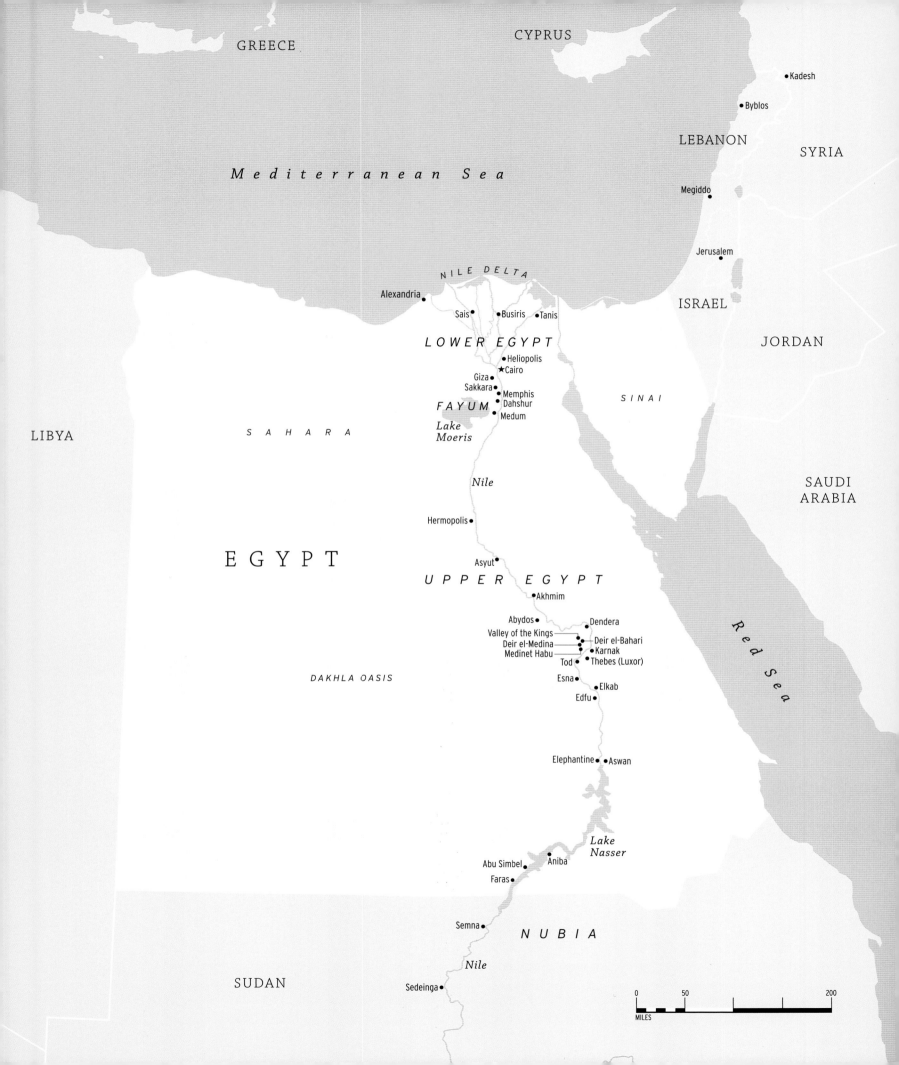

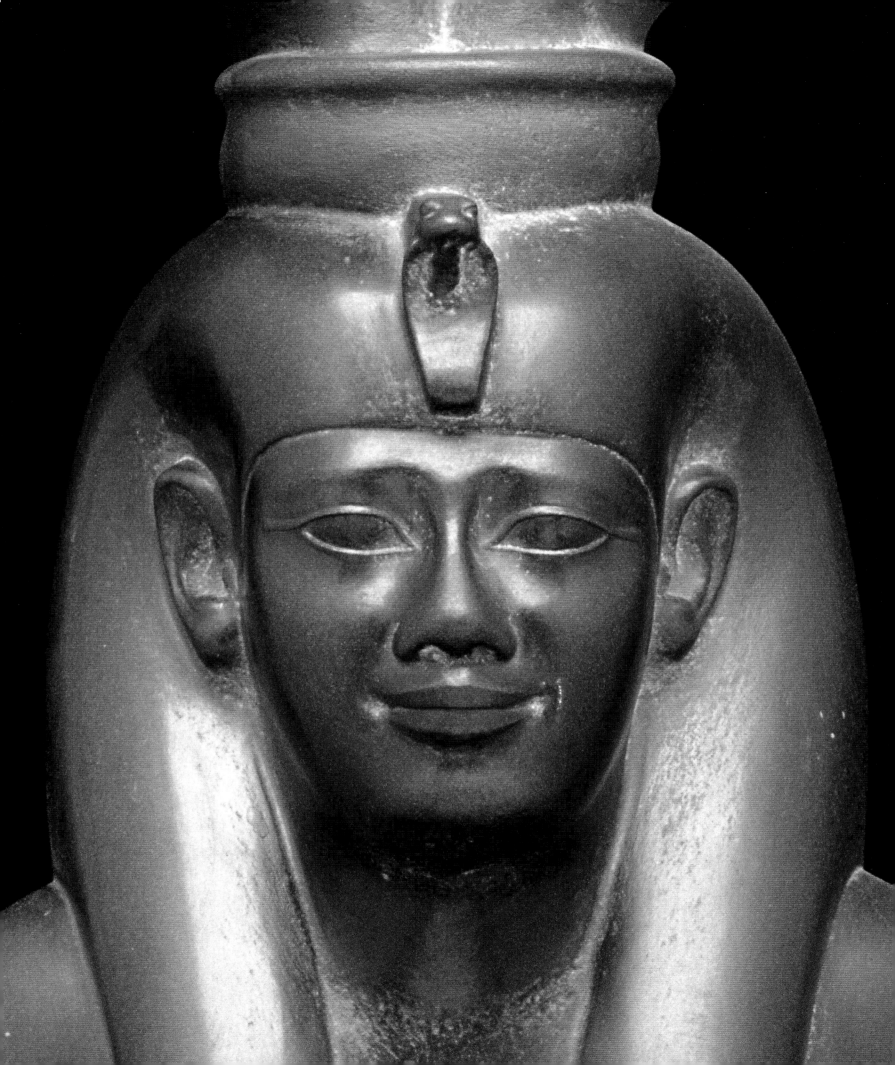

• The story of the quest for immortality that follows in this book details afterlife beliefs in the time of Thutmose III (1479–1425 BCE) and his successors in the New Kingdom. An understanding of funerary notions necessitates a look at two of the most important concepts from ancient Egypt—kingship and religion. In 1479 BCE, when Thutmose III ascended the throne in the Eighteenth Dynasty (1550–1069 BCE), Egypt had already seen fifteen hundred years of pharaonic rule. Writing, almost certainly the invention of a newly centralized monarchy, developed in the latter part of the fourth millennium BCE, and despite its primary use as an administrative tool, quickly was enlisted in the service of the state as the means of explicating the association of kingship with religious beliefs. Through writing the king's manifestation as the god Horus, the divine ruler on earth, could be linked to his role as "the favorite of the two ladies"—an allusion to Nekhbet and Wadjet, goddesses from the prehistoric cults of Upper and Lower Egypt, as well as his position as "he of the sedge plant and the bee," a reference to his ownership of the country, including the familiar sedge plant of Upper Egypt and the most significant product of Lower Egypt, bee's honey.

The ancient Egyptians were always concerned with explaining their world by the means of identifying it. Thus they were a nation of bureaucrats almost by definition. Titles and names and lists of both burgeoned in the documents of the First and Second Dynasties. By the Old Kingdom (c. 2686–2125) the tombs of officials carried long inscriptions made up almost entirely of titles and epithets of the tomb owners. In these early times, too, the tendency to make lists was manifest in the funerary context, where monuments carved with sculptured reliefs depicted deceased men and women accompanied by lengthy graphlike offering tables that detailed the names of breads, beer, ointments, clothes, et cetera, that they expected to be provided to them in perpetuity. The naming and illustration (for such were hieroglyphic writings) were tantamount to the presence of the offerings, just as were the actual food and objects placed in the tomb.

In addition to enabling the categorization of the world, writing also allowed for manipulation of concepts, such as the kingship. For example, as early as the middle of the First Dynasty (c. 2900 BCE), a list of kings is known, beginning with Narmer and ending with Den. The intent to memorialize the dynastic line of kings is evident here and constitutes an early use of writing to aid ideology. Interestingly enough, this first list added a name to those of the kings—the king's mother Merneith—for that queen, early forerunner to Hatshepsut, ruled Egypt and left a tomb and burial outfit consistent with those of her kingly ancestors. In later centuries the rule of Queen Merneith was reduced to a simple regency for Den by the compilers of king lists, as the potential of writing for reconciling history with political ideology and religion further evolved.

Religious literature developed within the context of the monarchy, where it served in the Old Kingdom to assure the king's journey to the heavens after death. The Pyramid Texts are first inscribed on tomb walls in the reign of Unas (2375–2345 BCE) at the end of the Fifth Dynasty and are entirely dedicated to the king's successful afterlife transformation. There were no parallel texts for private persons, although clearly there was a belief that a Field of Reeds awaited the blessed dead. Stress was rather placed on one's usefulness to the sovereign as a means to ensure travel to the next world. The Coffin Texts, which appeared by the First Intermediate Period (2160–2055 BCE), provided spells for all people hoping to gain the next world through their association with the sun god's daily rejuvenation. During the Middle Kingdom (2055–1650 BCE), Coffin Texts continued to be used for burials throughout the country, but kings made efforts to revive the central role of the monarchy in religion as well as in politics. The Middle Kingdom rulers attempted to recall the greatness of the Old Kingdom in their pyramid building and art styles, but they strengthened the kingship more by stressing other roles of the ruler. Rulers, such as Senusret I (1956–1911 BCE), built great national temples at the major cult centers in Egypt, some of which had been neglected

1

since the Sixth Dynasty (2345–2181 BCE). At Heliopolis, city of the sun god Re and the creator Atum, new constructions were carried out, and the temple of Karnak to Amun-Re was built in Thebes on the model of the Heliopolitan shrine. The temple of Ptah at Memphis was certainly expanded, as were the Theban temples to Montu. The rulers portrayed themselves as pious sons of the gods, while also fostering the notion that the king was the guarantor of life on earth. By encouraging the composition of literature that extolled the kingship, the personal connection between ruler and ruled was enhanced, as was the connection between the ruler and the powerful elites whose support was vital. Hymns were composed in honor of Senusret I and Senusret III, while other texts advised people to be loyal to the king who was Egypt's protection.

The roles of the ruler that developed during the Old and Middle Kingdoms continued to be prominent in the early Eighteenth Dynasty (1550–1295 BCE) but were enriched to form the New Kingdom kingship. The role of ruler as the guarantor of earthly order was greatly expanded, due to the wars to expel the Hyksos in the late Seventeenth and early Eighteenth Dynasties, followed by the conquests of Nubia, the Levant, and Syria. To emphasize the relationship between the new dynastic line and the major gods, kings sought to identify themselves as offspring of the deities. Ahmose called himself "son of Iah," the moon god honored in the royal name, while Thutmose III termed himself "son of Amun" and also "son of Mut," implying his association with the moon god Khonsu, the divine son of the Karnak gods. Hatshepsut even illustrated her bodily creation from Amun-Re on the walls of her temple at Deir el-Bahari, and Amenhotep III did likewise at Luxor Temple a hundred years later. Most commonly, however, kings spoke of themselves as the sons of the sun god, "the son of Re, of his body," the message repeated in numerous royal inscriptions. Even as the wealth and power of Amun-Re of Thebes was growing through the reigns of Hatshepsut to Amenhotep III, the connection of the kingship with the Heliopolitan gods Re-Horakhty and Atum also grew, in some ways overlaying the Amun cult itself. For example, within the great temple of Karnak, Thutmose III built an eastern temple dedicated to the sun god, while Osiride statues left by several kings wore the double crown of Atum and the white crown of Osiris. (The Middle Kingdom rulers also erected Osiride statues in Karnak, as well as in funerary temples.)

Indeed, the kings of the Eighteenth Dynasty did fuse the funerary with the national cults, pursuing a role for Amun-Re within the mortuary temples, while alluding to Re and Osiris in the temples on both banks of the river. In newly stressing the *sed*, or rejuvenation, festival, kings after Thutmose III particularly expanded the king's identification with the sun. Thutmose III ruled for fifty-four years, and after thirty years of reigning, kings were entitled to celebrate a *sed* festival. During this ritual the king demonstrated his physical worthiness to continue rule and showed his piety to the gods by visiting their numerous shrines, built to bring them together in a single complex. In response the gods bestowed the crowns of Upper and Lower Egypt on the king, renewing his kingship and granting him "millions of years like Re." Even as early as the Third Dynasty, the *sed* festival was an occasion for kings to adorn themselves with solar imagery, a custom elaborated during the time of Thutmose III. The king wears crowns hung with solar disks and uraei, making him the image of the sun. Thutmose III celebrated numerous *sed* jubilees, having been entitled to a renewal every three years following the first one. The solar connections were more evident late in his reign, particularly in the reliefs from his Deir el-Bahari temple, Djeser-Akhet.

During the reigns (1427–1352 BCE) of Amenhotep II, Thutmose IV, and most especially Amenhotep III, the last of whom called himself Re in inscriptions, this connection with the *sed* and the sun god was continued.

Here the quest for immortality joins the kingship to the religious beliefs of the Egyptians. While the Middle Kingdom rulers may have lacked a clear identification with the sun god, the New Kingdom kings recaptured that aspect of the Old Kingdom rulers. Without excluding the populace from its right to the afterlife, the kings kept the journey of the sun god through the twelve hours of the night to themselves (with the single exception granted to Thutmose III's vizier Useramun). The Book of the Secret Chamber, more often called simply the Amduat, was formulated by the beginning of the Eighteenth Dynasty and portrayed the king as the ram-headed *ba* of the sun descending into the netherworld to face the terrors of the night and to rise triumphantly at the eastern horizon. Although all people might hope to ride in the "barque of millions" together with Re, only the kings of the New Kingdom were to have the Amduat that ensured their identification with the sun, in body and soul.

The reign of Thutmose III (and Hatshepsut, his co-regent) was pivotal, for it brought together all the strands that characterize religion and kingship in the New Kingdom. The military king Thutmose III, who dominated the Levant and eventually Syria, effectively maintained the world order, while the builder Thutmose III humbly offered what the king possessed to the gods and showed the ruler offering to them as their priest. Having celebrated the *sed* festival, the king was imbued with solar connections that promised eternity for his rule. Even the form of the Amduat was innovative, since it was the first of its kind, an illustrated narrative. Although the ancient aim of identifying and categorizing the cosmos remained the prime aspect of the Amduat, the secret knowledge contained within the text was presented in a new way. Religious spells before the Eighteenth Dynasty had vignettes associated with them, and the Book of Going Forth by Day, often called the Book of the Dead, was so conceived. The Amduat, however, was designed with interdependent scenes and sequential texts. The scenes are labeled, with the expansion texts placed in relation to the figures to maintain connection between texts and representations. It is no coincidence that the earliest non-funerary example of this type of book is in Hatshepsut's Deir el-Bahari Temple, where, with the Punt reliefs and the divine birth sequence, complete narratives are presented in the same fashion. Although the invention of this book form appears to have occurred with the writing of the Amduat, with literature as with all of Egyptian culture, the realm of eternity was never distant from the realm of life on earth. That indeed is the meaning of the quest for immortality.

Betsy M. Bryan

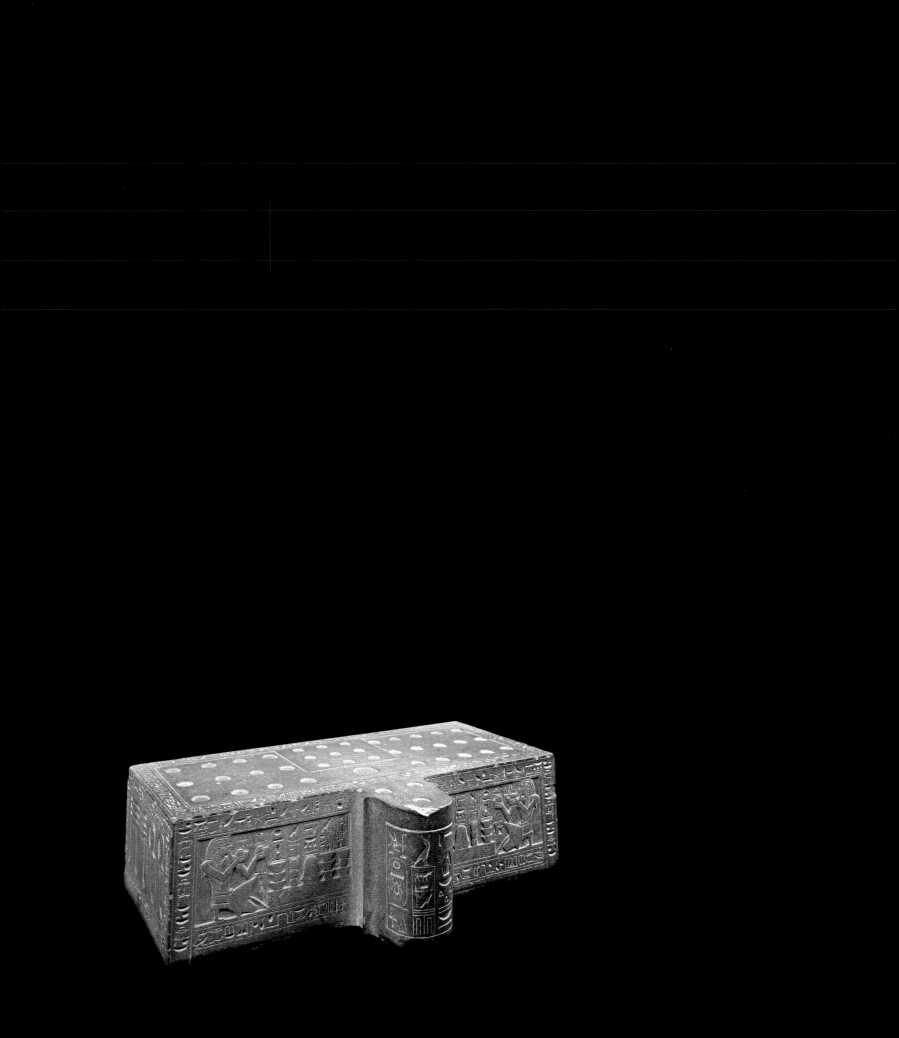

Thutmose III and the
Glory of the New Kingdom

Fayza Haikal

• Thutmose III is not only one of the greatest pharaohs of Egypt's ancient history, but he also belongs to its most glorious eras. Under this king many of the enduring concepts of Egypt's royal ideology as well as political and administrative systems came to be expressed on its monuments, thus giving us a better understanding of Egypt's daily life and beliefs and a better comprehension of the complexity and wealth of this ancient civilization.

Thutmose III was the fifth pharaoh of the Eighteenth Dynasty (fig. 1), the first dynasty of the New Kingdom (1550–1069 BCE), also known as the Empire. During more than fifteen centuries of recorded history, the Egyptian state had witnessed immense glory during the Old and Middle Kingdoms (2686–1650 BCE), economic depression during the First Intermediate Period (2160–2055 BCE), and despair and humiliation during the Hyksos occupation in the Second Intermediate Period (1650–1550 BCE). Now Egypt had finally recovered its spirit and hegemony. Recent experiences induced it to expand natural boundaries to protect itself and face the changing conditions and ascension to power of a number of neighbors on northeastern borders. This dramatic growth after the wars of liberation fought by the last kings of the Seventeenth Dynasty (c. 1580–1550 BCE) and the first kings of the Eighteenth (1550–1295 BCE), and resulting essentially from the exploits of Thutmose I, brought wealth home, opened new horizons, and prompted a renewed curiosity toward life in all its manifestations. It also demanded new developments in the administration of the country. Moreover, Thebes under Thutmose III was not only the religious center of the new empire but also the home of Amun-Re, king of the gods, under whose banner the wars were fought, and the city witnessed during the middle of

1 Statue of Thuthmose III. Eighteenth Dynasty, 1479–1425 BCE; graywacke. Karnak Temple cachette, The Luxor Museum.

2 Funerary temple of Queen Hatshepsut. Eighteenth Dynasty, 1473–1458 BCE; limestone. Deir el-Bahari. Modeled after the Middle Kingdom temple of Mentuhotep II, the ruins of which may be seen in the background.

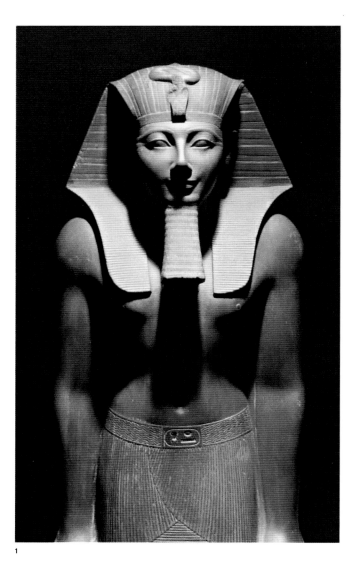

1

8

Having ascended to heaven, [Thutmose II] became united with the gods, and his son, being arisen in his place as king of the Two Lands, ruled upon the throne of his begetter, while his sister, the god's wife Hatshepsut, governed the land and the Two Lands were under her control; people worked for her, and Egypt bowed head.[1]

But somewhere before the seventh year of the king's rule, Hatshepsut assumed the full titulary of "King of Upper and Lower Egypt," and a co-regency was established, which lasted until near the twenty-second year of Thutmose III's rule, when Hatshepsut disappeared from the records and the scene was left entirely to the king. These two periods were extremely different, and it seems clear that Hatshepsut predominated during the co-regency, although there are references to Thutmose III on most of the official monuments. It also seems that the period of the co-regency affected the policies of the king during his autonomous rule.

Hatshepsut, King of Egypt

Already, as Thutmose II's wife and queen of Egypt, Hatshepsut must have had an important role as in ruling the country. Indeed, the female element in the ideology of kingship is prominent, since the royal couple is a reflection on earth of the primeval creative divinities. Their power of procreation is represented by their heir and the perpetration of kingship. The eminent political role of queens in periods of crisis is well documented in the history of Egypt after the end of the Middle Kingdom. During the wars of liberation at the end of the Seventeenth Dynasty, when kings were fighting on battlefields, the actual governing of the country was left to their wives. Tetisheri and Ahhotep, grandmother and mother of Ahmose I, the first king of the Eighteenth Dynasty, probably assumed important political roles, for their place on Ahmose's monuments is considerable.

Thus when Hatshepsut decided to become king of Egypt, the move was not without precedents. It only required some preparations. In her inscriptions in the temples of Karnak and Deir el-Bahari, she repeatedly

the second millennium BCE an unprecedented boom. Together with Thebes, the whole country was flourishing. This chapter endeavors to present the effervescence in all walks of life that informed this fascinating period.

Thutmose III ruled from about 1479 to 1425 BCE. He was the grandson of Thutmose I and son of Thutmose II and a lesser queen called Isis. He was still a young child when his father died, and his aunt and stepmother, Hatshepsut, daughter of Thutmose I and half-sister and wife of Thutmose II, ruled in his stead for a few years. The aged Ineni, the chief architect of Thutmose I and one of the most important officials under Thutmose II, described Thutmose III's accession to the throne:

mentions that her divine father Amun had indeed desired her to succeed her father. The god had designated her as his daughter and heiress to the throne through an oracle in the days of her father, Thutmose I, while they traveled to visit the gods in their sanctuaries and receive their blessings and the gift of life and power. According to an inscription concerning Hatshepsut's divine birth, Amun had even replaced Thutmose I in his union with Queen Ahmose to beget Hatshepsut. The images of this union of the god and the queen, her pregnancy, the birth of the princess, and her presentation to the god so he will recognize her, so exquisitely represented on the wall of one of the porticos of her temple at Deir el-Bahari, are the earliest scenes of theogamy that we have. They would be copied later in the temple of Luxor under Amenhotep III to symbolize his own divine birth and that of all the kings after him and to commemorate this essential characteristic of Egyptian kingship.

It is possible, therefore, that if Hatshepsut did not rule immediately after her father, it was because of the presence of a male successor whose sex better befitted the ideology of kingship (even though he was only the son of a secondary wife). Thus Hatshepsut, instead of ruling alone, was married to her half-brother, Thutmose II, who reigned briefly. But during his brief reign she is a prominent figure on his monuments and appears with him on official scenes. They begot Princess Nefrure, best known for her presence as a child on the beautiful statues of her tutor Senenmut (also her mother's chief steward and architect).

When Hatshepsut began to rule Egypt (c. 1473), the country was at the peak of its glory. Thutmose I's campaigns in Nubia and Syria had ensured the security and supremacy of Egypt, and wealth was flowing into the country from everywhere. There was no need for more campaigns in Asia because, as Hatshepsut says in her inscriptions, "The chiefs of Retenu were still under the fear of her father's time."[2] In the south, there are indications of expeditions to repress Kush, at the Third Cataract of the Nile in northern Sudan, which at some point had relations with the hated Hyksos themselves. To reach Punt, one of Hatshepsut's claims to glory, the expeditions must have crossed many regions that Dedwen, a Nubian

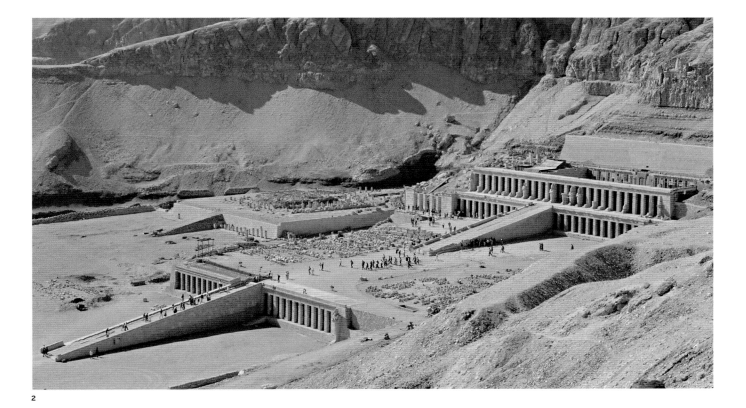

3 Funerary banquet scene from the tomb of Suemniwet, royal butler under Amenhotep II. Eighteenth Dynasty, 1427–1400 BCE; painted plaster on limestone. Theban tomb no. 92.

4 Obelisk of Queen Hatshepsut. Eighteenth Dynasty, 1473–1458 BCE; red granite. Karnak Temple, Luxor.

god, ceded to her under the name of "southern countries." Hatshepsut could therefore concentrate on her internal policies and building program in addition to the restoration of the sacred monuments of Egypt destroyed during the Hyksos domination and the liberation wars.

Hatshepsut's own building activities were many, particularly in Upper Egypt and Nubia. It is clear that she tried to link the New Kingdom with the Middle Kingdom as if to underline the continuity of the tradition and erase the Second Intermediate Period from the history of Egypt. Her temple at Deir el-Bahari is located near the Middle Kingdom Temple of Mentuhotep II and is certainly influenced by its architecture (fig. 2). Built in terraces against the mountain, with its sanctuary hewn into the rock, the temple, dedicated to Amun with additional chapels for Hathor and Anubis and an open court for Re-Horakhty, was also constructed for the celebration of Hatshepsut's own cult and that of her father, Thutmose I. In it, she also honors her Middle Kingdom ancestor Nebhetepre (Men-

tuhotep) and reinstates the ceremonies of "the Beautiful Festival of the Valley" established in the Middle Kingdom and apparently neglected in the Second Intermediate Period. During the festival, the god Amun of Karnak, accompanied by the reigning king, crossed the river to pay homage to the royal ancestors and visit them in their sanctuaries. This festival, to which the valley of Deir el-Bahari gave its name, continued to be celebrated until the Greco-Roman period in Egypt. In it, the link with the deified ancestors was established and annually renewed, thus legitimizing the reigning king's right to the throne. The festival developed through the ages and gradually became a commemoration of all the dead, private as well as royal (fig. 3), and after the onset of Christianity and even Islam some of its aspects remained part of the folklore of the country. Its echoes are still present in the traditional celebration of the dead performed today.

While Hatshepsut's temple architecture is inspired by its Middle Kingdom neighbor, the program of its decoration is newer to us, for in addition to the representation of "the festival of the valley" and "the divine conception and birth of the queen," the temple decoration also includes, next to traditional scenes, others typical of the reign of Hatshepsut. Her famous expedition to Punt, for example, is depicted in great detail. We see the Puntites in their habitat, with their houses built on pillars and their flora and fauna. The Egyptian expedition is welcomed by the chief of that land and by his enormous wife, too heavy to be carried by any donkey. The loading of the Egyptian fleet with gold and exotic products, including incense trees to be planted in the gardens of the god Amun in front of the terraces of Deir el-Bahari, is depicted on the wall of one of the porticos of the temple, while another shows the transportation of two obelisks by boat, all in a beautiful style reminiscent of the most splendid reliefs of the Middle Kingdom.

In addition to her memorial temple at Deir el-Bahari, Hatshepsut built extensively on the west of Thebes. Two tombs were made for her at different moments of her life, but it seems she essentially prepared one of those, tomb 20 in the Valley of the Kings, for her father, Thutmose I.

3

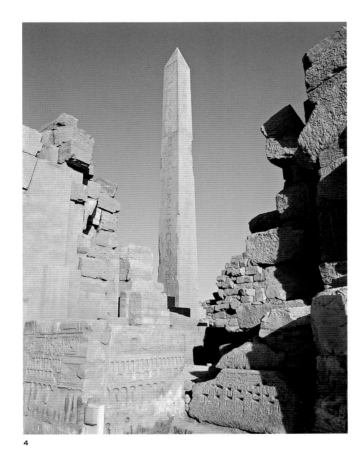

4

Indeed, the tomb contained two burials, and Hatshepsut had a stone sarcophagus, originally made for herself, enlarged to fit the taller body of her father. It is probable that the reappearance of stone sarcophagi for royal burials was another of the renewals and links with the Middle Kingdom that occurred under the queen. Certain scholars believe that she was the first pharaoh to have a tomb hewn in the Valley of the Kings.

Hatshepsut also began an exquisite little temple at Medinet Habu for the god Amun and the primeval ancestors of Amun. The temple played an important role in the rituals of the festival of the valley. Thutmose III completed it after the year when Hatshepsut disappeared from the records (regnal year 22). Later, other kings kept adding to it until the end of the Greco-Roman period.

In Karnak, Hatshepsut's program was just as ambitious and innovative. There she had a palace and erected several chapels in addition to two pairs of obelisks, one of which, the one presumably east of the temple, has now disappeared. Of the other pair, erected between the Fourth and Fifth Pylons—in a columned court behind the temple entrance, one is still standing (fig. 4), dominating the temple from its height, while the other, now broken and lying in the vicinity of the sacred lake, presents to us a beautiful scene of the queen's coronation as pharaoh! Hatshepsut also built the Eighth Pylon to better mark the processional way to the temple of Luxor, south of Karnak. The Theban triad (Amun, Mut, and Khonsu) visited Luxor Temple on the festival of Opet, the other essential festival for kingship, celebrating the divine birth of the pharaoh and his link with the gods. A series of repository chapels for the barques of the gods to rest in on their way to Luxor was also established. One of these was reused by Ramesses II and is now standing inside the temple of Luxor.

But among the most beautiful and most important monuments for the history of the co-regency is the Red Chapel in Karnak on which she appears, together with Thutmose III, in many official ceremonies of their common reign. Hatshepsut disappears from the records around year 22 of Thutmose III. We do not know how her reign ended or when she actually died. The transition from the co-regency to Thutmose's autonomous rule seems to have happened without major signal events. Monuments begun by Hatshepsut under the co-regency were completed in Thutmose's name alone, and sometimes with architectural alterations. But Hatshepsut's *"damnatio memoriae"* does not seem to have started then. Many historians now believe that it instead happened in the second part of Thutmose's autonomous reign, and there is evidence that it continued until the middle of the reign of his son and successor, Amenhotep II. Hatshepsut's image was erased from all monuments and her name replaced by that of either Thutmose I, Thutmose II, or Thutmose III as if to make sure that the lineage was totally undisturbed. It has been argued, therefore, that the main reason for the annihilation of her memory was to ensure the legitimacy of the succession to Amenhotep II against any other branch of the family related to Hatshepsut, people who could have had some aspiration to the throne.

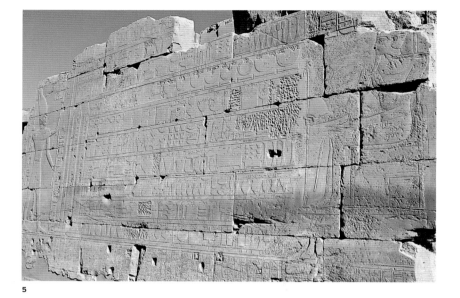

5 Annals of Thutmose III. Eighteenth Dynasty, 1479–1425 BCE; sandstone. Karnak Temple, Luxor. Records the military campaigns of the king over more than twenty years of his reign.

5

Sole Reign of Thutmose III

Thutmose III's autonomous rule began with a drastic change in foreign policy. After more than twenty years of relative peace, the king conducted no less than fourteen expeditions in Asia between year 22 and year 39 of his reign. His military exploits, found in contemporaneous military diaries and reports are recorded in what is now known as Thutmose III's annals, inscribed in year 42 on walls around the sanctuary of Amun's sacred barque in Karnak (fig. 5). These are further corroborated by a number of royal stelae and private inscriptions belonging to people who witnessed the events. His most important campaigns were the first and the eighth. The others were of a much smaller scale, more to complete what had been left undone or to crush secondary insurrections somewhere or another.

Military Campaigns

The long years of peace under the co-regency had encouraged the principalities of Palestine and Syria to rebel against Egypt's supremacy as established by Thutmose I, and it was reported to Thutmose III that a coalition led by the prince of Kadesh was forming against the country: "The vile enemy of Kadesh has come and entered Megiddo He has gathered to himself the princes of all lands who were loyal to Egypt, together with as far as Nahrin...and he says 'I will stand to fight against His Majesty here in Megiddo.'"[3] Thutmose didn't hesitate. He proceeded "to overthrow that vile enemy and to extend the boundaries of Egypt in accordance with the command of his father Amun-Re."[4] When he reached the town of Yehem, not too far from Megiddo, on the first days of his twenty-third regnal year, he called a council of war to decide about the best strategies. The shortest road to Megiddo was the most difficult. It went through a narrow pass at Arouna in which the army would have to stretch very thin and proceed slowly and thus be vulnerable to any attack. The courtiers and generals around the king thought it dangerous, preferring longer but safer routes. Based on these considerations Thutmose III assumed that the enemies would never expect him to take such a risk. So he decided to surprise them and took the shortcut. The battle was an absolute success, and the enemy fled toward Megiddo, leaving behind horses and chariots of gold and silver.

The doors of the city being closed, the enemy had to be shamefully hoisted up the walls by their garments. "Would that the army of His Majesty had not set their hearts upon looting the chattels of those enemies, for they would have captured Megiddo at that moment, while the vile enemy of Kadesh and the vile enemy of this town were being hoisted up,"[5] says the ancient Egyptian narrator. Instead, the Egyptian armies had to besiege the town for seven months before it fell to their hands, thanks to Thutmose III's perseverance and determination to concentrate on the siege as "all the princes of all northern countries were cooped up within it, and the capture of Megiddo equaled the capture of a thousand towns."[6] And, indeed, the temple of Karnak shows us many scenes of the military exploits of the king in which more than 350 Asiatic princes are represented as prisoners, their arms bound behind their backs, and their localities named. The Gebel Barkal stele in Upper Nubia corroborates the presence of no less than 330 Asiatic princes in the coalition at Megiddo. No wonder then that between year 22 and year 39 so many minor campaigns were needed to keep the entire region under control.

In year 33 Thutmose III conducted his eighth campaign even farther north to defeat the King of Mitanni. To cross the Euphrates, Thutmose had boats built for him in Lebanon, somewhere near Byblos. "They were placed on chariots, oxen dragging them, and they journeyed in front of My Majesty in order to cross that great river which flows between this country and Nahrin....Then my majesty set up a stele on that mountain of Nahrin...on the West side of the Euphrates,"[7] thus reaching as far north as the Egyptians ever did in battles. Because of the greatness of his victory, recalling that of his grandfather, Thutmose I, Thutmose III indulged, like him, in hunting elephants in the region of Niy, on his way back home, and he is said to have confronted 120 of them! His hunting prowess also included the capture of a rhinoceros during one of his Nubian campaigns.

Imperial Administration under Thutmose III

If such vivid and detailed descriptions of battles give us some insight on warfare strategies in antiquity, they also highlight the genius of Thutmose III as a military figure. But it was not enough to conquer; it was also necessary to administer properly. At the end of his year 39, Thutmose III controlled an empire stretching from the Upper Euphrates in Asia Minor to the fourth cataract in the Sudan. Such an expansion outside his natural borders required great skill in diplomacy and a number of innovations for its administration. The southern provinces, which had been in contact with Egypt throughout their history and which had more kinship to Egyptian culture, were left under the responsibility of the "King's Son, Overseer of Southern Countries," later called the "King's Son of Kush." This was a very high position. This official represented pharaoh in Nubia and reported directly to him. The "royal sons" whom we know for this period came originally from Thebes, where they first held administrative titles in the court or in Amun's domain. Their responsibilities in Nubia included essentially collection of taxes and construction of monuments in the name of the king in addition to administering Egyptian residential centers.

In the "northern countries" the situation was different. In spite of the presence of well-equipped Egyptian garrisons in coastal harbors and fortresses along the road to Asia and even inside conquered lands, like the fortress called "Menkheperre subdues the nomads" to keep watch and provide for the expeditions, Thutmose III had to rely on the loyalty of the local princes and their long-established administrations to control these lands. To secure their allegiance, after replacing rebellious princes with his own men, Thutmose III brought their children and younger brothers back to Egypt as hostages. There, they were educated with Egyptian princes to impress them with Egyptian culture and beliefs so they could better serve Egypt when they returned home to rule. Royal messengers, residents in the newly conquered or reconquered countries or traveling between Egypt and their own residences, also assisted in the administration of these provinces and in linking the local princes with the Egyptian court.

Inside Egypt itself new positions were created to face the challenge. Most important among these was that of overseer of the gate to the northern foreign countries held, by among others, a certain General Djehuty. The official in that position was to register taxes and receive the tribute brought annually to his majesty and ship it to Egypt. General Djehuty was also the king's man of trust for all foreign countries, including "the-islands-in-the-middle-of-the-sea" (Aegean Islands) and the "one who filled the treasury with lapis lazuli, silver and gold,"[8] as he is called on a golden cup now in the Louvre, offered to him by Thutmose III himself as a sign of his favor. General Djehuty was so famous for his military feats that his exploits passed into the realm of literature. Thus we find on a later papyrus (Papyrus Harris 500, now in the British Museum),[9] an account of his capture of the Syrian city of Joppa under Thutmose III. Since he could not capture it by force, General Djehuty managed to take it by tricking its prince out of the city while he introduced his own soldiers, hidden in baskets, in a way reminiscent of Ali Baba fooling the thieves.

13

6 Scene of the vizier receiving the produce of Egypt for the king. Eighteenth Dynasty, reigns of Thutmose III and Amenhotep II, 1479–1400 BCE; painted plaster on limestone. Theban tomb no. 100 of the Vizier Rekhmire.

7 Thutmose III Festival Hall. Eighteenth Dynasty, 1479–1425 BCE; sandstone. Karnak Temple, Luxor. Built after the king returned from his first campaign into Asia.

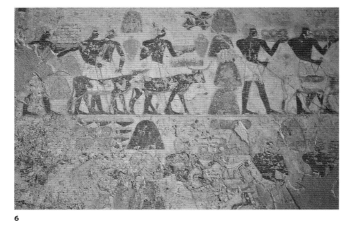

6

In the army itself, by then composed of professional permanent soldiers in all its arms, we begin to hear of "scribes of the army." Tjanen, for example, whose career began under Thutmose III whom he accompanied in his campaigns in the Levant, was overseer of the scribes of the army of the lord of the Two Lands (Upper and Lower Egypt). Hence he claims in his tomb that he was responsible for recording all the campaigns of the king.

Under Thutmose III we have for the first time, so far, a text that informs us fully on the duties of the most important official in Egypt, namely the vizier. The text is a welcome addition to studies based essentially on titles and prosopographies and gives us important clues on the administrative system of the country. The vizier reported directly to the king and coordinated with him both the administration of royal domains and the civil administration of the country. We know that more than one vizier could exercise the function at the same time, in different parts of Egypt. Under Thutmose III, there was a vizier in Thebes and another in Memphis, the northern administrative capital of Egypt since the beginning of history. In his magnificent tomb in the west of Thebes, the vizier Rekhmire recorded pharaoh's speech to him on the occasion of his appointment to the position and the king's constant stress on the importance of integrity and justice in all the vizier's dealings since he not only represents *maat* (justice, balance, right) but he also reflects the nature of his king and protects his reputation: "He is the copper that shields the gold of his master's house,"[10] and as the proverb says, "The king is mercy, but the vizier is control."

Rekhmire's tomb inscriptions and scenes combine elements of his private and professional life. As vizier and chief justice he gives audience to petitioners, imposes the laws and royal decrees, nominates and judges higher officials in case of misbehavior, supervises the cadastre and mining, receives foreign tribute from all over the empire, supervises building activities in the name of the king, and secures the pharaoh's security (fig. 6). His charges are indeed very heavy, but an army of officials and scribes, keeping the best archives possible in the ancient world, assists him. Other scenes necessary for his afterlife show, in addition to the sequences of the "opening of the mouth-ceremony," all the traditional scenes of funerals, offering bearers and banqueting on different religious occasions that we find in most tombs of western Thebes, though in various degrees of elaboration. Images of daily life are also recorded there, so that the study of this tomb alone could give us an almost complete account of Egyptian culture and society under Thutmose III.

It is not possible to enumerate here all the important officials of the reign whose tombs honeycomb the necropolis of western Thebes, in addition to those whose tombs were recently discovered in Memphis or elsewhere. But to give a better view of the complexity of Egyptian administration in the days of Thutmose III we cannot omit Menkheperre-seneb, the high priest of Amun-Re, whose duties toward the temple of Karnak necessitated the accumulation of treasures from various parts of the world, including costly Hittite and Syrian vessels and gold from the Egyptian eastern desert or from the land of Kush. Nor can we forget Amenemhab, Thutmose's companion in arms, in whose lively autobiography we read the most fascinating and amusing accounts concerning the pharaoh's battles as well as the mention of the exact date of the king's death.

At least two viziers of this reign, Ptahmose and Neferweben, have been recorded so far in the Memphite necropolis, in addition to a number of other high officials.

14

Menkheperre-seneb, for example, was overseer of foreign countries and chief of the Medjay (police) while Benermerut, the overseer of the two houses of silver and gold was also overseer of all works of the kings among other duties.

Building Program of Thutmose III

Thutmose's building activities probably surpassed most of the pharaohs. His monuments were everywhere in Egypt and Nubia, and there is evidence of Egyptian cult installations even in Asia, where in some places his name was fondly remembered many generations after his conquest. But unfortunately, of his building activities in the Nile Delta, little remains. Some structures were reused under later pharaohs or destroyed by humidity. We know about the existence of these monuments from contemporaneous accounts, such as Minmose, one of his overseers of works, or from titles of officials buried in Memphis. In addition to Benermerut who was "overseer of all works of the king," a certain Ameneminet, who was "chief of Memphis" and "general of the army" at the end of the Eighteenth Dynasty, was also "steward in the Temple of Thutmose III," a title that clearly indicates this king's presence in Memphis. This city, as already mentioned, was too important to be overlooked. It was not only the historical administrative center of Egypt but also a huge agglomeration not too far from the northeastern border, thus allowing proximity to events in Asia. Memphis was also the main center of worship of the god Ptah, one of the most important divinities of Egypt, and his temple was generously endowed with the pharaoh's bounty. The city's nearby harbor, Perunefer, was well known from the beginning of the Eighteenth Dynasty. In and around it many foreigners, coming to trade in Egypt, established themselves. It is well known that big cities in Egypt became quite cosmopolitan after the Eighteenth Dynasty expansion in Asia, as triumphant kings used to bring back prisoners as booty together with goods. A number were given as royal presents to the valiant generals who had captured them, but most went to crown properties or temple estates to express the king's piety and gratitude to his "fathers," the god protectors of Egypt under whose banners the battles were fought. Heliopolis, another great religious center of Egypt and perhaps the oldest, since it was the city of the sun god Re, was endowed by Thutmose III with a pylon and a temenos wall for its temple, in addition to the usual donation in grain, cattle, serfs and other riches to maintain life and production on the temple estates and better serve the god and provide for his offerings. Moreover, Thutmose erected at least two obelisks there. One is now on the Thames embankment in London; the other decorates Central Park in New York.

In Upper Egypt and Nubia, monuments have actually been found in many places, some in the form of additions to existing temples, some as distinct buildings. Akhmim, Atfih, Asyut, Medamud, Tod, Elkab, Edfu, and Elephantine are examples of such places. In Esna and Dendera, Thutmose's memory was still honored in the Greco-Roman period. In Nubia monuments in his name are already recorded from his regnal year 23, and between year 25 and 27 a fortress was built in his name farther south. From the later part of his reign monuments were erected everywhere down to the fourth cataract of the Nile. Amada, Ellesiya, Faras, Dakke, Argos, Doschai, Kubban, Semna, and Gebel Barkal are Nubian sites in Egypt and Sudan marked by his presence. But it is essentially through his monuments in Thebes that Thutmose III is best known (fig. 7).

15

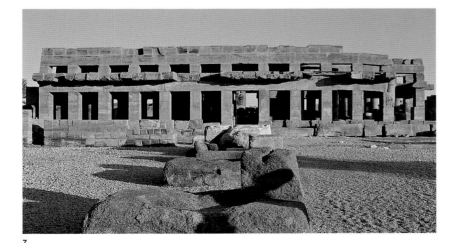

7

8 Relief of Thutmose III wearing the *atef* crown. Eighteenth Dynasty, 1479–1425 BCE; painted limestone. Funerary temple of Thutmose III at Deir el-Bahari, The Luxor Museum.

The Akhmenu Monument and Temple of Karnak

Immediately after his return from his first campaign in Asia, Thutmose III ordained the building of his famous Akhmenu in the temple of Karnak. Situated behind the sanctuaries of the east-west axis of the temple, the Akhmenu is a complex monument, in architecture and decoration. It seems to have gathered within its walls most of the monarchical rites confirming both the legitimacy of the kingship and its perpetuation. The temple was also designated by the king himself as a "great temple of millions of years,"[11] built for his fathers, the kings of Upper and Lower Egypt, in which their names would be established with new statues and offerings in unprecedented quantities. Indeed, in the Ancestors' Room, the king is represented making offerings to the statues of sixty-one kings distributed in four registers. The most ancient one among them is Snefru, father of Khufu and first king of the Fourth Dynasty (2613–2589). There are names of kings of the Old and Middle Kingdoms and of the Seventeenth Dynasty — kings who ruled the whole of Egypt before the New Kingdom and whose memory was respected and whose legitimacy never disputed. Thus the link with the ancestors was established and perpetrated through the ritual.

Related to that ritual was a series of chambers dedicated to the god Sokar, a Memphite deity associated with funerary rituals and festivals connecting with the ancestors and ensuring resurrection ever since the Old Kingdom. Because of his tie to monarchical rites of regeneration, this god is also present in the "great temples of millions of years" commonly known as "memorial/funeral temples" on the west of Thebes. His presence in the Akhmenu thus underscores the main purpose of that temple — to link the reigning king with his royal and divine ancestors and perpetrate and guarantee the regeneration of the royal function. It is also because of this potential for life and resurrection (dormant under his aspect of funerary god) that Sokar has such an important place in the book of Amduat, which ensures the resurrection of the deceased king after his merging with the sun god in the afterlife.

Another important royal ritual depicted in this temple is that of the Sed festival, commonly known as the jubilee, during which the king's physical power and ability to rule were reconfirmed. The ceremonies ended with the gods renewing their mandate to the king and giving him "eternity on the throne of Horus of the Living."

In addition to these rituals directly related to the monarchy, the god Re was also present in the Akhmenu in a solar chapel on the roof of the temple. Amun's secret sanctuary could be reached via the famous botanical garden on the walls of which Thutmose, for scientific or religious reasons, had represented all sorts of exotic flora and fauna he had encountered during his campaigns abroad.

In the period between the erection of the Akhmenu at the beginning of his autonomous rule and his annals established in year 42, Thutmose III added many monuments to the great temple of Karnak. These included a new enclosure wall for the sacred area, a pair of obelisks, one of which now decorates the city of Istanbul, two pylons (the Sixth and Seventh), a kiosk between pylons seven and eight, and ancestor shrines.

By the end of his fifty-four year reign, Thutmose had also built a new central barque shrine for the temple and had constructed an Eastern Temple, a contra-temple to his Akhmenou, where a cult of the sun god Re-Horakhty was enacted. He had built but never erected a single obelisk meant to stand before this Eastern Temple. Thirty-five years after his death, the king's grandson, Thutmose IV, had this obelisk set up, after adding an inscription telling how he had found it lying in the artisan's workshop.

In the west of Thebes, Thutmose completed what was started during the co-regency, but sometimes replaced the name of Hatshepsut with those of his father or grandfather. His own memorial temple, Henket-Ankh (who offers life), already in existence during the co-regency and functioning from at least year 23, was much enlarged. Ironically, it is almost totally destroyed today, and it seems that it was already out of use by the end of the New Kingdom. Thutmose also erected a high temple to the glory of Amun at Deir el-Bahari, next to but much smaller than that of Hatshepsut and raised over it in height (fig. 8). This one too is now mostly destroyed. The king had at least three tombs dug in the Valley of the Kings: one for himself,

high up in the hill, apparently unfinished at the time of his death; one for his wife Merytre-Hatshepsut, mother of his son Amenhotep II, and one for his grandfather Thutmose I. He also completed his father's tomb and his memorial temple both situated north of Medinet Habu, at the other end of the Theban necropolis.

Art and Science under Thutmose III

Thutmose III's piety and concern with the afterlife manifested itself not only through his monuments to his ancestors and to the gods and their endowment with the spoils of his conquests, but also through his interest in religious texts. The Litany of Re, for example, well known from later royal tombs, is written on his very shroud, while the complete Amduat, already known from Thutmose I's tomb, fully unfolds on the walls of his burial chamber and of those of his vizier, Useramun.

Together with religious compositions ensuring his merging with Amun-Re, other literary forms developed under Thutmose III. Poetry is best illustrated by the text of the famous "Poetical Stele" with the rhetorical address of the god to the king. The alternation of narrative passages with inventories that we find in his Annals, or his damaged Youth Text, where the oracle of Amun selects him as king, are also new developments, although Hatshepsut's

oracle may have been slightly earlier. An ostracon of the same period develops a theme unknown to us before, with a text expressing "longing for Thebes" on one side, while the other carries a passage from an invocation to "Amun as Inundation." Written in a late form of classical Egyptian, this longing for a place could be a more timid precursor of the love poetry famous among Egyptian creations of the Ramesside period. It is still part of Egyptian culture to inquire discreetly about the beloved by asking about the place where he or she lives.

Thutmose's interest in the sciences was made clear by the importance he gave to the flora and fauna of the countries he visited and also by his concern for medicine and public welfare as evidenced by prescriptions of his time, preserved and followed throughout ancient Egypt's history.

Thutmose's royal wives are represented on a pillar of his tomb. Sitiah and Merytre-Hatshepsut were each "great royal wife" while Nebetta does not seem to have borne this title. Besides his heir Amenhotep II, we know of a certain eldest son of the king, Amenemhat, who may have died before his father, as he never ruled; a Thutmose and a Menkheperre are also attested. Merytre-Hatshepsut, the mother of Amenhotep II, gave Thutmose III a daughter as well. The king had many secondary wives, some probably from Asia. They are best known today for the wonderful jewelry they left behind.

Thutmose's reverence for his ancestors and care for his country were gratefully paid back. In addition to the celebration of his cult in his own memorial temples, we find him worshiped on scenes of private stelae either as himself or as a form of Amun, Min, or Thoth, both in Egypt and in Nubia. Menkheperre' the throne name of Thutmose III as king of Upper and Lower Egypt, became a sort of spell or amulet and was inscribed on scarabs not only in Egypt but also in the egyptianized Levant long after his death. His life and deeds became an important part of the Egyptian Senruset saga famous in the Greco-Roman period, woven around and combining in one, the great pharaohs of ancient Egypt.

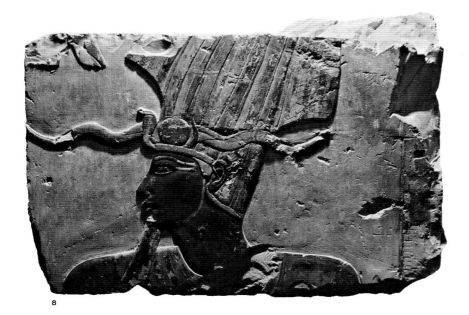

9 Relief sculpture of Amenhotep II
shooting arrows through copper targets.
Eighteenth Dynasty, 1427–1400 BCE;
red granite. Karnak Temple, The Luxor
Museum.

10 Giza stele of Thutmose IV.
Eighteenth Dynasty, 1400–1390 BCE;
red granite. Giza.

Amenhotep II

Amenhotep II ruled Egypt (1427–1400 BCE) for about thirty years after his father and followed the same firm policy in the Levant. Even as a youth he had been famous for his physical strength and love of martial arts. His great stele erected near the sphinx in Giza describes him as one "who had no equal on the battlefield"; "who knew horses and cavalry so that he didn't have his equal in his numerous army"; "there was no one who could draw his arc or surpass him at running"; "his arms were vigorous and indefatigable when he held the rudder to direct his barge."[12] And indeed, one of his most famous reliefs depicts him shooting arrows through a series of copper targets while driving his chariot full speed with the reins attached around his waist (fig. 9). This image of the king was so popular and so descriptive of his personality that we find it again on scarabs in the Levant. Some art historians even think might have been, together with similar representations of war divinities, a model for certain scenes in Greek mythology. No wonder then if, when in year 7 he had to face a coalition of unaligned chiefs in the region of Takhsy, he defeated them and brought seven of them bound, head-down, on the royal barge back to Egypt. The hanging of six of them in Thebes is depicted on the walls of his temple; the seventh was taken all the way down to Napata in Upper Nubia to display the might of Egypt and her young king. A second campaign in year 9 seems to have been sufficient to establish a lasting peace under the supremacy of Egypt so that the king could benefit from its economic rewards and concentrate on his building program inside the country. Among his many great and perhaps one of his most innovative monuments is the temple he built for the Sphinx at Giza, who had been identified in the New Kingdom with the god Horus in his form of Horemakhet, or "Horus in the Horizon," the whole site of the pyramids having become a place of pilgrimage for the worship of royal ancestors.

Thutmose IV

Thutmose IV's rule was short and peaceful (1400–1390 BCE). He is remembered mainly for the "dream stele," which he set between the paws of the Sphinx; for the beautiful art of this period, which we can admire in the private tombs of his high officials and courtiers; those of his father, and for gradually demilitarizing his court and the civil administration of the country. Thus we rarely find the title of general among his courtiers. The dream stele tells us how the Sphinx selected him, presumably among other royal princes, as his own son, to become his heir upon the throne of Egypt (fig. 10):

One of these days it happened that prince Thutmose came traveling at the time of midday. He rested in the shadow of this great god. [Sleep and] dream [took possession of him] at the moment the sun was at zenith. Then he found the majesty of this great god speaking to him from his own mouth like a father speaks to his son and saying: "Look at me, observe me my son Thutmose:

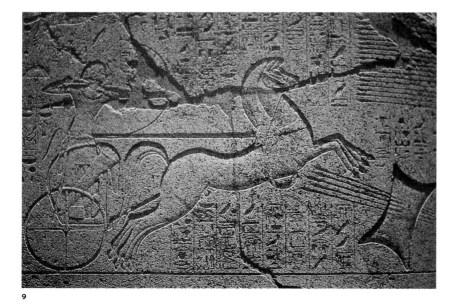

9

18

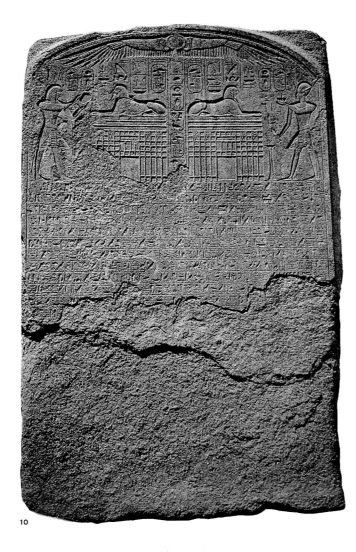

10

I am your father Horemakhet-Khepri-Re-Atum. I shall give to you
the kingship [upon the land before the living]…The sand of the
desert upon which I used to be, [now] confronts me; it is in order
to cause that you do what is in my heart that I have waited,
for you are my son, my protector. Look, I am with you. It is I who
guide you.[13]

Thus this stele not only gives us an account of
Thutmose's designation as king by the god, but also informs
us about, presumably, the Sphinx's first clearance from
the sands of the desert.

Amenhotep III

After Thutmose III the towering figure of the dynasty
must be seen in his great grandson Amenhotep III
(1390 – 1352). During nearly thirty-nine years under his
rule, Egypt enjoyed peace and affluence, and the peak of
prestige both in Nubia and in the Levant. Amenhotep III
and his era were dazzling. Internationally, it was sufficient
to conduct relations through diplomatic missions, not
only with Asia Minor, but also with Greece and the Aegean
islands. His prestige manifested itself in royal monuments
unprecedented thus far, and in the number of private
tombs and in the wealth and refinement of their decoration
and funerary accoutrements. The reliefs in the tombs
of Ramose, Khaemhat, or Kheruef would alone suffice to
illustrate the sophistication of social life and the arts.
Amenhotep, son of Hapu one of the king's most famous
courtiers, was in charge of the completion of some of his
most glorious monuments. He was allowed to have his
own memorial temple overlooking that of his king. Because
of Amenhotep, son of Hapu's great knowledge and wisdom,
his people later deified him. Tombs of other great officials
of this period were found in many places in Egypt.

The Colossi of Memnon that now dominate the
plain in western Thebes were cult statues of the king
protecting Amenhotep III's First Pylon at his memorial
temple. Literary texts abound that describe the beauty
of this temple, now totally destroyed, as well as the splen-
dor of "the gleaming Aten," his palace in Malkata south
of his temple. His monuments in Karnak and Luxor are
equally magnificent and particularly innovative. In Luxor
he reshaped the temple to underline its specific purpose —
regenerate the royal *ka* through the rites performed during
the Opet festival, when Amun of Karnak came to Luxor
in his form of Kamutef, the fecundity god, accompanied
by his consort Mut and their child Khonsu and the king
himself, to reenact the latter's divine birth to regenerate
his divinity and reassert his right to kingship as the legiti-
mate heir to the god.

19

11 The Ramesseum. Nineteenth Dynasty, 1279–1213 BCE; sandstone. Funerary temple of Ramesses II, Thebes. The temple plan included two pylons, two colossal statues, two courts, a hypostyle hall, a sanctuary, and subsidiary structures.

12 Colossal statues of Ramesses II. Nineteenth Dynasty, 1279–1213 BCE; sandstone. Temple of Abu Simbel. This temple was a powerful visual symbol of the pharaoh's strength and his deification.

13 Relief of the Sea People, a migratory population from the Mediterranean and Asia Minor repelled from Egypt by Ramesses III. Twentieth Dynasty, 1184–1153 BCE; sandstone. Temple of Ramesses III at Medinet Habu.

The monuments of Amenhotep III are too numerous to discuss here, but we should mention that in Memphis, the first known Apis-bull burial in the Serapeum dates to his reign. His building activities in Nubia indicate that his own deification is beyond doubt, as is that of his great wife, Queen Tiye, who not only appears with him in scenes of his jubilee on the wall of his temple in Soleb but who is also deified in her own temple nearby, at Sedeinga, as the sun god's counterpart. The deification of Amenhotep III and Queen Tiye became a model to be emulated later by the next outstanding pharaoh, Ramesses the Great, but it also paved the way to his own son Amenhotep IV's religious reform, which brought about the collapse of his dynasty.

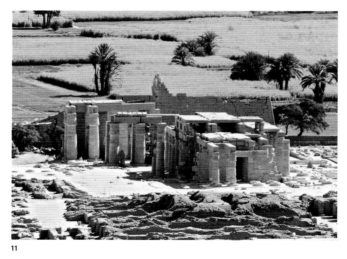

11

12

Ramesses II

Ramesses II's figure dominated the Nineteenth Dynasty (1295–1186), not only because he ruled for about sixty-seven years (1279–1213 BCE) but also because of the number and magnificence of his monuments and his policy inside Egypt and abroad. On the international scene he had to deal with a changing world and face the Hittites who, newly risen to power in Anatolia, were challenging Egypt's supremacy in the Levant. Ramesses waged a series of wars against them, the most important being that of regnal year 5, which ended in stalemate after the famous battle of Kadesh. The battle, however, was publicized as a feat of the king's personal valor and recounted on the walls of no less than five of his temples (fig. 11). The international political scene nevertheless remained highly unstable, and conflicts between the Hittites and their Assyrian neighbors induced the Hittites into peace negotiations with Egypt. A formal treaty was signed in year 21.

With peace on the eastern front, Ramesses II could concentrate on his western borders and build a whole series of fortifications to ward off Libyan invaders. In the south, generals of his army who kept peace and ensured prosperity occupied the position of King's Son of Kush. They also supervised his vast building program in lower Nubia, where rock-cut temples bear witness to his grandeur and the genius of his architects (fig. 12). His deification and that of his great wife, Nefertari, are particularly evident at Abu Simbel, where Ramesses is offering to his own deified self on the façade of the great temple, while Nefertari is clearly identified with Hathor in the small one.

Ramesses' monuments appear everywhere in Egypt. In addition to his own memorial temples, where his colossal statues received a special cult, both official and popular, he enlarged those of the gods under whose banners he fought. His presence is particularly strong in Luxor, where his pylon, courtyard, and colonnade are now essential features of the temple. In Karnak he completed the magnificent hypostyle hall that his father, Seti I, had started as a "temple of millions of years," like the Akhmenu of Thutmose III or the memorial temples of the west of Thebes.

Although many of his monuments in the north of Egypt have been dismantled and reused, Memphis still holds a number of his great colossi, one of which was moved to Cairo to decorate the central station square soon after the 1952 revolution.

Ramesses II's building program included the appropriation of many monuments, presumably as a sort of reconsecration, after restoring them. Thus we find his cartouches on statues originally belonging to Amenhotep III or to the great kings of the Middle Kingdom, whom Ramesses admired and wanted to emulate.

Among Ramesses' most extraordinary building activities is Pi-Ramessu, his residential capital in the western delta where his family originated. This city, which was started by his father Seti I as an extension of Avaris, the old Hyksos' headquarters, is, in fact, the Ramesses of biblical tradition, where the people of Moses were said to have worked and out of which their Exodus started. Its beauty and wealth are described in many literary texts of the period. It is said, among other things, that Pi-Ramesses was so vast that the sun rose and set within its boundaries.

During his long life the king had numerous wives and many children; his sons were often represented on his monuments, as young generals of his army. Because of his longevity, many of them predeceased him, and it

seems that they were buried in a monumental tomb in the Valley of the Kings, opposite that of their father. Among his sons, two are to be noted: Khaemwaset, the high priest of Ptah in Memphis who enjoyed restoring the monuments of his ancestors and who became a hero of later tales, and Merenptah, his thirteenth son and successor to the throne of Egypt who, like his father, had to face the changing balance of power on the international scene and fight the Libyans and Sea Peoples who had recently appeared and gradually controlled most of the eastern Mediterranean countries.

After Merenptah the dynasty ended in relative chaos due to further foreign pressures in the north, east, and west, and it took some time for the country to reorganize itself under Setnakht, the first king of the Twentieth Dynasty. But it is really his son, Ramesses III (1184–1153 BCE), who protected Egypt from the Libyans' intrusions in the western Delta and from the Sea Peoples, whom he destroyed in year 8 in a major land and sea battle represented in great detail on the walls of his memorial temple at Medinet Habu (fig. 13).

In spite of these military successes, the situation in Egypt was clearly declining. The state treasury, affected by huge donations to the temples and by all the military expenses, had problems paying workmen. Demonstrations against authority and organized strikes were reported for the first time in the history of Egypt. In the palace harem a conspiracy on the king's life was fomented. Although the criminals were discovered and mostly forced to commit suicide, it is not clear whether the king survived the plot. But we do know that his crown prince Ramesses IV eventually succeeded Ramesses III.

After Ramesses III, Egypt lost her provinces in the Levant and turmoil continued on the international scene. Internally, his successors could not stop the degradation. It continued until it brought about the collapse of the once-glorious New Kingdom.

If royal monuments and officials' private tombs give us a fairly good view of ancient Egypt's ruling class, we still have very little material data on the working classes, and ethno-archaeological research can be useful in

this respect. The only group of people whose history is fairly well documented is the one directly connected with the royal building projects. In western Thebes, a village was built for them in a desert valley between the Valley of the Kings and that of the queens. From there, they could also easily access the royal memorial temples on which they would be working. The village housed families of architects, draftsmen, sculptors, painters, and highly specialized craftsmen entrusted with the digging and decoration of the royal tomb. They were organized in two gangs, and each one with its foreman lived on one side of the main road of the village. The sizes of the houses varied according to the status of their owner, but on average they had four rooms—two main ones in the front, followed by a kitchen and a storeroom—on a surface of about seventy-five square meters. A stairway ran to the multipurposed roof, where the family could enjoy open air and socialize with neighbors. Because the village was away from the cultivated valley and water sources, the state provided the villagers with most of their needs, even domestic help. Wealthy residents who had their own plots of land outside the village could be provided with more luxurious commodities.

A small group of temples was built to the north of the village, and the villagers' tombs were hewn in the hills surrounding it. The funerary equipment of the tombs, their decoration, and the texts that the deceased wished to have with them in the afterlife give us a fairly complete view of their standards of life and beliefs. Although we know of no collective worship in a temple, personal piety is expressed in hymns to the gods written in their tombs or in more personalized ones inscribed on stelae and deposited in temples as votive monuments. These, often written in response to a particular experience or in moments of great need, are particularly moving. A passage of one of them reads as follows:

You are Amun, the Lord of the silent,
Who comes at the voice of the poor;
When I call to you in my distress,
You come to rescue me,
To give breath to him who is wretched,
To rescue me from bondage.[14]

Personal piety is also expressed through ancestor worship, which, so typically in ancient Egyptian culture, linked the world of the living with the other life and, somehow, ensured resurrection. A little shrine with a dedication or an ancestor's bust was fixed for this purpose on the wall, in the main hall of the house. The dead were also honored in their tombs and remembered on the many official religious festivals throughout the year.

If we know little about ordinary craftsmen, we know even less about peasantry in general. Houses and graves have completely disappeared. Satirical texts in literature mention them with disrespect rather than pity and consider that they are the most miserable, overtaxed, and overworked class of the population. Yet, officials always boast in their autobiographies of their kindness and fairness to their dependents, in accordance with the principles of ethics that will ensure the survival of their souls. Moreover, the New Kingdom version of the Loyalist Teaching insists on the dependence of the upper classes on their subordinates and on the importance of their labor. Thus we read:

Provide for men, gather people together, that you may secure [?] servants who are active. It is men who create that which exists; one lives on what comes from their hands. They are lacking, and poverty prevails.

One longs for the Inundation — one profits by it; [but] there is no ploughed field which exists by itself....Do not make the laborer wretched with taxes; enrich him and he will be there for you the next year....He who appoints the taxes in proportion to the corn, he is a [just] man in the eyes of God[15]

Such statements, written in the fifteenth century BCE, are also manifestations of the glory of the New Kingdom.

Translations are by Fayza Haikal, but see also sources referenced.

1. James Henry Breasted, *Ancient Records of Egypt.* Vol. 2, *The Eighteenth Dynasty* (London, 1988), 142, §341.

2. Ibid., 91, §225.

3. Ibid., 180, §420, and Miriam Lichtheim, *Ancient Egyptian Literature.* Vol. 2, *The New Kingdom* (Berkeley/Los Angeles, 1976), 30.

4. Lichtheim, *New Kingdom,* 30.

5. Ibid., 32.

6. Ibid., 33.

7. Breasted, *Eighteenth Dynasty,* 202.

8. Henri Stierlin, *The Gold of the Pharaohs.* English ed. (Verona, 1997), 121–22.

9. Papyrus Harris 500, Papyrus British Museum 10060.

10. Breasted, *Eighteenth Dynasty,* 268–69, §666.

11. Ibid., 240, §604.

12. Lichtheim, *New Kingdom,* 41.

13. Betsy M. Bryan, *The Reign of Thutmose IV* (Baltimore, 1991), 146.

14. Lichtheim, *New Kingdom,* 105.

15. Richard B. Parkinson, *Voices from Ancient Egypt: An Anthology of Middle Kingdom Writings* (Norman, Oklahoma, 1991), 71.

23

Exploring the Beyond

Erik Hornung

Translated by David Roscoe

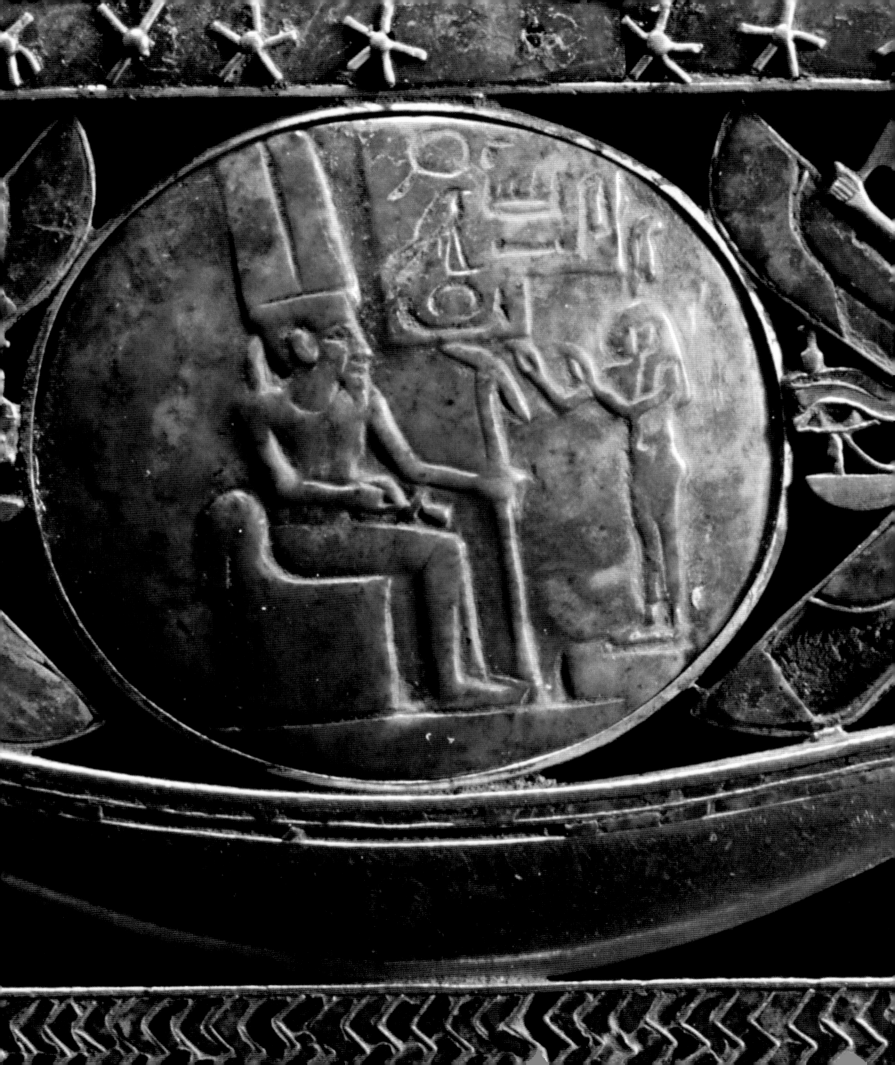

• Early on, the Egyptian turned his gaze to where the sun sinks every evening and tried to follow the celestial bodies in their nocturnal—to us invisible—path, in order to fathom the secret of their constant renewal: for every morning the sun appears, rejuvenated and refreshed on the eastern horizon, and repeats the creation of the world. In so doing, it conveys some sense of the forces of renewal beyond the grave.

Even in the Pyramid Texts, the oldest collection of religious spells that we know (around 2350 BCE), there are early descriptions of the Beyond, at the time still thought to be in heaven (fig. 1). The deceased pharaoh resorted to a number of aids to attain the desired goal among the stars that never set; his ascent to heaven, for which he used every means at his disposal, is a central theme of these spells. A particular destination in the Beyond is the Field of Reeds, a place of paradise where all the wishes of the deceased would be fulfilled. But there are also dangers in the forms of serpents, scorpions, and threatening sentries at the gate. This is why these texts contain not just hymns and rituals but also magic spells to ward off dangers. Osiris appears as the ruler of the dark netherworld, but the deceased would rather accompany the sun god in his barque to enter into the cycle of perpetual renewal.

After 2000 BCE the Pyramid Texts were replaced by the Coffin Texts, in which the world beyond death is depicted even more extensively. The ascent to heaven still played a role but now the gaze was turned more toward the depths of the netherworld, and the west definitely became the kingdom of the dead. A series of spells known as the Book of the Two Ways provided the deceased with information on how to bypass sentries and

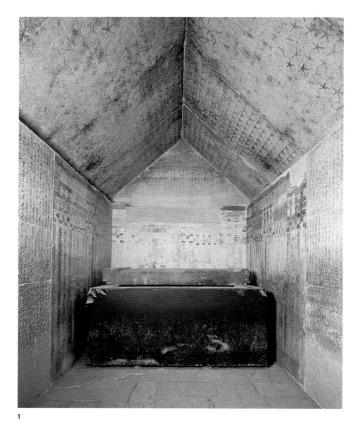

1 Detail, Pyramid Texts from the sarcophagus chamber of King Unas at Sakkara. Fifth Dynasty, 2375–2345 BCE; painted limestone.

28

dangers and includes a schematic drawing with the two ways that ensure a safe passage. The darkness of the Beyond was abhorrent to him and full of unseen dangers, but he had to pass through them to finally meet Osiris, whose gaze would make him immortal. Osiris, violently killed by his brother Seth and restored to life by his sister-wife Isis, embodies both the fate of death and its triumphal conquest.

The darkness of the netherworld is lit by the nocturnal sun, to which the deceased aspires in order to enter into its cycle and thus become immortal in another way. But the renewal of the sun is also fraught with danger, among them Apophis, now making his first appearance in the form of a giant serpent and constantly seeking to bring the sun to a standstill. This threat calls for the strongest of weapons known to the Egyptians — the power of magic.

In the Books of the Netherworld of the New Kingdom (1550–1069 BCE) this image of the Beyond is presented in clear, systematic order. For the first time, religious books no longer consist of individual sayings and spells that are constantly being revised, but rather, there is a permanent unchanging collection of texts. Nor are the images individual vignettes but instead form an integral part of the text. The Beyond is to be described in word and image. The framework is to be the sequence of the twelve night hours that the sun god passes through in his barque. The most important motifs of the nocturnal journey are continually distributed over the individual hours, sometimes reappearing in several hours.

The oldest and most important of the new Books of the Netherworld is the Amduat. The actual date it came into being is still the subject of discussion, but it is no earlier than 1500 BCE. Whereas the Middle Kingdom (2055–1650 BCE) has no specific royal funeral literature, in the New Kingdom (1550–1069 BCE) there is a clear distinction between the sayings and spells of the Book of the Dead, which are available to all deceased, and the Amduat and the ensuing Books of the Netherworld, which are found only in the tombs of kings. Thutmose III, however, allows his highest official, the vizier Useramun, to decorate his burial chamber with the Amduat and the Litany of Re.

The image presented in these works of the Beyond in the New Kingdom is incomparable in its wealth of detail and precision. It is as if the Egyptian illuminates the most hidden corners of the netherworld with the light of the nocturnal sun. Here, too, the sun uses a boat as mode of transport, for the landscape of the netherworld is still based on the earthly Nile Valley, in which the traffic routes are mainly by water.

But the "Hidden Chamber," as the netherworld is known in the Amduat, has different measurements and characteristics than earthly space. The first hour sphere corresponds to the full length of Egypt, and "divine cubits" are used for measuring rather than normal cubits. Into the "Largest City," as the netherworld is also called, throng all those who have died, and so one of the fundamental wishes of the deceased is to find a place there. The awareness of the different nature, nay the fact that this world is the wrong way around, finds expression in another wish — not to be turned upside down so as to avoid being forced to eat one's own excrement.

Other dimensions also apply to time. This is stressed in the Instruction for Merikare (c. 1900 BCE), where it says of the Judges of the Dead that they "see a life span as an hour." The fleeting moment of this world ("like a dream") is happily contrasted with the eternity of existence after death. As time that has elapsed vanishes into the Beyond, it is there and there alone that it is present in inexhaustible abundance. One of the great hopes for the dead is the fact that time in the Beyond is reversible; only thus is the rejuvenation of the sun possible every night anew, for as a "little child" it is born again every day to the Goddess of Heaven. The nocturnal movement of the sun also takes a reverse course, from the setting in the west back to the rising in the east.

The path to the Beyond is divided up by gates, which are not yet represented in the Amduat but are mentioned in the text. At the end of each nocturnal hour, the barque of the sun has to pass through such a gate, which opens up the path to the next field, at the same time keeping out all those who are unauthorized. This is why the gates are protected by threatening sentries, often in the form of fire-spitting serpents or as terrifying demons, bearing knives and names that augur disaster: "Swift killing without questioning"; "The one who loves to cut off heads"; "The one who sprays fire with his eye"; and so on. It is the individual's own fears that place themselves in the way as obstacles and have to be banished, thus enabling a renewal to take place.

In the Book of the Dead a series of spells (144 to 147) deal with these gates, although their number varies between 7 and 21; here there is evidence of an older tradition that has no connection with the division of nocturnal hours in the Books of the Netherworld. Here, the deceased wishes to pass through the gates to Osiris, and even the sentries are in the service of Osiris; the deceased thus proves that he knows them and their names and has divine characteristics; the role played by the right knowledge justifies the efforts made in Egyptian funeral literature to build up such a wealth of knowledge about the Beyond.

One of the main features of the Books of the Netherworld is the care of the sun god for the blessed dead. It was important to the Egyptians that the human person and his circumstances should be completely preserved beyond death. Nothing was to be lost, not from the body, either. That is why the mummy is accompanied by the entrails, interred separately, in the hope that all parts of the person temporarily separated by death will be joined together again in the Beyond, thus enabling the deceased to have a full and permanent existence in the realm of the dead.

One aspect of this is the liberation from the stiff mummy form, which represents an important protective cover for the journey into the Beyond and is then replaced by a new working body. This is why the deceased in the illustrations of the Beyond are only rarely pictured as mummies, for their body is similar to the one they had on earth. As mummies they lie or stand in enclosed shrines that are opened up by the call of the sun god, and many are the scenes depicting the gradual return to life of the dead, the transition from the mummy to the "transfigured" body.

What is decisive is the union of the complete body with its *ba*-soul (soul that can travel from realm of dead to realm of living), which is brought about by the sun god at the lowest point of its nocturnal journey, in the sixth hour of the night. For all beings, including the sun, this is the prerequisite for its daily return to life, and in the union there is also the shadow, which gives strength to the body and, like the *ba,* has freedom of movement. This ability to move freely through all spaces, up to heaven itself, is demonstrated by the bird form of the *ba.* Another soul idea, the *ka,* plays only a minor role in these texts, although the *ka,* as the provider of food and life force and as a "social soul," is otherwise of major importance. And ultimately a person can only become a "well-provided *Akh*-spirit" after death, which is what marks his blessed status in the Beyond. Also crucial is the continuation of the name, it too being a fixed component of the human person.

In ancient Egypt, there is no notion of a reincarnation in this world, for life in the Beyond signifies enhanced possibilities and the immediate presence of the world of the gods, with the deceased also becoming godlike. In its eleventh hour of the night, the Book of Gates reveals a quite unusual motif. The "face" of the

2 Thutmose III being suckled by a tree goddess, tomb of Thutmose III. Eighteenth Dynasty, 1479–1425 BCE; painted plaster. Valley of the Kings tomb no. KV 34.

sun is drawn through the netherworld in its own barque and turned to confront the observer, which is very rare in Egyptian art. This is intended to illustrate the fact that only now, beyond death, is it possible for there to be a "face-to-face" meeting with the gods, as expressed in the Harper's Songs (religious songs). Even more, the deceased is "indistinguishable" from a god, and in many scenes in the netherworld it remains unclear whether the figures are meant to be gods or the dead.

This godlike existence is only reserved for the blessed dead who have abided by the principles of *maat* and have proved their honesty in the Judgment of the Dead. On the orders of the sun god their every wish is granted; it states explicitly that they live on what the gods live on. This is symbolized most impressively in the scene with the Tree Goddess, first seen on one of the pillars in the burial chamber of Thutmose III, and later in many other tombs and in Book of the Dead papyri. A personified tree offers the deceased her breast or provides him with food and refreshing water (fig. 2). In addition to food, the blessed dead also receive air to breathe and clothing, and the sun's rays dispel the darkness around them.

Their reaction is rejoicing, which greets the god wherever he appears. All the inhabitants of the Beyond are united in this rejoicing, which gives way to general lamentation as the god moves on. Solar baboons have a special place among those rejoicing. They beat their breasts with their fists and call out in a secret language comprehensible only to the sun god; since Akhenaten (Amenhotep IV), the pharaoh has himself been represented in the company of these baboons as evidence that he belongs to the solar sphere.

In contrast to the rejoicing and to the care and attention bestowed on the blessed dead is the sad fate befalling the "fiends," condemned by the Judgment of the Dead because their evil deeds outweigh their good ones. They are punished in many different ways and this, too, like the provision for the blessed dead, is carried out on the "orders" of the sun god. In some places it is Horus, who blames the fiends for the murder of his father Osiris and punishes them. With their arms bound, they await

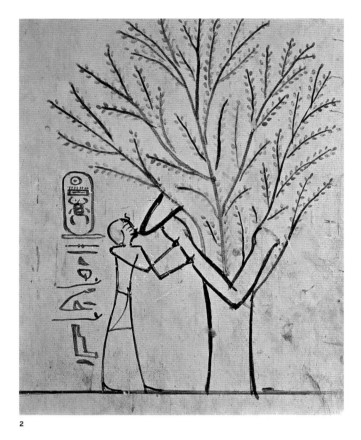

2

their extermination, which often comes about through the fiery breath of serpents. The individual components of their personality are also destroyed, in order to prevent them from being united, thus permitting a return to life.

This takes place in the ominous Place of Destruction (Hetemyt), situated in the very depths of the netherworld and representing the Egyptian hell "from which there is no escape." It is a place remote from the gods and a place of privation and also one of active punishment by painful torture. In the midst of the darkness there burns a purifying fire, consuming and transforming everything, and relighting the Light of the World every day. All the guilt that has accumulated is devoured by the purifying flame. This is where being transforms into non-being but gives rise to a new being. Time is also brought into this general recycling, whose hours are annihilated but return transformed.

Only in the royal Books of the Netherworld is this abyss of the world, this punishment and destruction of the

fiends, so graphically described, because only the pharaoh is equal to the view of this horror and can stand up to it. The spells of the popular Book of the Dead love to depict the joys of paradise and also set out to protect against dangers, but they avoid looking into the depths of hell and describing the process of destruction.

The worst "fiend" of all is Apophis, who often appears as a gigantic coiled serpent. He constantly attempts to bring the course of the sun to a standstill and with it the process of renewal and rejuvenation. The Book of Gates reinforces the impression of his omnipresence when describing its conquest in several nocturnal hours, whereas the struggle in the Amduat is concentrated on the seventh hour; this is immediately after the incipient renewal of light and life by the union of the sun-*ba* with its corpse, a particularly risky moment. By sucking noisily on the netherworld Nile, Apophis has created a sandbank on which the sun barque is supposed to run aground. But he is rendered lame by magic force, and in the Book of the Dead (Chapter 108) Seth thrusts his spear into the snake's body and forces him to regurgitate all he has swallowed, so that the barque can continue on its way.

The Book of Gates

Following the guidelines set down in the Amduat is a more recent composition known under the modern name of "Book of Gates." Here, the nocturnal journey is still divided into twelve hours, but each hour is separated from the next one by a large and well-guarded gate. Between the fifth and the sixth hour and at the end of the book, two special picture motifs have been inserted that show the Judgment of the Dead and the daily course of the sun. As in the Amduat, the sun's mode of transport is a barque, but there are only two escorts for the sun god, the creative forces Heka (Magic) and Sia (Mind). There are many other things that are simplified compared with the Amduat: the large number of divine beings are reduced to groups that can easily be counted; the individual names are not so important, and even the names of the nocturnal hours have been omitted. Nevertheless, the intent here is also to

convey knowledge about the Beyond and thus, above all, to ensure material welfare beyond death.

Alongside motifs familiar from the Amduat, one encounters a series of new motifs, such as the differentiation between the inhabitants of the Beyond into the four races of Egyptians, Nubians, Asians, and Libyans. Of particular interest in this book is the coming and going of time; time appears as a multicoiled serpent, out of whose body the individual hours are "born" and "devoured" again, or as an endless double-coiled rope that is unwound from the gorge of a divine being. The life span also allocated to the dead from this supply of time is made relative in the Beyond. One hour of the nocturnal journey corresponds to a full life span on earth.

In several scenes, the conquest of the sun's enemy Apophis is treated, and the two final hours depict in great detail the preparations for the daily sunrise, which is heralded by the baboons. The complex final scene offers a glimpse of all three dimensions of the world beyond: the depths of the primeval water Nun, on whose arms the sun barque reposes; and the depths of the earth and the depths of heaven, embodied by the goddess Nut.

The Book of Caverns

In the Book of Caverns, which came into being later and has been documented since Merenptah (c. 1213 BCE), the division into nocturnal hours is abandoned, and the sun god is only shown in the final scene in his barque. In the other scenes, his presence is indicated by a red sun disk, and it is significant that wherever fiends are being punished, the sun disk and hence the presence of the god is absent. The destruction of the fiends is depicted in greater detail and on each occasion is carried out in the lowest register, in other words, in the uttermost depths, where the rays of the nocturnal sun can never penetrate. Indeed, even the cauldrons are shown in which are cast the damned, their souls, shadows, and hearts. A picture from Egypt's Roman Period (30 BCE–395 CE) links this cauldron directly with the Judgment of the Dead.

In the first two sections, the sun god addresses the gods of the realm of the dead in lengthy monologues,

3 Detail, Book of the Earth, sarcophagus chamber of the tomb of Ramesses VI. Twentieth Dynasty, 1143–1136 BCE; painted limestone. Valley of the Kings tomb no. KV 9.

4 Detail from the Book of the Heavens, framed by the double form of the goddess Nut, on the ceiling of the sarcophagus chamber of Ramesses VI. Twentieth Dynasty, 1143–1136 BCE; painted plaster. Valley of the Kings tomb no. KV 9.

and in the third section, the corpse of Osiris in his "chest." The inexhaustible care and attention of the sun god is dedicated to him, the "Greatest of the Non-Beings" and his retinue of blessed dead. The numerous caverns or vaults where the dead stay have led to the modern name of the book, and in the pictures the many ovals can be seen which are to be understood as sarcophagi. Inside them lie the deceased in their sleep of death, from which they are aroused to new life by the call of the god. Here, too, at the end, a final picture traces the whole course of the sun.

3

4

The Book of the Earth

The last great composition, recorded above all in the burial chamber of Ramesses VI, is the Book of the Earth (fig. 3), in which the deities of the depths of the earth play an outstanding role, and yet the nightly rebirth of the sun is also depicted in these depths of the earth. It is raised up by numerous pairs of arms, out of the depths in which the fiends are punished and destroyed, and thus it is saved from falling.

The daily and nightly course of the sun above the sky is illustrated on the ceiling of the royal tombs in the Twentieth Dynasty (1186–1069 BCE), from Ramesses IV on in a series of pictures that can be called the Books of Heaven. There, under a different aspect, the Beyond is placed in the womb of Nut, the goddess of heaven, who devours the sun every evening and gives birth to it again every morning (fig. 4). Between the two, the sun wanders through the womb of the goddess and comes across the same regions of the Beyond as in the Books of the Netherworld. Even the primeval ocean Nun flows around the womb of the goddess, whose long, naked body forms the framework for these compositions. The hope of rebirth that she embodies is also established in the decoration of the coffins and the sarcophagi. On the inside of the sarcophagus lid of Thutmose III can be seen a picture of the goddess protecting the dead; thus pictorial form is given to the ancient wish of the dead, documented as far back as the Pyramid Texts, to be taken up among the stars into the womb of Nut.

The Book of the Celestial Cow

Another of the Books of Heaven is the Book of the Celestial Cow, which makes its first appearance on one of the gilded shrines of Tutankhamun. In the center is a picture of the sky as a cow, supported by Shu and other gods; on the stomach of this celestial cow the sun, moon, and stars pass along. The relevant text, which sets out to explain the present imperfect state of the world, contains at the beginning the well-known myth of the "Destruction of Humanity," the Egyptian version of the story of the Flood. What is significant is the fact that the punishment is not inflicted by flood but by fire, because the annual flooding

32

of the Nile is regarded as a blessing, guaranteeing recurring fertility.

After paradisiacal primeval times, in which the gods and people lived side by side on earth and when it was always daytime because of the permanent presence of the sun, the people became incensed about the sun god Re, who had grown old. Re holds discussions with the other gods and then sends the goddess Hathor as his "eye" (uraeus serpent) to punish the rebels. Some are destroyed by fire, but the rest are saved, since Re himself takes pity on them and has the goddess deceived by giving her beer dyed red with ocher. Hathor is so enraged that she drinks the blood, becomes drunk, and loses her desire to destroy humanity. After this episode, Re refurbishes heaven and the netherworld and leaves earth on the back of the celestial cow. From now on, the gods dwell in heaven and in the netherworld; human beings remain on earth and can only have a sense of the presence of the gods in the cult images of the temples.

The Book of the Dead

Still the most famous text of afterlife, the Egyptian Book of the Dead (with the original title "Book of the Going Forth by Day") replaces the older corpus of Coffin Texts and has usually come down to us on papyrus; it does not boast the exclusiveness of the Books of the Netherworld but was available to both kings and government officials. The main concern here is practical assistance for the deceased, his burial, his protection, and his welfare, rather than a description of the Beyond, and yet the right knowledge also plays a decisive role. In several spells, the deceased is interrogated by divine beings from the Beyond, to whom he has to provide evidence of his knowledge. These are above all the guardians of the gates, but also the ferryman who is to take the deceased across; part of the examination tests the deceased about parts of the ferry or of the Judgment Hall.

A very special part of the examination is the notion of the Judgment of the Dead, in which the heart of the deceased is weighed against a symbol of the *maat,* the right and proper world order, to provide evidence of his good behavior on earth; Thoth, the god of wisdom, notes the result and the monster Devourer of the Dead embodies the jaws of hell, which devour the condemned who do not live up to *maat.* By means of the "negative confession," which the deceased recites before Osiris and the 42 Judges of the Dead, he purges himself of all his transgressions; knowledge and purity enable him to enter the world of the gods. We have already mentioned the scene in the Book of the Gates in which the dead are allowed to look on the face of the sun, and the promise that he who gazes on Osiris cannot die. In the Book of the Dead, the deceased, in the face of the Gods, calls out again and again: "I am one of you."

The Tomb of a Pharaoh

The tomb of a pharaoh has always had a special place among tombs, both in size and in the abundance of the funeral equipment, as well as its favored location and the wealth of decoration. The oldest known royal tombs are in Abydos and date back to the end of the fourth millennium BCE. They consist of excavated chambers over which a flat tumulus curves; their monumental form ultimately led to the pyramid. The place for the funerary cult is marked by a stele with the name of the king; the discovery of writing made it possible to lift the deceased from the anonymity of prehistory and preserve his name beyond death.

In addition to their tombs in Abydos, the kings of the First Dynasty (c. 3000 BCE) had a secondary tomb in Sakkara, the necropolis of the new residence in Memphis. This duplication of the tomb now became another royal privilege, manifested in different ways; with the pyramids there was a second small pyramid, and later, in the New Kingdom there were two largely symmetrical halves to the one tomb.

The beginning of the Old Kingdom also signifies the beginning of the "Age of Pyramids," in which the royal tomb takes on this form — in the Third Dynasty as step pyramids and after the Fourth Dynasty as "genuine" pyramids. The oldest pyramids are also the first monumental stone buildings in history. The Egyptians regarded stone

as the ideal material with which to build for eternity beyond death. For this reason, many of the objects accompanying the deceased were made of stone, and with the first step pyramid in Sakkara, a complete royal residence was built of stone; the builder Djoser (with his chief architect Imhotep) came to be regarded by future generations as the one "who inaugurated stone."

Under Snefru, the founder of the Fourth Dynasty (2613–2494 BCE), we follow the transition to the genuine pyramid form, although some attempts (in Meidum and with the Bent Pyramid in Dahshur) are unsuccessful because they were built at too steep an angle. The sites for the funerary cult then found their permanent form in a trinity of Valley Temple, Causeway, and Funerary Temple.

The entrance to the burial chamber is from the north, indicating a stellar Beyond, whereas the sites for the funerary cult lie in the east of the pyramid, facing toward the fertile Nile Valley. These sites are decorated with colorful reliefs, whereas the rooms in the interior of the pyramid up to King Unas (c. 2375 BCE) are without decoration; with him, the last pharaoh of the Fifth Dynasty, there began the use of the Pyramid Texts as a form of decoration, consisting of religious spells related to the burial of the pharaoh, which are also found in the late Sixth Dynasty in the pyramids of the queens.

The pyramid of Khufu (c. 2589–2566 BCE), in which Prince Hemiunu was the chief architect, is the largest structure of antiquity. It was 146.6 meters high (480.9 feet) and the base at the side was 230.4 meters long (755.9 feet); 2.3 million blocks of limestone, each of them weighing 2.5 tons, were used in the construction. This technical feat alone has aroused admiration throughout the ages; furthermore, repeated attempts have been made to read secret information into the measurements and proportions, or to find secret chambers filled with material and spiritual treasures and cosmic measurements. But all the astuteness applied to such speculations has been to no avail, and this pyramid is nothing more than the monumental tomb of King Khufu. There still remains the technical problem of how such huge masses of stone could be assembled in such a relatively short space of time with such simple equipment. No accounts have come down to

us from the Egyptians themselves, so all explanations are pure speculation; every year new suggestions are put forward without bringing any definitive solution to the problem.

Khufu's son and his grandson Menkaure also chose the rock plateau of Giza (near modern-day Cairo) for their pyramids; in contrast to Khufu, the ornate statue decoration that is part of the cult sites has been preserved. These cult sites consisted of the valley temple, the funerary temple itself, and a long causeway between them. Then there were the ritual boats, available for the pharaoh in the Beyond, and a small secondary pyramid in accordance with the idea of the duplicated royal tomb.

Some queens were also given pyramids, for example three of the wives of Khufu, whereas all the other members of the royal house, as well as important government officials, had to content themselves with less monumental grave mounds, or *mastaba*, the Arabic word for a walled-up bench.

Menkaure set new directions by sharply reducing the dimensions of the pyramid (66 meters high, 216.5 feet). From then on the emphasis was on cult buildings, which became more and more flamboyant as the pyramid gradually lost its importance. In fact, after the end of the Old Kingdom (c. 2125 BCE), this form was temporarily abandoned and new paths were trodden; one example was the new uniter of the country, Mentuhotep, with his terracelike funerary temple in Deir el-Bahari, which was connected to a rock tomb.

The kings of the Middle Kingdom, Twelfth Dynasty (1985–1773 BCE), returned to the model of the Old Kingdom but now built their pyramids with bricks, which were made from the mud of the Nile and were supported by a stone core in the interior. The entrance was still in the north, but under Senusret II (1877–1870 BCE) a radical change was brought about. The straight north-facing corridor was replaced by a complicated labyrinth of passages in which the crooked paths of the netherworld are reflected.

At the beginning of the New Kingdom a fundamental change took place in the form of the royal tomb. The sites for the cult of the dead were separated from the actual tomb and moved to the edge of the cultivated land in western Thebes; the best preserved of these royal funerary temples are the Ramesseum of Ramesses II and the

Medinet Habu temple of Ramesses III, as well as the temple of Hatshepsut in Deir el-Bahari. In these temples alongside the dead pharaoh, Amun (or Amun-Re), then the principal god of Thebes, is also venerated, but despite his importance he does not play a major role in the tombs of these kings.

The tombs themselves were no longer built as pyramids but as rock tombs in the stone. The remote desert valley, selected as the site for the new tombs, was suitable from the point of view of security, but probably also because of the veneration of the goddess Hathor in the nearby valley of Deir el-Bahari. The form of the pyramid ceased to be a royal privilege and was now used by the officials of the New Kingdom, who often chose to erect a small pyramid above their rock tombs. Royal pyramids were only seen again with the Nubian kings of the Late Period in Napata and Meroe.

Located in remote parts of the valley, the oldest tombs of the Eighteenth Dynasty (1550–1295 BCE) were still very modest sites, but they were extended from reign to reign, although the length of the reign was not a decisive factor. From the late Middle Kingdom, the curved or bent axis was adopted, and only with Akhenaten was it replaced by a straight one again. After Thutmose III the transition from corridors and steps was interrupted by a pit and a pillared hall before one arrived at the chamber with the sarcophagus. For certain measurements, a fixed canon gradually emerges, especially with regard to the width and height of the corridors; ever since the Old Kingdom, pillars in royal buildings have had a cross section of 2 cubits (1.05 meters — 3.4 feet), whereas in the tombs of queens and officials they have been significantly smaller.

According to a rule that could be termed the "extension of the existing," every pharaoh sought to outdo his predecessors and extend his tomb (as with the temples) by adding new elements. This followed a strict hierarchy. Those few government officials granted a tomb in the Valley of the Kings as a special mark of honor had to content themselves with simple unadorned pit tombs, whereas their cult rooms in the Officials Necropolis were richly decorated. However, they were not allowed to have royal decoration elements, such as Books of the Netherworld or ceilings painted with stars.

The decoration of the royal rock tombs was initially concentrated on the burial chambers, the walls of which, up to Amenhotep III (1390–1352 BCE), show the Amduat, with its description of the netherworld. Another focal point was the scenes showing pharaoh before the deities, who play a significant role in the fate awaiting him in the Beyond; alongside Osiris, the ruler of the dead, are Hathor, the goddess of regeneration, and Anubis, who was responsible for the mummification and the further existence of the body generally. From reign to reign, more deities were added to the decoration program.

These scenes, which document the pharaoh's entrance into the world of the gods, are found mainly on the pillars of the burial chamber, but were also intended for the pit and the antechamber. Up to Seti I (c. 1294 BCE), the corridors were completely unadorned and initially were rather roughly hewn, whereas the walls and ceilings were later carefully smoothed out. The painting of the ceilings as starry skies continued the tradition of the Old Kingdom.

Amenhotep II, the son and successor of Thutmose III, abandoned the oval outline of the burial chamber and completely transformed it. Instead of the two pillars in his father's tomb we now find six, painted with divine and royal figures. The rear section of the chamber is made deeper, and the sarcophagus with the mummy of the king now stands here in the deepest part of the tomb. Under his successor, Thutmose IV (1400–1390 BCE), the scenes with gods are no longer simply line drawings but are painted.

After Akhenaten a new concept was sought for the royal tomb. The tomb of Tutankhamun, despite the rich treasures embellishing it, is a temporary measure, its decoration a blend of elements from royal and nonroyal tombs. The same can be observed with his successor, Ay (1327–1323 BCE), and only with Horemheb (1323–1295 BCE) was there a conscious return to the tradition of the Eighteenth Dynasty, which ended with him; however, he replaced the Amduat with a new Book of the Netherworld, the Book of Gates (fig. 5). His most important innovation was that he marked the transition from paintings to reliefs; since his decorative work was unfinished in many places,

5 Detail, the second hour of the Book of Gates from the tomb of Horemheb. Eighteenth Dynasty, 1323–1295 BCE; painted limestone. Valley of the Kings tomb no. KV 57.

6 The goddess Maat; detail from the tomb of Siptah, Nineteenth Dynasty, 1295–1186 BCE; painted limestone. Valley of the Kings. KV 47.

7 Detail, scene of the Opening of the Mouth ritual for statues of the king from the tomb of Seti I. Nineteenth Dynasty, 1294–1279 BCE; painted limestone. Valley of the Kings tomb no. KV 17.

5

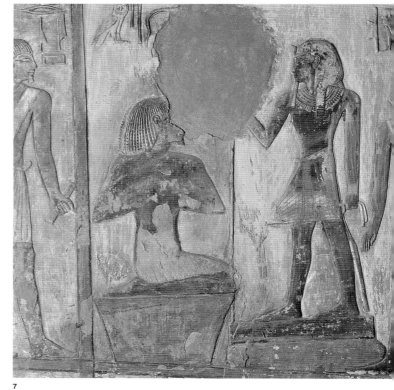

7

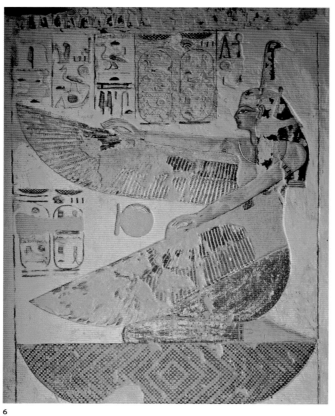

6

8

8 Detail, scene from the astronomical ceiling of the burial chamber of the tomb of Seti I. Nineteenth Dynasty, 1294–1279 BCE; painted plaster. Valley of the Kings tomb no. KV 17.

it enables us to study closely the working methods of the artists, from the first dividing up of the wall and the outlines of the figures right up to the finished product of the painted relief, which is of outstanding quality in this tomb.

Horemheb included some additional deities in his decoration, such as Horus "son of Isis"; his mother Isis; and the Memphite gods Ptah and Nefertem. The goddess Maat (fig. 6) receives him at the entrance of the burial chamber; in later tombs she appears in the passages between the rooms, and after Ramesses II appears already at the entrance of the tomb. Thus she provides the comforting certainty that the correct and harmonious order of things—known as *maat* in Egyptian—will also be preserved in the Beyond.

Initially Seti I continued the practice of decorating only the most important rooms in the tomb, but later he decided to extend the painted reliefs to the whole tomb, from the entrance to the rear wall of the burial chamber, a length of more than 100 meters (328 feet); in just two unfinished rooms he contented himself with the outlines

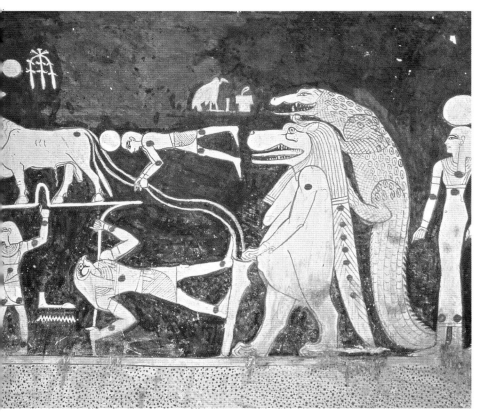

of figures and texts. The tomb consists of two halves, both ending with a pillared hall and their side rooms, and connected also in other ways; here the old idea of the duplicated royal tomb has been taken up again but in a different form. The axis of the two halves is shifted slightly but still runs straight, as was the case with Horemheb. The background colors used only in this tomb so differentiated, are white, blue, and yellow, with yellow being reserved for the burial chamber and intended to represent gold.

The larger area thus created allows for a much more lavish use of images. The fourteen decorated pillars alone provide space for fifty-six divine scenes (in contrast to the one scene with the Tree Goddess with Thutmose III), and the walls are now covered with a number of religious books, including ritual texts such as the so-called Opening of the Mouth (fig. 7). Even in the painting of the ceilings there are differentiations: in the first corridor there are protective winged creatures (vultures and serpents), as is common above the axis of temples; in other rooms there are star-studded skies; and above the sarcophagus itself, an astronomical ceiling with planets and constellations (fig. 8).

With Ramesses II (1279–1213 BCE) the sarcophagus hall was given a new layout, and this remained the norm until Ramesses III (1184–1153 BCE). There were now eight pillars and they stood at an angle to the axis, dividing the room up into three naves; the sarcophagus now stood in the central nave, which was made deeper. At the end of the Nineteenth Dynasty the royal tombs became less steep and were given imposing entrances, with wooden doors. The constant extending of the sites reached its limits and, with Ramesses IV (c. 1153–1147 BCE), led to a simpler layout, dispensing with pillars, steps, side rooms, and parts of the decoration. There was, however, an extension of the dimensions, specifically the width and height of the corridors, so that the tomb created an impression of space, and in fact served as a rather comfortable "hotel" for many of the expeditions in the nineteenth century.

A final extension was made by Ramesses VI (1143–1136 BCE), who covered the walls and ceilings of his tomb with almost the whole of the funeral literature of the New Kingdom, from Amduat to the Books of Heaven

9 Detail, a section of the Litany of Re from a pillar, sarcophagus chamber of the tomb of Thutmose III. Eighteenth Dynasty, 1479–1425 BCE; painted plaster. Valley of the Kings tomb no. KV 34.

and the spells of the Book of the Dead. That was the last time that two pillared halls were present.

Apparently even the last kings of the New Kingdom were no longer buried in the Valley of the Kings, but instead were placed in the north of the country, where after Seti I a new royal residence (City of Ramesses, later called Tanis) had been established in the East Delta. What we now see instead of the royal rock tomb is the "Temenos Tomb" in its final phase of development. In the district of the Amun temple of Tanis there is a royal cemetery from the Twenty-first (1069–945 BCE) and Twenty-second (945–715 BCE) Dynasties; the tombs are unpretentious (often just one chamber), and by way of decoration they use the Book of the Dead and parts of the Books of the Netherworld. For later royal necropolises there is evidence for the temple areas in Sais (according to the account by Herodotus), Mendes, and Alexandria.

The Tomb of Thutmose III

High above the valley, in a narrow gorge in the rock, lies the entrance to the tomb (Valley of the Kings tomb number 34) of Thutmose III. The approach to the tomb was discovered in February 1898 by people working for the Antiquities Organization, and shortly afterward the tomb of Thutmose's son and successor, Amenhotep II (1427–1400 BCE), was discovered in another corner of the valley. Until then, the only tombs of the Eighteenth Dynasty that were known were those of Amenhotep III and Ay in the west valley.

The axis of the tomb does not run straight but curves sharply, as is the case with all the early tombs in the Valley of the Kings. The entrance is in the north; the burial chamber turns to the east. This is the continuation of a tradition that began in the Middle Kingdom under Senusret II (1877–1870 BCE); at that time the hitherto straight north-facing corridor of the pyramid was replaced by a complicated system of passages, reflecting the curved space of the Beyond.

Linked to this new image of the Beyond is certainly the oval outline of the burial chamber that is also to be

found with Thutmose I and Thutmose II. New elements with Thutmose III are the pit (6 meters deep [19.6 feet]) and an upper hall with two unadorned pillars, which is connected directly with the burial chamber by a flight of steps. The pit is seen by many as an obstacle for tomb robbers and as a means of collecting any rainwater that might seep through, but it also has a religious significance as a direct approach to the netherworld and the cavern of the god Sokar. In later tombs, the rear wall was sealed off and, like the walls, painted with scenes of the gods to give the impression that it was the end of the tomb; the way it was decorated made it a place where the deceased pharaoh entered the world of the gods.

There is a rhythmic change from steps to corridors, broken only by the pit and the upper Pillared Hall, until one arrives at the burial chamber with its four small side rooms, which were intended for the various objects of funeral equipment. All that remained of these objects when the tomb was discovered were fragments of wooden figures of the king and various gods. The royal sarcophagus of quartzite is still in the tomb; the mummy was discovered in 1881 in the hiding place (cachette) of Deir el-Bahari, enveloped in a shroud, with the text of the Litany of Re (fig. 9).

As in all the tombs of the Eighteenth Dynasty, corridors and staircases are without decoration. But in the pit there is the frame for a painted decoration, with a decorative frieze of colorful bundles of reeds (*kheker* in Egyptian), which also bedecks the walls in the burial chamber; and the ceiling is painted as a blue sky with yellow stars. On the walls of the upper hall a catalogue with 741 deities from the Amduat that has no equal anywhere.

The Amduat, with its twelve nocturnal hours, adorns the walls of the burial chamber, which measures 14.60 by 8.50 meters (45.9 by 27.8 feet). The order of the hours follows the notes in the text of the book and is arranged according to the four points of the compass. The hours 1–4 are on the west wall, 5 and 6 on the south wall, 7 and 8 on the north wall, 9–12 on the east wall. This would have been the ideal arrangement, but it was not totally achieved, for owing to problems of space

9

certain things had to be rearranged and omitted; further-
more, a lot of figures had to be arranged in tight rows,
and registers had to be split up. The figures have only been
done in outline (line drawing), in black and red; the texts
are in cursive hieroglyphs, as used in the Book of the
Dead, thus producing the effect of a monumental papyrus.

Two sides of both pillars in the burial chamber are
decorated with the short version of the Amduat Book (just
text, no figures) and provide a comprehensive list of con-
tents. On four sides are the seventy-six figures of the
Litany of Re, also in line drawing; another one has the rep-
resentation of the king with his mother Isis in a boat, as
well as members of the royal family and also the famous
scene in which Isis as a Tree Goddess breastfeeds the
king; this is the only representation of gods in the tomb,
whereas in the following royal tomb of Amenhotep II, all
six pillars of the burial chamber have scenes with deities
painted on them. In the burial chamber, the ceiling is
painted as a blue sky with yellow stars, thus representing
the heavenly Beyond, open for the *ba*-soul of the pharaoh.

The Amduat

The original title of this oldest Book of the Netherworld
was Treatise of the Hidden Chamber; what has become the
modern name — Amduat — is actually a generic name for
all Books of the Netherworld. The oldest example comes
to us from the tomb of Thutmose I (1504–1492 BCE),
father of Hatshepsut, and can now be seen in the Egyptian
Museum in Cairo. Thutmose III also allowed his vizier,
Useramun, to have a complete version as part of the deco-
ration of his tomb; until the end of the New Kingdom, this
was the only version outside a royal tomb. Up to Amen-
hotep III, this Book of the Netherworld was the only form
of decoration in a royal burial chamber, and it was only
after Akhenaten that it was extended or replaced with
other compositions. With Tutankhamun (1336–1327 BCE),
the only thing on the walls of the burial chamber was a
quotation from the lists of the first nocturnal hour; but
two more hours were placed on one of the four gilded
shrines surrounding the sarcophagus of the young king.
As these shrines are missing for the other kings, there is
no way of knowing whether in other instances parts of the
book were to be found on such shrines, just as chapters
of the Book of the Dead were placed on various parts of
the burial equipment.

With Seti I (1294–1279 BCE), the Amduat found
its way back into the royal burial chamber, but now the
individual hours of the night were distributed over the
whole tomb. This practice was taken over by the remaining
royal tombs of the Ramesside Period (1295–1069 BCE),
although in the burial chambers it was usually replaced by
the newer books. Under the priestly rule of the Twenty-
first Dynasty, the Amduat was claimed as their own by
the new elite, the priesthood of the god Amun of Karnak,
and appeared in excerpts on their funerary papyri and
coffins. It was still used on the royal and nonroyal sar-
cophagi of the Thirtieth Dynasty as well as of the early
Ptolemaic Period, and was also still quoted in Egypt's
Roman Period.

10 Detail, the first hour of the Amduat in the tomb of Thutmose III. Eighteenth Dynasty, 1479–1425 BCE; painted plaster. Valley of the Kings tomb no. KV 34.

11 The second hour of the Amduat in the tomb of Amenhotep II, 1427–1400 BCE; painted plaster. Valley of the Kings tomb no. KV 35.

12 Detail, the middle register of the third hour of the Amduat in the sarcophagus chamber of Seti I. Nineteenth Dynasty, 1294–1279 BCE; painted limestone. Valley of the Kings tomb no. KV 17.

Its twelve sections correspond to the twelve hours that the sun god pursues on his nocturnal course through the "Hidden Space." Each section is divided into three registers, which correspond to the river of the netherworld with its two banks. A lengthy title emphasizes that this is the conveying of knowledge about the Beyond of the netherworld; hence the abundance of names given in the texts and in the writings accompanying the pictures. For some regions of the Beyond, they even give precise dimensions. There are frequent remarks to the effect that such knowledge is also very useful in this world.

The first hour of the night is depicted as a sort of intermediary realm and ends with the gate "which swallows all," which is where the netherworld actually begins (fig. 10). This hour presents itself in the form of a list of certain particularly important and typical beings to be found in the Beyond, who greet the sun god Re as he appears. Here, we meet the goddesses of the nocturnal

hours, the solar baboons, who cheer the sun as it rises and sets, the uraeus serpents, who bring light into the darkness as they breathe fire and drive away enemy forces and many others.

An even lengthier list is the catalogue of gods, found only in the tomb of Thutmose III, which lists and depicts 741 deities of the Amduat, without the "enemies." Ancient Egyptian science often employs such lists to arrange material in a manageable way and make it easier to grasp. In the Amduat, the Beyond is explored and opened up in this way, making it more familiar and less alien. Following the course of the sun enables the Egyptian to penetrate deep into these spaces.

The middle register is reserved for the sun ship and its escort. The name of the ship is "Barque of the Millions" because the vast numbers of all the blessed dead hope to sail in it and thus remain permanently in the vicinity of the god. In the center stands the god in his nocturnal form with a ram's head; the ram's head (*ba* in Egyptian) indicates that he is descending into the netherworld as *ba*-soul to be reunited with his body.

Right next to it, in a second barque, is his other main form, the scarab beetle, which represents the rejuvenated morning sun, already pointing out here, at the beginning of his nocturnal journey, the ultimate objective —the morning renewal of the sun. This is the great hope of everyone—to be renewed every day like the sun and thus vanquish death. This is why the scarab, which epitomizes this hope, was the Egyptians' favorite amulet even in the Middle Kingdom.

Immediately in front of the shrine of the god is the goddess Hathor, Mistress of the Barque, recognizable by the cow horns with the sun disk that she wears on her head. It is she who now, hour by hour, guides Re and his retinue through the nocturnal netherworld. As the goddess of regeneration she also guarantees the daily renewal of the world. The barque is occupied by a series of other deities, representing the "millions" who would like to sail in her. Horus has his place at the rudder, ensuring that the ship stays on course.

The deities in front of the barque are really to be seen in its accompaniment. At the head, in double form, is

40

10

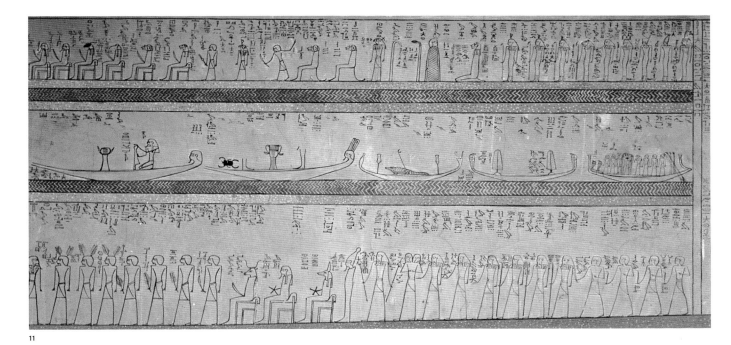

11

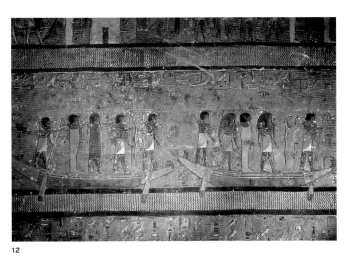

12

the goddess Maat; her presence creates the soothing certainty that the right and harmonious order of things, known to the Egyptians as *maat,* is preserved after death and accompanies the sun god on his nocturnal journey. This ensures that moderation, justice, truth, and order are guaranteed in the Beyond, despite all its terrors. In other representations, the goddess, regarded as the daughter of Re, is seen in the barque itself, and in the Amduat she appears again at the beginning of the second hour.

Osiris is also here, for the descent of the sun god leads into his kingdom, to the "being and non-being" ruled over by Osiris. Then comes the lion-headed Sakhmet, the goddess of healing, who is able to heal the injured eye of the sun and also fend off enemy forces. As in the Litany of Re, certain functions and aspects of the sun god appear as autonomous beings and accompany him in his entourage. In addition, there is a small selection from the many serpents with which the netherworld is populated; the god at the end of the register, the only one to turn toward the general direction of the sun's course, is the guardian of this region, who "seals up" the netherworld as soon as the sun and its entourage enter. This is intended to ward off anything that might disturb the process of regeneration and renewal that takes place every night in the netherworld.

The next two hours open up the actual netherworld, seen first as fertile fields dominated by the watery expanse Wernes in the second hour (fig. 11) and by the "Waters of Osiris" in the third (fig. 12). As with the Nile, his only river, source of all fertility, the Egyptian imagined there to be a broad river in the netherworld as well, whose banks are inhabited by the dead. The sun god sails along on this river in a boat, and in these hours is accompanied by other boats, whereas in the other hours his barque sails off alone. Traffic and transport for the Egyptian were via

13 Detail, the zigzag path in the fourth hour of the Amduat in the tomb of Thutmose III. Eighteenth Dynasty, 1479–1425 BCE; painted plaster. Valley of the Kings tomb no. KV 34.

waterways; the roads were continually broken up by canals and were of little significance, and the chariot was only used in war and for hunting.

The god attends to the welfare of the blessed dead, who, in the lower register, carry sheaves of wheat in their hands or wear them in their hair. They are the "Farmers of Wernes," whose material welfare is depicted here. In the kingdom of Osiris no one is expected to suffer shortage but should find everything necessary in abundance. People are provided with land that they can cultivate themselves. In the third hour, the presence of Osiris is documented on several occasions, and in the final text of the hour, Re turns directly to Osiris, to whom he allocates his creative force. But in the Amduat, Osiris remains oddly passive, neither acting nor speaking himself even though he is repeatedly present; this is a way of stressing his helplessness, into which he has been plunged by his violent death at the hands of his brother Seth.

There are also numerous reproachful beings with knives in their hands so as to render all fiends harmless, as well as their *ba*-souls and their shadows. For the threatening strangeness of the Beyond is embodied in dangerous

beings, which the deceased has to know to be able to pass them.

The texts describe the function of the beings represented and the orders from the sun god, with which he allocates to the dead everything they need for their renewed life in the Beyond—light, air to breathe, freedom of movement, food, and clothing. The long texts at the end of the first three hours also give the dialogues of the god with the inhabitants of the netherworld, who greet him joyously. When the god enters the "Land of Silence," as the realm of the dead is commonly called, it is filled with light and the sound of his voice; both of these arouse the deceased from their sleep of death and as he moves on a cry of lamentation goes up from those who have to remain behind in the darkness.

With the fourth hour, the fertile, well-watered landscape stops abruptly, giving way to the desert of Ro-setau, the "Land of Sokar, who is upon his Sand," a barren kingdom of sand populated with serpents; their sinister mobility is emphasized with legs and wings on the serpents' bodies. A zigzag path through this hour region that is full of fire ("from the mouth of Isis") and is repeatedly blocked by doors (fig. 13). For the first time, the sun barque can only advance by being towed and, in so doing, turns into a serpent whose fiery breath pierces a way through the otherwise impenetrable darkness. The other boats, which accompanied them in the previous hours, have to turn around here.

The darkness is so deep that the sun god is unable to recognize the inhabitants of this region; only the fire-spitting heads of the many serpents glow in the darkness. But the light needs the darkness to be able to renew itself. In the very center of the hour the solar eye is kept and protected by Thoth and Sokar, and it is the preservation and renewal of this solar eye that is at stake here. Sokar is actually the God of the Dead of the northern residence of Memphis, but in the New Kingdom he becomes a figure of Osiris. Thoth is the god of all arts and wisdom who succeeds in separating the quarrelsome brothers Horus and Seth and in healing the injured eye. At the end of the hour, the sky suddenly opens up to reveal that the Beyond does not merely consist of such desolate sand

42

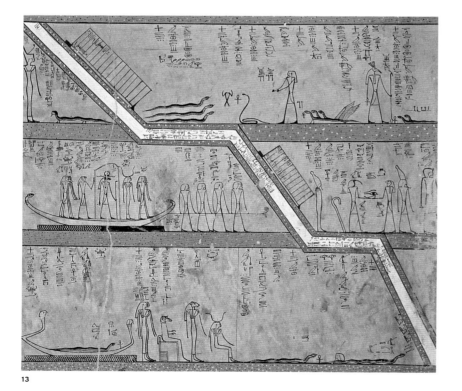

13

14 Detail, the fifth hour of the Amduat in the tomb of Thutmose III. Eighteenth Dynasty, 1479–1425 BCE; painted plaster. Valley of the Kings tomb no. KV 34.

15 Detail, the sixth hour of the Amduat depicting the sun as the scarab beetle Khepri, in the tomb of Seti I. Nineteenth Dynasty, 1294–1279 BCE; painted limestone. Valley of the Kings tomb no. KV 17

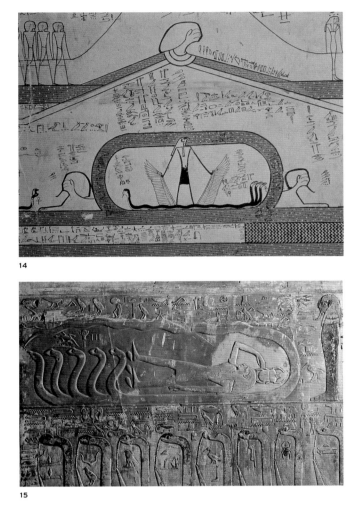

14

15

Seven male and seven female figures seize the tug rope, as does the solar beetle from above. The journey takes them across an oval that represents the cavern of Sokar and is embedded in the double-head of the Aker sphinx (fig. 14). It is probably once again an image of the whole netherworld, in which the mysterious union of Osiris-Sokar with the sun god occurs every night. The multiheaded serpent, whose wings are seized by Sokar, is an aspect of the sun god. The burial mound above the oval is crowned with the head of Isis, who protects the land of Sokar with her fiery breath. Farther down, the "Lake of Fire" is indicated as a place of punishment, which is described at greater length in the Book of Gates. There it is, surrounded by blessed dead with ears of corn, showing that from it they can draw food and refreshing water as a "Lake of Life," whereas for the fiends, those damned in the Judgment of the Dead, its water is fire.

In the sixth hour, after the desert of the land of Sokar, the sun reaches the depths of the netherworld, the "water-hole," which is filled with the primeval water Nun, whose personification appears at the end of the hour. Here lies the sun's corpse, with which the god unites as *ba*-soul. The corpse is illustrated twice, at the end of the upper and middle register; it is not shown as a mummy but as a scarab, or sun beetle (fig. 15), already associated with the rejuvenated morning figure, so that it contains within itself the germ of new life. Coiled around it protectively is a multiheaded serpent. But the body is also to be seen as an image of Osiris, who is embodied in the upper register by the lion-shaped "bull with the thunderous voice." The mystery in which the corpse of the sun is shrouded is given even greater prominence later in the Book of Gates; there he remains invisible, and there is not even any mention of his name, thus guaranteeing this invisibility.

Like *ba* and body, Re and Osiris are joined in union at the lowest point of the nocturnal journey, and the incipient return to life is indicated in the semi-raised, not yet totally upright stance of the deities in the upper and lower register. It is only at this crucial point that the "Kings of Upper and Lower Egypt" are present with their symbols of power (scepter, crowns, and uraei) so that they can assist the dead pharaoh to return to life. The lower register

43

regions. In the tomb of Thutmose III, this section is located near the only exit, thus showing the *ba*-soul of the king its heavenly destination. A single line of text points out that the king "leaves the netherworld to light up Heaven, to accompany Re in heaven and in the earth."

In the fifth hour, the gloomy region of sand continues, but it differs somewhat from the usual structure, and places emphasis on the center by means of an intersection of the registers. This hour sphere embodies the west and contains all the essential elements of the realm of the dead. The hill with the two birds of lamentation (Nephthys and Isis) is the burial mound of Osiris from which emerges the rejuvenated sun as a scarab. The butchers on the other side of the hill and the numerous threatening serpents are besought to let the sun god pass in peace so that he can negotiate the narrow pass in the center of the hour.

16 Detail, the sun god and Osiris being protected by the Mehen serpent during the seventh hour of the Amduat, in the tomb of Thutmose III. Eighteenth Dynasty, 1479–1425 BCE; painted plaster. Valley of the Kings tomb no. KV 34.

17 Detail of the eighth hour of the Amduat in the tomb of Seti I. Nineteenth Dynasty, 1294–1279 BCE; painted limestone. Valley of the Kings tomb no. KV 17.

18 Detail of the ninth hour of the Amduat in the tomb of Thutmose III. Eighteenth Dynasty, 1479–1425 BCE; painted plaster. Valley of the Kings tomb no. KV 34.

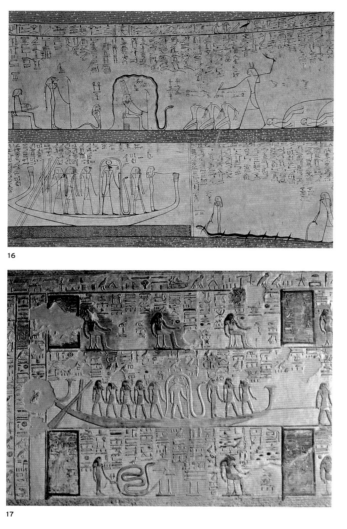

16

17

44

is framed by the crocodile-headed Sobek and by Nun as masters of the primeval water, and Tatenen also appears in the texts, the master of the depths of the earth, which is the point that has been reached here. A serpent with four human heads, given the names of the four "Sons of Horus," probably points to the separate burial of the entrails in four canopic jars that are entrusted to the care of the Horus sons.

Around midnight, the sun shines once again, but this self-procreation of light is also a moment fraught with great danger. This is why, in the seventh hour, the focus is placed on the "fiends," especially the arch fiend Apophis; he is lying on his "sandbank" in front of the barque, in the form of a serpent, and is attempting to bring the renewed course of the light to a standstill. He does not succeed,

for Isis and Seth cast a spell over him, and Selket throws her chains around his body, which is dismembered by other helpers; moreover, the sun is protected in her boat by the Mehen serpent (The Enveloper; see fig. 16). Symbolizing that resistance to Apophis is taking place in the vicinity of the corpse of the god are the four tombs behind his sandbank; they are protected by knives against the dangerous proximity of the fiend.

And in the register above, Osiris triumphs over his enemies, who have been fettered and decapitated in front of him by a punishing demon; "you cannot escape from his watch forever" the victims are told; furthermore, they are prevented from being reunited with their *ba*-souls and their shadows. And the enthroned Osiris, as well as Re from now on, are protected by the coils of the Mehen serpent. Like all deceased, he awakes from his death sleep and embarks on new activity, no longer being "The Weary-Hearted One." The exemplary punishment being meted out reminds us of his function as judge of the dead, familiar to us from the famous weighing scene in the Book of the Dead (chapter 125), where, before Osiris, the heart of the deceased is weighed against the symbol of *maat*. The Book of Gates inserts a scene of its own before the sixth hour with the Judgment of the Dead—before the crucial union of the *ba* soul with her body.

In the lower register, the sun god is enthroned as "Horus of the Netherworld" in order to ensure the correct movement of the celestial bodies, the personification of which fill the rest of the register; twelve gods and twelve goddesses all have a star above their heads. The conclusion comes with the helpful crocodile with the head of Osiris, which it has rescued from the water.

What is striking about the eighth hour is its regular structure. The upper and lower registers are divided up into five caverns or five vaults, which are closed off by doors but can be opened by the call of the sun god (fig. 17). Almost all the beings in these vaults are enthroned on the hieroglyph of fabric, which the texts describe as their clothes. Thus the theme of the nocturnal hour is the provision of clothes, which from time immemorial has always ranked high among wishes for the Beyond and among the material furnishing of the tomb; an important feature

of the rebirth of the deceased is their new clothing in shining white linen.

In addition, the texts describe how the *ba*-souls of the gods and the deceased from these vaults, which are representative of all vaults in the realm of the dead, respond jubilantly to the sun god; the tonal features of this jubilation can only be heard by human ears as the cries of animals and sounds of nature (humming of bees, banging on metal, screeching of tomcats, roaring of bulls, etc.), whereas for the god it is audible and recognizable speech. Thus the world of sounds is also distorted in the Beyond, and beings "with terrible voices" often appear! It is the music of hell, as described by John Milton in *Paradise Lost*:

A universal hubbub wild
Of stunning sounds, and voices all confused,
Borne through the hollow dark....

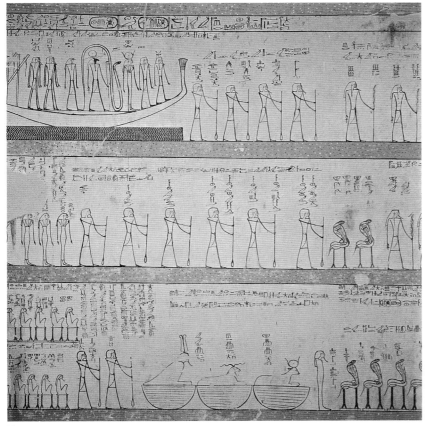

18

In the middle register the sun barque is once again being towed along so that it will reach its destination more quickly. It is followed by personified Schemes—hieroglyphs, symbols of jurisdiction and also of the "retinue" of the god; also present are the four "mysterious" rams of Tatenen, which, at the end of the New Kingdom, are compressed into the form of the solar ram with four heads. Important again here is that the ram can be "read" as the *ba*-soul.

In the ninth hour the crew of the sun barque is presented—with their oars in their hands, they are the dominant theme in the middle register, which is complemented by three images of deities that are responsible for providing the dead with bread and beer (fig. 18). The names of the rowers emphasize their diligence, with "The Indestructible" and "The Unwearying" actually coming from old names for stars.

In the upper and lower register is a continuation of the theme from the eighth hour, namely the providing of clothes. The first upper group, sitting on their fabric signs, is described as the court of judgment, which "overthrows the enemies of Osiris"; the following group of goddesses takes care of Osiris, which includes fending off his enemies. Also acting as a deterrent are the twelve fire-spitting uraeus serpents in the lower register, while the nine "field gods" alongside them, with stalks of grain in their hands, are there to ensure that the deceased are provided for. They are said to be the ones who "cause all the trees and all the plants to be created."

In the lower register, the tenth nocturnal hour brings the water rectangle with the drowned, which in the Book of Gates is filled by the ninth hour in the middle register (fig. 19). Those floating in the water, like the dead Osiris, are shown in various positions; they are kept from decomposing and decaying by Horus, son of Osiris, and are led later to a blessed existence, even though they could not be given a normal funeral. Here, the primeval water Nun is seen as a regenerating element and fills up the whole nocturnal hour, which is called "with deep water and high banks." Darkness reigns, lit up only by the four goddess with serpents coiled round their heads.

45

19 The tenth hour of the Amduat depicting the deified drowned in the lower register, in the tomb of Amenhotep II. Eighteenth Dynasty, 1427–1400 BCE; painted plaster. Valley of the Kings tomb no. KV 35.

20 Detail, the eleventh hour of the Amduat in the burial chamber of the tomb of Thutmose III. Eighteenth Dynasty, 1479–1425 BCE; painted plaster. Valley of the Kings tomb no. KV 34.

21 The twelfth hour of the Amduat in the burial chamber of the tomb of Amenhotep II. Eighteenth Dynasty, 1427–1400 BCE; painted plaster. Valley of the Kings tomb no. KV 35.

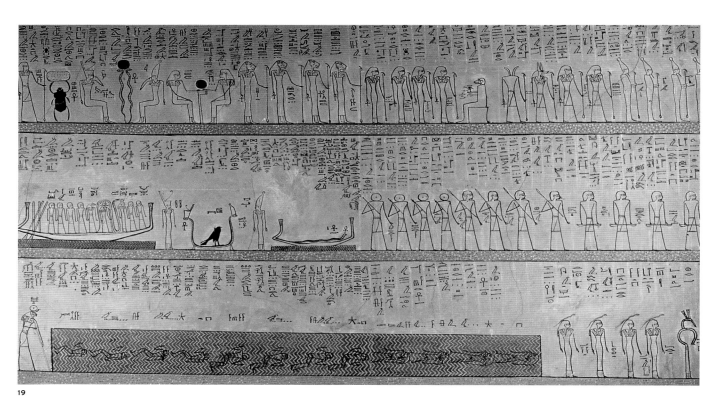

19

The upper register deals with the protecting and healing of the "eye," which appears as the eye of Horus and was already being protected in the fourth hour; also responsible here, in addition to Thoth (the enthroned monkey with the eye in his lap), is the lion-headed Sakhmet, the goddess of healing, who is present in many different forms. The scarab beetle at the beginning of the register once again anticipates the morning renewal. In the center, in front of the sun barque, are the *ba*-souls of Sokar (falcon on the serpent with legs) and Osiris (falcon-headed serpent in the boat), as well as the "bodyguard" of the sun god, who protect him against his enemies in the darkness and are armed with various weapons, most of them being archers. They escort him throughout his journey in the netherworld, preparing the way for him to the eastern horizon.

The eleventh hour is filled with intensive preparations for the imminent sunrise, the "emergence from the eastern mountain of Heaven." In front of the barque comes the "world-encircler"—a serpent inside which in the next hour the miracle of rejuvenation takes place. As uraeus serpents, Isis and Nephthys transport the two

crowns of Upper and Lower Egypt to the eastern "Gate of Sais," which is guarded by four forms of the goddess Neith, who is revered above all in Sais in the Nile Delta.

In the upper register, time and the birth of the hours are the central issue. What is important for the sun god as "Master of Time" is not to miss the right moment for the new sunrise. The double head of the god symbolizes the dual aspect that time had for the Egyptians; this can be seen clearly in the double names of Neheh and Djet for the meaning of "eternity" or even "time," with Neheh standing for the dynamic aspect of time and Djet for the static. Time itself is in the form of a serpent, which gives birth to the individual hours and then devours them again after they have run their course.

In addition to the entourage of the sun god, four goddesses appear on double serpents at the end of the upper register, each with a hand in front of her face. They give off their fiery breath, which burns the fiends in the lower register; these fiends have fallen into fire-filled pits (like hills in the representation; see fig. 20). Horus accuses them of having done harm to his father Osiris, for which they must be punished. The serpent "which

burns millions" and goddesses of punishment armed with knives execute judgment to ward off any danger that might threaten the sunrise. In the pits the bodies, the *ba*-souls, the shadows, and the heads of those punished are destroyed one by one. The final pit is "the desert valley of those upside down," where we find four goddesses with the sign for "desert" on their heads; thus judgment is passed in the desert, before the new rising of the sun, and the red morning sky reflects the bloody punishment.

In the twelfth nocturnal hour, the new birth of the sun finally takes place (fig. 21). As it is a repetition of the primeval creation, the primeval gods are in attendance, with two pairs (including the primeval water Nun) being depicted at the beginning of the lower register. The process is shifted to the interior of the serpent "world-encircler," who was brought along in the previous hour, and the traction force of what is going on is indicated by the unusually large number of those towing — twelve males and thirteen females. All of them pull the barque, with its "millions" of blessed dead, through the body of the giant serpent. They go back to front, from the tail to the mouth, which points to the essential reversal of time that enables a rejuvenation to take place; according to the texts, all the beings enter the tail of the serpent as frail and infirm old people, and emerge from the mouth as little children; the transformation thus takes place inside the body of the serpent.

At the end of the hour, the solar beetle, already present at the prow of the boat, flies into the open arms of the god of the air Shu, who raises the sun up to the day sky. The goddess of Heaven, Nut, is not depicted, but the text mentions the rising of the sun from her thighs and hence the process of a real birth. The whole event takes place amid the general cheering of the gods in the upper and lower register. This cheering is meant not just for the

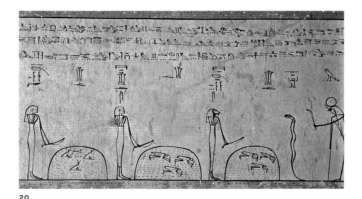

20

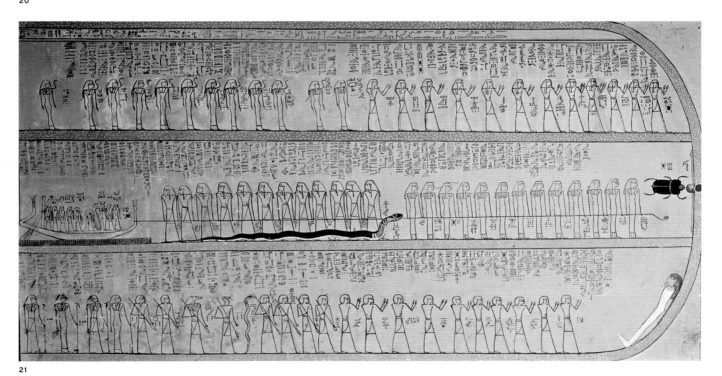

21

22 Detail of the Litany of Re in the tomb of Seti II. Two forms of the sun god enclosed by the disk. Nineteenth Dynasty, 1200–1194 BCE; painted limestone. Valley of the Kings tomb no. KV 15.

sun but also for Osiris who, although he has to remain behind in the realm of the Dead, is nevertheless promised life. In the upper register, the goddesses with their fire-spitting serpents drive away Apophis for the last time and continue to provide light for the dead with their living torches after the sun has left the netherworld. For a brief moment the netherworld is open, but Shu "seals" it up once again, and the nocturnal journey is over. Together with Osiris, who is shown in the form of a mummy at the end of the lower register, all the deceased sink back into the sleep of death. But with the rebirth of the sun, the whole of creation is renewed and rejuvenated.

In addition to the exhaustive, lavishly illustrated version of the Amduat, there has also, from the very beginning, been a short version that is like a summary of the book and has no illustrations. It serves as a quick guide to the most important names and places of the netherworld by giving a selection from the abundance thereof to be found in the full-length version; the actions of the sun god are also summarized hour by hour, and here too great stress is placed on the usefulness of knowledge about the realm of the dead. Thutmose III had this short version drawn on both pillars of his burial chamber, so that anyone entering would see it straightaway. His successor, Amenhotep II, had it follow the twelfth and final hour of the long version, at the foot of his coffin, so that he could see it easily and "at a glance" before his eyes; Seti I and Ramesses IV also arranged their incomplete version around the sarcophagus.

The Litany of Re

In addition to the Amduat, the tombs of Thutmose III and his vizier, Useramun, are also given parts of another composition that in old Egyptian bears the name "Book of Adoring Re in the West," but in modern times is known as the "Litany of Re." The shroud in which Amenhotep II wrapped the mummy of his father also had the complete text of the book written on it, without illustrations. Afterward the litany disappears for several generations, but is chosen by Seti I henceforth to decorate the first two corridors of the Ramesside royal tombs.

Thus it is given a very prominent place in the royal tomb, not without reason. Its theme is the direct equating of the deceased pharaoh with the sun god Re, with his *ba*-soul and with the daily course of the sun. "My birth is the birth of Re in the West" is how the king expressed his hope of entering into the daily journey of the sun and being born anew with it.

At the beginning of the "large" litany are seventy-five invocations of the god, all beginning with "Praise to you, oh Re, you with great power." Each invocation is illustrated by the figure of a god, and as the seventy-sixth figure we find the *ba*-soul of Re, as a ram's head in the red disk of the sun. Thutmose III had these figures placed separately on the two pillars of his burial chamber, together with a brief extract from the text. The vizier Useramun distributes the figures over two walls, and extends them to include figures of himself and members of his family, who are thus elevated to the status of gods. Such extensions of the series of figures went on to include the coffins and papyri of the Twenty-first Dynasty (1069–945 BCE); there they were regarded as protective gods of the deceased, and have long been objects of a cult.

Most of the figures are mummiform, with a few in the form of animals, such as the ram and the scarab as the

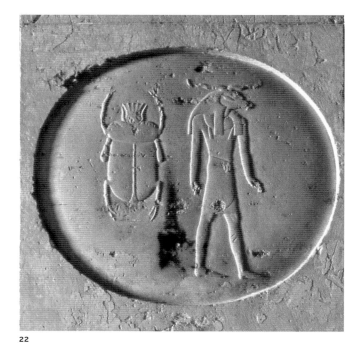

22

two main figures of the sun god (fig. 22), and the "Big Tom-cat," which embodies his punishing aspect, and the "Divine Eye." After Seti I a sort of title picture is added, showing the ram-headed god and the scarab beetle in a large sun disk, accompanied by crocodile, serpent, and gazelle, who, as enemy beings, flee from the sun.

The Litany is not influenced by the Books of the Netherworld in form but in theme. It deals here with the nocturnal journey of the sun god, as role model of a daily regeneration; there is also the description and praise of that deity that descends into the netherworld at night, arouses the dead to new life, attends to the blessed, and punishes the damned. What is important here is the fact that the pharaoh enters into the sun's course, which ensures his daily regeneration.

The many names and figures of the god are all related to the realm of the dead and to the hope for regeneration. In the Books of the Netherworld, the texts consist of dialogues of the sun god with the inhabitants of the Beyond, whereas in the Litany, the deceased himself speaks, as in the Book of the Dead. He stresses that he would like to walk along the right paths, on the "paths of the west," and repeatedly expresses his hope that he will be saved from the dangers lurking there.

The names and the figures that illustrate them refer to the most important forms and functions of the sun god in the netherworld. Thus the morning figure Khepri is met (three times), the evening figure Atum, the *ba* of Re (as an additional figure), the forms of ram, tomcat, and child, the "Divine Eye" and the sun disk, as well as the escort figure of the baboon are also met. In addition to Atum, the other gods and goddesses of the "Ennead" appear, although Seth is replaced by Horus. Of the remaining gods, Nun and Tatenen are still represented, that is the depths of the water and depths of the earth.

Osiris appears among the figures only as Khentyamentiu, but two names indicate the union of the two gods Re and Osiris, which is a central theme of the whole Litany. Descending into the netherworld, the sun god meets Osiris as the ruler of the netherworld and of the dead. Thus there arises the question of their mutual relationship, and at the beginning of the New Kingdom the

permanent solution has been found—to see in Re the *ba*-soul of Osiris, which unites every night with the body of the god, permeates him with her light, and thus awakens him to new life. They are temporarily united into one single deity, which "speaks with one mouth," as the texts do not fail to point out.

This union has been pictorially depicted in the tomb of Nefertari and some other tombs; it is a figure that combines the attributes of Re (ram's head, sun disk) and Osiris (mummiform, with Isis and Nephthys as escorts) into one figure; to a certain extent it is a picture of the night sun, uniting within itself the essence of Re and Osiris. In the text, however, Osiris is an independent figure; he receives Re and offers him his hand. His location is so secret that it is known only to the deceased who knows everything.

Apart from this, there are several names emphasizing the close connection of the god with the realm of the dead in the netherworld; examples include "He of the Netherworld," "He of the Cave," "He who commands the cave," "He Who Renews the Earth," and even directly "The West." There are other names that mark him as a wanderer through this sphere, as the "one who passes by," and in the final text of the Large Litany even as the "Migratory Bird" who disappears and returns. Jubilation and mourning are both represented, for both death and rebirth are involved here, and in some names, references are made to the corpse of the god, even to its decomposition, which must precede regeneration. As a corpse he is "He in the Sarcophagus," and as *ba*-soul he unites with his hidden body. His name "The Weeping One" refers to the popular motif of human beings emerging from the tears of the creator god.

The double face of the night sun is seen in the juxtaposition of lights and rays on the one hand, and shrouding and darkness on the other. Re is "The Dark One" or "The One with the Dark Face" but also "The Shining One," whose rays are longed for by the dead. Finally, emphasis is placed on the benefits of the god on behalf of the blessed dead—he sheds light on them, awakens them from their sleep of death, and gives the breath of life to their souls.

But there are also many references to his punishing function; he is "The One Who Enchains" and "The One

22 View of burial chamber of
Amenhotep II, 1427–1400 BCE; with
first and second hours of the Amduat.
Valley of the Kings tomb no. KV 35.

from the Cauldron"; in fact generally "The One Who Destroys his Enemies," and "he has arranged the heat in the Place of Destruction." He also has to vanquish his adversary Apophis, who constantly threatens his progress.

The first "large" Litany is followed by eight others, as well as various intermediary texts identifying the deceased pharaoh with the sun god, as well as with the primeval water Nun and hence the world before the creation, from which the sun itself once emerged. There is a short piece of text chosen by Thutmose III as the only one for his tomb, alongside the figures and which, after Seti I, was placed separately on the ceiling of the second corridor. This text is addressed to the "United One," meaning the night sun and Osiris.

Only toward the end does the deceased present himself as Osiris but the most important thing is his wish to be born again, like the sun, and to be protected from all dangers, specifically the "Slaughterers" and the "Demons with sharp knives." The pelican goddess greeting him is probably an embodiment of Nut, the goddess of Heaven, who is there to help the deceased and the sun to new life. His complete deification graphically depicts the "Member Apotheosis"—a litany in which every part of the body is equated with a deity, so that at the end it can be said: "No part of me is without God." In a final litany, the deceased worships the "west," which stands for the whole realm of the dead and at the same time is an aspect of the goddess Hathor, our guide.

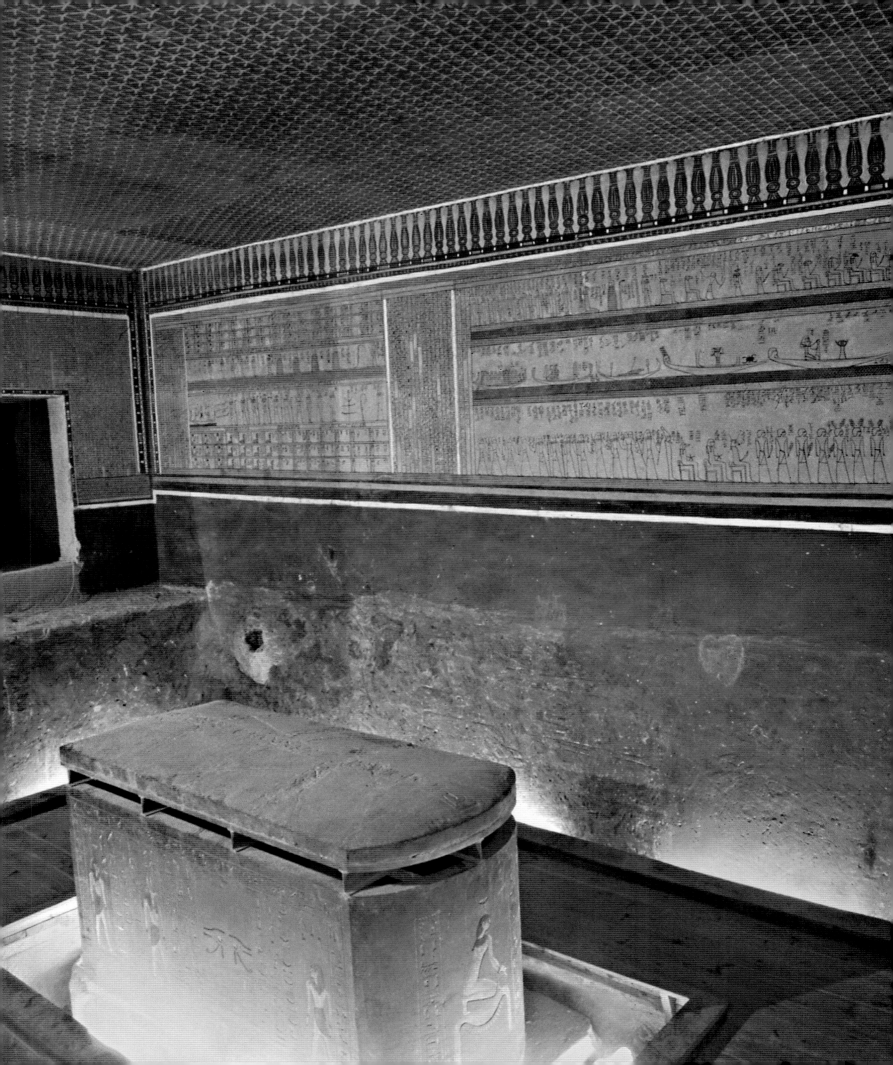

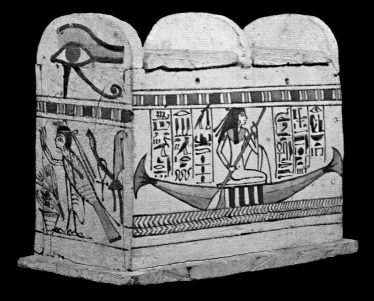

Art for the Afterlife

Betsy M. Bryan

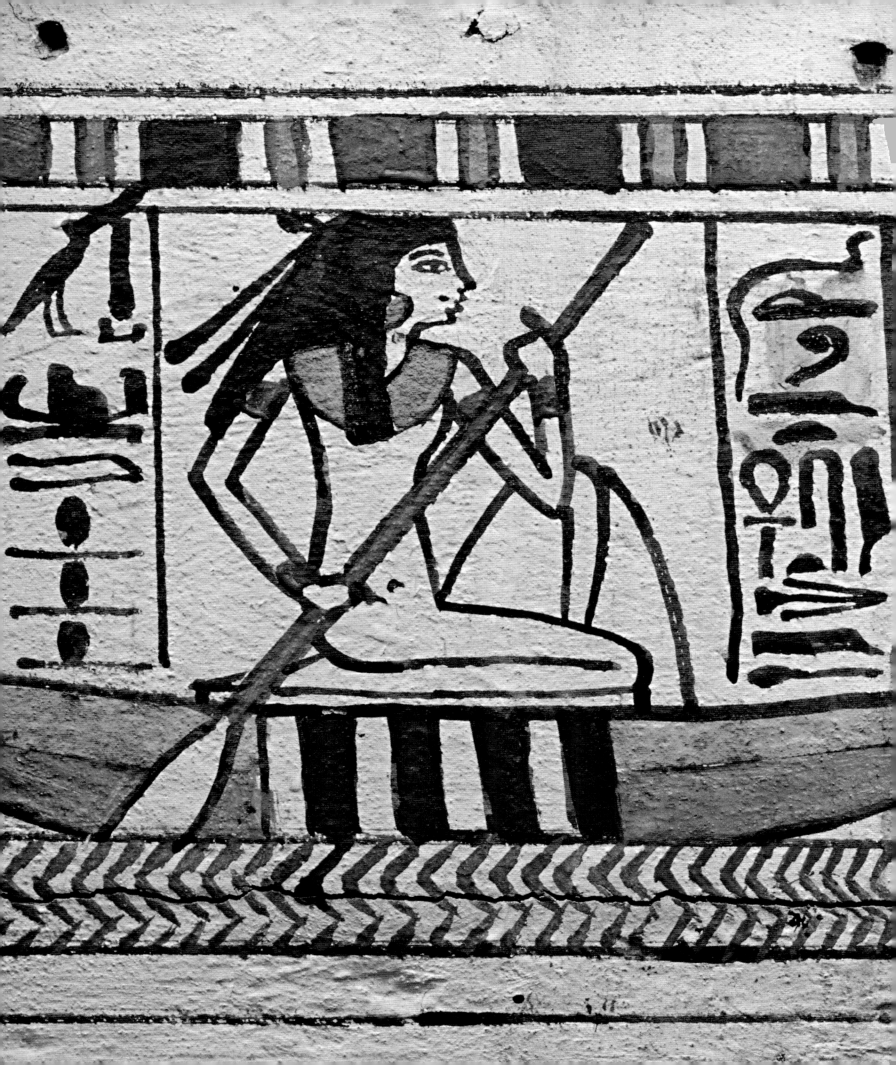

• As early as 4500 BCE, Egyptians adorned their deceased loved ones with jewelry, laid them upon textiles, and carefully placed prized belongings, such as combs, weapons, and magical figures, beside them. They set offerings of food and drink next to the bodies, which, even at that early time, exhibited attempts at preservation that presaged the practices of mummification. Neolithic remains have been found wearing wigs and padding for bodies and faces, to resemble better the skin of the living. Craftsmen fashioned handmade pots for the burials, which as early as the fifth millennium BCE were painted with scenes of hippopotamus hunts or crocodiles soaking in the Nile. Some pots had tiny sculptures of animals made separately out of clay and attached to the rims of the vessels, as if marching in a circle. Obviously the creative abilities of the early Egyptian culture were strongly directed to preparation for the afterlife. The hope of a continued existence fueled the production of funerary arts for more than five thousand years, as artisans worked together with priests to portray in images and texts an understanding of this world and the next.

The Egyptian artisan often is not granted the label "artist," however, in what may be an unwarranted modern view. "Beauty," or more accurately, "perfection" was commonly applied as an epithet to images commissioned by rulers for themselves or the gods. The great scribe and Overseer of Royal Works for Amenhotep III (1390–1352 BCE), Amenhotep, son of Hapu (cat. 15), spoke as follows of the Colossi of Memnon in western Thebes, which were made for the king: "I directed the works for his statues, great of breadth, higher than his pillar. Its *(sic)* beauty *(neferu)* eclipsed the pylon."[1] The matter-of-fact cultural view of

the ancient Egyptians reveals itself to us in descriptions of monuments and artworks. The idea of "perfection" or "beauty" would have included an aesthetic notion, but it was expressed as an index of "knowledge" and "craftsmanship." Because iconographic value was intrinsically part of any Egyptian object or image, the artist's acquaintance with symbolism and the mythology associated with symbols was on a par with his technical skill. Amenhotep, son of Hapu, on another statue of himself (cat. 15), spoke of directing the production of statues for the temple of Karnak made from quartzite stone and quarried hundreds of kilometers to the north of the temple: "I brought very many monuments consisting of statues of his Majesty being of knowledgeable artisanship" *(em hemut rekhet).*[2] "Knowledgeable artisanship" occurs in a number of inscriptions and demonstrates well that the Egyptians valued both the technical skill of artistry and the learning and experience needed to assure the proper functioning of the work. Therefore, to refer to what Egyptian artisans produced as "art" and to the craftsmen themselves as "artists" is by no means unjustified.

Writing and Art

The invention of writing in Egypt took place sometime late in the fourth millennium BCE, and the system that developed consists of signs that are either phonetic or pictographic. The signs themselves, hieroglyphs, are drawings of nearly everything the Egyptians saw and used, whether naturally occurring or produced by humans. The word for "out of," *em,* was an owl, with its face turned forward and its body in profile, while the word for "to go forth," *per,* joined the sign of a house, phonetically *per,* with two walking legs, a sign informing the reader that the word is one of "action." Egyptian writing combined hieroglyphs to write words, phrases, sentences, and ultimately lengthy literary and religious treatises; art cannot be separated from this hieroglyphic writing system.

Egyptian art is hieroglyphs writ large. The human body, when depicted in two dimensions, is not presented realistically in the manner of Western cultures. Rather, it is formed as a composite hieroglyph, made up of several signs for parts of the body. For example, a man's head will appear in profile, but his eye is a complete eye, as if seen from the front (see cat. 7)—a combination of two images (see fig. 1). The man's shoulders are shown in frontal view, but his torso and the remainder of the body are shown in profile. In addition, through most of Egyptian history, feet are shown with only the big toe visible—the far rather than the near foot—such that everyone has two feet showing only the big toe. These separate hieroglyphic renderings of parts of the body are ones the Egyptians felt were either characteristic or magically significant. The eye, for example, was an important symbol of agency and action, and the Egyptians believed that an injured eye was a threat to the power of the gods. Therefore, they chose not to show an eye in profile, as if not complete. The frontal shoulders may have been preferred because they communicate the strength of men and accentuate a virile physique when contrasted with a narrow waist shown in profile. Despite the fact that the human figure was a composite hieroglyph, the Egyptian artists brought the several elements together seamlessly, and often the modern viewer does not even notice how unrealistic the image really is.

1

56

2

Egyptian artists worked with several aims in mind, as can be deduced from the description above. They built a composite hieroglyph made up of several characteristic or meaningful pieces, and the product had a meaning derived from these parts. For example, the standing man in figure 1 is, as noted, a powerful person, the image of an Egyptian elite. He is also bald, wears a broad collar and a long kilt and sandals, and holds a censer and a libation jar, from which water pours in defiance of the laws of gravity. These are the iconographic indicators that the man is a priest, since priests are bald, and they wear sandals within a sacred environment. They make liquid offerings and provide incense to the statues of gods and men. The representation is not, however, crudely composed, but rather, seeks to join the parts in a way that obscures the lack of realism. The viewer does not focus on the fact that the man's shoulders are shown frontally and his torso in profile, because the figure is in the act of extending both arms with ritual implements. The action is the viewer's focal point, and Egyptian artists labored within this strict hieroglyphic format to reveal the function of art in the most pleasing way they could.

Representations of Egyptian gods are even clearer examples of the notion that images are composite hieroglyphs. For example, the Great Sphinx at Giza, one of the best known monuments from antiquity (fig. 2), combines the body of the lion with the head of King Khafre (c. 2558– 2532 BCE), fourth ruler of the Fourth Dynasty.[3] The lion was an image of power and leadership as early as the late Neolithic period (c. 3500 BCE), such that its combination with the head of the ruler created the perfect representation of kingship. The lion and the sphinx in the Old Kingdom (2686 BCE) were already also associated with deities who guard the horizons for the sun and are therefore linked to the sun god. Not surprisingly, by the New Kingdom (c. 1550 BCE) the Great Sphinx was worshiped as the sun god Horemakhet (Horus at the Horizon), and when Thutmose III was represented in the form of a sphinx (see cat. 3), he was meant to be understood both as the powerful king and as an image of the sun. The sphinx was a form often chosen to depict the king and would have been understood by all Egyptians, literate or not. A form similar to the sphinx is that of the human-headed snake (see cat. 97) depicted with the head of a king. The deities identified with Upper and Lower Egypt can be shown as cobras (uraei) wearing the crowns of the north and south, and they are the protective goddesses for the king, worn on the forehead of his crowns. The composite hieroglyph may invoke the protection both of the uraeus goddesses and of the ruler who, by virtue of the deities on his brow, was immune to snakebite.

57

Art for the Tomb: Historical Overview

Think of the day of burial, the passing into reveredness. A night is made for you with ointments and wrappings from the hand of Tait [the goddess of weaving]. A funeral procession is made for you on the day of burial; the mummy case is of gold, its head of lapis lazuli. The sky is above you as you lie in the sled, oxen drawing you, musicians going before. The dance of the *muu*-dancers is done at the door of your tomb; the offering-list is read to you; sacrifice is made before your offering-stone.[4]

In ancient Thebes the death of a well-known citizen prompted much activity. The body was delivered to the purification tent and then to the house of embalming

3 Procession by water and land to the tomb. Theban tomb 181 of Nebamun and Ipuki, Thebes. Eighteenth Dynasty, c. 1360 BCE; painted plaster.

4 Funerary procession with burial objects. Theban tomb 92 of Suemniwet, Thebes. Eighteenth Dynasty, c. 1425 BCE; painted plaster.

called the *wabet* (pure place), or the *per nefer* (the house of completion). For some seventy days the embalmers cleaned, dried with natron salts, anointed with oils and herbs, and finally wrapped the body of the deceased. Rituals were recited throughout this period and accompanied every step in the process, for the mummified body, together with the divine spirits — the *ka* and the *ba* — made up each blessed deceased person. The mummy, for the ancient Egyptians, was thus in some ways treated like a statue — as the work of artisans making a *tut,* or perfected likeness, which could likewise contain spirits. Upon completion the mummy, which was now a new form of the person "filled with magic" as a result of the ritual act performed,[5] was placed within coffins that served as further likenesses and protections for the journey through the next world.

At the time of burial, family members and friends may have accompanied a water procession that led from the shore of the Nile, where, one assumes, stood the embalming house, next to a harbor nearer the rock-cut tombs of western Thebes (fig. 3). From the landing place, sleds pulled by oxen carried the coffins, now hidden within large wooden shrines. The other funerary equipment was either dragged or carried by the long line of mourners as they moved across the desert to the cemeteries laid out

beneath the pyramidal shaped hill today called the Qurn, but referred to as Meretseger (she who loves silence) by the ancients. The burial goods ranged from objects used in everyday life — mirrors, headrests, jewelry, cosmetic vessels — to objects made specifically for the funerary rituals — canopic boxes and jars, *ushebtis* (funerary statues), and magical implements (fig. 4).

The building and furnishing of a tomb was considered the duty of any Egyptian who could afford it. The legendary advice of King Khufu's son, Hardedef, to his son states: "Make good your dwelling in the cemetery, make worthy your station in the west. Accept that death humbles us; accept that life exalts us. The house of death is for life."[6] For the Egyptians the final journey to the tomb was the important beginning of a new life in the afterworld, but it was also a very human display of wealth amassed during life. Many of the objects borne to a burial place had been acquired long before death, and the most important works, such as coffins or Books of the Dead, might be commissioned directly from the artists with individual specifications from the purchaser, just as with the scenes placed on the walls of tombs. The artisans who built and decorated the royal tombs in the Valley of the Kings (c. 1300 – 1050 BCE) also provided one another with tombs and burial objects. In a letter written around 1250 BCE, an artisan writes to his son: "Please make arrangements to procure the two faience heart amulets about which I told you, 'I will pay their owner whatever he may demand for the price of them,' and you shall make arrangements to procure this fresh incense, which I mentioned to you in order to varnish the coffin of your mother. I will pay its owner for it."[7] Here we see the family of the artisan compiling the burial outfit for that day whenever it might come.

As with the amulet and coffin mentioned, all Egyptian art was functional; the concept of pure decoration probably did not exist in ancient times. The vast majority of objects deposited in tombs was religious in meaning and purpose, but this did not mean that they were slavishly produced as exact replicas for hundreds of years. Rather, within the hieroglyphic artistic form, styles came and went, materials and colors changed, and details of decoration varied. A look at some of the most important

3

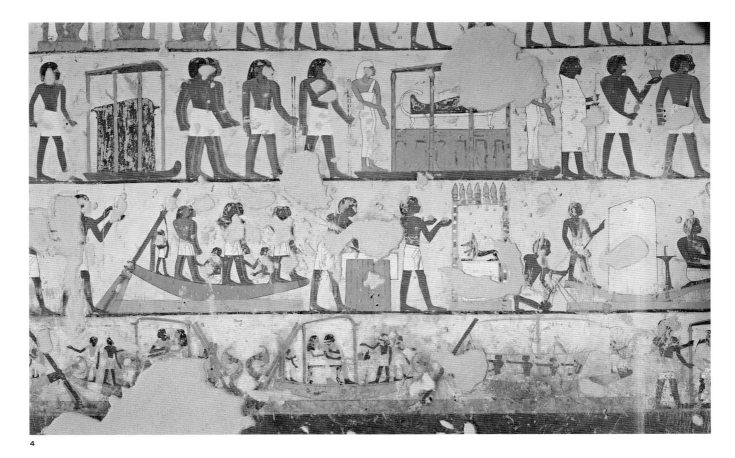

4

burial objects and their specific relationships to the journey of the deceased through the netherworld illustrates this point.

The Symbolism of Materials

Egypt is a country rich in minerals, and the ancient Egyptians quarried hundreds of different types of stones for building and statue making. Their choices were guided not only by the beauty of the materials but also by the symbolism they considered to be attached. For example, red granite *(mach)* came from the Aswan region, and because of its red color the Egyptians associated it with the sun. Kings are often carved from red granite (see cat. 4), while royal sarcophagi are nearly always made of a solar stone (see cat. 100), whether granite or quartzite. Red, yellow, orange, and gold materials were all associated with the sun, and the more common materials, limestone

(iner hedj) and sandstone *(iner hedj en rudjet),* respectively, may have been included in this category. Black stones were used to indicate resurrection and rebirth. Black was the color of the fertile silt deposited by the Nile flood each year, and from that new silt came verdant crops that covered the countryside and nourished the population. Thus the Egyptians called their country the "Black Land," and likewise called granodiorite *iner kem* (black stone). The objects shown in catalogue numbers 3, 10, 11, 14, 15, 76, and 77 are all sculpted of this stone, while another dark gray material, graywacke, favored in the Late Period (664–332 BCE), was used to fashion images of Osiris and Isis (see cats. 78, 79). In all these cases the black stone was chosen either to allude to eternal life for kings and elites or to point to the rejuvenating powers of the gods. The same meaning is attached to objects painted black, as seen in catalogue numbers 8 (the god Amun with black skin), and 28 and 29 (statues from the tomb of Thutmose III meant to assist in his rebirth).

5 Statue of Amenhotep II, Karnak
Temple, Eighteenth Dynasty, 1427–1400
BCE; limestone.

6 Detail, coffin of Queen Ahhotep.
See cat. 25.

7 Head of King Ahmose, sandstone.
Kelekian Collection.

60

Materials used in the production of jewelry like-wise had important meaning to the Egyptians. Gold was the flesh of the gods and was therefore the material par excellence to render mummy masks and coffins. Semi-precious stones, such as carnelian and sard (herset), were red in color and considered to be solar stones, while turquoise (mefket) was prized for its beauty and identified with the fecundity of green vegetation. The dark blue lapis lazuli (khesbed) was an imported stone, brought from Afghanistan. Its connection with the night sky is certain, and the hair and beards of the gods were also considered to be lapis.

Statuary

Thus it is said of Ptah: he gave birth to the gods...he made their bodies according to their wishes. Thus the gods entered into their bodies, of every wood, every stone, every clay, every thing that grows upon him (Ptah Tatjenen), in whom they came about.
—from The Memphite Theology[8]

Statues were provided as the containers of the spirits of the person or god depicted, and their functions were various. A portrait statue embodied the *ka*, the spirit that could receive food and drink in order that the person might live. These images represented the statue owner in an eternal and divine form, defined by iconography. The composite hieroglyph communicated what role the statue was meant to enact. For example, striding statues included the hieroglyph for action (the walking legs), and these images portray the statue owner in movement to receive offerings or to perform a ritual act. Whether placed within a chapel in the tomb or within a great temple such as Kar-nak, these statues received daily sustenance from priests in the hope of assuring eternal life for the statue owner. The *ka* could enter the statues to receive the offerings and also keep in connection with the mummy in the burial chamber or the living person whose statue was placed in a temple. *Ka* statues could be large (see cat. 4) or small, and there may have been a number of them produced for the temple or tomb chapel.

In the New Kingdom tomb chapels often contained seated statues of the deceased and family. Similar sculp-tures were placed in temples. The statue of Sennefer and Sentnay (see cat. 14) is an example of this, having been made for the temple of the great god Amun-Re of Karnak. Sennefer and Sentnay appear seated, she on his left (viewer's right). In Egyptian art the position of higher status in a pair statue is the right (viewer's left). In most cases, as here, that position is given to the male, but there are exceptions. Sennefer's left arm and Sentnay's right cross as they embrace each other. This image of family love and support is common in the mid-Eighteenth Dynasty. The seated posture itself is meaningful and rep-resents the couple as divinities awaiting offerings. Their free hands are extended toward food and drink that might have been placed before the statue, and they gaze at the offerer from the eternal world, where they can receive nourishment and grant petitions to the living. The laps of the statues have been rubbed nearly clean by the hands of petitioners who hoped Sennefer and Sentnay were attentive in the next world and would mediate for them with the gods.

Sennefer is shown with an idealizing face that bears the traits of King Amenhotep II, 1427–1400 BCE (fig. 5). Until the Late Period, private persons were rarely repre-sented with features identifiable as their own, but rather, commissioned images of themselves with the face of the sovereign they served. It was the loyalty and usefulness of a noble to the ruler that early in Egyptian history guar-anteed his life in the hereafter. In the Old Kingdom only the king was guaranteed a place in the boat of the sun god, but his followers could hope for inclusion because he found them indispensable. Although by the Middle Kingdom (2055–1650 BCE) and later, private people could hope to become deified as the god Osiris, without the assistance of the king, the loyalty and closeness of officials to their ruler remained a strong cultural element. In the New Kingdom, courtiers' tombs were often sited in direct view of their lords' funerary temples, and their temple and tomb statues stated their fealty by the portrait faces carved on them.

5 6 7

Portraiture

In the catalogue following these essays are a number of
statues that bear the recognizable face of a ruler. As said
already, these will not necessarily be statues of kings, but
of private persons and gods. From the New Kingdom
onward (and earlier as well), in periods of strong kingship,
the royal administration fostered artistic centers, clustered
around cemeteries and temples. The artistic centers pro-
duced large- and small-scale statues for kings and private
persons, and by a process still unknown to us, composed a
royal portrait type for each ruler. There were variations
in the portraits, and sometimes more than one type was
created. However, through the Eighteenth Dynasty (1550–
1295 BCE) and part of the Nineteenth, statues bore the
identifiable face of the sovereign. The waning of the New
Kingdom affluence in the later Nineteenth and Twentieth
Dynasties left fewer royal statues with recognizable
visages. A resurgence of true portrait types occurred at the
end of the Third Intermediate Period (c. 750 BCE) and
lasted through the Twenty-fifth and Twenty-sixth Dynasties
(747–525 BCE).

When we speak of portraiture, as with all Egyptian
art, we do not mean a realistic rendering of a person.
Rather, the artists designed a composite hieroglyph that
represented a particular ruler and had characteristic facial,
and often body, features. The oldest portrait type shown
in this book is that of Queen Ahhotep (fig. 6), mother of
King Ahmose, who founded the New Kingdom (c. 1550
BCE). Ahhotep was an exceptional queen who ruled south-
ern Egypt for her son while he waged war against the
Hyksos overlord in the north. We do not have a statue of
Ahhotep with her name preserved on it, but she may be
represented in a limestone work now in the Metropolitan
Museum of Art (acc. no. 16.10.224). Her son Ahmose's few
portraits indicate ovoid, slightly oblique, and wide open
eyes, with perceptible bulging of the eyeballs (fig. 7).
The facial type is somewhat short and broad, particularly
across the upper cheekbones. His mouth is wide and
slightly smiling, and several works that may represent
him or his predecessor and probable brother King Kamose
show the mouth plastically shaped as if applied to the
stone surface. The coffin portrait of Ahhotep displays
the ovoid, obliquely set eyes, though here of separate mate-
rials that do not accommodate a bulging eyeball. The
facial shape is likewise similar to that of Ahmose, and con-
sequently one would likely place the production of this
coffin in his reign.

The colossal head of Thutmose I (1504–1492 BCE;
see cat. 2) derives from a sandstone mummiform statue of

8 Bust of Senusret I, Osiride statue from Karnak Temple. Twelfth Dynasty, 1956–1911 BCE; limestone. The Luxor Museum J. 174.

9 Detail, Sphinx of Thutmose III. Karnak Temple. See cat. 3.

10 Detail, Thutmose III. See cat. 4.

the king as the god Osiris. A series of these statues was placed in the temple of Karnak within the columned hall at that time just within the entrance pylon. These so-called Osiride statues are now all lacking their faces, but this head was found lying in the hall and is of the same scale as the colossi. In the fifty years that passed since the reign of Ahmose, the portrait type changed dramatically. Although the eyes are still large and wide open, they are not obliquely turned and are delicately outlined. They are shaped naturally, the lower lid being nearly horizontal and the upper highly arched. There is no visible bulge. Thutmose I has a long nose that in profile appears somewhat aquiline. This is a distinctive feature of the ruler's family, and the trait first appears in sculpture of this time and is characteristic of the rulers from Thutmose I through Thutmose III. The facial type is simplified with cheekbones prominent in the middle of the face. The idealized and refined look recalls the statuary of Senusret I of the Twelfth Dynasty (fig. 8), whose sculpture and monuments dominated Karnak until the Eighteenth Dynasty. An intentional archaism was frequently introduced by the

sculptors at Karnak who used the sweet and elegant images of Senusret I as a visual reference. Thutmose I has a wide mouth that is clearly smiling. A hard edge is visible surrounding the mouth but does not interfere with the swell of the lips. The upper lip is somewhat thinner than the lower and gives the impression of being slightly pulled over the teeth. The family of Thutmose I had a distinct overbite, the effect of which is seen in all statuary through the reign of Amenhotep III.

Thutmose III's statuary (1479–1425 BCE) is represented by two portraits in the catalogue (see figs. 9, 10). The first was found in the king's temple at Karnak, called the Akhmenu ([Thutmose III is] Effective of Monuments). This building was largely constructed and decorated in the first years after the king assumed sole rule of Egypt. His aunt and stepmother, Hatshepsut, had ruled as co-regent with him since his young boyhood, but once he ruled alone he began work on his temple in Karnak. The portrait type of Thutmose III changed little over the first twenty-five years of his sole rule. This statue's face does, however, show strong links to the image of Hatshepsut, whose many sculptures were left in her funerary temple at Deir el-Bahari. The facial shape here is triangular, tapering from broad cheekbones, heavy in the mid-face, to a narrow chin. Later statues of Thutmose III reveal less of a tapering face shape (see cat. 4). The nose here is quite large and curved in profile. The mouth, slightly smiling, is as wide as the base of the nose, and the eyes, wide open, are slightly smaller than those of Thutmose I but shaped naturally. The face of the king on the sphinx is similar but not identical. Made perhaps a decade later than the last, this statue shows a more idealized facial type. The nose is slightly smaller and little hooked when seen in profile. The eyes are smaller too, but are shaped similarly to those in catalogue 3. The overall appearance has eliminated the strong feminized elements of Hatshepsut's statuary and accented the robust and fleshy face of the king but with less individualization of features.

The statue of Sennefer and Sentnay (fig. 11) preserves the features of Amenhotep II (c. 1427–1400 BCE), son of Thutmose III. Similar to the portraits of his father in the last years of his reign, Amenhotep II has a full face,

8

11 Detail, Sennefer, mayor of Thebes. See cat. 14.

12 Head of Amenhotep III. Eighteenth Dynasty, 1390–1352 BCE; granodiorite. Cleveland Museum of Art, Gift of the Hanna Fund 52.513.

9

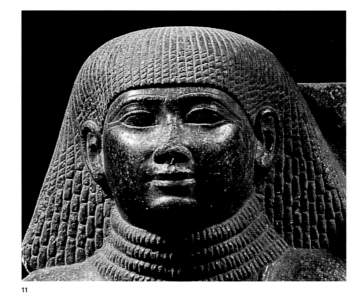

11

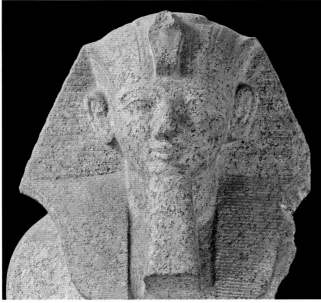

10

12

broad across the cheekbones, but slightly higher on the face than his father — at the middle of his nose. The king's eyes are somewhat wide open and are neither entirely naturally shaped nor ovoid. The upper lids are less arched than on Thutmose III's statuary, creating a more oval shape. The king's nose is long and thin at the top, then splayed at its base. His mouth is as wide as the base of the nose but shows no smile. The statuary of Amenhotep II often suggests idealization that forbids personality, and

Sennefer's face is representative. Without the elaborate wig and festive gold collars and heart amulets that he wears, Sennefer's face is fleshy (perhaps intended to suggest he is overweight) but not distinctive.

Amenhotep III's portrait is represented by two statues (see cats. 15, 76), one a god and the other a private person. In contrast to the image of Amenhotep II, that of his grandson Amenhotep III is highly individualized. The king (fig. 12) has a rather long and highly fleshy face, with

13 Detail, Ushebti of Hat. See cat. 59.

14 Head of Tutankhamun. Eighteenth
Dynasty, 1336–1327 BCE; limestone.
The Metropolitan Museum of Art,
New York, Rogers Fund, 1950 50.6.

13

14

64

little or no suggestion of bone structure. The eyes of the
ruler are entirely ovoid in shape, and they are narrow.
In most cases the eyes are set at a slight angle, in a manner
one might call Asian. The mouth is as distinctive as the
eyes. It is a full mouth, as wide as the king's nose at its base,
and the upper and lower lips are full. The upper lip has
a deep "vee" in its center and a slight bulge where it meets
the lower one. This represents that same Thutmoside
overbite seen as early as the statuary of Thutmose I, but
on a generous mouth such as here it purses the lip. The
entire mouth is rimmed by a raised rim, a lip line, consis-
tently found on the statuary and sculpture of this king.
All in all this is a highly identifiable face.

The Ushebti of the Adjutant Hat (fig. 13) is a small
masterpiece of Egyptian art, re-creating as it does the
perfectly sculpted face of an Amarna ruler in a miniature
scale. The face preserves the portrait style of the late
Amarna Period — the end of the reign of Akhenaten
(Amenhotep IV) — or early in the reign of Tutankhamun.
The round and youthful face and the large almond-shaped
eyes, characteristically outlined in black, are hallmarks
of the late Amarna age. The mouth, with its full lower lip
and slightly down-turning corners, is also a feature of
the period, originating in the depictions of Amenhotep III's
widow Tiy at the beginning of her son Amenhotep IV's
reign (1352 BCE). The traits seen so often earlier in the Eigh-
teenth Dynasty — aquiline nose, strong cheekbones, and
evidence of an overbite have all disappeared. The portrait
here betrays a break in the royal family succession (fig. 14).

The image in catalogue 13 preserves the features of
Ramesses II of the Nineteenth Dynasty (c. 1279–1213 BCE),
although it began its existence as a colossal statue of King
Senusret I of the Twelfth Dynasty (c. 1956–1911 BCE). One
of a series of granite statues of Senusret I made for the
temple of Ptah at Memphis, this piece and the others were
re-carved for Ramesses II when he rebuilt that cult center.[9]
The face of Ramesses II was often round in shape, although
it could be fleshy but long. This second model seems the
guide here and conforms better to the original shape of
Senusret's own face. Ramesses had oval-shaped eyes, but
these were carved more wide open than seen in the reign of
Amenhotep III or the Amarna era. His eyeballs are often,
as here, made to bulge slightly. A highly distinctive feature

15 Detail, Paakhref. See cat. 105.

16 Detail, Osiris dedicated by Nitocris. See cat. 78.

17 Detail, Statue of Isis. See cat. 79.

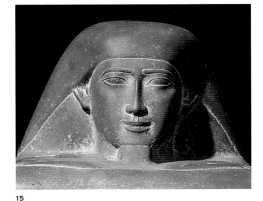

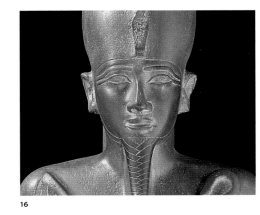

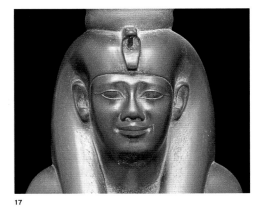

15

16

17

of his eyes is an upper lid area carved back from the surface of the eye, producing a convexity between the upper lid and the eyebrow. Here that has been "faked" by a wide lid line in higher relief than the lid above it. Ramesses' mouth often emulated that of Amenhotep III, and here that is particularly true. The nose is narrow and long, being mildly aquiline. The mouth is wider even than the base of the nose and is drilled at the corners and rimmed by a raised lip line. Even the pursed upper lip is copied here, although it is unlikely that Ramesses II's family had the same overbite prevalent in the family of the Thutmosides. This portrait type is meant to invoke the memory of important earlier rulers, whose identification with Ramesses might inject his image with more power, but it is still unmistakably Ramesses II.

Not again until the Twenty-fifth Dynasty can we talk decisively of royal portraits. The catalogue includes several pieces that date from the beginning of the Twenty-sixth Dynasty (c. 664 BCE), the so-called Saite period, and presumably preserve the features of Psamtik I, first king of the period (although actual statues of the king are lacking for the comparison). The block statue of Paakhref (fig. 15), inscribed with the name of Psamtik I on his shoulder, displays a long thin face set with extremely long and almond-shaped eyes. Bone structure is apparent in the upper face. The eyes are delicately rimmed on the upper lid by a narrow cosmetic line, and the brows above are quite nearly horizontal. The nose is long, thin, and quite narrow at its base. The mouth is the most characteristic feature of the face, since it is wide and bowed in a smile. This smile is common to the Saite period and is often claimed to be the inspiration for the "archaic smile"

seen on early Greek *kouroi*. The statue of Osiris (fig. 16), dedicated by Psamtik I's daughter Nitocris, depicts a very similar facial type and might be considered a true royal image, since Osiris appears wearing the royal crown of Upper Egypt. Finally, the sarcophagus of Nitocris herself displays the feminized portrait face of Psamtik I (see cat. 100).

The statue of Isis dedicated by one Psamtik dates from the end of the Twenty-sixth Dynasty and is the latest portrait type shown here. The face displays the Saite features of the ovoid and outlined eyes and horizontal brow types, but the facial shape is shorter and has lost its strong structure — it is now fleshy and almost cherubic. These are features similar to those seen on statues bearing the name of King Amasis or Psamtik III (c. 526 BCE; fig. 17).

The more generalized facial images, such as that of Hekaemsaef (cat. 53) or Isis-em-akhbit (cat. 51), cannot strictly be called portraits, but they are representative of the periods in which they were made. Isis-em-akhbit, for example, has a large fleshy face, almond-shaped eyes, and a thick mouth, reminiscent of the later New Kingdom (compare the face of Ramesses II). These features were still in fashion in the Twenty-first Dynasty (1069–945 BCE), when Isis-em-akhbit's coffin was made. The mummy mask made for Hekaemsaef is typical of later Saite faces. The almond-shaped eyes with narrow straight brows are quite evident, as is a fleshy face and the archaic Saite smile. Without our knowing that this piece dates from the time of Amasis, however, we might not be able to assign it to a specific reign. Nonetheless, the influence of Egyptian portraiture was such that even simplified forms, such as coffin faces or masks, reveal the general time in which they were fashioned.

65

18 Coffin of Henutwedjbu. Eighteenth
Dynasty, reign of Amenhotep III,
1390–1352 BCE, wood, bitumen, gold.
Washington University Gallery of Art,
St. Louis. Gift of Charles Parsons, 1896.

Coffins

**May your souls not remove themselves from you! May your forms
live and speak to your spirits! — Second Hour of the Amduat**[10]

Certainly among the most important objects purchased
for tomb preparation was the coffin. The purpose of coffins,
from earliest times, was the protection of the body — its
preservation from deterioration or mutilation. Like mum-
mification, coffins provided an image, or *qed* (form), of
the deceased that could house the corpse and its spirits.
A sarcophagus, a larger container to hold coffins, might
also be placed in the tomb. The Greek etymology of "sar-
cophagus" is "flesh eater," but this meaning, confined as it
was to the classical world's dreary understanding of death,
could not have been further from the Egyptian interpreta-
tion. In the Egyptian language the sarcophagus might be
called *neb ankh* (the possessor of life), for it held that possi-
bility. There are several other words for coffins and sar-
cophagi, but perhaps the most relevant to our discussion
are *wet* and *suhet*. The meaning of *wet* is perhaps not
entirely understood, but it appears to be derived from the
words for "mummy bandages" and "to embalm," which
are also *wet*.[11] The Egyptians were always attracted to word
play, so it is likely no coincidence that another word, *wetet,*
which would have sounded similar, meant "to beget" —
playing on the meaning of coffin as the place from which
the deceased will be reborn. The possibility that this pun
was in the minds of the ancient Egyptians is strengthened
by the word *suhet,* used for "inner coffins" or perhaps
"mummy board." This is the word for "egg," from which
new life emerges. In the later New Kingdom, wealthy
Egyptians might prepare for their rebirth by acquiring
a sarcophagus (possessor of life), a coffin (the bound
mummy, or "that which begets"), and an inner coffin or
mummy board (the egg). Each purchase would have
brought them closer to the assurance of their successful
transition to the next world.

As with portraits, coffin styles and decoration
changed over time, and a number of those types are repre-
sented in small and large scale in this book. Earliest coffins
were rectangular wooden boxes, and these remained
the norm through the Middle Kingdom. The anthropoid-

shaped coffin originated during the Middle Kingdom as
an inner container for the body placed within the rectan-
gular outer coffin. During the Second Intermediate Period
(1650–1550 BCE), the anthropoid coffin became the stan-
dard form for all coffins, and the style was quite distinctive.
The elites of the Seventeenth Dynasty, centered in Thebes
during the Second Intermediate Period, were buried in
anthropoid coffins decorated all over the lids with repre-
sentations of the vulture's wings. These winged *rishi*
coffins were either painted or, as in the case of Queen
Ahhotep (see cat. 25), plastered and gilded. Because Thebes
suffered from limited access to precious raw materials
at this time period, the royal coffins, such as Ahhotep's
and that of Nubkheperre Intef VII, had only a thin layer
of gold over a plaster ground that itself covered a rather
roughly hewn log coffin. The wood, however, was cedar,
an imported material from the Levant. Ahhotep's son,
Kamose, attacked and looted wood, gold, and bronze from
the Hyksos capital at Avaris only a few years before this
sarcophagus was made. That event may have provided
both the cedar and the material for Ahhotep's personal
objects, which were found in the coffin (see cats. 21–24).
The Ahhotep coffin shows the queen wearing the wig
associated with Hathor, made of two long tresses that are
curled at the ends. Just as Hathor gave birth to the sun
each day, in the guise of that goddess Ahhotep becomes
the mother of the sun god. Taken together with the
Hathor wig, the wings of the vulture, which envelop the
queen, suggest that she is the sky goddess who carried
the sun across the heaven.

In the Eighteenth Dynasty anthropoid coffins first
were painted white and crisscrossed with bands, imitating
wrappings. Often their sides were painted with tomb
scenes. By the middle of the dynasty (c. reign of Hatshepsut),
coffins were normally covered with black pitch, inter-
rupted by bands, again running vertically down the front
and horizontally as well. On the finest examples, the
faces were gilded, and the bands were gold as well (fig. 18).
Wealthy tomb owners may have had an outer and an inner
coffin of this type, placed one within the other. The model
coffin for Amenhotep Huy's *ushabti* represents this type
(see cat. 60), although the color there was green rather
than black. Green is an easier color than black to achieve

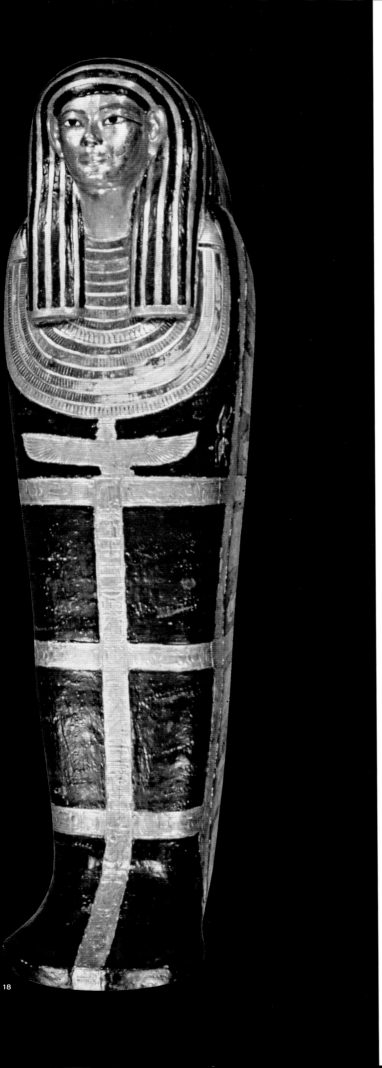

in faience, or Egyptian blue, which this model coffin may be, and both green and black had the same symbolic significance to the Egyptians — they were the colors of resurrection. Thus the god Osiris, lord of the afterlife, also a vegetation god, was often pigmented green (cat. 85), while the creator god Amun-Re appears with black skin on a block from the Deir el-Bahari temple of Thutmose III (see cat. 8).

Throughout the New Kingdom the most affluent elites acquired multiple coffins for their burials, and then commissioned sarcophagi to hold them. These wooden boxes were topped by pitched roofs, imitating the archaic icon of the Egyptian shrine of Upper Egypt and were equipped with sleds, so that they could be pulled by oxen across the desert to the cemetery. The sarcophagus shown in catalogue 68 is this sort, made for an artisan named Khonsu, son of the chief artisan Sennedjem. Both men were buried in Sennedjem's tomb in the Deir el-Medina cemetery. Khonsu would have died in the reign of Ramesses II (1279–1213 BCE), but the similarity of his sarcophagus to that of his father suggests it was made for him earlier in his life, in anticipation of that day of crossing over. The style of black resin as a ground for coffins and sarcophagi had recently given way to coffins with yellow backgrounds and brightly painted representations of the gods of the afterlife. Khonsu's sarcophagus, like his coffins, is covered with vignettes associated with spells from the Book of the Dead, such as Chapter 17, which is illustrated with the lions of the horizon and the embalmer's tent among other scenes. "Here begin the celebrations and evocations so that Khonsu may go forth and reenter the cemetery, that he might be happy in the beautiful west, that he might go forth by day, take every form that pleases him, play with draughts, sit in the chapel, and go forth as a living soul after death."[12] The long text of Chapter 1 covers the lower portion of the two long sides of the sarcophagus. The decoration of the sarcophagus of Khonsu is unusual, since it nearly substitutes for scenes on a tomb wall. Sennedjem's own sarcophagus is similar but not identical, and only a few other examples, such as the fragmentary one from the tomb of Pashed, Theban Tomb 3 at Deir el-Medina, remain.[13]

The yellow ground coffins with polychrome scenes continued past the New Kingdom, but in the Twenty-first Dynasty the motifs represented were greatly expanded. Images derived from the Book of the Dead—i.e., The Book of Going Forth by Day—were often used, as were newly created compositions. The emphasis in these scenes was on solar religion combined with the myth of Osiris. During the Twenty-first Dynasty, tomb building ground nearly to a halt in Thebes, and the Valley of the Kings was abandoned. Kings now ruled from the north and were buried within the temple of Amun-Re at Tanis, in the northeastern Delta. In the absence of tombs, coffins for most private people became an even more important repository of the deceased's hopes for the next world, and this likely explains their intricate detailing with scenes from the Book of the Dead. A coffin and a mummy board (cat. 73) is a fine example of a Twenty-first Dynasty coffin. The inscriptions on the coffin lid refer to the "Beloved God's father, Master of Mysteries, he who opens the doors of heaven for Karnak Temple, Paduamen." This priest was among those who penetrated the deepest parts of the temple of Karnak and opened the shrine of the god in the holy of holies.

On the interior of the coffin lid a figure of green-skinned Osiris is identified as "The Osiris, the praised one in the Temple of Amun, the God's father of Amun in Karnak, the Master of Mysteries of heaven, earth, and the netherworld, he who sees Re-Atum in Thebes, Setem priest of the horizon forever, Paduamen." Paduamen's coffin and board were found in the cache burial at Deir el-Bahari that contained numerous burials of priests of Amun. His Book of the Dead also came from that tomb and is now in the Egyptian Museum, Cairo (temp. no. 23.4.40.2). The Book of the Dead gives Paduamen's fullest titles. In addition to those already cited, he was "priest of Amun, lector priest of all the mysteries of the gods." His male ancestors are also named, but the relationships are somewhat in question. Paduamen is once called "son of AhaneferAmun, the God's father, master of mysteries of heaven, earth, and the netherworld, priest of Amun." He is elsewhere referred to as "son of Hori, the God's father, master of mysteries of Amun, son of AhaneferAmun, the God's

father Master of mysteries of Amun." The second example implies that Paduamen's father was Hori and that AhaneferAmun was his grandfather. Since the Egyptians used the word "son" to mean son, grandson, or simply male heir, we cannot be certain of Paduamen's parentage.[14]

Since the later Eighteenth Dynasty, coffins often represented the male deceased with his hands grasping amulets of protection and life. The coffin of Paduamen continues this tradition, and the identity of the deceased as a blessed one is also implied to us by the presence of the beard on the face—the divine beard, an allusion to Paduamen's new identification with Osiris. The scenes on Paduamen's coffin lid are stock offerings before the gods, Osiris and Re-Horakhty, as well as the Four Sons of Horus. The sides of the coffin body do have some representations inspired by the Book of the Dead, including the vignette that accompanies the beginning of that book where the deceased is first introduced before Osiris. There is also the vignette from Chapter 60, where a tree goddess provides food and drink for Paduamen in the next world. Next to this appears to be the vignette accompanying Spell 101, for protecting the boat of the sun god. All of these scenes are painted in bright colors—red, blue, green on a yellow ground. The entirety is varnished thickly such that the present color of the coffin is probably a bit darker than it was originally, since the resins used collect dirt and naturally darken over time. Nonetheless, this is a highly representative example of the many coffins left to us from the Twenty-first Dynasty.

The lid of Isis-em-akhbit (cat. 51) is an example of a late Twenty-first Dynasty coffin. This beautifully preserved example belonged to a woman with royal-like parentage. She was the daughter of the High Priest of Amun Menkheperre, who ruled over Thebes during a period of divided political control. Her uncle was Psusennes I, who ruled as king in Tanis (see cats. 40, 47, 49). The Twenty-first Dynasty kings were in the Delta, but they maintained connections with the theocratic state in Thebes, ruled over by the high priests at Karnak. Isis-em-akhbit became the wife of the High Priest of Amun Pinudjem II and probably died in the reign of King Psusennes II (959–945 BCE). Like her father, mother,

and husband, she performed important priestly roles in the temple of Karnak. Her titles were those of "One who is over the Great ones of the first entertainment group of Amun, priestess of Mut, great one of the temple of Mut, God's mother of Khonsu the child, chieftain of the noble ones." Only the position of "God's Wife of Amun" would have been greater than the position held by Isis-em-akhbit, and that role was probably still occupied by Maat-ka-re, daughter of Psusennes I. It appears that Henuttawy, perhaps a daughter of Isis-em-akhbit and Pinudjem III, did become God's Wife of Amun.

The coffin demonstrates a changing style that took hold at the end of the Twenty-first Dynasty. The background colors were no longer predominantly yellow but might be, as here, red, or other colors, including white or light blue. Scenes on coffins could now include vignettes from the Amduat or perhaps rituals associated with kingship. The lid of Isis-em-akhbit is somewhat conservative and preserves five representations of the sky goddess with wings spread across the body. Images of the sun god, particularly as the scarab beetle, punctuate the spaces between the goddesses, and the overall effect is decidedly less Osirian than solar. It may be that the accent on the winged goddess is meant to recall Isis, whose role as protector of the dead included her representation as a winged female or a kite (a hawklike bird). This might be expected, given the coffin owner's name, Isis-em-akhbit, which alludes to Isis, who hid her son Horus in the papyrus swamp of the Delta at Akhbit (Chemmis) to prevent his murder by Seth. If this is the case, then Isis-em-akhbit commissioned a coffin whose lid scenes underscore her association by name and divine role with the great goddess Isis.

In the later Third Intermediate Period, coffins continued to change, and they often were made with a foot pedestal so that the mummy could be placed vertically. The backs of these coffins were decorated with the *djed* symbol, meaning "stability" but here implying the strong backbone of Osiris. Wealthy elites and members of the royal family would also have sarcophagi (see cat. 100), which belonged to a princess of the early Twenty-sixth Dynasty. The daughter of Psamtik I (664–610 BCE), Nitocris, became God's Wife of Amun soon after her father's accession to the throne. Her sarcophagus of red granite emulates a type popular in the New Kingdom, when effigies of the deceased kings were sculpted atop the stone lids. The box was likely cut down from an earlier, probably New Kingdom, royal sarcophagus, since its head end is shaped in a curve to conform to the lid, but its former rectangular shape is betrayed by unfinished carving. Rather old-fashioned scenes of the Four Sons of Horus decorate the sides of the box, together with the protective inscriptions often found on New Kingdom sarcophagi and on canopic jars. In general this sarcophagus betrays the penchant for archaizing that is characteristic of the Twenty-fifth and Twenty-sixth Dynasties.

The lid, probably fashioned separately to cover the older box, shows Nitocris in a mummiform, her arms crossed on her chest. In her clenched hands are the symbols of Osiris' kingship, the crook and the flail, and this is perhaps a reference to Nitocris' royal pedigree as well as her position as the king's religious representative in Thebes. A further iconographic allusion to Nitocris' royal birth is the presence of the vulture headdress lightly carved over her heavy wig. The uraeus, or cobra, indicating kingship, is also sculpted on her brow.

Canopic Jars and Canopic Boxes

To guarantee the integrity of the body, mummification dried and sweetened the flesh of the deceased. From at least the Old Kingdom the organs of the abdomen were removed and preserved in containers that were then buried with the dead. Although there is great variation seen in Egyptian mummies, both in a single period and over time as well, in most periods the organs were treated separately, although the heart was left in the body, since it was thought to be the center of thought and will. The Egyptians knew well how bodies spoiled, and their funerary literature even refers to this. At the end of the Second Hour of the Amduat, the god Re speaks to the gods who inhabit that area of the netherworld: "May there be air for your nostrils! May you not perish. May your limbs be dry and there be no odor of your decomposition!"[15] Jars to

19 Chest with jackal reclining on lid, from tomb of Tutankhamun. Eighteenth Dynasty, 1336–1327 BCE, gilded wood. The Egyptian Museum, Cairo JE 61444.

20 Shrines containing the deceased awaiting rejuvenation. Third Hour of the Book of Gates, Tomb of Seti I. Nineteenth Dynasty, reign of Seti I, 1294–1279 BCE, painted limestone.

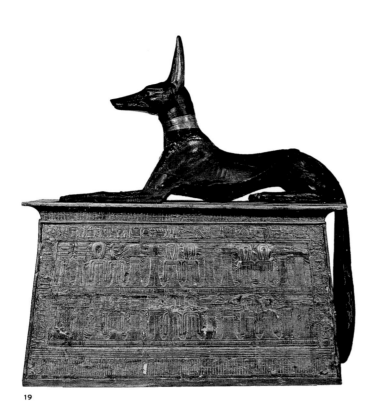

19

70

contain the viscera were considered to be the province of the Four Sons of Horus, who protected the body. Although these gods appear in anthropomorphic form through the Eighteenth Dynasty, later they appear differently. Imsety was human headed; Hapy, baboon headed; Duamutef, jackal headed; and Kebehsenuef, falcon headed (see cat. 41), one of two sets of canopic jars from the tomb of King Osorkon II at Tanis. The jars belonged to Prince Hornakht of the Twenty-second Dynasty, although the lids were certainly taken from a New Kingdom royal set. The gold plaque used to cover King Psusennes I's embalming incision (cat. 40) also shows the Four Sons.

Boxes to hold the canopic jars were also commonly provided in tombs and, since the early New Kingdom, had been shaped in the form of the shrine of Upper Egypt. The box shown in catalogue 75 belonged to Queen Nedjmet of the Twenty-first Dynasty, a sister of Ramesses XI. Atop the canopic box lies the jackal god Anubis whose watchful state betrays his role as guardian of the cemetery. A wooden shrine from the tomb of Tutankhamun shows Anubis atop a differently shaped chest. This box may have

had a parallel function to that of the canopic box (fig. 19). Within that shrine were compartments that held amulets identified with mummified limbs, as well as embalming materials and jewels.

Shabtis, *Shawabtis*, *Ushebtis*, and Their Boxes

During the Middle Kingdom the Egyptians began producing small mummiform figures to be placed with other funerary objects in a tomb. These roughly carved wooden figures supplanted models of agricultural workers often placed in graves from the Old Kingdom on, and their purpose was to perform labor on behalf of the deceased. By the Second Intermediate Period the mummiform figures were often inscribed with an utterance from the Book of Going Forth by Day, Spell 6: "The spell for causing that the funerary servants do work in the other world." The word for these funerary figures varied, from *shabti* in the Eighteenth Dynasty, to *shabti* and *shawabti* in the later New Kingdom, and finally to *ushebti* in the first millennium BCE. The meaning of *shabti* and *shawabti* is uncertain, although deities called *shebty* from the Ptolemaic Edfu temple inscriptions and associated with the creation of the cult may be related. *Ushebti* may derive from the verb in Egyptian, *wesheb* (to answer), since the spell addresses the figure and tells it to respond when the deceased is called to perform conscripted labor in the next world.

At the beginning of the New Kingdom, tomb owners might acquire a group of ten to thirty *shabtis* for their burial, while kings had hundreds. In the Twenty-first Dynasty, *ushebtis*, as they were now known, appeared in more standardized numbers. Boxes made for the purpose contained 365 figurines plus 36 overseers. A worker for every day of the year was thus provided, but these were organized into groups of 10 overseen by the 36 directors. Since the Egyptians identified the length of the year and the hours of the night by observing 36 groups of stars that changed every 10 days (and to which they added 5 days) at the beginning of the year, the *ushebtis* were clearly thought to correspond to the same time periods. In the Egyptian netherworld each hour of the night was associated with a geographic region or

town. Those regions were organized just as on earth and consisted of lands donated by the sun god to the blessed dead and the gods who dwelled there. These *ushebti*s worked this land instead of the deceased themselves.

This book illustrates several New Kingdom funerary figures. The earliest is from the reign of Amenhotep III and belonged to the king's father-in-law, Yuya. The image shown in catalogue 35 is a wooden mummiform figure with a gilded face and a striped headdress, the typical mummy head covering. The *shabti's* hands are shown as fists, but they are not holding anything. Since the reign of Thutmose IV, Amenhotep III's father, *shabti*s had appeared holding hoes in their hands and carrying bags on their backs. Yuya lacks these implements on this figure, but these figures are accompanied into the next world. Separately made model hoes, adzes, and even a mud-brick mold were included in Yuya and Tuya's burial, along with wooden yoke poles with bronze bags to hang across the servant's shoulders. These very well equipped *shabti*s also had shrine-shaped boxes for containers, such as that seen in catalogue 38. In the netherworld we see mummies standing in shrines like this as they waited for the sun god's arrival, when they would be awakened by his power (fig. 20).

Late in the reign of Amenhotep III or in that of his son Amenhotep IV (before he termed himself Akhenaten), the Royal Scribe Amenhotep, called Huy, acquired a *shawabti* and model coffin for his burial (cat. 60). The figure shows Huy with a long wig, rather than a headdress, and a divine beard. His hands hold the amulets for stability and protection, rather than agricultural implements, but the inscription on the *shawabti* is the standard Spell 6. A figure belonging to the adjutant Hat (cat. 59) dates from the Amarna Period (c. 1352–1327 BCE), during which the temples of the great gods were closed and the funerary deities were forbidden by King Akhenaten. The man Hat must nonetheless have hoped for a life in the next world and purchased a figurine holding the by-then traditional hoes and carrying a basket on his back. Instead of Spell 6 from the Book of the Dead, Hat's text is an offering addressed to the only god recognized by Akhenaten, the Aten, or sun disk.

From the tombs of Sennedjem and his son Khabekhnet come two last *shawabti* examples. Khabekhnet is represented in a mummy form (cat. 61) with a long wig, no beard, and holding hoes. The seed bag is on his back. The traditional *shawabti* spell is written in horizontal lines, as on Yuya's example. Here, the colors are different from earlier examples, however, for at Deir el-Medina particularly, *shabti*s are frequently painted with a white ground and then decorated in red, yellow, green, and black. Sometimes these *shawabti*s are varnished and thus appear more yellow, but they are more often painted as here. The figure in catalogue 62 represents Sennedjem himself, but here he is depicted as if in real life. He wears an elaborate wig made of plaits and echelons, and his garment consists of a shirt with pleated sleeves and an over kilt with an intricately pleated front apron. The figure was originally white on the garment areas and red on the body, but varnish has turned

the body nearly entirely yellow. The inscription is not the standard *shawabti* spell, but rather, a dedication formula which guarantees offerings for Sennedjem's cult from the temple of Karnak. The form of the figure in the guise of real life is first seen in the tomb of Yuya and Tuya, and it has been suggested that figures such as these acted as overseer figures for the other *shawabti*s when they performed their labors.

Khabekhnet's box (cat. 63) was designed in the form of two shrines, to contain two *shawabti*s. One side of the box is decorated with images of the two figurines. From the Twenty-first Dynasty comes a *ushebti* box for the Singer of Amun and Lady of the House Djed-Maat-iuesankh (cat. 104). This box type was designed to hold some 401 small figurines, probably of faience. The form retains the shrine shape, but the interior is divided into several compartments each of which held many *ushebti*s. Figure 21 shows the deceased rowing herself across the sky in a boat, while the text states: "The Osiris, the Lady of the House,

Singer of Amun-Re King of the gods, Djed-Maat-iuesankh Ferrying across in peace to the Field of Reeds so that excellent spirits [*bas*] may be received."

From the survey of several types of objects given above, the reader may conclude that the burial outfit was intended to facilitate and support the rituals for the afterlife. The Books of the Dead, carried by so many who expected to travel the ways of the netherworld, were aided in their effectiveness by the many tomb objects that could be made to function through magic. *Ushebti* formulas from the Book of the Dead, Chapter 6, have already been mentioned, and heart scarabs were inscribed with Chapter 30, "Spell for not letting [name of the deceased] heart create opposition against him in the world of the dead." The rubric for Chapter 30 shows how important were the objects themselves: "To be inscribed on a scarab made from nephrite, mounted in fine gold, with a ring of silver, and placed at the throat of the deceased."[16] Spell 140 includes the instruction that it should:

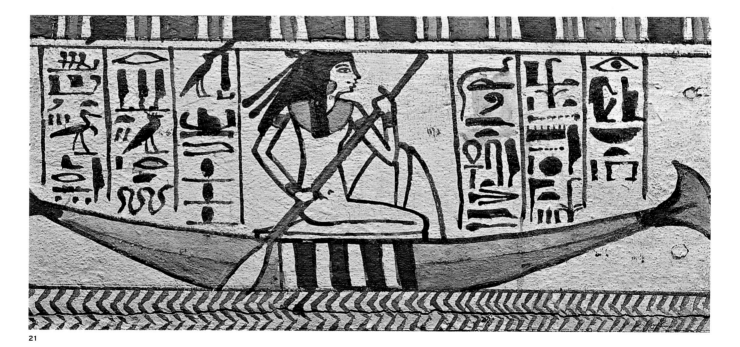

21

be spoken over a *wedjat* eye of real lapis lazuli or carnelian, decorated with gold. There should be offered to it everything good and pure before it when Re shows himself in the second month, last day; and there shall be made another Wedjat eye of red jasper which is to be placed for a man on every member which he desires. He who utters this spell will be in the Bark of Re when it is taken out with these gods, and he will be like one of them; he will be raised up in the world of the dead.[17]

In both of these instances objects are described which, because of the materials employed, only wealthy elites and royalty could have afforded to possess, and yet the description probably betrays, as said at the beginning of this essay, the ideal Egyptian aesthetic. Artistry and fine materials, combined with correct ritual form, produced the most desirable — artistic — objects, which were believed to have the greatest efficacy.

But lest we think the ancient Egyptians never questioned their own values and beliefs, let us end with a quote from a great literary work, composed around 1900 BCE, "The Dispute of a Man with His *Ba*."

My *ba* opened its mouth to me, to answer what I had said: If you think of burial, it is heartbreak. It is the gift of tears by aggrieving a man. It is taking a man from his house, casting [him] on high ground. You will not go up to see the sun. Those who built in granite, who erected halls in excellent tombs of skilled workmanship — when the builders have become gods [i.e., died], their offering-stones are desolate, as if they were the dead who died on the riverbank for lack of a survivor....Listen to me! It is good for people to listen. Follow the feast day, forget worry![18]

73

Translations not otherwise referenced are by Betsy Bryan.

1. Wolfgang Helck, *Urkunden der 18. Dynastie* (Berlin, 1957), 1822 – 23.

2. There are several entries for the term "knowledgeable artisanship" in Adolf Erman and Herman Grapow, *Belegstellen* for the *Wörterbuch der Ägyptischen Sprache,* vol. 2 (Leipzig, 1938), 445, 4, under the entry for *rh.* One is from the Papyrus d'Orbiney 18, 3: The king sends craftsmen to cut down a persea tree and make fine furniture from it. The men sent are referred to as "knowledgeable craftsmen." Another, from P. Salliers I 1, 6, mentions "knowledgeable scribes"; a third, similar to the Amenhotep, son of Hapu reference, is from the Stela of Piye and describes the building of a battlement as "an act of knowledgeable craftsmanship." Finally a citation refers to "an act of knowledgeable craftsmanship; I do not do incompetent craftsmanship."

3. In fact, the Great Sphinx was pictured on stelae of the New Kingdom, drawn with wings folded on the lion body. These are not visible on the monument today, but they may have existed in paint in antiquity. This naturally merely adds to the composite hieroglyph. See Christiane Zivie, *Giza au Deuxième Millénaire* (Cairo, 1976).

4. From the "Tale of Sinuhe," Miriam Lichtheim, *Ancient Egyptian Literature: A Book of Readings.* Vol. 1, *The Old and Middle Kingdoms* (Berkeley, 1975), 229.

5. For a fascinating discussion of the initiation rites in the funerary (and other) contexts, see Jan Assmann, "Death and Initiation in the Funerary Religion of Ancient Egypt," in William K. Simpson, ed., *Religion and Philosophy in Ancient Egypt* (New Haven, 1989), 135 – 59.

6. For a full translation in English, see Lichtheim, *Ancient Egyptian Literature,* vol. I, 58 – 59.

7. Edward Wente, *Letters from Ancient Egypt* (Atlanta, 1990), Letter 218, 153.

8. "The Memphis Theology" in Lichtheim, *Ancient Egyptian Literature,* vol. I, 55, with some minor translation changes.

9. It is only due to the extraordinary work of Hourig Sourouzian that we know exactly which Middle Kingdom ruler this image once represented. Remarks here are summarized from her study, "Standing Royal Colossi of the Middle Kingdom Reused by Ramesses II," *Mitteilungen des Deutschen Archäologischen Instituts, Abteilung Kairo* 44 (1988): 229 – 54, Tafeln pls. 62 – 75.

10. The final text of the Second Hour of the Amduat, cited in Alexandre Piankoff, *The Tomb of Ramesses VI,* vol. I (New York, 1954), 246.

11. Erman and Grapow, *Wörterbuch der Ägyptischen Sprache,* vol. 1, 378 – 79.

12. Jean-Louis de Cenival, *Le Livre pour Sortir le Jour* (Paris, 1992), 52.

13. Bernard Bruyère, *Rapport sur les fouilles de Deir el Médineh (1924 – 1925),* 27 – 28, fig. 18.

14. For the Book of the Dead of Paduamen, see Alexandre Piankoff, trans., and Nina Rambova, ed., *Mythological Papyri* (New York, 1957), 1090 – 116.

15. The final text of the Second Hour of the Amduat. See Piankoff, *Tomb of Ramesses VI,* vol. I, 246.

16. Raymond O. Faulkner, ed. and trans., *The Ancient Egyptian Book of the Dead* (London, 1972), 56.

17. Ibid., 132.

18. Lichtheim, *Ancient Egyptian Literature,* vol. I, 165.

The King and Society in the New Kingdom (catalogue nos. 1–16)

The king in ancient Egypt held a singular position as the ultimate authority on earth. During the New Kingdom (1550–1069 BCE), Egypt was once again unified under strong and ambitious kings. The king not only held a place at the top of a pyramid of governmental officials but he was also the chief officiant of the cults of the various deities. Images of the gods reflect the features of the king during whose reign they were created, further strengthening the connections between the king and the gods.

1 Boat from the tomb of Amenhotep II

Eighteenth Dynasty, reign of Amenhotep II, 1427–1400 BCE; painted wood. Height 50 cm (19 11/16 in); length 234 cm (92 1/8 in); depth 41 cm (16 1/8 in). Thebes, Valley of the Kings, KV 35. The Egyptian Museum, Cairo JE 32219/CG 4944

• The tombs of kings contained boats, either life-sized or models, from as early as the First Dynasty. The ruler traveled by water, whether it was to inspect his land, visit the temples, or in the afterlife, journey through heavens. In the New Kingdom the ships placed in tombs were models of royal vessels whose primary function was travel. Examples of both rigged and unrigged vessels have been found, since the mast and sails were needed to go upstream, but the voyage downstream would be accomplished with rowers alone.

The long hull accommodated several deck fixtures.[1] At the prow and the stern of the ship are castles represented by wood plaques deco-rated with scenes of the king as sphinx. The two steering oars stood just before the stern castle and were supported by painted posts. The cabin was likely of two stories, though here the remains of the upper story are not indicated. The elabo-rate running spiral decoration is similar to that seen on house and palace walls of the Eighteenth Dynasty, such as at Malkata, the palace of Amen-hotep III. Openings in the walls of the partially preserved cabin were doorways for the structure, and the upper story was probably reached from within and served as a storage area.

It has been noted that Amenhotep II's ships are painted with scenes of the king tram-pling foes of the Levant and Nubia and that they may, therefore, be war ships. The likelihood is, however, that Egyptian vessels were not so finely distinguished by function and that the same ships carried troops headed to war with the ruler and led processions up and the down the river when the king visited the temples and towns of Egypt on inspections.

This ship was designed to sail upstream with a central mast and two yards to carry its sail. The mast ran through the center of the deck cabin, and the fixed yards ran the length of the

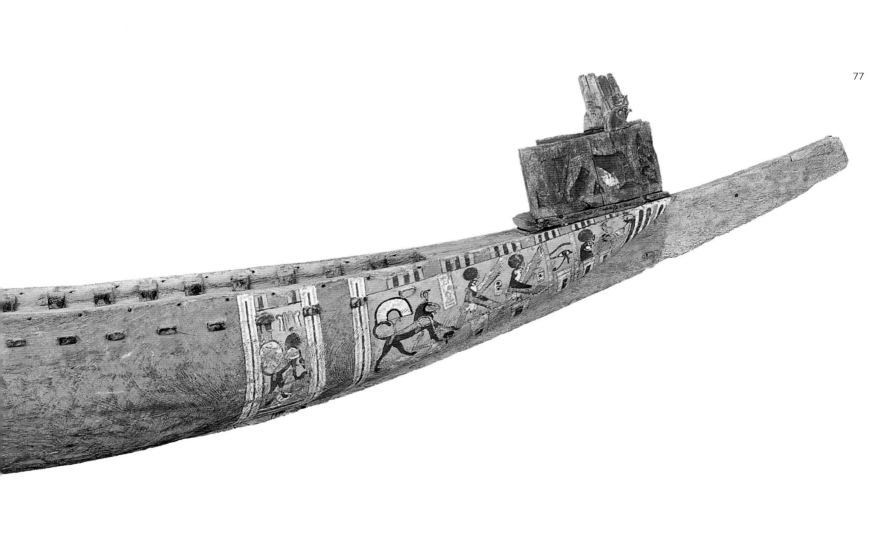

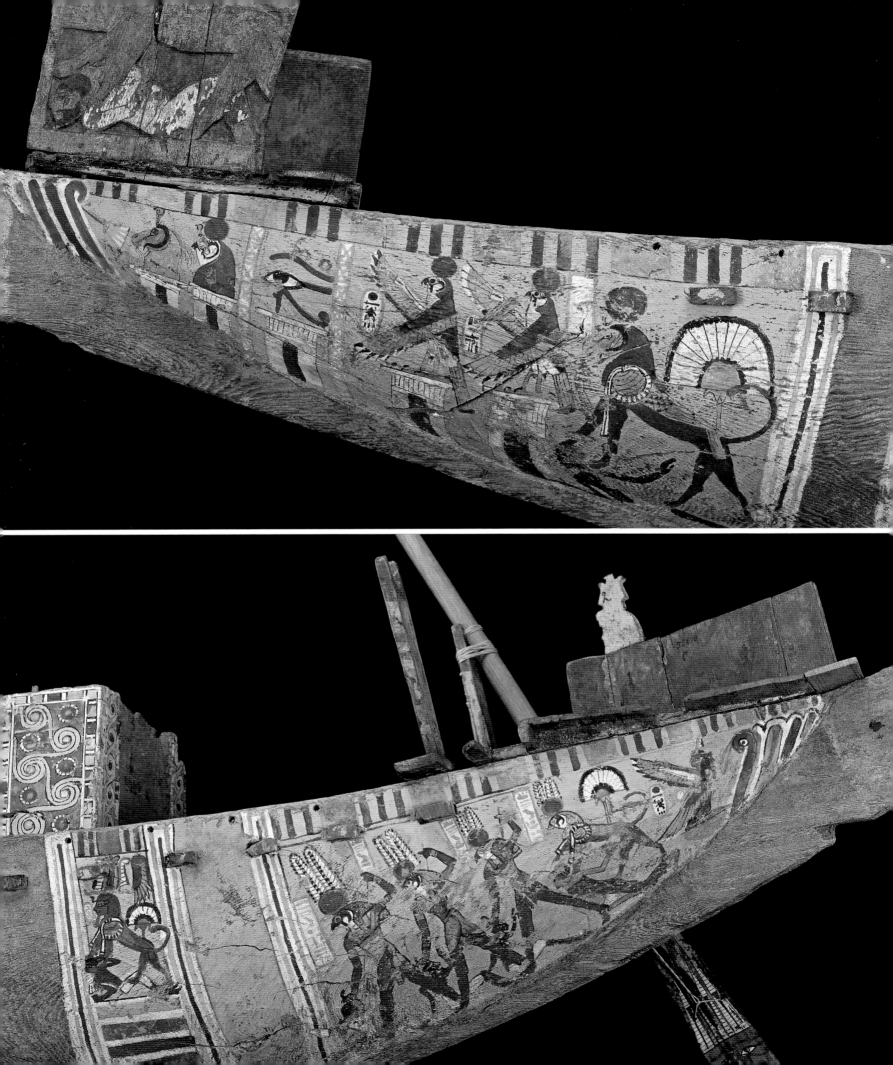

deck, such that raising and lowering sails was a lengthy process. The deck of the ship is fitted along both sides with bench seats for the rowers. The construction of the hull is also visible on the sides of the ships where thorough-going beams are visible and set in place between the planks, making the strength of the ship very great. The ends of the ship may once have had terminals in the shape of papyrus umbels, but these would have been removable in the event the ship was needed for less-ceremonial duties. A scene in the tomb of Rekhmire, the vizier of Thutmose III and Amenhotep II, shows a similar ship under sail, with the deck rowers pulling oars and the sail up. Like the scene on the block from Thutmose III's Deir el-Bahari temple (cat. 9), the rowers are standing as they approach the port of Thebes. When under sail and in mid-voyage, as in the scenes of Hatshepsut's expedition to Punt, the sails are up but the rowers are in a sitting position at the oars.

On the sides of the ship are painted scenes showing the god Montu smiting the enemies of Egypt and the gods. The painting at the stern is typical and shows, from right to left, the goddess Maat kneeling on a basket with her wings outspread in a protective gesture. Before her is a falcon-headed sphinx, with a sun disk on its head and a fan shown above its back. It is trampling a Libyan, identified by a feather on his head. To the left are three falcon-headed gods with sun disks and tall plumes on their heads. They are spearing a Libyan on the left, a Syrian in the center, and a Nubian on the right. In a separately defined area to the left is a sphinx of the king wearing the *atef* crown trampling a Nubian. The fan is again on the back of the sphinx, and above is a winged sun disk. The four depictions of Montu are labeled on the opposite side of the boat to identify the cult places of the god, from left to right: "Montu lord of Armant, Montu lord of Tod, Montu lord of Thebes, and Montu lord of Medamud."

The god Montu had predominated in the Theban region before Amun-Re's ascension to primary local deity, and Thebes was surrounded by a rectangle of temples of Montu in the First Intermediate Period (2160–2055 BCE) and Middle Kingdom (2055–1650 BCE). Armant and Tod represent the southwest and southeast temples of the god respectively, while Medamud is the northeast one. The temple of Montu, lord of Thebes, remains uncertain, although it is likely to be represented by a monument in the northern cemetery area on the west bank, perhaps at Mentuhotep's Deir el-Bahari or farther to the north. Montu, as here, was often shown wearing a corselet that formed a type of armor, and he was commonly invoked in battle inscriptions to fight alongside the ruler. The fan on the back of the two sphinxes indicates the royal *ka*'s presence in the scene, such that the king is present in the depiction of the gods. Amenhotep II may be understood to have been manifest as Montu and as a trampling sphinx. **Betsy M. Bryan**

1. Björn Landström, *Ships of the Pharaohs: Four Thousand Years of Egyptian Shipbuilding* (London, 1970), 108–10.

2 Head of Thutmose I

Eighteenth Dynasty, reign of Thutmose I, 1504–1492 BCE; painted sandstone. Height 102.8 cm (40½ in). Karnak, Wadjyt Hall. The Egyptian Museum, Cairo JE 38235/CG 42051

• This head of Thutmose I derived from one of the standing colossal statues of the king in the form of Osiris, shown as a mummy wearing either the white or double crown. The statues on the south side of the court wore the white crown of Upper Egypt, associated with Osiris, while those on the north wore the double crown seen also on the great solar god of Heliopolis, Atum. Thus, in the sculpture, as in the Amduat and all New Kingdom religious literature, the union of Osirian and solar theologies was presented. Since this statue's crown is lacking, its original head-dress and placement in the court are uncertain.

The head itself is sandstone painted red, with the remains of blue on the beard and black on cosmetic lines and eyebrows. The beard is long (55 cm [21 ¼ in]) and curved at its end, it being the traditional beard of a god. The face shows a slightly smiling and youthful visage, characterized by prominent cheekbones that are nonetheless tempered by fleshy cheeks. The nose is long and just slightly curved beginning from its very high root above the level of the eyes. The mouth is thicker in the lower lip than the upper, which rather betrays the slight protrusion caused by an overbite — a feature that distinguished the Thutmoside family at least through the reign of Amenhotep III (1390–1352 BCE). The eyes are the dominant feature of the face, being very large and wide open. They are rimmed above by a thin lid line, and the eyelids are deep and convex. The eyebrows are plastically rendered in low raised relief.

The head of Thutmose I was found in 1903 near the southeast angle of the masonry that surrounds the southern obelisk of Hatshepsut, lying against the north face of the column there. Recent work in the Wadjyt Hall has elucidated the architectural history of the hall in the Eighteenth Dynasty (1550–1069 BCE). It is now established that Thutmose I built both the Fourth and Fifth Pylons, and the platform between them was planned as a unit, thus indicating that both gateways were built at a single time, along with the court. The court began

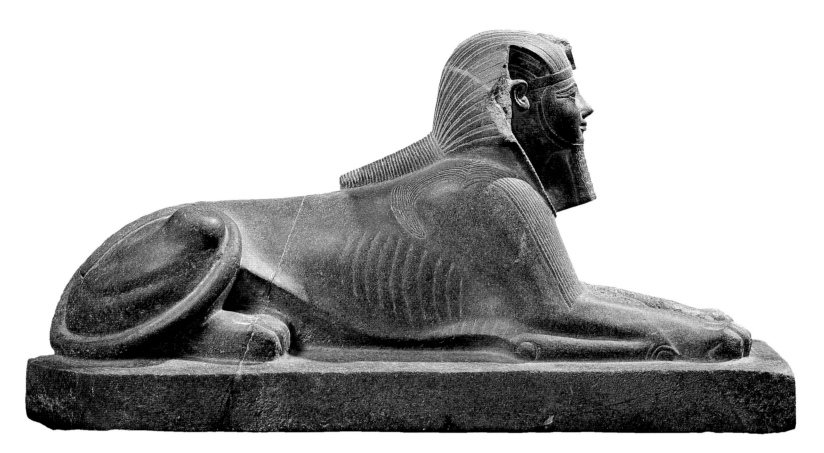

as one open to the sky, but later, in a second building phase, Thutmose I had the series of Osiride statues placed there and created a peristyle court, roofing over the columns he had erected. Sixteen statues stood in the northern half of the hall and twenty in the southern. Of the thirty-six sculptures, this one bears the only completely preserved face, although fragments of some remain in situ. All the statues bore the name of Thutmose I, and none shows any trace of name changes. In the period following Thutmose I's decoration of the hall, Hatshepsut altered it into a Wadjyt Hall, meaning she changed the columns to papyriform ones, of wood supporting a wooden roof. She had already erected her two great obelisks by that time. Both she and Thutmose III (1479–1425 BCE) avoided dismantling or obscuring the statues of her father, Thutmose I, but late in his reign and in that of his son, Amenhotep II (1427–1400 BCE). Hatshepsut's obelisks were hidden by stone masonry adorned with four Osiride figures of Thutmose III. **Betsy M. Bryan**

1. Luc Gabolde and Jean-François Carlotti, "Nouvelles Donnés sur la Ouadjyt. I. La chronologie relative des enceintes du temple et les murs de la Ouadjyt: es sondage à l'angle nord-est de la salle," *Cahiers de Karnak II* (forthcoming).

3 Sphinx of Thutmose III

Eighteenth Dynasty, reign of Thutmose III, 1479–1425 BCE; granodiorite. Height 33 cm (13 in); width 21.5 cm (8 7/16 in); depth 62.5 cm (24 5/8 in). Karnak, court of the cachette. The Egyptian Museum, Cairo JE 37981/CG 42069

• Carved for King Thutmose III, this imposing statue, once stood in the temple complex of Karnak. Its original position in the temple is unknown, but it probably lay near one of the main features constructed there by Thutmose III: the court between the Fifth and Sixth Pylons, in front of the sanctuary; the Seventh Pylon, south of the sanctuary; or the festival temple known as the Akhmenu, behind the sanctuary. From the Middle Kingdom onward, royal and private statues were continually erected within the temple complex. To make room for them, older statues were occasionally removed and ceremoniously

buried in the court in front of the Seventh Pylon. Eventually more than seventeen thousand statues were disposed of in this cachette, including Thutmose III's sphinx.

The sphinx form, combining the human head of a king with the body of a lion, is generally thought to have symbolized the pharaoh's might. Set within the temple of Karnak, it would have served both to perpetuate the king's presence there and to protect the image of the temple's god, Amun-Re. In this example the king's head wears the royal *nemes* headdress with a uraeus, and the royal beard; the beard was part of the king's ceremonial regalia and was tied on by means of straps, shown here on either side of the face. The king's face exhibits the typical features of Thutmose III's statuary, with its slightly arched nose and pleasant mouth. The lion's body masterfully evokes the animal's latent power, even though a number of its features, such as the ribs and mane, are stylized rather than realistic (see fig. 9, "Art in the Afterlife").

The sphinx was a favorite form of Thutmose III, who had at least fourteen such statues created for him. In his case the image was partic-

ularly appropriate. Thutmose III led some fifteen military campaigns abroad, extending Egypt's influence from Nubia to Mesopotamia. Stylistic features indicate that this statue was carved between the king's twenty-second and forty-third years on the throne.

The inscription on the statue's front identifies its owner as "the young god, lord of the Two Lands, Menkheperre, [beloved of] Am[un-Re, lord of the thrones of the Two Lands], alive forever." Menkheperre was the throne name of Thutmose III, and the phrase "young god" identifies him as the current king in contrast to his predecessor, the "elder god," who was assimilated with the god Osiris. The reference to Amun reflects both the temple within which the statue was set up and the ultimate source of the divine power of kingship embodied in the person of the king. This part of the inscription was erased during the anti-Amun iconoclasm of King Akhenaten (also known as Amenhotep IV, 1341–1336 BCE), indicating that the statue was still visible at that time. Such erasures were usually restored by Akhenaten's successors, particularly Seti I, of the Nineteenth Dynasty (1294–1279 BCE). Since this statue shows no such restoration, it may have been buried in the cachette in the interim, possibly by the last king of the Eighteenth Dynasty, Horemheb (1323–1295 BCE), who initiated extensive building and remodeling in the temple. **James Allen**

82

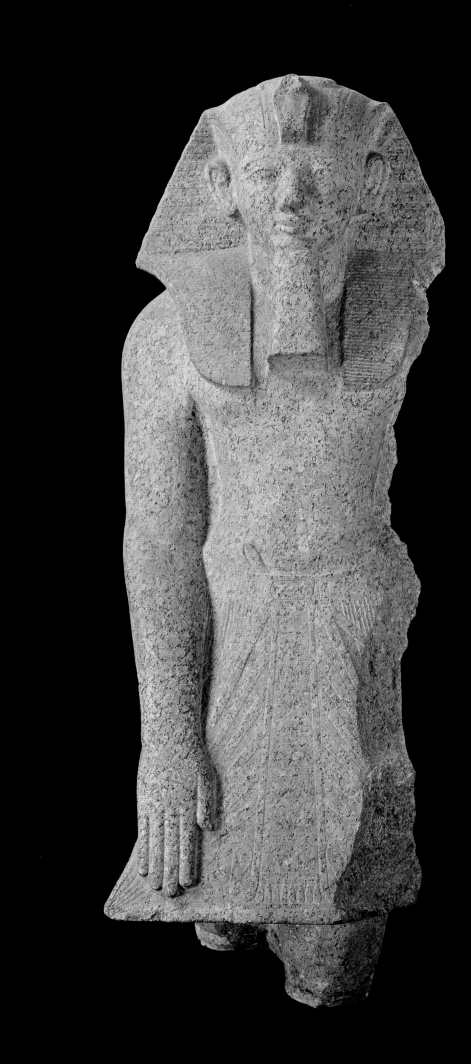

4 Thutmose III

Eighteenth Dynasty, reign of Thutmose III,
1479–1425 BCE; red granite. Height 178 cm
(70 1/16 in); width 60 cm (23 5/8 in); depth 54.5 cm
(21 7/16 in). Karnak, Akhmenu room 27. The
Egyptian Museum, Cairo JE 11249 / CG 594

• A king, dressed in the traditional *nemes* head-cloth, uraeus, long straight beard, and kilt stands with both hands flat on the kilt's projecting front section. The name deeply incised in a horizontal cartouche on the belt is the prenomen of Thutmose III (1479–1425 BCE), Menkheperre, the sixth king of the Eighteenth Dynasty. But who is represented here? The area around the cartouche is slightly roughened and, underneath it, remains of a vertically oriented cartouche are visible.[1] Both the base and the back pillar, additional areas that would have contained inscriptions, have been deliberately destroyed, together with the proper left side of the statue. Nevertheless, an overview of the history and art history in the years before Thutmose III reigned yield the true identity of the commissioner of this splendid over-life-size statue.

The distinctive gesture of the king is one associated with statuary placed in temples beginning with the reign of Senusret III of the Twelfth Dynasty (c. 1870–1831 BCE). It is generally viewed as a gesture of devotion before the gods. Here, the pleats of the kilt radiate out from a central narrow apron to each bottom corner, a fashion that began with sculptures of Senusret III's son, Amenemhat III. It may be seen on sculptures he erected at Karnak, the same temple in which this statue was discovered in 1860.

The king's facial features provide more clues to its dating (see fig 10, "Art in the Afterlife"). The eyes are large and almond shaped. The high arc of the upper lid is echoed in the plastically rendered brow. Narrow cosmetic lines extend from the corner of the eye toward the temples. In contrast to the delicacy of the eyes, the nose is large and aquiline. The mouth gives the appearance of a slight smile. Pronounced cheekbones combined with a narrow chin give the face a triangular or heart shape. These are attributes of Hatshepsut, the queen of Thutmose II (1492–1479 BCE), who first served as regent with her young stepson, Thutmose III but proclaimed herself pharaoh shortly afterward. However, here, the body and garments are decidedly those of a male.

When Hatshepsut was depicted as Thutmose II's queen and shortly after his death, she was shown with female attributes, including a feminine body with breasts and a long, tight-fitting dress.[2] Throughout her reign, which lasted for nearly twenty-two years according to Manetho, she erected monuments in her name throughout the country but particularly at Deir el-Bahari, where she built her funerary temple, and at Karnak, where she set up several structures, including four obelisks, the Eighth Pylon, a sanctuary (the so-called Red Chapel), and several barque shrines. It is generally believed that as her reign progressed, her sculptures took on an increasingly androgynous or masculine appearance, and she is depicted with a beard, bare muscular torso, and kilt, attributes depicted on the statue here. Upon her death Thutmose III continued as sole ruler and also built extensively. Statues from the early part of his reign, as often happens, resemble those of his stepmother and predecessor, in this case so much so, that they are often indistinguishable. Adding another element of confusion, toward the end of his reign, which lasted an additional thirty-one years, there is a tendency for male bodies to become increasingly feminized, including fleshier torsos and higher buttocks.[3]

Around year 42 of his reign, or approximately twenty years after the death of Hatshepsut and for unclear reasons, Thutmose III appears to have begun a campaign to destroy, desecrate, and/or reinscribe his stepmother's works. That is what most likely happened here. It is probable that this statue was made for Hatshepsut around the middle of her reign, following a model of the Twelfth Dynasty. Originally, it was probably placed at one of her many Karnak structures, perhaps beside the Eighth Pylon. Some decades later it was carefully reinscribed and moved to a corridor beside a row of magazines in the festival temple Thutmose III built at Karnak. There it was found in the late nineteenth century. What may be its base, which also bears the name of Thutmose III, was found in an adjoining chamber.[4]

Although scholars today may argue over who is represented, in antiquity, there would have been no dispute. Egyptian sculpture followed a prescribed set of rules that dictated how a person was represented, regardless of how he actually looked. Therefore, it was the name that gave a statue its identity, rather than any individual characteristics. since this statue bears the name of Thutmose III, for ancient Egyptians, it depicted their great warrior king. **Rita E. Freed**

1. I am grateful to Dr. Nadia Lokma, General Director of Conservation, The Egyptian Museum, Cairo, for confirming this. While some scholars believe the present inscription is palimsest, others disagree. For an enumeration of both arguments, see especially Dimitri Laboury, *La statuaire de Thoutmosis III: Essai d'interprétation d'un portrait royal dans son contexte historique* (Liège, 1998), 169, n. 586, and 520, n. 1465.

2. Roland Tefnin, *La statuaire d'Hatshepsout: Portrait royal et politique sous la 18e Dynastie* (Brussels, 1979), 139.

3. Gay Robins, *Proportion and Style in Ancient Egyptian Art* (Austin, 1994), 254.

4. Laboury, *Statuaire de Thoutmosis III*, 167–68, 170.

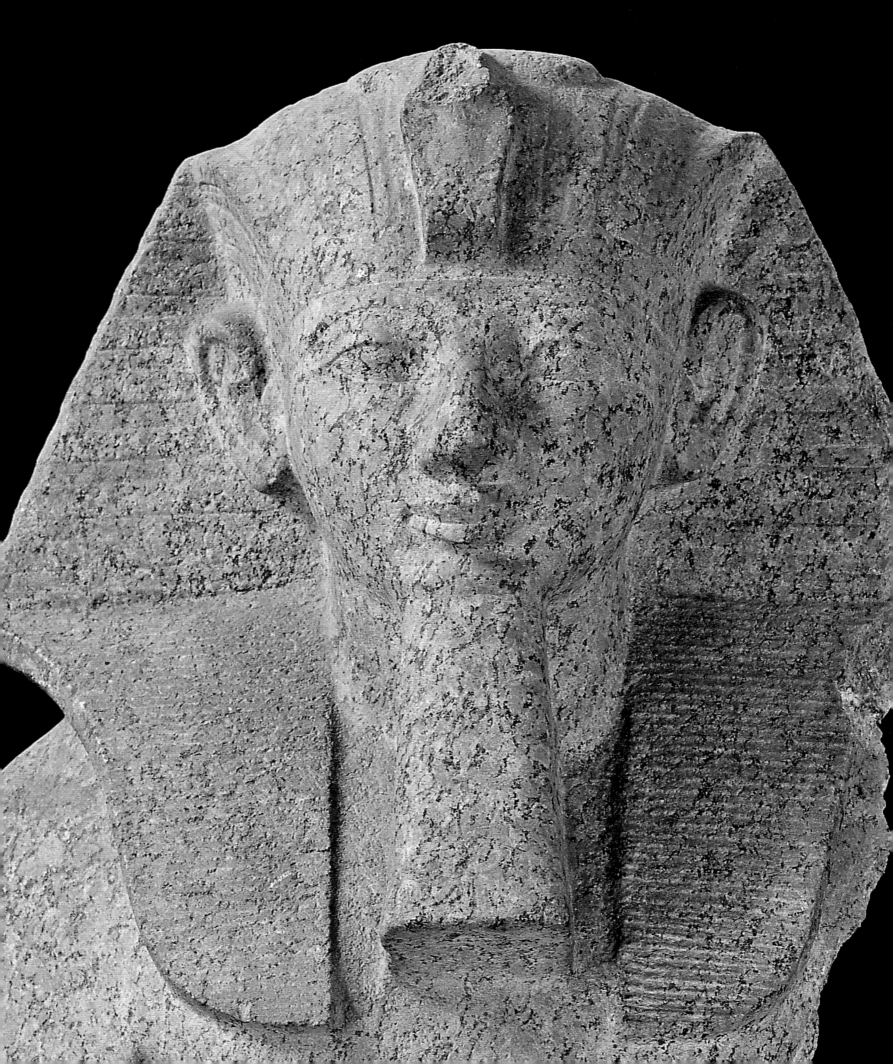

5 Fragment of an obelisk

Nineteenth Dynasty, reign of Ramesses II, 1279–1213 BCE; red granite. Height 335.6 cm (140 in); width 101.6 cm (40 in); depth 139.7 cm (55 in). Tanis (possibly taken from Pi-Ramesses); Supreme Council of Antiquities, Tanis

• This fragment of an obelisk was most recently at the site of Tanis (modern San el-Hagar), located in the northeastern Delta. Tanis was the residence and burial place of the Twenty-first and Twenty-second Dynasty kings, but much of the city was constructed using older materials taken from nearby sites. This obelisk fragment is one such example of re-used material. It is inscribed with names and images of Ramesses II, who reigned during the Nineteenth Dynasty, and may have originated at his own capital city, Pi-Ramesses, located not far south of Tanis.

This is the top portion of an obelisk fashioned out of red granite. Standing over 335.6 cm (eleven feet), only two of its four sides are well preserved, and portions of its pyramidion are damaged. However, what remains is enough to determine that its original owner was Ramesses II. Carved in sunken relief, the uppermost decoration consists of epithets of the king, as well as his *nomen* and *prenomen*, both enclosed in cartouches. Only one side of the pyramidion inscription can be read in full, but what remains on the damaged side suggests that the glyphs were the same there. They read: "Lord of the two lands, Usermaatre-Setepenre" and "Lord of appearances, Ramesses, Meryamun, given life like Re."

Below Ramesses' epithets and names are two offering scenes, also carved in sunken relief. They depict Ramesses kneeling and making offerings to the god Atum. On one side of the obelisk, Ramesses is shown wearing a cloth headdress known as the *nemes;* on the other side, he wears a wig topped by plumes, ram's horns, and a sun disk. It is only possible, however, for us to observe the god to whom Ramesses is offering on one side of this obelisk. The god is shown seated on a throne wearing the double crown of Upper and Lower Egypt. This is the usual headdress of Atum, and the *was*-scepter and ankh that he

holds in his hands are his customary insignia. Above the heads of Atum and Ramesses is an inscription bearing their names. Atum is called "Lord of the two lands, the Heliopolitan" and Ramesses, like the inscription on the pyramidion, is both "Lord of the two lands" and "Lord of appearances."

Below the offering scene on both sides of the obelisk is a Horus falcon wearing the double crown. Behind the falcon is a sun disk with a uraeus hanging from it, and the uraeus holds

an ankh. All are carved in low relief. These royal symbols are the markers of a king's Horus name, which is usually written inside a rectangular frame with a niched facade at the bottom, called a *serekh*. On this obelisk fragment, only the upper portion of the rectangular frame and the first two words of Ramesses' Horus name remain. They are *ka-nakht* or "strong bull." The rest is broken off, but would have continued down the side of the obelisk, most likely followed by Ramesses' other names as well.

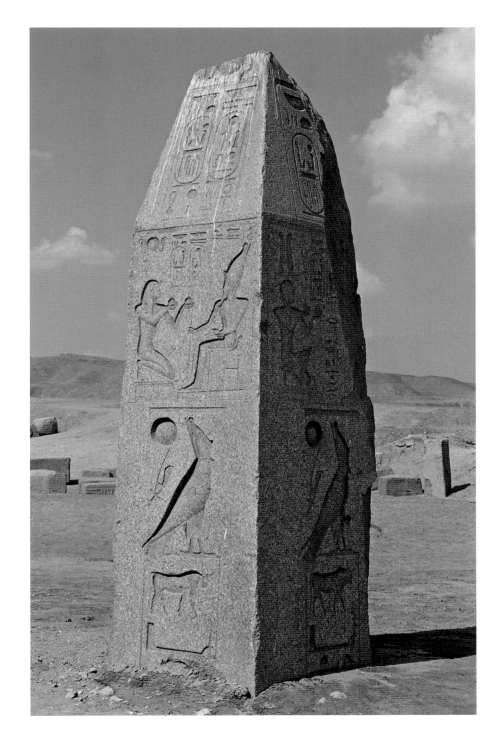

Obelisks were constructed by Egyptian kings from the Old Kingdom (2686–2125 BCE) until the Roman Period (30 BCE–395 CE), and had associations with solar cults. Knowing this, it is not surprising to find that on this obelisk, Ramesses II offers to Atum, a creator god with solar affinities. Obelisks were primarily erected in temples and in front of tomb chapels, and most often occurred in pairs. However, due to its fragmentary state and secondary location, it is impossible to say if this obelisk had a doppelgänger or where the two might have originally stood.

Most obelisks, including this one, were fashioned from red granite quarried at Aswan, located at the First Cataract of the Nile. Evidence from more complete obelisks suggests that three sides of an obelisk were smoothed and inscribed while it was still in the ground, the fourth side being decorated once the obelisk was erected. In addition, the pyramidions at the top of obelisks were sometimes gilded, making them radiant in the sunlight. The average height of New Kingdom obelisks was 20 to 30 meters (sixty-two to ninety-two feet), so we may assume that this obelisk was at one time of a comparable height.

Since their erection, however, many obelisks have been moved from their original positions, both by ancient and modern peoples. This fragment is an example of an obelisk that was moved during pharaonic times, most likely having come to Tanis from Pi-Ramesses during the Twenty-first or Twenty-second Dynasty, as noted above. Such usurpation of monuments was not unusual in ancient Egypt, as part of a king's duty was to build as many edifices as possible to proclaim his greatness. Thus, when materials were scarce, reuse of predecessors' monuments became the fastest and most efficient way to construct buildings and even entire cities. The kings who founded Tanis did exactly that, and today the site is full of reused building materials, of which this fragmentary obelisk is just one. **Elizabeth A. Waraksa**

6 Offering table of Thutmose III

Eighteenth Dynasty, reign of Thutmose III, 1479–1425 BCE; red granite. Height 23 cm (9¹/₁₆ in); width 73.5 cm (28¹⁵/₁₆ in); depth 44.5 cm (17¹/₂ in). Karnak, temple of Amun-Re, central court, excavations of Chevrier, 1949. The Egyptian Museum, Cairo JE 88803

• Carved in the form of a conical loaf of bread upon a reed mat, the hieroglyphic sign for *hetep*, "offering table," this handsome table is itself a permanent offering in stone. The same word, *hetep*, was used both for the offering table and the gifts that were placed upon it, as well as the verb "to be pleased, satisfied," and related concepts like peace and contentment. The king satisfied the gods with offerings, and no king offered with greater zeal than Thutmose III, who dedicated to his father Amun the fruits of his numerous victories in western Asia.

This offering table dedicated by Thutmose III to Amun of Karnak is unusually elaborate. Instead of the usual offerings in relief, the top has forty circular depressions: twelve on the left (arranged in four rows of three), nine in the center (three rows of three), fifteen on the left (five rows of three), one larger depression front and center, and three more on top of the projecting loaf of bread. On the front of the offering on either side of the bread sign symmetrical scenes show the king kneeling with round offering vessels in his hands. Before him is an offering table with a large conical loaf in the center and, on either side, various containers again stacked in threes, demonstrating how the offering table was to be used. The short sides of the tables are decorated with *djed* (stability) pillars and *tyet* (protection) knots—symbols of divine protection—while on the sign for bread itself the royal names of Thutmose III face that of Amun, lord of Karnak. Hieroglyphic inscriptions run around the borders. One on the front mentions the king's first Sed festival, or jubilee, with the wish that he celebrate a great many of them. **Lawrence M. Berman**

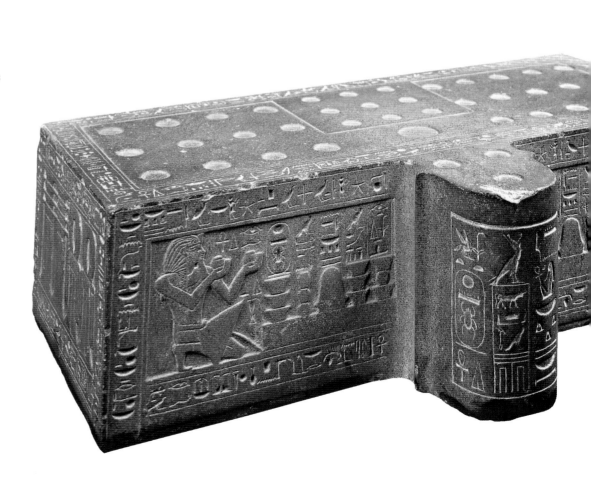

7 King facing Amun

Eighteenth Dynasty, reign of Thutmose III, 1479–1425 BCE; painted limestone. Height 43 cm (16¹⁵⁄₁₆ in); width 41 cm (16⅛ in); depth 28 cm (11 in). Excavator's no. 55. Supreme Council of Antiquities, Deir el-Bahari

• This painted limestone relief shows the head of the king (viewer's left) facing the god Amun-Re. At Deir el-Bahari, Thutmose III constructed a temple late in his fifty-four-year reign. Djeser-Akhet (Holy One of the Horizon) was designed to sit between the temples of Mentuhotep II (2055–2004 BCE, Eleventh Dynasty) and Hatshepsut (1473–1458 BCE, Eighteenth Dynasty). Although not large, it was built as a high place, with a shrine to the cow goddess Hathor at a lower level, nearer Mentuhotep's complex. As a Temple of Millions of Years, Djeser-Akhet was dedicated to the god Amun-Re as much as to Thutmose III himself. The sanctuary provided a home for Amun when he visited the west bank of Luxor during festivals such as the Beautiful Feast of the Valley, which took place each year in the second month of the summer (Shemu). At that time Amun traveled to the temples built for kings west of Thebes, and cult places were designed for his statues in all these great monuments.

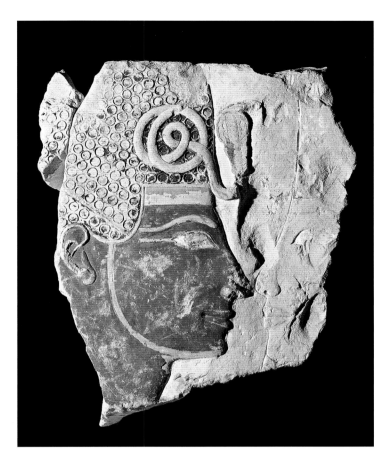

From continued quarrying of its limestone for other local uses, the temple was destroyed by the end of the New Kingdom (c. 1069 BCE). Many wall blocks with beautifully preserved paint were left on site, however, and found by a Polish expedition beginning in 1962. This block and two others (cats. 8 and 9) derive from interior pillared halls. The viewer may admire the strong profile of Thutmose III, whose slightly beaked nose just touches that of Amun-Re. Scenes such as this, showing the god embracing the king, were often placed on square-cut pillars that form porticoes leading to interior chambers. If the block derived from such a pillar, it must have come from the inner face because its raised relief suggests it was meant for a protected environment.

The king wears the *khepresh* crown, a helmet-shaped headdress often associated with royal activity, whether ritual or military. The protective uraeus cobra is curled above the king's brow. Note that the king's eyebrows and beard are blue, emulating the lapis lazuli hair of the gods. The face of Amun-Re is difficult to see and nearly devoid of paint. If one looks closer, it becomes apparent that the facial features — a sensuous mouth and a rather short, nearly upturned nose — are not those of Thutmose III, nor are they characteristic of his period. In fact, the face of Amun-Re was mutilated by the agents of Akhenaten during the heretical Amarna Period (c. 1352–1327 BCE) and was later restored, most probably during the reign of Tutankhamun (1336–1327 BCE). **Betsy M. Bryan**

8 Relief of Amun

Eighteenth Dynasty, reign of Thutmose III, 1479–1425 BCE; painted limestone. Height 65 cm (25 9/16 in); width 103 cm (40 9/16 in); depth 41 cm (16 1/8 in). Excavator's no. 14. Supreme Council of Antiquities, Deir el-Bahari

• This block from Thutmose III's temple Djeser-Akhet at Deir el-Bahari preserves the head and headdress of the god Amun-Re as well as a small amount of hieroglyphic inscription. One text reads, "Amun-Re, Ruler of Thebes, lord of the thrones of the Two Lands, lord of the sky. May he give all life, all stability, and all dominion." Another, facing text identifies "the king of Upper and Lower Egypt, Menkheperre [the son of Re Thutmose]." This particular block is unusual because it depicts Amun-Re but has not, like the relief in catalogue 7, been mutilated and later restored. Rather, the original profile in the style of Thutmose III's own portraiture — including wide-open, natural-shaped eyes and a slightly hawkish nose — adorns Amun-Re's face.

Amun-Re is shown here with the most typical headdress for him — a low, flat hat topped with two tall plumes. His skin is painted black —

a feature that sometimes appears but does not dominate the iconography of the god. Black is a color of fertility, reminiscent of the rich silt deposited yearly by the Nile floods, and the black skin of statues and images creates associations with resurrection.[1] Amun-Re's image in a Temple of Millions of Years on the west side of Thebes underlines his support for the eternal life of Thutmose III. The god is shown with one arm raised, as if in salute, with the flail of authority bending over it.

Had we the remainder of the block, we would see that Amun-Re is shown as a mummi-form figure, with a hand out of the wrapping and an erect phallus, in a so-called ithyphallic form. This manifestation connects Amun-Re with his fertility form, Amun Ka-mut-ef — "the bull of his mother," who assures an heir by procreation with his divine mother. Rituals associated with this aspect of Amun-Re are frequent at Karnak Temple but even more so at Luxor Temple, where the resident god was Amun-Re in his ithyphallic form. Given his association with the earth and its rejuvenatory abilities, Amun-Re as a fertility deity was appropriately linked with funerary cults on the west bank of Egypt.

Not long before he built Djeser-Akhet, Thutmose III completed the small temple at Medinet Habu begun by Hatshepsut. The temple housed a procession called the Decade Festival that came from Luxor Temple every ten days. The Medinet Habu shrine was seen as the primeval mound from which Amun-Re as a chthonic deity emerged. At the time of the Beautiful Feast of the Valley the processions continued on to other temples, presumably including Djeser-Akhet. Apparently, Thutmose III's priests designed his temples to accommodate not only Amun-Re of Karnak for the Beautiful Feast of the Valley but also Amun as a god of creation and rejuvenation.

Betsy M. Bryan

1. Compare Luxor Museum J. 139, "God with a Black Face," also from Djeser-Akhet (*The Luxor Museum of Ancient Egyptian Art Catalogue* [Cairo, 1979], 57).

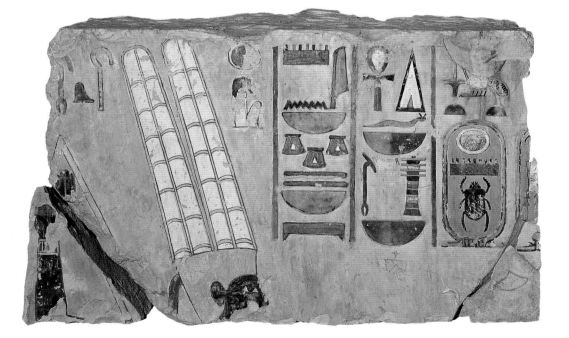

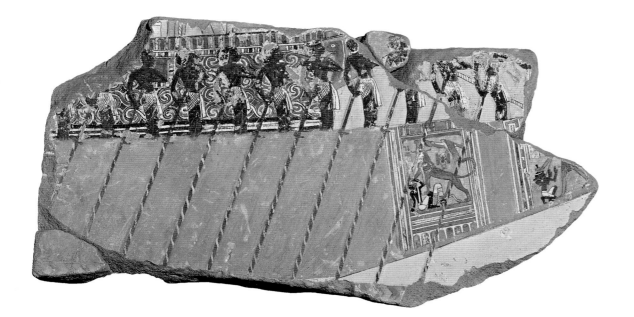

9 Royal barque of Thutmose III

Eighteenth Dynasty, reign of Thutmose III, 1479–1425 BCE; painted limestone. Height 39 cm (15 3/8 in); width 71 cm (27 15/16 in); depth at least 38 cm (14 15/16 in). Excavator's no. 69. Supreme Council of Antiquities, Deir el-Bahari

• This block preserves part of a boat procession bringing statues of the king and gods to the temple of Djeser-Akhet at Deir el-Bahari. Other parts of the scene preserve figures of priests carrying standards of the deities as well as a shrine containing a statue of Thutmose III. The boat is a royal ship nearly identical to the model boat from the tomb of Amenhotep II (1427–1400 BCE; see cat. 1). Both are painted green and exhibit panels showing the ruler as a griffin or sphinx trampling his foes.

Here, we see Thutmose III as a sphinx trampling a Nubian. To the right, only partially preserved, is the king as a man, smiting an Asiatic from the Levant. Nubians and Asiatics were the two great foes of Egypt during the mid-Eighteenth Dynasty, and ships such as this one were used not only for temple festival processions on the river but also for transporting troops and military equipment when the king went to war.

Egyptian ships varied little, although they could be rigged with sails or without, with single masts amidships. The royal ships, painted with images of the ruler himself as the defender of Egypt, were recognizable from the banks of the Nile whenever the boats sailed south or north.

The rowers stand on the deck of the royal ship and hold long pole-shaped oars. Other scenes of ships crossing the river show the rowers seated, as seen in several cases in the Hathor shrine of Hatshepsut's Deir el-Bahari temple. Those ships were crossing for festivities at New Year's Day or some other feast and are depicted with their sailors pulling oars as they must have during normal sailing conditions. In this block the ship has perhaps already crossed the Nile and is shown arriving at the quay, so that poling, rather than rowing, is necessary. It is quite likely that this scene formed part of a procession associated with the Beautiful Feast of the Valley, which took place in the second month of the summer (Shemu). **Betsy M. Bryan**

10 Statue of Senenmut and Nefrure

Eighteenth Dynasty, reign of Hatshepsut,
1473–1458 BCE; granodiorite. Height 60 cm
(23⅝ in); width 30 cm (11¹³⁄₁₆ in); depth 36 cm
(14³⁄₁₆ in). Karnak, courtyard of the cachette.
The Egyptian Museum, Cairo JE 36923/CG 42116

• This statue depicts Senenmut, a high-ranking
official during the reign of the female pharaoh,
Hatshepsut. A man of common birth, Senenmut
came to have many functions, including architect
of Hatshepsut's mortuary complex at Deir el-
Bahari. Here, Senenmut is shown in his capacity
of "Steward of the Princess Nefrure." He is
depicted seated on a base, with his right leg folded
in front of him and his left leg pulled up against
his chest. Perched on his lap is Nefrure, the
daughter of Hatshepsut.

Senenmut is wearing a knee-length kilt
and a shawl, the latter covering all of his upper
body except for his hands. He also sports a
shoulder-length wig that is rendered with evenly
spaced incised lines that move unbroken across
his forehead, with no indication of a part. His
eyes are naturally shaped and lidless, which is
characteristic of early Eighteenth Dynasty statu-
ary, and his gaze is directed upward, over the
head of the child in his lap. His eyebrows and
the cosmetic lines around his eyes are shown in
raised relief, and both slant slightly downward.

The princess Nefrure is seated perpen-
dicular to her steward. Her hairstyle consists of a
sidelock on the right side of her head, a typical
symbol of childhood. A uraeus, a mark of royalty,
is placed on her forehead, with its coils extending
back across her shaven head. She gazes straight
ahead, her body swathed in a cloak. Only her
right index finger emerges from her garment and
rests on her mouth, yet another symbol of
childhood. Around her back and across her legs
are Senenmut's extremely large hands, which
envelop her in a gesture of both protection and
affection. Next to Nefrure, an inscription runs
along the hem of Senenmut's kilt, identifying
him as "Steward of the Princess Nefrure."

The base of the statue is four-sided with
rounded corners. Inscribed all around it are some
of Senenmut's other official titles, including
"overseer of the grain stores of Amun," "overseer
of the livestock of Amun," and "overseer of the
dominion of Amun."

Of the twenty-five known statues of
Senenmut, several of them depict him with Prin-
cess Nefrure. These statues often render the two
in poses not previously seen in official statuary.
This statue is an example of one of those unique
poses. It combines the well-known seated scribe
position of a man with one leg folded beneath
him and one leg up against his body, with another
well-known motif, that of a nursing woman who
holds a child to her breast. By merging these two
motifs, the statue makes it clear to the viewer that
this man is not only learned but also very close
to the royal family. One need not even be able to
read the inscriptions on the statue to see how
intimately Senenmut must have been connected
to royalty. Simply "reading" the poses of the
steward and the princess reveals the proximity
to the pharaoh that Senenmut enjoyed, and thus
his extremely high position at her court.

Elizabeth A. Waraksa

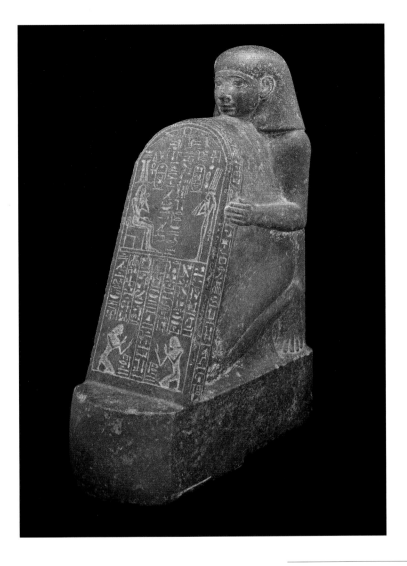
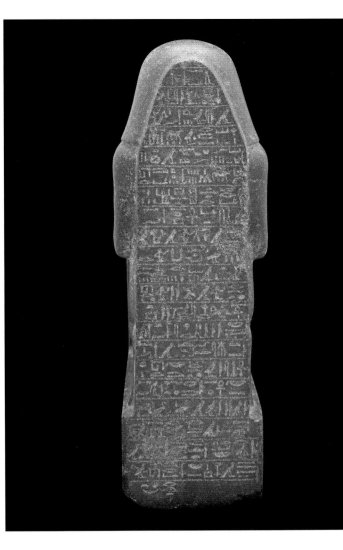

11 Stelophore of Nefer-peret

Eighteenth Dynasty, reign of Thutmose III, 1479–1425 BCE; granodiorite. Height 59.5 cm (23 7/16 in); width 19 cm (7 1/2 in); depth 36 cm (14 3/16 in). Karnak Temple, cachette. The Egyptian Museum, Cairo JE 37177 / CG 42121

• The royal butler Nefer-peret served the administration of Thutmose III, most probably following a career in the army. This statue shows Nefer-peret in a supplicant's pose, offering a monument in the name of Thutmose III and his great royal wife, Merytre Hatshepsut, mother of Amenhotep II (1427–1400 BCE). In front of him, Nefer-peret holds a stele depicting Thutmose III enthroned, with his wife facing him. In the lower register, kneeling figures of Nefer-peret raise their arms in adoration of the king and queen. On the left, the text celebrates Merytre

Hatshepsut, and on the right, the might and victories of Thutmose III. Another dedication to Nefer-peret runs around the edge of the stele, and additional text is found on the rear of the statue.

Statues such as this, called stelophores because they show a person holding a stele, were to be placed either in tombs or temples, depending on the function of the inscriptions on the stelae. Here, Nefer-peret offers praise to his king, showing him as a god seated in a temple. In this manner, the royal butler hoped to secure the favor of the king and partake of whatever eternal cult Thutmose III might have within the temple of Karnak. Since Thutmose III had built his own Temple of Millions of Years within Karnak, the Akhmenu, where the cult of rulers and particularly of Thutmose himself were emphasized,[1] Nefer-peret may have wished to be connected with that enduring kingship.

The simplified head and wig of Nefer-peret are carved out of the extremely hard stone granodiorite often used for temple statuary because it is so durable.[2] The dark color, associated with rejuvenation, is appropriate for a statue meant to be an eternal monument. The face bears the features of Thutmose III (compare cats. 3 and 4), which are particularly similar to his portraits from the period of his sole rule but closest to several deriving, like this statue, from Karnak Temple. Nefer-peret's wig is a type seen in the mid-Eighteenth Dynasty and suggests Middle Kingdom (2055–1650 BCE) models. Similar wigs may be seen on block statues, such as that of Maanakhtef dated to the reign of Amenhotep II.[3]

Betsy M. Bryan

1. For the style of Thutmose III statues, see Dmitry Laboury, *La statuaire de Thoutmosis III: Essai d'interprétation d'un portrait royal dans son contexte historique* (Liège, 1998), 640.

2. For comparison with Middle Kingdom wigs, see Elisabeth Delange, *Statues égyptiennes du Moyen Empire* (Paris, 1987), 66.

3. For the statue of Maanakhtef, see Christophe Barbotin, "Maanakhtef" in *Ägyptens Aufstieg zur Weltmacht* (Mainz, 1987), 248–49.

92

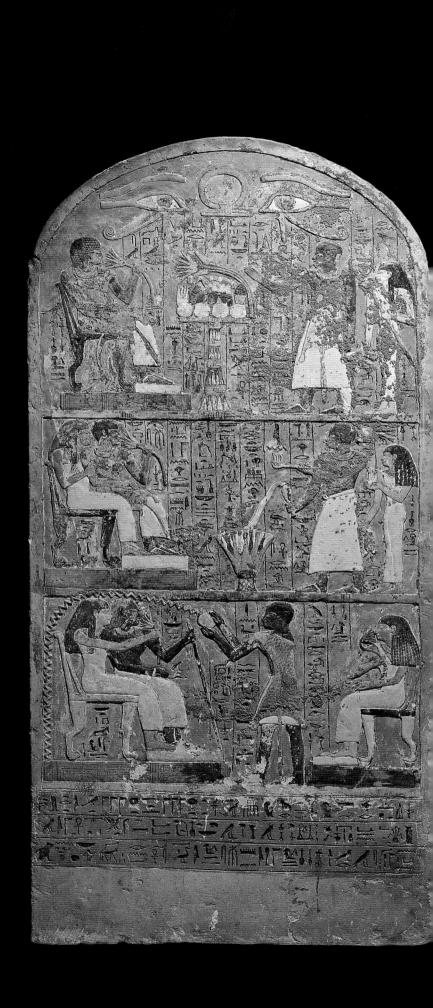

12 Stele of Nebnakht and family

Early Eighteenth Dynasty, c. 1550–1458 BCE; painted limestone. Height 109 cm (42 15/16 in); width 53 cm (20 7/8 in); depth 17 cm (6 11/16 in). Sedment el-Gebel by F. Petrie, 1921. The Egyptian Museum, Cairo JE 46993

• This carved and brightly painted funerary stele depicts the dedication of offerings for members of the priest Nebnakht's family. The lunette, or rounded top of the stele, contains a central *shen* symbol (the circuit) flanked by two *wedjat* eyes (wholeness or health), which provide eternal protection for all those represented. Below, the Egyptian artist divided the images into three divisions called registers, each of which holds a scene independent in time and place from the others. In the first register, Sennefer, who bears the titles High Priest of Heliopolis and High Priest and Chief of Artisans at Memphis, sits upon a dais, accompanied by his pet monkey. He wears a wig, collar, and the traditional garb of his exalted office, the spotted leopard skin. Before him, a table of offerings is heaped with goods presented by the two standing figures, the priest Nebnakht and his wife, the daughter of Sennefer, Sheritre. In the central register, the parents of Nebnakht, the priest Amenmose and the lady Iuty, are seated according to standard Egyptian artistic protocol: side by side (in two dimensions this is portrayed by placing one figure in front of the other) with the man in the more prestigious position on the viewer's right. Here, Nebnakht pours a libation and burns incense while Sheritre offers ducks and a lotus petal. Nebnakht is joined by his mother, Iuty, in receiving libations in the bottom register; this time it is his son, the priest Amenhotep, who makes the offerings. Seated behind him is again Sheritre. Three final bands of inscription repeat an offering formula dedicated to the gods on behalf of Sennefer and Amenmose, given by Nebnakht.

The stele of Nebnakht is fashioned in typical New Kingdom style, with the figures separating the lunette above from the text below. Like other stelae depicting only private individuals, the lunette contains *wedjat* eyes of "wholeness" instead of a winged solar disk — an image that appears on stelae including gods or royal figures. Egyptians used stelae in funerary contexts from the beginning of pharaonic times as a means to record their names and mark offering places. This example was found in a niche of the family funerary chapel, with an inscribed offering table of a man named Amenmose and a stelophorus statue of the scribe Minmose in front of it. Although the Egyptians went to great lengths to preserve their physical bodies through burial and mummification, they believed that the existence of their images in artistic form could also function to ensure their survival. These representations of the deceased's *ka*, the aspect of a person that could live on in artistic form, needed the life-preserving force of goods like food and drink to survive. Funerary chapels functioned as public memorial places where relatives, priests, or even strangers could supply the *ka* of the deceased with the necessary staples. If they neglected their duties, the pictures of tables heaped with gifts, along with written inscriptions of offerings, could nourish the *ka*. A person's name was also a vital aspect of the self that needed preservation, and stelae like this one often complemented scenes with hieroglyphic writings explaining the names, titles, and actions of the individuals shown. Nebnakht, Amenmose, and Amenhotep all held the important position of priest of the god Harsaphes, and their titles are recorded for eternity next to their figures. The cult of Harsaphes, a ram-headed god who was associated with both concepts of agricultural fertility and war, was maintained primarily at the ancient city of Herakleopolis (Nennisu in the Egyptian language). This city, located near the entrance to the Lake Fayum area, acted as a seat of kingship in Egypt's First Intermediate Period, and retained its role as an administrative capital after the reunification of the Middle Kingdom. The necropolis for the city stood on a mound at Sedment el-Gebel, where archaeologists uncovered the stele and funerary chapel of Nebnakht. **Elaine Sullivan**

1. W.M. Flinders Petrie excavated the tomb of the family of Nebnakht in 1921 (W.M. F. Petrie and Guy Brunton, *Sedment,* vol. 2 [London, 1924], 169).

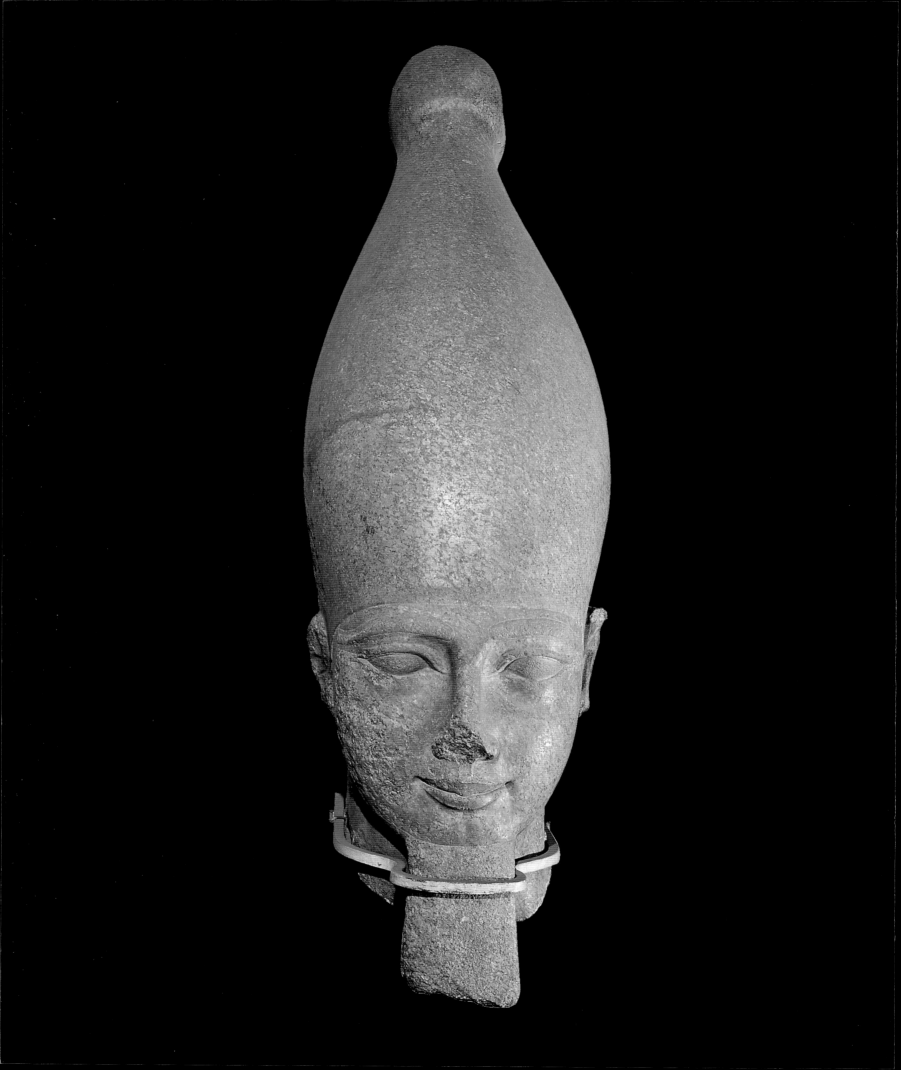

13 Colossal head of Ramesses II usurped from Senusret I

Nineteenth Dynasty, reign of Ramesses II, 1279–1213 BCE, and Twelfth Dynasty, reign of Senusret I, 1956–1911 BCE; red granite. Height 230 cm (90 9/16 in); width 71.5 cm (28 1/8 in); depth 106 cm (41 3/4 in). Memphis. The Egyptian Museum, Cairo CG 644

• Ramesses II has left more monuments bearing his name and/or face than has any ruler of Egypt. In many cases, however, the objects did not originally carry either his name or portrait. Ramesses took over the statues and buildings of other kings with frequency and industry. While we might consider this activity as usurpation, it may not have been perceived as such by Ramesses. Indeed, when a king with the affluence and power of Ramesses II chose to recarve a statue of an earlier pharaoh, he may have expected to partake of the greatness of that ancestor. In the case of this statue and several others from Memphis,[1] the Nineteenth Dynasty king placed his own face on a colossal, 6.7 meters (22-feet) striding image of Senusret I, second king of the Twelfth Dynasty. Senusret, like Ramesses II, ruled a long time and left his monuments prominently visible even seven hundred years later. He was responsible for the early complex at Karnak Temple, where his greatest official, Mentuhotep, left statues of himself near the central part and where he built for Senusret a temple to Amun-Re recalling the sun god Re's sanctuary in Heliopolis.[2] In the case of this statue and at least four others like it, Senusret apparently punctuated a temple entrance at Memphis with colossal images of himself.

The careful viewer of this statue will see the hallmarks of the artists whose task it was to turn Senusret I into Ramesses II. Look at the sides near the ears, where the chin strap has been narrowed and cut over the lower border of the crown. The crown meets the face at the brow with a higher surface, suggesting the entire face was cut down for reshaping. The face of Senusret I differed greatly from that of Ramesses II, but the later king's artists attempted to preserve links to the earlier work. Ramesses' eyes, for example, are normally more ovoid in shape than those of Senusret I, but despite this reshaping the sculptors added a heavy and wide lid line above the eyes and a deeply cut lower lid as well, features seen on the portraits of Senusret. In adapting the eyes, the artists widened the corners. According to Hourig Sourouzian, who recently commented: "With good light, one can still discern … traces of the original spring of the upper lid and the remnants of the deeply cut horizontal inner canthi,"[3] Ramesses' mouth is far fuller than that of Senusret and is modeled on that of Amenhotep III. Profiles of statues of Senusret show that king's mouth protruding prominently beneath the nose. Ramesses' artists carved back the mouth surface to re-create the lips, and the profile now shows little or no protrusion. **Betsy M. Bryan**

1. David Jeffreys, Jaromír Malék, and H.S. Smith, "Memphis 1985," *Journal of Egyptian Archaeology* 73 (1987): 19, gives a list of Ramesside statuary from Memphis. G7 is CG 643.

2. For the Middle Kingdom form of Karnak, see Luc Gabolde, *Le "grand château d'Amon" de Sésostris I er à Karnak: La décoration du temple d'Amon-Ré au Moyen empire*. Paris, 1988.

3. Hourig Sourouzian, "Standing Royal Colossi of the Middle Kingdom Reused by Ramesses II," *Mitteilungen des Deutschen Archäologischen Instituts, Abteilung Kairo* 44 (1988): 231.

14 Sennefer and Sentnay

Eighteenth Dynasty, reign of Amenhotep II, 1427–1400 BCE; granodiorite. Height 135 cm (53 1/8 in); width 76 cm (29 15/16 in); depth 67 cm (26 3/8 in). Karnak, Temple of Amun-Re, north of the Great Hypostyle Hall, discovered by George Legrain 1903. The Egyptian Museum, Cairo JE 36574 / CG 42126

• This statue of Sennefer, the mayor of Thebes, and his wife, Sentnay, represents them seated on a high-backed chair. Their bodies are carved in high relief with arms interlaced. Sennefer wears a heavy wig that reaches to his shoulders but leaves his ears exposed. He has a slight smile and the features of a middle-aged man. Sentnay's face is narrower than that of her husband and does not have the extended eyeline that prolongs the corners of his eyes. Their faces, however, have almost identical features: well-defined almond-shaped eyes and eyebrows in relief, a straight nose with a rather wide base, and a small, fleshy mouth.

Around Sennefer's neck is the massive *shebyu* collar of four strands that would have been composed of gold rings. He is also wearing a double heart-shaped necklace and a long skirt with a knot at his waist. His right arm rests flat on his lap. Sentnay is seated to his left wearing a long tripartite hair wig with thin braids that cover her ears, a broad collar, and a long tight dress with two shoulder straps.

Between the couple is one of their daughters, Mutnofret, represented on a much smaller scale and standing on a small base. She is wearing a long dress and a long tripartite wig ending in braids. She is positioned once again on the right side of the chair sitting in front of an offering table sniffing a lotus flower (detail, p. 97). The scene is repeated on the left side of the chair but with her sister Nefertari.

New Kingdom elites were keen to put their statues in the temple of Karnak in order to receive the offerings and blessings of visitors. The owner of this statue was rewarded with this privilege. Sennefer was the mayor of Thebes during the reign of Amenhotep II, and his wife, Sentnay, was the royal wet nurse. His tomb at Thebes, famous for its beautiful scenes and grape

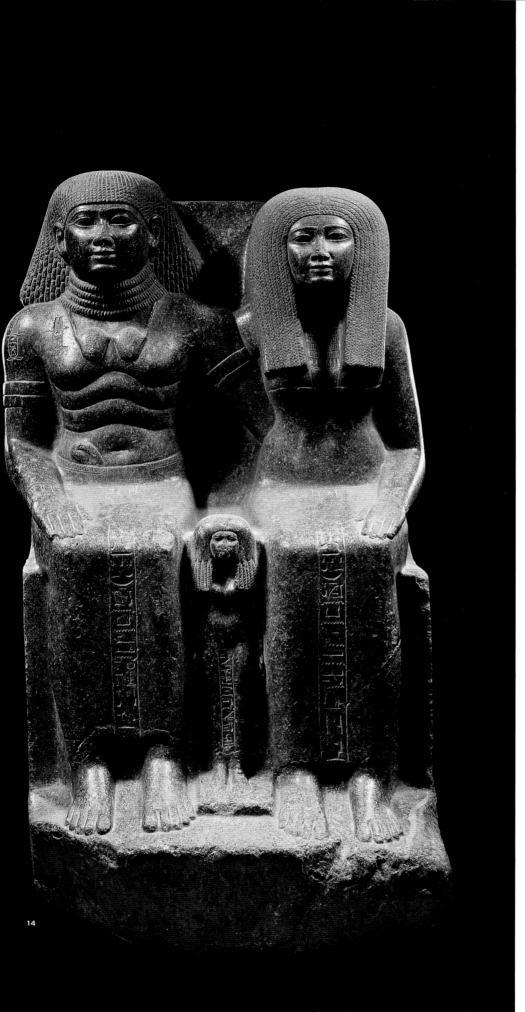

arbor ceiling, is another mark of the high prestige of this couple. The massive collar and the necklace, as well as the armlets, are part of an honorific award from the king for his distinguished duties. Sennefer proudly wears this "gold of favor," which began in the time of Thutmose III, both on his statue and in the painted scenes of his tomb.

The stylized folds of fat on Sennefer's torso are a sign of well-being and a prosperous life according to popular fashion in the Eighteenth Dynasty, originating in the Old Kingdom (2686 – 2125 BCE; compare the statue of Amenhotep, son of Hapu, cat. 15). The interlacing arms were also a fashion of the New Kingdom, as was the appearance of children between the legs of their seated parents, especially in the Eighteenth Dynasty, although this tradition goes back to the Old Kingdom as well.

Two cartouches of King Amenhotep II are incised on Sennefer's right shoulder. Cartouches on the shoulder first appeared on private statues in the reign of Thutmose III and became more common in the later New Kingdom.

On the left side of the seat, next to the scene of the daughter Nefertari, is an inscription identifying two draftsmen, or artisans, Amenmose and Djed-khonsu. This has been thought to be a signature for the statue, but could also be an addition intended as a votive offering to invoke Sennefer's intermediacy. The addition could date from the Eighteenth to the Twenty-first Dynasties.

Fatma Ismail

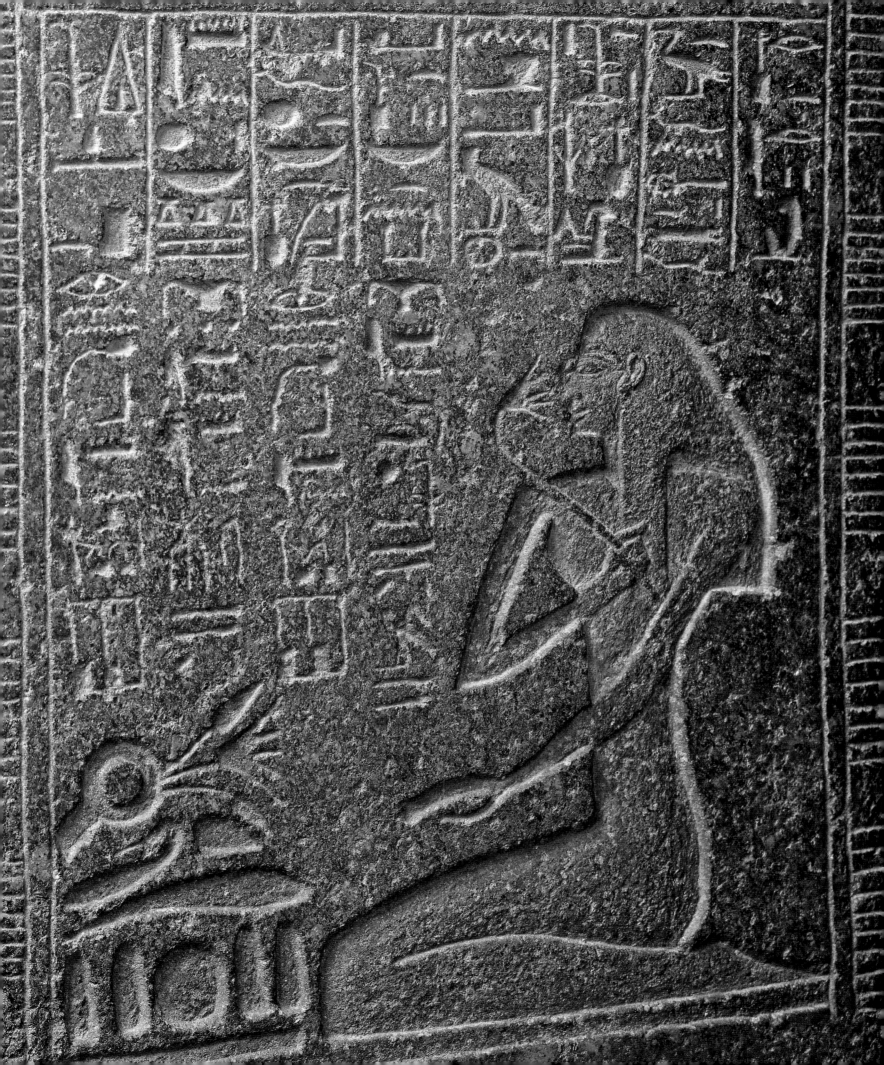

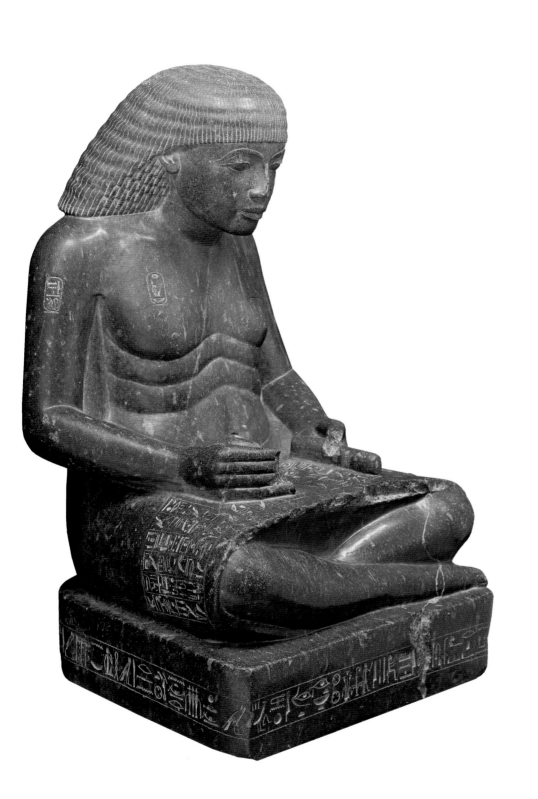

98

Eighteenth Dynasty, reign of Amenhotep III,
1390–1352 BCE; granodiorite. Height 125 cm
(49 3/16 in); width 73.5 cm (28 15/16 in); depth 71 cm
(27 15/16 in). Thebes, Karnak, Temple of Amun-Re,
north face of Tenth Pylon, east side of doorway,
excavations of Legrain, 1913. The Egyptian Museum,
Cairo JE 44861

· The scribe statue, seated cross-legged, a papyrus
roll stretched over his lap, has had a long and
distinguished history in Egyptian art, and the
highest officials were proud to display themselves
in this deceptively humble attitude. This magnifi-
cent example is one of a pair showing Amenhotep,
son of Hapu, Amenhotep III's greatest official and
one of the most important individuals in Egyp-
tian history, that were in a prominent position in
Amun's temple at Karnak.[1] The inscription on
the papyrus is oriented toward the sitter and reads:

Placed as a favor from the king to the hereditary
prince, count, sealbearer of the king of Lower Egypt,
royal scribe, scribe of recruits Amenhotep, vindi-
cated, who says, "The king placed me as overseer
of works in the mountain of quartzite to direct the
monuments of his father, Amun of Karnak. I brought
back numerous great monuments consisting of
statues of his majesty of skilled work, brought from
Lower Egyptian Heliopolis to Upper Egyptian Heli-
opolis, that they may rest in their place in western
[Thebes]. My lord did something useful for me,
placing my image in the house of Amun, knowing
it would remain [there] for eternity.

Quartzite, with its ruddy hue, was con-
sidered the most solar of stones. As overseer of
recruits, Amenhotep, son of Hapu, had all the
country's manpower at his disposal to carry out
the king's orders. Enormous quantities of quartz-
ite quarried at Gebel Ahmar (Lower Egyptian
Heliopolis), near present-day Cairo, were then
shipped some seven hundred kilometers up-
stream to Thebes (Northern Egyptian Heliopolis)
to adorn the courtyards and pylons of Amen-
hotep III's vast buildings at Karnak and on the
west bank with monumental images of the king.
Perhaps the most famous are the two seated
figures known as the Colossi of Memnon, which

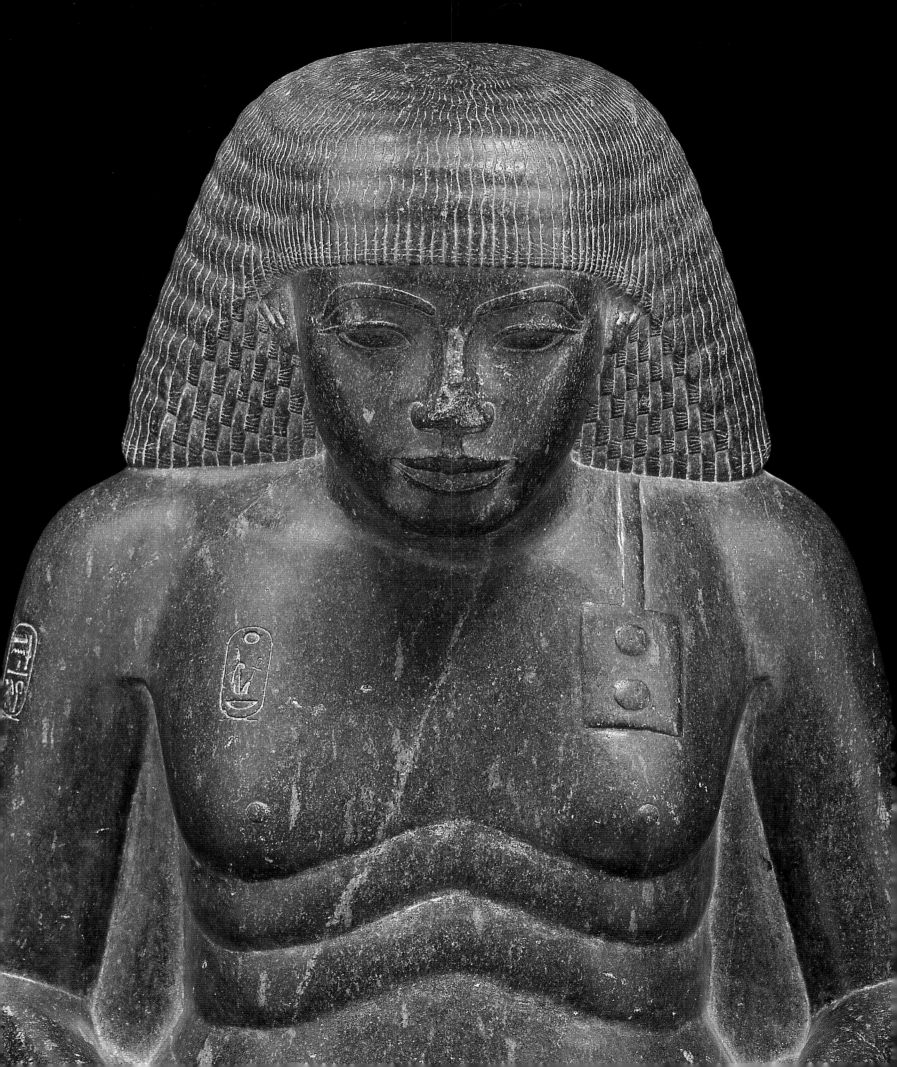

still mark the entrance to the site of Amenhotep III's mortuary precinct in western Thebes. Each is fashioned out of a single block of quartzite, 17.3 meters (57 feet) high and weighing about seven hundred tons.[2] On the back of the southern colossus the king actually refers to himself as "one great of monuments matching his strength, which were brought from Lower Egyptian Heliopolis to Upper Egyptian Heliopolis."[3] Amenhotep, son of Hapu, took the king's mandate seriously, for in another statue inscription he states:

I established the king's name for eternity. I did not imitate what had been done before, but I created for him a mountain of quartzite, for he is indeed the heir of Atum [creator god of Heliopolis].[4]

An additional inscription on the base of the statue invites passersby to call on Amenhotep, son of Hapu, to intercede for them with the god:

O people of Upper and Lower Egypt, every eye that beholds the sun disk, who comes upstream or downstream to Thebes to pray to the lord of the gods, come to me and I shall relay your words to Amun of Karnak. And make a libation to me with what you have, for I am the spokesman appointed by the king to hear your words of supplication and to promote the affairs of the two lands.

The people evidently took him at his word, for the papyrus roll is worn smooth by the hands of countless visitors. In the Ptolemaic Dynasty he attained the status of a god, being worshiped alongside Imhotep (architect of Djoser's Step Pyramid at Sakkara), as a wise man and a healer.[5]

Lawrence M. Berman

Translations are by Lawrence M. Berman.

1. The other is Luxor J. 4 (ex Cairo JE 44862) (Bertha Porter and Rosalind Moss, *Topographical Bibliography of Ancient Egyptian Hieroglyphic Texts, Reliefs, and Paintings*. Vol. 2, *Theban Temples*, 1929 [2d ed., rev. Oxford, 1964, 1972], 188; *The Luxor Museum of Ancient Egyptian Art Catalogue* [Cairo, 1979], 90–91, no. 117, with figs. 68–69 and pl. VIII). For photos of the statues as found, see Claude Traunecker and Jean-Claude Golvin, *Karnak: Résurrection d'un site* (Fribourg, 1984), 182, fig. 168.

2. See Dieter Arnold, *Building in Egypt* (New York, 1991), 60, table 3.1.

3. Wolfgang Helck, *Urkunden der 18. Dynastie*, vol. 20 (Berlin, 1957), 1746, line 15; Lawrence M. Berman, "Amenhotep III and His Times" in Arielle P. Kozloff and Betsy M. Bryan, *Egypt's Dazzling Sun: Amenhotep III and His World* (Cleveland, 1992), 34.

4. Limestone block statue, Cairo CG 583 and 835. Helck, *Urkunden der 18. Dynastie*, vol. 20, 1822, lines 16–19; Berman, "Amenhotep III and His Times," 46.

5. Dietrich Wildung, *Egyptian Saints: Deification in Pharaonic Egypt* (New York, 1977).

16 Tomb statue of Nakhtmin's wife

Eighteenth Dynasty, reign of Tutankhamun or Ay, 1336–1323 BCE; limestone. Height 84.5 cm (33¼ in); width 42 cm (16 9/16 in); depth 30 cm (11 13/16 in). The Egyptian Museum, Cairo JE 31629

• Arrayed in the height of late Eighteenth Dynasty fashion, this woman wears a wrapped garment of sheer, finely pleated linen and a heavy, elaborately crimped and curled wig. She holds a *menat,* a counterweighted, multistranded bead necklace, which she would have shaken like a rattle during temple ceremonies. In contrast to the detailed rendering of her finery, her form and face are softly and sensuously modeled. This style, which is also characteristic of Tutankhamun's statuary, was strongly influenced by the art of the late Amarna Period. (c. 1352–1327 BCE). Surviving traces of paint on this statue indicate that the fine white stone was colored only with red on the mouth and black for the eyes and brows, the line between the lips, and the creases on the neck.[1]

The figure was part of a dyad that showed the woman, whose name is lost, standing beside the seated figure of her husband, who was a high-ranking military officer and courtier named Nakhtmin.[2] Although his head has also survived, the rest of the statue was smashed, apparently by Nakhtmin's enemies. They would also have attacked the tomb in which the statue stood; since the tomb has not been located, it may have been so thoroughly destroyed that it is no longer recognizable.

Nakhtmin is thought to have been a protégé of Tutankhamun's short-lived successor, Ay, to whom he may have been related.[3] Nakhtmin's status was exalted: he was one of only two courtiers permitted to dedicate funerary objects to Tutankhamun in that king's tomb. The attack on Nakhtmin's tomb and statue suggests that his fall was precipitous, probably triggered by the death of Ay and the resulting power struggles among the inner circle of courtiers. One of them, the general Horemheb, prevailed to become Ay's successor.

During most of the Eighteenth Dynasty, statues made for the tombs of nonroyal people tended to be quite small. But, whether to reflect the ostentatious life-style of the highest elite during the late Eighteenth Dynasty, or to signal their underlying ambitions, the tomb statues of these great men and their wives were often lifesized or larger.[4] Although the scale of Nakhtmin's wife is less than life, her husband's figure was over lifesized. The dyad was thus typical of the grandiose tomb sculpture of its day.

The composition of the statue, however, is highly unusual for pair statues of the New Kingdom (1550–1069 BCE), which almost always show couples on the same scale and in similar poses.[5] Not only was the large figure of Nakhtmin seated while his wife stood to his left, but her figure was also scaled down, apparently so that the top of her head would be at the same level as his. This isocephalic principle of composition is commonplace in Old Kingdom (2686–2125 BCE) sculpture, with its frequent disparities of scale. In the New Kingdom, the more naturalistic approach to the relative sizes of couples had made it obsolete. It is not impossible that this dyad's depiction of figures in an isocephalic composition of different sizes and poses was inspired by much earlier statues, but this kind of archaizing imitation was almost unknown in the late Eighteenth Dynasty. It was a period when social and family relationships could be crucially important, and it thus seems more likely that the relatively small size of this elegant figure was somehow intended to demonstrate her status, or her role in relation to her husband. **Edna R. Russman**

1. This type of partial polychromy on limestone sculpture and reliefs was practiced from late Eighteenth Dynasty into the early Nineteenth. It is best known from the tomb of Ramose at Thebes (TT 55), which spans the reigns of Amenhotep III and Akhenaten.

2. Ludwig Borchardt, *Statuen und Statuetten von Königen und Privatleuten,* vol. 3. Catalogue général des antiquités égyptiennes du Musée du Caire (Cairo, 1911–36), 87–89; Mohamed Saleh and Hourig Sourouzian, *The Egyptian Museum, Cairo: Official Catalogue* (Cairo/Mainz, 1987), nos. 195–96. For a putative Theban provenance, see Bertha Porter and Rosalind Moss, *Topographical Bibliography of Ancient Egyptian Hieroglyphic Texts, Reliefs, and Paintings.* Vol. 1, *The Theban Necropolis,* 1927, part 2, *Royal Tombs and Smaller Cemeteries* (2d ed., rev. Oxford, 1964, 1972), 784–85, which also cites part of another (?) group statue of Nakhtmin: The Egyptian Museum, Cairo, JE 36526.

3. For a recent and balanced assessment of Nakhtmin's monuments and career within the political climate of his day, see Jacobus van Dijk, "The New Kingdom Necropolis of Memphis: Historial and Iconographical Studies" (Ph.D. diss., Groningen, 1993), 58–64.

4. According to Jacques Vandier, *Manuel d'archéologie égyptienne.* Vol. 3, *Les grandes époques* (Paris, 1958; reprint, 1981), 520–23, these large tomb statues span the post-Amarna Period to the early reign of Ramesses II. Besides the social explanations suggested above, their prominence may support van Dijk's argument that the large tombs for which most were made should be interpreted as mortuary temples ("The New Kingdom Necropolis of Memphis," 204).

5. When children are represented with their parents on New Kingdom statues, they are often, as on Old and Middle Kingdom examples, shown on a much smaller scale.

The ancient Egyptians strove to equip their dead with magical means by which to pass protected through the netherworld, the necessities of daily life, and as many luxuries as possible. The most important of the royal tomb furnishings were coffins, sarcophagi, and canopic equipment. Statues of the king preserved his image, and images of the gods and goddesses strengthened the connection between the king and the deities. Persons of royal stature were interred with stores of foods and beverages, amuletic jewelry, *ushebtis*, fans, mirrors, cosmetics, perfumed oils, items of furniture, and symbols of their office and status.

17 Girdle of Mereret

Twelfth Dynasty, reign of Senusret III, 1870 – 1831 BCE; gold. Extended length 40.8 cm (16 in). Dahshur, pyramid precinct of Senusret III, tomb of Mereret. The Egyptian Museum, Cairo CG 53074

• On 8 March 1894, working in one of the galleries inside the enclosure wall of the pyramid of Senusret III, Jacques de Morgan uncovered a box inlaid with gold underneath the floor of a room that contained an empty coffin. Inside was a large hoard of jewels and cosmetic items belonging to Princess Mereret, daughter of Senusret III and sister of Amenemhat III (1831 – 1786 BCE). This splendid cowrie-shell girdle was part of her hoard.

Large and small shells have been strung together here, although originally they may have been part of two separate girdles, some parts of which are missing. One shell consists of two parts, one of which has a tongue and the other, a groove. Slotted together, they served as an invisible clasp. The shells are hollow inside, but contain tiny pellets that would have jingled seductively as the princess walked. The shells were made as identical halves, cast over a solid mold, soldered together, and then chased with parallel incised lines to represent the lip of the shell.

Because their shape recalls the vulva, cowries were associated with fertility. Marine shells were imported into the Nile Valley as early as the Badarian Period (c. 4400 – 4000 BCE), and included in tombs. Girdles of cowry shells are first depicted with some frequency from the early Middle Kingdom on (2055 – 1650 BCE), when they are worn by otherwise nude servant girls or concubine figures. Many of the royal princesses included them in their burial equipment. Sit-Hathor-Yunet, a daughter of Senusret II (1877 – 1870 BCE), had two splendid examples in her tomb at Lahun, one of which consisted of both cowrie shells and acacia seeds, and the other, of panther heads, which undoubtedly provided protection to the wearer.

Girdles continued to be popular in the New Kingdom (1550 – 1069 BCE), but the cowrie shape was reduced to a semicircle decorated with parallel incised lines around the curved edge.
Rita E. Freed

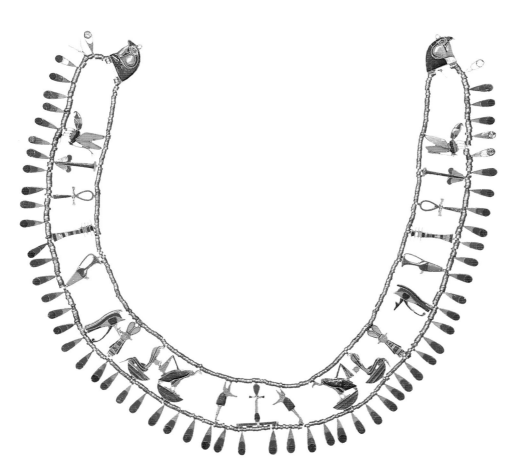

18 Necklace of Princess Khnumet

Twelfth Dynasty, reign of Amenemhat II, 1911–1877 BCE; gold, carnelian, lapis lazuli, turquoise. Total length 34.9 cm (13 3/4 in); width 2 cm (13/16 in). Dahshur, funerary complex of Amenemhat II. The Egyptian Museum, Cairo JE 31113, JE 31115

• Many would say the Middle Kingdom represented a high point of the jeweler's art, and this is nowhere better reflected than in the delightful collar of Khnumet, daughter of Amenemhat II and wife of Senusret II (1877–1870 BCE). In 1894 Jacques de Morgan discovered her intact burial at Dahshur within the enclosure wall of her father's pyramid.[1] The jewels were found directly on her mummy, but unfortunately their exact order could not be recovered. Accordingly, the individual elements were subsequently restrung in an arbitrary way.[2]

Broad collars were important elements in the funerary parure from the Old Kingdom on (2686–2125 BCE), judging from the frequency in which they were found on mummies, represented in sculpture, depicted on tomb or coffin walls, and mentioned in the funerary literature.[3] Traditionally, they were composed of rows of tubular beads separated by tiny disk beads. Here, the tubular beads were replaced by amuletic hieroglyphs, which represent such good wishes as long life, kingship, stability, and health. Each element is composed of gold cloisons into which semiprecious stones have been precisely fitted and then polished. The gold most likely came from the Eastern Desert or Nubia, the turquoise from Sinai, and the lapis lazuli from Afghanistan. Only carnelian would have been readily available throughout the Egyptian desert. Although falcon-headed terminals are depicted as early as the Sixth Dynasty (2345–2181 BCE),[4] Khnumet's are among the first actual examples. The pleasing juxtaposition of color gives this necklace a vitality that is unsurpassed. Few jewels today can match its delicacy.

In addition to other necklaces, Khnumet went to her tomb wearing three bracelets on each arm. An additional hoard of jewelry was found under a cosmetic box on the floor of the offering chamber. Altogether, there were more than two thousand beads, pendants, bracelets, and diadems. Some of the elements are thought to exhibit Aegean influence.[5] Although three of Khnumet's sisters were buried near her, none of them were buried with the same quantity or variety of jewelry. She must have been her father's favorite.

Rita E. Freed

1. Jacques de Morgan, *Fouilles à Dahchour en 1894–1895* (Vienna, 1895–1903), vol. 2, 40ff and pl. 2.

2. Ibid., 51.

3. For a detailed treatment, see Edward Brovarski, "Old Kingdom Beaded Collars," in Jacke Phillips, ed., *Ancient Egypt, the Aegean, and the Near East: Studies in Honor of Martha Rhoads Bell*, vol. 1 (San Antonio, 1997), 137–62.

4. Dwarf jewelers make them in a relief in the tomb of Mereruka, as cited by Alix Wilkinson, *Ancient Egyptian Jewellery* (London, 1971), 32.

5. Ibid., 66.

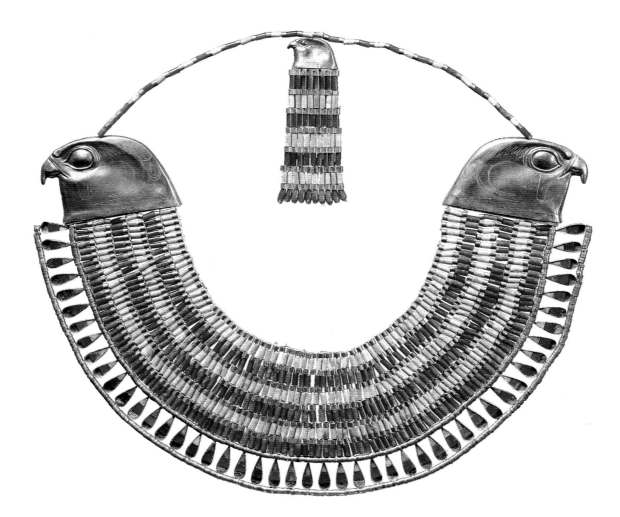

19 Falcon collar of Princess Neferuptah

Twelfth Dynasty, reign of Amenemhat III, 1831–1786 BCE; gold, carnelian, feldspar. Length 32 cm (12 ⁵⁄₈ in); width 37 cm (14 ⁹⁄₁₆ in). Hawara, Pyramid of Neferuptah, excavations of the Egyptian Antiquities Service, 1956. The Egyptian Museum, Cairo JE 90199

• This beautiful broad collar adorned the body of Princess Neferuptah of the Twelfth Dynasty (1985–1773 BCE). She was most probably the daughter of King Amenemhat III (1831–1786 BCE). The collar is composed of six alternate strings of tubular feldspar and carnelian beads separated by beads of gold. Droplet pendants inlaid with feldspar and carnelian border the lowest row of gold beads. Each terminal of the collar ends with a falcon's head of hammered gold. A third, smaller falcon head with similar design acts as a counterpoise over the back of the neck of the wearer to balance the heavy collar.

Collars and necklaces were very popular pieces of jewelry. The broad, or *wesekh*, collar was by far the most common personal ornament used in ancient Egypt. It was worn by deities, kings, queens, and common people. It was made from cylinders that are graded in size and strung vertically between semicircular terminals. The terminals are pierced along their flat side by as many holes as there are strings, which emerge united from a single hole in the center of the terminals, to be tied together to fasten the collar. The collar of the falcon is often found painted on coffins and in funerary contexts. There are examples of the falcon collar made out of faience, metal, and stone.

The lists of offerings painted on the friezes of the sarcophagi of the Middle Kingdom mention different types of broad collars, always called *wesekh*, meaning "wide." The one with the hawk shoulder pieces is called on the coffins *wesekh en bik,* "collar of the hawk." The counterpoise is called *mankhet,* meaning, perhaps, "that which lives." The broad collar was considered as an ornament as well as a protective element for the owner.

Nagib Farag and Zaky Iskander discovered the pyramid of Neferuptah and her unviolated tomb southwest of the Pyramid of Amenemhat III. A granite sarcophagus housed another one of wood, inside of which the mummy of Neferuptah was placed. At the bottom of the sarcophagus were many vessels, staves, scepters, a club, the breast panel from the mummy, collars, bracelets, kilts, and rings.

Fortunately, most of the parts composing this collar were found in their original places during the clearing of the contents of the sarcophagus. The pieces were strung together according to the order of the beads as they were found and by a comparative study of similar types of collars.
Fatma Ismail

20 Bracelet with gold couchant lions

Twelfth Dynasty, 1985–1773 BCE; gold, granite, lapis, carnelian, glass paste. Length 15 cm (5⅞ in); width 1 cm (⅜ in). Dahshur. The Egyptian Museum, Cairo CG 52840 (beads), CG 53137 (lions), CG 53149 (clasp)

• This bracelet consists of two strands of beads on which gold couchant lions have been threaded. The beads are made of gold, carnelian, lapis lazuli, granite, and glass paste. The clasps, fashioned in the shape of knots, are gold. While the exact positions of the beads, lions, and clasps were not recorded during their original excavation, several clues have aided their reconstruction. For instance, although these two gold lions were found with four others, they are the only two with two holes in their plinths (the others have only one), indicating that they were originally part of a double-stranded bracelet. In addition, the jewelry found at the nearby site of Lahun, dating to the same period as this bracelet and fashioned from similar components, were carefully recorded and patiently reassembled, providing excellent examples for the way this Dahshur bracelet might have originally looked. It is thanks to the Lahun jewelry finds that we can say that this bracelet most likely appears as it did when it was buried with its owner.

Jewelry made during the Middle Kingdom is some of the finest to survive from ancient Egypt. These bracelets are no exception. The combination of fine stones and gold accents is aesthetically pleasing, as well as a testament to the wealth of the owner. Found by Jacques de Morgan, who excavated royal burials at Dahshur at the end of the nineteenth century, this bracelet most likely belonged to a woman of the royal family.

The Egyptians attached symbolism to nearly every color and material; some of those symbols can be read in this bracelet. The red beads can mean life, power, and energy. The green ones, are most likely fashioned to imitate turquoise, fertility, and growth. The blue beads can evoke the protective night sky, and gold, the most precious of all materials for the Egyptians, represented both the sun and purity. Bedecking a mummy in these materials, or even simply placing them in a tomb, was thought to ensure a successful afterlife for their owner.

Symbolism was attached to lions as well. They were emblems of kingship from the earliest times of Egyptian history, representing the might and ferocity of the pharaoh. They were also viewed as magical guardians with apotropaic qualities. In addition, lions had solar affinities; pairs of lions shown back to back with a solar disk between them were representative of the eastern and western horizons, and were called "yesterday" and "tomorrow." Furthermore, lions are featured in underworld texts such as the Amduat, and can be seen in hours five (as sphinxes) and six (as the bull of roaring). The lions on this bracelet no doubt combine many of these aspects, evoking royalty, magical protection, solar notions, and underworld creatures.

Elizabeth A. Waraksa

1. The objects have Catalogue général (CG) numbers, but the associated volume was never published.

21 Gold-covered handle and base of a fan of Queen Ahhotep

Seventeenth Dynasty, reign of Kamose, 1555–1550 BCE; wood, gold. Height 41 cm (16⅛ in); width 16.5 cm (6½ in); depth 2.5 cm (1 in). Dira Abu el-Naga, Mariette excavations 1859. The Egyptian Museum, Cairo JE 4672 / CG 52705

• The flat semicircular piece at the top of this object has three staggered rows of holes that originally held the ostrich plumes of an impressive royal fan. Found among the tomb furnishings of Queen Ahhotep, this fan may have been buried with her simply because it was a necessary part of the household furniture of a woman of her rank. The size of the fan with its ostrich feathers (which would surely have been extant at the time of the burial) make it exceedingly unlikely that the fan was placed inside the queen's coffin as the original reports stated.

Made of cedar and covered with sheets of gold, both sides of the semicircular base are embossed with rather crude scenes showing King Kamose offering to the falcon-headed god, Khonsu, an important god of the Theban area, where Kamose's family originated. Khonsu is also a god associated with the moon. Moon divinities seem to have been especially popular with the royal family of the early New Kingdom (1550–1479 BCE), which favored personal names referring to moon gods like Iah and Djehuty (Thoth), for example, Ahmose, Ahhotep, Djehutymose (Thutmose), and Sit-Djehuty.

Kamose himself is identified both by his Horus name, written behind him in the rectangular frame surmounted by a falcon, called a *serekh*, and his throne name, Wadjkare, which is written in a cartouche next to his triangular bread offering. He is given the title "the good god" and on one side he is said to be "given life." He wears a simple kilt, with a corselet and a cap-shaped crown, perhaps a precursor of the blue battle crown. Kamose, who was probably a stepson of Queen Ahhotep and her husband's successor, had only a brief reign and may have died in battle. (This is one of two pieces in Ahhotep's burial furnishings that mentions Kamose; King Ahmose, Kamose's successor, is more frequently cited.)

The handle of the fan was a separate piece, attached to the fan base by a gold pin. Its top is a papyrus umbel, gilded only in its basal leaves and the tips on either side of the central umbel. Its "stem" is not the typical triangular stem of a papyrus, but a cylindrical shaft ringed with gold bands. This shaft widens a bit at the base. The upper part of the handle is similar to that of the mirror also found in Ahhotep's burial (see cat. 23).

In addition to its function as a part of Ahhotep's tomb furnishings, the fan may also have had funerary significance. Fans are often shown over the king, particularly when he is depicted as a sphinx. Such large fans also provided shade, and the Egyptian concept of a "shade" had the same association with the spirit of a dead person as occurs in our own culture. The papyrus of the handle can be a hieroglyph representing rejuvenation and rebirth, but may here simply allude to the papyrus marshes of the delta in the north of Egypt and the cool breezes that proverbially come from there. **Ann Macy Roth**

22 Two fly pendants of Queen Ahhotep

Eighteenth Dynasty, reign of Ahmose I, 1550–1525
BCE; gold and silver. Length 4.5 cm (1¾ in); width
3.8 cm (1½ in). Dira Abu el-Naga, Mariette excava-
tions 1859. The Egyptian Museum, Cairo JE 4725

• Two different necklaces decorated with flies
were found in the burial of Queen Ahhotep.
The larger and more impressive one (CG 52671)
consists of three large, somewhat stylized flies
on a gold chain. The two smaller flies represented
here were presumably also part of a necklace,
since there are horizontal holes drilled through
their heads through which the necklace would be
strung. They are even more stylized than their
larger counterparts. Their wings are of electrum,
that is, silver with a small admixture of gold; and
their heads are of gold, apparently folded onto
the wings, and slightly raised on the front side.
Some sketchy incised details represent the features
of the flies' heads.

 Fly necklaces such as the two worn by
Ahhotep were normally bestowed by the king in
recognition of military valor. It may be that
Ahhotep's flies were actually given to her by a
later king in recognition of the military service of
her husband, probably King Tao II (c. 1560 BCE),
whose mummy shows wounds consistent with
death in battle against the Hyksos, a Syro-Pales-
tinian people who had taken over the northern
part of Egypt. It is also possible, however, that
these flies honor her for her own service: a slightly
later queen, also named Ahhotep, was honored
in a stele erected by her son for her role in ruling
Egypt, presumably both during his minority and
while he was away from the capital leading his
army. The fly necklaces may represent the reward
for similar service by our Ahhotep. **Ann Macy Roth**

23 Mirror of Queen Ahhotep

Eighteenth Dynasty, reign of Ahmose I,
1550–1525 BCE; gold, bronze, and cedar. Height
32 cm (12 ⅝ in); width 14 cm (5½ in); depth
3.2 cm (1¼ in). Dira Abu el-Naga, Mariette
excavations 1859. The Egyptian Museum, Cairo
JE 4664 / CG 52664

• The mirror is often connected with both birth
and rebirth after death, and is particularly
associated with women. Mirrors are often shown
under the chairs of ladies in offering scenes.
Their connection with rebirth may relate to their
"creating," by reflection, another version of the
individual looking into them.

 The mirror of Queen Ahhotep is in
two parts. The mirror itself is simply a bronze
disk, with a pierced tang that allowed it to be
attached to the handle. The handle is very similar
to the handle of the ostrich-feather fan found
in the same burial (see cat. 21). At its top is a
papyrus umbel, through which a pin attaches the
handle to the tang of the mirror disk. The cedar
of the handle is only partially covered with gold:
at the base of the umbel, where outer leaves are
incised in the sheet gold; on the two tips, which
are connected by a narrow band of gold along the
upper edge of the papyrus umbel; and in a band

of four rings below the umbel's base. Unlike
the fan handle, however, the cedar shaft of the
handle seems to represent a papyrus stem.
Although it is round rather than triangular, the
basal leaves of the plant are incised on a gold
cup that covers the bottom of the handle. The
shape of the column, which flares out toward the
base but then narrows again to fit into the basal
leaves, is typical of papyrus columns, if not neces-
sarily of the plant itself.

 The fact that the papyrus plant is used
to write words like "green," "fresh," "young,"
and "rejuvenation" may explain why it was so
often represented in the handles of mirrors.
Ann Macy Roth

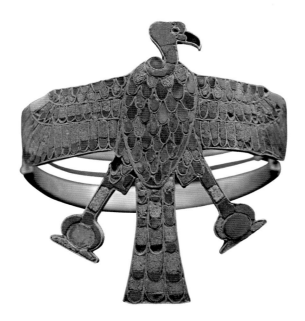

24 Vulture bracelet of Queen Ahhotep

Eighteenth Dynasty, reign of Ahmose I, 1550–1525 BCE; gold, inlaid with lapis lazuli, carnelian, and turquoise. Height 7 cm (2 ¾ in); width 7.5 cm (2 ¹⁵⁄₁₆ in); depth 7 cm (2 ¾ in). Dira Abu el-Naga, Mariette excavations 1859. The Egyptian Museum, Cairo JE 4679/CG 52068

• The vulture bracelet said to have been found on the body of Queen Ahhotep is a rigid ring made in two pieces and connected by two hinges, one of which opens with a removable pin. The front part of the bracelet consists of a vulture with feathers and other features detailed in red, dark blue, and turquoise enamel cloisonné. The head and talons are of lapis and the eye of red carnelian. The wings of the vulture are spread, stretching out in a curve that ends at the two hinges; its head, body, and tail are thus perpendicular to the bracelet. The head, tail, and talons, which may have been visible when the bracelet was worn, are also given some incised details on the gold inner face of the bracelet. In its talons, the vulture holds two *shen* hieroglyphs, loops of rope that represent eternity.

The vulture is the animal that represents Nekhbet, an Upper Egyptian goddess who is often shown as a protector of the king. Queens are especially associated with this vulture goddess, in that one of the most common form for the queens' crowns is a vulture clasping the top of the lady's head. However, in funerary context, Nekhbet may have had special meaning as a protector of the dead. Like the mortuary god Anubis, who is represented by a jackal, Nekhbet is associated with an animal that one would otherwise assume might threaten the safety of the dead, since cemeteries are often disturbed by vultures and jackals. By assigning those forms to divinities, the Egyptians turned these threats into a magical protection for the bodies of the dead. Vultures are often shown hovering protectively on the ceilings of tombs and temples.

The back part of the bracelet also shows an Upper Egyptian emblem — the blue lotus. Two lotus buds of turquoise cloisonné touch the hinges of the bracelet, with their stems curving back to join at a red carnelian disk. The design is framed by two rounded bands of gold striped with lapis, above and below the gold wires that represent the stems of the lotus buds. It would be tempting to connect these two Upper Egyptian motifs to the queen's political origins: her dynasty originated in Upper Egypt, from which they reunited the country, freeing the north from the rule of a Syro-Palestinian people, the Hyksos, by means of a war in which Ahhotep may have played a part. However, the vulture and lotus are far too common in jewelry designs to make such a speculation certain. **Ann Macy Roth**

25 Coffin lid of Queen Ahhotep

Eighteenth Dynasty, reign of Ahmose I, 1550–1525 BCE; gilded wood. Height 216 cm (85 ¹⁄₁₆ in); width 70 cm (27 ⁹⁄₁₆ in); depth 26 cm (10 ¼ in). Dira Abu el-Naga, Mariette excavations 1859. The Egyptian Museum, Cairo CG 28501

• In February 1859 the excavations of Auguste Mariette in Dira Abu el-Naga, near ancient Thebes, turned up a large gilded coffin dating to the early Eighteenth Dynasty. The coffin is often said to have been loose in the fill, but both its depth and the fact that it was accompanied by four jars containing embalmed organic material suggest that the workmen had discovered an intact burial. The objects found there, made of gold and other rare materials, and bearing the names of two kings, Kamose and Ahmose, would tend to support this idea. The circumstances are obscure because the excavation was unsupervised, and the finds were delivered to the local governor, who discarded the body after unwrapping it.

The owner of the coffin was a queen named Ahhotep. She was almost certainly not, as is often stated, the famous Queen Ahhotep who was the mother of Ahmose, the founder of the Eighteenth Dynasty. The coffin of the more famous queen was found in the Deir el-Bahari cache, and was later, both in style and in the form of its inscriptions. The Dira Abu el-Naga coffin does not bear the all important title "king's mother," though the owner was a king's wife, probably the wife of Tao II and the mother of a little prince who died young and whose statue is in the

Louvre. Like the other monuments of this queen, her coffin and all of the burial equipment found with it use a form of the "Ah," or moon sign, that is not used after the twenty-second regnal year of Ahmose.

The coffin depicts the queen's face and neck, as well as a stylized wig with a royal uraeus at the brow. Her wig is of the Hathoric type popular in the preceding Middle Kingdom period (2055–1650 BCE), ending in two curls that wrap around a blue spool or ball. The queen's almond-shaped eyes are inlaid, the whites with Egyptian alabaster (calcite) and the irises with a black stone, possibly obsidian. Her eyebrows and cosmetic lines are indicated in blue paint. The shape of her body and feet are indicated only generally. With the exception of her face, the entire coffin is covered with a variety of different patterns of feathers and is known as a *rishi*, or feathered, coffin. This type was developed in the Seventeenth Dynasty (1580–1550 BCE), when it was common, but was restricted to royalty from the Eighteenth Dynasty. The feathers may represent the wings of a goddess wrapped around the body of the deceased for protection.

The pectoral represented on the chest of the coffin shows a vulture and a cobra, the two goddesses who are associated with the protection of a king. The cobra and vulture pectoral is common on coffins of non-kings as well as kings, because these animals are also associated with the god Osiris, a dead king who was resurrected in the *duat*, the realm of the gods. A form of Osiris that combines him with two older mortuary gods, Ptah and Sokar, is mentioned in the offering formula that runs down the front of the coffin:

May the king give an offering to Ptah-Sokar-Osiris, the lord of Buto and the lord of Abydos, and Hathor, the chief lady of Aphroditopolis[?], that they may give invocation offerings of bread, beer, meat, poultry and every pure thing on which a god lives, all the good products of the Beloved Land [Egypt] and everything goes forth from the altar of Osiris to the *ka* of the great royal wife, she who is joined with the white crown, Ahhotep, may she live forever.

Ann Macy Roth

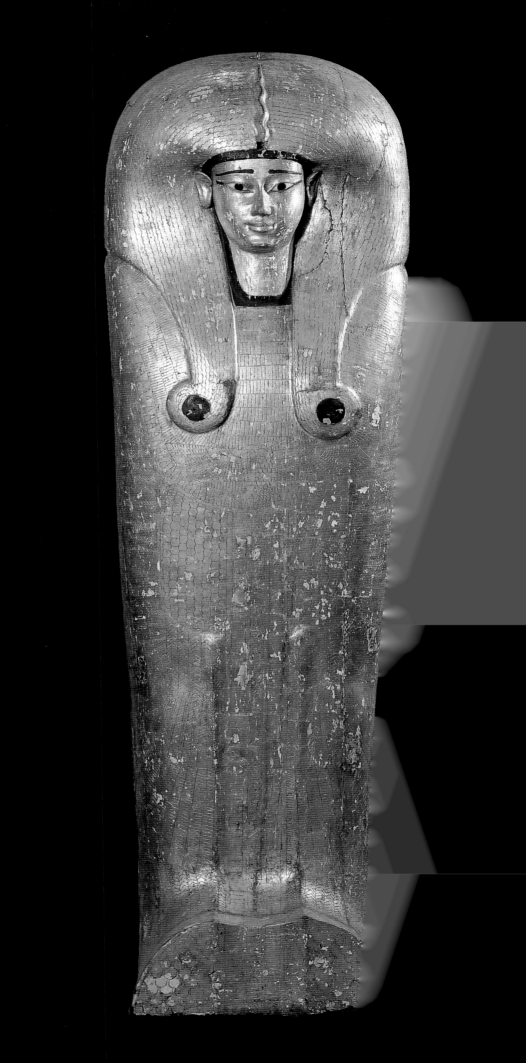

26 Ankh

Eighteenth Dynasty, reign of Amenhotep II, c. 1427–1400 BCE; painted wood. Height 53 cm (20⅞ in); width 26 cm (10¼ in) depth 3 cm (1³⁄₁₆ in); Tomb of Amenhotep II, Thebes. The Egyptian Museum, Cairo JE 32547

• This exquisitely crafted wooden figure of an ankh, the Egyptian symbol of life, was among the objects excavated by Victor Loret in 1898–99 at the tomb of King Amenhotep II in the Valley of the Kings. About forty objects of a similar kind were discovered there. Also found in the same tomb were numerous *djed* pillars of wood painted in various colors (see cat. 27). Much of the original blue pigment has been erased. This object, crafted in two sections, resembles the numerous smaller ankh-signs of faience and other materials that were among the most popular of Egyptian amulets. It is difficult to be sure precisely what function, if any, these figures had beyond their protective magical effect. They were probably custom-made for the king in his tomb to guarantee new life for him in the beyond.

The ankh is one of the most potent symbols represented in Egyptian art. It frequently forms part of decorative motifs. Ankh signs were commonly carried by deities in human or partly human form. Gods are seen placing them in front of the king's face to symbolize the breath of life. In the art of Akhenaten, the sun disk has arms that end in ankh signs. The significance of the ankh is often misunderstood as applying only to the mundane world, whereas words associated with ankh refer also to life in the netherworld. Hence the dead are called *ankhu*, and *neb-ankh* (possessor of life) is a common term for the sarcophagus. What the sign itself represents is disputed. Sir Alan Gardiner thought it showed a sandal strap, but if so, the symbolism is obscure, and the idea has found little favor. Wolfhart Westendorf felt it was associated with the *tyet* emblem or the "knot of Isis," both in his view being ties for ceremonial girdles. Winfried Barta connected the ankh with the royal cartouche in which the king's name was inscribed. It seems to be an evolved form of, or otherwise associated with, the Egyptian glyph for magical protection, *sa*. The presence of a design resembling a pubic triangle on one ankh of the New Kingdom (1550–1069 BCE) lends support to the idea that the sign may be a specifically sexual symbol. Perhaps, indeed, it combines female and male elements — a kind of abbreviated version of the Hindu lingam-yoni. It is significant that ankh was the word for "mirror" from at least the Middle Kingdom (2055–1650 BCE) onward. Mirrors shaped like ankh signs are not uncommon. Life and death mirror each other, and mirrors are employed in many cultures by shamans for purposes of divination. In any case, the symbolism is multi-layered. The ankh survived into the Christian era and was used by the Copts on their funerary stelae. **Terence DuQuesne**

27 *Djed* pillar

Eighteenth Dynasty, reign of Amenhotep II,
1427–1400 BCE; painted wood. Height 54 cm
(21¼ in); width 24 cm (9⁷⁄₁₆ in); depth 2.5 cm (1 in).
Tomb of Amenhotep II, Thebes. The Egyptian
Museum, Cairo JE 32386.

• Like the blue-painted wooden ankh (cat. 26),
this figure of a *djed* pillar forms part of the Loret
excavations of the tomb of Amenhotep II. Many
similar objects were excavated there. The wood is
painted in various colors, the crosspieces ren-
dered in yellow and the bands between them in
(from top) blue, green, and red. The lower part
of the *djed* consists of thick bands of blue, yellow,
green, blue, red, green, and blue, between each
of which is a narrower band of yellow. As in the
case of the ankh from Amenhotep II's tomb, the
workmanship of this object is very fine.

 The *djed* pillar is one of the most impor-
tant symbols of Osiris, lord of the netherworld,
protector of the justified soul, and judge of the
dead. Osiris is also a deity of plant fertility, and
the pillar may be a schematic representation of
a sacred tree, though the fact that early examples
are made of ivory militates against this theory.
Alternatively it could represent a pole to which
sheaves of grain were attached. In any case, it is a
very ancient sacred object. A ritual of erecting the
djed pillar was carried out by the pharaoh himself,
no doubt to ensure the continuing fertility of
the fields and to guarantee that the god himself,
as corn king, was periodically revived. A further
purpose in raising the *djed* was to repel the god
Seth, enemy of Osiris and incarnation of the
chaos factor. The *djed* emblem was associated not
only with Osiris but also with the Memphite god
Ptah, and probably with Sokar. These connections
would suggest an origin in Memphis, capital of
Egypt during the Old Kingdom (2686–2125 BCE)
and a perennial sacred center. Ptah, Sokar, and
Osiris were merged into a single composite deity
in the course of the New Kingdom (1550–1069
BCE). Perhaps because of the resemblance of the
pillar to a spinal column, it was represented on
the bottom of New Kingdom coffins in line with
the actual location of the backbone. The symbol-
ism of the *djed* is indicated by the meaning of the
word in Egyptian: "firmness, capacity to endure."
Terence DuQuesne

28 Thutmose III

Eighteenth Dynasty, reign of Thutmose III,
1479–1425 BCE; wood covered with bitumen.
Height 79 cm (31⅛ in); width 23 cm (9¹⁄₁₆ in);
depth 30 cm (11¹³⁄₁₆ in). Tomb of Thutmose III,
Thebes. The Egyptian Museum, Cairo CG 24901

• The plundered tomb of Thutmose III, one of
Egypt's greatest military leaders, contained only
a few objects when reopened in 1898. Among
the pieces still remaining were an alabaster vase
belonging to his wife, a model boat, faience
plaques, and this statue of the king. Pharaohs
placed their stone images, whose purpose was
to receive offerings for eternity, at temple sites,
as opposed to in their burials, where wooden
statues functioned adequately. Here, Thutmose
holds a typical stately pose. His left leg strides
forward, hinting at the Egyptian king's capacity
for action. The left arm is bent, grasping a cane
or staff that is now missing, while the right arm
remains at his side, the hand curled around what
probably was a scepter. Both the arms are attached
as separate pieces. His youthful, idealized body
is wrapped in a kilt, the front of which juts out
to form a flat triangular apron. The statue is
crowned by a *nemes* headdress, originally with a
uraeus at the brow, that falls over the king's chest
in two lappets in front, and hangs as one tail down
his back. Inlays would have formed pharaoh's
eyes, but they, like the king's beard and feet, are
now missing. The entire statue was coated with
bitumen and would have stood on a base.

 Thutmose III was the son of the pharaoh
Thutmose II by Isis, a secondary wife, and inher-
ited the throne as a young boy. His stepmother,
Hatshepsut, served as his co-regent at first, but
eventually took the title of king for herself. When
she died in her twentieth or twenty-first year of
rule, Thutmose III demonstrated his military
prowess by focusing a series of highly successful
campaigns in the Levant, Palestine, and southern
Syria. On his eighth campaign, he and the Egyp-
tian army crossed the Euphrates River, erecting a

stela to mark their unchecked advances through the region. Back in Egypt, a great pharaoh needed to be a great builder, and Thutmose promoted his name by constructions at sites including Nubia, Elephantine, Kom Ombo, Edfu, Thebes, Hermopolis, and Heliopolis. In the rare evidence relating to the personal side of the king, we discover that he held a great interest in botany — a room in his Festival Temple at the Karnak Temple precinct is covered with carved representations of exotic plants and animals that he brought back from his campaigns. Thutmose apparently possessed a wide range of talents, as his proficiency in writing led Rekhmire, who served as vizier under Thutmose III, to equate him with the divinities Seshat and Thoth.

After his fifty-four years of sole rulership, Thutmose was laid to rest in tomb 34, hewn high into a cliff in the Valley of the Kings. The tomb consists of a number of rooms and corridors, mostly undecorated, which lead to the king's burial chamber. The shape of this oval room, where the king's mummy was enclosed in a quartzite sarcophagus, mimics the circular form of the underworld as the Egyptians understood it. Painted on the walls were the twelve hours of the religious book of the Amduat, a text mapping out the pharaoh's journey through the next world. The cursive writings and almost sketchy figures, drawn in red and black ink, were imbued with the power and magic to assist the king in his quest for rebirth with the rising of the sun. **Elaine Sullivan**

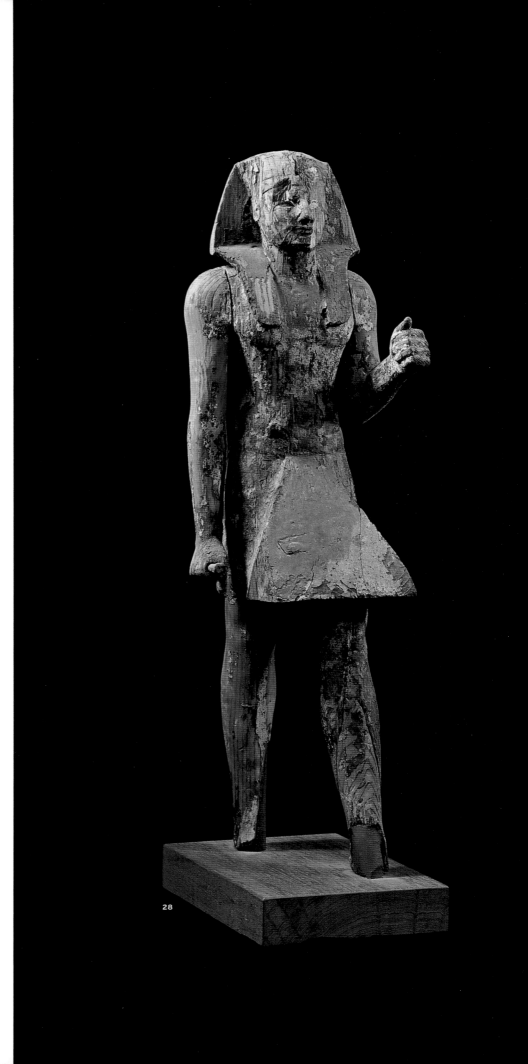

28

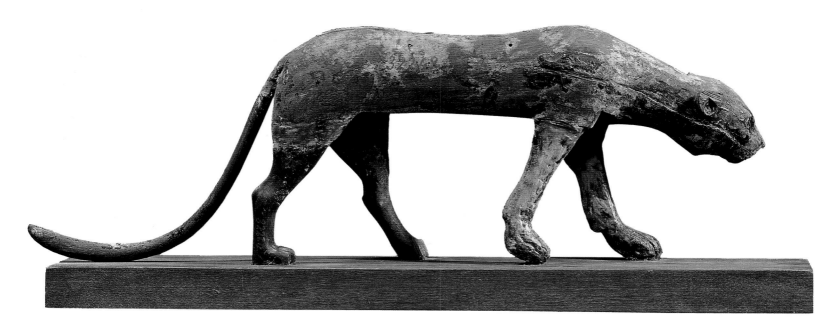

29 Leopard of Thutmose III

Eighteenth Dynasty, reign of Thutmose III, 1479–1425 BCE; wood covered with bitumen. Height 25 cm (9 13/16 in); length 75 cm (29½ in); depth 12 cm (4¾ in). Thebes, Valley of the Kings, tomb of Thutmose III KV 34, excavations of Loret, 1898. The Egyptian Museum, Cairo JE 32248/CG 24912

• The leopard strides stealthily forward, left paws advanced, neck craning ahead, head lowered; its long tail trails gracefully behind, curving up at the tip. The leopard's skin is not spotted, but black. Black was the color of the fertile Nile silt and thus held the promise of resurrection, and bitumen was liberally slathered over all sorts of funerary equipment from coffins to statuary both as a preservative and for its symbolic value. On the animal's back are two rectangular mortises for the insertion of tenons. The leopard, therefore, did not stand alone, but was part of a group composition.

This is one of two striding leopards from the tomb of Thutmose III. Similar animals were found in the tombs of Amenhotep II, Thutmose IV, Tutankhamen, and Horemheb. As usual the pair from Tutankhamen's tomb are the most instruc-

tive, being intact. Each leopard carried on its back a striding figure of the king of gilded wood. Other statuettes show the king in a papyrus skiff, in the acting of harpooning an unseen victim. Wrapped in linen shawls and stored in black wooden shrines, these groups appear to have been standard items of New Kingdom (1550–1069 BCE) royal funerary equipment. The same statuettes appear painted on the walls of a chamber in the tomb of Seti II.

Egyptologist Hartwig Altenmüller relates the two groupings to two standard themes of tomb decoration: the hunt in the papyrus marshes and the hunt in the desert.[1] The statuettes of the king harpooning are conceptually located in the Delta marshes; his unseen but implicit enemy is the hippopotamus. The statuettes of the king on a leopard, a wild desert animal, refer to the hunt in the desert. This leopard is not the king's adversary, but rather his hunting leopard. Such a hunting leopard appears in the desert hunting scene in the Fourth Dynasty (2613–2494 BCE) tomb of Nefermaat at Maidum.

Looked at in this way, it is not a statuette of a king on a leopard, but of a king and a leopard, the two working as a pair, the leopard at the king's side (and on the king's side), in the battle between good and evil. For these scenes are not merely (or even mainly) the depiction of a noble pastime. Rather, they embody through ritual a cosmic struggle of order against chaos, Horus against Seth, the king against his enemies. Both marsh and desert were perceived as battle zones, each a no-man's land between the world of the

living and the world of the dead. The passage through these unknown regions is full of obstacles, manifested in the wild and dangerous animals that need to be overcome. The leopard lived on the desert fringe, between two worlds; a liminal being, it was a fitting escort for the deceased.

The leopard was also an ancient sky goddess, straddling the nocturnal horizon, her pelt studded with stars. A leopard or cheetah skin was part of the costume of the *sem*-priest, who performed the opening of the mouth ceremony, revivifying the deceased and his images. The leopard's spots are sometimes rendered as stars, as on the statue of Anen, chief of sightings (high priest of Ra), *sem*-priest, and second prophet of Amun in Thebes under Amenhotep III (1390–1352 BCE).

Yet another interpretation, bound up with the concept of the leopard as the sky goddess, ties it in with the solar circuit, the king's vehicle across the heavens (like the solar boat), protecting him along the way and insuring his safe journey. All these interpretations are interrelated. There will probably always remain more to this statuette than meets the eye. **Lawrence M. Berman**

1. Hartwig Altenmüller, "Papyrusdickicht und Wüste: Überlegungen zu zwei Statuenensembles des Tutanchamun," *Mitteilungen des Deutschen Archäologischen Instituts, Abteilung Kairo* 47 (1991): 11–19.

30 Amuletic plaque of Maat

Twenty-first Dynasty, c. 1000 BCE; gold. Height
10.5 cm (4⅛ in); width 26 cm (10¼ in); depth
5 cm (1¹⁵⁄₁₆ in). Sakkara. The Egyptian Museum,
Cairo JE 34526

• This finely detailed amulet represents a kneel-
ing figure on a small base, with face and body
turning toward the viewer's right. This graceful
figure of a goddess is shown wearing a tight-
fitting dress, armlets, bracelets, and a collar. She
has a long wig of straight hair, and a solar disk
surmounts her head. Her arms are wide open,
and she holds the feather sign in each hand. Out-
stretched under her arms are two wings. This
rather heavy plaque is skillfully executed, render-
ing every detail of the body, wings, and dress.
There are many small holes pierced all around its
fine edges.

When this plaque was found, it was cov-
ered by bitumen and accompanied by gold images
of the Four Sons of Horus, indicating that it was
stitched onto a mummy's bandages, or it may
have been part of a beaded mummy net. The
mummy net of Hekaemsaef (cat. 53) holds a nearly
identical plaque. Each hole is incorporated into
a thread of the beaded net. The mummy net
still has the figurines of the Four Sons of Horus,
who were responsible for protecting the internal
organs of the body.

The identity of this goddess is slightly
problematic, especially since many ancient
Egyptian goddesses are represented with the sun
disk, including Hathor, Isis, Bastet, Nut, and
Maat. Fortunately the inscription on the mummy
net clearly shows that the deity there is Nut,
the sky goddess. Nut is usually represented on
coffins, spreading her wings to protect the body
of the deceased.

That gesture is also associated with Isis,
the mother goddess and one of the four protectress
deities for the mummy. However, the presence
of the two feathers in this plaque indicates that
the goddess here is Maat. Maat was one of the
daughters of the sun god and represents the

divine order, truth, justice, and the balance of
the universe. Representations of Maat are attested
as early as the Old Kingdom (2686–2125 BCE).
She increasingly acquired distinctive funerary
associations. Maat (or her dual form, Maaty) is
usually pictured in the Amduat leading the solar
barque of her father, Re.

There is sometimes confusion between
amulets used in daily life and amulets specially
made for use in the afterlife and for helping
the deceased in the difficult journey to the other
world. Obviously this plaque is designed for
funerary use. Maat is a visual reminder of the
judgment scene, wherein the heart of the
deceased is weighed against the small figure of
Maat to evaluate his or her worthiness.

Funerary texts usually indicated the
exact placement of an amulet on a mummy. Since
the New Kingdom, the exact positioning was
important. According to the archaeologist Sir
Flinders Petrie, and in conjunction with the
mummy net of Hekaemsaef, a plaque of this type
was to be placed below the breast of the mummy.
Fatma Ismail

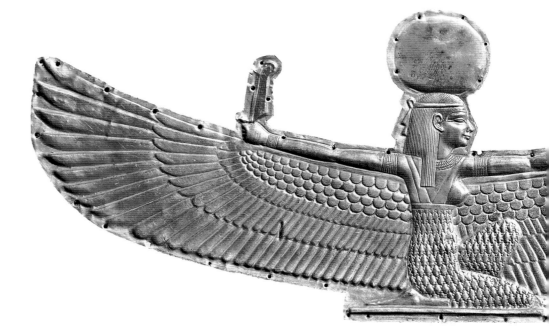

31 Funerary sandals

Late New Kingdom, 1200–1069 BCE; gold. Length
21 cm (8 ¼ in); 5 cm (1 ¹⁵⁄₁₆ in); width 7 cm (2 ¾ in);
other sandal: length 21 cm; width 7 cm (6 ½ in).
The Egyptian Museum, Cairo JE 35422 1 and 2

· When the royal mummies were prepared for
burial, they were fitted with gold protections for
their fingers, toes, and faces. In addition, they
were clothed and their feet were placed in gold
sandals. Funerary sandals were not intended to
be usable in real life, but rather, were made of
sheet gold that rapidly formed itself to the shape
of the deceased's feet. The mummy of Tutankh-
amun (1336–1327 BCE) wore thin sheet-gold
sandals similar to these but with preserved straps.
Betsy M. Bryan

32 Pendant in the form of a Hathoric head

Twenty-second Dynasty, reign of Osorkon II, 874–850 BCE; gold and lapis lazuli. Height 5.1 cm (2 in). Mit Rahina (Memphis). The Egyptian Museum, Cairo JE 86780

• This pendant, in the form of the head of the goddess Hathor, was found on the mummy of the high priest and king's son Prince Sheshonk. Hathor was an important goddess worshiped in three forms: as a cow, as a woman wearing a headdress consisting of a wig, horns, and sun disk, and as a woman with the ears of a cow. This pendant, depicting the goddess in the third form, is made of lapis lazuli, a metamorphosed form of limestone rich in the blue mineral lazurite. Lapis lazuli was highly valued by the ancient Egyptians, who believed that its dark blue color imitated that of the heavens. It was widely used in jewelry through the Late Period (664–332 BCE), when it was particularly popular for amulets. In order to distinguish it from faience or glass imitations, the Egyptians often referred to it as "true," *khesbed*. Since lapis lazuli does not occur naturally in Egypt, it had to be imported either directly, from Afghanistan, or indirectly, as tribute or trade goods from the Near East.

Gold, also highly valued by the ancient Egyptians and referred to as "the flesh of the gods," is used here as inlay to outline Hathor's naturally shaped eyes with their extended cosmetic lines and for her long eyebrows and also to highlight her hair. Her heart-shaped face has a small but broad nose; her mouth is small with relatively full lips. The goddess wears a crown, representing the sky. Hathor is the goddess of love and the embodiment of beauty: "mistress of joy," "mistress of music," and "mistress of love" are her epithets. As the mistress of dance and drunkenness, she provides ecstasy and intoxication, thus breaking the barrier between man and god. In her vengeful aspect, Hathor sometimes also took the leonine form of the goddess Sakhmet and was regarded as one of the "eyes" of the sun god Re. She was also described as "lady of the sky," and played the role of the daughter of Re, which was emphasized in the temple of Horus at Edfu, a falcon god associated with the heavens. The literal meaning of Hathor's name was "house of Horus," and the hieroglyphs for her name were written in the form of a falcon contained within a representation of a rectangular building. The ruling king was identified with Horus, and, in turn, Hathor was regarded as the divine mother of each reigning king. "Son of Hathor" was one of the royal titles.

In her funerary aspect, particularly at Thebes, Hathor was known as "lady of the West" or "lady of the western mountain." It was believed that each evening she received the setting sun, which she protected until morning. This is why, in this piece, she is depicted wearing a crown representing the sky. In the Amduat, she is, therefore, seen during several hours of the night, guiding and protecting the sun god, during his journey in the netherworld, until he is reborn in the morning. The dying desired to be "in the following of Hathor" so that they would be similarly protected in the netherworld. This belief made pendants of Hathor excellent amulets to be worn by the deceased in the tomb.

This pendant was found in Memphis, an important center of Hathor worship, where she was described as "lady of the sycamore." However, since the Old Kingdom (2686–2125 BCE), her principal cult center was in the Upper Egyptian town of Dendera. **Yasmin El Shazly**

33 Sistrum

Ptolemaic Period, 332–30 BCE; gilded wood.
Height 16 cm (6⁵⁄₁₆ in); width 4.5 cm (1³⁄₄ in);
depth 1.8 cm (¹¹⁄₁₆ in). Provenance unknown.
The Egyptian Museum, Cairo JE 67887

• This *sistrum* (rattle) is a particularly fine example
of late Egyptian art. It is unusual in being very
small. Whether it was intended to be used is
unclear: this object has all the usual features of
larger examples. It could have been held and
shaken by a woman or even a child. The fact that
it is made of gold is not accidental: the *sistrum*
was particularly sacred to the goddess Hathor,
and gold was a mineral closely associated with
her, as her designation "the golden lady" testifies.
The head of Hathor herself, shown full face and
with a characteristic wig with curved ends, is
seen in high relief on the front of the object. Rep-
resentation of the face of the goddess Hathor is
a conventional feature of Egyptian *sistra*.

Shaking of the *sistrum* formed an impor-
tant element in ancient Egyptian ritual. It is
thought that the rattle still used in Coptic liturgi-
cal music and a similar Ethiopian instrument are
derived from the Egyptian prototype. The *sistrum*
was used by priests and priestesses as well as by
musicians and singers, and its use probably origi-
nated in the cult of Hathor. The strange sound
that issues when a *sistrum* is shaken was no
doubt intended to induce an altered state of con-
sciousness in ritual participants, much as the
bull-roarer does in African and other traditional
societies. The importance attached to the *sistrum*
is indicated by the fact that certain *sistra* found in
the Ptolemaic temple of Hathor at Dendera were
regarded as themselves being manifestations of
the goddess. In the New Kingdom (1550–1069
BCE), the priestesses known as "divine wives of
Amun," as well as other female celebrants, were
often shown wielding the instrument. Among
other rites in which the *sistrum* figured, the New
Year festival for propitiating the warlike goddess
Sakhmet is notable. In the Greco-Roman Period,
the *sistrum* became a cult object of the goddess
Isis. **Terence DuQuesne**

34 Nine gold gods

New Kingdom to Ptolemaic Period, 1550–30 BCE;
gold. Heights: Cobra with sun: 2.8 cm (1⅛ in);
Bes: 3.2 cm (1¼ in); Ptah: 3.4 cm (1⁵⁄₁₆ in); Sobek:
3.8 cm (1½ in); Isis: 6 cm (2³⁄₈ in); Hathor: 4.5 cm
(1³⁄₄ in); Amun: 3.7 cm (1⁷⁄₁₆ in); Ptah 2: 3.4 cm
(1⁵⁄₁₆ in); Patek: 3.4 cm (1⁵⁄₁₆ in). The Egyptian
Museum, Cairo JE 5290; CG 38715; JE 28129/
CG 38463; JE 28130/CG 38687; JE 22075;
JE 22076/CG 38876; JE 38387; JE 17364/
CG 38464; JE 46106

• These tiny gold figurines each represent a god
of the Egyptian pantheon. They are from left
to right: A uraeus or cobra, Bes, Ptah, Sobek,
Isis, Hathor, Amun, Ptah, and Patek. The cobra
was a protective symbol used to represent many
Egyptian goddesses and was often associated
with solar deities, hence the sun disk on the head
of this tiny cobra. Cobras are often seen on kings'
headdresses but were also among the creatures
who inhabit the underworld. They were thought
to spit fire to protect the deceased from harm
and are depicted in the Amduat as doing just that.

Bes was a god in the form of a dwarf with
a lion's head, and he often wears a crown of tall
feathers. This statuette of Bes is in fact an amulet
that could be worn around the neck, because it
has a suspension loop on its back. A protector
of expectant mothers, children, and sleepers, Bes
is a very common figure for small amulets and
figurines.

Both figurines of Ptah show him in his
usual form: wearing a tight skullcap, a straight
bead, and a large collar with a counterpoise hang-
ing behind his neck. His body draped in a cloak,
Ptah's hands emerge from it to hold a scepter
with the symbols ankh, *was,* and *djed*—life,
stability, and dominion. Regarded as the patron
deity of arts and crafts, Ptah is also mentioned
in Old Kingdom Pyramid texts as a provider of
food for the deceased.

Sobek, here shown with a human body
and crocodile head, was associated with the Nile's
annual flood and the fertility of the land. From
the Middle Kingdom on, Sobek was syncretized
with the sun god Re and took on the essence of
a creator god. Because Sobek is shown here with
a solar disk and uraeus on his head, he is most
likely being represented in that capacity.

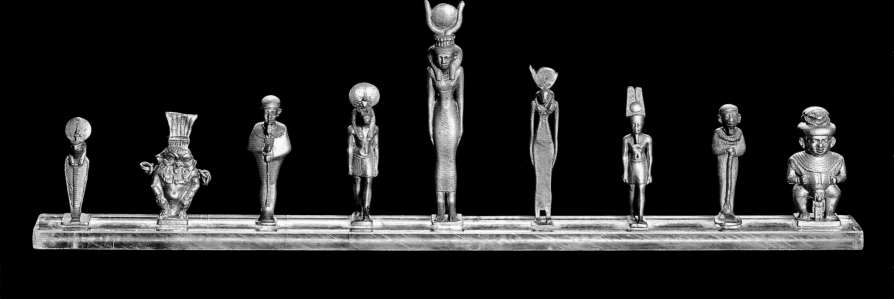

The goddess Isis appears frequently in myths and rites associated with death and rebirth. She is shown here as a woman with cow horns and a sun disk on her head, iconography she shares with the goddess Hathor. Isis was believed to aid in the purification and mummification of the dead and also functioned as a mourner and a protectress.

Hathor, a goddess of love, music, and dancing, is shown here looking remarkably similar to the goddess Isis, owing to the fact that the two were often shown as women with cow horn and sun-disk headdresses. in the Amduat, Hathor, a maternal figure, was regarded as the deceased's guide and appears frequently in illustrations of the underworld journey.

Amun, whose name means "the hidden one," was a primeval creator deity. Considered the father of the gods and of the pharaohs, he was called "king of the gods" in the New Kingdom. Here Amun is depicted as striding forward wearing his usual crown of double plumes.

Patek is a god in the form of a dwarf. This small god is a typical representation of Patek: a naked achondroplastic figure with short, bent limbs, clenched fists, a long trunk, and a large, flat-topped head. The sun disk on the god's head elucidates the connection between dwarfs and the solar notions of regeneration, rebirth, and fertility. Most images of Patek are small figurines or amulets and were used by both the living and the dead as protective magical objects.

Gold was as precious a material in ancient Egypt as it is now. However, it was valued not as much for its rarity, for it was readily mined in Egypt and Nubia, as for its significance. Its color and brilliance were reminiscent of the sun, and because it does not rust or tarnish, gold came to represent the purity and everlasting nature of the

gods themselves. Gold was even called "the flesh of the gods," thus making it a perfect material for the fashioning of amulets and figurines like the nine shown here.

Both the extraction and the working of gold were enterprises controlled by the state. This enabled pharaohs to equip their tombs with gold masks, jewelry, statuary, and other objects for eternity, all symbolic of their wealth, power, and quest for immortality. It is likely that these nine gold gods were once part of royal burial assemblages, since their quality is high and their workmanship excellent. Despite their small size, the many individual traits that help us to identify them have been rendered in careful detail, a testament to the skill of Egyptian craftsmen and their familiarity with this highly valued metal.

Elizabeth A. Waraksa

35 *Ushebti* of Yuya

Eighteenth Dynasty, reign of Amenhotep III, 1390–1352 BCE; painted wood. Height 25 cm (9¹³⁄₁₆ in); width 8.5 cm (3³⁄₈ in); depth 6 cm (2³⁄₈ in). Tomb of Yuya and Tuya KV 46, Valley of the Kings. The Egyptian Museum, Cairo JE 95371

• This *ushebti* (funerary figure) of Yuya, the father of Queen Tiye and father-in-law of King Amenhotep III, was found in the tomb he shared with wife, Tuya. The tomb contained a total of twenty *ushebti*s for the royal couple, of which seventeen are in the Egyptian Museum, Cairo, and three are in the Metropolitan Museum of Art.

*Ushebti*s (also spelled "shabti" and "shawabti") were placed in the tomb to perform any labor that was assigned to the deceased in the afterlife. They are magical figures meant to be activated by the spell from the Book of the Dead written on them.

The images of Yuya and Tuya bear the characteristic features of Amenhotep III: long, narrow almond-shaped eyes, a somewhat broad nose, and a generous mouth. The face is round and fleshy, accentuating the youthful appearance. This *ushebti* displays the classical mummy form and wears a long headdress of alternating blue and gold stripes, with bands at the ends. A broad collar hangs in several rows around the neck, and the crossed arms are suggested within the mummy shroud. Only the hands are sculpted as if protruding from the linens, and these, together with the face, collar, and headdress, are gilded.

In the late Eighteenth Dynasty not all *ushebti*s held agricultural equipment, as would be the case slightly later. Yuya's figurines had separately supplied hoes, adzes, and yokes (cats. 36, 37).

The text of the *ushebti* (here called *shabti*, the most common writing during the Eighteenth Dynasty[1]), consists of seven incised lines of hieroglyphic inscription, written horizontally around the body. The hieroglyphs are incised in the wood and filled with blue pigment. A shortened form of the so-called Amenhotep III version of chapter six of the Book of the Dead appears.

Illumination of Osiris, Yuya, he says: O *shabti*, as to an assignment of Osiris Yuya, for any works which are wont to be done in the god's land as a man at his duty, indeed, or an obstacle implanted for [me], in order to plant the field, in order to irrigate the lands, to move the sand from the east to west, if one assigns you work, at any time daily [say] "Me, look at me."

Adel Mahmoud

1. For the *shabti* formulae, see Lawrence M. Berman, "Funerary Equipment," in Arielle P. Kozloff and Betsy M. Bryan, *Egypt's Dazzling Sun: Amenhotep III and His World* (Cleveland, 1992), Chapt. 10.

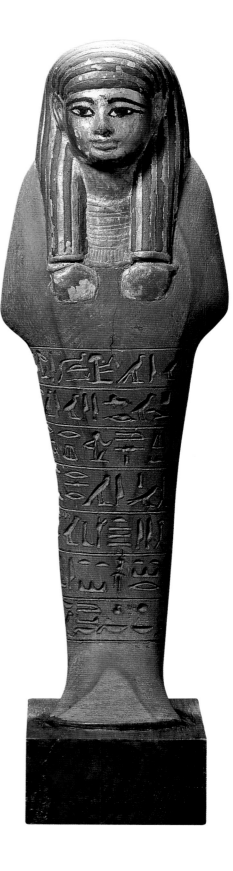

119

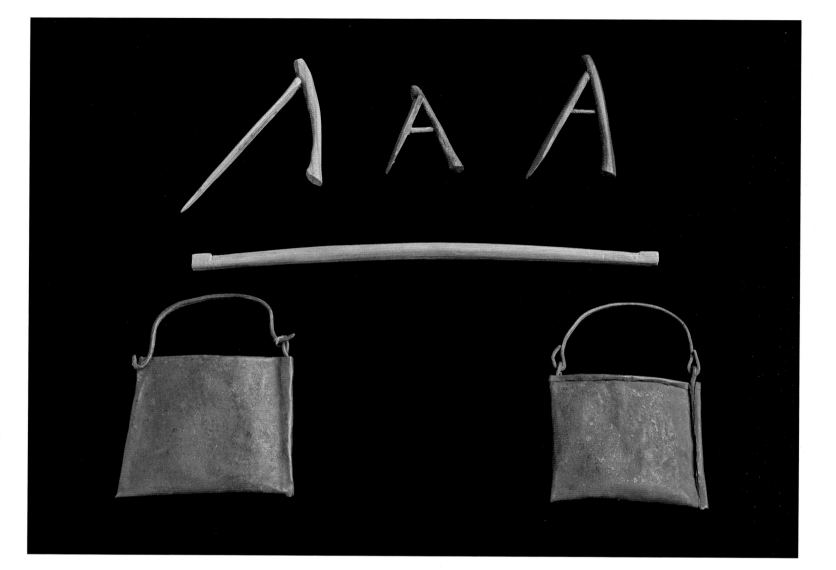

36 and 37 Model tools
for *ushebti*

36 Model hoes; wood. Hoe 1: length 7.5 cm (2¹⁵⁄₁₆ in); width 4 cm (1⁹⁄₁₆ in). Hoe 2: length 3.7cm (1⁷⁄₁₆ in); width 3 cm (1³⁄₁₆ in). Adze: length 5.5 cm (2³⁄₁₆ in); width 3.5 cm (1³⁄₈ in). Tomb of Yuya and Tuya KV 46; Valley of the Kings. The Egyptian Museum, Cairo CG 51145/CG 51155/CG 51156

37 Model bags and yoke; wood and bronze. Yoke: length 16 cm (6⁵⁄₁₆ in); depth 0.6 cm (¼ in). Bag 1: height 6 cm (2³⁄₈ in); width 7.5 cm (2¹⁵⁄₁₆ in); depth 1.3 cm (½ in). Bag 2: height 5.5 cm (2³⁄₁₆ in); width 7 cm (2³⁄₄ in); depth 1.3 cm (½ in). Tomb of Yuya and Tuya (KV 46; Valley of the Kings. The Egyptian Museum, Cairo CG 51134

Eighteenth Dynasty, reign of Amenhotep III, 1390–1352 BCE; Tomb of Yuya and Tuya (KV 46); Valley of the Kings. The Egyptian Museum, Cairo

• Yuya was priest of Min, and his wife Tuya was the lady of the harem of the god Min. Their daughter, Tiye, became wife to Amenhotep III, and Yuya moved to the court to take a higher position. Yuya and Tuya's tomb contained a large number of objects made in the court workshops as well as extremely fine *ushebti*s and equipment for them, including twenty-five yokes, twelve adzes, and six bags. Chapter 6 of the Book of the Dead describes the duties of *ushebti*s: to move the sand from east to west, to irrigate the riparian lands, to fill the canals with water, and to take hoes, yokes, and baskets, as every child does for his master. Since the *ushebti*s of Yuya and Tuya were not depicted with tools in their hands, the tools here were separately fashioned and placed in the tomb for use by the funerary figures. This practice is known primarily from the reigns of Thutmose IV (1400–1390 BCE) and Amenhotep III (1390–1352 BCE). Thereafter, it became the norm to represent the tools in the hands of the *ushebti*s. **Adel Mahmoud**

38 *Ushebti* box of Yuya

Eighteenth Dynasty, reign of Amenhotep III,
1390–1352 BCE; painted wood. Height 37 cm
(14 9/16 in); width 14 cm (5 1/2 in); depth 14 cm (5 1/2 in).
Tomb of Yuya and Tuya (KV 46); Valley of the
Kings. The Egyptian Museum, Cairo CG 51043

• *Ushebtis* (funerary figures) were often stored
inside boxes that took the form, as they do
here, of a shrine facade, the decoration of which
imitates the appearance of the sanctuary of the
north, dating back to the archaic era of the kings
of Lower Egypt. The box, made of wood that
has been lightly plastered and then painted in
green, blue, red, and white, is distinguished by a
barrel-vaulted roof. The frames of false doors
were inspired by niching on early mud-brick temple
facades. The structure is mounted on a base,
which is likewise painted, here white. The knobs
(decorated with rosettes) on the lid and the front
enabled the box to be tied shut with a small cord,
which was stamped with a mud seal.

A vertical column of inscription on the
lid is in black. It identifies the owner of the box
as "the one revered by Osiris, the god's father
Yuya, justified." The *ushebti* box was found inside
the tomb of Yuya and Tuya, which held fifteen
ushebti boxes, thirteen of which are in the Egyp-
tian Museum, Cairo, with two in the Metropolitan
Museum of Art, New York.

The barrel-vaulted shrine shape was also
identified with the burial chest of Osiris, and
one word for a sarcophagus, *djebat*, took the form
of this Lower Egyptian shrine. In addition, the
dead in the afterworld wait in similar shrines for
their reawakening by the appearance of the sun
god in the dark nether regions. The form of the
shrine for *ushebti* boxes was traditional by this
time and continued in use for hundreds of years.
Adel Mahmoud

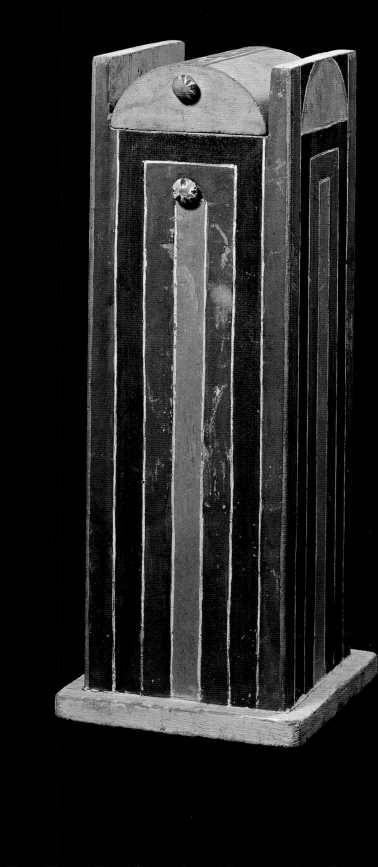

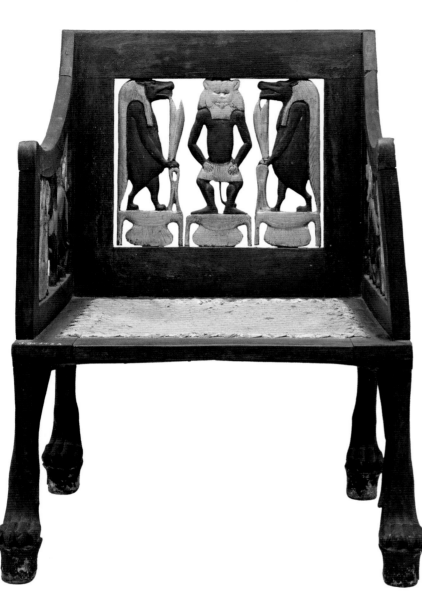

39 Chair from tomb of Yuya and Tuya

Eighteenth Dynasty, reign of Amenhotep III, 1390–1352 BCE; wood, gold. Height 60 cm (23 ⁵/₈ in); width 43 cm (16 ¹⁵/₁₆ in); depth 39 cm (15 ³/₈ in). Tomb of Yuya and Tuya (KV 46), Valley of the Kings. The Egyptian Museum, Cairo JE 95343A/CG 51111a

• Three chairs were found in the tomb of Yuya and Tuya, the parents of Queen Tiye, wife of Amenhotep III. Two are clearly associated with princess Sit-Amun, daughter of Amenhotep III and Tiye. This chair, although it does not bear an inscription, is likely another belonging to the princess. Given its small size, it was certainly made for her as a child. Its decoration is associated with the domestic sphere and particularly the realm of women.

The chair is made of various parts of pigmented dark wood (perhaps ebony or yew) with gilding, fixed together by tenon-and-mortise construction. A pillow stuffed with pigeon feathers was found with the chair. The seat is made of woven rushes. The legs, carved separately to imitate lion's legs, were added last. The paws rest on silvered bases. The back of the chair shows the god Bes flanked by two images of the goddess Taweret. Bes was a household deity who protected women and children from the perils of childbirth or illness. His representation is based on a lion shown frontally but over time gradually took on the characteristics of a dwarf as well. Bes, like Taweret, was a protector of Re, and in the Middle Kingdom (2055–1650 BCE) he often occurred on "magical wands" used to protect women and children at childbirth. The rebirth of the sun each day was identified with the birth of all children. Taweret also assisted with childbirth. Here, she holds two knives in one hand while resting her other hand on the hieroglyph for protection, *sa*. With her knives she will repel any threats to the family members, and in the funerary realm will challenge the enemies of the sun god.

The sides of the chair each show an antelope with legs folded beneath. The submissive attitude for the antelope suggests that the animal offers itself on behalf of the chair's owner. In some love poetry allusion is made to the gazelle, equating it to the man whose quest for a beautiful woman is frightening but rewarding. "O that you came to your sister swiftly, like a bounding gazelle in the wild; its feet reel, its limbs are weary, terror has entered its body, for a hunter pursues it with hounds.... As you pursue your sister's love, the Golden one (Hathor) gives her to you."[1] As is usual in artifacts from ancient Egypt, both understandings of the ibex are present here.

Adel Mahmoud

1. Miriam Lichtheim, *Ancient Egyptian Literature: A Book of Readings.* Vol. 2, *The New Kingdom* (Berkeley, 1976), 187.

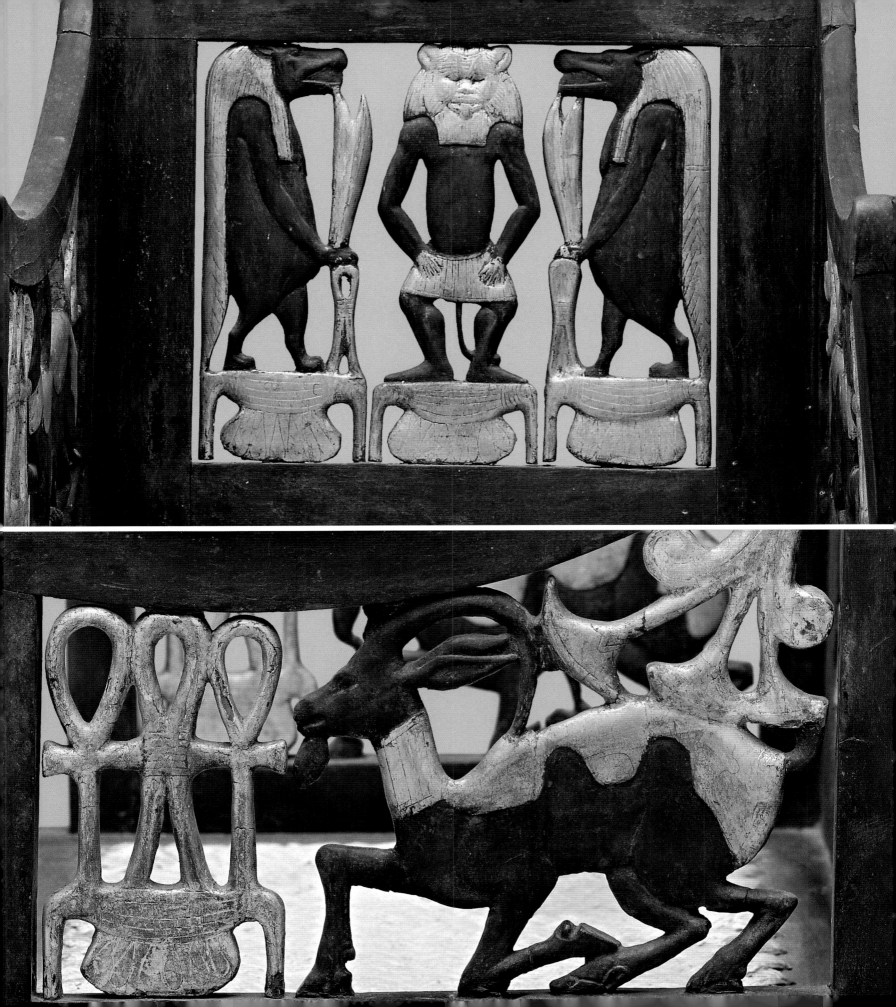

40 *Wedjat* eye plaque

Twenty-first Dynasty, reign of Psusennes I,
1039–991 BCE, gold. Height 10.2 cm (4 in);
width 15.2 cm (6 in). Tanis, tomb of Psusennes I.
The Egyptian Museum, Cairo JE 85821

• Mummies were created by a process that
included an incision in the left flank of the body,
through which the organs were removed for
separate embalmment. The incision was then
sewn up and a covered with a plaque. The plaque
here covered the incision of King Psusennes I,
who was buried within a silver coffin, which itself
was placed within a granodiorite sarcophagus
and again within a great red granite sarcophagus.
On the plaque is chased the *wedjat*, or sound eye,
of Horus. According to Egyptian mythology,
Seth took and mutilated the eye of Horus, leaving
that god in need of his sharp sight (associated
with the falcon). It became necessary for Horus
to find and, with the help of Thoth or other gods,
restore his eye so that he could properly keep the
cosmic order for the sun god. According to some
myths, Thoth magically completed the part of
the eye that had been destroyed, then presented
it back to its owner. The *wedjat* became an amulet
for health and completeness, which was the

major aim of mummification as well. Placing
the eye directly over the incision pronounced the
mummy healthy. The deities who protect the
deceased are shown flanking the *wedjat*.

These Four Sons of Horus are shown
adoring the *wedjat*, and inscriptions identify
them as Hapy (baboon), Imsety (human), Dua-
mutef (jackal), and Kebehsenuef (falcon). Above
the eye itself is the inscription: "For the Osiris,
King Psusennes, beloved of Amun." Here, in a
second layer of meaning for the plaque's deco-
ration, the four gods worship the eye as an equiv-
alent of the sun god who descends and travels
the underworld, often in his form of the eye.
The king is then identified with the sun god, as
he is in all the Amduat sequences found in the
Valley of the Kings. The Four Sons of Horus are
shown with uraeus snakes emerging from their
heads. Since these snakes protected the sun
by spitting fire, perhaps here they allude to
the production of light for the sun god's journey
through the darkness of the night's twelve
hours.[1] **Betsy M. Bryan**

1. Erik Hornung, *Das Amduat: Die Schrift des Verborgenen Raumes*,
3 vols. (Wiesbaden, 1963–67), with a complementary edition
of all versions of the New Kingdom in idem, *Texte zum Amduat*,
3 vols. with continuous pagination. Aegyptiaca Helvetica, 13–15
(Geneva, 1987–94), 171. For discussion of the burial generally, see
Henri Stierlin and Christiane Ziegler, *Tanis: Trésors des Pharaons*
(Fribourg/Paris, 1987), 27, fig. 7, and 61–70.

124

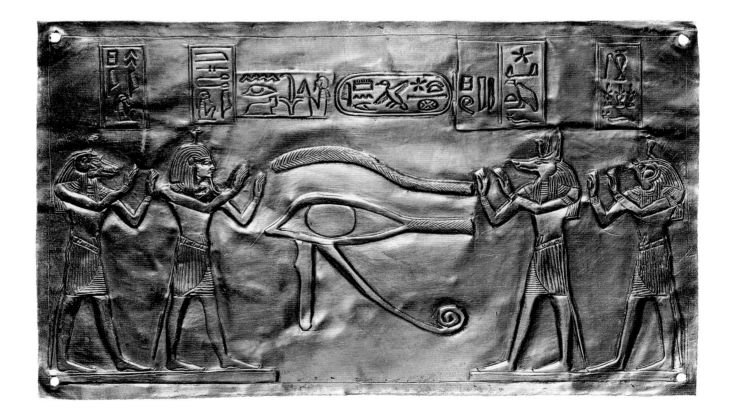

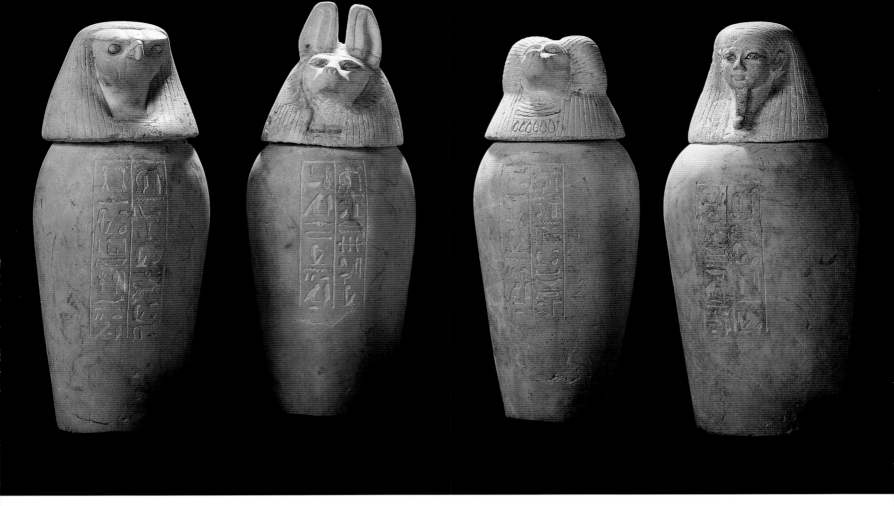

41 Four canopic jars of Prince Hornakht

Twenty-second Dynasty, reign of Osorkon II, 874–850 BCE; calcite. Falcon: Height 37 cm (14 9/16 in); diameter 15 cm (5 7/8 in). Jackal: Height 39.5 cm (15 9/16 in); diameter 15 cm (5 7/8 in). Baboon: Height 36.5 cm (14 3/8 in); diameter 14 cm (5 1/2 in). Human: Height 37 cm (14 9/16 in); diameter 16 cm (6 5/16 in). Tanis, tomb of Osorkon II (874–850 BCE), discovered by Pierre Montet in 1939. The Egyptian Museum, Cairo JE 87087 a–d

• These canopic jars contained the viscera of Prince Hornakht, son of King Osorkon II. They were discovered together with Hornakht's sarcophagus in the tomb of his father. The jars were placed inside a small chest of sandstone with a curved lid. Although he is given the title of high priest, both the size of the sarcophagus and the examination of the mummy of Hornakht proved that he was actually a child of eight or nine.

These jars are among the rare examples of stone vessels found in the royal tombs of Tanis and are reused. The sculpture of the stoppers is executed in the fine quality of the New Kingdom (1550–1069 BCE). Their quality is even more elaborate than the sets of Kings Takelot and Osorkon that were found at Tanis.

Evidently each head was outlined in black and painted. Still visible are the outlined black color of the eyes and the blue and red colors on the wigs and collars of each jar. Canopic jars formed an essential component of funerary equipment. After the viscera were removed from the body, they were dried in natron, anointed with unguents, coated with resin, and wrapped in linen before being placed in the four canopic jars that were then placed in the burial chambers of the tombs, close to the coffins.

The shapes of the jars changed throughout Egyptian history. The simple jar lids of earlier times became human-headed stoppers in the Middle Kingdom (2055–1650 BCE). In the Ramesside Period (1295–1069 BCE), the stoppers began to be made in the form of the Four Sons of Horus—Kebehsenuef with the head of a hawk, Duamutef with a jackal head, Hapy with a baboon head, and Imsety with a human head. They were responsible for the protection of the intestines, stomach, lungs, and liver respectively. They were also connected with the four protective goddesses, Isis, Nephthys, Neith, and Selket.

The inscriptions are in two vertical columns over the body of each jar. Although the inscriptions do not mention the name of Hornakht, each jar evokes the protection of all four goddesses. **Fatma Ismail**

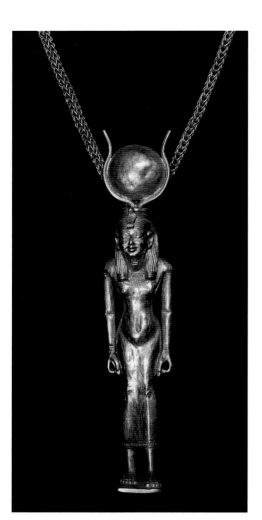

42 Necklace with pendant
in the form of Isis

Twenty-first Dynasty, reign of Psusennes I,
1039 – 991 BCE; gold. Height 50 cm (19 11/16 in); width
2.3 cm (7/8 in); depth 2.2 cm (7/8 in). Tanis, tomb
of King Psusennes I. The Egyptian Museum, Cairo
JE 87716

• The goddess Isis was the wife of Osiris — the
primary deity of the afterlife — and the mother
of Horus. She has strong associations with regen-
eration, for according to myths, she was impreg-
nated by her husband after his death, creating
the cycle of birth from death symbolized by the
never-ending solar cycle and the Amduat.

Isis was also the archetypal symbol of
a protective and caring mother, as attested by
the thousands of bronze statues that have been
found of Isis holding her son Horus in her lap.
According to myth, she had the ability to protect,
as indicated by texts that refer to her hiding her
newborn son in the papyrus swamps of Khemmis
to shield him from his evil uncle/brother Seth.
From the Third Intermediate Period into the
Roman Period (c. 1069 BCE – second century CE),
Isis was associated with magical protection, and
it was in that role that her cult flourished in the
Ptolemaic and Roman Periods.

In a more strictly funerary context,
Isis was one of the two chief mourners of Osiris,
and hence she was one of the deities featured
on coffins, canopic shrines, and other mortuary
furnishings.

This figurine, with its wide hips, high
waist, and breasts placed in the upper portion
of her chest, is in the style of Third Intermediate
Period statuary. She wears bracelets that are
pushed up improbably on her arm. Her tightly
fitting dress with a decorated hem is topped by a
multilayer broad collar. A protective uraeus is
on her brow.

It is often impossible to differentiate Isis
from the anthropomorphic form of the goddess
Hathor. Both wear headdresses composed of
lyre-shaped cow horns and sun disks. However,
the identity of this figure is assured by the
inscription "Isis, Mother of the God," which is
incised on the underside of its base. This was
one of six gold amulets of deities found on the
neck of the mummy of General Wenudjebauendjed
who was buried in the tomb of King Psusennes I
at Tanis. Emily Teeter

43 Funerary mask of
Wenudjebauendjed

Twenty-first Dynasty, reign of Psusennes I,
1039 – 991 BCE; gold. Height 20.3 cm (8 in); width
17.8 cm (7 in); depth 15.2 cm (6 in). Tanis, Royal
tomb no. 3, chamber 4. The Egyptian Museum,
Cairo JE 87753

• The courtier Wenudjebauendjed held important
military and priestly titles but was not definitely
a member of the royal family.[1] Nevertheless, and

perhaps a reflection of Libyan influence on Egyp-
tian culture in what has been called the Libyan
Period (Twenty-first or Twenty-second Dynasty
through Twenty-fourth Dynasty), he was buried
in the tomb of the king he served, Psusennes I.[2]

Wenudjebauendjed was buried with opu-
lent furnishings, including his funerary mask.
This was probably made in the same workshop as
that of his king's, both sharing the taste of the
other golden funerary masks of the Twenty-first –
Twenty-second Dynasty from the royal cemetery
at Tanis for slightly dull rather than highly pol-
ished surfaces. Unlike Psusennes' mask, Wenu-
djebauendjed's mask covered only the face, rather
than the entire head, and does not have attri-
butes of royalty such as a royal headdress and
beard. Nevertheless, it is one of the few surviving
examples of the gold masks made for kings and
great nobles.

Gold's symbolism may have been more
significant than its economic value. Not subject
to corrosion, gold could represent the solar, the
imperishable, and the flesh of the gods. Hence
the funerary mask helped represent the deceased
as a transfigured spirit eligible for eternal life
and possessing divine qualities. Like some of
the royal individuals buried at Tanis, Wenudje-
bauendjed, who had a gilded wood coffin, also
had a silver coffin, which raises the question
of whether or not these body and face coverings
of gold and silver somehow symbolized solar and
lunar regeneration.[3] Richard Fazzini

1. Despite a lack of royal titles, he has recently been described as
a prince and member of King Psusennes' family by Henri Stierlin,
The Gold of Pharaohs, trans. P. Snowdon (Paris, 1997), 170. Another
Egyptologist has recently argued that he was royal in some way
(G. Broekman, "Facts and Questions about Wen-Djeba-en-djed,"
Göttinger Miszellen 165 [1998]: 25 – 27). Equally unusual was the
burial in this tomb of Psusennes' chief queen and of another man
who was probably their son.

2. For an overview of the history and culture of the Third Inter-
mediate Period, see John Taylor, "The Third Intermediate Period
(1069 – 664 BC)," in Ian Shaw, ed., *The Oxford History of Ancient
Egypt* (Oxford/New York, 2000), 330 – 68 and 466 – 68.

3. For the symbolism of silver, see Sydney Aufrère, *L'Univers
minéral dans la pensée égyptienne. Vol. 2, L'intégration des
minéraux, des métaux et des "Trésors" dans la marche de
l'univers et dans la vie divine*, BdÉ CV/2 (Cairo, 1991), 409 – 28.

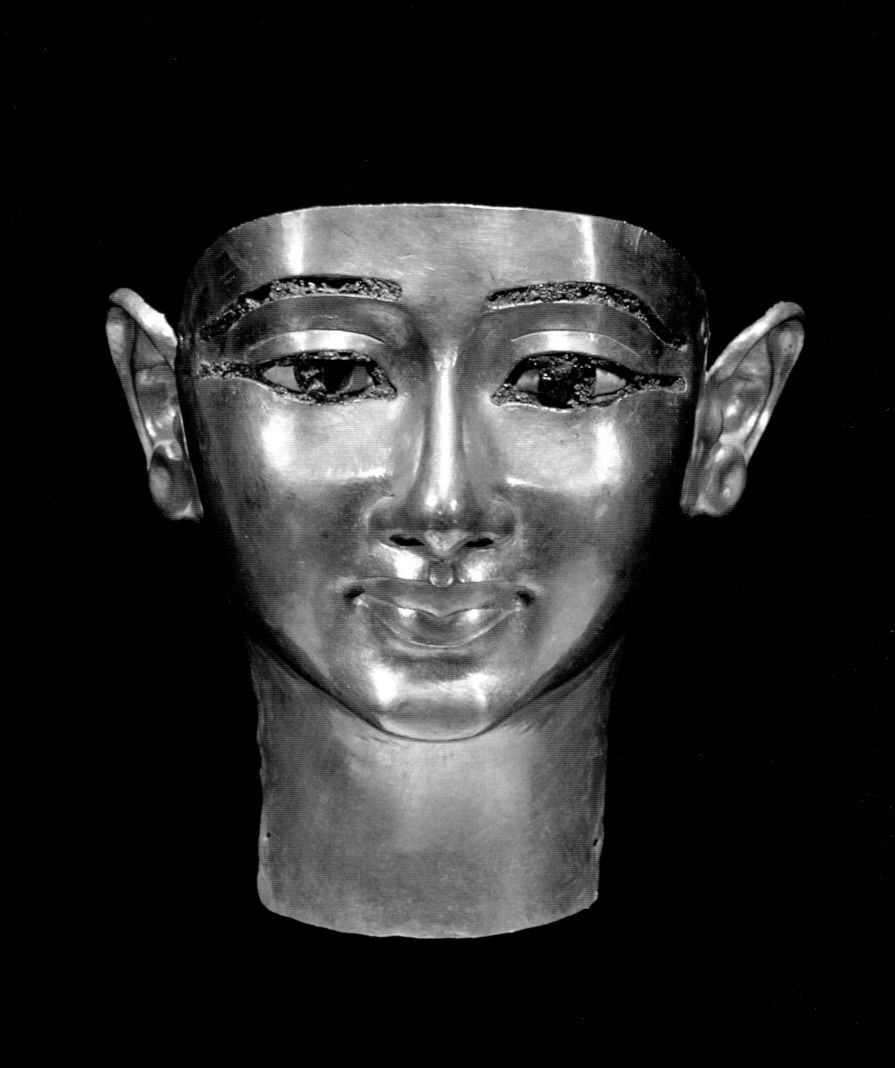

44 Pectoral from the tomb of Sheshonk II

Twenty-second Dynasty, reign of Sheshonk II, c. 890 BCE; gold and precious stones. Height without band: 6.4 cm (2½ in); width 5.1 cm (2 in); length of chain 31.5 cm (12¼ in). Tanis, tomb of Sheshonk II. The Egyptian Museum, Cairo JE 72172

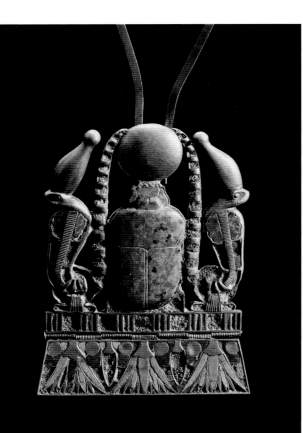

• One of the most enduring elements of the desire for eternal existence in the afterlife was the wish of the deceased to join the sun in its predictable cycle of rising and setting. This most prominent feature of the environment provided a comforting analogy for the idea of rejuvenation and formed the basis of New Kingdom funerary theology. As with so many aspects of ancient Egyptian religion, the basic precepts of beliefs were derived from the natural phenomena that they observed around them every day.

The complex iconography of this pectoral represents the cosmos and the rising of the sun at dawn from the darkness of the underworld. The lapis lazuli scarab, the representation of the newly born sun, as well as the hieroglyph for "to come into being," is shown emerging from the horizon that is represented by a double curved sign below it. The scarab pushes the round gold disk of the sun up into the sky to illuminate and revive the world.

The earthly realm is represented by the horizontal baseline, while the watery realm is shown as a row of aquatic plants that are hinged to the pectoral so that their movement mimicked that movement of water. The two uraei, wearing the white crown of Upper Egypt, symbolize the king. The king's successful association with the rising sun, and from it his rebirth, is symbolized by the attachment of the snakes' tails to the sun disk, for as the sun rises, the king would be carried with it to rejuvenation. The permanence of the cosmos and the king's association with the rising sun is symbolized by the circular hieroglyphs for "eternity" that are looped over each uraeus. The tails of the uraei and sections of the aquatic plants were originally filled with bright paste, which has now decayed.

The use of two white crowns on the heads of the snakes, rather than the expected red and white crowns, suggests that the composition is a rebus of the throne name of Sheshonk I: *hedj* (white crown) – *kheper* (scarab beetle) – *Re* (sun disk). Other pieces of jewelry, gold dishes, and even a stone sarcophagus were brought to Tanis from Thebes and elsewhere for reuse.

The decoration on the reverse side is chased rather than inlaid, the anatomy of the underside of the scarab being rendered naturalistically. This pectoral was part of a group of eight ornaments found suspended from the neck of the mummy of Sheshonk II. Most of the pectorals from the tomb were suspended on thin flat ribbons of gold rather than the more common chains. **Emily Teeter**

45 Bracelet with the eye of Horus

Twenty-second Dynasty, reign of Sheshonk I, 945–924 BCE; and Sheshonk II, c. 890 BCE; gold, semiprecious stones. Height 4.5 cm (1¾ in); diameter 7 cm (2¾ in). Tanis, tomb of Sheshonk II. The Egyptian Museum, Cairo JE 72184A

• Sheshonk II (with the *prenomen* Hekakheperre) had two cylindrical bracelets showing the *wedjat* eye, but on inscriptions added inside these jewels we learn that they both had once belonged to the founder of the Twenty-second Dynasty, Sheshonk I (Hedjkheperre). That ruler is considered to have been the biblical Shishak who sacked Jerusalem in the tenth century BCE, and Sheshonk II must have believed that his heirlooms were powerful magic for his journey to the next world.

Although made of gold inlaid with stone and glass, the form of bracelet seen here imitates one that was already very ancient. Earlier the rigid cylindrical shape had been achieved in rows of beads of different colors separated by gold vertical bars. Here, vertical gold bars interrupt bands of carnelian and lapis lazuli inlays. The bracelets are made of two unequal sections of heavy sheet gold. They are hinged and closed with a pin that retracts. This rigid type of bracelet is first known from the burial of Queen Ahhotep, mother of King Ahmose, founder of the Eighteenth Dynasty (1550–1069 BCE; see cats. 21–25), which also

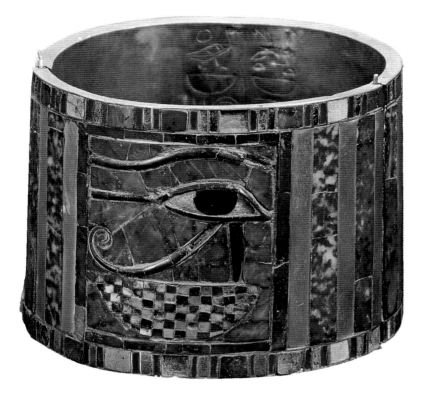

contained the older form made with beads and gold bars. Here, the bands of decoration are interrupted by a cloisonné field of lapis, carnelian, and black and white stone. The cloisonné method consisted of creating cloisons by soldering gold strips to the beaten gold base in the pattern desired. They were then layered with a cement to hold slivers of stone or glass cut in exactly the shape of the cloisons.

The cloisonné field contains the *wedjat* eye hovering over a basket, providing a hieroglyphic wish for "all health." The eye of Horus invokes the health of the mummy, particularly his bones, and these bracelets thus were meant to protect his wrist bones and keep his body intact. Since the *wedjat* is also a symbol for the sun god, the king's journey through the netherworld with Re is also alluded to. The *wedjat*, or right, eye adorns the bracelet for the right wrist, and the lunar, or left, eye adorns that of the left wrist. This bracelet and its companion were found on the mummy of Sheshonk II.

Betsy M. Bryan

46 Pendant of the god Ptah in his shrine

Twenty-first Dynasty, reign of Psusennes I, 1039–991 BCE; lapis lazuli and gold. Height 6 cm (2 ³⁄₈ in); width 3 cm (1 ³⁄₁₆ in); depth 1.7 cm (¹¹⁄₁₆ in). Tanis, tomb 3. The Egyptian Museum, Cairo JE 87712

• This pendant is composed of a reused lapis lazuli amulet representing the god Ptah, the feet of which had been accidentally broken. The mummiform god has a beard and holds a scepter surmounted by a *djed* pillar (primarily known to be a symbol of Osiris, but also a symbol of Ptah, who is called "the august *djed*"). The identity of the god may be confused by the solar disk, flanked by two ostrich feathers, which he wears on his head. However, the same headdress is worn by Ptah in a representation from a private tomb dating to the time of Ramesses VI (1143–1136 BCE) and suggests a syncretism with the primeval god Tatjenen. One may argue that this iconographic originality makes this damaged amulet valuable enough for it to have been later sheltered in a gold representation of the shrine of the god. The double cornice on the top of the shrine denotes

two chapels fit together. The god is flanked by two papyrus-shaped columns, each supporting a pair of falcons carrying a sun disk on their heads. On the exterior of the sides of the shrine are representations of twenty-four small gods, facing each other, split into two symmetrical sections.

The lapis lazuli from which this little Ptah amulet was carved is a metamorphosed form of limestone, rich in the mineral lazurite, which is dark blue in color. It was highly valued by the ancient Egyptians, for they believed that its appearance imitated that of the heavens. It was widely used in jewelry through the Late Period (664–332 BCE), when it was particularly popular for amulets.

Ptah was the creator god of Memphis. He was usually depicted as a mummy with his hands protruding from the wrappings, holding a staff combining the *djed* pillar (symbol of stability), the ankh sign (symbol of life), and the *was* scepter (symbol of dominion). He wears a tight-fitting skullcap on his head, leaving his ears exposed. From the Middle Kingdom (2055–1650 BCE) onward, he was represented with a straight beard. In Hellenistic times he was identified with the Greek god Hephaistos. Ptah was part of a Memphite triad consisting of his consort, Sakhmet (the lioness-headed goddess), and the lotus god Nefertem, whose relationship with Ptah is unclear. Although not a member of the triad,

129

Imhotep, the deified architect of the Sakkara Step Pyramid, came to be regarded as a son of Ptah.

In cultic terms, Ptah was originally associated with craftsmen, and the high priest of Ptah held the title *wer kherep hemw* (supreme leader of craftsmen). His position was then elevated to that of a creator god. He was thought to have brought the world into existence through the thoughts of his heart (the ancient Egyptians regarded the heart, rather than the brain, as the source of human wisdom and the center of the emotions and memory) and the words of his tongue. Ptah devised the Opening of the Mouth ceremony, a funerary ritual by which the deceased and his or her funerary statuary were brought to life. **Yasmin El Shazly**

47 Pectoral of Psusennes I

Twenty-first Dynasty, reign of Psusennes I, 1039–991 BCE; gold, semiprecious stones. Necklace length with pectoral 60 cm (23 5/8 in); width of pectoral 13.5 cm (5 5/16 in); depth 1.5 cm (9/16 in). Tanis, tomb of Psusennes I. The Egyptian Museum, Cairo JE 85785

• This handsome pectoral from the tomb of Psusennes I perfectly preserves both the breast plaque and the necklace attached to it. The pectoral was an elite necklace type seen from at least the Middle Kingdom (2055–1650 BCE) and was worn by both men and women. Nofret, the wife of Senusret II (1877–1870 BCE) of the Twelfth Dynasty, is shown wearing a pectoral on a statue of her found at Tanis, and examples of similar small breast plaques were found in the tombs of Middle Kingdom princesses at Dahshur. Psusennes' pectoral is in a larger scale, similar to a number of examples from the tomb of Tutankhamun (1336–1327 BCE). The iconography, decidedly funerary, is also paralleled by necklaces

from Tutankhamun's burial, while the Middle Kingdom pieces displayed more royal themes, centering on the king's conquest of his enemies.

The plaque is made of pieces of heavy gold sheet fitted with small gold strips to create cloisonné cells. The pectoral is shaped like a shrine, with a cornice at the top and color bands of carnelian, turquoise, and lapis framing the interior space. Color bands were used in tomb chapels to decorate the corners of rooms and sometimes the tops of walls as well. They are therefore intended to define the sacred space, as they do here. As if the shrine were open, we look within where the cult object is shown — a large lapis lazuli scarab beetle with wings. The scarab is identified by a cartouche beneath it — it is Psusennes I, his actual name being Pasebakhaemniwet, "the star appearing in Heliopolis." Hanging above the scarab is a winged sun disk from which hangs the king's *prenomen*, Aakheperre, setepenAmun, "Great of transformation is Re, the chosen one of Amun." Uraei are seen in four different places, twice with sun disks on their heads, since they are the sun's agents who can spit fire for his protection. The solar imagery is overwhelming here and assures that the king is associated with the sun god who will journey through the netherworld to rise in the morning as the scarab beetle. Flanking the king's solar image are the goddesses Isis (right) and Nephthys (left), both shown with skin of turquoise, a color associated with rejuvenation. In a kneeling position they protectively touch the wings of the scarab. The inscription above Isis calls her "Isis the Great, mother of the god, mistress of the West." The text before Nephthys states: "Come to me in order that I may be your protection." Beneath the frame of the shrine, hanging from a gold hinge is a row of sun disks in carnelian and beneath them alternating signs for (left to right) "stability" and "protection." The necklace is made up of drop-shaped gold, lapis lazuli, and turquoise beads. **Betsy M. Bryan**

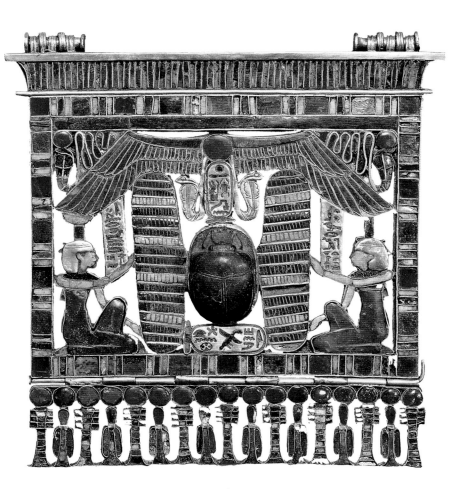

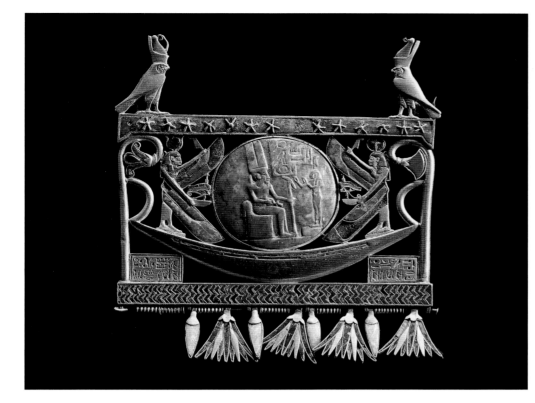

Upper and Lower Egypt, the papyrus and the lotus. Suspended from a golden pin on the lower edge of the pectoral are closed lotus buds, inlaid with blue-green glass paste (in imitation of turquoise) and open lotus blossoms with alternating gold and lapis petals. The buds and blossoms are separated by tiny gold ring beads. The suspension of the flowers allows them to undulate as if they were floating in the water.[1] Because the blue lotus closes and sinks below the surface of the water each evening only to reemerge and reopen the following morning with the rising of the sun, it became a symbol of the solar cycle of regeneration.

The simple act of inscribing this amulet with the name of the deceased ensured that he would continue to exist. The depiction of the solar barque and the protection of the sun on its journey are symbolic of the desire of the deceased to travel along with the sun god, passing through the dangers of the underworld unharmed and rising to a new existence after the journey is completed. The very materials and colors would also have been selected for their symbolic value. Gold was symbolic of the sun and the flesh of the gods. The deep rich blue of lapis lazuli was symbolic of the gods, the primeval waters of creation and the night sky. Green was symbolic of vegetation and fertility and red was symbolic of the sun and the powers of birth and regeneration. **Tammy Krygier**

1. For almost identical motif of this suspended frieze of closed and open inlaid lotus blossoms, see Cairo Museum, JE 72172, cat. 54.

48 Gold pectoral with solar boat

Twenty-second Dynasty, reign of Sheshonk I, 945 – 924 BCE; gold, lapis lazuli, and glass. Height 37.5 cm (14 ¾ in); width 19 cm (7 ½ in); depth 1.2 cm (½ in). Tanis, tomb of Psusennes I, grave of Sheshonk II. The Egyptian Museum, Cairo JE 72171

· This intricate gold pectoral inlaid with lapis lazuli and colored glass paste was discovered by Montet in 1939 during excavation of the grave of Sheshonk II. This burial was located within the tomb of Psusennes I (1039 – 991 BCE) at Tanis. The Egyptians often included heirloom objects made for their ancestors within their own graves. The inscription carved into two gold plaques beneath the solar barque mentions Sheshonk, son of Nimlot and Great Chief of the Meshwesh, and this Sheshonk is believed to have become Sheshonk I, first pharaoh of the Twenty-second dynasty.

The central motif of this pectoral is the image of the sun traveling in his solar barque on his daily circuit. The sun is represented by a lapis lazuli disk carved in raised relief with the seated figure of the composite solar god Amun-Re-Horakhty, holding a *was* scepter (the symbol of dominion) and an ankh sign (the symbol of life). A more diminutive figure of the goddess Maat stands before him. Two protective goddesses extend their wings to shelter the sun from any dangers encountered along the journey. They extend protective ostrich feathers, *nefer* signs, *wedjat* eyes, and *neb* basket signs toward the disk. Each goddess may be identified by her symbolic headdress. Hathor, the daughter and protector of the sun god, is depicted with a solar disk and the golden horns of a cow. Maat, the embodiment of truth and order, is depicted with a solar disk and her golden feather.

Above the barque the starry night sky is inlaid with lapis lazuli and covered in a line of applied gold stars. Two delicately modeled golden falcons, each wearing the combined white and red crowns of Upper and Lower Egypt, stand in opposition to each other at the upper corners. Beneath the barque the primeval waters are depicted by a stylized bar of wavy lines. The sides of the scene are framed by the heraldic plants of

49 Toe stalls with rings

49

Twenty-first Dynasty, reign of Psusennes I, 1039–991 BCE; gold. Length of the largest stall 5 cm (1^{15}/16 in); width 2.5 cm (1 in). Length 4.5 cm (1^{3}/4 in); width 2 cm (13/16 in). Length 4.5 cm (1^{3}/4 in); width 2 cm (13/16 in). Length 4 cm (1^{9}/16 in); width 1.8 cm (11/16 in). Length of smallest stall 3 cm (1^{3}/16 in); width 1.5 cm (9/16 in). Tanis, tomb of Psusennes I, discovered by Pierre Montet. The Egyptian Museum, Cairo JE 85831–85835

• These toe stalls were found on the right foot of King Psusennes' body, and an identical set was found on the left foot. They are made of beaten gold adorned with simple rings. The king's mummy was also fitted with ten finger stalls. There were more rings found on this mummy's golden fingers and toes than on any other pharaoh's mummy. Amulets in the shape of body parts increased in number after the First Intermediate Period (2160–2055 BCE). They were intended to endow the owner with their particular bodily function, as well as to substitute for the physical parts should they decay.

These toe stalls were made specifically for funerary purposes. After the process of mummification and wrapping of the body, they were placed over the toes of the deceased, a fashion introduced in the New Kingdom (1550–1069 BCE).

According to burial ritual, the mummy should be fitted with gold, "the flesh of the gods." Psusennes' mummy, with its gold mask, beautiful gold jewelry and amulets, and finger and toe stalls, was placed under a large one-meter (39 inches) sheet of gold foil that enveloped the body from chest to ankles.

Gold was always considered the most noble and expensive material. It had many religious, mythical, and symbolic values. Gold resisted time and atmospheric variations, thus becoming the symbol for survival and eternity. The burial chamber was also known as the "house of gold." **Fatma Ismail**

50 Finger stalls

New Kingdom, 1550–1069 BCE; gold. Average length 5.8 cm (2^{7}/25 in). Overall, on board: Height 15 cm (5^{7}/8 in); width 27 cm (10^{5}/8 in); depth 33 cm (13 in). The Egyptian Museum, Cairo TR 20-12-21-24/SR 6162-6169

• Like toe stalls, finger stalls were made specifically for funerary purposes. After the process of mummification and wrapping of the body, they were placed to protect the easily broken small bones of the fingers. This fashion was introduced in the New Kingdom. According to burial ritual, the mummy should be fitted with gold, "the flesh of the gods." **Betsy M. Bryan**

50

51 Coffin Lid of Isis-em-akhbit

Twenty-first Dynasty, reign of Psusennes II, 959–945 BCE; painted wood, gold. Height 208 cm (81⅞ in); width 65 cm (25⁹⁄₁₆ in); depth 50 cm (19¹¹⁄₁₆ in). Thebes, Cachette of Royal Mummies. The Egyptian Museum, Cairo CG 51031

• Princess Isis-em-akhbit was the daughter of the priest king Menkheperre and wife of the High Priest of Amun Pinedjem II. Her mummy was found in the cachette of Deir el-Bahari together with the bodies of many of the great kings and queens of the New Kingdom (1550–1069 BCE). The image of the lady, with its gilded face, is one of the most beautiful coffins of the Third Intermediate Period. We see the lotus flower over her head, her fleshy face with large outlined eyes, large ear studs from the fashion of the day. All of these are gilded, while her eyes are inlaid with glass. A garland of flowers adorns her neck. Beneath the portrait-like head the coffin lid becomes a veritable tabloid of divinities, laid out in five registers divided by goddesses with outstretched wings.

The uppermost register shows the goddess Mut, in whose service Isis-em-akhbit passed much of her life, seated with the sun disk above her head. She is protected by two snakes, and the scarab beetle appears as well. The second through fifth registers likewise show the scarab and the sun disk, underlining the priority of the solar rebirth in funerary beliefs. On the feet of the lid are five columns of inscription and included here are the name and titles of Isis-em-akhbit. She is called the "favorite one of Amun-Re, King of the Gods, the priestess of Mut, the great, mistress

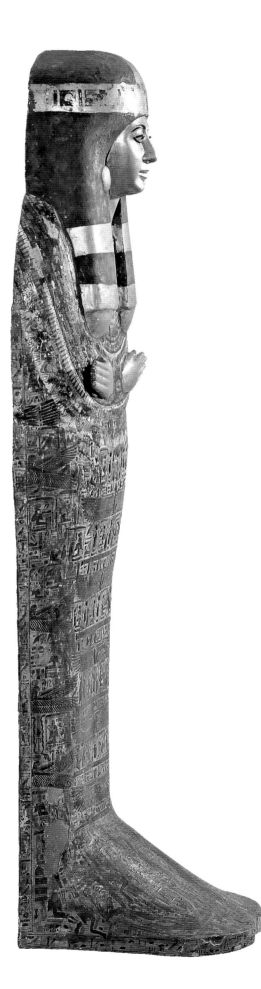

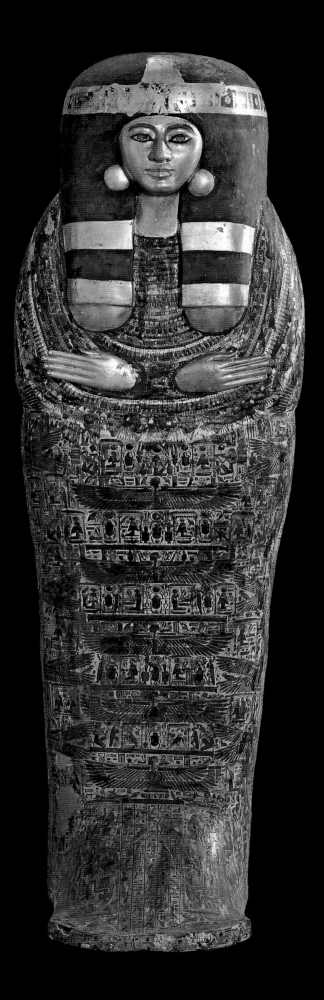

of Isheru" (Mut's temple at South Karnak). She was also known to have carried the title of "god's mother of Khonsu," an allusion to her role as the substitute for Mut in the rituals that brought Amun and Mut together to produce their offspring, Khonsu, the moon god. The importance of this role in the late Twentieth and Twenty-first Dynasties is underlined by its relief depiction on the walls of the Khonsu Temple at Karnak. The involvement of women in the birth aspects of the cult was probably expanded at this time. In the tomb of Hormose at Hierakonpolis, dated to the reign of Ramesses XI (1099–1069 BCE), the god's mother of Isis who performed a similar role to Isis-em-akhbit in the cult of Horus of Nekhen, participates in a procession and separate ritual apparently exclusively conducted by women. Isis-em-akhbit had at least two daughters, one of whom, Heryweben, was a chief of entertainers in the temple of Karnak and a second priest of Mut.

Isis-em-akhbit is also known to have possessed a Book of the Dead, which gives a fuller list of her titles. **Ibrahim El-Nawawy**

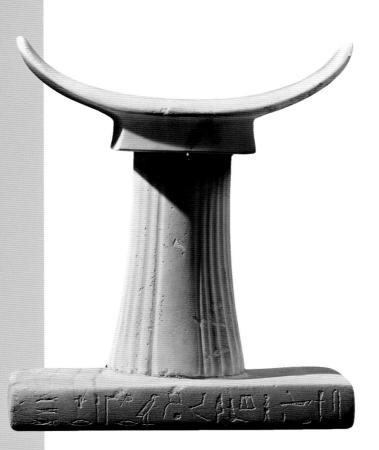

The Tomb of a Noble (catalogue nos. 52–75)

Constructing a proper tomb was a vitally important goal for the nobility in ancient Egypt. Commissioning coffins and canopic equipment was also a top priority. Tombs often included images of the deceased, many of which reflect the connection of the deceased to the gods. Tomb furnishings could include foods to sustain the dead person, amuletic jewelry, tools, furniture, and luxury goods. Because the world beyond death was agrarian, burials included statuettes known as *ushebtis*, which were designed to stand in whenever the deceased was called upon to perform tasks of manual labor.

52 Headrest

Late Old Kingdom – First Intermediate Period, c. 2345–2055 BCE; calcite. Height 20.7 cm (8⅛ in); width 18 cm (7 1/16 in); depth 9.5 cm (3¾ in). The Egyptian Museum, Cairo JE 88563

• This finely carved headrest is a type that can be dated Old to Middle Kingdom. The curved upper portion is characteristic of nearly every Egyptian headrest, while the fluted stem first appeared in the Old Kingdom. The base of the headrest is no wider than the curved upper portion, creating a symmetrical effect. While such a form may at first appear simple, this stone headrest shows expert skill in carving and proportion. In fact, the stem bears a resemblance to a building column, giving the headrest an architectural feel and making the object not just functional, but also attractive.

The headrest is inscribed for "the sole companion and lector priest, venerated one before the great god, Hery-adj-mer. (This last could also be an additional title, "chief irrigation canal supervisor.")

The Egyptian word for headrest is *weres*, and such objects were in use from the Third Dynasty (2686–2613 BCE) to the Late Period (664–332 BCE). Headrests were designed to support the space between a person's head and shoulder, and the upper portions were sometimes cushioned by linen. Headrests were made from a variety of materials, with stone being most popular in the Old Kingdom. In the Middle and New Kingdoms, wood became the preferred material, but stone, ivory, and faience were also used.

Headrests were used in everyday life as well as in burials. In some cases inscriptions were added to headrests to make them more appropriate for a burial, with the owner's name being inscribed together with the occasional funerary epithet like "justified" or "repeated life." This headrest, although it does not have any inscriptions, was probably part of a burial assemblage. Calcite, or Egyptian alabaster, was a stone regarded as appropriate for funerary equipment. Its whitish-yellow color and translucence was thought to evoke purity, a concept important for the deceased. Both the fine workmanship of this headrest, along with its material, make it exactly the type of headrest that a well-to-do Egyptian would want to lie on as he or she passed into the afterlife. **Elizabeth A. Waraksa**

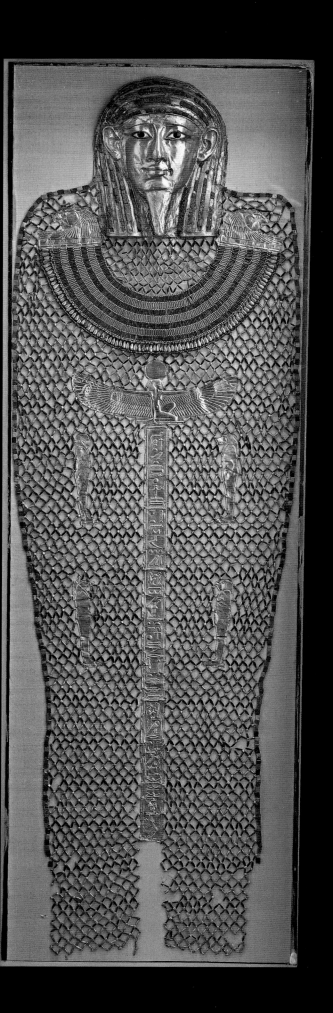

53 Bead net and gold mask of Hekaemsaef

Twenty-sixth Dynasty, 664–525 BCE; gold, semi-precious stones, faience. Height 145 cm (57 1/16 in); width 47 cm (18 1/2 in); depth .7 cm (1/4 in). Sakkara, tomb of Hekaemsaef. The Egyptian Museum, Cairo JE 35923 / CG 53668

• Although the Egyptians often placed reproductions of objects from daily life in their burials, some items, like this magnificent funerary set of Hekaemsaef, including a beaded mummy covering, mask, and collar, held a more ritualistic and protective meaning. The gilded mask, inlaid with eyes of feldspar and obsidian and brows and lids of lapis lazuli, preserves forever the idealized countenance of its owner. A divine beard hangs from the chin, and the face is surrounded by a headdress of black and green glass paste.

The net itself, which was reconstructed by scholar George Daressy, uses beads of gold, lapis lazuli, and amazonite to form a lozenge-patterned shroud. Hekaemsaef's *wesekh* collar, capped at each end with beaten-gold falcon heads, is strung with eighteen rows of these beads. The net is edged with rectangular beads of the same materials, all three of which the Egyptians considered extremely valuable and therefore appropriate for use in burials. Lapis lazuli, the most prized of all stones, is a lustrous dark blue mineral that was likely imported into Egypt from modern northeastern Afghanistan. Amazonite, also known as feldspar, is a green or blue-green mineral. Its origins are possibly the eastern desert of Egypt and the Libyan mountains. Both lapis and amazonite, called *khesbed* and *neshmet* in the ancient Egyptian language, were continually imitated by Egyptian craftsmen, using the domestically produced glasseous material faience. Gold, commonly mined in Nubia, was the most precious and favored material of the Egyptians. These costly beads are intersected with disks of gilded copper.

Woven into the net are five elements of beaten gold. The central figure depicts the sky goddess Nut, topped by a sun disk, stretching out

her protective winged arms over the body. A row of hieroglyphics runs beneath her, giving praise to the goddess and naming its owner as "Osiris, overseer of the royal boats, Hekaemsaef." The standing figures beside the inscription represent the Four Sons of Horus, commonly found on canopic jars, which held and protected the internal organs of the deceased.

By the end of the First Intermediate Period (2160–2055 BCE), the association of the deceased person with Osiris expanded from a strictly royal prerogative to an acceptable practice for private individuals, like Hekaemsaef. By merging with this chthonic deity—who had been murdered and then brought back to life—the dead could be regenerated into his eternal cult. Osiris was occasionally depicted wearing a shroud with a bluish-green diamond pattern, which looks similar to this type of beaded mummy net. The net appears in the funerary customs of the Twenty-fifth Dynasty (747–656 BCE) and remained popular through the Roman Period (30 BCE–395 CE). Those who could not afford the expensive net covering often replicated the lozenge pattern with paint on the outermost wrapping of their body, or even on their cartonnage coffin. Others used knotted string to form a more modest version of the beaded net.

Hekaemsaef's toes and fingers were covered with sheaths of gold, and his body was wrapped in a linen sheet. A large number of amuletic objects, including figurines of gods, animals, and scarabs in gold and stone were found with the mummy, all encased within a painted wooden coffin protected by a limestone sarcophagus. The intact tomb, discovered east of the pyramid of Unas in the Sakkara necropolis, safeguarded a variety of objects Hekaemsaef deemed necessary for his existence in the afterlife: canopic jars, faience *ushebti* figures, and models of boats, palettes, and pottery. **Elaine Sullivan**

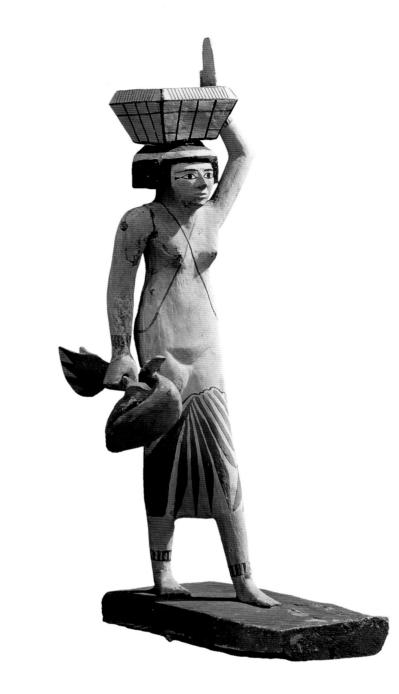

54 Offering bearer

Tenth Dynasty, c. 2100 BCE; painted wood. Height 56.5 cm (22¼ in); width 15.5 cm (6⅛ in); depth 34 cm (13⅜ in). Tomb of Nakht, Assiut. The Egyptian Museum, Cairo JE 36291

• This wooden statuette is in the form of a woman wearing a form-fitting white garment held by a strap over the left shoulder, leaving the chest bare. The bottom of the skirt is decorated with a large feather pattern, and she wears two long, colored chains over her shoulders and wrist and ankle bands. Her round wig is short and black; a white headband runs around the back of a pigtail.

She has a full face, with eyebrows and eyes clearly defined in black, extending in fishtail-like cosmetic lines. The fact that she is depicted with her left leg striding forward in a broad step identifies her as a young, active woman. She stands on a rectangular base and carries an offering basket on her head, which she supports with a very peculiar, rigid gesture of her left hand. In her right hand she holds a duck by its wings. Some argue that the revealing garment, the jewelry, and the duck identify the woman as a concubine, for ducks and geese had sexual connotations and often appeared in love poetry.

Offerings to the dead were known in Egypt from prehistoric times, through finds in graves. Special offering places in connection with graves were found throughout ancient Egyptian history. The earliest offerings were placed outside the superstructures of the tombs; later they were placed inside. Offerings were given to the dead to restore life. The ancient Egyptians believed that the dead were momentarily in an inert state. In order to bring them out of that state and back to life, they were given "all good and pure things on which the god lives." However, even though great numbers of actual offerings were given to the dead, the material offering was not the most important thing. What was essential was the act of devotion itself, which is why substitute offerings were often given instead of actual material goods. This offering bearer is an example of such a substitute: by being placed in the tomb of the deceased, she was to provide him or her with offerings for eternity. **Yasmin El Shazly**

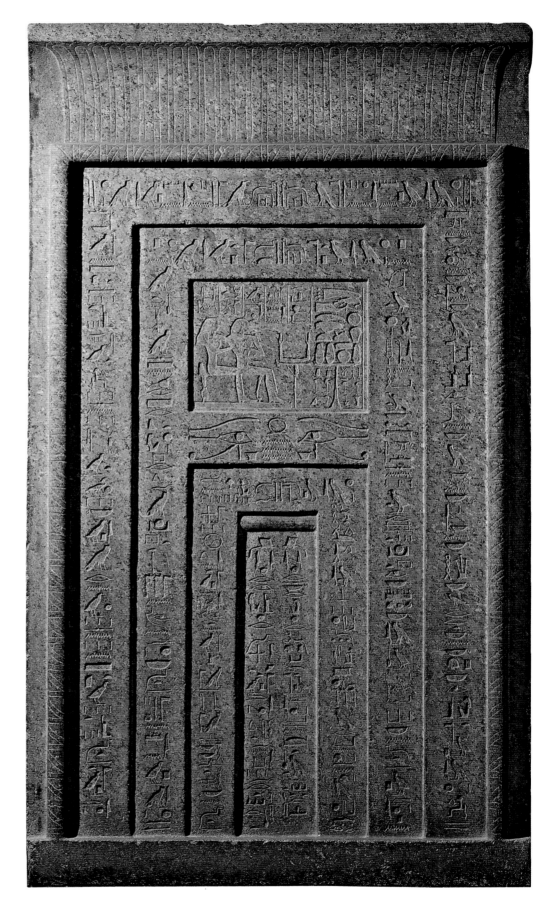

55 False door of Puyemre

Eighteenth Dynasty, reigns of Hatshepsut/
Thutmose III, 1479–1425 BCE; red granite. Height
213 cm (83 7/8 in); width 118 cm (46 5/8 in); depth
34 cm (13 3/8 in). Thebes, el-Khokha, tomb of
Puyemre (TT 39), removed by Maspero, 1882.
The Egyptian Museum, Cairo JE 34047

• An Egyptian tomb basically consisted of an
offering chapel at ground level and a burial cham-
ber below ground. The burial chamber was reserved
for the mummy and was closed except for funerals.
The offering chapel was open to the public. Family
came to visit departed relatives; priests came
to present offerings and recite spells; and tourists
came, then as now, to admire the ornate decora-
tions and, perhaps, say a little prayer.

 As the dead were supposed to dwell in
the beautiful west, the principal offering place
in the tomb was located on the west wall of
the offering chapel. In New Kingdom tombs at
Thebes, the focal point of the cult of the deceased
—the interface between this world and the
beyond—was most often marked by a niche for
statues of the deceased (sometimes along with his
relatives) hewn out of the living rock, less often
by a false door. False doors in primary position
on the western wall are mostly limited to mid-
Eighteenth Dynasty and then only to the highest
and most privileged officials, like Rekhmire,
the vizier of Thutmose III, whose false door is in
Paris,[1] or Senenmut, Hatshepsut's overseer of
works, whose false door is in Berlin.[2] Freestand-
ing monoliths of granite or quartzite, these were
very expensive and prestigious monuments. It
is no coincidence in this age of sun worship that
both of these reddish stones, granite and quartz-
ite, were charged with solar meaning.

 This sumptuous false door in Cairo
belonged to a prominent clergyman, Puyemre,
second prophet of Amun under Hatshepsut
and Thutmose III. A central niche or blind entry-
way is surmounted by a drum representing
the rolled-up reed matting that in real doors
could be pulled down much like a modern window
shade. The doorway to the beyond is nested
within three pair of jambs and four lintels. Top and
sides are framed with a convex molding (torus),
and the whole is crowned with a curved cornice
(cavetto) in the form of a frieze of palm leaves.

 A panel in relief above the doorway shows
Puyemre and his wife, the priestess Senyseneb,
seated to the left of a table heaped with offerings.
Between them and the table is a hieroglyphic
sign in the form of two raised arms atop a pole or
standard. This sign represents the *ka,* or vital
energy, of the deceased, which required nourish-
ment in the afterlife.

 The rest of the door is covered with
inscriptions, the signs painted green. The magical
spells assert and proclaim Puyemre's transforma-
tion into a god, having made a successful passage
to the afterlife. Some of these spells go back hun-
dreds of years, to the texts carved on the walls
inside the Old Kingdom Pyramids: "Puyemre has
arisen as Nefertem, a lotus blossom at the nostrils
of Ra when he rises on the horizon. The gods are
purified at the sight of him, every day and forever:
the second prophet of Amun, Puyemre" (right
middle jamb).[3] Nefertem was the primeval lotus
from which the sun god emerged at the dawn
of creation, an event that was reenacted each day.
There could be no better guarantee of resurrection.
Lawrence M. Berman

1. Louvre C 74; Bertha Porter and Rosalind Moss, *Topographical
Bibliography of Ancient Egyptian Hieroglyphic Texts, Reliefs,
and Paintings.* Vol. 1, *The Theban Necropolis*, 1927, part 1, *Private
Tombs* (2d ed., rev. Oxford, 1964, 1972), 214.

2. Berlin 2066; Porter and Moss, *Private Tombs*, 141.

3. Cf. Raymond O. Faulkner, ed. and trans., *The Ancient Egyptian
Pyramid Texts*, vol. 1 (Oxford, 1969; reprint, Warminster, England,
1985), 61, section 266.

56 Offering table of Khety

First Intermediate Period to Middle Kingdom,
c. 2160–2055 BCE; red granite. Height 80 cm
(31 1/2 in); width 62.5 cm (24 1/2 in); depth 27.3 cm
(10 3/4 in). Provenance unknown. The Egyptian
Museum Cairo JE 67858

• Offering tables were used in Egypt from at
least the first dynasties, if not earlier. Stones were
placed in tombs in front of statue niches or
false doors and were carved in the shape of the
Egyptian hieroglyph for offering (*hetep*). Visitors
to the tomb were expected to pour libations
or water or wine over the stone; hence the small
channel on the top of the table, through which
the liquid would run toward the statue or doorway.
This piece was likely placed in the tomb of a man
who lived around 2000–1900 BCE, for his name,
Khety, identifies the ruling house of Herakleopo-
lis during the First Intermediate Period. Although
this man may not have been royal himself, his
name suggests a link to that general time period
of soon thereafter. His titles are high ones of
both priesthood and administration.[1] The treas-
urer was one of the most important men in Egypt.

The horizontal inscription on the top of the table reads, from right to left: "The venerated one before the great god, the lord of Abydos [Osiris], the beloved god's father, venerated one Khety, vindicated." Below the sculpted images of bread and wine, each of which is inscribed with Khety's name, is an offering formula: "A gift which the king gives: one thousand of bread, beef, fowl, and a good burial for the Treasurer and venerated one Khety."

Beneath the offering sit two images of the god Hapy, a personification of the Nile itself and the nourishment it brings. Each figure is labeled. Left: "Hapy, may he give all offerings." Right: "Hapy, may he give all foodstuffs."
Betsy M. Bryan

1. For the officials in the early Middle Kingdom, see James Allen, "Some Theban Officials of the Early Middle Kingdom," in *Studies in Honor of William Kelly Simpson* (Boston, 1996), 1–26. For other offering tables in Cairo, see Ahmed Kamal, "Tables d'offrandes" (Cairo, 1906–09), CG 23001–23256.

57, 58 Glass vessels

Eighteenth Dynasty, c. 1400–1300 BCE; polychrome glass. Height 9 cm (3 9/16 in); width 6 cm (2 3/8 in); depth 6 cm (2 3/8 in). Sakkara, grave 25, discovered 1923. The Egyptian Museum, Cairo JE 47778

Eighteenth Dynasty, c. 1400–1300 BCE; polychrome glass. Height 8 cm (3 1/8 in); width 5 cm (1 15/16 in); depth 5 cm (1 15/16 in). Sakkara, grave 25, discovered 1923. The Egyptian Museum, Cairo TR 12-3-26-2

• The two vases, in the shape of small kraters, are composed of bright blue glass with yellow, white and blue decoration. The prominent rims and wide necks of both vases are balanced by the swollen bodies and tall bases upon which they rest. The chevron pattern on the neck of the handleless vase ends after spreading a bit past its joint with the body. A similarly colored garland pattern resumes the ornamentation, continuing downward, leaving only the base unadorned. A large handle, extending from below the striped lip down to the shoulder, distinguishes the second vase. Garland patterns also trim this vase, with the colors peaking like waves on the neck and ballooning upward on the body. Two additional handles, placed on the shoulder, follow the decorative style. Vertical bands of color slide down the neck and foot of the object.

Ancient Egyptian artisans created objects from naturally occurring obsidian glass and a manufactured material called faience in prehistoric times, but it was not until the New Kingdom that the techniques for producing a true glass vessel appeared. As early styles of that period indicate, the technology and craftsmen likely arrived from western Asia. A proliferation in the use of glass for decorative objects such as beads, amulets, vessels, jewelry, and inlays began in the reign of Thutmose III, with the quality of glass objects reaching their zenith under Amenhotep III. These small vessels would have held unguents and perfumes destined for use by their owners in the afterlife. The Egyptians believed the world of the dead was similar to the world of the living, so they supplied their burials with the same objects needed in daily life. The costliness and resemblance to precious stones like lapis lazuli, amethyst, and turquoise made glass objects like these popular grave goods for kings, queens, and members of the royal court. Vessels were produced by melting a molten glass mixture of quartz sand, alkali and a mineral-based coloring agent around a clay core. Rods of heated colored glass were then wrapped around the vessel, pulled and draped to create a design. Once the vessel had been cooled in hot ash, the clay core was scraped out, leaving a hollow for the interior of the vessel. The lip could be formed from the reheated piece of glass itself by using tongs, and craftsmen attached the foot and handles separately. Archaeological excavations have uncovered crucibles, unworked glass, broken vessels and the by-products of glass production or glass reworking at various ancient sites in Egypt, including Malkata, Tell el-Amarna, and el-Lisht. These appear to have functioned as centers of glass manufacturing, and operated under the auspices of the pharaoh. **Elaine Sullivan**

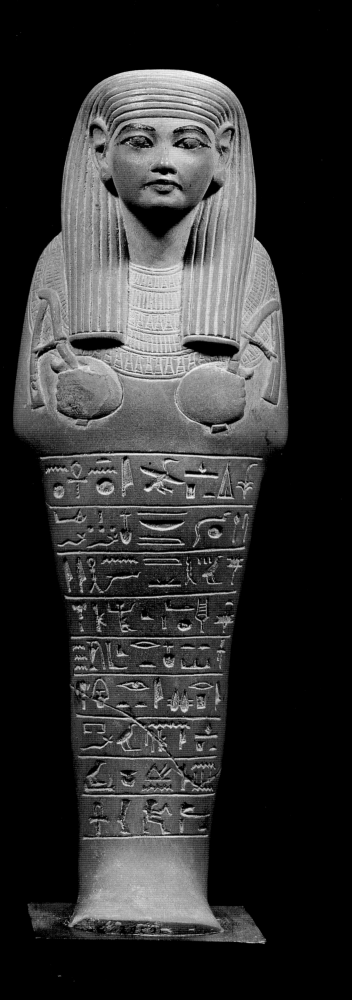

59 Funerary figure of the Adjutant Hat

Late Eighteenth Dynasty, reign of Akhenaten/Tutankhamun, 1352–1327 BCE; limestone. Height 20 cm (7 7/8 in); width 6.5 cm (2 9/16 in); depth 4.5 cm (1 3/4 in). Purchase, Tuna el Gebel. The Egyptian Museum, Cairo JE 39590

· This beautifully sculpted servant figure perhaps originated at the site of Tell el-Amarna, residence city of King Akhenaten of the late Eighteenth Dynasty. The king rejected the traditional gods of Egypt to embrace a single deity, the sun god Aten. Akhenaten condemned the representation and mention of other gods, and he particularly abhorred the great god of Thebes, Amun-Re, and his consort Mut. The inhabitants of Amarna continued to build tombs and have funerary goods made for their burials, but the prohibition of Osiris and other deities left the dwellers in Amarna without the customary guides to the underworld, including the Amduat. They nonetheless placed ushebtis in their burials, modified with inscriptions that omit Osiris and instead invoke Aten.

141

Instead of the standard ushebti text, Hat's inscription bears an offering formula normally found on stelae or on tomb walls. "A gift which the king gives and the living Aten who illuminates every land with his beauty, that he might give the sweet breath of the north, a long [literally high] lifetime in the beautiful west, cool water, wine, and milk for the offering for his tomb, on behalf of the ka [spirit] of the Adjutant Hat, repeating life." Typical of Amarna offerings, the list includes no meats and emphasizes libations.

The facial style of this figure is consistent with the end of the Amarna Period itself, including the thick mouth with downturned corners, ovoid eyes, heavily outlined in black (as compared to the hieroglyphic shaped *wedjat* eyes in cats. 40 and 101), and pierced ears.

The form of the funerary figure itself includes hoes in the hands of the mummy, as well as a seed bag hanging behind Hat's left shoulder. This latter feature became characteristic of ushebtis in the reign of Seti I, some fifty years later, and this is an early example.[1] **Betsy M. Bryan**

1. Jacques-F. Aubert and Liliane Aubert, *Statuettes égyptiennes: chaouabtis, ouchebtis* (Paris, 1974), 55.

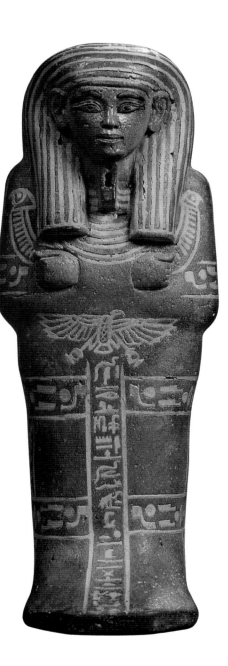

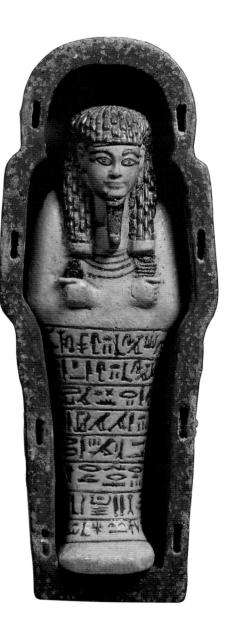

142

60 *Shabti* of Huy with model coffin

Eighteenth Dynasty, reign of Amenhotep III, 1390–1352 BCE; polychrome faience. Mummy: height 14 cm (5½ in); width 4.8 cm (1⅞ in); depth 3 cm (1³⁄₁₆ in). Lid: height 17.5 cm (6⅞ in); width 6.5 cm (2⁹⁄₁₆ in) depth 5 cm (1¹⁵⁄₁₆ in). Bottom: height: 17 cm (6⁴⁄₁₆ in); width: 6.5 cm (2⁶⁄₁₆ in); depth: 4 cm (1⁹⁄₁₆ in). Abydos, acquired 1950. The Egyptian Museum, Cairo JE 88902

· This *shabti* of the king's scribe Huy, also called Amenhotep, is one of a small group made of polychrome faience during the reign of Amenhotep III.[1] His artisans specialized in this painstaking technique, also used in the manufacture of inlaid faience luxury vessels, tiles, and jewelry.[2]

The *shabti* is mummiform and shrouded in white, arms crossed, holding a red *tyet*-knot in his left hand and a green *djed*-pillar in his right. The face is beautifully detailed, with inlaid eyebrows, cosmetic lines, and pupils. The flesh is truly flesh-toned, not the usual red or yellow or otherworldly blue/black/green associated with Osiris, a feature that it shares with the two *shabtis* of Sati in Brooklyn, its closest parallels.[3] There is an inscription in eight horizontal blue lines of Chapter 6 of the Book of the Dead—the spell that empowers the *shabti* to substitute for the deceased when called upon to perform manual labor in the afterlife—in this case for the royal scribe Huy.

The model is a faithful replica of a contemporary gold-on-black coffin, down to the very joints in the wood.[4] Crisscross bands of inscriptions imitate the outer binding straps of a mummy. In the center of the lid, below a vulture with outstretched wings, is a prayer to the sky goddess Nut: "Words spoken by the Osiris, the royal scribe Amenhotep: 'O my mother Nut, stretch yourself over me.'" The complete prayer would have continued, "that I may be placed among the imperishable stars which are in you, and that I may not die." *shabti* and coffin thus reflect two different, but coexisting, traditions concerning the afterlife. Implicit in the *shabti* spell is the belief in an afterlife modeled on life on earth, spent performing agricultural tasks in service to the gods. The prayer to Nut, however, envisions an afterlife in heaven among the stars, carefree and without obligation.

The short columns qualify Amenhotep as "one honored by" Anubis, god of embalming, and the Four Sons of Horus, who protect the body, certifying that Amenhotep has been provided with everything necessary to make a successful transition from this life to the next. The gods themselves appear in the spaces between the inscriptions.

Called Huy — short for Amenhotep — on the *shabti* and Amenhotep on the model coffin, the same individual is represented. His only title is royal scribe, but this meant being a member of the king's inner circle: he was no office secretary, but secretary of labor, agriculture, or defense. Two royal scribes called Amenhotep/Huy are known from this reign. One was the famous Amenhotep, son of Hapu, represented in this book by his splendid scribe statue. The other was the king's steward in Memphis, the northern capital, certainly a lucrative position.[5] The high quality of these pieces would have done credit to either.

One usually finds *shabtis* in tombs, but neither of the officials discussed above were buried at Abydos, where these artifacts were found. Amenhotep, son of Hapu was buried at Thebes, Amenhotep the steward, at Sakkara. There was a tradition, however, of sending a proxy *shabti* to Abydos, holy city of Osiris, a tradition strengthened in Eighteenth Dynasty, when the tomb of King Djer was identified with the tomb of Osiris.[6] Such *shabtis* tended to be very fine gifts of the king.[7] This *shabti* and model coffin meet these criteria eminently well.

Lawrence M. Berman

1. The others are the *shabti* of High Priest Ptahmose in Cairo, CG 48406 (Mohamed Saleh and Hourig Sourouzian, *The Egyptian Museum, Cairo: Official Catalogue* [Cairo/Mainz, 1987]) and the two *shabtis* of Lady Sati in Brooklyn, 37.123E and 37.124E (Betsy M. Bryan, "Funerary Equipment," in Arielle P. Kozloff and Betsy M. Bryan, *Egypt's Dazzling Sun: Amenhotep III and His World* [Cleveland, 1992], 328–29, no. 70, and Florence Dunn Friedman, "*Shabti* of Lady Sati," in Florence Dunn Friedman, ed., *Gifts of the Nile: Ancient Egyptian Faience* [Providence, 1998], 240, no. 150).

2. See Kozloff and Bryan, *Egypt's Dazzling Sun*, 398–400, 404, 445–47, nos. 100–102, 106, 124–26; Friedman, "*Shabti* of Lady Sati," 183–84, nos. 23–25.

3. Bryan, "Funerary Equipment," 328–29, no. 70, and Friedman, "*Shabti* of Lady Sati," 240, no. 150.

4. See Lawrence M. Berman, "Coffin of the Singer of Amen, Henut-wedjebu," in Kozloff and Bryan, *Egypt's Dazzling Sun*, 312–17, no. 61.

5. For the steward of Memphis, Amenhotep, see Berman, "Coffin of the Singer of Amen," 54–55 and 322–323, no. 65.

6. Barry Kemp, "Abydos" (pp. 36–37) in Wolfgang Helck and Wolfhart Westendorf, eds., *Lexikon der Ägyptologie,* vol. 1 (Wiesbaden, 1975).

7. Hans D. Schneider, *Shabtis: An Introduction to the History of Ancient Egyptian Funerary Statuettes with a Catalogue of the Collection of Shabtis in the National Museum of Antiquities at Leiden,* vol. 1 (Leiden, 1977), 268–70.

61 *Ushebti* of Khabekhnet

Nineteenth Dynasty, c. 1270 BCE; painted limestone. Height 24.3 cm (9 9/16 in); width 7 cm (2 3/4 in); depth 7.3 cm (2 7/8 in). Tomb of Sennedjem, no. 1, at Deir el-Medina. The Egyptian Museum, Cairo JE 27217 / CG 47745

· This *ushebti* (funerary figure) of Khabekhnet, the eldest son of Sennedjem, was found in the tomb of his father, Sennedjem, at Deir-el-Medina. *Ushebtis* (also spelled *shabti* and *shawabti*) were placed in the tomb to perform any labor that was assigned to the deceased in the afterlife. They are magical figures meant to be activated by the spell from the Book of the Dead written "on them."[1] They would then be expected to carry sand from east to west and to cultivate land. The number of the *ushebtis* varied in the New Kingdom (1550–1069 BCE), from a few dozen to hundreds. More than sixty-five *ushebtis* belong to the family of Sennedjem, while Khabekhnet himself had seven. By the Third Intermediate Period (1069–664 BCE) it was standard to have 401 *ushebtis*, including 365 workmen, one for each day of the year, plus 36 overseers, one for each decade (week of ten days) to direct the work.

The mummiform statuette has a long, full wig with bands painted red and yellow at the ends. The painted red face is detailed with ovoid, but not slanted, eyes and eyebrows, both of which are drawn in black to indicate cosmetic bands. A broad collar in several rows is visible, and the arms are crossed over the chest, each hand holding a hoe. Painted oblong bags are incised at the back of each shoulder.

The *ushebti* text is made up of eight lines of hieroglyphic inscription running in horizontal lines around the body, from Chapter Six of the Book of the Dead:

Illumination of Osiris, servant in the place of truth, Khabekhnet justified. He says: O my [this] *ushebti,* as to the assignment thereof, of the Osiris, servant in the place of truth, Khabekhnet justified, for all works which are wont to be done in the god's land, or indeed, an obstacle implanted for me, for a man at his duty, in order to plant the field, in order to irrigate the lands, to move the sand from the west to east, as to the assignment thereof at any time, daily, [say] "here I am the other, here I am."

Adel Mahmoud

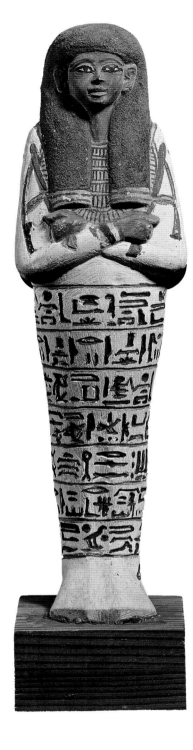

1. For the genealogy of Sennedjem's family, see M.L.Bierbrier, *The Late New Kingdom in Egypt (c. 1300-664 BC): A Geneological and Chronological Investigation* (Warminster, England, 1975), 30–33. For the discovery of the tomb of Sennedjem, see Georges Daressy, "La Trouvaille de Sen-nedjem," *Annales du Service des Antiquités de l'Egypte [ASAE]* 28 (1929): 7–11; Eduardo Toda, "Découverte et L'inventaire du Tombeau de Sen-nezen," *ASAE* 20 (1921): 45–158; and Bernard Bruyère, *La tombe no. 1 de Sen-nedjem à Deir el Medineh* (Cairo, 1959), 14. For the *ushebti* spells, see Hans D. Schneider, *Shabtis: An Introduction to History of Ancient Egyptian Funerary Statuettes with a Catalogue of the Collection of Shabtis in the National Museum of Antiquities at Leiden,* (Leiden, 1977).

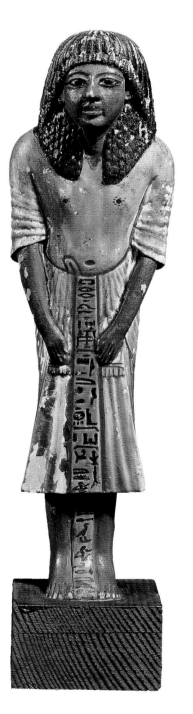

62 Funerary figure of Sennedjem

Nineteenth Dynasty, c. 1300 BCE; painted limestone. Height 22.5 cm (8⅞ in); width 6.5 cm (2⁹⁄₁₆ in); depth 6 cm (2⅜ in). Tomb of Sennedjem, no. 1 at Deir el-Medina. The Egyptian Museum, Cairo JE 27221/CG 47744

· This funerary statuette of Sennedjem is unique from his tomb in that it is a figure wearing the dress of daily life rather than the mummy shroud commonly seen on *ushebti*s. Statuettes such as this may have been intended to perform ritually with the *ushebti*s, which were expected to labor in the next world. On the other hand, this figure may be a small-scale representation of Sennedjem that was more votive in function. Although no other statuette like this exists for Sennedjem, one of him and his son Khonsu are in a private collection, the Harer Family Trust.

Sennedjem is shown standing, his hands resting on his kilt. The tomb owner wears an elaborate wig with echeloned locks hanging down below the shoulders and a fringe of curls around the round face. The white linen garments, including a pleated kilt and shawl, are covered with yellowed varnish, which we see in tomb paintings as well. During banquets perfumed oils were often placed on the heads of guests; when the oils melted, they stained clothing, as we see here. Sennedjem is providing us a glimpse of his elite society life.

An inscription runs vertically down Sennedjem's kilt and continues to his feet. The text reads, "Everything which goes forth upon the offering table of Amun in Ipet-sut, that is, the Temple of Karnak, for the *ka* of Sennedjem, justified, happy in peace."

Sennedjem, who lived in Deir el-Medina on the western side of Luxor, was an artisan during the reign of Seti I (1294–1279 BCE). Luxor was the home of the artisans responsible for excavating and decorating the royal tombs. Sennedjem's title was *Sedjem ash em set maat,* or "servant [or workman] in the place of truth," referring to work in the royal tombs and the Valley of the Kings. Although it was common in the Eighteenth and Nineteenth Dynasties in Deir el-Medina, the title was largely replaced later. Sennedjem was the son of Khabekhnet and Tahenu, whose tomb was next to his. Sennedjem's wife was Ii-neferti, and together the couple lived in Deir el-Medina in a house located close to their tomb. They had at least ten children, most of whom were buried in Sennedjem's tomb.

The tomb of Sennedjem was discovered in February 1886 under the supervision of Gaston Maspero, then Director of Antiquities. It was full of the funerary equipment of the family, totaling more than 165 items. Most of the objects were moved to the old Boulaq Museum in Cairo, while the others were scattered and today are principally in Cairo and the Metropolitan Museum of Art, New York. **Adel Mahmoud**

1. For the title *sedjem ash em set maat* (literally, "the one who hears the call in the Place of Truth"), see Jaroslav Çerný, *A Community of Workmen at Thebes in the Ramesside Period* (Cairo, 1973).

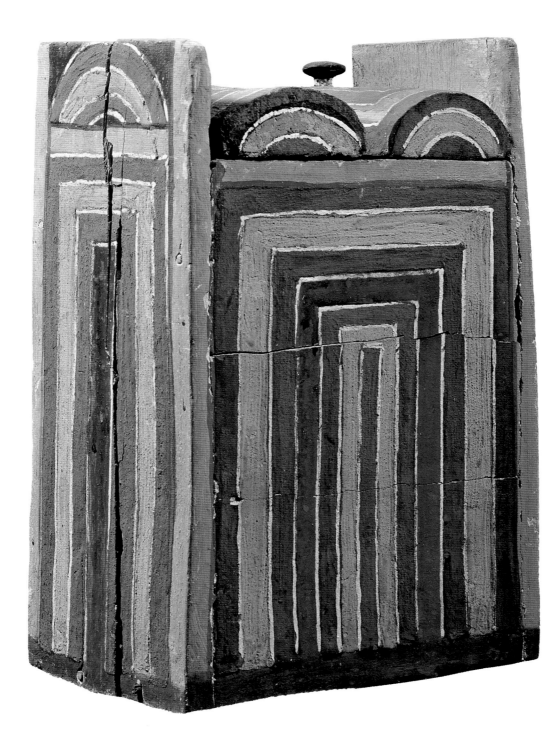

63 *Ushebti* box of Khabekhnet

Nineteenth Dynasty, c. 1270 BCE; painted wood.
Height 28.5 cm (11¼ in); width 18.5 cm (7 5⁄16 in);
13 cm (5⅛ in). Tomb of Sennedjem, no. 1, at Deir
el-Medina. The Egyptian Museum, Cairo JE 27282

• A double *ushebti* box in the name of Senne-djem's son Khabekhnet housed funerary figures. The boxes took the form of the shrine of the north relating them to the prehistoric kings of Lower Egypt. The structure is distinguished by a barrel-vaulted roof (compare the shrine of the south, represented by the shape of the sarcophagus of Khonsu, cat. 68). Two knobs on the lids (one missing) and two on the upper part of the front (both missing) were used to tie the box shut with a small cord and fasten it with a terra-cotta seal, the classical manner of closing the doors. A number of *ushebti*s of Khabekhnet would have stood inside this box. He had at least eight *ushebti* boxes, all found in Sennedjem's tomb rather than his own. The number of *ushebti*s owned by Khabekhnet remains uncertain, but it could have been dozens.

Like the other boxes from his father's tomb, this one was once mounted on a sledge runner. It has been plastered lightly and painted, with a yellow ground color and black inscriptions.

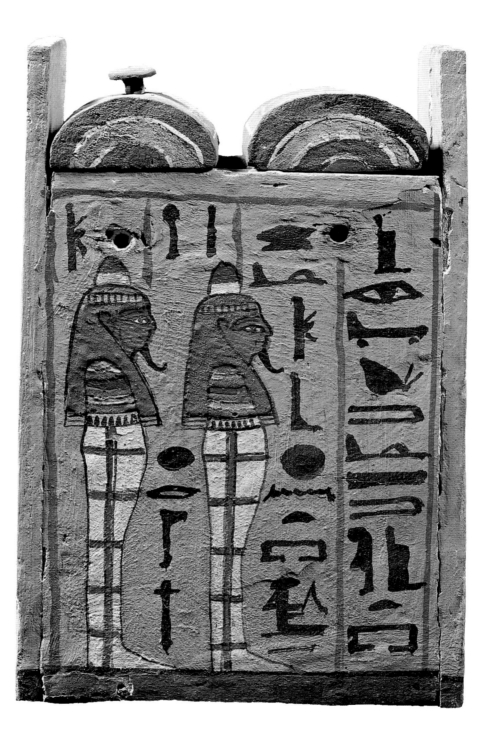

146

Four vertical columns of inscription read, "Osiris, the servant in the place of truth Khabekhnet, justified by the great god." On the front, two mummies are shown, carefully wrapped, covered with a funerary mask, and surmounted by an unguent cone.

Khabekhnet II, named for his paternal grandfather, was the eldest son of Sennedjem and Ii-neferti. He had the same title as his father, "servant in the place of truth." Khabekhnet was born during the reign of Seti I (1294–1279 BCE) or earlier, and functioned during that of Ramesses II (1279–1213 BCE). His own tomb lay next to that of his father. Khabekhnet married Sahte, the daughter of sculptor Piay and Neferkha. He had many children, all mentioned in the tombs of Sennedjem and Khabekhnet. Khabekhnet also married Isis, who was probably his niece, the daughter of his brother Khonsu.[1] On the lid of the sarcophagus of Khonsu, Khabekhnet appears with Isis in front of Khonsu and his wife Tamaket. The other sides of the box are painted with frames, suggesting the false doors in the ancient niched temples facades through which the *ushebtis* could enter and depart when needed. **Adel Mahmoud**

1. For the genealogy of Sahte, see M.L. Bierbrier, *The Late New Kingdom in Egypt (c. 1300–664 BC): A Genealogical and Chronological Investigation* (Warminster, England, 1975), 21, 24, 30–33, 125 no. 91. For the marriage of Khabekhnet to Isis, see Jaroslav Černý, Bernard Bruyère, and J.J. Clère, *Repertoire Onomastique de Deir el Medineh* (Cairo, 1949), 1.

64 Stool from the tomb of Sennedjem

Nineteenth Dynasty, c. 1300 BCE; painted wood. Height 36 cm (14 3/16 in); width 39 cm (15 3/8 in); depth 32 cm (12 5/8 in). Tomb of Sennedjem, no. 1, at Deir el-Medina. The Egyptian Museum, Cairo JE 27290

• The ancient Egyptians used a number of different types of seats, from plain low stools to the folding stools and armchairs with backrests. The lattice stool seen here was probably the most common and is widely represented in Theban tomb scenes as a seat for people of all ranks.

The construction of this stool is simple and elegant, with four slender legs joined by tenon and mortise to a sloping seat. Crossbars between the legs provide stability, and the space below the seat on all four sides was strengthened with vertical struts and angled braces, which created a design for the sides. Indeed, tables were fashioned in nearly the same way but with flat tops in place of the curved seats. These lightweight tables were portable and are often seen in scenes with bearers carrying food for banquets. Likewise such tables and seats are shown being carried to the tomb during funeral processions.

The seat is formed of curved wooden slats and woven plant fibers, which pass through holes in the edge of the seat frame. It was sloped for comfort. It is noteworthy that this seat and several others from Sennedjem's tomb look worn on the top, indicating certain use in life, probably moved inside and out as needed.

Sennedjem's house would have been furnished with tables and chairs for receiving guests. The range of furniture discovered in his tomb show that Sennedjem played an important social role with his colleagues and neighbors in Deir el-Medina. **Adel Mahmoud**

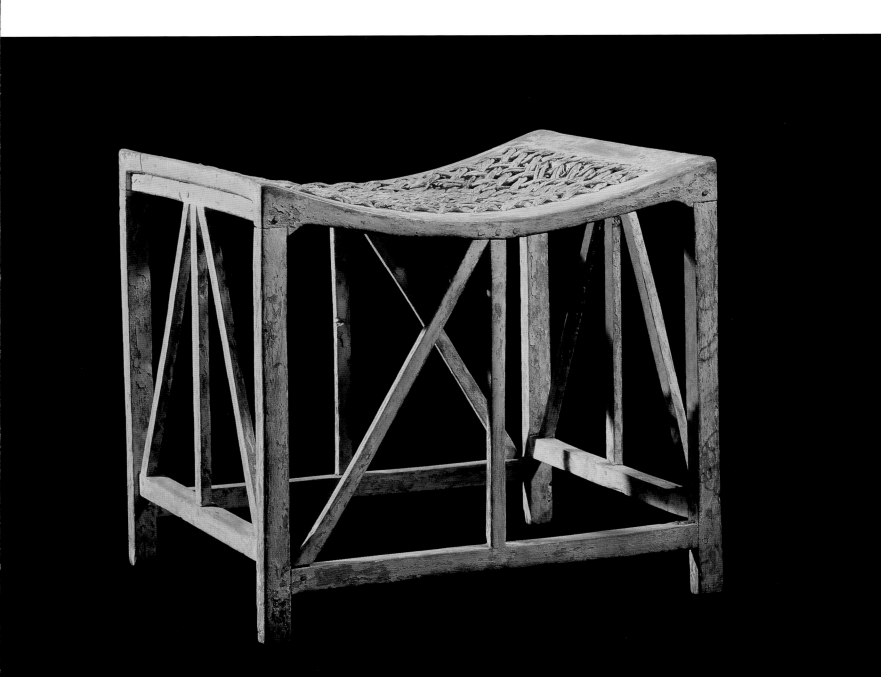

65 Triangle level of Sennedjem

Nineteenth Dynasty, c. 1300 BCE; painted wood. Height 36.5 cm (14 3/8 in); width 36.5 cm (14 3/8 in); depth 2 cm (13/16 in). Tomb of Sennedjem, no. 1, at Deir el-Medina. The Egyptian Museum, Cairo JE 27258

• The ancient Egyptian architects and craftsmen used the triangular level and plumb level to ensure that all building surfaces were smooth and perfectly aligned. From the tomb of Sennedjem came a set of these tools, including a royal cubit rod, a triangle level, two plumb levels, two right squares, and several other pieces. Sennedjem may have used these instruments to help build and decorate the tombs of Seti I and Ramesses II in the Valley of Kings, as well as his own splendid burial place.

This triangle level is constructed of two diagonal pieces of wood joined at right angle, with a short horizontal piece running between these two. The plumb bob in the shape of a heart, is suspended by a string from the top of the right angle, when the level is placed on a flat surface, the string of the plumb would fall exactly in the middle of the marks incised in the center of the horizontal piece. If the surface were not properly aligned, the plumb would then indicate the necessary corrections. The inscription that runs around the triangle asks the god Ptah and Re-Horakhty-Atum-Hemiunu for burial and benefits in the afterlife for the *ba* of Sennedjem.
Adel Mahmoud

66 Mummy bed of Sennedjem

Nineteenth Dynasty, c. 1300 BCE; painted wood.
Height 22.5 cm (8⅞ in); length 175 cm (68⅞ in);
width 55.5 cm (21⅞ in). Tomb of Sennedjem, no. 1,
at Deir el-Medina. The Egyptian Museum, Cairo
JE 27254

• Like most Egyptian furniture, the bed of Senne-
djem was made of local woods, pieced together.
Two long curved side rails and four wooden slats
across the long sides are held together by tenons
and fixed by a small wedge. The short legs are
carved in the form of a lion's legs and attached by
tenons to the frame. Acacia was probably the
most widely used of the native trees, not only in
the making of furniture but also in boat building
and large construction projects. The selection
of wood for felling was an important process,
for lumber had to be cut from straight trunks of
good quality having sufficient heartwood with
few defects. In tombs of families less affluent than
Sennedjem's, furniture might be built of several
types of wood pieced together from small seg-
ments. This manufacturing method was also
commonly used for coffins in the Third Interme-
diate and Late Periods (1069–332 BCE).

Nine pieces of furniture were found in
the tomb of Sennedjem: one chair, one bed, and
one stool for Sennedjem, two stools for his wife
Ii-neferti, one stool for Mes, a son of Khabekhnet
and grandson of Sennedjem, and two stools and
one offering table without a name. The stools,
like the bed, are painted white, but they look
worn, indicating use during life. The bed, however,
may well be specifically a funerary bed, for the
sides of the bed are decorated by two long snakes
painted yellow with black markings and outlines.
The snake head of one and the jackal head of
the other face each other on one end of the bed,
while the tails overlap on the other end. Perhaps
the jackal head on one snake is an allusion to
Anubis, whose presence signals preparations of
the mummy. Like the snakes that surround the
sun god in his burial place in the Sixth Hour
of the Amduat, the snakes here protect the corpse
from danger. They also identify the resting place
of the blessed dead, a follower of Osiris, who,
at the command of the sun god, wakes from his
sleep of death and is renewed and provided with
a new body. The two central slats are inscribed
in black on a yellow background: "The Osiris, the
servant of the two lands, Sennedjem; The blessed
Osiris, Sennedjem, justified." **Adel Mahmoud**

67 Jewelry box from the tomb of Sennedjem

Nineteenth Dynasty, c. 1300 BCE; painted wood. Height 11.5 cm (4½ in); width 27 cm (10⅝ in); depth 24.5 cm (9⅝ in). Tomb of Sennedjem, no. 1, at Deir el-Medina. The Egyptian Museum, Cairo JE 27270

• Found among the funerary equipment of Sennedjem's family were nine jewelry boxes, two of which are inscribed for Sennedjem's wife Ii-neferti.[1] Two others carry the name of her son Khabekhnet, and another that of Ramose, also a son of Sennedjem's. Four are uninscribed, as is this example.

Linen, cosmetic articles, jewelry, and personal effects were frequently stored in boxes such as this. The excavated jewelry of Sennedjem's family included three pectorals for Sennedjem, two pectorals and one necklace for Khonsu, two rings for his mother, and one pectoral without an associated name. It is quite likely that other personal items were removed from the tomb in antiquity.

This rectangular box rests on four short legs. Formed of several pieces of wood held together by tenon-and-mortise construction, the box has a flat lid that opens by two pivoting hinges. There were originally two knobs: one on the lid and the other, now missing, on the front. The two knobs allowed the box to be tied shut by small cord and then stamped with a mud seal in the classical manner of closing all doors and containers.

The sides of the box are painted in black, white, and red decoration, in imitation of red cedar surrounded by ivory inlay, as if it were fabricated from costly imported wood. The lid is painted with a pattern of repeating hanging lotus friezes, a design often used around the tops of tomb walls and as garlands on necklaces.
Adel Mahmoud

1. One is in the Egyptian Museum, Cairo, and the other is in the Metropolitan Museum of Art, New York.

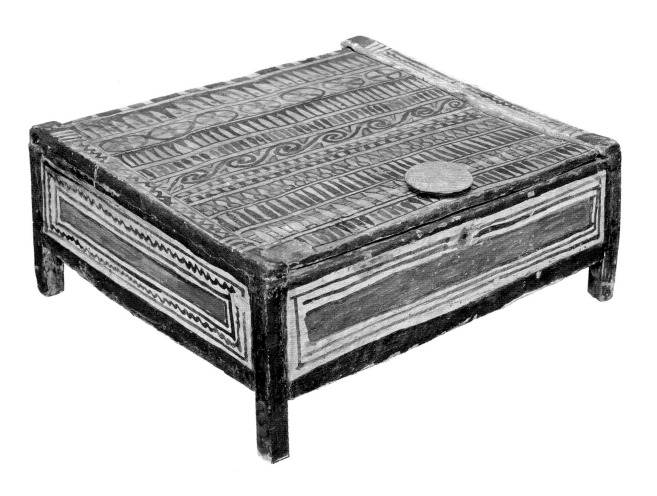

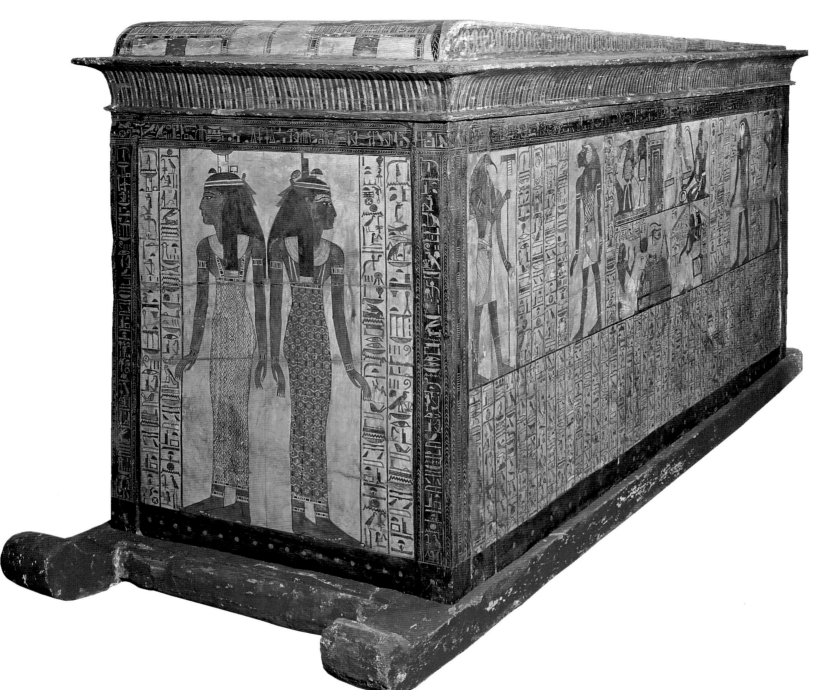

68 Sarcophagus of Khonsu

Nineteenth Dynasty, c. 1270 BCE; stuccoed, painted, and varnished wood. Height 116 cm (45 11/16 in); length 236 cm (92 15/16 in); width 99.5 cm (39 3/16 in). Khonsu and sled: Height 122 cm (88 in); length 261 cm; width 94 cm (32 in). Tomb of Sennedjem, no. 1, at Deir el-Medina. The Egyptian Museum, Cairo JE 27302

• Khonsu was a son of Sennedjem and had the same title as his father, "Servant in the Place of Truth." He may have helped decorate and equip the tomb of Ramesses II (1279–1213 BCE). Khonsu married Tamaket, with whom he had three sons and one daughter. He died somewhere between fifty and sixty years of age.

The sarcophagus of Khonsu is one of most important funerary objects found in the splendid tomb of Sennedjem.[1] The sarcophagus contained two anthropoid coffins of Khonsu, one inside the other, and a mummy mask covering the head.

The coffins are now in the Metropolitan Museum of Art, New York, while Khonsu's mummy was transferred in 1933 to the Peabody Essex Museum, Salem, Massachusetts.

The box was held together by tenon on the long sides and mortise on the small sides to be assembled over and around the mummy. The sarcophagus was mounted on a removable sledge runner, to facilitate its transport from the place of mummification to the tomb. It was

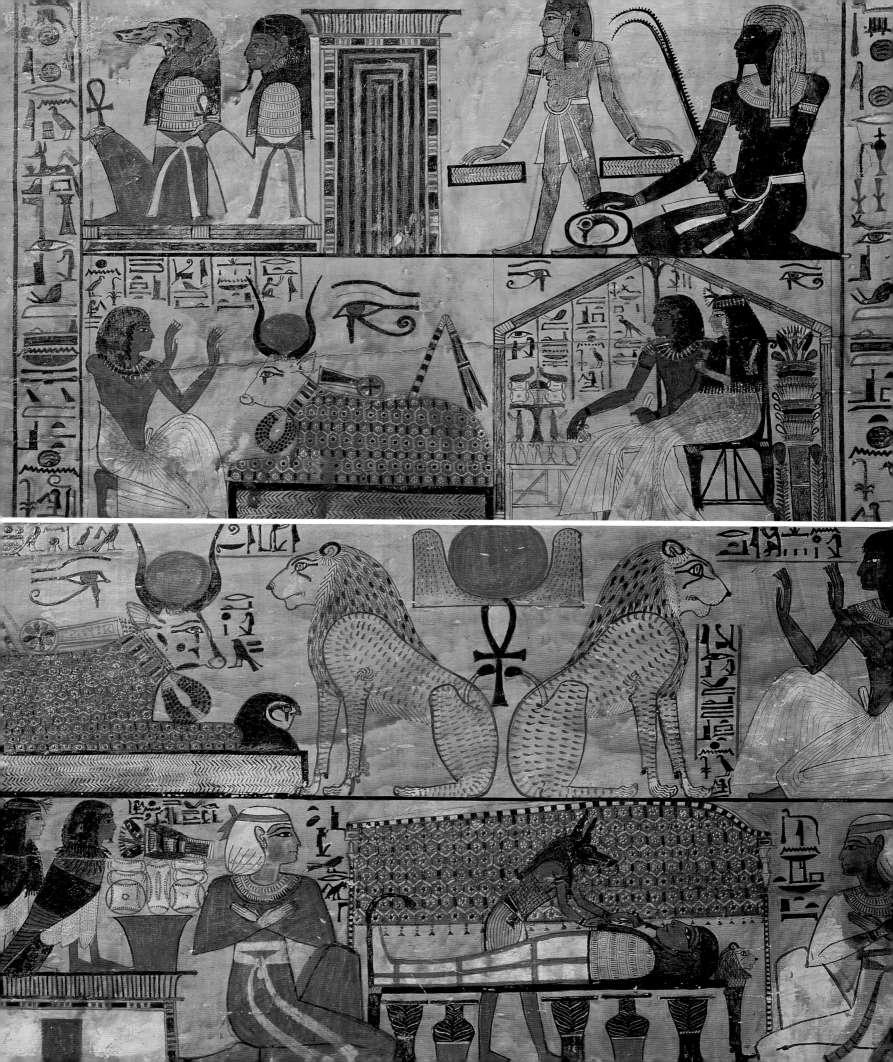

furnished and curved with sloping lid below the edge of the roof, a decorative cavetto cornice with a stylized frieze. Its roof shape is that of the shrine of the South, an archaic architectural form originally reflecting construction of wood posts and reeds. The sloped roof of the early shrine was used throughout Egyptian history for shrines and boxes that contained images of divine beings, including the deceased.

The sarcophagus was painted with beautiful scenes of the afterlife. On the two long sides, the text and the vignette are taken from the Book of the Dead. The short sides are decorated with the goddesses who defend the mummy; on the north side are Selket and Neith, who were responsible for protecting the deceased's head (p. 154). Before each goddess is her speech written in three vertical columns. On the south side are Nephthys and Isis, who were charged with protecting the deceased's feet.

The west side of the sarcophagus is divided into two registers, the upper one showing ibis-headed Thoth twice on each side. Two of the Four Sons of Horus are shown as well — human-headed Imsety on the right and jackal-headed Duamutef. In the middle of the upper register is a vignette of Chapter 17 of the Book of the Dead, an introduction to many of the important features of the next world. Khonsu is shown adoring double lions who represent "yesterday" and "tomorrow," with the horizon resting between them to suggest where the sun will rise. Behind the scene is the cow goddess Mehet-weret, "the great flood," associated with the goddess Hathor (p. 152, bottom).

In the lower scene the deceased's mummy, lying in a tent on a lion-headed bed, is attended by Anubis, who completes the embalming processes. The *bas* of Khonsu and his wife Tamaket appear in the scene to the left, watching the preparation of the corpses, with which they must join to complete the regeneration process. Bread and flowers, offerings for the mummies, also suggest that the necessities of life will be required for rejuvenation.

The lowest register contains forty vertical columns of text from Chapter 1 of the Book of the Dead, the subject matter of which is the funeral ceremony, consisting of several stages and dramatic scenes. The main purpose was to place the deceased in the tomb to be revitalized in the afterlife. The east side also shows Thoth twice in the upper register. Two sons of Horus — baboon-headed Hapy and falcon-headed Kebehsenuef — also appear.

Another vignette of Chapter 17 of the Book of the Dead occurs here as well. Khonsu is shown adoring the celestial cow (p. 152, top). Nearby he and his wife are seated in a tent, where we see them holding a playing piece for the game *senet*. The game, which means "passing over," symbolized the preparations for entering the next world. It was played in real life but was equally appropriate for the funerary setting. The lower register has forty-three vertical columns of the Book of the Dead.[2]

The lid is decorated with panels showing the funerary deities, and Khonsu and Tamaket kneeling in adoration in the corners.

Adel Mahmoud

1. Khonsu's sarcophagus is similar to that of his father, Senne-djem, in the Egyptian Museum, Cairo, JE 27301.

2. For more details on the Book of the Dead, see Raymond O. Faulkner, Ogden Goelet Jr., and Carol Andrews, ed. and trans., *The Ancient Egyptian Book of the Dead* (San Francisco, 1994).

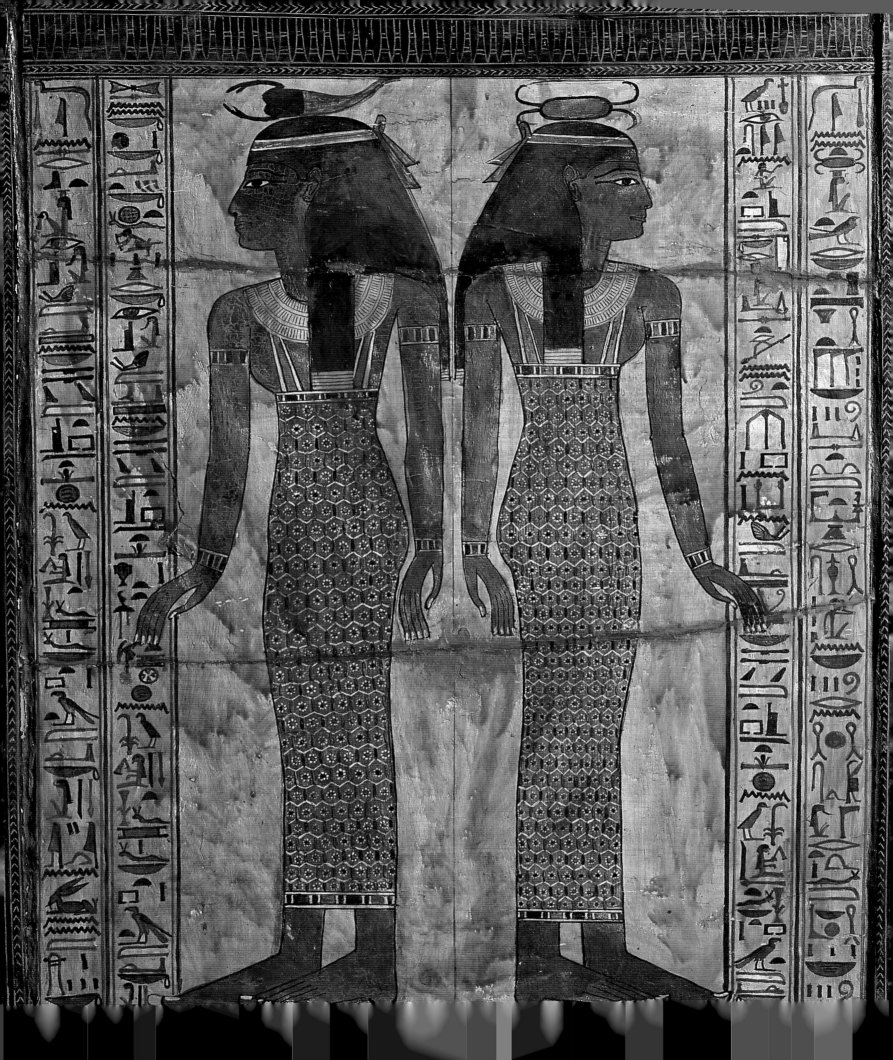

69 Clappers

Seventeenth Dynasty, c. 1580–1550 BCE; ivory. Length 20 cm (7⅞ in); width 6.5 cm (2⁹⁄₁₆ in); depth 1 cm (⅜ in). Provenance unknown. The Egyptian Museum, Cairo CG 69224

New Kingdom, 1550–1069 BCE; ivory. Length 25.5 cm (10¹⁄₁₆ in); width 10 cm (3¹⁵⁄₁₆ in); depth 1 cm (⅜ in). Deir el-Medina. The Egyptian Museum, Cairo CG 69247

· These two clappers, carved from ivory hippopatamus incisors into the shape of the human arm, belong to the genre of one of ancient Egypt's most popular and enduring musical instruments. Both culminate in the shape of a left hand with long, thin digits. One of the clappers has an inscription, which names its owner "Hereditary Princess, King's Daughter Nensemekhtuef, may she live" (or Life, Prosperity, Health!). This name means "he shall not be forgotten," perhaps here referring to a deity. The inscribed clapper retains traces of carved fingernails, and a bracelet design at the wrist. The other clapper also sports bracelet ornamentation but no fingernail markings. It has a small hole at its upper end, which would have been used to tie it to another clapper or around the musician's wrist. While the decorative sides of the clappers maintain the rounded outer surface of the original material, their interior sides are flat.

Clappers appear in the archaeological record of Egypt and Southern Palestine from the fifth millennium BCE. The earliest examples display a boomerang shape, but later clappers can also take a more vertical, pear shape. The top of the instrument often was carved into the form of a hand, but examples with lotus flowers or the heads of gazelles, cows, ducks, humans, and the goddess Hathor all exist. Designs covering the rest of the instrument consist of incised dots and circles, crisscrosses and bracelet designs as seen on the examples here. Musicians played the clappers by beating two against each other, creating a snapping sound that could maintain a rhythm. Unfortunately, no examples of musical notation have yet been identified, so ancient Egyptian music can not be reproduced. Some tomb contexts have revealed exceptionally fine and delicate clappers, suggesting that a number of individuals had these objects produced specifically for their use in the next world.

It is evident that music played a vital role in Egyptian life, in both celebrations and religious rituals. Temple and tomb reliefs depict groups of professional musicians performing and practicing. By the period of the Old Kingdom (2686–2125 BCE), individuals held titles that related to their musical functions—a tradition that would remain important to both women and men throughout later periods. A Middle Kingdom (2055–1650 BCE) tomb shows its owner Senbi receiving *menat* necklaces (a type of beaded necklace that could be shaken to produce a rattling sound) while clapper-wielding attendants stand by. The corresponding inscriptions reveal a ritualistic association with Hathor, whose strong affiliation with music is clearly depicted at her temple in Dendera. The god Bes also was linked with music, and images of him dancing, playing the harp or shaking a tambourine can be found.

Elaine Sullivan

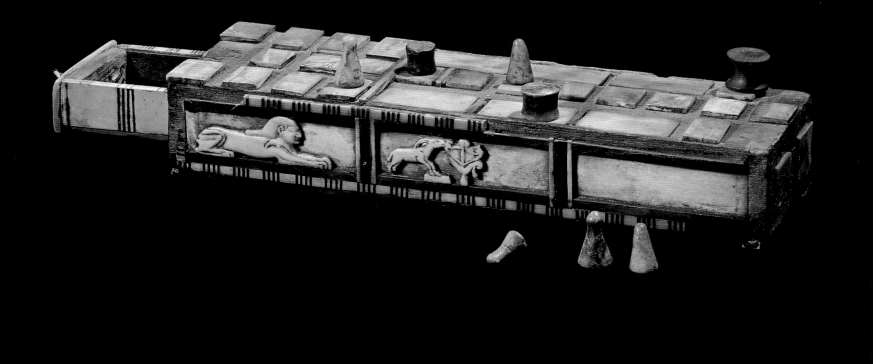

70 Senet game

Seventeenth Dynasty, c. 1580–1550 BCE; ebony, ivory, and faience. Height 5 cm (1¹⁵⁄₁₆ in); width 27.5 cm (10¹³⁄₁₆ in); depth 8.5 cm (3³⁄₈ in). Thebes, Dira Abu el-Naga, tomb of Akhor. The Egyptian Museum, Cairo CG 68005

- The board game known as *senet* is attested throughout the entire span of ancient Egyptian history. This example is typical of many created during the peak of the game's popularity, the New Kingdom and Ramesside Period (Eighteenth to Twenty-first Dynasties, c. 1550–1000 BCE). It has pieces in the shape of cones and cylinders, which were stored in a drawer in the body of the gaming board itself. In this case, the gaming pieces (not original to this set) are of faience, while the board is crafted of ebony and ivory. A recumbent sphinx and an ibex grazing on a tree decorate two of the panels in the board's side.

A game for two players, *senet* seems to have remained relatively unchanged throughout its long history. Each player had five pieces (seven in the Old Kingdom 2686–2125 BCE), which were maneuvered on a playing surface of thirty squares arranged in three rows of ten. This surface is on one side of Akhor's board; the other had twenty squares and eight rectangles for a slightly different game.

The exact rules of *senet* are unknown, but occasional references in Egyptian texts and scenes, as well as clues from the gaming boards themselves, have made possible the reconstruction of its general principles. Players apparently moved their pieces through the thirty squares from the upper left to lower right and then off the board. Moves were determined by casting four throwsticks or two astragals (the square-shaped anklebones of sheep or other mammals), and the game ended when all the pieces of one player had left the board. The squares are occasionally inscribed, indicating that some were considered disadvantageous, such as square 15 or 16 (5th or 6th from the right in the middle row), known as the "House of the Net." Square 26 (5th from the right in the bottom row) is often marked with the word *neferu* "end": from there, a piece

could move to one of the last three squares and then apparently required an exact throw to leave the board. Square 27, however, was considered a pitfall: it was often marked by the hieroglyph for "water," and texts suggest that a piece landing there had to go back to the middle or to the beginning of the board.

Senet was undoubtedly enjoyed as a pastime, but like all ancient Egyptian artifacts it was also invested with a deeper symbolic significance. *Senet* means "passing" and may have referred initially to the movement of the game pieces across and off the board. Their journey, however, was also seen as a metaphor for the nightly passage of the sun and the spirits of the deceased through the dangers of the netherworld toward new life at dawn. This cycle of nightly passage and daily rebirth as a spirit among the living was the ancient Egyptian vision of the afterlife. For that reason, senet games were often included as part of the burial equipment in New Kingdom tombs, as this one was, and the playing of *senet* was occasionally depicted in funerary papyri or on the walls of tomb chapels.
James Allen

71 Frog

New Kingdom, 1550–1069 BCE; ivory. Height 3.5 cm (1 3/8 in); width 3.5 cm (1 3/8 in); depth 5.5 cm (2 3/16 in). Provenance unknown. The Egyptian Museum, Cairo CG 68182

· Examples of the ancient Egyptian love of sports, games, and toys spring forth from the numerous depictions of recreation shown on tomb walls. Actual items of entertainment found—such as dolls, leather-covered balls, board games, and toy animals—were included as grave goods by their owners. This amusing frog boasts a hinged jaw attached under its belly, which can be lowered and then snapped shut with the pull of a string. It sits on a rounded base which retains most of its left foot, although the upper portion of this leg is broken off. The dark, bulging eyes are made from a different material. Other examples of animals with moving parts have been uncovered. The fragility and costliness of their materials puts into doubt whether these objects ever served as toys themselves, but similarly conceived items, including a wooden cat whose mouth opens and a clay mouse with a movable wooden tail and jaw show that the Egyptians did create playthings out of less delicate materials.

The frog (named *bekhen* or *kerer* in the Egyptian language) was a common domestic motif in ancient Egypt, likely because of its link to concepts of fertility. Both frogs and toads (rarely differentiated by the Egyptians) achieved fame for producing copious offspring. The goddess Heket, who manifested herself in the shape of a frog, or as a woman with a frog's head, was associated with childbirth. In Egyptian myth, she watched Khnum form the divine child on his potter's wheel. Heket is shown on the divine birth scenes of Hatshepsut on the Deir el-Bahari temple. Representations of frogs can be found on apotropaic wands, objects associated with the protection of new mothers and their babies. Faience and stone amulets and rings with figures of frogs gave their wearer similar protection.

The frog's relationship to fertility imbued it with significant funerary meaning. Its effluent reproductivity apparently led to its association with the rejuvenation and renewal of life after death. Roman writer Pliny the Elder reported that the Egyptians believed the countless frogs which emerged yearly from the banks of the Nile after its flood were spontaneously generated. By the Middle Kingdom (2055–1650 BCE), the hieroglyphic sign for the tadpole, signifying one hundred thousand, can additionally be read: *wehem ankh*, (repeating life). The desire to live again played a fundamental role in Egyptian funerary ideology, and frog-shaped amulets were placed with mummies to ensure the deceased's rebirth in the next world. **Elaine Sullivan**

72 Hounds and jackals playing set

Seventeenth Dynasty, 1580–1550 BCE or later; wood. Gaming board: length 17.5 cm (6 7/8 in); width 9.5 cm (3 3/4 in); Base: length 5.5 cm (2 3/16 in); width 3.5 cm (1 3/8 in); height 1.5 cm (9/16 in); Playing pieces between 5.4 and 7.9 cm long. Tomb of Neferhotep, Dira Abu el-Naga, Thebes. The Egyptian Museum, Cairo JE 28564 / JE 6146-6152

· This very unusual group of objects is composed of six sticks, five with the head of a lop-eared dog and one with the head of a jackal, fitted into a wooden base in the form of a turtle. Originally there would have been equal numbers of dogs and jackals. The base has four rows of five and one row of three holes bored into it. The set includes a gaming board shaped roughly like a turtle, also of wood. When studies of this group originally appeared, it was thought that the sticks were hairpins and that the ensemble was part of a woman's toilet set. However, it has since become apparent that it is a playing set for the game described by Egyptologists as "Hounds and Jackals." Its original name is not known, though we do know the names of other Egyptian board games such as *senet* and *mehen*.

Very few examples of "Hounds and Jackals" have survived. Some isolated playing pieces, jackal or dog headed, have been found. One extant gaming set of this type, from the tomb of Reni-senbu in Thebes, can be dated to the Twelfth Dynasty (1985–1773 BCE) and another, also from a Theban tomb, probably of the Seventeenth Dynasty (c. 1580–1550 BCE) and quite closely resembling the group under discussion, has survived.

Evidence, relating chiefly to the game called *senet*, suggests that "Hounds and Jackals" was intended to be played at the time of death and with a view to securing the assistance of deities and spirits for one's safe passage into and through the netherworld. Such games were evidently also played in life. We cannot be sure how the game was played, but its purpose is hinted at by a passage from a funerary text of the Twentieth Dynasty (c. 1186–1069 BCE) that was designed to give magical empowerment to the player.

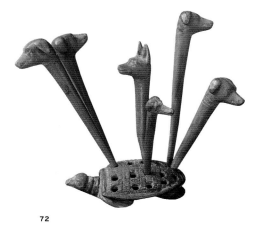

72

My game pieces are made to endure in the
 embalming chamber
I have the full complement throughout the
 embalming chamber
My seven pieces are indeed winners
My fingers are like the jackals who tow the
 solar barque

I grasp his [my opponent's] pieces…
And pitch him into the water
So that he drowns together with his pieces.

The symbolism of this game is extremely rich
and is hard to elucidate fully. The jackals must be
connected with Anubis, the jackal deity who
weighs the heart in the other world and guides
the soul. One of the squares in the *senet* game
bears the image of a walking jackal. This and the
jackal-headed sticks are associated with the Spirits
of the West who tow the barque of the sun
through the night sky. Jackal-headed sticks call
to mind the Egyptian hieroglyph for "strong,"
weser, and the jackal-headed pole called *wesret.*
The turtle was an animal regarded as inimical
to the sun god and was perhaps seen as a mani-
festation of the chaos-spirit Apopis. The fact
that its image was bored with holes suggests an
apotropaic magical function. **Terence DuQuesne**

158

73 Anthropoid coffin of Paduamen

Twenty-first Dynasty, reign of the High Priest
Pinudjem II, 1069–945 BCE; painted and varnished
wood. Coffin: Height 198 cm (77¹⁵⁄₁₆ in); width 55 cm
(21⁵⁄₈ in); depth 30 cm (11¹³⁄₁₆ in). Inner board:
Height 180 cm (70⁷⁄₈ in); width 37 cm (14⁹⁄₁₆ in);
depth 12 cm (4¾ in). Lid of coffin: Height 198 cm
(77¹⁵⁄₁₆ in); width 55 cm (21⁵⁄₈ in); depth 35 cm
(13¾ in). From the tomb of Bab El-Gasus, found
in 1891 in Deir el-Bahari. The Egyptian Museum,
Cairo CG6233–6235

• Coffins to contain the mummy of the deceased
were an important element in the burial assem-
blage of ancient Egypt. They developed from a
simple rectangular form to very elaborate designs
of the New Kingdom (1550–1069 BCE) and the
Third Intermediate Period (1069–664 BCE).

This beautiful coffin is rich in detail. The
coffin figure of Paduamen wears a long, straight
headdress that leaves his ears exposed. On the
outer lid of the coffin a beard is attached to Padu-
amen's chin; he holds an Isis knot, symbol of
protection, in his hand. Below his arms are repre-
sentations of the scarab beetle and three winged
deities, among which is the sky goddess, Nut,
spreading her wings over the body of the deceased.
Below the representation of Nut, the lid of the
coffin is divided into compartments, bordered by
four horizontal bands and one wide vertical band
of inscriptions, giving the names and titles of
Paduamen. His principal titles were "God's Father,

Master of Mysteries in Heaven, Earth, and the
Netherworld, He who opens the doors of Heaven
in the Temple of Karnak." These ranks indicate
that Paduamen accompanied the high priest
of Amun into the holy of holies in the temple of
Karnak and opened the doors of the shrine that
held the statue of the deity.

At the foot, the deceased Paduamen and
his wife are shown making offerings to the gods
Osiris, Isis, and Horus. The interior of the coffin
lid is reminiscent of the style used at the end
of the Twentieth Dynasty, when the interior of
coffins was decorated with bright colors on a dark
red background. A large figure of Osiris occupies
almost all of the interior lid of Paduamen's coffin
(p. 161, left).

The interior of the coffin box is dominated
by the figure of the winged goddess Isis standing
on the sign for gold; she has a frieze of uraei
adorning her head (p. 160, left). The two patron
goddesses of Upper and Lower Egypt, Nekhbet
and Wadjet, are shown as winged cobras holding
the ankh sign over the shoulders of Isis. Horus,
Anubis, the *ba* bird, and the Isis knot sign are used
alternately around the figure of Isis. The lower
half of the coffin's interior bears images of Isis
and Nephthys, each goddess standing on the
sign for gold. Between them are representations
of the god Wepwawet. The horizon sign is in
the lowest register.

Among the most interesting scenes
on the exterior of the coffin box are the represen-
tation of the sun barque drawn by jackals, the
judgment scenes where Paduamen is led by Maat,
the goddess of truth, and by Thoth to Osiris who
is seated on his shrine (p. 160, right). Another
scene on the exterior right side of the box repre-
sents Paduamen in front of the tree goddess
providing him with life-giving water.

The mummy board was placed directly
over the wrappings of the mummy (pp. 159 and
161, right). It is almost identical in shape, deco-
ration, and coloring to those of the lid. The
arms are clenched and may have had some sacred
emblems placed within them. Below the wide
collar is the goddess Nut spreading her wings.
Paduamen is represented with his wife making
offerings to several deities.

The tomb of Bab El-Gusus, where this
coffin was found, is an old tomb that was extended
and reused, in the time of the high priest Menk-
heperre, to accommodate the coffins of members
of the high priest's family. **Fatma Ismail**

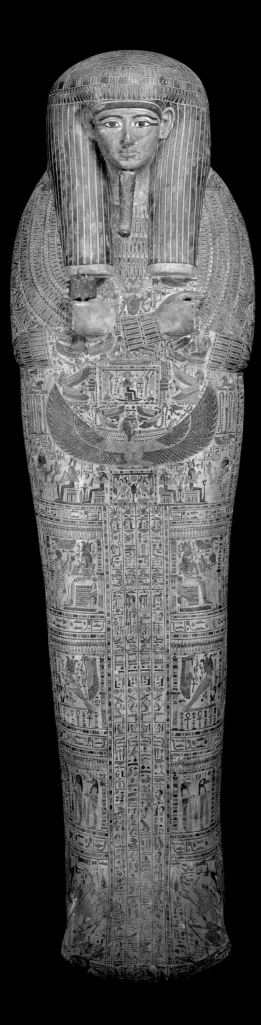
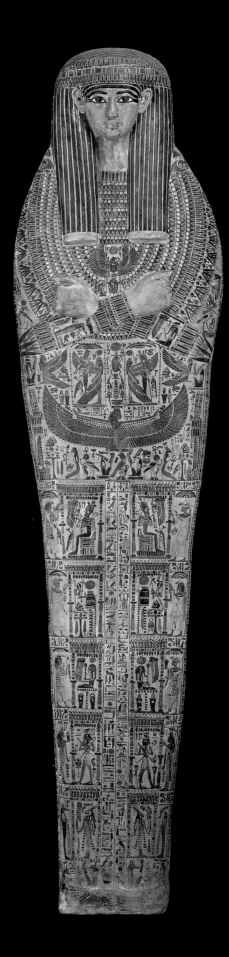

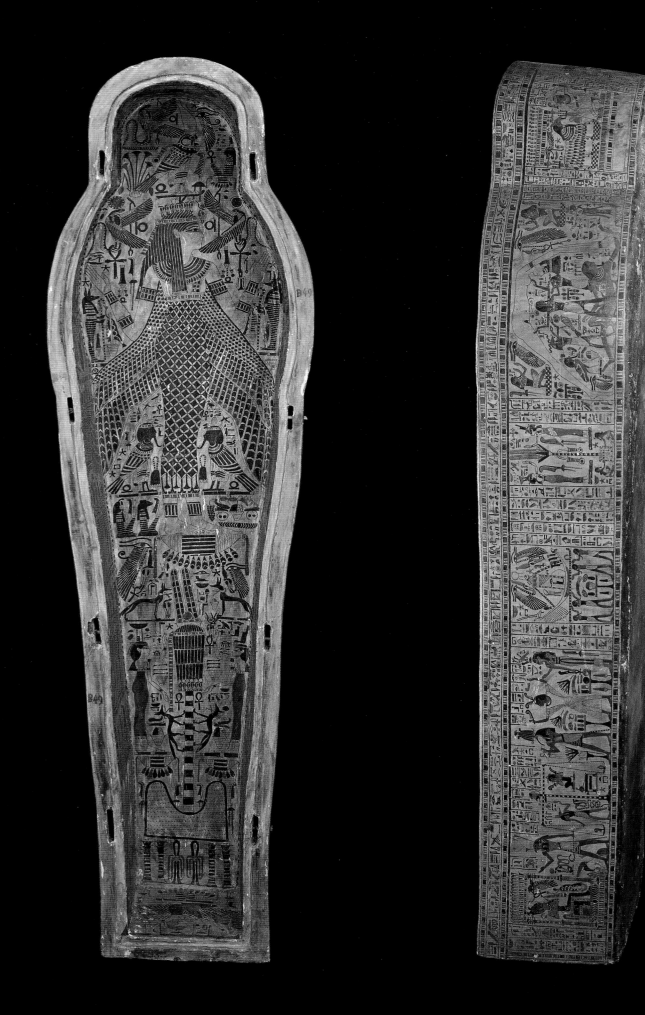

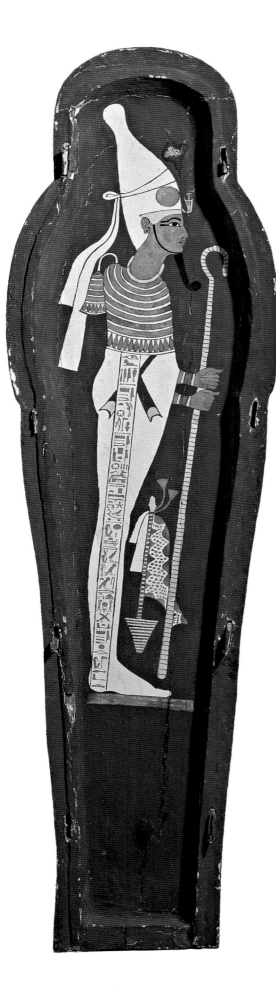
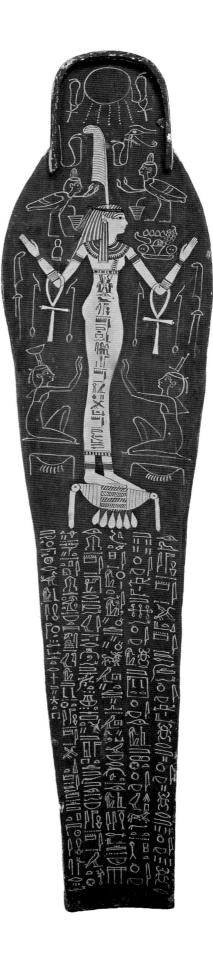

161

74 Jubilation relief

Nineteenth Dynasty, 1295–1186 BCE; limestone. Height 60 cm (23⅝ in); width 110 cm (43⁵⁄₁₆ in); depth 15 cm (5⅞ in). Found reused in the Serapeum; likely from a tomb at Sakkara. The Egyptian Museum, Cairo JE 4872/SR 11754

· This scene, capturing a celebratory moment in a procession, embodies the vitality that the skilled Ramesside artists infused into their reliefs and paintings. Two rows of women attired in elaborate wigs and diaphanous robes rattle tambourines and stamp their feet, while a pair of small girls, absorbed in their frenzied dance, accompany the rhythm with the snap of their hand-held clappers. Examples of these rhythmic objects, usually formed out of bone, ivory, or wood, are included in this catalogue (cat. 69). Opposite them arrives a contingent of men, conducted by one of its members wielding a baton. Their contrasting dress suggests they hold different occupations: simply attired soldiers in front, three priests follow with clean-shaven heads, and elaborately garbed nobles rejoice in the rear. The raised heels of each man suggests a spirited gait, emphasizing the forward motion of their march. Arms held aloft, the retinue participates in the acts of jubilation and praise. The Egyptian artist chose to depict the straight lines of the parade by deftly overlapping the bodies of each man, carving just enough of the figures in the background to delineate their physiques. The exclusion of certain details, like the legs and feet of the top row of musicians and the back arms of the middle section of marchers, only adds to the scene's feeling of motion and energy. The hieroglyphic inscriptions above and beside the second row of men list the names of two of the participants, "Aanacht," and the scribe "Amenkhau."

In the Nineteenth Dynasty, decorative themes for tomb reliefs stressed the journey of the deceased to the next world, giving popularity to scenes such as divine adoration, the weighing of the tomb owner's heart, or mourners accompanying the sarcophagus to the tomb. This relief has previously been labeled as part of a funerary procession, but other interpretations are possible — it may show a parade accompanying the divine barque of the god on its movement at times of festival. Sakkara, from whence this piece likely derives, served as a necropolis for the Memphite officials and members of court in the Eighteenth, Nineteenth, and part of the Twentieth Dynasties. Unlike the famous rock-cut tombs of the Theban area, many of the burial places at Sakkara were freestanding tombs built of mud-brick or stone blocks. Even in ancient times the draw of ready-made building material was too tempting to resist, and the tombs were dismantled to be reused in newer construction works. This block appeared reused in the Serapeum, a cultic center nearby.

Elaine Sullivan

162

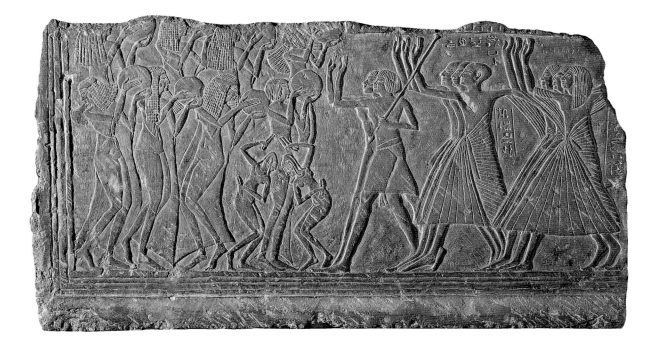

75 Canopic chest of Queen Nedjmet

Late Twentieth Dynasty, c. 1087–1080 BCE;
gilded and painted wood. Height 83 cm (32 $^{11}/_{16}$ in);
width 50 cm (19 $^{11}/_{16}$ in); depth 66 cm (26 in).
Deir el-Bahari Cache, Thebes, discovered in 1881.
The Egyptian Museum, Cairo TR 20-12-25-11

· This canopic chest belonged to Queen Nedjmet, wife of the high priest Herihor. The term canopic is used to designate containers for the internal organs removed during mummification. The term is mistakenly associated with the Greek hero Kanopos who was worshiped in the form of a jar in the city of Canopus, modern Abu Kir.

This chest is represented in the form of a *naos* shrine: the upper part of the chest has a cavetto cornice, whereas its lid is rounded at the front and slopes down to the rear. It is mounted upon a portable sledge with four carrying poles. When this chest was found, it contained only *ushebti*s of Pinudjem II, the high priest of Amun in the Twenty-first Dynasty, and his wife Nesikhonsu.

A statue of Anubis is affixed to the lid of the chest. The statue is made of wood, stuccoed and coated with a black resin. The interior of the ears, the scarf, and the collar are gilded. Anubis was a funerary god, lord of the necropolis. He guided the dead in the next world and oversaw mummification.

The sides of the canopic chest represent friezes of cobras with the sun disk over their heads. There are also representations of the Isis knot and *djed* pillar of Osiris, symbols of protection and stability. On the front side of the chest, Queen Nedjmet is represented twice, standing before both Osiris and Anubis.

In the earliest canopic preparations the wrapped visceral bundles were placed directly into a chest or a specially built cavity in the tomb wall. Beginning in the Middle Kingdom (2055–1650 BCE), a chest, reflecting the design of the contemporary coffin or sarcophagus began to be used to house four canopic jars, each containing a human organ. By the New Kingdom (1550–1069 BCE) the canopic chest imitated the form of *naos* shrines, and was decorated with images of the recumbent figure of the jackal god Anubis or the four protector goddesses Isis,

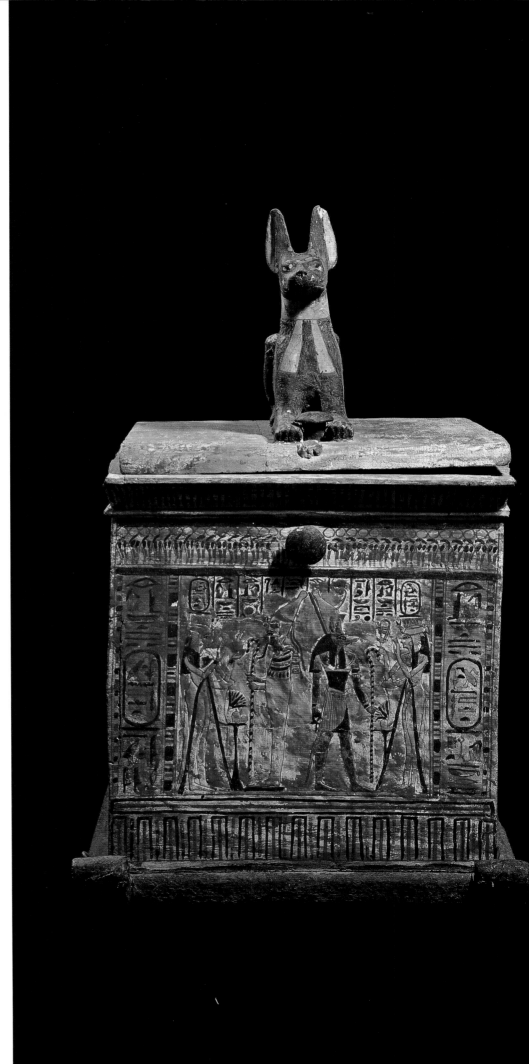

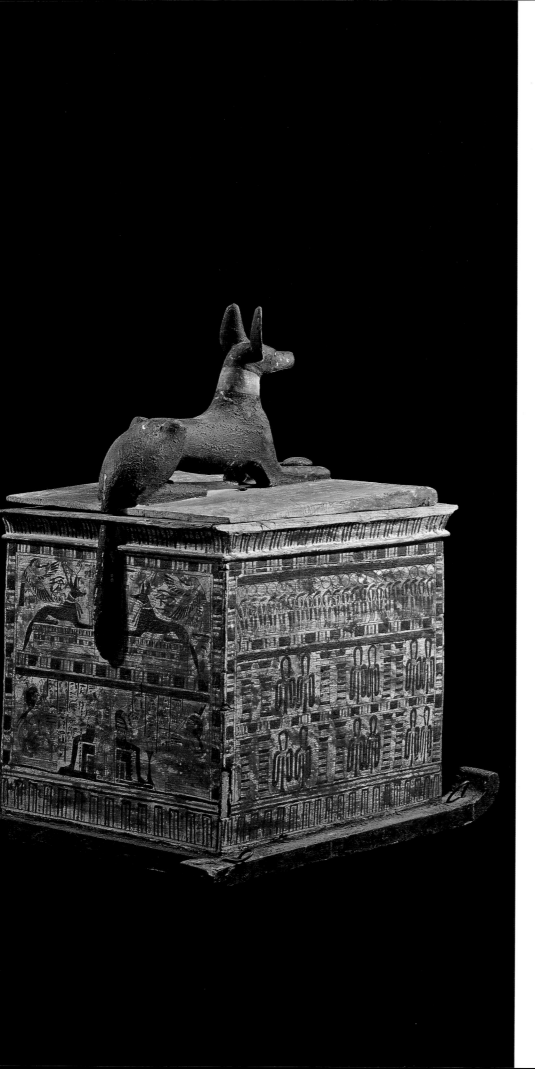

Nepthys, Neith, and Selket. By the end of the New Kingdom, a recumbent jackal of Anubis was normally attached to the lid of the chest and protective goddesses were no longer represented.

In the Twenty-first Dynasty, the viscera were returned to the body cavity of the mummies after embalming, each with an amuletic figure of the relevant deity attached. However, the symbolic function of the canopic equipment did not end. Many high-status individuals continued to place empty jars in their tombs. When the canopic packages came to be placed again inside jars, the amuletic set of the Four Sons of Horus continued to be incorporated into the mummy wrappings. Unlike contemporary mummies, the internal organs of Queen Nedjmet do not seem to have been returned to the body.

Nedjmet's husband, Herihor, created a ruling class of the high priests of Amun at Thebes toward the end of the New Kingdom. Nothing is known about his burial equipment except a joint funerary papyrus with his wife. Based on indications in scratched graffiti, we believe that his tomb may still await discovery in Thebes. Queen Nedjmet may have been a sister of Ramesses XI. Her mummy was found in the Deir el-Bahari cache with wrappings referring to year 1 of Smendes (1069 BCE) of the Twenty-first Dynasty. **Fatma Ismail**

Realm of the Gods and the Amduat
(catalogue nos. 76–107)

The ancient Egyptians were careful to equip their dead with detailed instructions for safe passage through the myriad perils of the netherworld. The texts and vignettes of the Amduat facilitated the safe journey of the deceased through the barriers and dangers of the twelve-hour nightly passage through the netherworld. Images of protective deities were dedicated in temples and included in tombs. Those of kings in particular could be filled with an abundance of statuettes of gods and goddesses. Deities connected to the netherworld, regeneration, and the solar cycle of rebirth took precedence.

76 Statue of
mummiform deity

Eighteenth Dynasty, reign of Amenhotep III, 1390–1352 BCE; granodiorite. Height 180 cm (70 3/16 in); width 30 cm (11 13/16 in); depth 100 cm (39 3/8 in). Sheikh Abada. The Egyptian Museum, Cairo JE 89616

• The life-sized seated statue of a god is carved out of granodiorite, one of the hardest stones that Egyptian sculptors used. Despite the reticence of the material, the artisans achieved a highly smoothed and polished surface, marking the statue unmistakably as the creation of Amenhotep III's artists. Some one thousand statues in this stone were produced for the funerary temple of that king, the majority of them representing deities. This example was probably among that group, but, like many of these images, was later (perhaps already during the reign of Amenhotep III) moved to the site of Sheikh Abada in Middle Egypt. Even without the fine technical treatment of the stone, the statue would be assigned easily to the reign of Amenhotep III, given the characteristic ovoid and slightly slanting eyes with smooth convex eyelids (in contrast to the eyelids of Ramesses II, which are hollowed, or concave). The fleshy face of the god also bears the imprint of Amenhotep III's portrait, as do the thick lips, entirely encircled by an incised "lipline."[1] Although some of Ramesses II's portraits (see cat. 13) did emulate the facial shape and mouth of Amenhotep III, his artists nonetheless eliminated the lip lines and carved a mouth more like that from the late Eighteenth Dynasty than from the time of Amenhotep III. Here is the classic portrait face of that last named ruler.

This statue of a mummiform deity was not inscribed during the reign of Amenhotep III, but was later inscribed with the dedication, "The good god Usermaatre, beloved of Isis; the son of Re, Ramesses, beloved of Isis." A mate to this piece also came from Sheikh Abada (Cairo temp. no. 7/3/45/2). It is also mummiform in shape, but it has a beard, which this piece lacks. The inscription on its socle dedicates the statue to Ramesses II, beloved of Osiris. The site in Middle

165

Egypt also yielded an uninscribed life-sized striding statue of a falcon-headed god. Although it is unknown whom this deity represented, it is notable that a temple to the falcon god, Horus of Hebenu, was situated a few miles north of Sheikh Abada, where Amenhotep III carried out construction work late in his reign. Ramesses II reused the remains of those constructions for his own work at the site and perhaps took over these statues at that time.[2]

In its original conception, this statue may not have represented a female deity, but rather the chthonic god Tatjenen whose name, "the land is risen," alludes to creation on a primeval hill out of the water of chaos.

Deities in their mummy forms are not uncommon in the Egyptian underworld, where they are among the guardians of the hours of night who praise the sun god when he sails through on his boat. Scenes depicting the second hour of the night show a row of mummiform gods seated on thrones, just as they are here. The row is completed by a depiction of the goddess Isis as a bearded male. The statue's gender is nearly as ambiguous as this masculine form of Isis, since only slightly enlarged breasts appear through the mummy's shroud. Here, Isis has stepped out of her usual roles as wife of Osiris and protector of the mummy and is more to be understood as a member of the pantheon that guarantees the maintenance of the sun god's order, within both this world and the netherworld. **Betsy M. Bryan**

1. For a discussion of the portraits of Amenhotep III, see Betsy M. Bryan, "Royal and Divine Statuary" in Arielle P. Kozloff and Betsy M. Bryan. *Egypt's Dazzling Sun: Amenhotep III and His World* (Cleveland, 1992), 125–92.

2. Gomaà Farouk, "Hebenu (pp. 1075–76) in Wolfgang Helck and Wolfhart Westendorf, eds., *Lexikon der Ägyptologie*, vol. 2 (Wiesbaden, 1977).

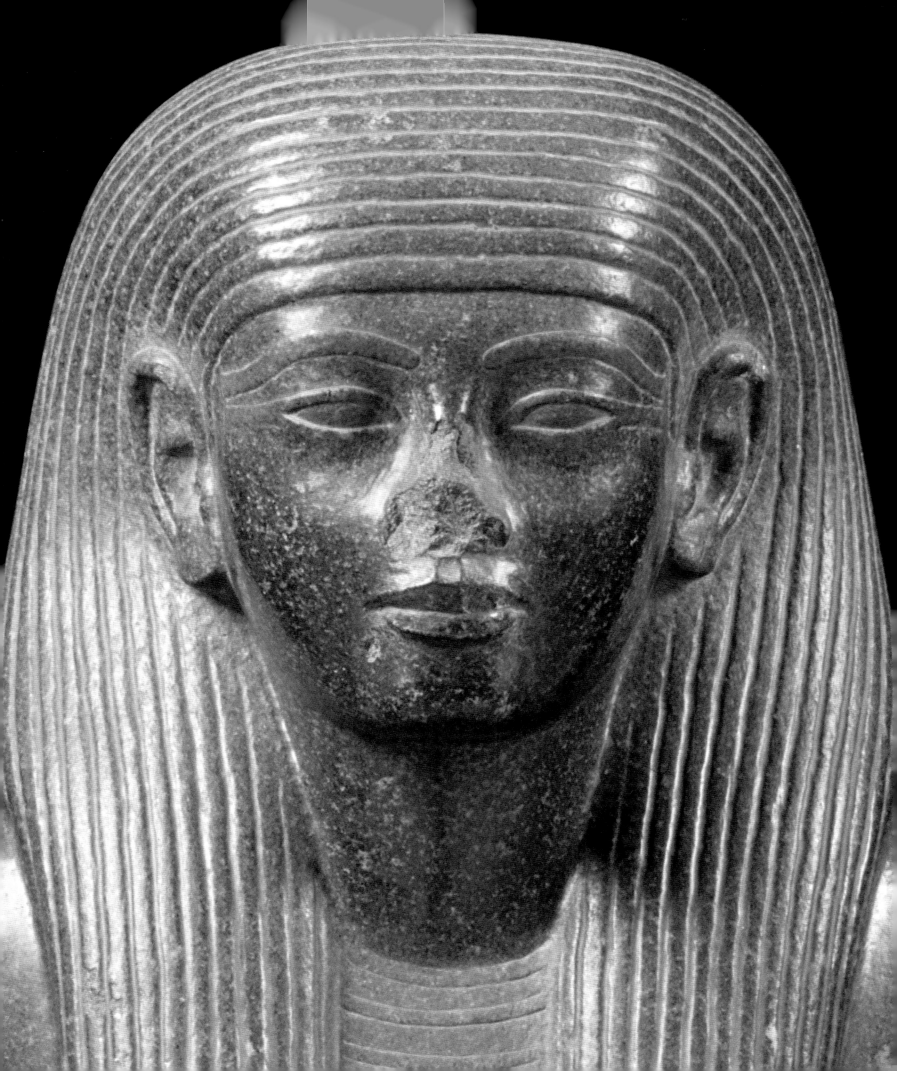

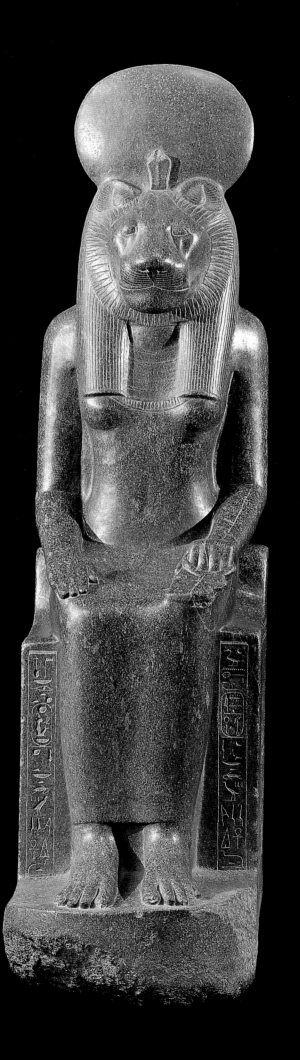

77 Seated statue of the goddess Sakhmet, "mistress of fear"

Eighteenth Dynasty, reign of Amenhotep III, 1390–1352 BCE; granodiorite. Height 207 cm (81½ in); width 56 cm (22¹⁄₁₆ in); depth 98 cm (38⁹⁄₁₆ in). Temple of Mut, Karnak. The Egyptian Museum, Cairo CG 39063

• This is one of many similar statues of the lioness-headed goddess Sakhmet found in the first court of the temple of Mut in Karnak. The lioness head is joined to the human body in such a way that the lion's fringe of hair is extended into a wig. The figure is seated and bears on its head a sun disk with the uraeus. Its right hand rests flat on the right knee, and the left hand holds an ankh sign (the symbol of life). Around her neck, the goddess wears a broad collar of several rows of beads, known as a *wesekh* collar. The throne is of a standard form, with a backrest. A square at the side of the throne contains the plant of the north (the papyrus) and the plant of the south (the lily); between them is the *sema-tawi* sign, symbolizing the unity of Upper and Lower Egypt under the rule of one strong pharaoh. On the front of the throne is a vertical rectangle surmounted with the sign representing the sky. On the left is the following inscription: "The good god, lord of the cult act, of Nebmaatre, beloved of Sakhmet, mistress of fear, given life forever." The inscription on the right reads: "The son of Re of his body, Amenhotep, ruler of Thebes, beloved of Sakhmet, mistress of fear, given life forever."

Remains of paint indicate that the statue was probably painted. The eyes of some Sakhmet statues were tinted red. Most of the Sakhmet statues found at the temple of Mut were dedicated to the Eighteenth Dynasty king Amenhotep III, which is why Auguste Mariette ascribed to him the foundation of the entire temple. Some of the statues are inscribed with a dedication by Sheshonk I (945–924 BCE), the Shishak of the Bible (Twenty-second Dynasty). It was likely that Mariette regarded these inscriptions as usurped; although there is no trace of an earlier cartouche being chiseled out.

Sakhmet's name meant "she who is powerful." A member of the Memphite triad, the consort of the god Ptah, and the mother of Nefertem, Sakhmet personified the aggressive aspects of female deities. She was usually depicted as a woman with the head of a lioness but, as the daughter of the sun god, Re, she was also closely associated with the royal uraeus in her role as the fire-breathing "Eye of Re." It is mentioned twice in the Pyramid Texts that the king was conceived by Sakhmet.

As the Theban rulers of the New Kingdom (1550–1069 BCE) rose to power, the Theban triad (Amun, Mut and Khonsu) became increasingly important and began to acquire the attributes of other deities. As a result, Sakhmet began to be identified as an aggressive manifestation of the goddess Mut. Seven hundred thirty statues, two for each day of the year, were erected by Amenhotep III, in his mortuary temple in western Thebes. Most of these were later moved to the Temple of Mut at Karnak.

The aggressive nature of Sakhmet made her the perfect protector of the sun god as he journeyed through the netherworld. This is why she appears frequently in the Amduat. **Yasmin El Shazly**

78 Statue of Osiris

Twenty-sixth Dynasty, reign of Psamtik I, 664–610 BCE; graywacke. Height 150 cm (59¹⁄₁₆ in); width 24.5 cm (9⅝ in); depth 43 cm (16¹⁵⁄₁₆ in). Medinet Habu, discovered 1 January 1895. The Egyptian Museum, Cairo JE 30997 / CG 38231

• This large standing statue of the god Osiris shows him in mummified form, wrapped in an enveloping cloak, leaving the forearms free, with the crook and flail held in his crossed-over hands. His torso is slender and his legs are attenuated. A pyramidal-topped back pillar rises to the apex of the high crown of Upper Egypt.

The head of the deity is well carved. A long beard is attached to the chin with straps that descend from the ears and run along the lower jawline. The slight smile on the full-lipped mouth is accentuated by visible drill holes at its outer corners. The nose is straight and very thin. The wide eyes, almond shaped and delicately rimmed, surmounted by arched raised-relief eyebrows, are elegantly carved, with long plastically rounded

cosmetic lines emerging from their outer corners. This statue epitomizes the high Saite style. It is sculpted with great care and attention to detail in a comparatively soft stone, which makes its own elegant statement.

The inscriptions on the base of the statue and on the back pillar indicate that it was dedicated by the divine wife of Amun, Nitocris, to "Osiris, in front of west and the lord of life." Nitocris, daughter of Psamtik, was adopted as successor at Thebes to the divine wife of Amun Shepenwepet II, the daughter of King Piankhi.

Osiris was the god of the dead who presided over the court of justice in the hereafter. His usual representation was a form of mummified man wearing the *atef* crown, or the crown of Upper Egypt, as here, with his arms crossed over his chest and holding a crook and flail. The cult of Osiris dates back to at least the Fifth Dynasty (2494–2345 BCE), when his name occurs for the first time in the texts from the pyramid of King Unas. The cult center of Osiris is not easy to locate, because it was connected with all of the ancient nomes of Egypt, as mentioned in the texts of the Egyptian temples from the Ptolemaic Period (332–30 BCE), parts of the dismembered body of Osiris were dispersed to all of the forty-two Egyptian nomes. Each nome claimed to contain a grave of Osiris.

The god's main cult centers included the sites of the Abaton near Philae, Abydos, and Busiris. He was at the center of the festivals of the month of Khoiak between the end of the annual Nile flood and the sowing season. The main purpose of this festival was to re-create the scene of the death and resurrection of the god. Osiris was the absolute master of the afterlife — he who first defeated death to live once more in a new dimension beyond the grave. Osiris was one of the most important gods in the Egyptian pantheon, and his exploits were well known as a result of Plutarch's description that has survived. Osiris, the beloved lord of the earth, was killed and his body dismembered by his jealous brother Seth, but his sister-wife Isis and his sister Nephthys searched and found the scattered parts of his body and put them back together again, returning him to existence. **Mamdouh El-Damaty**

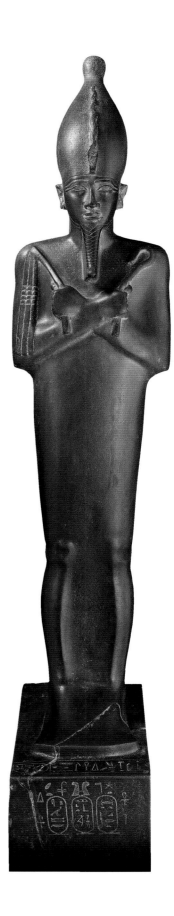

79 Statue of Isis

Twenty-sixth Dynasty, 664–525 BCE; graywacke.
Height 89 cm (35 1/16 in); width 21 cm (8 1/4 in);
depth 46 cm (18 1/8 in). Sakkara, tomb of Psamtik,
discovered by Auguste Mariette in 1863 south
of the causeway of Unas. The Egyptian Museum,
Cairo CG 38884

· This statue shows the goddess seated on a
throne with one horizontal line of inscription
around the base including an offering verse
dedicated from Psamtik to Isis, who is termed
mut-netjer, the mother of the god Horus. This
statue was found beside two others, one of Osiris
in mummified form seated on a throne and
the other of Hathor as a cow, protecting Psamtik,
the chief scribe, superintendent of seals, and
governor of the palace at Sakkara.

This statue shows Isis with a round face,
delicate features, and a smooth, tripartite wig
that falls onto her ears. The wig is decorated with
a uraeus serpent that appears on her forehead.
Her features are characteristic of the Saite Period:
the eyes, surrounded by rims in relief, are nar-
row; the nose is small, and the mouth shows a
slight smile. The goddess wears a narrow garment
that reaches her ankles. The two hands of the god-
dess rest on her thighs; the left is empty, placed
palm down, but the right holds an ankh sign. The
traditional crown of the goddess was the throne,
but here she wears a modius with the attributes
of Hathor, two horns and a sun disk. Since as
early as the Fifth Dynasty (2494–2345 BCE), Isis
was frequently assimilated to Hathor, something
that was very clear in the Late Period (664–332 BCE)
and in Greco-Roman times (332 BCE–CE 395).

Isis, as one of the deities of the Helio-
politan Ennead and the sister-wife of Osiris and
the mother of Horus, was the guarantor of the
progression of the royal line from father to son.
Following the death of her husband, killed by his
brother Seth, Isis recomposed the dismembered
body and brought Osiris back to life by means
of her magical powers. She then conceived with
him an heir, Horus, who would later avenge his
father and take his rightful place on the throne
of Egypt. **Mamdouh El-Damaty**

170

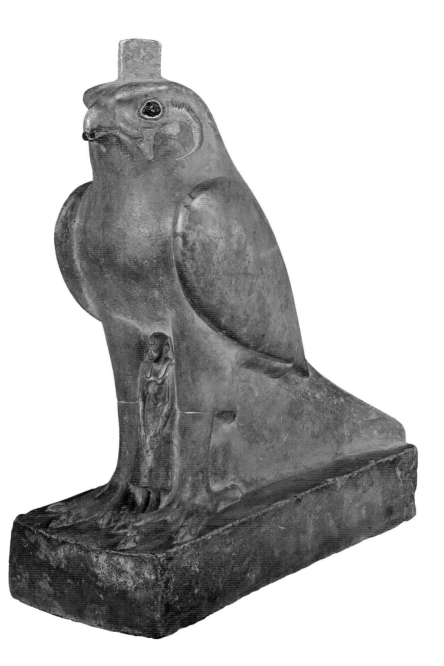

80 Falcon with King Nectanebo

Thirtieth Dynasty, reign of Nectanebo II, 360–343 BCE; limestone. Height 54.5 cm (21⁷⁄₁₆ in); width 19 cm (7½ in); depth 42 cm (16⁹⁄₁₆ in). The Egyptian Museum, Cairo JE 33262

• This fine statue of a falcon god is sculpted of hard limestone; its eyes were inlaid with glass, although only one now holds its complete inlay. The statue once had a headdress, probably a crown, given the sizable tenon left on the head. The double crown may well have been attached here, made of precious materials.

Despite its lack of inscription, the identification of this statue with Nectanebo II is highly likely, since that king is known to have had a number of statues with a falcon shown behind him. One of the most beautiful is in the Metropolitan Museum of Art, New York (34.2.1) and is of nearly identical scale. The falcon here is very similar to the Metropolitan Museum example, being quite erect, with wings precisely but not naturalistically sculpted with a minimum of detail. None of the surfaces of either falcon have visible feathering; rather the reliance is upon the

power of the falcon's image. In both cases the front legs indicate the end of plumage about half-way down, and the appearance is more that of the hem of a garment than of feathers. The stylization is quite complete.

The figure of the king here is in relief between the falcon's legs. It does not protrude beyond the depth of the bird's legs, as on the New York piece, but here the king is posed differently and wears different clothing. This depiction of Nectanebo shows him wearing a long kilt that reaches nearly to his ankles. The king's hands are flat against the kilt, and his legs are placed together. This is the pose of a king in humble

prayer before a deity. Amenemhat III left several statues of himself at Karnak in a similar pose, and this is highly reminiscent of that statue series. The king on the Metropolitan Museum example is shown, rather, wearing the short royal kilt and is in a striding pose, holding emblems that help the sculpture to spell out the king's name visually.

The significance of the falcon within the statuary of Nectanebo indicates several points. In the later dynasties the importance of the king as a person waned, due to the frequent remoteness of that ruler, particularly as in the case of the Persian Twenty-seventh Dynasty (525–404 BCE). The importance of the falcon associated with the king grew such that ultimately it was the bird that was recognized as the living Horus. This result accommodated the fact that the Ptolemaic rulers rarely visited the temples of Upper Egypt in person, but the priests could raise the birds that could be, with the proper plumage markings, identified as the living god.

It has been argued that the statues of Nectanebo II with the falcon are part of a cult of the king. Inscriptions refer to the ruler as *pa bik* (the falcon), both during his lifetime and in the Ptolemaic era as well. This would suggest that this statue, like his others, shows Nectanebo II as a divine falcon deity who, simultaneously, exists as the human reigning king. **Betsy M. Bryan**

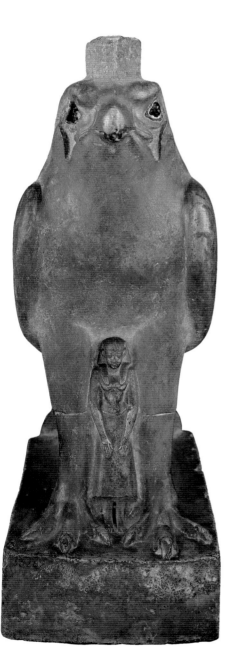

172

81 Statue of Ptah

Saite Period, Twenty-sixth Dynasty, 664–525 BCE; bronze. Height 28.8 cm (11⁵⁄₁₆ in); width 9.5 cm (3³⁄₄ in); depth 5.5 cm (3³⁄₁₆ in). Sakkara, the Serapeum. The Egyptian Museum, Cairo CG 38445

• This statue represents the god Ptah, a major divinity in the ancient Egyptian pantheon, whose worship extended throughout the country. The god wears his customary skullcap and straight beard, here composed of twelve undulations that widen slightly toward the bottom. A tight-fitting mummiform garment encloses Ptah's body, revealing only hints of the knees and lower legs. His hands emerge from the sleeves to clutch a *was* (meaning "dominion" or "power") scepter. His right hand also wraps around the curved section of an ankh or "life" symbol. The objects, which signify "dominion" and "life" are commonly held by Ptah, along with the *djed,* or the sign for stability, in both his two- and three-dimensional representations. An incised collar of four rows graces his shoulders. The eyes, once inlaid, are now missing.

Egyptians worshiped Ptah from the earliest historic times. In later periods, his titles reveal his characteristics as "Lord of Maat" (truth, justice, and order), "Benevolent of Face" and "Great of Strength." Egyptians believed Ptah served as protector of artists, craftsmen, and builders. The priesthood dedicated to him even held special titles like "great one of the controller of crafts," referring to this role of the god as craftsman and creator. Ptah's role in Egyptian myth extended to that of a creator god. In one of the numerous Egyptian genesis stories, Ptah fashions the world by thinking of it with his heart, and then producing it with his speech. Like many Egyptian gods, Ptah was syncretized with other deities, leading to his associations with Sokar and Tatjenen. Although Ptah is described as a participant in the "Opening of the Mouth" ceremony in the Coffin Texts, and occasionally linked with Osiris as the ruler of the netherworld, his religious role is not funerary.

Ptah's central site of worship was his temple at Memphis, whose name *hut ka ptah* (Temple of the *ka* of Ptah) became the designation for the entire city. Memphis and its temple to Ptah have long since been destroyed, but other remains of cults for this god appear at Serabit el Khadim, Abydos, Piramesse, Nubia, Karnak Temple, and western Thebes. **Elaine Sullivan**

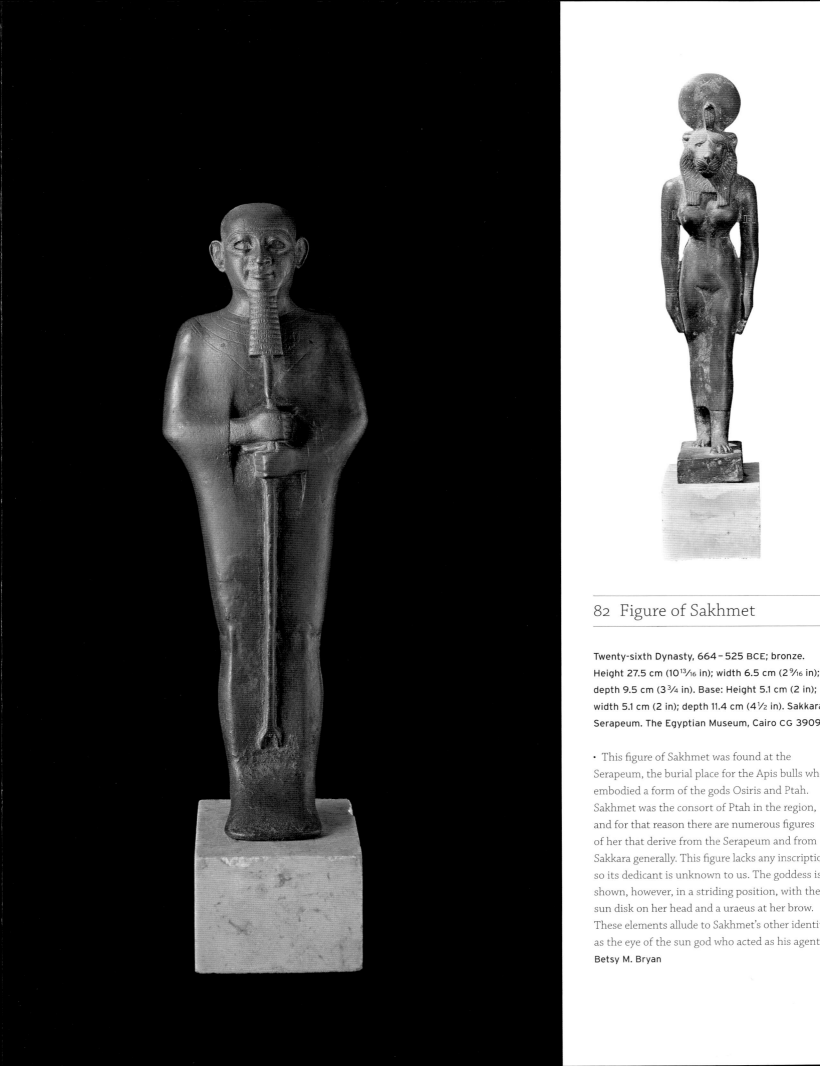

82 Figure of Sakhmet

Twenty-sixth Dynasty, 664–525 BCE; bronze.
Height 27.5 cm (10¹³⁄₁₆ in); width 6.5 cm (2⁹⁄₁₆ in);
depth 9.5 cm (3¾ in). Base: Height 5.1 cm (2 in);
width 5.1 cm (2 in); depth 11.4 cm (4½ in). Sakkara,
Serapeum. The Egyptian Museum, Cairo CG 3909

• This figure of Sakhmet was found at the
Serapeum, the burial place for the Apis bulls who
embodied a form of the gods Osiris and Ptah.
Sakhmet was the consort of Ptah in the region,
and for that reason there are numerous figures
of her that derive from the Serapeum and from
Sakkara generally. This figure lacks any inscription
so its dedicant is unknown to us. The goddess is
shown, however, in a striding position, with the
sun disk on her head and a uraeus at her brow.
These elements allude to Sakhmet's other identity
as the eye of the sun god who acted as his agent.
Betsy M. Bryan

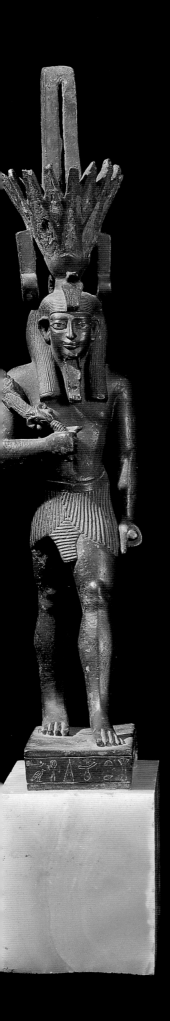

83 Statuette of Nefertem

Late Period, 664 – 324 BCE; bronze. Height 41.5 cm
(16 5⁄16 in); width 6.5 cm (2 9⁄16 in); depth 13.5 cm
(5 5⁄16 in). Sakkara, Serapeum. The Egyptian
Museum, Cairo CG 38076

· This very fine bronze statue of the god Nefertem
represents him with his left leg striding forward.
He wears a striped *shendyt* kilt and a striated wig
surmounted by a uraeus. His complicated head-
dress consists of a large lotus flower from which
emerge two long plumes, shown in profile, which
are attached to each other only at the top and
bottom. The lotus is inlaid with fine blue enamel
fixed with white mastic. The plumes are engraved
with lines similar to those on the beard. On
either side of the lotus is an emblem in the form
of a counterpoise (*menat*) emblem, on the tops
of which are engraved images of the goddess
Bastet-Sakhmet holding a papyriform scepter. On
the left side she wears a sun disk on her head;
on the right side, she wears a uraeus. The round,
bottom part of each *menat* emblem is carved with
a *wedjat* eye (the eye of Horus). The left arm
of the statue hangs down at the side of the body,
with the hand closed in a tight fist. The right
arm is bent across the chest and holds a weapon
similar to a scimitar, the top of which rests on
the right shoulder. The curved handle ends with
a papyrus flower, out of which comes the curved
blade, engraved like a feather, ending with the
head of a hawk surmounted by a sun disk.

The beard would have been inlaid with gold and
enamel; the white of the eyes with silver.
Between the head and the lotus flower one can
see a ring at the back, which would have been
used to hang the statue suggesting how such
votive statuettes were displayed in temples. The
image of the god stands on a rectangular base
inscribed with the name of the statue's dedicant
and his mother and father.

Bronze is an alloy combining copper
and tin. Its production appears to have spread
from western Asia. The first known bronze
artifacts seem to date from the Second Dynasty
(2890 – 2686 BCE). It was not before the Middle
Kingdom (2055 – 1650 BCE) that bronze replaced
the use of copper hardened with arsenic. The
percentage of tin used varied from about 2 to
16 percent.

Nefertem is the god of the primeval lotus
blossom and is represented by the blue lotus.
He was usually depicted as a man wearing a head-
dress in the form of a lotus flower. Sometimes
added are two necklaces and two counterpoises,
symbols of fertility through their connection
with Hathor.

Nefertem was linked to the sun god, since
the sun was believed to have risen from a lotus
and is therefore described in the Pyramid Texts
(Utterance 266) as the "lotus blossom which
is before the nose of Re." This can be seen as an
allusion to the use of this particular flower by
guests at banquets.

Nefertem was regarded as a member of
the Memphite triad — the son of Ptah and his
consort, the lioness-headed goddess Sakhmet.
As a result, he was sometimes depicted as lion
headed, and sometimes the cat goddess Bastet
played the role of his mother. At Buto in the
Delta he was regarded as the son of the Lower
Egyptian cobra goddess Wadjet. His epithet,
"protector of the two lands," suggests that he may
have been seen as guardian of a unified Egypt.
Yasmin El Shazly

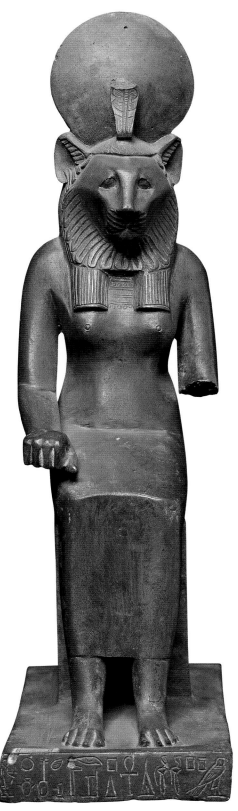

84 Seated statuette of Sakhmet

Late Period, 664–332 BCE; bronze. Height 28.5 cm (11¼ in); width 8.5 cm (3⅜ in); depth 17 cm (6¹¹⁄₁₆ in). Sakkara, Serapeum. The Egyptian Museum, Cairo CG 39082

• This small bronze statue of the lioness-headed goddess Sakhmet (see cat. 77) depicts her sitting on a simple, undecorated throne. Her right hand is closed and rests on her right knee. Her left arm, on the other hand, is broken off at the elbow. The lioness head is joined to the human body in such a way that the lion's fringe of hair is extended into a wig. She wears a sun disk on her head and a collar of three rows of beads around her neck. Her simple dress goes down to her ankles and is form fitting. The base of the statue bears a dedicatory inscription.

Sakhmet's name meant "she who is powerful" and refers to magical power especially. As one of the Memphite triad of Ptah, Sakhmet, and Nefertem, the goddess uses her power to protect her husband and son and often, on analogy, the king as well. Cults of Sakhmet and of Bastet are known in several parts of the Memphite region, including one as yet not located called "Ankh Tawy," "Life of Two Lands."

Sakhmet's power extended over people's fortunes. Like Hathor and Mut, Sakhmet determined good and bad luck and represented an Egyptian version of the fates known from classical mythology. In great national temples Sakhmet could therefore guarantee the coming of good years with high Nile floods and excellent harvests. For dedicants of personal objects, such as the statuette, Sakhmet could provide the promise of health and prosperity. **Yasmin El Shazly**

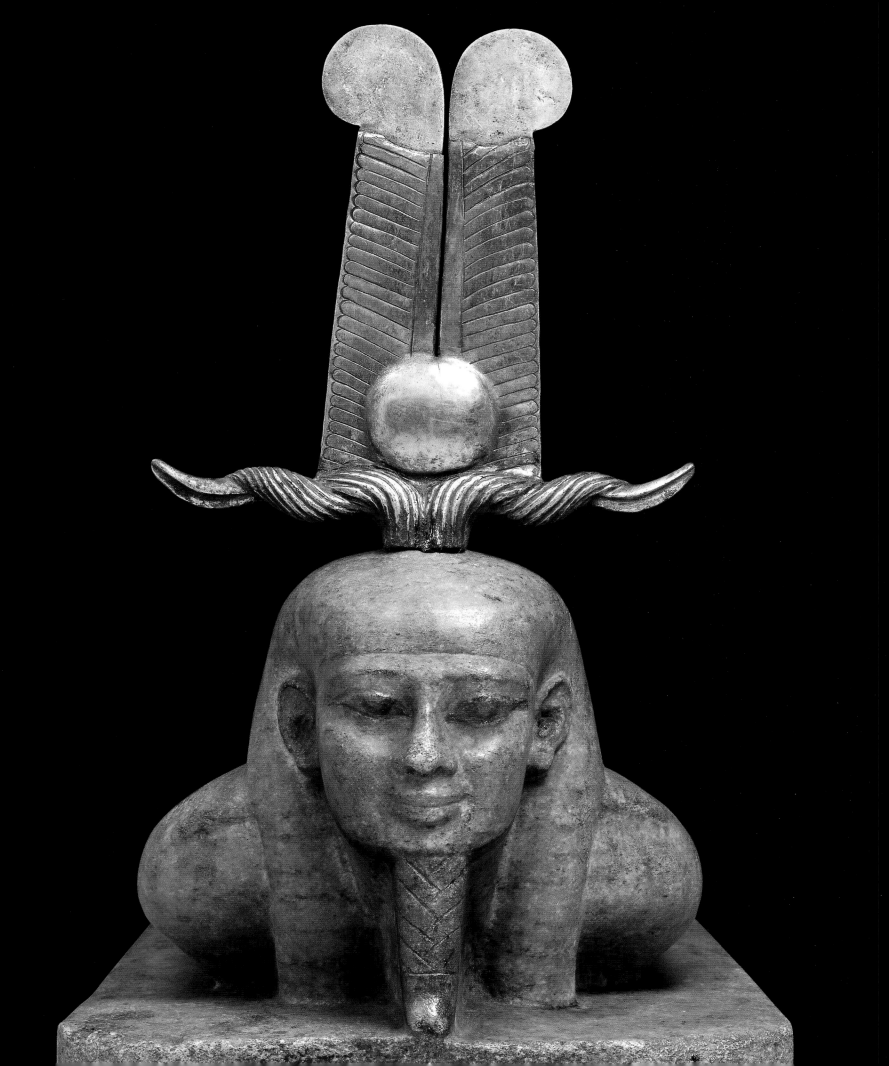

85 Osiris resurrecting

Twenty-sixth Dynasty, 664–525 BCE; gneiss, with a headdress in electrum and gold. Height 29.5 cm (11 5/8 in); width 18 cm (7 1/16 in); depth 55.5 cm (21 7/8 in). From Horbeit. The Egyptian Museum, Cairo CG 38424

• Close in length to the ancient Egyptian measurement of a cubit (average length 52.5 cm.), this prone figure wears a common divine headdress with lappets surmounted by two ostrich plumes. The plumes are a headdress called *shuty* worn by several gods, including Osiris. Here it is adorned with a pair of ram's horns and a sun disk that relate it further to the solar sphere. On the god's chin is a braided and curved beard of the type often worn by deities. The plinth on which the figure rests may have been intended for insertion into an inscribed base. Unfortunately, the lack of a text and a specific find-spot prevent a detailed interpretation of the statue's original function and its date of manufacture.

When studies were first published in 1872, the face of Osiris was likened to those of other images of King Apries (589–570 BCE); and although it does not closely resemble works recently attributed to that king, its idealizing style and hint of a smile are at home in that general era.[1]

Also since 1872, it has been identified as an image of the god Osiris in the process of resurrecting, on the basis of related reliefs and paintings in temples and tombs of the New Kingdom and later, some of which have the words "awake" or "awaken" above the figure.[2] That a god who died and was revived should be shown wrapped as a mummy is hardly surprising since this symbolized both the protection of the body and the potential for rebirth. Indeed, the daily solar cycle could be seen in terms of the sun god and Osiris, with sunset viewed as the solar deity's death as Osiris followed by his rebirth at sunrise. In addition to being a rare image in the round of Osiris in this pose, the sculpture is in the hard stone gneiss little used during the Late Period.[3]

Richard Fazzini

1. August Mariette, *Monuments divers recueillis en Égypte et en Nubie* (Paris, 1872), 11–12. For a recent attribution of statues to Apries, see Jack A. Josephson, "Royal Sculpture of the Later Twenty-sixth Dynasty," *Mitteilungen des Deutschen Archäologischen Instituts, Abteilung Kairo* 48 (1992): 93–95, pls. 16–19.

2. E.g., Jan Assmann, *Das Grab der Mutirdes*, AV 13 (Mainz, 1977), 90–92.

3. Dietrich Wildung, "Two Representations of Gods from the Early Old Kingdom," *Miscellanea Wilbouriana*, vol. 1 (Brooklyn, 1972), 151, and Thierry De Putter and Christina Karlshausen, *Les pierres utilisées dans la sculpture et l'architecture de l'Égypte pharaonique: Guide pratique illustré* (Brussels, 1992), 79–80.

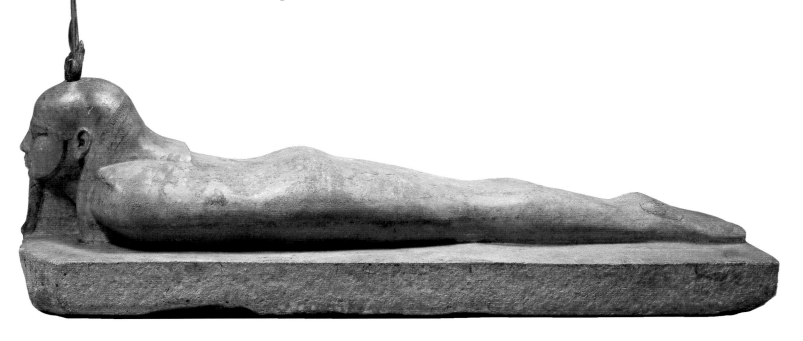

86 Isis with Horus child

Late Period, c. 664 – 332 BCE; bronze. Height
26.5 cm (10 7/16 in); width 8.5 cm (3 3/8 in); depth
12 cm (4 3/4 in). Sakkara, Serapeum. The Egyptian
Museum, Cairo CG 39320

· The goddess Isis became a central figure in
religious worship from the late New Kingdom
(1550 – 1069 BCE) onward, and her cults continued
to grow over the next thousand years of Egyptian
history. The temple of Isis at Philae (an island in
the river above Aswan) was the last functioning
ancient temple in Egypt, continuing in use through
the third century CE. The role of Isis as mother
of the god Horus who himself was inextricably
bound to the kingship was one of her most

significant, such that a favored epithet of Isis
was that of "mother of the god." Temple dedicants
offered statuettes in bronze of Isis and Horus
in enormous numbers during the last eight
centuries BCE, and this figurine represents just
such a donation.

Isis is shown in a very typical fashion,
as a female deity wearing a crown of uraei and the
horns of a cow with the sun disk between. She
wears an archaic style of wig composed of two
long tresses in front of the shoulders and one
behind. Isis also wears a uraeus at her brow, as
would a queen, for she was consort to Osiris,
the legendary king who became lord of the after-
world. The iconography of Isis was identical to
that of Hathor and other goddesses as well, since
the attributes of these divinities were often inter-
changeable. The Horus child is shown with a cap
crown and uraeus to imply his role as the ruler-to-
be. The child leans back slightly, his mother
supporting his weight with her left hand, while
with her right she gestures to her left breast,
offering it to her son.

The simplified forms here defy precise
dating, but the Twenty-sixth to Thirtieth Dynasty
(664 – 343 BCE) seems likely. Bronze technology
improved greatly by the Third Intermediate
Period, and the numbers of votive bronzes soared
from that time. The style here suggests a later
date, however. The popularity of bronze may also
have been related to its availability at reasonable
cost, since there is a rise in the production of
bronze figures and other objects across the Medi-
terranean beginning in the early first millennium
BCE. The original role of bronze as a rare metal
used for tools and weapons had meant that before
the Third Intermediate Period it was hardly avail-
able to the average person for other uses. Its
accessibility and consequent artistic exploitation
undoubtedly made the material greatly popular
as a material for temple donations.

The text on the socle identifies "Isis, gives
life — Shep bastet (gift of the goddess Bastet),
son of Horpakheredkanefer (Horus the child is
a perfect *ka*). **Betsy M. Bryan**

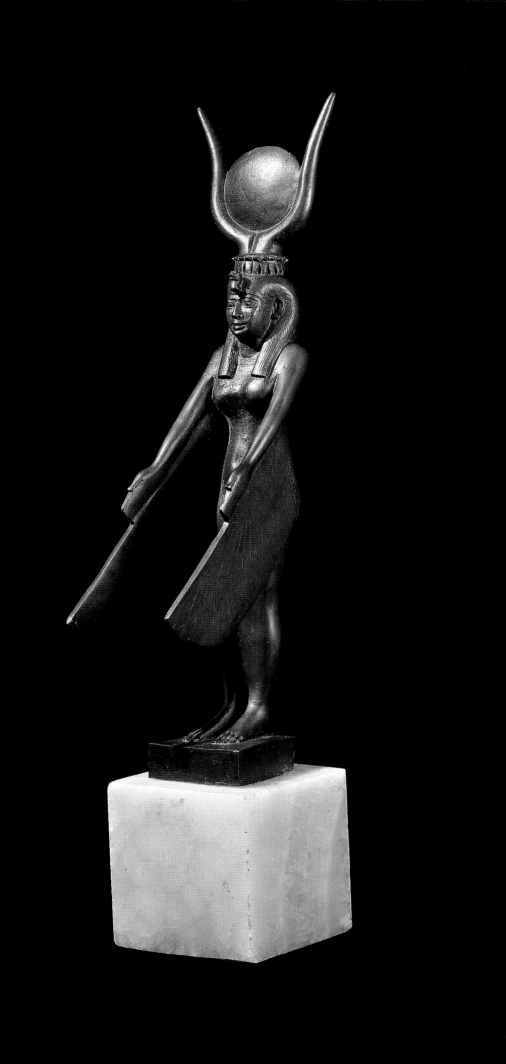

87 Winged goddess

Late Period, c. 664–332 BCE; bronze. Height 42 cm (16 9/16 in); width 10 cm (3 15/16 in); depth 15 cm (5 7/8 in). Sakkara, Serapeum. The Egyptian Museum, Cairo CG 38891

• The iconography for several female deities was identical during much of Egyptian history such that they wear the crown, here with uraei, topped by the cow horns and sun disk. The figure here also wears the vulture headdress over her wig. This goddess holds her wings in a protective gesture, suggesting that she may once have been part of a small group that placed another figure in the care of the winged goddess — possibly a mummiform figure of Osiris. A number of sculptures exist that represent Isis in just this pose supporting a figure of her husband.[1] All the major goddesses such as Isis, Hathor, Nephthys, Maat, and Nut could appear in the form of a winged female deity, and when they did all signified their role as protectress of the sun god whose wings carried him across the sky. Isis and Nephthys appeared as winged deities (kites) who protected the god Osiris from the destruction of his body.

179

The fleshy round face of the goddess here, with somewhat long and low cheeks, is characteristic of the later Twenty-sixth Dynasty (664–343 BCE), but this piece need not date only to that time since the type appeared for centuries after its introduction. The athletic body of the goddess, with rounded abdomen, breasts, and buttocks, is also typical of the Late Period.

Betsy M. Bryan

1. Georges Daressy, *Statues des divinités*, vols. 1 and 2. Catalogue général des antiquités égyptiennes du Musée du Caire (Cairo, 1905–06), CG 39271–39272, pl. LIX.

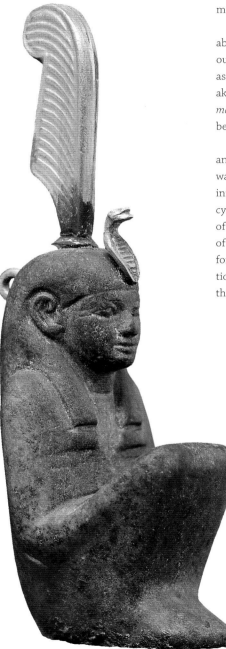

88 Goddess Maat

Third Intermediate Period, c. 800–700 BCE;
lapis lazuli and gold. Height 7 cm (2 ¾ in);
width 2.5 cm (1 in); depth 2.5 cm (1 in). Khartoum.
The Egyptian Museum, Cairo CG 38907

• This statuette depicts the goddess Maat as a seated woman. The uraeus on her forehead identifies her as a goddess, and the feather on her head is the hieroglyph with which her name was often written. The statue was apparently meant to be worn around the neck of its owner.

The ancient Egyptian word *maat* is an abstract term meaning essentially "things as they ought to be." The Egyptians viewed this concept as part of the order of the universe, somewhat akin to the concept of natural law. For that reason, *maat* was seen as a divine principle, female because the word is feminine in gender.

In theory, *maat* governed all aspects of ancient Egyptian life. On the broadest level it was the principle behind the regularity of nature, initiated at the first sunrise of creation: the daily cycle of sunrise and sunset, the yearly progression of the seasons, and the continual phenomenon of life, death, and new life. The uraeus on the forehead of this statue, which is unusual in depictions of *maat,* reflects the governing power of this principle.

Maat was also the moral and ethical principle that determined the proper mode of behavior in human society, from correct treatment of one's fellow human beings to just government. Its moral aspect is reflected in the funerary corpus known as the Book of the Dead, where the heart of the deceased is depicted in the final judgment being weighed against the feather that symbolizes *maat.* Temple scenes and statues also show the pharaoh presenting *maat* to the gods, commemorating his proper conduct of government. National and local officials were also supposed to exercise their offices in accordance with *maat.* For that reason the vizier, head of the national bureaucracy, sometimes wore an image of *maat* around his neck. The gilding on the feather and uraeus of this statue suggest that it may have belonged to one of these high officials., or perhaps from one of the Kushite royal family, since the figure comes from the Sudan, the home of the Twenty-fifth Dynasty conquering rulers of Egypt. **James Allen**

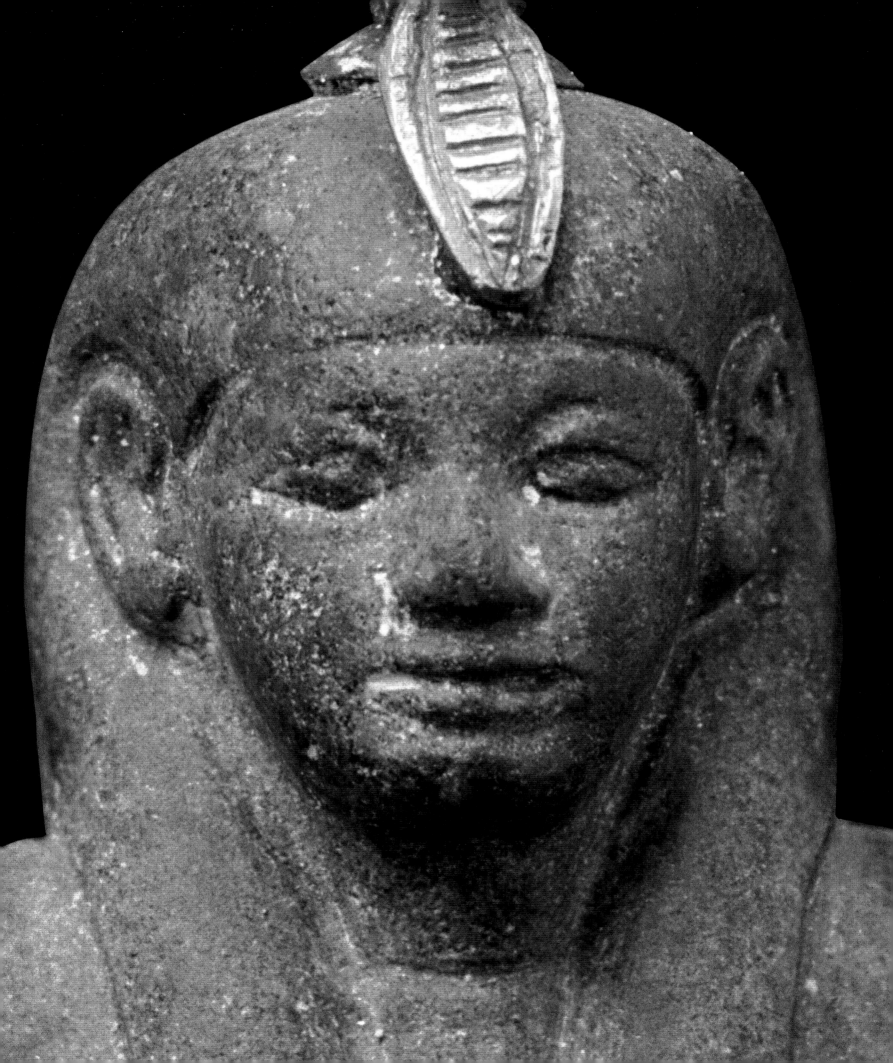

89 Stele of a woman

Twenty-first Dynasty, 1069 – 945 BCE; painted wood. Height 43.5 cm (17 1/8 in); width 33 cm (13 in); depth 5 cm (1 15/16 in). Deir el-Bahari cachette. The Egyptian Museum, Cairo JE 29308

· This small wooden stele is typical of those dedicated in the numerous Theban burials of the Third Intermediate Period. Caches of coffins and burial goods were found in tombs around the temple of Deir el-Bahari, and these often belonged to the priestly families of Twenty-first Dynasty Thebes. This stele shows a lady dressed in a long flowing garment, with wide sleeves and a shawl that hangs below the arms. As is typical of the period, the garment is delineated by the red out-line, and it is shown with the body beneath as visible as the garment. The fine linens of the time could be nearly transparent, so this effect may have been a real one. The lady holds a tray of food, including onions, breads, and fruit for the satisfaction of Osiris. The god is shown enthroned wearing the *atef* crown, with the two feathers of truth, alluding to Osiris' role of judgment in the afterlife. His mummiform body has been painted with elaborate patterns, and his skin is shown green to indicate a color of rejuvenation. The face of Osiris intentionally archaizes to the time of Thutmose III, and we see the slightly aquiline features of that king represented here some three hundred and fifty years after his death. In front of Osiris is the emblem of Anubis, a stuffed animal skin attached to a weighted post. This somewhat obscure element signifies the presence of the funerary preparations.

The inscription above the lady and the god identifies the god on the left: "Utterance by Osiris, lord of eternity, foremost of the westerners, perfect one in Abydos." On the right the text reads: "The Osiris, the mistress of the house, the singer of Amun-Re, king of the gods, the noble lady Med-jaseshet, vindicated."[1] The horizontal text below the scene gives Osiris even more epithets: "Utter-ance by Osiris foremost of the westerners, Wen-nefer, the ruler of the living, the king of upper and lower Egypt, ruler of everlastingness, Ptah-Sokar, the lord of the Shetyt. May he give every good and pure thing (to) the Osiris, the mistress of the house, the singer of Amun-Re king of the gods, Medjaseshet, vindicated." **Betsy M. Bryan**

1. This exceptional name, written twice identically on the stele, appears to mean, literally, "the book of the lotus bloom," but *medja* may sometimes refer to amulets, so perhaps her name means "the lotus amulet," the lotus being a symbol of rebirth (Adolf Erman and Hermann Grapow, *Wörterbuch der ägyptischen Sprache: Im Auftrage der deutschen Akademien* [Leipzig, 1928], vol. 2, 187).

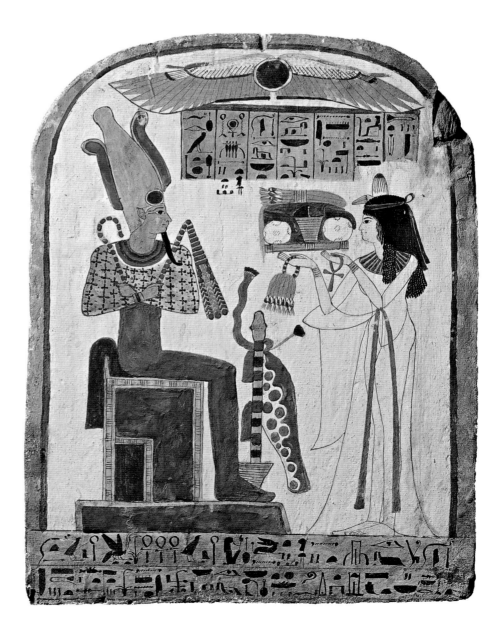

90 Scorpion stone

Early to mid-Eighteenth Dynasty, c. 1550–1400 BCE; limestone. Height 12.5 cm (4 15/16 in); width 18 cm (7 1/16 in); depth 22 cm (8 11/16 in). The Egyptian Museum, Cairo JE 36507

• Scorpions were and are a commonly encountered danger in Egypt. The small arachnid appears in a light colored form and measures some 8 to 10 cm in length, without its tail. Scorpions inhabit the desert and are most active at night, remaining under rocks or within crevices during the day. They are not uncommonly found in the mud brick houses of modern Egypt just as they were in antiquity. The bite of the scorpion is a neurotoxin and can be fatal to children and the elderly. The use of amulets to protect families from the bite of the scorpion was widespread; they could be small and portable or, as here, a heavier object kept in the home or even donated in a temple.

The most common word for scorpion in Egyptian is *wehet,* and the best known deity identified with it is Selket, shown as a lady with a scorpion on her head. Selket was associated with people who removed scorpions from temples or accompanied expeditions to the desert quarries to perform their exorcist duties there. These men were called the *shed wehet* (he who removes scorpions). Another deity Heddjet or Isis-Heddjet helps to repel the danger of the scorpion. Indeed the function of amulets against scorpions was to gain control over the arachnid and turn its power to one's benefit. Images that show the child god Horus standing on crocodiles and holding scorpions in his hands are designed to demonstrate his power over those potential evils and to bring them into his employment as he desired. This scorpion stone would have had a similar purpose.

The text of this scorpion stone runs as follows: "Isis Heddjet, mother of the god who created his beauty. A gift which the king gives to Isis the great, the mother of the god, that she may give life, prosperity, and health, cleverness, favor, love, and existence on earth in her following everywhere for the *ka* of Djehuty, his wife, the Nurse of Heddjet, Iret."

The cult of Heddjet is known from Edfu where, as here on the stone, Isis Heddjet was considered to be the mother of the local Horus. However, this scorpion stone is now the earliest known monument naming Isis Heddjet, since the cult was attributed to the end of the Eighteenth Dynasty,[1] on the basis of a stele from Edfu. And even in the Coffin Texts and Book of the Dead the association of Isis with Heddjet had not been apparent. The text and the form of the stele, with a single-winged sun disk and a *wedjat* eye, are more consistent with a mid-Eighteenth Dynasty date. Indeed, the text is nearly identical to that on the scorpion stone here. There is a strong likelihood that Djehuty and his wife Iret came from Edfu where Iret was attached to the temple and perhaps Iret functioned as a nurse relating to

scorpion bites. This alludes to the role of Isis, here Isis Heddjet, as magician and healer whose powerful spells protected her son and also guarded the sun god during his journey through the netherworld. In the Amduat we see Isis hurling magical spells at the evil snake Apophis in the Seventh Hour. We also see the scorpion in the Fourth Hour, placed to guard the descending passage, apparently of a royal tomb, that cuts through the netherworld space. The scorpion here is, as said above, under the control of the sun god, obeying his order to stay in one location — certainly not the normal behavior of a scorpion.

Betsy M. Bryan

1. Georges Daressy, *Notes et Remarques.* Vol. 7 of *Recueil de travaux, rélatifs à la philologie et à l´archéologie égyptiennes et assyriennes* (Paris, 1886), 43, XCI. The barber Siese before Behdety and Heddet: "Giving praise to Horus Behdet, kissing the ground to the great god by the barber Siese. A gift which the king gives to Horus Behdet and Heddet, they may give life, prosperity, and health, cleverness, favor, and love to the *ka* of the barber of Horus Behdet Siese. He acted for his mistress Heddjet, being silent, perfect of character, and favored of Horus in his temple."

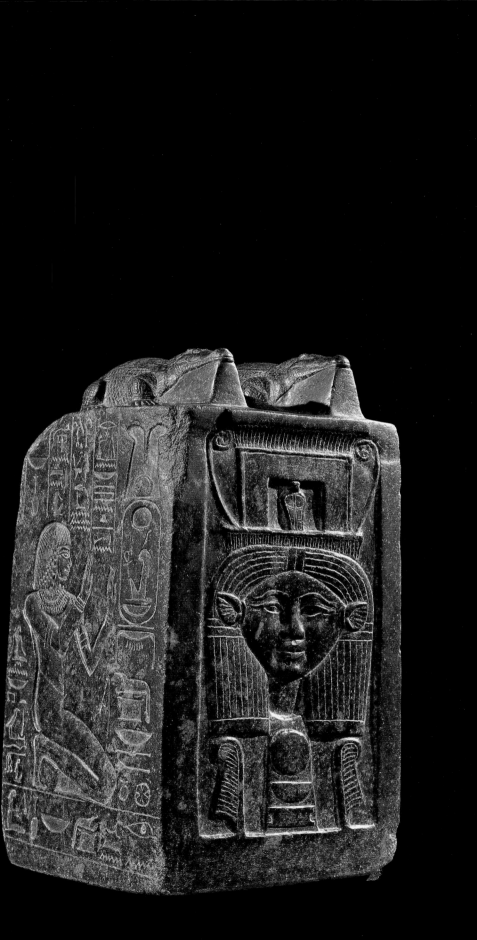

91 Block with relief of Nebnefer

Eighteenth Dynasty, reign of Amenhotep III, 1390–1352 BCE; granodiorite. Height 55.5 cm (21⅞ in). Discovered in 1987 at the Sobek Temple of Dahamsha. Luxor Museum J 136

• This block is from the Sobek Temple in Sumenu (modern Dahamsha), a town southwest of Luxor. It shows on the right side in sunk relief an official, Nebnefer, adorned with an elaborate wig, worshiping the cartouche or royal name of Amenhotep III. On the left side the same man pays obeisance to the crocodile god Sobek and the goddess Hathor. Fittingly two crocodiles, the sacred animal and symbol of Sobek, crouch upon the block. This important deity is naturally most closely associated with water, streams, and swamps. He was particularly worshiped in the Fayum, but also had cult centers throughout the rest of Egypt, such as Sumenu.[1] In the front of the monument a Hathor *sistrum* is represented, this being a sacred rattle instrument used in temple cult. In the back the wife and mother of Nebnefer are shown playing the *sistra*, and holding the *menat,* a type of necklace also sacred to Hathor.

 Crocodile deities appear, for example, in the Sixth Hour of the Amduat. In that section a male deity, perhaps Sobek, is merely called "crocodile," while a female deity is said to be associated with the primeval water of Nun.[2] Sobek is a god of fertility, feared for his power and mastery over the water. It is in this aspect that he appears in such underworld compositions as the Coffin Texts.[3] Generally Sobek has no wife among the goddesses, but he is often represented in company with Hathor, as in this monument.[4] Amenhotep III seems to have built installations at Semenu intended to house sacred crocodiles.[5] Such a votive monument as this one would have been displayed in the Sobek Temple, attesting to the piety of the donor, Nebnefer.

The vertical lines of inscription on the right side may be translated: "Giving praise to the Lord of the Two Lands; kissing the earth for the Ruler of Thebes by the priest, overseer of the treasury of Amun, Nebnefer." Behind Nebnefer: "Born to the mistress of the house, Djuf." Horizontal line at the bottom of the right side: "Made by the master of the secrets of Sobek, Nebnefer." The vertical lines on the left side may be rendered: "Giving praise to Sobek Sobek (sic). Kissing the earth for Hathor. I have given to you adoration to the height of heaven, while I cause your hearts to be satisfied every day, by the priest, royal scribe, and divine sealer of Amun, Nebnefer." Beneath this is a horizontal band of hieroglyphs: "Made by the priest of Amun, Nebnefer." In the back the vertical column in the middle runs: "Offerings and provisions which their *ka* gives to the *ka* of the priest, overseer of the Treasury of Amun, Nebnefer." Above the female figure with the *menat* and sistrum on the right: "His mother, the mistress of the house, Djuf." Above the female figure with the *menat* and *sistrum* to the left: "His sister, the chantress of Amun and mistress of the house, Huy." Beneath the two women in the back is a horizontal line: "Son of the overseer of the wine storeroom and scribe, Sobekhotep, justified of voice." Beneath the *sistrum* in the front may be read: "Beloved of Nebmaatre [i.e. Amenhotep III]."

Richard Jasnow

1. See Edward Brovarski, "Sobek" (pp. 995–1031) in Wolfgang Helck and Wolfhart Westendorf, eds., *Lexikon der Ägyptologie,* vol. 5 (Wiesbaden, 1984).

2. Erik Hornung, *Die Unterweltsbücher der Ägypter* (Zurich/ Munich, 1992), 125. The male deity is said to be Sobek in Hornung, *The Ancient Egyptian Books of the Afterlife* (Ithaca, New York, 1999), 37.

3. Brovarski, "Sobek," 1000.

4. Ibid., 1008.

5. Ibid., 1004.

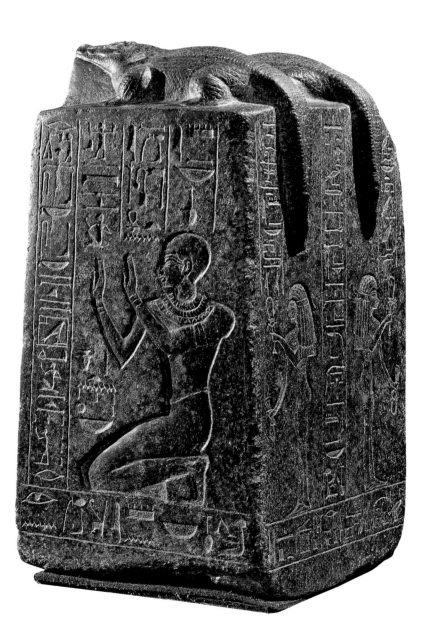

185

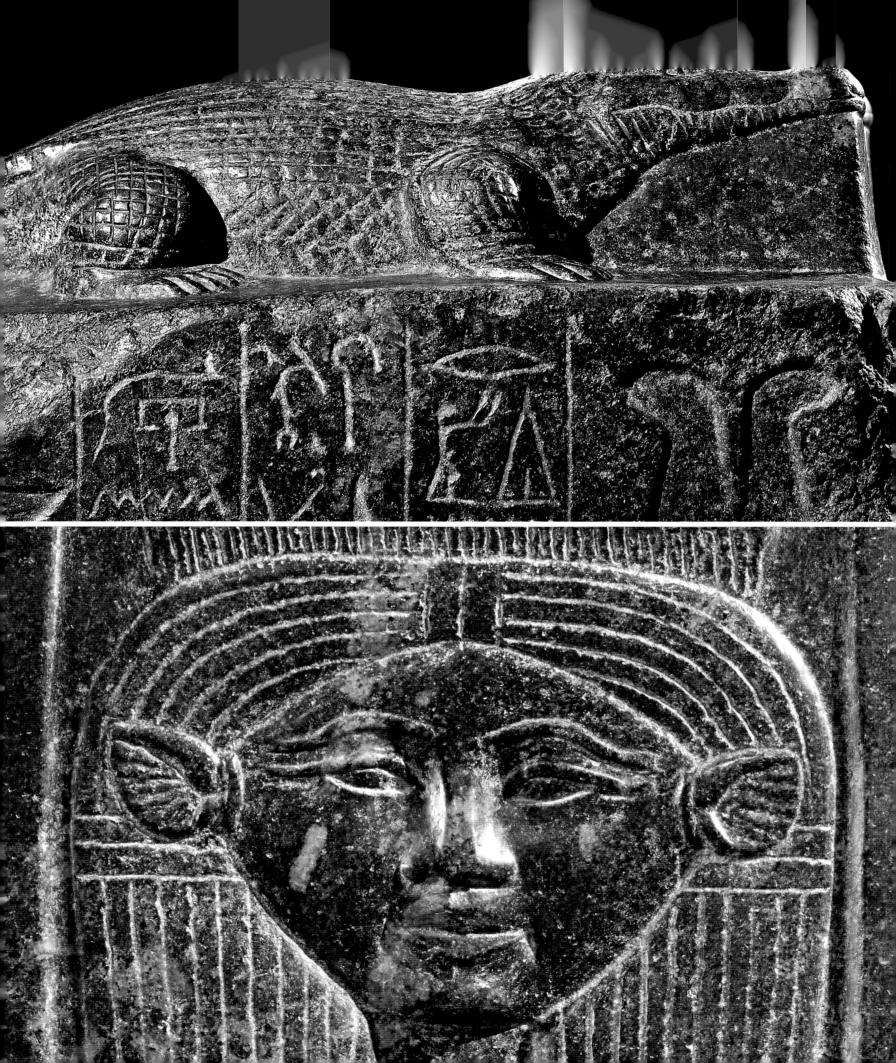

92 Falcon

Twenty-second Dynasty to Twenty-sixth Dynasty, c. 945–525 BCE; bronze with gold inlay. Height 22.5 cm (8 7/8 in); width 7.5 cm (2 15/16 in); depth 17 cm (6 11/16 in). The Egyptian Museum, Cairo JE 30335

• The very beautiful and commanding Horus falcon was a votive offering to the god in the Twenty-second Dynasty. Bronze casting was greatly improved during the New Kingdom (1550–1069 BCE) and by the Third Intermediate Period (1069–664 BCE) it had become common to make gifts to the gods in the form of bronze statuettes inscribed with the donor's name and often a prayer as well. This piece is inscribed for "Horus the son, gives life [to] Imhotep, son of Padi-Neith." Unfortunately we do not know where the falcon was donated, and Horus the son of Isis was honored in a variety of locations, both in the north and the south. The inlay of gold was particularly characteristic of the Third Intermediate Period, when bronze working was at its apogee. Here it is used to outline the eyes, making them even more penetrating. It also forms the eye markings of the falcon, the leg bands of the bird, and, of course, the necklace, designed to imitate lotus garlands. Hanging down from the collar is a pendant with a heart and a sun disk. The falcon wears the crown of Lower Egypt, very brightly painted in red over the bronze. Whether the original crown also combined the Upper Egyptian crown or not is unknown, but it is possible.

Horus was the god embodied in the office of kingship, and through most periods of Egyptian history, images of the falcon also conjured up the presence of the ruler. In the temple of Seti I at Abydos several images show falcons on altars with shrines behind. The inscriptions make it clear that these are the great living falcons, but they are identified with Seti himself. In the Third Intermediate Period rulers at Tanis emphasized this association by fashioning coffins with falcon heads rather than human ones. The king as solar falcon could then enter the west quite prepared. The bronze falcon here also has solar connotations, as witness the sun disk around his neck. Whether it was associated in the minds of the Egyptians with the king is uncertain, but certainly the falcon Horus was a popular image for donation in the temples of the Third Intermediate Period. **Betsy M. Bryan**

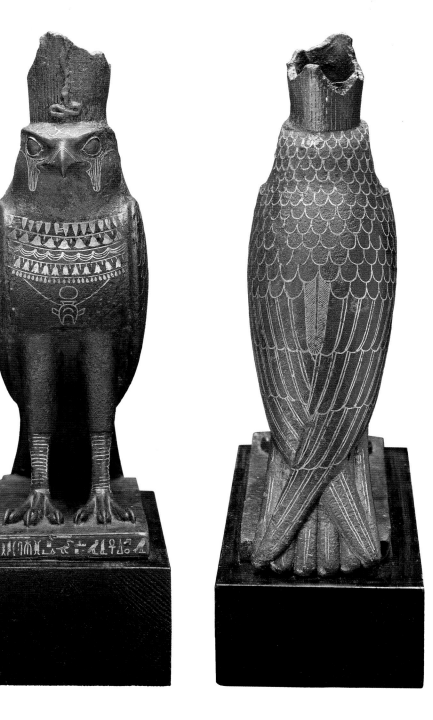

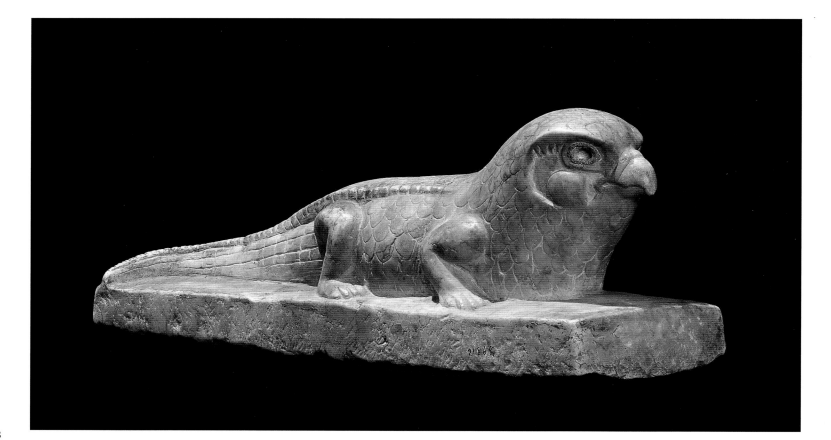

188

93 Falcon-headed crocodile

Late Period, 664–332 BCE; indurated limestone.
Height 12.5 cm (4 15/16 in); length 36 cm (14 3/16 in);
depth 9.5 cm (3 3/4 in). Mansoora. The Egyptian
Museum, Cairo JE 21868

• Egyptian gods were represented in a variety of
forms. They can be shown in human (anthropo-
morphic) forms, animal forms, and in combina-
tions such as human bodies with animal heads,
and bodies of animals with the heads of different
animals. This statue is an example of the latter
combination. It is a statue of a god with the body
of a crocodile and the head of a falcon.

This statue is carved in the round from
a single piece of stone, giving the appearance
of an animal standing on a rectangular base. The
crocodile body is rendered quite naturalistically,
with its scales indicated by means of incised
lines. These scales not only cover the body, but
also extend onto the forehead and neck of the
falcon. The eyes, cheeks, and beak of the falcon
head are also carved in a natural way, and blend
well into the reptile body of the god. The statue
is uninscribed, but may once have fit into a larger,
inscribed base.

This piece clearly represents a deity
whose essence could be manifest in the form of
a falcon-headed crocodile. While there are several
gods who were depicted in this fashion, it is
not possible to determine precisely which one is
shown here. One possibility is Sobek the Shedite
Horus, a god worshiped during the Middle King-
dom (2055–1650 BCE) first at the marshy Fayum
site of Shedet, and then in various other parts of
the country, including Hawara, Gurob, and
Kahun. A second candidate for this statue is Her-
wer, or Horus the Elder, a New Kingdom (1550–
1069 BCE) deity who was sometimes represented

as a crocodile with a falcon head, in particular
at another marshy site, Kom Ombo.

A third instance in which a crocodile
and falcon appear as one is in the Osiris cycle,
in which Sobek assimilates to Horus in order to
avenge Osiris' death. In the myth, Horus is said
to have brought his father Osiris out of the river
in the form of a crocodile. If this piece did origi-
nate at Mansoora, a site in the Delta, then it may,
in fact, be evoking Horus in this capacity, since
the Osiris cult was very popular in that region
during the Late Period.

Regardless of the exact deity being repre-
sented here, it is clear from its body that refer-
ence is being made to the ferocity and strength
of the crocodile. However, the protective nature
of the falcon is also invoked by the god's head,
perhaps taming the dangerous tendencies of the
crocodile, and making this statue an embodiment
of the power and protection desired by the per-
son who dedicated it. **Elizabeth A. Waraksa**

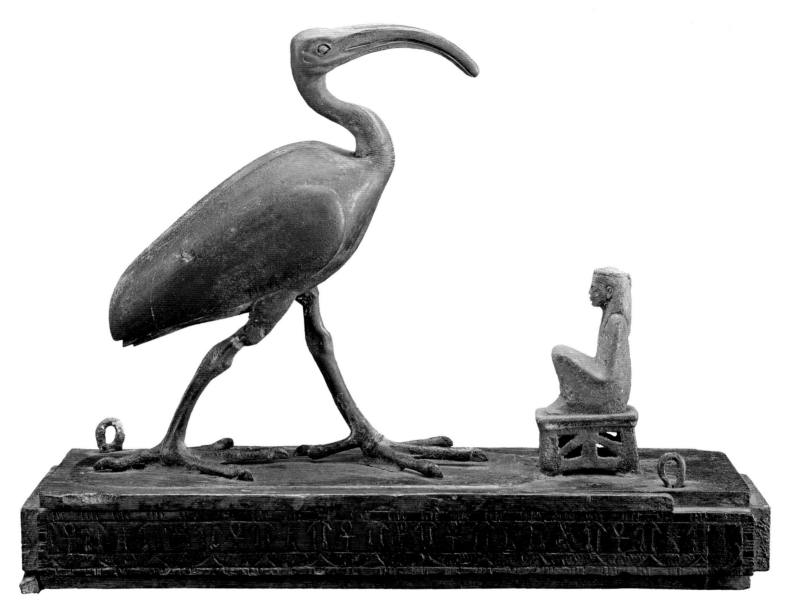

94 Thoth and Maat

Late Period, c. 664–332 BCE; wood and bronze.
Height 26.5 cm (10 7/16 in); length 33.5 cm (13 13/16
in); depth 10.5 cm (4 1/8 in). The Egyptian Museum,
Cairo JE 71971

• One of the most pivotal moments in an individual's transition from life to eternal existence in the afterlife was the judgment of his or her soul. This event took place before Osiris, the main deity of the afterlife, and a group of other gods including forty-two divine judges who assisted in the weighing of the heart that tested the moral worth of the individual. Among the other attendant gods were Thoth, shown here as an ibis, who served as the scribe and recorded the judgment of the deceased, and Maat, shown here as a seated woman, who was the incarnation of truth and cosmic order.

In the course of the weighing of the heart, the deceased was required to recite the "negative confession" swearing that he or she had not committed transgressions against society, the state, or the gods. A representation of the heart of the deceased—a symbol of the individual's conscience—was placed in one pan of a balance scale, and Maat, or her feather emblem (which is missing from this statue group), was placed in the other. Since depictions of the mythical act always show the pans balanced, it is unclear whether the virtuous heart, in the form of a stone scarab or heart amulet, was heavier or lighter than Maat. However, since the scarabs and amulets were usually made of stone, it seems likely that a "heavy" heart was a sign of goodness.

This statue group reflects the taste for composite groups that emerged in the New Kingdom (1550–1069 BCE) and gained increasing favor in the Late Period (664–332 BCE). The most popular groupings incorporated a figure of a god, very commonly Thoth in the form of an ape or ibis, facing a devotee. Many of these statues were donated to temples by individuals to demonstrate their piety and devotion to the god.

This group has been attached to a rectangular base that is carved with ankh and *sa* signs to provide life and protection. The function of the metal loop at the front of the base is unknown. **Emily Teeter**

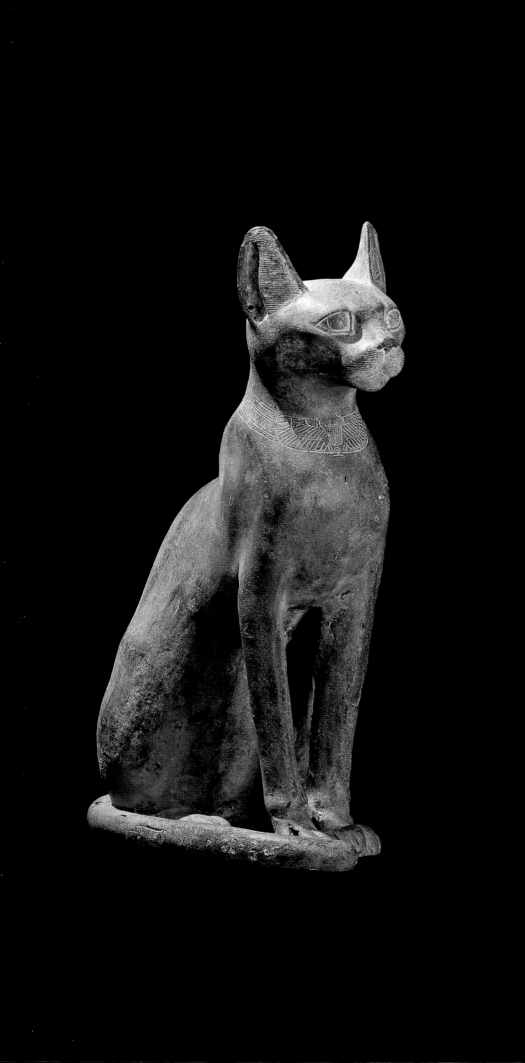

95 Bronze cat

Late Period–Ptolemaic Period c. 664–30 BCE; bronze. Height 38.5 cm (15³⁄₁₆ in); width 15.5 cm (6⅛ in), depth 29 cm (11⁷⁄₁₆ in). The Egyptian Museum, Cairo, JE 28147

• Bronze statues of cats were an important part of religious cult devotions from the Late Period into the Ptolemaic Period (c. 664–30 BCE). It was believed that buying, and then donating, a statuette to the temple could bring merit before the gods, and consequently ensure one's own life after death.

Thousands of bronze representations of cats are known, varying in size from small amulets to greater than life-size. The larger ones, like this example, had two functions. Those with a small interior cavity are thought to be votive statuettes that devotees would dedicate to one of the feline-form deities such as the goddesses Bastet, Pakhet, and Sakhmet. The statuettes would be left at a shrine or temple to bear witness of the individual's devotion. In some cases, the statue, or its base, would bear the name of the devotee, and more rarely, a short dedication text might be added.

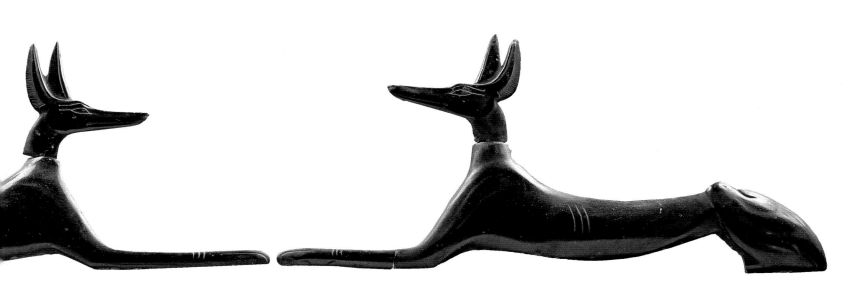

The figurines that have a larger interior cavity were, in some cases, used as coffins for mummified cats. In the beginning of the first millennium BCE, cult practices increasingly included animal mummies, which like the statues, were donated to the temple. The animals were considered to be the *ba*, or visible manifestation of the power of the deity, that they symbolized. Texts relate that priests bred the animals that were associated with the patron deity of the temple.[1] Maintaining a breeding stock, the priests culled the offspring and mummified them. Radiographic examination has shown that kittens were killed within a year of their birth, usually by having their neck broken. At times the mummy packets were very ornate and were decorated with false eyes, ears, and tails. Some mummies were inserted into the bronze cat coffins, while others had a bronze bust of a cat sewed to the mummy packet. In the second-century BCE Archive of Hor, which deals with sacred ibises, mummies and coffins were sold to pilgrims who then donated them to the temple where they were stored in the "hall of waiting" until they were transferred en masse to the temple catacomb each year. Thousands of bronze cat coffins and cat mummies have been recovered from sites throughout Egypt.

This statuette shows the cat proudly seated on its haunches, its tail curled around its front paws. The representation of a necklace is incised on its neck. Some examples of bronze cats were further decorated with small gold earrings. In a similar fashion, Herodotus related that sacred crocodiles were bedecked with glass or gold earrings and bracelets. **Emily Teeter**

96 Recumbent jackals

Late Period, 664–332 BCE; glass. Right and left, each: Height 8 cm (3⅛ in); width 19 cm (7½ in); depth 2 cm (¹³⁄₁₆ in). The Egyptian Museum, Cairo TR 21-12-26-19/TR 21-12-26-20

• Each of this exquisite pair of objects represents a couchant jackal, with the head cut separately from the torso and front legs. The back legs and tail are missing and would in all likelihood originally have formed a third piece. The material is black-colored glass. Since the figures are certainly intended to represent the god Anubis, black is an appropriate color, symbolizing the sanctity and mystery of night and the deity's chthonic aspects.

The objects would have been inlaid within a coffin or wooden shrine, more likely the former. The coffin of Petosiris of the Thirtieth Dynasty, (c. 350 BCE), was decorated entirely of polychrome glass inlays. Between the head and body of the jackals would have been placed a red glass band, normal shown on Anubis' neck.

Anubis is the guardian of the body, its divine embalmer and protector for the journey to the other world, where he has the further function of guide of souls. He is also closely involved in the judgment of the soul after death. In later Egyptian history, Anubis was associated with healing and with love magic. In view of his many important attributes both in this world and the next, it is not surprising that many jackal amulets have been found. The significance of this pair probably relates to the common practice of depicting, in the lunette of funerary stelae of the Middle Kingdom (2055–1650 BCE) and later, pairs of jackals seated en face to indicate not only the protection of Anubis but of the closely related twin deity Wepwawet, "Opener of the Ways." One of these jackals is often named as Wepwawet of Upper Egypt, and the other Wepwawet of Lower Egypt. The deity Wepwawet is invoked to open the ways to the netherworld, but he also has important functions in this life, as defender of the king and protector against enemies. **Terence DuQuesne**

97 Double snake coffin

Late Period, 664–332 BCE; bronze. Height 15.5 cm
(6⅛ in); width 44 cm (17 5/16 in); depth 6 cm (2 3/8 in).
Provenance unknown; The Egyptian Museum, Cairo
JE 27254 / CG 38704

• On top of this rectangular box, inscribed with
two horizontal lines of hieroglyphs at the front,
are two identical hybrid deities, in bronze, with
human heads and the bodies of upright cobras.
The bodies of the cobras are crosshatched and
have a ladderlike design down the front of the
hood. Each human head is adorned with a long
wig and false beard and topped with an *atef*

crown with plumes and horns; the two figures are
joined at the horns. The weathered inscription
on the front of the box may be rendered as "May
Atum give life to Teshnefer, son of Amenirdis."

The iconography of this very curious
object may be unique. Occasionally in the Late
Period the god Atum was represented as a cobra,
though without a human head, or as an eel. From
the same period a few examples of human-headed
eels, also sacred animals of Atum, have been
found. In three cases they have human heads
topped with the double crown and no doubt
represent Atum; they rest on rectangular boxes
that evidently served as coffins for individual eels
or snakes. Hybrid forms of Atum and other deities
are common in the Late Period. By this time the
god Atum had acquired the status of a near-uni-
versal deity. Such hybrid entities were generated
in order to maximize magical effectiveness; hence
the figures of Bes Pantheos with a large composite

crown, feet in the shape of jackal heads, and
attributes of various other deities. In the case of
the snake or eel coffins or boxes the object would
have been, in part, to obtain favor from the
deity in exchange for providing a casket for one
of his sacred animals. This object may have
been intended to thank the deity for rescue from
illness or, like the "healing statues" and Horus
stelae that are found from the Late Period onward,
to ward off some malady such as snakebite.

Terence DuQuesne

192

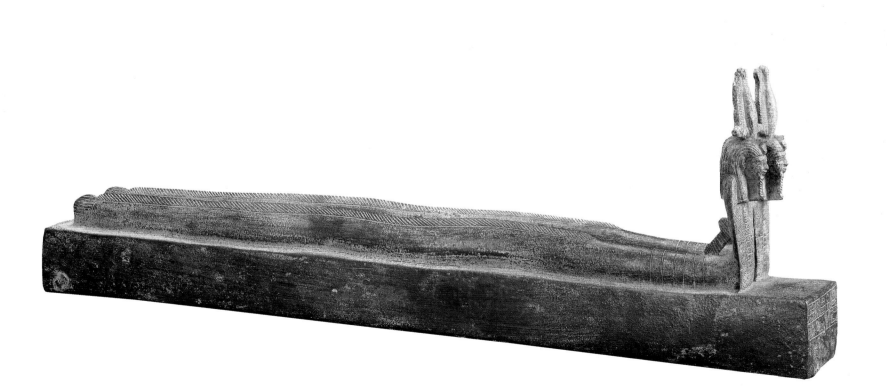

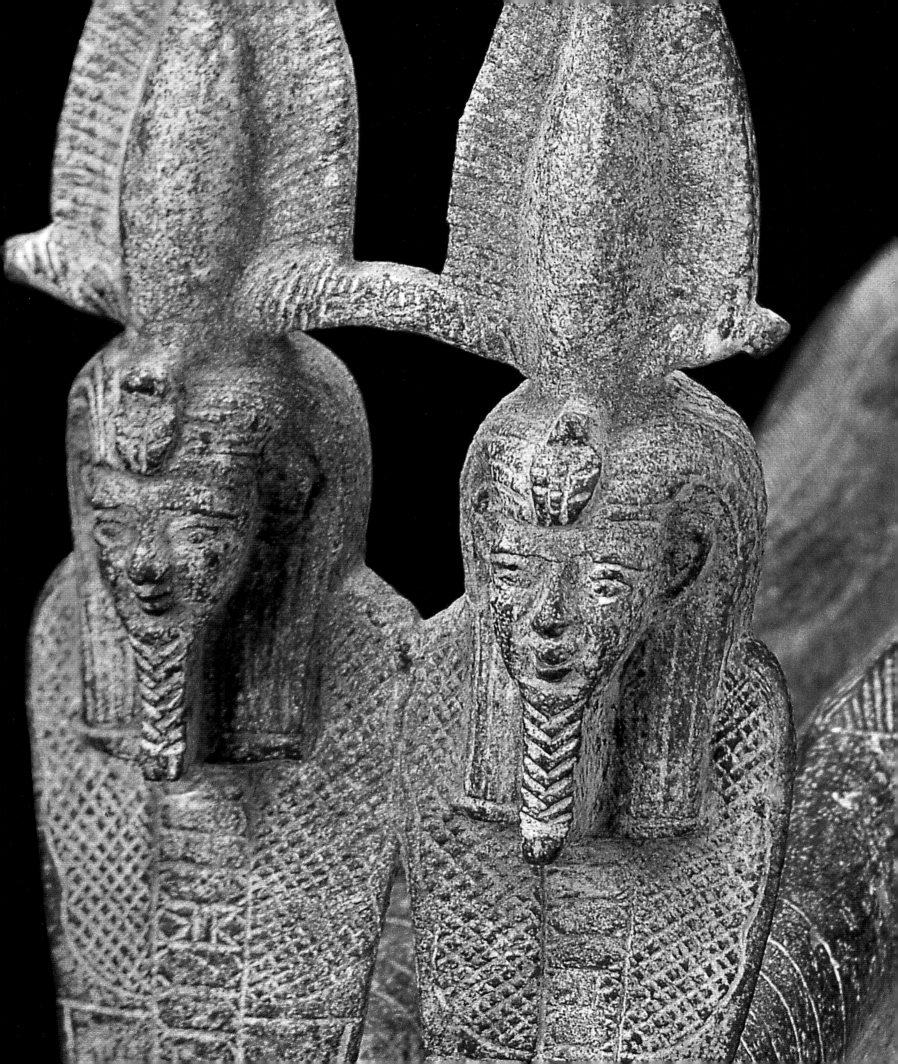

98 West

98 Pyramidion of Amenhotep-Huy

Nineteenth Dynasty, reign of Ramesses II, 1279–1213 BCE; granodiorite. Height 47.5 cm (18 11/16 in); width 53 cm (20 7/8 in); depth 52 cm (20 1/2 in). Top and bottom erased. Sakkara. The Egyptian Museum, Cairo TR 7-11-24-1

· The term *pyramidion*, a modern coinage, is generally used in two senses: to refer to a pyramidal structure set to form the tip of an obelisk, and also to indicate the topmost structure of a pyramidal tomb. Such tombs are associated with nobles of the New Kingdom (1550–1069 BCE) and later and not with royal pyramids. It is clear that the pyramidia that survive were not in all cases intended to be part of a larger construction: some, probably including this one, are more likely to be independent works of art similar to the votive stelae common in the Ramesside Period. Such pyramidia chart the journey of the sun through the sky and include hymns and prayers to solar divinities, with a view to guaranteeing the celestial ascent of the object's owner.

This pyramidion belonged to Amenhotep-Huy, a "true scribe of the king [Ramesses II]," who was also "the great overseer of Memphis," or "the great count of Memphis," probably its governor. This official is further described as "well loved" by the king and the "mouthpiece of the king at the temple of Ptah" in Memphis.

Pyramidia of this date and type may be characterized as being either Osirian, that is, connected with death and rebirth, or solar, that is, more associated with the journey of the sun through the sky in which the deceased intends to participate. This object is rather unusual in that it is both Osirian and connected with Re. It is also extremely sophisticated in its combination of two of the forms of each of the gods Re (Horakhty and Atum) and Osiris (Osiris and Sokar), which emphasize the indissoluble link between the two and their complementarity for ensuring the sun's continued daily course.

West face, upper register:
The winged sun disk is shown with wings outspread over a shrine. Within the shrine, the god Osiris is standing upright and wearing the White Crown. In front of Osiris, the *imyut* emblem of Anubis is seen, and behind him the symbol of the western netherworld. Above right, in the shrine, are hieroglyphs for "the west." On either side of the shrine are symmetrical figures of two couchant jackals on standards. Inscription (beneath jackal on left):

[Anubis], he who is in the Embalming-Place, lord of Ro-qerert. Inscription [beneath jackal on the right]: [Anubis], lord of Ro-setau, foremost of the Funerary Workshop.

West face, lower register:
To left, a kneeling male figure with arms raised in adoration. Inscription (left):

Praise to you, son of Geb, [Osiris] the Perennially Fresh, forever king and ruler of the necropolis, [you who are present] in the sweet north wind, in the pure breath that rises from Atum; for the Osiris, the one who is venerated before Anubis, lord of purification, the true scribe of the king, by whom he is well loved, the principal count in Memphis, Amenhotep, triumphant.

To right, a kneeling male figure with arms raised in adoration, balancing the figure to left. Inscription (right):

Praise to you [Osiris], the one who awakens in peace in your manifestation as lord of the transfigured spirits. May you grant him a place of peace in the necropolis and a great burial place in the West, [this being] for the Osiris, the true scribe of the king, by whom he is well loved, the overseer in his temple, the principal count in Memphis, Huy, triumphant.

South face, upper register:
The sun disk with wings outspread and with two uraei descending from them, from the wings a pair of arms projecting, the hands touching the upper sides of a shrine in which stands the falcon-headed Re-Horakhty wearing a sun disk on his head and carrying the *was* scepter. The shrine is set within a boat with papyrus prow and oars, with vaguely anthropomorphic figures standing fore and aft. The latter is probably Horus, as on the north face. The other may perhaps be Sia.

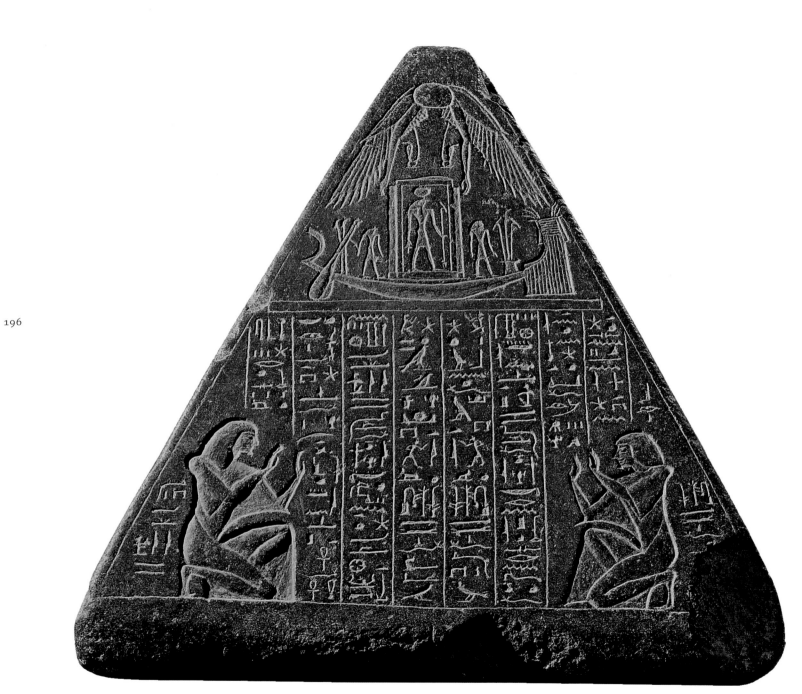

98 South

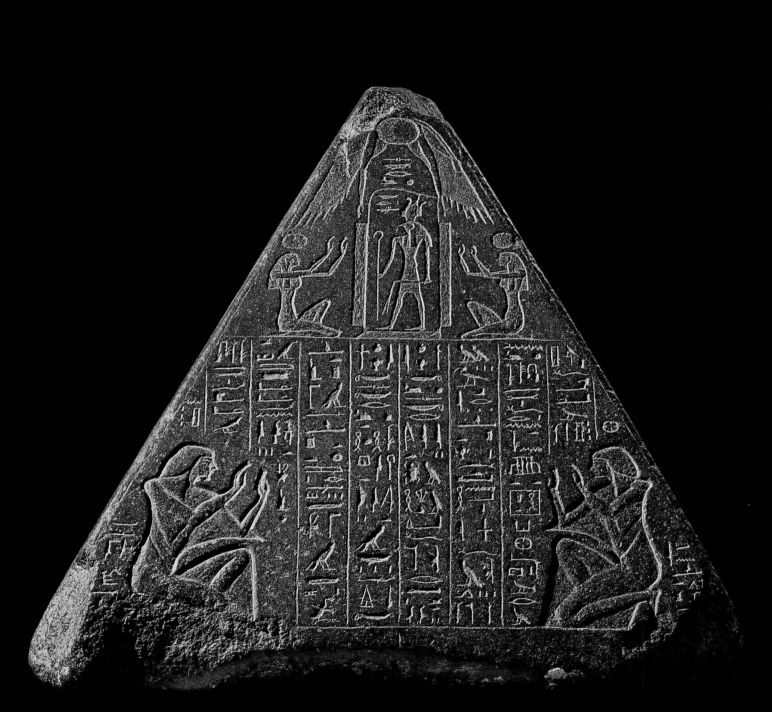

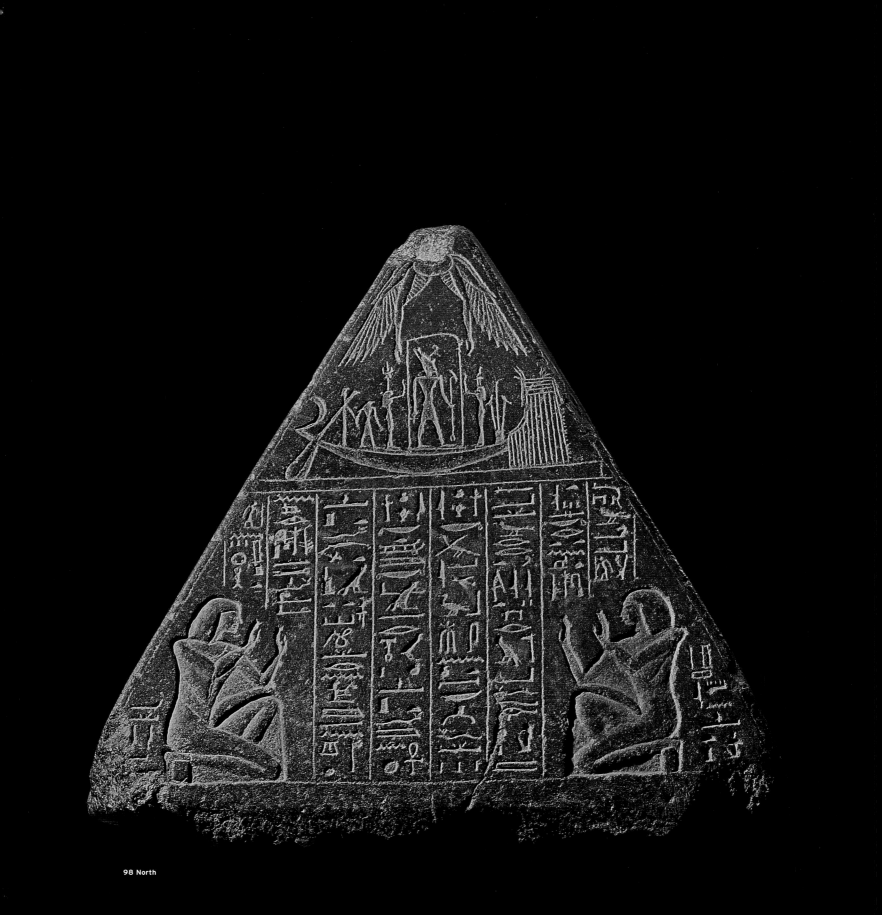

South face, lower register:
To left, a kneeling male figure with arms raised in adoration. Inscription (left):

Glorification to Re-Horakhty, to the divine image upon the horizon, by the Osiris, the true scribe of the king, by whom he is well loved, the great local count of Memphis, Huy, triumphant. He says: "Praise to you doubly, youth of the morning at Edfu, you who traverse the sky each day and who watch over the netherworld at night." Let him [the god] come to rest on the body of the Osiris Amenhotep, so that he may live as the southern stars live, the Osiris, the overseer of the temple, triumphant.

To right, a kneeling male figure with arms raised in adoration, balancing the figure to left. Inscription (right):

Glorification to Re when he sails up to the horizon, by the Osiris, the true scribe of the king, by whom he is well loved, the great overseer of the temple of Memphis Amenhotep, triumphant. He says: "Praise to you, youth, who renew the lovely sun disk of the morning." May he [the god] grant the sight of sunrays in the morning, and kissing the earth for him who is in the netherworld [Osiris], for the Osiris, the true scribe of the king, by whom he is well loved, [Amenhotep, triumphant].

East face, upper register:
Below a winged sun disk, two female figures with solar disks on their heads (probably Isis and Nephthys) kneel either side of a shrine within which stands a falcon-headed deity wearing the *atef* crown, bearing a crook and flail. He is named as "Sokar, lord of Ro-setau."

East face, lower register:
To left, a kneeling male figure with arms raised in adoration. Inscription (left):

Praise to you, Sokar-Osiris, king of everlasting, ruler of the Land of Silence, inspirer of great affection. May you visit the resting place of the great god, the setting of the sun in Ro-setau, the celestial company in the Shetayet, and the horizon in its visible appearance, for the inhabitants of the West, and for the Osiris, the true scribe of the king, by whom he is well loved, the great overseer of the temple of Memphis Huy, triumphant.

To right, a kneeling male figure with arms raised in adoration, balancing the figure to left. Inscription (right):

Praise to you, Osiris-Sokar, inspirer of affection, the one who comes into existence in the *henu*-barque. May you direct the celestial company to the Shetayet among the excellent transfigured spirits and (grant) rest for the body and (cause) it to be in the royal company of the great god, for the Osiris, the scribe of the king, by whom he is well loved, the king's mouthpiece in the temple of Memphis, the great overseer in his (Ptah's) temple, the principal count of Memphis, Amenhotep, triumphant.

North face, upper register:
Above, a winged sun disk with arms stretching down to touch a shrine in which Atum, the setting sun, anthropomorphic and wearing the double crown, stands holding a scepter. The shrine is set in the solar bark. To left and right of the shrine respectively, female figures stand with arms upraised. The female figure to the left wears the Abydos emblem on her head, and the one to the right has the symbol for the west on her head. At the stern of the boat, a standing falcon-headed deity, no doubt Horus, mans the rudder, just as on the south face.

North face, lower register:
To left, a kneeling male figure with arms raised in adoration. Inscription (left):

Praise to you, Atum in the evening, you who come to rest in life, you who set (as) a dead body in the western place. May my name be vigorous in the Land of Silence[?], for the Osiris, the scribe of the king, by whom he is well loved, the principal count of Memphis, city of Ptah, Huy, [triumphant].

To right, a kneeling male figure with arms raised in adoration, balancing the figure to left. Inscription (right):

Praise to you, you heir of Geb, born of Nut, possessor of glory, with great uraeus crown, inspirer of affection, who ascends as a god. May you grant the seeing of the sun in the Shetayet[?] of Sokar, for the Osiris, the scribe of the king, the principal overseer, the principal count of Memphis, Amenhotep [triumphant].

Terence DuQuesne

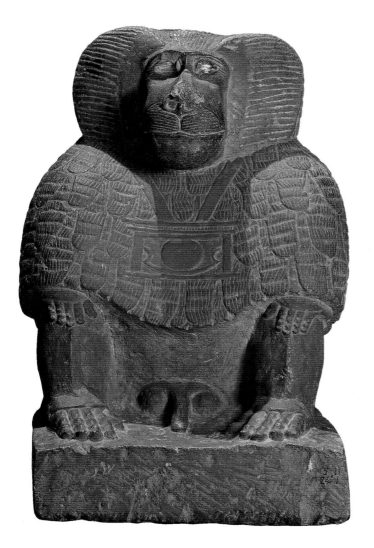

99 Baboon

**New Kingdom? 1550–1069 BCE; sandstone.
Height 60 cm (23⅝ in); width 43.5 cm (17⅛ in);
depth 44 cm (17⁵⁄₁₆ in). Provenance unknown.
The Egyptian Museum, Cairo TR 5-11-24-1**

• This statue depicts a cynocephalus (dog headed) baboon, considered one of the main manifestations of the god Thoth. The baboon stands on a square base with its hands resting on its knees. The details are carefully incised. The eyes and nose are hollow, suggesting that they may once have been inlaid with a material that is now lost. The hair is carved in such a way that it almost looks like feathers. The genital area is left exposed, probably emphasizing the sexual symbolism of these creatures to the ancient Egyptians. A pectoral with a representation of a sun barque is carved around the neck.

The Egyptians had been familiar with apes since the fourth millennium BCE. They were linked with the rejuvenation rituals and festivals of Upper Egyptian chieftains in Predynastic times (c. 5300–3000 BCE), and later to those of Early Dynastic Horus kings (c. 3000–2686 BCE). Since then, they had a permanent place in ancient Egyptian religion as one of the more important animal forms into which the gods might be transformed. As primeval animals, baboons and green monkeys were prominent parts of the Egyptian cosmogony. The earliest gods are sometimes depicted with baboon heads. The baboon became an aspect of the sun god, Re (probably the result of the observation that baboons greet the rising sun in the morning by barking), and of the moon god, Thoth-Khonsu.

Thoth (Djehuty in ancient Egyptian) was the god of writing and knowledge, who was depicted in the form of two animals: the baboon *(Papio cynocephalus)* and the sacred Ibis *(Threskiornis aethiopicus)*. In his baboon form Thoth was closely associated with the baboon god, Hedj-wer (the great white one) of the Early Dynastic period. By the end of the Old Kingdom (2686–2181 BCE) he was usually portrayed as an ibis-headed man, holding a scribal palette and pen or a notched palm leaf, performing some kind of act of recording or calculation.

Thoth was worshiped together with his lesser-known consort, Nehmetawy, at Hermopolis Magna (the ancient city of Khmun), in Middle Egypt. There was also a temple dedicated to him at Dakhla Oasis and one at Tell Baqliya in the Delta. Not much remains of the temple at Khmun besides two colossal baboon statues erected by Amenhotep III (1390–1352 BCE). In the vignettes of the "judgment of the dead," usually included in the Book of the Dead of the New Kingdom, Thoth appears both in his anthropomorphic, ibis-headed form, recording the results of the weighing of the heart of the deceased, and as a baboon perched on top of the scales. Thoth played the role of guardian of the deceased in the netherworld, and as an intermediary between the various deities, which is probably why he became associated with the Greek god Hermes in the Ptolemaic Period (332–30 BCE). **Yasmin El Shazly**

100 Sarcophagus lid of Nitocris

Twenty-sixth Dynasty, 664–525 BCE; red granite. Height 82 cm (32 5/16 in); width 274 cm (107 7/8 in); depth 112 cm (44 1/8 in). Deir el-Medina. The Egyptian Museum, Cairo TR 6-2-21-1

• This lid is part of a massive granite sarcophagus made for Nitocris, who was a daughter of Psamtik I, the first king of the Twenty-sixth Dynasty. Like many monuments of this period, the sarcophagus is archaizing, based on royal sarcophagi of the later New Kingdom.[1] The princess, represented as a mummiform figure lying atop the lid, is carved almost in the round. Her pose is Osiride, with arms crossed over her chest, holding a crook and flail. She wears the lappet wig and vulture headdress of high female royalty; above her brow are the remains of a uraeus (or possibly a vulture head). In contrast to these traditional elements, Nitocris's facial features, especially the shapes of her eyes and brows and her upturned mouth, are early examples of the Twenty-sixth Dynasty "Saite" style.

When Psamtik I gained control of southern Egypt in 656 BCE, he installed Nitocris as the "God's Wife of Amun" at Thebes, thus continuing the Third Intermediate Period practice of appointing a royal daughter to this exalted, wealthy, and powerful priestesshood. "Married" to the god Amun, these princesses functioned as royal surrogates for the kings. Since the office was celibate and succession was through adoption, Nitocris was adopted by her predecessor, the Kushite princess Shepenwepet II, in what was clearly a political arrangement. Psamtik further strengthened his daughter's position by also naming her high priest of Amun.

Like earlier god's wives, Nitocris had a mortuary chapel built within the precinct of the Small Temple at Medinet Habu.[2] This small structure also contains chapels for her adoptive mother, Shepenwepet II, and her birth mother, Queen Mehytenweskhet. Both women are also named in the inscriptions on the lid, along with her father.

The sarcophagus and its lid were found in 1885, at the bottom of a huge pit, in a cliff grotto above the temple of Isis at Deir el-Medina.[3] Whether Nitocris was actually buried there, or whether her sarcophagus was later removed from her original burial at Medinet Habu, is still unclear.[4] The sarcophagus of her successor, Ankhnesneferibre, the daughter of Psamtik II (595–589 BCE), which was found in another pit nearby,[5] had been reused during the Ptolemaic Period. Nitocris's sarcophagus, however, shows no obvious signs of reuse.

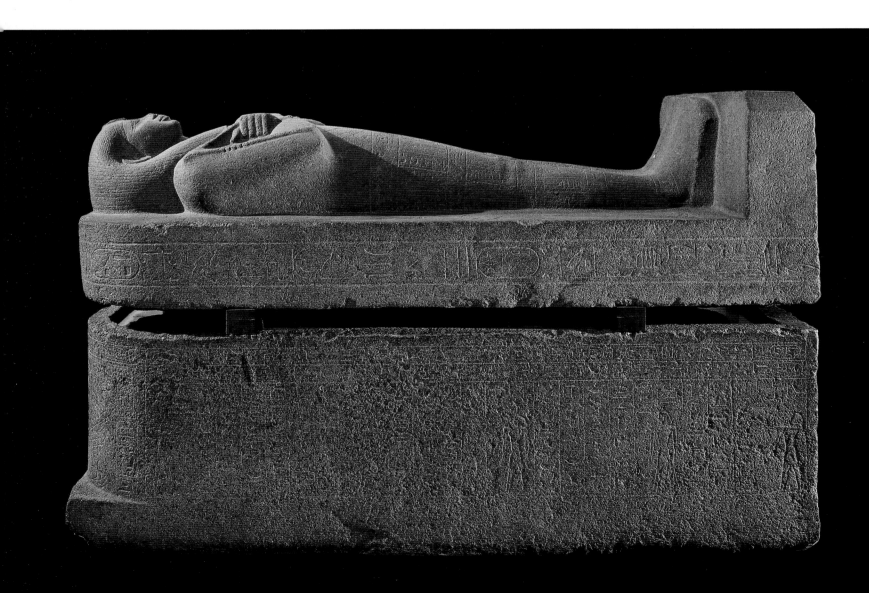

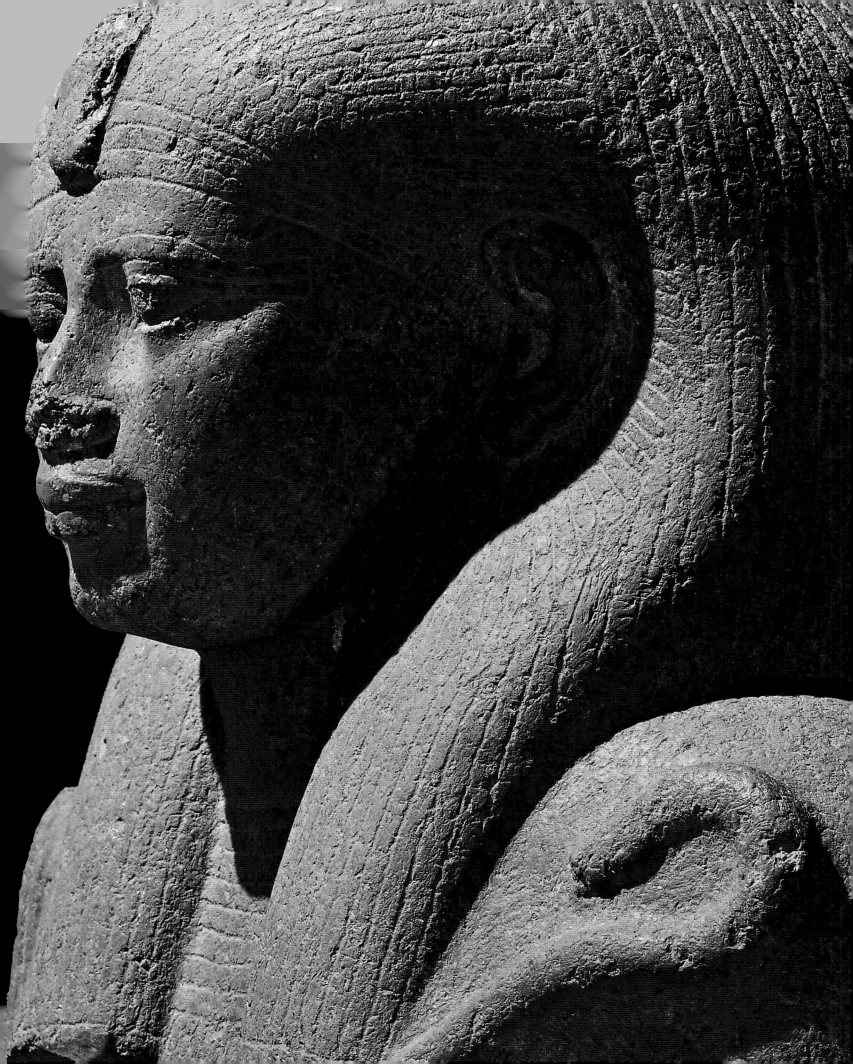

The separation of a tomb from its mortuary structure is consistent with royal burial customs during the New Kingdom and earlier; but it would have been anomalous in the Third Intermediate and Late Periods, when kings and members of their family were typically buried in small funerary chapels, within a temple precinct. The best known burials of this kind are at Tanis; but there are numerous other known or presumed examples, including Shepenwepet II's predecessor as God's Wife, the Kushite Amenirdas I, at Medinet Habu, and Psamtik I and his successors at Sais.

Nitocris's Medinet Habu chapel appears similar in type to these examples; but the huge pit in which the sarcophagus was found is not unlike those of the Twenty-sixth and Twenty-seventh Dynasties nonroyal shaft tombs at Sakkara and Abusir. If Nitocris — and Ankhnesneferibre — were indeed buried at Deir el-Medina, it is possible that this location was chosen because of its proximity to the temple of Isis. **Edna R. Russmann**

1. See Salima Ikram and Aidan Dodson, *The Mummy in Ancient Egypt* (London, 1998), 268–69.

2. Bertha Porter and Rosalind Moss, *Topographical Bibliography of Ancient Egyptian Hieroglyphic Texts, Reliefs, and Paintings.* Vol. 2, *Theban Temples,* 1929 (2d ed., rev. Oxford, 1964, 1972), 478–80.

3. Porter and Moss, *Topographical Bibliography.* Vol. 1, *The Theban Necropolis,* 1927, part 2, *Royal Tombs and Smaller Cemeteries,* 686 (tomb 2005).

4. The former view has been expressed by Bernard Bruyère, and the latter by Ikram and Dodson, *Mummy in Ancient Egypt,* 269.

5. Porter and Moss, *Theban Necropolis,* 685–86 (tomb 2003).

101 Pair of *wedjat* eyes

Late Twelfth Dynasty, c. 1800 BCE; Egyptian blue, calcite, and bronze. Height 13 cm (5⅛ in); width 28 cm (11 in); depth 1 cm (⅜ in). Provenance unknown. The Egyptian Museum, Cairo JE 90194

• These two eyes probably come from the side of a rectangular coffin, into which they were once inlaid. Coffins with inlaid eyes of this kind are typical of the later Twelfth Dynasty, particularly the reigns of its last three pharaohs (Amenemhat III, Amenemhat IV, and Sobekneferu, 1831–1773 BCE).

The eyes and eyebrows are human in form, but the markings below them come from the face of a falcon. Together they symbolize the eyes of the god Horus, the Egyptian principle of kingship, who was usually depicted as a falcon. Horus was thought to operate both in the sun, the dominant force of nature in ancient Egypt, and through the person of the Egyptian king. According to ancient Egyptian mythology, Horus once fought a cosmic battle with Seth, the principle of chaos, during which Seth tore out one of his eyes. After Horus defeated Seth, the eye was restored. The Egyptians referred to this renewed organ as *wedjat,* meaning "the sound one," and saw in it a metaphor for the ultimate triumph of good over evil.

Eyes were depicted on the exterior front of Middle Kingdom coffins, opposite the head of the mummy, which usually lay on its side within the coffin. In the burial chamber, this side of the coffin normally faced east, allowing the deceased symbolically to view the new life engendered each day by the rising of the sun. Like the sun, the deceased's spirit was believed to travel through the netherworld at night before being reborn at dawn. By depicting the coffin's eyes in *wedjat* form, the Egyptians hoped to incorporate the power of this new life into the coffin itself, making it possible for the deceased's spirit not only to view but also to participate in the phenomenon of daily rebirth. The eyes thus served both as a window onto the world of the living and, more important, as a portal through which the spirit could enter that world every day. **James Allen**

203

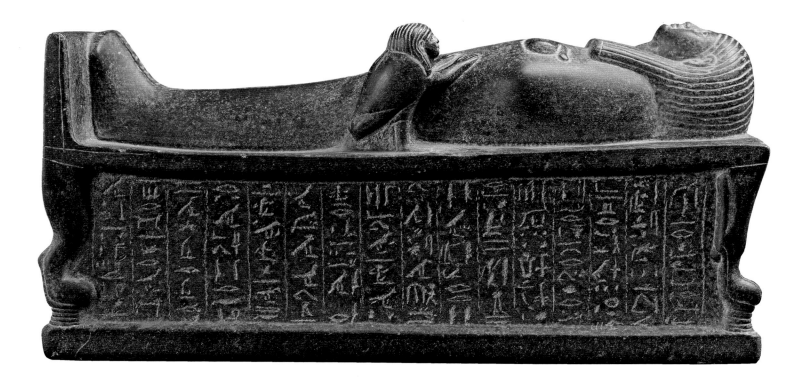

102 Mummy on bier

Reigns of Thutmose IV and Amenhotep III,
1400–1352 BCE; granodiorite. Height 11.5 cm
(4½ in); width 24 cm (9⁷⁄₁₆ in); depth 8.5 cm
(3³⁄₈ in). Thebes. The Egyptian Museum, Cairo
JE 7752/CG 48483

• Among the most important aspects of the search for immortality was the survival of the spirit and its communication with the mummy. One aspect of the soul, called the *ba,* was represented from the Eighteenth Dynasty as a human-headed bird. The *ba* allowed the deceased to maintain contact with the sunlit world, which was essential to the ancient Egyptians. During the day, the *ba* left the subterranean burial chamber, flew up the burial shaft, and entered the offering chamber of the tomb through the false door, and from there into the daylight. Tomb paintings and papyri show the *ba* enjoying the sun and partaking of cool water. As the sun set, the *ba* returned to the body and rested upon it during the night, reuniting the mummy with its soul.

This funerary statuette shows the *ba* of the royal herald, Re, resting its human arms protectively upon the mummy, which is shown upon a lion-legged funerary bed. The area under the bed is inscribed with a corrupt version of Book of the Dead Spell 89, calling upon the gods to protect the *ba* as it returns to the mummy.

The statuette was found within a model sarcophagus, which is richly covered with texts and images of protective gods. The right and left sides are divided into three panels, each decorated with a deity. Of the six deities, four are the Sons of Horus who guarded the viscera of the deceased. Anubis, the god of embalming, is shown twice. The head and foot show the goddesses Isis and Nephthys, the sisters of Osiris, who traditionally mourn the deceased.

The inscriptions on the sarcophagus call upon the gods to provide food, protection, and a good burial in the afterlife. However, a significant portion of the text is devoted to Re's many titles and the specific mention of his name, for the preservation of the individual's name was of critical importance for immortality. The combination of his name and bureaucratic titles served to immortalize the individual and to show how he fit into the fabric of society. These texts relate that Re had a distinguished career in the time of Thutmose IV and Amenhotep III. Among his titles were Overseer of the Treasure House, the First of the Royal Heralds, the God's Father, the

Overseer of Works in Upper and Lower Egypt, and Royal Scribe. His perseverance in his duties is reflected in his claim to be "the eyes of the king," and "ears of Horus." He was buried in Theban tomb 201.

Other similar artifacts indicate that this statuette was a variant form of a *shabti.* A small statue of a mummy on a bed with a *ba* at its side (Cairo CG 48574)[1] is inscribed with the *shabti* spell (Spell 6 from the Book of the Dead). A wood effigy from the tomb of Tutankhamun (Cairo 60720)[2] which, like the figure of Re, was paired with a wood sarcophagus and shows the *ba* on the chest, was equipped with miniature tools that are characteristic of those supplied for *shabti* figures.[3] A third statue, in Turin (no. 2805),[4] shows a mummy on a bed with the *ba* on his chest. Small *shabti* figurines, incised with Book of the Dead Spell 6, stand at the head and foot of that statuette. **Emily Teeter**

1. J.D. Ray. *The Archive of Hor* (London 1976); Dieter Kessler, *Die heiligen Tiere und der König* (Wiesbaden, 1989).

2. Percy E. Newberry, *Funerary Statuettes and Model Sarcophagi.* Catalogue général des antiquités égyptiennes du Musée du Caire (Cairo, 1930), 404–5, pl. 28.

3. I.E.S. Edwards. *Treasures of Tutankhamun* (New York, 1976), 150–51.

4. On the Tutankhamun statue, the mummy of the king is also protected by a falcon, an expression of the king's royalty.

5. W. Seipel, *Ägypten: 4000 Jahre Jenseitsglaube* (Linz, 1989), no. 199.

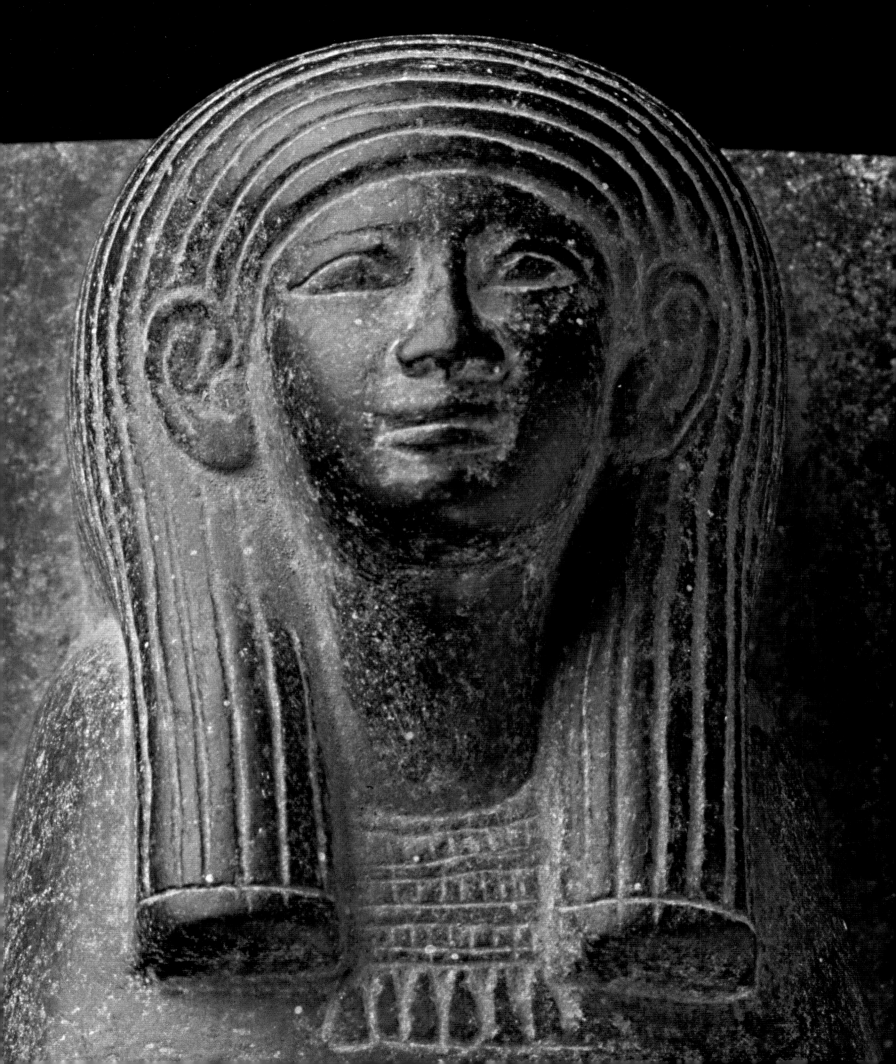

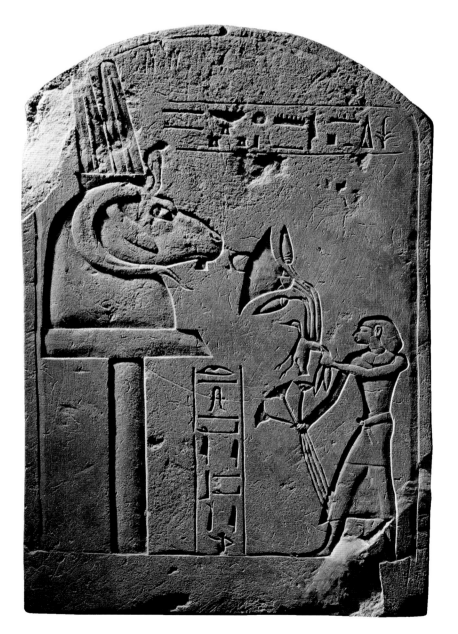

103 Stele of Amun-Re

Eighteenth Dynasty, c. 1550–1400 BCE; limestone.
Height 50 cm (19 11/16 in); width 33.5 cm (13 3/16 in);
depth 5 cm (1 15/16 in). Provenance unknown.
The Egyptian Museum, Cairo JE 67566

• This stele is an example of the personal piety
expressed in ancient Egypt particularly during
the New Kingdom and later. Here on a mid-
Eighteenth Dynasty monument dedicated by a
private person is represented a direct relationship
between the offerer and the great national god
Amun-Re. Guglielmi has discussed the personal
connection expressed by images of Amun as
ram receiving worship from pious offerers.[1] The
dedicant, Benaty, is shown not before a statue
of Amun-Re, to which he would almost certainly
not have had access, but before an emblem
of that god, such as would have been carried in
temple processions. Amun was often embodied
in the image of a ram, as was the sun god, and
here we see the ram with the tall plumes usually
seen on images of Amun-Re in a human form.
The ram horns when worn by the king associate
him both to Re and to Amun, and this is true
for the image of Amun as ram as well. Benaty
proffers a great lotus bouquet and a goose. The
goose was sacred to Amun and here may well be
an intentional allusion. The dedication at the top
of the stele simply reads: "A gift which the king
gives [to] Amun-Re, lord of the thrones of the Two
Lands." This indicates that this is indeed Amun
of Karnak temple and may suggest that this stele
derived from the Theban area. **Betsy M. Bryan**

1. Waltraud Guglielmi and Johanna Dittmar, "Anrufungen der
persönlichen Frömmigkeit auf Gans- und Widder-Darstellungen
des Amun" in *Gegengabe. Festschrift für Emma Brunner-Traut*,
(Tübingen, 1992), 119–142.

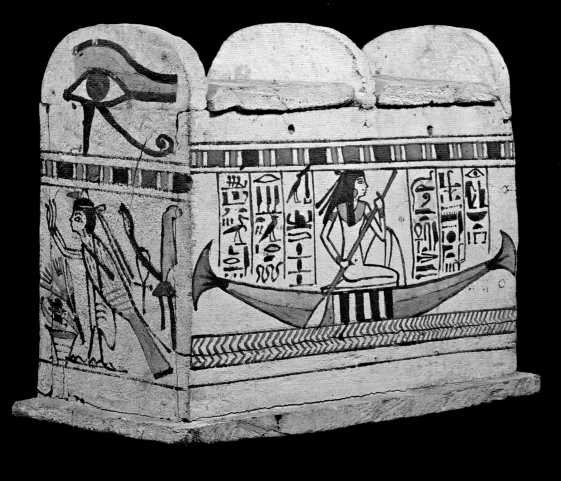

104 *Ushebti* box of Djed-Maat-iuesankh

Twenty-first to Twenty-second Dynasties,
1069–715 BCE; painted wood. Height 39 cm (15 3/8 in);
width 48 cm (18 7/8 in); depth 27 cm (10 5/8 in).
The Egyptian Museum, Cairo TR 4-12-24-4

• This lady's *ushebti* box would have contained the full complement of funerary figures required for burial in the Third Intermediate Period. Probably small glazed faience *ushebtis*, numbering 401, were deposited in the box, where they were believed to lie sleeping until invoked to work by the names and spells inscribed on them. In the Twenty-first Dynasty it was common to inscribe the figures only with the name and titles of the deceased, but this was sufficient to identify the *ushebtis* when work was ordered in the afterlife.

The box is designed with the barrel-vaulted roof associated with the Lower Egyptian Shrine. Examples as shown in cats. 38 and 63, both at least three hundred years older, are more archaic in form, being decorated with false door or niched temple facades, suggesting more specifically the origin of the architectural form. Here the exterior surface has been given over to scenes similar to those on papyrus or tomb walls. The box itself is made of a number of pieces of wood that have been pegged together and plastered over to hide any differences in materials. The lids, hardly vaulted at all, have pegs as knobs, and similar pegs had been placed on the sides so that the lids could be tied down for sealing.

On one side of the box the god Anubis is shown lying in a wakeful pose (p. 208, top). His tail does not hang down but is up as if he were ready to spring. The god holds the crook and flail of rulership, the emblems associated with Osiris particularly. Anubis thus protects the deceased who becomes an Osiris and her funerary equipment as well. The opposite side of the box shows the deceased kneeling in a papyrus boat, as she rows herself across the sky (p. 208, bottom). The inscription runs as follows, from right to left: "The Osiris, the mistress of the house, the singer of Amun-Re, king of the gods, Djed-Maat-iuesankh, vindicated. Ferrying in peace to the Field of Reeds, that excellent bas may be received." The lady is shown wearing a long linen garment that spreads out around her one upraised knee. She wears a red fillet on her head, similar to those worn by participants in funerary rituals. On the short side of the box we see the left eye of the sun god, here indicating the moon, or evening solar orb. Djed-Maat-iuesankh rows away from the evening toward the morning and the right eye of the sun. Beneath the left eye, on the right, is the hieroglyph for the west, reaching out to extend life to the deceased. The *ba* of Djed-Maat-iuesankh stands over food offerings in the gesture of adoration, presumably toward the sun god. The *ba* hopes through the journey into the west and across the waters to be reunited with its corpse and ultimately rejuvenated to live with other *bas*. **Betsy M. Bryan**

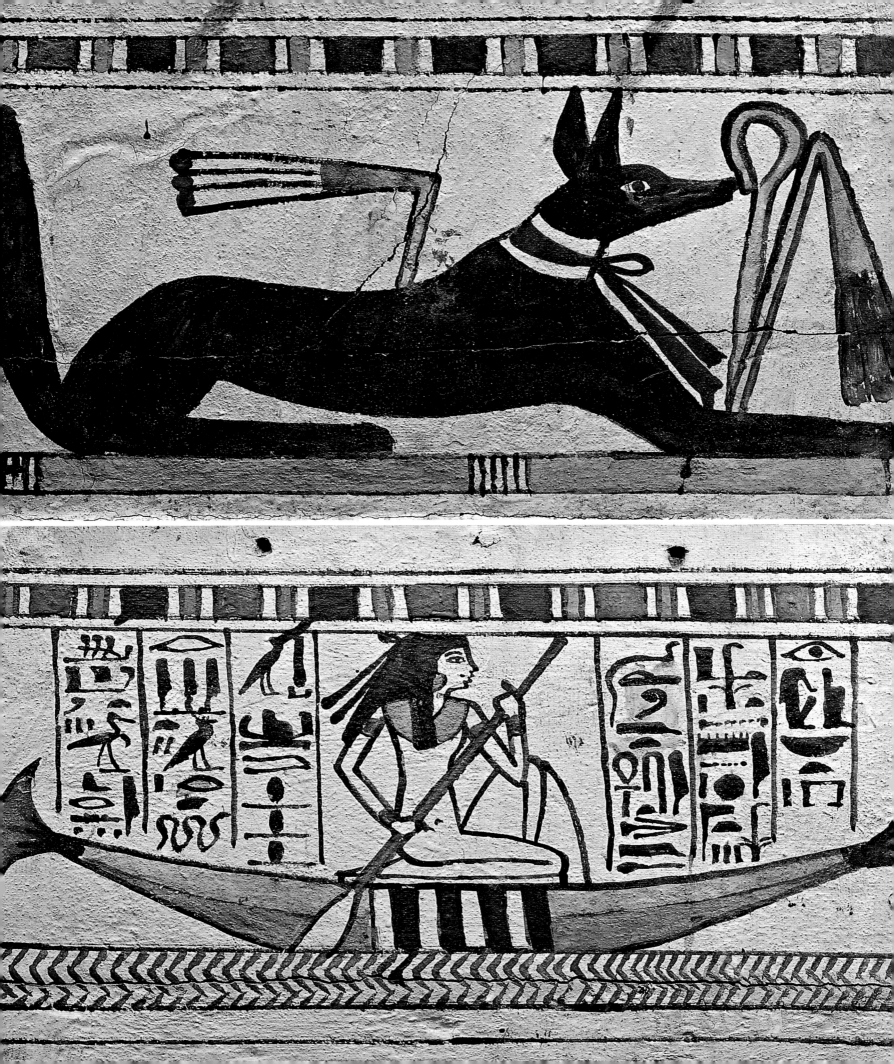

105 Statue of Paakhref

Twenty-sixth Dynasty, reign of Psamtik I,
664–610 BCE; graywacke. Height 48 cm (18 7/8 in);
width 22 cm (8 11/16 in); depth 32 cm (12 5/8 in).
Karnak cachette (K. 364). The Egyptian Museum,
Cairo JE 37171/CG 48642

· This squatting statue represents Paakhref, son
of Harsiese, the overseer of cargo boats of the
Lord of the Two Lands. This type of statue is also
known as a "block" or "cubic" statue. Squatting
statues appear from at least the beginning of the
Middle Kingdom (2055–1650 BCE), as an addition
to the repertoire of standing and seated private
statues. These squatting statues represent an
individual sitting on the ground, as here, or on a
low cushion, with the legs bent up against the
body, so that the knees are approximately at the
same level as the shoulders. The cubic block of
these statues shows more stiffness and allows
inscriptions and representations to be carved
more easily on its surface. These squatting statues
were only made to represent private individuals,
and at the first were only situated in tombs. Later
they became a temple statue, as the pose repre-
sents a position of dignity. This statue type,
starting as a funerary and commemorative offer-
ing, served well as an ex-voto, as the owner
could put himself before the god and thus share
in the offering.

In the Late Period (664–332 BCE), with
the development of private statuary, squatting
statues were preferred to other types. As with
most statues of this period, the statue of Paakhref
came from Karnak. The face of Paakhref is long
and thin; it is well connected to the body by the
typical double wig, leaving half of the ears uncov-
ered, with a short beard protruding from the
chin. His features are characteristically Saite: the
mouth displays a faint smile, he has long almond
eyes with short cosmetic lines under plastically

rounded eyebrows, very wide cheeks, and a thin
nose. The front of the enveloping garment of the
statue is dominated by a large head of Hathor in
bold raised relief. The feet are free of the bottom
of the garment, revealing widely spread toes with
well-defined nails. His disembodied hands lie on
the upper surface of the cube. Adjacent to and
toward the shoulders are cartouches of Psamtik I
(664–610 BCE). The back pillar bears two columns
of well-drawn inscription enclosed in framing
lines. The inscription's continuation down onto
the statue's base is an unusual feature. The base
has a rounded front and is encircled by a horizon-
tal band of signs on its sides. **Mamdouh El-Damaty**

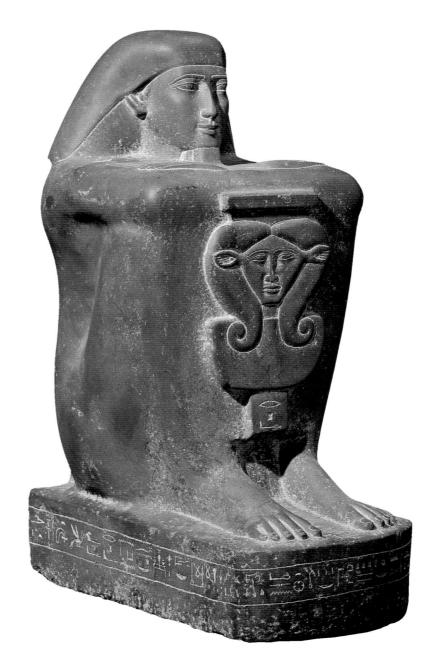

106 Scarab

Ptolemaic era, 332–30 BCE; Egyptian blue frit on gilded wood. Height 2.5 cm (1 in); width 11 cm (4 5/16 in); 7 cm (2 3/4 in). The Egyptian Museum, Cairo TR 15-1-25-44

• The scarab beetle is an insect seen to drag a dung ball from which often its offspring may appear to arise. As a coprophagous beetle, the scarab both consumes dung and sometimes lays its eggs within it, such that the dung ball does indeed give birth to new scarabs. This glass

scarab is a depiction of the beetle in movement rather than at rest, the form more often seen on Egyptian scarab amulets.

The dung beetle (*kheper* in Egyptian) was associated with its homonym deity Khepri, the rising sun. From prehistoric times scarabs and other beetles were venerated and regarded as magical and sacred. The click beetle, for example, was sacred to the goddess Neith from the First to the Fourth Dynasties (*c*. 3000–2498 BCE), and perhaps later as well. Many early burials contained jars with dried beetles in different sizes. With the domination of the sun god in the Old Kingdom, the scarab beetle supplanted the

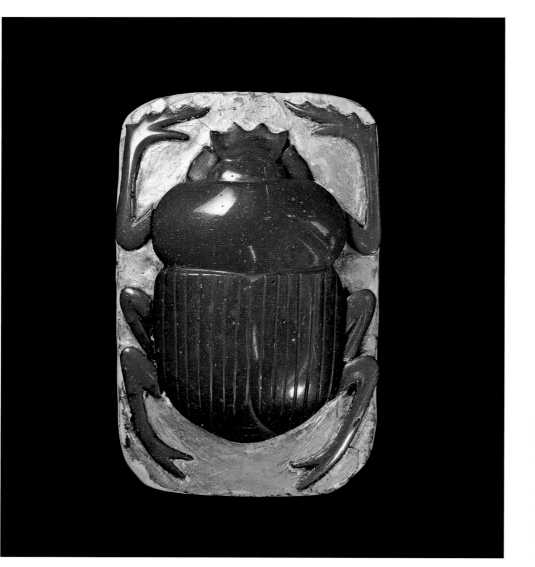

click in significance, and after that time the scarab emerged as one of the potent symbols of resurrection and solar worship. Because of its dung ball larvae, the scarab was an image of self creation.

Scarabs were made for a variety of purposes—funerary, memorial, and even administrative. In the funerary context there were heart scarabs inscribed with Chapter 30 of the Book of the Dead that addressed the heart directly. The spell directs the heart not to speak against the deceased in the judgment hall before Osiris. Scarabs could also be inscribed with royal names and divine ones as well. These probably provided the scarab's owner with the amuletic power of those divinities, and in the case of ruling kings, allowed the carrier of such a scarab to be recognized (empowered) as a servant of the pharaoh. Similar to these scarabs were administrative seals carrying the name and titles of administrator, particularly in the Middle Kingdom (2055–1650 BCE). So-called historical scarabs carried texts that commemorated events, such as the slaughter of 102 lions by Amenhotep III or his marriage to the Mittani ruler Shuttarna's daughter Gilukhipa.

As amulets scarabs were made of numerous materials, including stones, both common ones and precious, including lapis lazuli and jade, as well as faience. Glazed steatite was a favored material for scarabs, since it had a bright finish similar to faience, but it was more durable. The form and size of this beetle suggest that it was not a simple amulet, to be worn on a string or carried as a talisman. Rather, it may be a funerary object, one that perhaps even once was part of a larger group of objects or composition. Nonetheless, its meaning is the same as all scarabs— it indicates the regenerative dawning of the sun on the eastern horizon and promises thereby regeneration for all. The scarab beetle, backing its way into the morning as it pulls the sun disk with it, may be seen at the end of the Twelfth Hour of the Amduat. It looks just like this beetle.

In the latest periods of Egyptian pharaonic history, when this scarab was fashioned, the beetle was still identified with the sun and seen as a symbol of the light that ringed the world continuously. In the astronomical setting the beetle appeared in the newly introduced zodiac in the place of Cancer the Crab. This was a reference to its appearance at the summer and winter solstices (the beginning and midyear solar births). The scarab thus typified self-reproducing power in nature. **Ibrahim El-Nawawy**

107 Relief with two snake deities and griffin

Roman Period, 30 BCE – CE 395; limestone. Height 31.5 cm (12 3/8 in); width 29.5 cm (11 5/8 in); depth 15 cm (5 7/8 in). The Egyptian Museum, Cairo CG 27528

• This limestone relief shows two coiled snakes in high relief, with a more lightly incised griffin between them. The cobra on the left wears a crown consisting of cow's horns, a sun disk, and double plumes. Such a headdress is closely associated with both Isis and Hathor. The snake on the right is bearded and is adorned with the White Crown of Upper Egypt. There is a short, unfortu-nately illegible demotic inscription on the top of the relief.[1] Campbell Cowen Edgar, who first published the piece, noted traces of black paint on the head of the bearded serpent as well as red paint on the sun disk and tail of the other serpent.

The griffin is in shallow sunk relief. Under one of its paws is a wheel in the shape of a rosette. The griffin was a popular figure in the Roman Period. It was equated with Nemesis (the goddess of vengeance) and often shown with a wheel, a symbol of fate (the Wheel of Fortune). The bearded cobra on the right has been identi-fied as Agathodaimon, or Fate, also important in the Late Ptolemaic and Roman Periods. This personification of fate was widely worshiped by Greeks and Egyptians, and the deity probably has characteristics drawn from both native and Hellenistic religious traditions. The snake with the Isis crown is most likely the goddess of Har-vest, Renenutet, who was the female counterpart to Agathodaimon.[2] Such female deities as Rene-nutet were closely identified with Isis in the Roman Period.

Snakes and snake symbolism play an important role in Egyptian mythology. This imagery is frequently used for deities associated with the earth and fertility, but guardian beings and other kinds of gods also appear as snakes. Snakes and serpents populate the underworld regions according to the Amduat and other underworld books. In the desert the sun barque itself assumes the guise of a snake, so that it can navigate in the sand more easily.[3] Naturally, the snake form not only possesses a positive protective nature, but can also appear in a threat-ening aspect. The archenemy of the sun god in the underworld, Apophis, for example, has the shape of a snake or serpent. **Richard Jasnow**

1. Wilhelm Spiegelberg, *Die Demotischen Inschriften I: Die Demotischen Denkmäler 30601–31116* (Cairo, 1904), 77. Catalogue général des antiquités égyptiennes du Musée du Caire.

2. Jan Quaegebeur, *Le dieu égyptien Shaï dans la religion et l'onomastique* (Louvain, 1975), 173.

3. Erik Hornung, *The Ancient Egyptian Books of the Afterlife* (Ithaca, New York, 1999), 36.

Facing the Gods: Selected Guide

Chronology of Ancient Egypt

Glossary

Bibliography

Index

Illustration Credits

Epilogue

Facing the Gods: Selected Guide

Terence DuQuesne

On the walls of Thutmose III's tomb no fewer than 741 gods and goddesses are depicted, all of whom interact with the king when he comes to life again in the Beyond.

The task of comprehending such a refined and complex system of religion is not easy at this distance in time and metaphysical belief. Part of the problem is in classifying the inhabitants of the other world in some appropriate way. Not all the deities shown or referred to in the Egyptian Books of the Netherworld and other texts are of equal consequence. Relatively few are major figures, such as the sun god Re and Hathor, Lady of the Sky. Some are not full-fledged goddesses and gods with their own personalities but are instead just manifest functions. Among these are the pair of gods Hu and Sia, who respectively symbolize "magical utterance and divine understanding." Certain others represent the divine aspects of natural phenomena, such as the divisions of time: hence there are twenty-four goddesses of the hours. Many more, perhaps better described as spirits or demons although still called *netjeru* (gods) in Egyptian, have ancillary and other subordinate functions, such as the Spirits of the West, who are shown as black jackals and whose tasks include towing the barque of the nocturnal sun.

All these entities, separate as they may seem, nevertheless work as an ensemble. Every aspect of Egyptian funerary art is planned—nothing is arbitrary or without symbolic meaning. Even the colors in which the tomb walls are painted, while allowing sometimes for artistic idiosyncrasy, conform to principles or canons that are self-consistent and never completely arbitrary. If the face of Osiris is shown as black, that signifies, among other things, that the god is symbolizing the fertility of the earth and the numinous magic of night.

The owner of the tomb, royal or otherwise, would expect to be familiar with the principal divinities, so as to engage with them, and if necessary propitiate them, in the other world. He would see the images of the major divinities painted on the walls of his tomb as a sort of aide-mémoire to guide him on his travels as a justified soul.

Amun

Amun, see cat. 103

Name: The name means "The Hidden One."

Appearance: Amun is most commonly shown in entirely human form. Often he is standing or sitting on a throne and wearing a flat-topped crown with two tall plumes. In his aspect as "bull of his mother," he takes a form identical to that of the god Min and is represented as an ithyphallic, mummiform deity. Amun can also assume the appearance of a ram, his particular sacred animal.

Divine associations: The syncretism of Amun and Re became important in the later New Kingdom, when Amun-Re, creator and sun god, was seen as the preeminent divine entity, and his popularity for a time eclipsed that of other major deities. Since both Amun and Min are deities of generation and natural increase, they are closely associated. The warrior-god Montu was known as a manifestation of Amun. A Theban triad consisted of Amun; his wife Mut; and their offspring Khonsu, the moon god. All three had temples at Karnak.

Origin and cult: It is possible, but not certain, that Amun's original cult center was Thebes, where he was worshiped as the major local god from the Middle Kingdom onward. The enormous temple complex of Karnak was then the principal home of his worship, although the nearby Luxor temple was also dedicated to him by the New Kingdom. He may have been native to Hermopolis in Middle Egypt.

Character: Amun is a god whose attributes are so extensive that he seems to lack the personality of other deities. His role as creator is emphasized in many hymns. Regarded as having been self-generated, he is a fertility god who impregnates his mother, the Celestial Cow, to ensure the fecundity of animals and plants. He was closely involved with kingship, and many pharaohs regarded themselves as one of his incarnations and included the god's name in their own. Amun was therefore also seen as the divine consort of Egyptian queens. Queen Hatshepsut presented herself as an offspring of the god during a visit to her mother. His virile strength made

him an appropriate deity for ensuring military victory for the pharaoh. Amun was invoked for healing from the bites of dangerous animals and other illnesses. During the New Kingdom he was a personal-savior god of ordinary working people, as numerous devotional stelae testify.

Myth: Religious texts relating to the city of Hermopolis speak of Amun and his shadowy consort Amaunet as creators of the pantheon of the eight primeval deities.

Assmann, Jan. *Re und Amun.* Fribourg, 1983.

——. *Egyptian Solar Religion in the New Kingdom: Re, Amun, and the Crisis of Polytheism.* Trans. Anthony Alcock. London/ New York, 1995.

Barta, Winfried. *Untersuchungen zum Götterkreis der Neunheit.* Munich, 1973.

Otto, Eberhard. *Osiris und Amun.* Munich, 1966.

——. *Egyptian Art and the Cults of Osiris and Amon.* Trans. Kate Bosse Griffiths. London, 1968.

Sethe, Kurt. *Amun und die acht Urgötter von Hermopolis.* Leipzig, 1929.

Zandee, Jan. *Der grosse Amonhymnus des Papyrus Leiden I 344, verso.* 3 vols. Leiden, 1992.

Anubis

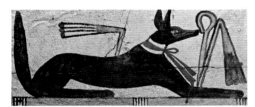

Anubis, see cat. 104

Name: Of uncertain meaning, the name may be an onomatopoeic word for young jackal or puppy.

Appearance: Anubis is most often seen as either a jackal-headed god in human form or a seated black jackal.

Divine associations: He is given as the son of Re or of Osiris. Among the goddesses regarded as being his mother are Isis, Sakhmet, and the cow-goddess Hesat.

Origin and cult: It is likely, but not certain, that the original jackal deity of the sacred city of Abydos, Khentyamentiu, was the prototype of Anubis. On the other hand, he may originally have been venerated in the Cynopolitan province of Middle Egypt, whose local deity, the goddess Anupet, was his original manifestation or his consort. As a complement to his fellow jackal deity, Wepwawet of Asyut in Middle Egypt, Anubis

was the patron deity of the necropolis of that town. He was also closely connected with the Memphite region.

Character: The best-known function of Anubis is that of embalmer. He is frequently depicted with his jackal's head as he tends the mummy on its bed. Anubis is also associated with the judgment of the dead at the Tribunal of Osiris, where he tests the accuracy of the balance. His role in reviving the deceased and guiding him through the netherworld is important and attested early. Anubis is an archetypal deity of initiation and was probably involved in the circumcision of the divine king. In later times he was often invoked for healing and especially in love-magic. In the Amduat, Anubis is the only deity to have access to the subterranean cavern of Sokar, through which the sun god passes at midnight.

Myth: Anubis is recorded as having assisted Isis in the quest for and regeneration of the scattered limbs of Osiris after the latter's dismemberment by the god Seth. Later myths report how the goddess Hesat squirts her milk on the cow skin that is the emblem of Anubis to separate the bones and the soft organs prior to rebirth of the deceased. Another mythical story relates how Anubis' mother, Isis-Sakhmet, taking the form of a snake or a scorpion, bites or stings her son, who is then told to lick the wound to heal it.

DuQuesne, Terence. *Jackal at the Shaman's Gate.* Thame Oxon, U.K., 1991.

——. *Black and Gold God: Colour Symbolism of the God Anubis.* London, 1996.

Grenier, Jean-Claude. *Anubis alexandrin et romain.* Leiden, 1977.

Geb

Geb: Detail, painting of a goose from the tomb of Iter at Meidum, Fourth Dynasty, c. 2600 BCE. The Egyptian Museum, Cairo

Name: The meaning is uncertain, but the word is possibly onomatopoeic, from the sound made by a goose: the Cackler.

Appearance: Geb is usually seen in entirely human form. Often he is shown supine below the sky goddess Nut. His color is green. The sacred animal of Geb is the goose, and he is sometimes depicted in that form.

Divine associations: Relationships between Geb and the other chthonic deities such as Sokar and Tatjenen are hard to unravel, but Geb is primeval. References to him in the Books of the Netherworld are elliptical. In the Book of Earth the corpse of Geb seems to be complementary to that of Osiris, with both personifying the fallow earth.

Origin and cult: Geb's association with the ritual hoeing of the earth in Heliopolis may suggest an early cult association in that city. Geb's origin is entirely obscure, but he was believed to have been the earliest earthly king.

Character: Geb represents the power and fecundity of the earth. Funerary offerings were made to him. Minerals, food plants, and natural phenomena such as earthquakes were considered to be his gifts. As the ancestral member of the Divine Ennead (the nine great gods of Heliopolis, the family of the sun god), together with the sky goddess, he had the highest judicial power.

Myth: When Horus and Seth, sometimes explained as nephew and uncles and sometimes as brothers, engaged in conflict over which of them was to rule over Egypt, it was Geb as president of the divine tribunal who eventually ordered that Horus would prevail. A late myth records how, during a time of turbulence, Geb wrested the kingship of the gods from his father Shu.

Bedier, Shafia. *Die Rolle des Gottes Geb in den ägyptischen Tempelinschriften der griechisch-römischen Zeit.* Hildesheim, 1995.

215

Hathor

Hathor, see cat. 32

Name: The name means something like "Dwelling of Horus," probably expressing a symbolism similar to that of the *shekhinah,* or earthly habitation of the divinity, in Jewish mysticism.

Appearance: One of Hathor's most consistent manifestations is that of a cow. But she is also often shown as a human figure with the head of a cow, or as an entirely human deity with a headdress of cow's horns and a sun disk.

Divine associations: In later Egyptian history Hathor of Dendera was regarded as the consort of Horus of Edfu, and an annual procession traveled up the Nile from Edfu to Dendera so that the two deities could renew their sacred marriage. Hathor is often regarded as assimilated to the goddess Isis. She was likewise the fire- and life-giving Eye of the Sun and therefore has close connections with Re, occurring as his daughter.

Origin and cult: The cult of Hathor is very ancient and is recorded in Gebelein in Upper Egypt and the Memphite region during the Old Kingdom, at which time there were also temples to her in the royal funerary complexes of Giza and Sakkara. Her many other centers of worship included Deir el-Bahari, Kusae, Atfih, and Byblos. In Asyut, Hathor of Medjed was the consort of the warlike jackal deity, Wepwawet. It is impossible to determine when worship of her began.

Character: From the Old Kingdom or before, Hathor was believed to be the mother of the king, a function that was extended later to all humanity, and the queen was regarded as her incarnation. Her numerous solar associations have to do with the life-giving power of the sun. As a goddess who manifested in the form of a cow, milk was sacred to her, and so she was concerned with nourishment and child-rearing. In the Pyramid Texts, the Old Kingdom guide to the afterlife for kings, and elsewhere, she is described as Lady of the Sycamore, and is mistress of the Tree of Life. She is strongly associated with love. Hathor is quintessentially the goddess of regeneration, patroness of song and dance and ecstatic states, whether induced by sex or intoxicants. She was invoked for healing and to encourage pregnancy. By the Middle Kingdom, one of Hathor's aspects was Lady of the West. She presided over the burial ground on the west bank of Thebes and participated in guiding the justified soul to the netherworld. Her numerous functions and attributes made her virtually a universal goddess.

Myth: In the Book of the Celestial Cow, Hathor in her warrior aspect annihilated much of the human race before restoring the sun god Re.

Allam, Schafik. *Beiträge zum Hathorkult*. Berlin, 1963.

Bleeker, Claas Jouco. *Hathor and Thoth*. Leiden, 1973.

Daumas, François. "Hathor" (pp. 1024–33) in Wolfgang Helck and Wolfhart Westendorf, eds., *Lexikon der Ägyptologie*, vol. 2. Wiesbaden, 1977.

Pinch, Geraldine. *Votive Offerings to Hathor*. Oxford, 1993.

Roberts, Alison. *Hathor Rising: The Power of the Goddess in Ancient Egypt*. Totnes, U.K., 1995; Rochester, Vermont, 1997.

Horus

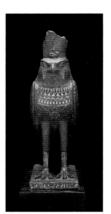

Horus, see cat. 92

Name: The name probably signifies "The Far Away One."

Appearance: Commonly shown as a falcon or a falcon-headed human; in the latter case, he often has the solar disk on his head. In his aspect as Horus the Child, he is represented as a preadolescent boy with a finger in his mouth.

Divine associations: Re and other solar deities link up with various aspects of Horus, notably Horakhty, "Horus of the Two Horizons."

Origin and cult: From predynastic times, Horus was a quintessentially royal god, as well as a divinity of the sky, and in the Old Kingdom the pharaoh's Horus name was of exceptional importance. His earliest cult site may have been at Hierakonpolis in Upper Egypt, but he was worshiped throughout Egypt. His many cult centers include Letopolis, Edfu, Aniba, Libya, and the Fayum.

Character: Horus has many manifestations, of which only the most important are named here. It is not at all clear whether the various deities called Horus were originally separate, or whether a single divine archetype evolved to encompass many functions, as in the case of Re and Isis. Harsomtus (Horus the Uniter of the Two Lands) conjoins Upper and Lower Egypt in the name of the king. Harpocrates (Horus the Child) symbolizes the undifferentiated but still potent aspect of childhood, and in this form was considered a strong healing divinity. Harendotes (Horus the Avenger of His Father) is the son and heir of Osiris and is instrumental in securing his father's royal inheritance. He is therefore often equated with the pharaoh. In the Books of the Netherworld, Horus and Sokar protect the Solar Eye. Amulets in the shape of the *wedjat*, or Eye of Horus, symbolize completeness, healing, and magical protection.

Myth: According to one story, Horus and Seth were rival claimants to the Egyptian throne, and Horus was granted the kingship by the god Geb, who acted as judge. Horus and Seth represent order and chaos and hence are often described as being in conflict.

Alliot, A. *Le culte d'Horus à Edfou*. 2 vols. Cairo, 1949, 1954.

Mercer, Samuel. A. B. *Horus: The Royal God of Egypt*. Grafton, Mass., 1942.

Isis

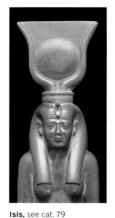

Isis, see cat. 79

Name: The name of Isis could mean foundation, seat, or throne, or all of these.

Appearance: Generally, Isis is seen as a beautiful young woman with the usual attributes of Egyptian deities. Sometimes she wears the cow's horns associated with Hathor. She is sometimes shown as a flying or resting kite, and more often in later iconography as a royal cobra. Her twin sister, Nephthys, who may be seen as her dark alter ego, is frequently depicted with her.

Divine associations: Isis shares a number of characteristics of Hathor, both being patronesses of ecstasy and fertility and also deities of the sky. The goddess Sothis, the star Sirius in the Orion constellation, is one of her manifestations. As Sothis, Isis was associated with the annual flood that rose at the time Sirius reappeared in the sky.

Origin and cult: Isis seems to have been originally an Upper Egyptian goddess, but the earliest evidence is obscure.

Character: The first attested functions of Isis have to do with birth and funerary rituals. As she protected and complemented her consort, Osiris, and cared for their son, Horus, it was hoped she would exert a similar role for mortals. In the Pyramid Texts, Isis and Nephthys help the deceased king ascend to the sky. Later, her cult expanded greatly. Isis became a goddess of magic and healing, eventually assuming the functions of universal mother goddess and queen of the sky.

Myth: In the best-known myth, recorded in classical times but obviously referring to much earlier documents, Isis searches the land of Egypt for the scattered limbs of Osiris after his dismemberment by Seth, finds them, and restores the god to life.

Merkelbach, Reinhold. *Isis regina — Zeus Sarapis.* Stuttgart, 1995.

Münster, Maria. *Untersuchungen zur Göttin Isis.* Berlin, 1968.

Witt, Reginald Eldred. *Isis in the Ancient World.* London, 1971. Reprinted as *Isis in the Ancient World.* Baltimore, 1997.

Khnum

Name: The name is no doubt connected with an Egyptian verb meaning "to unite."

Appearance: Most commonly, Khnum is represented with a human body and the head of a ram, his sacred animal.

Divine associations: Khnum is associated with the sun god (as Khnum-Re) and with the air god Shu. He was also assimilated to the crocodile god Sobek.

Origin and cult: His worship is attested very early at Elephantine in the cataract region of Upper Egypt, and in Ptolemaic times he had an important temple at Esna, south of Thebes.

Character: Khnum was always regarded as the creator of human beings, as is shown by numerous images in which he is seen fashioning people on a potter's wheel. In later times he was a god of oracles.

Badawy, Alexander. "Der Gott Chnum." Ph.D. diss. Berlin, 1937.

Neith

Neith, see cat. 68

Name: The name is possibly connected with the Lower Egyptian or northern crown.

Appearance: Neith is commonly depicted as a woman wearing the Red Crown of Lower Egypt and carrying a bow and arrows.

Divine associations: She shares with the jackal god Wepwawet the designation "Opener of the Ways," in her case probably meaning the ways to royal conquest.

Origin and cult: The principal cult center of Neith was Sais in Lower Egypt, and as early as the First Dynasty she was, like Horus, associated with the royal family, primarily with the queens. She was supplanted by Hathor in the Fourth Dynasty.

Character: Essentially Neith is a warrior goddess, who is also concerned with the magical protection of the body after death.

El-Sayed, Ramadan. *La déesse Neith de Saïs.* 2 vols. Cairo, 1982.

Nut

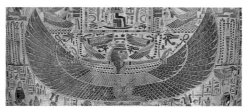

Nut, see cat. 73

Name: The meaning is not certain; it is perhaps connected with a verb for vision or with the word for waters, *nu.*

Appearance: Nut appears either as a young woman with divine attributes and a pair of large wings, or as a schematic female figure stretched out with her hands and feet touching the ground. Her body is blue and arrayed with figures of stars.

Divine associations: The closest associations are with Geb, her consort, god of earth, and with Shu, the deity of air. She is also connected with Hathor, both being manifestations of the tree goddess.

Origin and cult: Nut may have had her origin in Heliopolis, but this is uncertain.

Character: From being originally a personification of the sky, Nut became a funerary goddess in the sense that the deceased person would expect to be wrapped in her body and become part of the heavenly host. At the western horizon, Nut swallowed the sun each evening, and, within her, the solar deity traveled the netherworld and was reborn twelve hours later, as she gave birth to him in the east.

Myth: According to the Book of Nut, one of the Books of the Netherworld, Geb and Nut argued about the propensity of the goddess to eat the stars, which were regarded as her children. The god Shu then decreed that the heavenly bodies were to be born again periodically.

Rusch, Adolf. *Die Entwicklung der Himmelsgöttin Nut zu einer Totengottheit.* Leipzig, 1922.

Osiris

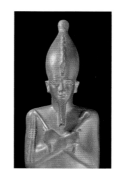

Osiris, see cat. 78

Name: The name of Osiris is of uncertain interpretation, but possibilities include "seat of the eye" and more plausibly, "the one who copulates with the throne" (the goddess Isis).

Appearance: Osiris is usually depicted as a mummiform man, sitting on a throne or standing. He wears either the crown of upper Egypt or the tall *atef* crown with two plumes at either side and carries the crook and flail, symbols of royal authority.

Divine associations: The syncretism between Osiris and Re in Egyptian religious texts, which developed after the Old Kingdom, is important as representing the union of the king of the netherworld with the ruler of the sky—a union that was believed to be transferred to the dead king and, later in Egyptian history, to other humans. Osiris was equated with many other deities, especially chthonic gods such as Sokar and Khentyamentiu. Osiris has strong astronomical associations, being identified with Orion and linked to Sirius through its connection with Isis.

Origin and cult: Osiris may well have been originally a form of Khentyamentiu (Foremost of the Westerners), the ancient chthonic deity of the city of Abydos in Upper Egypt who took the form of a jackal and was closely connected with Anubis. Important centers of his cult were Heliopolis and Busiris in Lower Egypt.

Character: A useful key to his character is the frequent epithet *wennefer,* "the one who is perennially fresh" as ruler of the netherworld. This is a reference to mummification and to Osiris as the corn king, who dies in autumn to be reborn in springtime. Each justified soul took on the characteristics of Osiris and had his or her name prefixed by that of the god. This process would guarantee the integrity of the mummy, and hence rebirth in the netherworld. Similarly, Osiris represents the fertility of the earth that continues underground even during winter. As one manifestation of the king of the gods, the pharaoh was identified with him from very early times. The importance of Osiris as god of grain is illustrated

217

by the figures of the god made of earth and corn that have been found in New Kingdom and later tombs—in some cases the grain can be seen to have sprouted. Osiris is also a deity of seasons and water, and generally of the cyclical phenomena of nature, as his associations with Sirius and Orion, and with the Nile inundation, testify. Equally important, he was regarded as judge of the dead and presided over the tribunal in which the heart of the deceased was weighed against the feather of Maat (balance). In the Books of the Netherworld, Osiris occupies a passive role as the dead king of the Beyond. By being united with Re, he is brought back to life and empowered. In the Amduat and the Book of Gates, the sun god, shown with a ram's head, symbolizes the union of Re and Osiris.

Myth: Such myths as survive about Osiris emphasize the god's death and capacity for rebirth. In one version, he was murdered by his brother Seth and found and revived by the goddesses Isis and Nephthys. A later account by the Greek writer Plutarch describes the etiological myth whereby the disjunct members of Osiris, scattered all over Egypt, were discovered by Isis and Anubis and magically restored. The places where Seth scattered the severed limbs became the capitals of each of the provinces of Egypt.

Budge, E. A. Wallis. *Osiris and the Egyptian Resurrection.* 2 vols. London, 1911. Reprint, New York, 1973.

Griffiths, John Gwyn. *The Origins of Osiris and His Cult.* Leiden, 1980.

Hare, Tom. *Remembering Osiris.* Stanford, 1999.

Helck, Wolfgang. "Osiris: Number, Gender, and the Word in Ancient Egyptian Representational Systems" (pp. 469–513). In Pauly-Wissowa, *Realenzylopaedie der klassischen Altertumswissenschaft,* suppl. 9. Leipzig, 1962.

Otto, Eberhard. *Osiris und Amun.* Munich, 1966.

———. *Egyptian Art and the Cults of Osiris and Amon.* Trans. Kate Bosse Griffiths. London, 1968.

Re

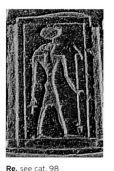

Re, see cat. 98

Name: The name Re originally meant the visible disk of the sun.

Appearance: Images of Re are ubiquitous in Egyptian art in the New Kingdom. He is most frequently shown as a falcon or falcon-headed human figure. He wears the solar disk, around which the uraeus snake is coiled on his head. Sometimes he is fully human in form. In the Book of the Dead, he assumes the appearance of a tomcat who fights the chaos serpent Apophis in the city of Heliopolis. The Books of the Netherworld show Re either as ram headed or falcon headed.

Divine associations: In the Pyramid Texts, Re is the son and consort of the sky goddess Nut. Later, he is blended with his son Horus as Re-Horakhty (Re-Horus of the Two Horizons) as a composite deity. Forms of Re include Khnum, the ram-headed creator deity, as well as Khepri, the rising sun, and Atum, the setting sun, who was regarded as the primeval creative force. The falcon, the scarab beetle, and the tomcat are the principal animals sacred to Re.

Origin and cult: Like certain other deities such as Maat (personification of cosmic order), Re is more of a symbol or function than a god (such as Anubis or Thoth) with a defined personality, no doubt in part because of the multiplicity of his divine tasks. This may somewhat explain the fact that evidence for a specific cult of Re is very scanty. From early times, his major cult center was Heliopolis in Lower Egypt, though it is possible that another form of the solar deity, the falcon god Horakhty, may originally have been venerated there. It is significant that Heliopolis was near the royal pyramids of the Old Kingdom across the river in Memphis. Atum, god of the setting sun, also had a temple in Heliopolis. A round-topped stone, called the *benben,* is associated with Heliopolis, and later obelisks were erected there as larger forms of the solar symbol of "ascent to the sky." The phoenix *(benu)* is closely associated with the city. The solar cult is exemplified in the New Kingdom by the Books of the Netherworld, in which the king joins Re on his travels through the twelve districts of the Beyond that represent the night hours.

Character: From early times, Re was closely linked with the Egyptian kingship. Many royal names, the first of which occurs in the Second Dynasty, are compounded with the name Re. Early examples are Re-neb and Men-kau-Re. By the Fifth Dynasty, a special "son of Re" name was accorded to the pharaoh. The pyramids of the Old Kingdom are often correctly regarded as being, or incorporating, temples to the sun.

As king of the gods, as early as the Pyramid Texts, which were the Old Kingdom guides to the afterlife, Re was regarded as sovereign over the inhabitants of the sky. Later, he received many of the same designations and attributes as the earthly pharaoh. Re was also seen as a universal deity, as is shown by his epithet either "lord of all" or "lord to the limit." Titles such as "the one who generated himself" reveal him as a form of the primeval godhead. As a manifestation of Atum, Re was naturally regarded as the creator of all living things. Re probably preceded Osiris as administrator of justice, and specifically as president of the divine tribunal and guarantor of universal equilibrium (Maat). From the Old Kingdom onward, Re had strong funerary associations—initially the king, and then others, hoped to effect a celestial ascent like the rising of Re, joining the personnel in the boat of the sun on its journey through the sky. In the Books of the Netherworld, for the first time the king's participation is detailed, and in the Book of Gates he accompanies Re through the night sky.

Myth: The sun was regarded by the Egyptians as traveling through the sky in two boats, one for the day and one for the night. According to the Books of the Netherworld, Re becomes united with the funerary god Osiris in the underworld, and the two effectively defeat the forces of chaos while the world sleeps. Re is renewed each morning in the form of Khepri, the rising sun often shown as a scarab beetle, and comes to rest at night as Atum, the complete one. The conjunction of Re and Osiris was considered to guarantee the continuation of the solar cycle and hence, ultimately, of all life. According to a myth preserved in the Book of the Celestial Cow, humanity rebelled against the authority of Re, who sent his Eye, in the form of the warlike Sakhmet (the destructive aspect of the goddess Hathor), to quell the uprising. The conflict ends with the establishment of the heavenly cow goddess Hathor (the nurturing aspect of Sakhmet), who conveys Re to heaven again on her back.

Assmann, Jan. *Re und Amun.* Fribourg, 1983.

———. *Egyptian Solar Religion in the New Kingdom: Re, Amun, and the Crisis of Polytheism.* Trans. Anthony Alcock. London/New York, 1995.

Assmann, Jan. "Re" (pp. 156–80) in Wolfgang Helck and Wolfhart Westendorf, eds., *Lexikon der Ägyptologie,* vol. 5. Wiesbaden, 1984.

Quirke, Stephen. *The Cult of Re.* London, 2001.

Sakhmet

Sakhmet, see cat. 82

Name: The name signifies "The Powerful One."

Appearance: This goddess is regularly shown with a woman's body and the head of a lioness.

Divine associations: Sakhmet has close associations with Hathor, Isis, and Mut, the consort of Amun-Re, for each of whom she can alternate.

Origin and cult: Sakhmet's cult center was in Memphis, where she was the consort of the artificer god Ptah.

Character: Sakhmet was associated with the fortune of passing time, particularly governing the good or bad outcome of the year. She had the potential for a warlike temperament and was invoked to smite foreigners and the enemies of the sun god. Her color is red, for the blood of menstruation and warfare. She was regarded as a powerful protective and healing divinity, and some of her priests appear to have been surgeons.

Myth: In the myth of the Destruction of Mankind, Sakhmet slaughters large numbers of people after a revolt of humanity against the gods. She is prevented from annihilating the human race by the ruse of being plied with intoxicating liquor, colored red to resemble blood. In the Book of Gates, persons of foreign races awaiting rebirth are placed under the protection of Sakhmet and Horus.

Germond, Philippe. *Sekhmet et la protection du monde.* Geneva, 1981.

Hoenes, Sigrid-Eike. *Untersuchungen zu Wesen und Kult der Göttin Sachmet.* Bonn, 1976.

Känel, Frédérique von. *Les prêtres-ouâb de Sekhmet et les conjurateurs de Serket.* Paris, 1984.

Sobek

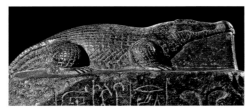

Sobek, see cat. 91

Name: The meaning is unknown, but the name is conceivably connected with *sebeq*, a word related to keenness of the senses and good fortune.

Appearance: Sobek is almost always represented as a crocodile, his sacred animal, or as a crocodile-headed human.

Divine associations: In the Middle Kingdom and later, Sobek was regarded as a manifestation of Re and was linked with the ram deity Khnum. He was equated with Horus as a royal god, and later with Osiris. He was regarded as the son of Neith, perhaps because of her warlike character.

Origin and cult: It is likely that the Fayum, an oasis west of Middle Egypt, dominated by a large lake, Moeris, was the earliest center of Sobek's cult. He was popularly venerated there until Roman times. In the New Kingdom an area close to Thebes was also sacred to him, as was the Upper Egyptian site of Kom Ombo, where he shared veneration with Horus the Elder. At all his cult centers, as early as the reign of Amenhotep III (1390 – 1352 BCE) sacred crocodiles were bred and venerated. Sobek also had celestial aspects and was believed to have a palace at the horizon.

Character: Sobek began as a deity of fertility and water. He was later regarded as a primeval creator god and was associated with magical effectiveness.

Brovarski, Edward. "Sobek" (pp. 995 – 1031) in Wolfgang Helck and Wolfhart Westendorf, eds., *Lexikon der Ägyptologie,* vol. 5. Wiesbaden, 1984.

Dolzani, Claudia. *Il dio Sobk.* Rome, 1961.

Sokar

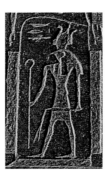

Sokar, see cat. 98

Name: The name may be connected with a verb of movement, perhaps related to sledging.

Appearance: Sokar appears either as a falcon (living or mummified) or as a falcon-headed human.

Divine associations: Sokar is closely linked with the Memphite god Ptah, no doubt partly because of the latter's role as divine artificer. He was also seen as a form of Osiris with the potential for rebirth.

Origin and cult: The necropolis of Memphis (Ro-setau) was sacred to Sokar from very early times and was likely his home — Ro-setau was the gateway between this world and the next, and Sokar's role as its guardian was crucial to the process of rebirth. Most of his sanctuaries appear to have been in Lower Egypt, but he was also venerated in towns elsewhere, such as Sheikh Said and Dendera. An important sacred boat is closely connected with his cult.

Character: He was regarded early as a patron deity of metalworkers and other craftsmen. His chthonic and funerary aspects are probably also very ancient. The Cavern of Sokar is the liminal place in the Amduat where the sun god, becalmed in his boat, spends midnight.

Graindorge-Héreil, Catherine. *Le dieu Sokar à Thèbes au Nouvel Empire.* 2 vols. Wiesbaden, 1994.

Tatjenen

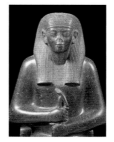

Tatjenen, see cat. 76

Name: The meaning is uncertain but is possibly "the rising earth."

Appearance: Tatjenen is generally entirely human in appearance. He may be shown wearing a ram's horn and two tall plumes on his head.

Divine associations: He was assimilated to Osiris, Ptah, and Sokar in their function as earth deities, and later with Khnum. In the Books of the Netherworld he is closely associated with Re. Tatjenen can be seen as a manifestation of the earth god Geb.

Origin and cult: It is not certain where his cult originated, but the god's home may have been in Memphis. He seems to have had local associations in Asyut in Middle Egypt. He became an important deity only in the New Kingdom.

Character: Originally, Tatjenen seems to have been a deity of the depths of the earth, presiding over its mineral and vegetable resources. In the Book of Gates, Tatjenen personifies the entire area of the netherworld, protecting the deceased in the Beyond. He is able to rejuvenate the sun on its nocturnal journey. In later Egyptian history, he was thought of as a creator deity, like Khnum, fashioning humans on a potter's wheel. The sacred animal of both was the ram.

Schlögl, Hermann Alexander. *Der Gott Tatenen: nach Texten und Bildern des Neuen Reiches.* Fribourg, 1980.

219

Thoth

Thoth, see cat. 94

Name: The meaning of Thoth's name is completely obscure, and perhaps derives from the name of a town where he was worshiped.

Appearance: Typically, he is shown as an ibis or as a human with the head of an ibis. Sometimes he is represented as a baboon, one of his sacred animals and a symbol of wisdom.

Divine associations: Of the deities linked with Thoth, Khonsu and Iah are also lunar deities. Thoth is associated with Anubis at the Weighing of the Heart of the deceased, and with the goddess Seshat. Both Thoth and Seshat are guardians of the sacred hieroglyphs.

Origin and cult: The cult of Thoth may have originated in the Delta, or in the area of Hermopolis, the city sacred to him, in Middle Egypt. He was venerated in various other areas of Egypt, such as at Pnubs in Nubia and in the Dakhla Oasis region.

Character: Thoth is a lunar god and also the patron of knowledge and writing. He also exercised judicial functions, mediating disputes between deities. The profession of scribes was under his protection, as the writing of hieroglyphs was a sacred and magical act. In the netherworld, Thoth records the names of every justified soul who passes through the Tribunal of Osiris.

Myth: In the myth of the Eye of the sun, Thoth must go in search of the missing Eye and return it to Re. The Eye, identified with Tefnut in the myth, was eventually restored.

Bleeker, Claas Jouco. *Hathor and Thoth.* Leiden, 1973.

Boylan, Patrick. *Thoth, The Hermes of Egypt.* Oxford, 1922.

Derchain-Urtel, Maria-Teresa. *Thot: A travers ses épithètes dans les scènes d'offrandes des temples d'époque gréco-romaine.* Brussels, 1981.

Kurth, Dieter. "Thot" (pp. 497–523) in Wolfgang Helck and Wolfhart Westendorf, eds., *Lexikon der Ägyptologie*, vol. 6. Wiesbaden, 1986.

General References

Bonnet, Hans. *Reallexikon der ägyptischen Religionsgeschichte.* Berlin, 1952.

Hart, George. *A Dictionary of Egyptian Gods and Goddesses.* London, 1986.

Hornung, Erik. *Der Eine und die Vielen: Ägyptische Göttervorstellungen.* Darmstadt, 1971.

———. *Conceptions of God in Ancient Egypt: The One and the Many.* Trans. John Baines. Ithaca, New York, 1982.

Kees, Hermann. *Der Götterglaube im alten Ägypten.* 2d. ed. Berlin, 1956.

Koch, Klaus. *Geschichte der ägyptischen Religion.* Stuttgart, 1993.

Lesko, Barbara S. *The Great Goddesses of Egypt.* Norman, Okla., 1999.

Helck, Wolfgang, and Eberhard Otto, eds. *Lexikon der Ägyptologie.* 7 vols. Wiesbaden, 1972–92.

Meeks, Dimitri, and Christine Favard-Meeks. *La vie quotidienne des dieux égyptiens,* 1993. Reprinted as *Les dieux égyptiens.* Paris, 1995.

———. *Daily Life of the Egyptian Gods.* Trans. G.M. Goshgarian. Ithaca, New York, 1996.

Quirke, Stephen. *Ancient Egyptian Religion.* New York, 1992.

Traunecker, Claude. *Les dieux de l'Égypte.* Paris, 1992.

———. *The Gods of Egypt.* Trans. David Lorton. Ithaca, New York, 2001.

Vernus, Pascal. *Dieux de l'Égypte.* Paris, 1998.

———. *The Gods of Ancient Egypt.* Trans. Jane Marie Todd. New York, 1998.

Principal Divine Symbols

Clark, R.T. Rundle. *Myth and Symbol in Ancient Egypt.* New York, 1959.

Goff, Beatrice Laura. *Symbols of Ancient Egypt in the Late Period: The Twenty-first Dynasty.* The Hague, 1979.

Lurker, Manfred. *Götter und Symbole der alten Ägypter.* 2d ed. Munich, 1974.

———. *The Gods and Symbols of Ancient Egypt: An Illustrated Dictionary.* Trans. Barbara Cummings. London, 1982.

Wilkinson, Richard H. *Symbol and Magic in Egyptian Art.* London, 1997.

Chronology of Ancient Egypt

Predynastic Period

c. 5300–3000 BCE

Lower Egypt

Neolithic	c. 5300–4000 BCE
Maadi cultural complex	c. 4000–3200 BCE

Upper Egypt

Badarian Period	c. 4400–4000 BCE
Amratian (Naqada I) Period	c. 4000–3500 BCE
Gerzean (Naqada II) Period	c. 3500–3200 BCE

After c. 3200 BCE the same chronological sequence applies to the whole of Egypt.

Naqada III/ "Dynasty 0"	c. 3200–3000 BCE

Early Dynastic Period

c. 3000–2686 BCE

First Dynasty	**c. 3000–2890**
Aha	
Djer	
Djet	
Den	
Queen Merneith	
Anedjib	
Semerkhet	
Qa´a	

Second Dynasty	**2890–2686**
Hetepsekhemwy	
Raneb	
Nynetjer	
Weneg	
Sened	
Peribsen	
Khasekhemwy	

Old Kingdom

2686–2125 BCE

Third Dynasty	**2686–2613**
Nebka	2686–2667
Djoser	2667–2648
Sekhemkhet	2648–2640
Khaba	2640–2637
Sanakht?	
Huni	2637–2613

Fourth Dynasty	**2613–2494**
Snefru	2613–2589
Khufu (Cheops)	2589–2566
Djedefra (Radjedef)	2566–2558
Khefre (Chephren)	2558–2532
Menkaura (Mycerinus)	2532–2503
Shepseskaf	2503–2498

Fifth Dynasty	**2494–2345**
Userkaf	2494–2487
Sahura	2487–2475
Neferirkara	2475–2455
Shepseskara	2455–2448
Raneferef	2448–2445
Nyuserra	2445–2421
Menkauhor	2421–2414
Djedkara	2414–2375
Unas	2375–2345

Sixth Dynasty	**2345–2181**
Teti	2345–2323
Userkara	2323–2321
Pepy I	2321–2287
Merenra	2287–2278
Pepy II	2278–2184
Nitiqret	2184–2181

Seventh and Eighth Dynasties	**2181–2160**

Numerous kings, called Neferkara, presumably in imitation of Pepy II.

First Intermediate Period

2160–2055 BCE

Ninth and Tenth Dynasties	**2160–2025**
(Herakleopolits)	
Khety	
Khety	
Khety	
Merykara	

Eleventh Dynasty (Thebes only)	**2125–2055**
Mentuhotep I	
Intef I	2125–2112
Intef II	2112–2063
Intef III	2063–2055

Middle Kingdom

2055–1650 BCE

Eleventh Dynasty (all Egypt)	2055–1985
Mentuhotep II	2055–2004
Mentuhotep III	2004–1992
Mentuhotep IV	1992–1985

Twelfth Dynasty	1985–1773
Amenemhat I	1985–1956
Senusret I	1956–1911
Amenemhat II	1911–1877
Senusret II	1877–1870
Senusret III	1870–1831
Amenemhat III	1831–1786
Amenemhat IV	1786–1777
Queen Sobekneferu	1777–1773

Thirteenth Dynasty	1773–after 1650
Wegaf	
Sobekhotep II	
Iykhernefert Neferhotep	
Ameny–intef–amenemhat	
Hor	
Khendjer	
Sobekhotep III	
Neferhotep I	
Sahathor	
Sobekhotep IV	
Sobekhotep V	
Ay	

Fourteenth Dynasty	1773–1650

Minor rulers probably contemporary with the Thirteenth or Fifteenth Dynasty

Second Intermediate Period

1650–1550 BCE

Fifteenth Dynasty (Hyksos)	1650–1550
Salitis / Sekerher	
Khyan	c. 1600
Apepi	c. 1555
Khamudi	

Sixteenth Dynasty	1650–1580

Theban early rulers contemporary with the Fifteenth Dynasty

Seventeenth Dynasty	c. 1580–1550
Rahotep	
Sobekemsaf I	
Intef VI	
Intef VII	
Intef VIII	
Sobekemsaf II	
Siamun (?)	
Taa	c. 1560
Kamose	1555–1550

New Kingdom

1550–1069 BCE

Eighteenth Dynasty	1550–1295
Ahmose	1550–1525
Amenhotep I	1525–1504
Thutmose I	1504–1492
Thutmose II	1492–1479
Thutmose III	1479–1425
Queen Hatshepsut	1473–1458
Amenhotep II	1427–1400
Thutmose IV	1400–1390
Amenhotep III	1390–1352
Amenhotep IV/Akhenaten	1352–1336
Neferneferuaten	1338–1336
Tutankhamun	1336–1327
Ay	1327–1323
Horemheb	1323–1295

Ramessid Period

1295–1069 BCE

Nineteenth Dynasty	1295–1186
Ramesses I	1295–1294
Seti I	1294–1279
Ramesses II	1279–1213
Merenptah	1213–1203
Amenmessu	1203–1200?
Seti II	1200–1194
Saptah	1194–1188
Queen Tausret	1188–1186

Twentieth Dynasty	1186–1069
Sethnakht	1186–1184
Ramesses III	1184–1153
Ramesses IV	1153–1147
Ramesses V	1147–1143
Ramesses VI	1143–1136
Ramesses VII	1136–1129
Ramesses VIII	1129–1126
Ramesses IX	1126–1108
Ramesses X	1108–1099
Ramesses XI	1099–1069

Third Intermediate Period

1069–664 BCE

Twenty-first Dynasty	1069–945
Smendes	1069–1043
Amenemnisu	1043–1039
Psusennes I	1039–991
Amenemope	993–984
Osorkon the Elder	984–978
Siamun	978–959
Psusennes II	959–945

Twenty-second Dynasty	945–715
Sheshonk I	945–924
Osorkon I	924–889
Sheshonk II	c. 890
Takelot I	889–874
Osorkon II	874–850
Takelot II	850–825
Sheshonk III	825–773
Pimay	773–767
Sheshonk V	767–730
Osorkon IV	730–715

Twenty-third Dynasty	818–715

Kings in various centers, contemporary with the later Twenty-second, Twenty-fourth, and early Twenty-fifth Dynasties, including:

Pedubastis I
Iuput I
Sheshonk IV
Osorkon III
Takelot III
Rudamon
Peftjauawybast
Iuput II

Twenty-fourth Dynasty	727–715
Bakenrenef	720–715

Twenty-fifth Dynasty	747–656
Piy	747–716
Shabaqo	716–702
Shabitqo	702–690
Taharqo	690–664
Tanutamani	664–656

Late Period

664–332 BCE

Twenty-sixth Dynasty (Saite Period)	664–525
Nekau I	672–664
Psamtik I	664–610
Nekau II	610–595
Psamtik II	595–589
Apries	589–570
Ahmose II	570–526
Psamtik III	526–525

Twenty-seventh Dynasty (First Persian Period)	525–404
Cambyses	525–522
Darius I	522–486
Xerxes I	486–465
Artaxerxes I	465–424
Darius II	424–405
Artaxerxes II	405–359

Twenty-eighth Dynasty	404–399
Amyrtaios	404–399

Twenty-ninth Dynasty	399–380
Nepherites I	399–393
Hakor [Achoris]	393–380
Nepherites II	c. 380

Thirtieth Dynasty	380–343
Nectanebo I	380–362
Teos	362–360
Nectanebo II	360–343

Second Persian Period	343–332
Artaxerxes III Ochus	343–338
Arses	338–336
Darius III Codoman	336–332

Ptolemaic Period

332–30 BCE

Greco-Roman refers to the Ptolemaic and Roman periods.

Macedonian Dynasty	332–305
Alexander the Great	332–323
Philip Arrhidaeus	323–317
Alexander IV	317–310

Ptolemaic Dynasty	
Ptolemy I Soter I	305–285
Ptolemy II Philadelphus	285–246
Ptolemy III Euergetes I	246–221
Ptolemy IV Philopator	221–205
Ptolemy V Epiphanes	205–180
Ptolemy VI Philometor	180–145
Ptolemy VII Neos Philopator	145
Ptolemy VIII Euergetes II	170–116
Ptolemy IX Soter II	116–107
Ptolemy X Alexander I	107–88
Ptolemy IX Soter II (restored)	88–80
Ptolemy XI Alexander II	80
Ptolemy XII Neos Dionysos (Auletes)	80–51
Cleopatra VII Philopator	51–30
Ptolemy XIII	51–47
Ptolemy XIV	47–44
Ptolemy XV Caesarion	44–30

Early Roman Period

30 BCE–138 CE

Augustus	30 BCE–14 CE
Tiberius	14 CE–37
Gaius (Caligula)	37–41
Claudius	41–54
Nero	54–68
Galba	68–69
Otho	69
Vespasian	69–79
Titus	79–81
Domitian	81–96
Nerva	96–98
Trajan	98–117
Hadrian	117–138

Chronology of Ancient Egypt adapted from Ian Shaw, ed., *The Oxford History of Ancient Egypt* (Oxford and New York: Oxford University Press, 2000), 480–83.

Glossary

akh The form that the soul took to inhabit the underworld after the *ba* and *ka* were successfully united.

Akhmenu A temple built by Thutmose III within the temple complex at Karnak.

Amarna Period/Amarna Era A period during the late Eighteenth Dynasty centered around the reign of Amenhotep IV, also known as Akhenaten.

Amduat A text describing the sun's twelve-hour passage through the night into the netherworld.

annals Records from the reign of Thutmose III inscribed on the walls of Karnak Temple.

Apis bull A carefully chosen cult animal identified with the *ba* of the god Ptah. When the bull died, it was mummified and entombed at Sakkara.

***atef* crown** A tall crown flanked by plumes at either side and worn by kings and Osiris.

ba The part of the soul that could move between the physical body and the area outside the tomb, including the underworld. It is often depicted as a bird with a human head and arms.

barque of the sun In Egyptian mythology the sun was believed to move through the sky by day and the underworld by night by means of a barque, or sacred boat.

***benben* stone** An obelisk-like stone topped by a pyramidion that was symbolic of the primeval mound of creation in Heliopolis.

Book of Caverns A Nineteenth Dynasty text in which the netherworld is divided into six parts. On its journey through the netherworld the sun must pass over caves or pits in each section.

Book of the Celestial Cow A text from the late Eighteenth Dynasty describing an attempt of the sun god to destroy all of mankind.

Book of the Dead/Book of Going Forth by Day A collection of spells from the Second Intermediate Period and later, some of which are continuations of Coffin Text spells. These texts were placed within burials to aid passage to the next world after death.

Book of the Earth A royal text from the Twentieth Dynasty concerning the voyage of the sun through the netherworld.

Book of Gates A late Eighteenth Dynasty text referring to the necessary passage through various gates that divide each of the twelve hours of the night.

canopic chests Chests or boxes designed to contain the four canopic jars.

canopic jars Vessels specially designed to contain the mummified viscera including the lungs, stomach, intestines and liver. The jars came in sets of four, and each of the Four Sons of Horus were assigned the duty of protecting the contents of one of the vessels.

cataract A dangerous area of rapids along the Nile River. There are six cataracts south of Aswan.

chthonic deities Deities deriving from the earth.

Coffin Texts A group of spells to assist the deceased's journey to the next world, some of which were derived from the Pyramid Texts. They were inscribed on coffins during the Middle Kingdom.

Colossi of Memnon A pair of colossal statues of Amenhotep III erected by that same pharaoh as part of his vast mortuary temple on the west bank at Thebes. One of the statues — the true Colossus of Memnon — made a whistling sound when the wind passed through it and ancient Greek travelers equated it with the Homeric figure of Memnon.

crook and flail Both part of the royal regalia. The pharaoh was often depicted holding these items crossed over his chest. The crook was a curved scepter and the flail may represent a fly whisk. These symbols were also associated with the god Osiris.

Deir el-Bahari A site on the western bank of the Nile at Thebes where Mentuhotep, Hatshepsut, and Thutmosis III built terraced funerary temples in a large bay in the cliffs.

Deir el-Medina A walled village on the west bank of the Nile at Thebes that housed the workmen who built and decorated the royal tombs in the Valley of the Kings and some tombs of courtiers in the Theban necropolis.

Destruction of Mankind A myth in which the sun god, tired of people's evil doings, sends his daughter, an avenging goddess, to destroy all of humankind. In the end the sun god relents, and the goddess is tricked into stopping her rampage. See Book of the Celestial Cow.

devourer of the dead Known as Ammit, this composite creature has the head of a crocodile, the forelegs of a lion, and the back legs of a hippopotamus. She sits at the scales of the Judgment of Osiris, waiting to eat the heart of the deceased if it is found to be unjust.

djed pillar The symbol of stability depicting a pillar of woven plants. It came to be associated with the backbone of Osiris, god of the underworld.

Ennead A group of nine deities. The Heliopolitan creation myth revolves around the Ennead of Heliopolis, which includes Atum, Shu, Tefnut, Geb, Nut, Osiris, Isis, Seth, and Nephthys.

Eye of Re/Solar Eye The wandering eye of the god Re; often associated with the goddesses Hathor, Sakhmet, and Wadjet.

faience A material made of crushed quartz, lime, plant ash, or natron used to make a variety of objects including amulets and vessels. It is pressed into a mold, covered in glaze, and fired to form a vitreous-like material.

feather of Maat During the Judgment of Osiris the heart of the deceased was weighed on a scale against the feather of Maat, the symbol of truth and justice. If the heart was light the deceased was allowed to pass, but if it was heavy it was eaten by the devourer and the deceased ceased to exist.

Festival of the Valley/Beautiful Festival of the Valley A Theban festival in which the cult statues of Amun, Mut, and Khonsu were brought in procession from Karnak Temple to the funerary temples on the west bank. Deir el-Bahari was a favored destination.

Four Sons of Horus Four deities associated with the embalmed internal organs of the deceased. These gods include the human Imsety, the jackal Duamutef, the baboon Hapy, and the falcon Kebehsenuef.

funerary temple A structure built for the maintenance of the funerary cult of a deceased king. They functioned before and after the death of a ruler.

Giza A necropolis just outside modern Cairo. The site includes several cemeteries, the Great Pyramids, and the Great Sphinx.

God's Wife of Amun A priestess who played the consort of the god Amun in temple rituals. In the early Eighteenth Dynasty the position was associated with the royal house, and the holder of the title appointed her own successor.

Great Sphinx at Giza A colossal statue of a human-headed lion. The pharaoh represented may be Khafre of the Fourth Dynasty. During the New Kingdom the Great Sphinx was identified with the god Horemakhet.

hieroglyphic writing system Pictographs used to write the ancient Egyptian language. Three types of signs were used: phonograms, logograms, and determinatives.

Hyksos A group from Syria-Palestine who migrated into Egypt during the later Middle Kingdom. They settled in the Nile Delta and by the Second Intermediate Period controlled the northern half of Egypt. The Fifteenth Dynasty is often referred to as the Hyksos Dynasty.

inundation An annual event in which the Nile would flood its banks every June through September, starting at Aswan and moving northward to the area around Cairo. The layer of silt deposited by the flooding made the soil exceptionally fertile.

Intermediate Period A designation made by modern historians for periods of Egyptian history during which there was no strong, central, unified Egyptian government.

Judgment of Osiris/Tribunal of Osiris The heart of the deceased would be weighed upon a scale against the feather of the goddess Maat, the personification of truth and justice.

ka Part of the Egyptian concept of the soul. The *ka* came into being at the moment of birth and formed a type of double for a person. After death the *ka* continued to live on and needed to be sustained with offerings. The *ka* would eventually join with the *ba* to form the *akh*.

Karnak Temple A huge temple complex located in modern Luxor and dedicated to the Theban triad of deities: Amun, Mut, and Khonsu. The temple complex was modified and expanded from the Middle Kingdom onward into the Greco-Roman Period.

Kush Also known as Upper Nubia; including in modern geographical terms northern Sudan and the southern border of Egypt. At various points in their history the ancient Egyptians controlled this area and relied heavily upon it as a source of gold. During the Twenty-fifth Dynasty, rulers from Kush took over the throne of Egypt.

lapis lazuli A dark blue stone with inclusions of gold or pyrite. It was prized by the Egyptians for use in amuletic jewelry and had to be imported over great distances from northern Afghanistan.

Litany of Re An Eighteenth Dynasty text found in royal tombs that describes the seventy-five names of the sun god Re. This text also elaborates on the role of the king and his connection to the deities.

Lower Egypt Ancient Egypt was divided into Upper and Lower Egypt. Located in the North, Lower Egypt extended from the Nile Delta to just south of Memphis. It was designated "Lower" because the Nile River flows northward.

Luxor Modern geographical name for the ancient city of Thebes.

Luxor Temple Founded in Thebes during the reign of Amenhotep III. It was dedicated to the cult of Amun and modified by successive pharaohs down to and including Alexander the Great. It was connected to Karnak Temple by a processional road.

mastaba A term derived from an Arabic word meaning bench. It denotes a type of tomb with a rectangular brick or stone superstructure with sloping walls surmounting a burial chamber and storage area. This type of tomb was used for royal and non-royal burials.

Medinet Habu A temple complex built on the western bank of the Nile at Thebes. It was founded during the Eighteenth Dynasty, but the mortuary temple of Ramesses III dominates the site.

mehen **serpent** A great serpent who protected the sun god Re.

Memphis The capital of the first Lower Egyptian nome. Memphis was an important administrative center during most of the pharaonic period.

Memphite Theology A creation myth centered around the god Ptah of Memphis. Ptah creates by conceiving an idea within his heart and then speaking it aloud. He first created the god Atum and the deities of the Ennead.

mummification A process developed in ancient Egypt to preserve the remains of the deceased. The body was chemically cleansed and desiccated. It was then packed, perfumed, and wrapped in linen. Often the viscera were removed and embalmed separately.

natron A naturally occurring desiccant composed of sodium carbonate and sodium bicarbonate. It could be found on the banks of the Wadi Natrun and at a few other sites in Egypt. It was a principal ingredient in the mummification process and in some temple rituals of purification.

necropolis "City of the dead," a term for a burial ground.

negative confession Also known as the "declaration of innocence." The deceased would recite his negative confessions before Osiris and the forty-two gods of the judgment. It illustrated the innocence of the deceased and his right to pass through. For example: "I have not lied, I have not stolen, [etc.]."

nome One of the forty-two provinces or districts into which ancient Egypt was divided. There were twenty-two nomes in Upper Egypt and twenty in Lower Egypt. Forty-two was a sacred number.

Nun The primeval waters of chaos. The primeval mound of creation arose from the Nun. The depths of the netherworld were also associated with the Nun.

obelisk A tall, tapering four-sided monument topped by a pyramidion.

ogdoad A group of eight deities. There were four frog gods and four snake goddesses who represent the pre-creation chaotic elements of water, hiddenness, infinity, and darkness.

Opening of the Mouth ritual Performed upon the mummy and the statues of the deceased before they were placed into the tomb. By a series of anointments, actions, and repetition of spells, the senses of the deceased were restored so that he could breathe, eat, and move through the netherworld.

Opet festival An annual festival in which the statue of the god Amun was carried in procession from Karnak Temple to Luxor Temple.

Punt An area in eastern Africa to which Egypt sent trading expeditions. The exact location of Punt is unknown. The famous expedition sent to Punt by Hatshepsut is illustrated on the walls of her temple at Deir el-Bahari.

Pyramid Texts A group of some eight hundred funerary spells inscribed on the walls of the burial chambers of the pyramids beginning at the end of the Fifth Dynasty. The texts were designed to protect the deceased king and aid his journey into the sky.

Qurn The pyramidal shaped mountain that rises up behind the royal and non-royal necropoli on the western bank of the Nile at Thebes.

Red Crown The crown of Lower Egypt. It was often combined with the White Crown to symbolize the power of the pharaoh over both Upper and Lower Egypt.

rishi **coffin** A type of coffin decorated with a feather pattern. The feathers were symbolic of the protective wings of several winged deities.

Saite Period c. 664–332 BCE. The Saite Period is a name for the Twenty-sixth Dynasty. The kings of this dynasty ruled from the site of Sais in the Nile Delta.

Sakkara Located near modern Cairo; the necropolis for the city of Memphis. The site was in use from the First Dynasty through the post-Roman Christian period.

sarcophagus An outer container for a coffin; used to give the physical remains of the deceased an additional layer of protection.

scarab beetle Symbolic of the god Khepri and the rising sun. The scarab beetle became a powerful symbol of resurrection.

Sea People A migratory population of groups from Asia Minor and the Mediterranean. Ramesses III illustrated his repulsion of the Sea Peoples from Egypt's border on the walls of his temple at Medinet Habu.

Sed festival A ceremony of the renewal of kingship. It was normally celebrated for the first time during a king's thirtieth regnal year, although some kings appear to have celebrated their festivals much earlier in their reigns.

Serapeum The burial place of the Apis bulls at Sakkara.

shabti/shawabti/ushebti Funerary statuette that was often mummiform. The *shabti* was intended to stand in for the deceased in the afterlife to perform any necessary manual tasks, such as planting fields and clearing irrigation ditches.

sphinx Most often a combination of the body of a lion with the head of a human. Kings desired to combine their own images with that of the lion in order to absorb the power of the animal. The sphinx was also associated with the sun god.

stele A flat, round-topped monument.

Thebes Ancient name for the modern city of Luxor.

triad A group of three gods, generally a family grouping of a god, his consort, and their child. Each site in ancient Egypt had its own local triad.

Upper Egypt Ancient Egypt was divided into Upper and Lower Egypt. Located in the South, Upper Egypt extended from just south of Memphis to Aswan. It was designated "Upper" because the Nile River flows northward.

uraeus A symbol of kingship. It is the figure of a rearing cobra, representing the cobra goddess Wadjet. The uraeus was often added to the brow of the king as part of his headdress.

ushebti See *shabti*.

Valley of the Kings The necropolis of the New Kingdom kings located on the west bank of the Nile at Thebes. The necropolis is composed of an eastern and a western valley containing a total of sixty-two numbered tombs.

wedjat **eye** The eye of the god Horus. Horus lost his eye in a fight with Seth, but the goddess Hathor was able to restore it. The eye of Horus thus became a powerful symbol of healing and protection.

West Considered the realm of the dead.

White Crown The crown of Upper Egypt. It was often combined with the Red Crown to symbolize the power of the pharaoh over both Upper and Lower Egypt.

Abbreviations for Frequently Cited References

Catalogue général:
Catalogue général des antiquités égyptiennes du Musée du Caire. Cairo, 1906–25, 1930, 2000.

Lexikon der Ägyptologie:
Lexikon der Ägyptologie. 7 vols. Ed. Wolfgang Helck and Wolfhart Westendorf. Wiesbaden, 1972–92.

Oxford Encyclopedia:
The Oxford Encyclopedia of Ancient Egypt. 3 vols. Oxford, 2001. Ed. Donald B. Redford.

Thutmose III and the Glory of the New Kingdom

Baines, John. "Classicism and Modernism in the New Kingdom." In Antonio Loprieno, ed., *Ancient Egyptian Literature: History and Forms.* Leiden/New York, 1996.

Bryan, Betsy M. "The Eighteenth Dynasty before the Amarna Period (c. 1550–1352 BC)." In Ian Shaw, ed., *The Oxford History of Ancient Egypt.* Oxford/New York, 2000.

Gardiner, A. H. *Egypt of the Pharaohs.* Oxford, 1961.

James, T. G. H. *Pharaoh's People: Scenes from Life in Imperial Egypt.* Oxford, 1985.

Martin, G. T. "Memphis: The Status of a Residence City in the Eighteenth Dynasty." In Miroslav Bárta and Jaromír Krejcí, eds., *Abusir and Saqqara in the Year 2000.* Praha, Czech Republic, 2000.

Lichtheim, Miriam, comp. *Ancient Egyptian Literature: A Book of Readings.* Vol. 2, *The New Kingdom.* Berkeley, 1976.

Parkinson, R. B., ed. and trans. *Voices from Ancient Egypt: An Anthology of Middle Kingdom Writings.* London, 1991.

Radwan, Ali. "Thutmosis III als Gott." In Heike Guksch and Daniel Polz, *Stationen: Beiträge zur Kulturgeschichte Ägyptens: Rainer Stadelmann Gewidmet.* Mainz, 1998.

Romer, John. *Ancient Lives: Daily Life in Egypt of the Pharaohs.* New York, 1984.

Valbelle, Dominique. *Histoire de l'Etat pharaonique.* Paris, 1998.

Vandersleyen, C. *L'Egypte et la Vallee du Nil, Tome 2.* Paris, 1995.

van Dijk, Jacobus. "The Amarna Period and the Later New Kingdom (c. 1352–1069 BC)." In Ian Shaw, ed., *The Oxford History of Ancient Egypt.* Oxford/New York, 2000.

Vernus, Pascal, and Jean Yoyotte. *Dictionnaire des pharaons.* Paris, 1996.

Exploring the Beyond

Introduction

Allen, Thomas George. *The Book of the Dead or Going Forth by Day: Ideas of the Ancient Egyptians Concerning the Hereafter as Expressed in Their Own Terms.* Ed. Elizabeth B. Hauser. Studies in Ancient Oriental Civilization, no. 37. Chicago, 1974.

Assmann, Jan. *Tod und Jenseits im alten Ägypten.* Munich, 2001.

Faulkner, Raymond O., ed. and trans. *The Ancient Egyptian Coffin Texts.* 3 vols. Warminster, England, 1973–87. Reprint, 1994.

Faulkner, Raymond O., Ogden Goelet Jr., and Carol Andrews, ed. and trans. *The Ancient Egyptian Book of the Dead.* San Francisco, 1994.

———. *The Ancient Egyptian Pyramid Texts.* 2 vols. Oxford, 1969. Reprint, Warminster, England, 1985.

Hodel-Hoenes, Sigrid. *Life and Death in Ancient Egypt: Scenes from Private Tombs in New Kingdom Thebes.* Trans. David Warburton. Ithaca, New York, 2000.

Hornung, Erik. *The Ancient Egyptian Books of the Afterlife.* Ithaca, New York, 1999.

———. *Die Nachtfahrt der Sonne: Eine altägyptische Beschreibung des Jenseits.* Zurich/Munich, 1991.

———. *Die Unterweltsbücher der Ägypter.* Zurich/Munich, 1992.

Piankoff, Alexandre. *The Tomb of Ramesses VI*, vol. 1. Ed. Nina Rambova. Bollingen Series XL. New York, 1954.

Taylor, John. *Death and the Afterlife in Ancient Egypt.* Chicago, 2001.

Zandee, Jan. "Book of Gates." In *Liber Amicorum: Studies in Honour of Professor Dr. C. J. Bleeker.* Leiden, 1969.

227

The Tomb of a Pharaoh

Fornari, Annamaria, and Mario Tosi. *Nella sede della verità: Deir el Medina e l'ipogeo di Thutmosi III*. Milan, 1987.

Hornung, Erik. *The Valley of the Kings: Horizon of Eternity*. Trans. David Warburton. New York, 1990.

———. *The Tomb of Pharaoh Seti I/Das Grab Seti' I*. Zurich/Munich, 1991.

Lehner, Mark. *The Complete Pyramids: Solving the Ancient Mysteries*. London, 1997.

Reeves, Carl Nicholas, and Richard H. Wilkinson. *The Complete Valley of the Kings: Tombs and Treasures of Egypt's Greatest Pharaohs*. London, 1996.

Romer, John. "The Tomb of Tuthmosis III." *Mitteilungen des Deutschen Archäologischen Instituts, Abteilung Kairo* 31 (1975): 315–51.

Schneider, Thomas. In Hanna Jenni, ed., *Das Grab Ramses' X*. (KV 18). Basel, 2000. Aegyptiaca Helvetica, 16.

Weeks, Kent R. *Atlas of the Valley of the Kings*. Cairo, 2000.

Weeks, Kent R., ed. *Valley of the Kings: The Tombs and the Funerary Temples of Thebes West*. Vercelli, Italy, 2001.

The Amduat

Hornung, Erik. *Das Amduat: Die Schrift des Verborgenen Raumes*. 3 vols. Wiesbaden, 1963–67, with a complementary edition of all versions of the New Kingdom in idem, *Texte zum Amduat*, 3 vols. with continuous pagination. Geneva, 1987–94. Aegyptiaca Helvetica, 13–15.

Sadek, Abdel-Aziz Fahmy. *Contribution à l'étude de l'Amdouat*. Fribourg, 1985.

Litany of Re

Hornung, Erik. *Das Buch der Anbetung des Re im Westen*. 2 vols. Geneva, 1975–76. Aegyptiaca Helvetica, 2 and 3.

Piankoff, Alexandre. *The Litany of Re*, vol. 4. Bollingen Series XL. New York, 1964.

Quirke, Stephen. *The Cult of Ra: Sun-Worship in Ancient Egypt*. London, 2001.

Art for the Afterlife

Andrews, Carol. *Egyptian Mummies*. Cambridge, Mass., 1984.

Assmann, Jan. "Death and Initiation in Ancient Egypt." In William K. Simpson, ed., *Religion and Philosophy in Ancient Egypt*. New Haven, 1989.

Aubert, Jacques-F., and Liliane Aubert. *Statuettes égyptiennes: chaouabtis ouchebtis*. Paris, 1974.

Brock, Edwin. "Sarkophag" (pp. 471–85) in *Lexikon der Ägyptologie*, vol. 5. 1984.

Bryan, Betsy M. "The Eighteenth Dynasty before the Amarna Period (c. 1550–1352 BC)." In Ian Shaw, ed., *The Oxford History of Ancient Egypt*. Oxford/New York, 2000.

David, Ann Rosalie. "Mummification" (pp. 439–44) in *Oxford Encyclopedia*, vol. 2.

De Cenival, Jean-Louis. *Le Livre pour Sortir le Jour: Le Livre des Morts des anciens Egyptiens*. Paris, 1992.

Freed, Rita E., Yvonne J. Markowitz, and Sue H. D'Auria, eds. *Pharaohs of the Sun Akhenaten, Nefertiti, Tutankhamen*. Boston, 1999.

Faulkner, Raymond O., Ogden Goelet Jr., and Carol Andrews, ed. and trans. *The Ancient Egyptian Book of the Dead*. San Francisco, 1994.

Gitton, Michel, and Jean Leclant. "Gottesgemahlin" (pp. 792–812) in *Lexikon der Ägyptologie*, vol. 2. 1977.

Hornung, Erik. *The Valley of the Kings: Horizon of Eternity*. Trans. David Warburton. New York, 1990.

Houlihan, Patrick F. *The Animal World of the Pharaohs*. London, 1996.

Janssen, Jac. J. *Commodity Prices from the Ramessid Period*. Leiden, 1975.

Kozloff, Arielle P., and Betsy M. Bryan. *Egypt's Dazzling Sun: Amenhotep III and His World*. Cleveland, 1992.

Laboury, Dimitri. *Le statuaire de Thoutmosis III: Essai d'interprétation d'un portrait royal dans son contexte historique*. Liège, 1998.

Lacovara, Peter, and Betsy Teasley Trope. *The Realm of Osiris Mummies, Coffins, and Ancient Egyptian Funerary Art in the Michael C. Carlos Museum*. Atlanta, 2001.

Lichtheim, Miriam. *Ancient Egyptian Literature: A Book of Readings*, vols. 1 and 2. Berkeley, 1975, 1976.

Lindblad, Ingegerd. *Royal Sculpture of the Early Eighteenth Dynasty in Egypt*. Stockholm, 1984.

Niwinski, Andrzej. *Studies on the Illustrated Theban Funerary Papyri of the Eleventh and Tenth Centuries B.C.* Göttingen, 1989.

Niwinski, Andrzej, and Günther Lapp. "Coffins, Sarcophagi, and Cartonnages" (pp. 279–87) in *Oxford Encyclopedia*, vol. 1.

Porter, Bertha, and Rosalind Moss. *Topographical Bibliography of Ancient Egyptian Hieroglyphic Texts, Reliefs, and Paintings*. Vol. 1, *The Theban Necropolis*, 1927. Part 1, *Private Tombs*. Part 2, *Royal Tombs and Smaller Cemeteries*. Vol. 2, *Theban Temples*, 1929. 2d ed., rev. Oxford, 1964, 1972.

Reeves, Carl Nicholas, and Richard H. Wilkinson. *The Complete Valley of the Kings: Tombs and Treasures of Egypt's Greatest Pharaohs*. London, 1996.

Robins, Gay. *The Art of Ancient Egypt*. Cambridge, Mass., 1997.

Romano, James. "Observations on Early Eighteenth Dynasty Royal Sculpture." *Journal of the American Research Center in Egypt* 13 (1976): 97–111.

Russmann, Edna R. *Egyptian Sculpture: Cairo and Luxor*. Austin, 1989.

Saleh, Mohamed, and Hourig Sourouzian. *The Egyptian Museum, Cairo: Official Catalogue*. Cairo/Mainz, 1987.

Sandison, A. T. "Balsamierung" (pp. 610–14) in *Lexikon der Ägyptologie*, vol. 1. 1975.

Shaw, Ian, ed. *The Oxford History of Ancient Egypt*. Oxford/New York, 2000.

Simpson, William K., ed. *Religion and Philosophy in Ancient Egypt*. New Haven, 1989.

Spanel, Donald B. "Funerary Figurines" (pp. 567–70) in *Oxford Encyclopedia*, vol. 1.

Stierlin, Henri, and Christine Ziegler. *Tanis: Trésors des Pharaons*. Preface by Jean Leclant. Fribourg/Paris, 1987.

Taylor, John. "The Third Intermediate Period (1069–664 BC)." In Ian Shaw, ed., *The Oxford History of Ancient Egypt*. Oxford/New York, 2000.

van Voss, Matthieu Heerma. "Sarg" (pp. 430–68) in *Lexikon der Ägyptologie*, vol. 5. 1984.

Wildung, Dietrich, and Sylvia Schoske. *Nofret, die Schöne: Die Frau im Alten Ägypten*. Mainz, 1984.

Catalogue

The King and Society in the New Kingdom (cats. 1–16)

Altenmüller, Brigitte. "Harsaphes" (pp. 1015–18) in *Lexikon der Ägyptologie,* vol. 2. 1977.

Baines, John, and Jaromír Malék. *Atlas of Ancient Egypt.* Oxford, 1980.

Berman, Lawrence M. "Amenhotep III and his Times." In Arielle P. Kozloff and Betsy M. Bryan. *Egypt's Dazzling Sun: Amenhotep III and His World.* Cleveland, 1992.

Dabrowski, Leszek Teodozy. "A Famous Temple Re-examined: Queen Hatshepsut's Temple at Deir El Bahari — And a Hitherto Unknown Temple." *Illustrated London News* 245, no. 6529 (September 19, 1964): 413–15.

Borchardt, Ludwig. *Statuen und Statuetten von Königen und Privatleuten,* vols. 2 and 3. 1911–36. Catalogue général.

Dorman, Peter. "Senenmut" (pp. 265–66) in *Oxford Encyclopedia,* vol. 3.

———. *The Monuments of Senenmut: Problems in Historical Methodology.* London/New York, 1988.

Graham, Geoffrey. "Tanis" (pp. 348–50) in *Oxford Encyclopedia,* vol. 3.

Hope, Colin A. *Gold of the Pharaohs: An Exhibition Provided by the Egyptian Antiquities Organisation.* Melbourne/Sydney, 1989.

Laboury, Dimitri. *Le statuaire de Thoutmosis III: Essai d'interprétation d'un portrait royal dans son contexte historique.* Liège, 1998.

Legrain, Georges. *Statues et statuettes de rois et de particuliers,* vol. 1. 1906. Catalogue général.

Lipinska, Jadwiga. *The Temple of Tuthmosis III.* Vol. 2, *Architecture.* Deir el-Bahari. Warsaw, 1977.

Michalowski, Kazimierz. "Dans la Vallée de Rois les Polonais à Deir-el-Baheri." *Archeologia,* no. 9 (March–April 1966): 66–73.

Museum of Fine Arts. *Mummies and Magic: The Funerary Arts of Ancient Egypt.* Boston, 1988.

Petrie, W. M. Flinders. *Sedment,* vol. 2. London, 1924.

Porter, Bertha, and Rosalind Moss. *Topographical Bibliography of Ancient Egyptian Hieroglyphic Texts, Reliefs, and Paintings.* Vol. 1, *The Theban Necropolis,* 1927. Part 2, *Royal Tombs and Smaller Cemeteries.* Vol. 2, *Theban Temples,* 1929. 2d ed., rev. Oxford, 1964, 1972.

Quirke, Stephen. *Ancient Egyptian Religion.* New York, 1992.

Robins, Gay. *Egyptian Painting and Relief.* Aylesbury, U.K., 1986.

———. *The Art of Ancient Egypt.* Cambridge, Mass., 1997.

Russmann, Edna R. *Egyptian Sculpture: Cairo and Luxor.* Austin, 1989.

Saleh, Mohamed, and Hourig Sourouzian. *The Egyptian Museum, Cairo: Official Catalogue.* Cairo/Mainz, 1987.

Sethe, Kurt. *Urkunden der 18. Dynastie.* Berlin, 1988.

Simpson, William Kelly. "Senenmut" (pp. 849–51) in *Lexikon der Ägyptologie,* vol. 4. 1982.

Smith, William Stevenson. *The Art and Architecture of Ancient Egypt.* Rev. and ed. by William Kelly Simpson. New Haven, 1998.

Sourouzian, Hourig. "Standing Royal Colossi of the Middle Kingdom Reused by Ramesses II." *Mitteilungen des Deutschen Archäologischen Instituts, Abteilung Kairo* 44 (1988): 229–54.

Spanel, Donald B. "Herakleopolis" (pp. 91–93) in *Oxford Encyclopedia,* vol. 2.

Terrace, Edward L. B., and Henry George Fischer. *Treasures of Egyptian Art from the Cairo Museum.* London, 1970.

Tiradritti, Francesco, ed. *The Treasures of the Egyptian Museum.* Cairo, 1999.

Vandier, Jacques. *Manuel d'archéologie égyptienne.* Vol. 3, *Les grandes époques.* Paris, 1958. Reprint, 1981.

van Dijk, Jacobus. "The New Kingdom Necropolis of Memphis: Historial and Iconographical Studies" (Ph.D. diss., Groningen, 1993).

Van Siclen, Charles C. "Obelisk" (pp. 561–64) in *Oxford Encyclopedia,* vol. 2.

The Royal Tomb (cats. 17–51)

Aldred, Cyril. *Jewels of the Pharaohs.* New York, 1971.

Altenmüller, Hartmut. "Djed-Pfeiler" (pp. 1000–1105) in *Lexikon der Ägyptologie,* vol. 1. 1975.

Altenmüller, Hartwig. "Papyrusdickicht und Wüste: Überlegungen zu zwei Statuenensembles des Tutanchamun." *Mitteilungen des Deutschen Archäologischen Instituts, Abteilung Kairo* 47 (1991): 11–19.

Andrews, Carol. *Amulets of Ancient Egypt.* London/Austin, 1994.

———. *Ancient Egyptian Jewelry.* New York, 1991.

Assmann, Jan. *Egyptian Solar Religion in the New Kingdom: Re, Amun, and the Crisis of Polytheism.* Trans. Anthony Alcock. London/New York, 1995.

Galeries nationales du Grand Palais. *Tanis: L'or des pharaons.* Paris, 1987.

Barsanti, Alexandre. "Tombeua de Zannehibou: Rapport sur la decouverte." *Annales du Service des Antiquités de l'Égypte* 1 (1900): 262–71.

Bissing, F. W. von. *Ein Thebanischer Grabfund aus dem Anfang des Neuen Reiches.* Berlin, 1900.

Capart, Jean. *L'Art égyptien,* vol. 4. Les Arts mineurs. Brussels, 1947.

Bleeker, Claas Jouco. *Hathor and Thoth.* Leiden, 1973.

Bresciani, Edda. "Eléménts de rituel et d'offrande dans le texte démotique de l'Oeil du Soleil." In Jan Quaegebeur, ed., *Ritual and Sacrifice in the Ancient Near East.* Proceedings of the International Conference Organized by the Katholieke Universiteit Leuven, April 17–20, 1991. Louvain, 1993.

Careddu, Giorgio. "L'art musical dans l'Egypte ancienne." *Chronique d'Egypte* (1991): 39–59.

Daressy, Georges. *Fouilles de la Vallée des Rois.* Cairo, 1902.

———. *Statues des divinités,* vols. 1 and 2. 1905–06. Catalogue général.

Dasen, Véronique. *Dwarfs in Ancient Egypt and Greece.* Oxford, 1993.

Daumas, François. "Les objets sacrées de la déesse Hathor à Dendara." *Revue d'Egyptologie* 22 (1970): 63–78.

Davis, Theodore M., et al. *The Tomb of Iouiya and Touiyou.* London, 1907.

Derchain, Philippe. "Anchzeichen" (pp. 268–69) in *Lexikon der Ägyptologie*, vol. 1. 1975.

Doxey, Denise M. "Sobek" (pp. 300–301) in *Oxford Encyclopedia*, vol. 3.

Eaton-Krauss, Marianne. "The Coffins of Queen Ahhotep, Consort of Seqeni-en-Re and Mother of Ahmose." *Cahiers d'Egypte* 65 (1990): 195–205.

Farag, Nagib, and Zaky Iskander. *The Discovery of Neferuptah*. Cairo, 1971.

Gosline, Sheldon Lee. "The *mnjt* as an Object of Divine Assimilation." *Discussions in Egyptology* 30 (1994): 37–46.

Goyon, Georges. *La découverte des trésors de Tanis: Aventures archéologiques en Egypte*. Preface by Jean Leclant. [Paris?], 1987.

Griffiths, J. Gwyn. "Isis" (pp. 188–91) in *Oxford Encyclopedia*, vol. 2.

Guglielmi, Waltraud. *Die Göttin Mr.t: Entstehung und Verehrung einer Personifikation*. Leiden/New York, 1991.

Hickmann, Hans. *Dieux et déesses de la musique*. Cairo, 1954.

Hope, Colin A. *Gold of the Pharaohs: An Exhibition Provided by the Egyptian Antiquities Organisation*. Melbourne/Sydney, 1989.

Hornung, Erik. *The Valley of the Kings: Horizon of Eternity*. Trans. David Warburton. New York, 1990.

Houlihan, Patrick F. *The Animal World of the Pharaohs*. London, 1996.

———. "Felines" (pp. 513–16) in *Oxford Encyclopedia*, vol. 2.

Jéquier, Gustave. *Considérations sur les religions égyptiennes*. Neuchâtel, 1946.

Kákosy, László. *Zauberei im alten Ägypten*. Leipzig, 1989.

Koemoth, Pierre. *Osiris et les arbres: Contribution à l'étude des arbres sacrés de l'Egypte ancienne*. Liège, 1994.

Bedford, Donald B. "Thutmose III" (pp. 540–48) in *Lexikon der Ägyptologie*, vol. 6. 1986.

Lise, Giorgio. *Egyptian Amulets*. Milan, 1988.

Malaise, Michel. "Bes" (pp. 179–80) in *Oxford Encyclopedia*, vol. 1.

Markowitz, Yvonne J., and Peter Lacovara. "Gold" (pp. 34–38) in *Oxford Encyclopedia*, vol. 2.

Martin, Karl. "Uräus" (pp. 864–68) in *Lexikon der Ägyptologie*, vol. 6. 1986.

Maspero, Gaston. *Guide du visiteur au Musée du Caire*. 4th ed. Cairo, 1915.

Montet, Pierre. "La Nécropole des Rois Tanites." *Kemi* 9 (1942): 1–96.

———. *La nécropole royale de Tanis*. Paris, 1947– . Vol. 2, *Les contructions et le tombeau de Psousennès à Tanis*. Paris, 1951.

Mysliwiec, Karol. *The Twilight of Ancient Egypt: First Millennium B.C.E.* Trans. David Lorton. Ithaca, New York, 2000.

Müller, Hans Wolfgang, and Eberhard Thiem. *Gold of the Pharaohs*. Trans. Pierre Imhoff and Dafydd Roberts. Ithaca, New York, 1999.

Morgan, Jacques Jean Marie de. *Fouilles à Dahchour en 1894–1895*. 2 vols. Vienna, 1895–1903.

Müller-Winkler, Claudia. *Die ägyptischen Objekt-Amulette: mit Publikation der Sammlung des Biblischen Instituts der Universität Freiburg, Schweiz, ehemals Sammlung Fouad S. Matouk*, vol. 1. Orbis biblicus et orientalis: Senes Archaeologica. Fribourg/Göttingen, 1987.

Münster, Maria. *Untersuchungen zur Göttin Isis*. Berlin, 1968.

Naguib, Saphinaz-Amal. *Le clergé féminin d'Amon Thébain à la 21e dynastie*. Louvain, 1990.

Petrie, W. M. Flinders. *Amulets*. London, 1914.

Pinch, Geraldine. *Votive Offerings to Hathor*. Oxford, 1993.

Poole, F. "Tanis, Royal Tombs" (pp. 757–59). In *Encyclopedia of the Archaeology of Ancient Egypt*. London/New York, 1999.

Porter, Bertha, and Rosalind Moss. *Topographical Bibliography of Ancient Egyptian Hieroglyphic Texts, Reliefs, and Paintings*. Vol. 1, *The Theban Necropolis*, 1927. Part 2, *Royal Tombs and Smaller Cemeteries*. 2d ed., rev. Oxford, 1964, 1972.

Quibell, James Edward. *The Tomb of Yuyaa and Thuiu*. 1908. Catalogue général.

Reeves, Carl Nicholas, and Richard H. Wilkinson, *The Complete Valley of the Kings: Tombs and Treasures of Egypt's Greatest Pharaohs*. London, 1996.

Reisner, George Andrew. *Canopics*. Revised, annotated, and completed by Mohamad Hassan Abd-ul-Rahman. 1967. Catalogue général.

Reynders, Marleen. "Sšš.t and Shm: Names and Types of the Egyptian Sistrum." In *Egyptian Religion, The Last Thousand Years: Studies in Memory of Jan Quaegebeur*, vol. 2. Louvain, 1998.

Roberts, Alison. *Hathor Rising: The Power of the Goddess in Ancient Egypt*. Totnes, U.K., 1995; Rochester, Vermont, 1997.

Roth, Ann Macy. "The Ahhotep Coffins: The Archaeology of an Egyptological Reconstruction." In Emily Teeter and John A. Larson, eds., *Gold of Praise: Studies on Ancient Egypt in Honor of Edward F. Wente*. Chicago, 1999.

Roulin, Gilles. "Les tombes royales de Tanis: analyse du programme décoratif." In Philippe Brissaud and Christiane Zivie-Coche, eds. *Tanis: Travaux récents sur le tell Sân el-Hagar, Mission française des fouilles de Tanis, 1987–1997*. Paris, 1998.

Saleh, Mohamed, and Hourig Sourouzian. *The Egyptian Museum, Cairo: Official Catalogue*. Cairo/Mainz, 1987.

Schneider, Hans D. *Shabtis: An Introduction to the History of Ancient Egyptian Funerary Statuettes with a Catalogue of the Collection of Shabtis in the National Museum of Antiquities at Leiden*, 3 vols. Leiden, 1977.

Shaw, Ian, and Paul Nicholson. *British Museum Dictionary of Ancient Egypt*, London, 1995.

Spanel, Donald B. "Two Unusual Eighteenth-Dynasty Shabtis in the Brooklyn Museum." *Bulletin of the Egyptological Seminar* 10 (1989/90): 145–67.

Speleers, Louis. *Les figurines funéraires égyptiennes*. Brussels, 1923.

Stierlin, Henri. *The Gold of the Pharaohs*. Trans. P. Snowden. Paris, 1997.

Stierlin, Henri, and Christine Ziegler. *Tanis: Trésors des Pharaons*. Preface by Jean Leclant. Fribourg/Paris, 1987.

Tiradritti, Francesco, ed. *The Treasures of the Egyptian Museum*. Cairo, 1999.

Tobin, Vincent Arieh. "Amun and Amun-re" (pp. 82–84) in *Oxford Encyclopedia*, vol. 1.

van Dijk, Jacobus. "Ptah" (pp. 74–76) in *Oxford Encyclopedia*, vol. 3.

Vernier, Émile Séraphin. *Bijoux et orfèvreries*. 3 vols. 1907–27. Catalogue général.

Vilímková, Milada. *Egyptian Jewellery*. Prague/Feltham, New York, 1969.

Vischak, Deborah. "Hathor" (pp. 82–85) in *Oxford Encyclopedia,* vol. 2.

Wildung, Dietrich, and Sylvia Schoske. *Nofret, die Schöne: Die Frau im Alten Ägypten.* Mainz, 1984.

Wilkinson, Alix. *Ancient Egyptian Jewellery.* London, 1971.

Wilkinson, Richard H. *Symbol and Magic in Egyptian Art.* New York, 1994.

Winlock, Herbert. "The Tombs of Kings of the Seventeenth Dynasty at Thebes." *Journal of Egyptian Archaeology* 10 (1924): 217–77.

Ziegler, Christiane. "Sistrum" (pp. 959–63) in *Lexikon der Ägyptologie,* vol. 5. 1984.

The Tomb of a Noble (cats. 52–75)

Al-Misri, Mathaf. *Le Musée Egyptien,* vol. 3. Cairo, 1890–1915.

Anderson, Robert. "Music and Dance in Pharaonic Egypt." In Jack M. Sasson, ed., *Civilizations of the Ancient Near East,* vol. 4. Peabody, Mass., 2000.

Andrews, Carol. *Amulets of Ancient Egypt.* London/Austin, 1994.

————. *Ancient Egyptian Jewelry.* New York, 1991.

————. *Egyptian Mummies.* Cambridge, Mass., 1984.

Aufrère, Sydney. *L'Univers Minéral dans la Pensée Égyptienne.* Cairo, 1991.

Barsanti, Alexandre. "Le Tombeau de Hikaoumsaf Rapport sur la découverte." *Annales du Service des Antiquités de l'Égypte* 5 (1904–05): 69–83.

Bénédite, Georges. *Objets de toilette,* vol. 1. Cairo, 1911.

Bietinski, Piotr, and Piotr Taracha. "Board Games in the Eastern Mediterranean: Some Aspects of Cultural Interrelations." In *Studia Aegaea et Balcanica in Honorem L. Press.* Warsaw, 1992.

British Museum. *A Handbook to the Egyptian Mummies and Coffins Exhibited in the British Museum.* Department of Egyptian and Assyrian Antiquities. London, 1938.

Brunner-Traut, Emma. *Die Alten Ägypter: Verborgenes Leben unter Pharaonen.* Stuttgart, 1974.

Bruyère, Bernard. *Mert Seger à Deir el Bahari.* Cairo, 1930.

————. *La tombe no 1 de Sen-nedjem à Deir el Médineh.* Cairo, 1959.

Daressy, Georges. *Cercueils des cachettes royales.* Cairo, 1909.

————. *Statues des divinités*, vols. 1 and 2. 1905–06. Catalogue général.

Davies, Norman de Garis. *The Tomb of Puyemrê at Thebes.* 2 vols. New York, 1922–23.

Decker, Wolfgang, and Michael Herb. *Bildatlas zum Sport im alten Ägypten,* vol. 1. Leiden, 1994.

Dodson, Aidan. *The Canopic Equipment of the Kings of Egypt.* London, 1994.

————. "Canopic Jars and Chests" (pp. 231–35) in *Oxford Encyclopedia,* vol. 1.

DuQuesne, Terence. *Anubis and the Spirits of the West.* Thame Oxon, U.K., 1990.

Fischer, Henry George. *Ancient Egyptian Representations of Turtles.* New York, 1968.

————. "Kopfstütze" (pp. 686–93) in *Lexikon der Ägyptologie,* vol. 3. 1981.

Freed, Rita E. *Ramesses the Great.* Memphis, Tennessee, 1988.

Friedman, Florence Dunn. "*Shabti* of Lady Sati." In Florence Dunn Friedman, ed., *Gifts of the Nile: Ancient Egyptian Faience.* Providence, 1998.

Galeries Nationales du Grand Palais. *Ramses Le Grand.* Paris, 1976.

Hayes, William Christopher. *The Scepter of Egypt,* vol. 2. New York, 1990.

Hermann, Alfred. *Die Stelen der thebanischen Felsgräber der 18. Dynastie.* Glückstadt, 1940.

Hickmann, Ellen. "Klapper" (pp. 447–49) in *Lexikon der Ägyptologie,* vol. 3. 1981.

Hickmann, Hans. *Instruments de Musique,* 1949. Catalogue général.

Hill, Marsha. "The Life and Work of Harry Burton" In Erik Hornung, *The Tomb of the Pharaoh Seti I/Das Grab Seti' I.* Zurich/Munich, 1991.

Hornung, Erik. *The Valley of the Kings: Horizon of Eternity.* Trans. David Warburton. New York, 1990.

Houlihan, Patrick F. "Frogs" (p. 563) in *Oxford Encyclopedia,* vol. 1.

Kákosy, Lászlo. "Frosch" (pp. 334–36) in *Lexikon der Ägyptologie,* vol. 2. 1977.

Kampp, Friederike. *Die thebanische Nekropole: Zum Wandel des Grabgedankens von der XVIII. bis zur XX. Dynastie.* Mainz, 1996.

Kendall, Timothy. *Passing through the Netherworld.* Belmont, Mass., 1978.

Kendall, Timothy, et al. "Les jeux de table dans l'antiquité" (pp. 122–65). In *Jouer dans l'antiquité. Musée d'Archéologie Méditerranéenne – Centre de la Vielle Charité, 22 novembre 1991 – 16 février 1992.* Marseille, 1992.

Killen, Geoffrey. "Ancient Egyptian Carpentry: Its Tools and Techniques." In Georgina Hermann, ed., *The Furniture of Western Asia, Ancient and Traditional.* Papers of the Conference held at the Institute of Archaeology, University College London, June 28–30, 1993. Mainz, 1996.

————. *Ancient Egyptian Furniture.* Vol. 2, *Boxes, Chests and Footstools.* London, 1994.

————. *Egyptian Woodworking and Furniture.* London, 1994.

Kozloff, Arielle P., and Betsy M. Bryan. *Egypt's Dazzling Sun: Amenhotep III and His World.* Cleveland, 1992.

Lawergren, Bo. "Music" (pp. 450–54) in *Oxford Encyclopedia,* vol. 2.

Lilyquist, Christine, and Robert H. Brill. *Studies in Early Egyptian Glass.* New York, 1993.

Maspero, Gaston. *Les momies royals de Déir el-Baharî.* Paris, 1889.

Milde, H. *The Vignettes in the Book of the Dead of Neferrenpet.* Leiden, 1991.

Museum of Fine Arts. *Egypt's Golden Age: The Art of Living in the New Kingdom, 1558–1085 B.C.* Boston, 1982.

————. *Mummies and Magic: The Funerary Arts of Ancient Egypt.* Boston, 1988.

Niwinski, Andrzej. *Studies on the Illustrated Theban Funerary Papyri of the Eleventh and Tenth Centuries B.C.* Fribourg/Göttingen, 1989.

————. *Twenty-first Dynasty Coffins from Thebes: Chronological and Typological Studies.* Mainz, 1988.

Niwinski, Andrzej, and Günther Lapp. "Coffins, Sarcophagi, and Cartonnages" (pp. 279–87) in *Oxford Encyclopedia,* vol. 1.

Otto, Eberhard. *Egyptian Art and the Cults of Osiris and Amon.* Trans. Kate Bosse Griffiths. London, 1968.

Pieper, Max. *Das ägyptische Brettspiel.* Leipzig, 1931.

231

Porter, Bertha, and Rosalind Moss. *Topographical Bibliography of Ancient Egyptian Hieroglyphic Texts, Reliefs, and Paintings.* Vol. 1, *The Theban Necropolis,* 1927. Part 1, *Private Tombs.* Part 2, *Royal Tombs and Smaller Cemeteries.* Vol. 2, *Theban Temples,* 1929. Vol. 3, *Memphis,* 1931. Part 1, *Abû Rawâsh to Dahshûr.* 2d ed., rev. Oxford, 1964, 1972.

Pusch, Edgar Bruno. *Das Senet-Brettspiel im alten Ägypten.* Munich/Berlin, 1979.

Ranke, Hermann. *Die ägyptischen Personennamen.* Glückstadt, 1935.

Redford, Donald B. "Offerings" (pp. 564–69) in *Oxford Encyclopedia,* vol. 2.

Reisner, George Andrew. *Canopics.* Revised, annotated, and completed by Mohammad Hassan Abd-ul-Rahman. 1967. Catalogue général.

Robins, Gay. *The Art of Ancient Egypt.* Cambridge, Mass., 1997.

Saleh, Mohamed. *Das Totenbuch, Text und Vignetten.* Mainz, 1984.

Saleh, Mohamed, and Hourig Sourouzian. *The Egyptian Museum, Cairo: Official Catalogue.* Cairo/Mainz, 1987.

Schlick-Nolte, Birgit. *Die Glasgefässe im alten Ägypten.* Berlin, 1968.

———. "Glass" (pp. 30–34) in *Oxford Encyclopedia,* vol. 2.

Schneider, Hans D. *Shabtis: An Introduction to the History of Ancient Egyptian Funerary Statuettes with a Catalogue of the Collection of Shabtis in the National Museum of Antiquities at Leiden,* vol. 1. Leiden, 1977.

Scott III, Gerry D. *Temple, Tomb and Dwelling: Egyptian Antiquities from the Harer Family Trust Collection.* San Bernardino, 1992.

Spencer, A. Jeffrey. *Death in Ancient Egypt.* New York/Harmondsworth, U.K., 1982.

Taylor, John. *Egyptian Coffins.* Vol. 11 of *Shire Egyptology.* Aylesbury, U.K., 1989.

Terrace, Edward L. B., and Henry G. Fischer. *Treasures of Egyptian Art from the Cairo Museum.* London, 1970.

Tiradritti, Francesco, ed. *The Treasures of the Egyptian Museum.* Cairo, 1999.

Toda, Eduardo. "Découverte et L`inventaire du Tombeau de Sen-nezen." *Annales du Service des Antiquités de l'Égypte* 20 (1920): 145–58.

Vandier, Jacques. *Manuel d'archéologie égyptienne,* vol. 4. Paris, 1964.

Vernier, Émile Séraphin. *Bijoux et orfèvreries.* 3 vols. 1907–27. Catalogue général.

Wenig, Steffen. *The Woman in Egyptian Art.* Trans. Barbara Fischer. New York, [1969].

Wildung, Dietrich, and Sylvia Schoske. *Nofret, die Schöne: Die Frau im Alten Ägypten.* Mainz, 1984.

Realm of the Gods and the Amduat (cats. 76–107)

Altenmüller, Brigitte. "Anubis" (pp. 327–33) in *Lexikon der Ägyptologie,* vol. 1. 1975.

American Research Center in Egypt. *The Luxor Museum of Ancient Egyptian Art Catalogue.* Cairo, 1978.

Andrews, Carol. *Amulets of Ancient Egypt.* London/Austin, 1994.

Arslan, Ermanno A., et al. *Iside: Il mito, il mistero, la magia.* Milan, 1997.

Assmann, Jan. *Maât, l'Égypte pharaonique et l'idée de justice sociale.* Paris, 1989.

Aubert, Jacques-F., and Liliane Aubert. *Statuettes égyptiennes: chaouabtis, ouchebtis.* Paris, 1974.

Bakry, Hassan S. K. "The Discovery of a Temple of Sobk in Upper Egypt." *Mitteilungen des Deutschen Archäologischen Instituts, Abteilung Kairo* 27 (1971): 131–46.

Barocas, C. "Les statues 'réalistes' et l'arrivée des Perses dans l'égypte saïte." In *Gururajamanjarik: Studi in onore di Giuseppe Tucci.* Naples, 1974.

Benson, Margaret, and Janet Gourlay. *The Temple of Mut in Asher.* London, 1899.

Bianchi, Robert. *Cleopatra's Egypt: Age of the Ptolemies.* Brooklyn, 1988.

Bonhême, Marie-Ange, and Annie Forgeau Pharaon. *Les secrets du pouvoir.* Paris, 1988.

Bothmer, Bernard V., comp. *Egyptian Sculpture of the Late Period, 700 B.C. to A.D. 100.* Contributions by Herman de Meulenaere and Hans Wolfgang Müller. Ed. Elizabeth Riefstahl. New York, 1960.

Bouriant, Urban. *Petits monuments et petits texts.* Vol. 7 of *Recueil de travaux, rélatifs à la philologie et à l´archéologie égyptiennes et assyriennes.* Paris, 1886.

Brunner-Traut, Emma. "Crocodile" (pp. 320–21) in *Oxford Encyclopedia,* vol. 1.

Bryan, Betsy M. "The Statue Program for the Mortuary Temple of Amenhotep III." In Stephen Quirke, ed., *The Temple in Ancient Egypt: New Discoveries and Recent Research.* London, 1997.

Bury, J. B., S. A. Cook, and F. E. Adcock, eds. *The Cambridge Ancient History.* Vol. 1, *Egypt and Babylonia to 1580 B.C.* Cambridge, 1927.

Cook, Stanley A. "The Gods of the Twilight: Man's Early Efforts towards an Embodiment of His Spiritual Needs in a Personal Religion." In John Alexander Hammerton, ed. *The Universal History of the World,* vol. 1. London, 1927.

Daressy, Georges. *Statues des divinités,* vols. 1 and 2. 1905–06. Catalogue général.

Doxey, Denise M. "Sobek" (pp. 300–301) in *Oxford Encyclopedia,* vol. 3.

———. "Thoth" (pp. 398–400) in *Oxford Encyclopedia,* vol. 3.

DuQuesne, Terence. *Black and Gold God: Colour Symbolism of the God Anubis.* London, 1996.

Edgar, Campbell Cowan. *Greek Sculpture.* Osnabrück, 1974; reprint of 1903 ed. Catalogue général.

Eggebrecht, Eva. "Greif" (pp. 895–96) in *Lexikon der Ägyptologie,* vol. 2. 1977.

Ferrari, Daniela. *Gli amuleti dell'antico Egitto.* Imola, 1996.

Graefe, Erhart. "Upuaut" (pp. 862–64) in *Lexikon der Ägyptologie,* vol. 6. 1986.

Harris, James Renel. *Egyptian Art.* London, 1966.

Helck, Wolfgang, and Eberhard Otto. "Pavian" (pp. 915–20) in *Lexikon der Ägyptologie,* vol. 4. 1982.

Holmberg, Maj Sandman. *The God Ptah.* Lund, 1946.

Holm-Rasmussen, Torben. "On the Statue Cult of Nectanebos II." *Acta Orientalia* (Copenhagen) 40 (1979): 21–25.

Hornung, Erik. "Komposite Gottheiten in der ägyptischen Ikonographie." In Christoph Uehlinger, ed., *Images as Media: Sources for the Cultural History of the Near East and the Eastern Mediterranean, First Millennium B.C.E.* Fribourg, 2000.

Hüttner, Maria. *Mumienamulette im Totenbrauchtum der Spätzeit.* Vienna, 1995.

Ikram, Salima, and Aidan Dodson. *The Mummy in Ancient Egypt.* London, 1998.

232

Johnson, Janet H. "The Demotic Chronicle as a Statement of a Theory of Kingship." *Journal of the Society for the Study of Egyptian Antiquities* 13 (1983): 61–72.

Josephson, Jack A., and Mamdouh Mohamed Eldamaty. *Statues of the Twenty-fifth and Twenty-sixth Dynasties.* 2000. Catalogue général.

Kákosy, László. "Atum" (pp. 550–52) in *Lexikon der Ägyptologie,* vol. 1. 1975.

Kessler, Dieter. *Die heiligen Tiere und der König.* Wiesbaden, 1989.

Killen, Geoffrey. *Ancient Egyptian Furniture.* Vol. 2, *Boxes, Chests and Footstools.* London, 1994.

Kozloff, Arielle P., and Betsy M. Bryan. *Egypt's Dazzling Sun: Amenhotep III and His World.* Cleveland, 1992.

Leclant, Jean. *Les pharaons,* vol. 3. Paris, 1979.

Legrain, Georges. "La statuette de Hor fils de Djet Thot Efankh." *Annales du Service des Antiquités de l'Égypte* 16 (1916): 145–48.

Málek, Jaromír. *The Cat in Ancient Egypt.* London, 1993.

Mariette, Auguste. *Monuments divers recueillis en Égypte et en Nubie.* Paris, 1872.

———. *Notice des principaux monuments exposés dans les galeries provisoires du musée d'Antiquités Egyptiennes.* Alexandria, 1864.

Meeks, Dimitri. "Hededet" (pp. 1076–78) in *Lexikon der Ägyptologie,* vol. 2. 1977.

Müller-Winkler, Claudia. *Die ägyptischen Objekt-Amulette: mit Publikation der Sammlung des Biblischen Instituts der Universität Freiburg, Schweiz, ehemals Sammlung Fouad S. Matouk,* vol. 1. Orbis biblicus et orientalis: Senes Archaeologica. Fribourg/Göttingen, 1987.

Myer, Isaac. *Scarabs: The history, manufacture and religious symbolism of the scarabaeus in ancient Egypt, Phoenicia, Sardinia, Etruria, etc.; also remarks on the learning, philosophy, arts, ethics, psychology, ideas as to the immortality of the soul, etc. of the ancient Egyptians, Phoenicians, etc.* London, 1894.

Mysliwiec, Karol. *Studien zum Gott Atum,* vol. 1. Hildesheim, 1978.

———. "Zwei Pyramidia der XIX. Dynastie aus Memphis." *Studien zur Altägyptischen Kulturkunde* 6 (1978): 145–55.

Moret, Alexandre. *Rois et dieux d'Égypte.* Paris, 1911.

Newberry, Percy E. *Funerary Statuettes and Model Sarcophagi,* 1930. Catalogue général.

Niwinski, Andrzej. "Untersuchungen zur ägyptischen religiösen Ikonographie der 21. Dynastie/Mummy in the Coffin as the Central Element of Iconographic Reflection of the Theology of the Twenty-first Dynasty in Thebes." *Göttingen Miszellen* 109 (1989): 53–66.

Pernigotti, Sergio. "Una statua di Pakhraf (Cairo JE 37171)." *Rivista degli Studi Orientali* 44 (1969): 259–71.

———. "Due sacerdoti egiziani di Epoca Tarda." *Studi classici e orientali* 21 (1972): 305–6.

Petrie, W. M. Flinders. *Scarabs and Cylinders with Names: Illustrated by the Egyptian Collection in University College, London.* London, 1917.

Picard-Schmitter, M-Th. "Une tapisserie hellénistique d'Antinoé." *Fondation Eugène Piot: Monuments et Mémoires* 52 (1961): 50–51.

Piehl, Karl Fredrick. "Varia." *Zeitschrift für Ägyptische Sprache und Altertumskunde.* 1888.

Pijoán, José. *History of Art,* vol. 1. Trans. Ralph L. Roys. New York, 1927.

Pirelli, Rosanna. "Statue of Isis from the Tomb of Psamtek." In Francesco Tiradritti, ed., *The Treasures of the Egyptian Museum.* Cairo, 1999.

Porter, Bertha, and Rosalind Moss. *Topographical Bibliography of Ancient Egyptian Hieroglyphic Texts, Reliefs, and Paintings.* Vol. 1, *The Theban Necropolis,* 1927. Part 1, *Private Tombs.* Part 2, *Royal Tombs and Smaller Cemeteries.* Vol. 2, *Theban Temples,* 1929. Vol. 3, *Memphis,* 1931. Part 1, *Abû Rawâsh to Dahshûr.* 2d ed., rev. Oxford, 1964, 1972.

Quaegebeur, Jan. "Divinitiés égyptiennes sur des animaux dangereux." In *L'Animal, l'homme, le dieu dans le Proche-Orient ancien.* Louvain, 1984.

———. "De L'Origine égyptienne du Griffon Némésis." In François Jouan, ed., *Visages du destin dans les mythologies: Mélanges Jacqueline Duchemin, Actes du Colloque de Chantilly 1er–2 mai 1980.* Paris, 1983.

Rammant-Peeters, Agnès. *Les pyramidions égyptiens du Nouvel Empire.* Louvain, 1983.

Ray, J.D. *The Archive of Hor.* London, 1976.

Redford, Donald B. "Monkeys and Baboons" (pp. 428–32) in *Oxford Encyclopedia,* vol. 2.

———. "Thoth" (pp. 398–400) in *Oxford Encyclopedia,* vol. 3.

———. "Felines" (pp. 513–16) in *Oxford Encyclopedia,* vol. 1.

Ritner, Robert K. *The Mechanics of Ancient Egyptian Magical Practice.* Chicago, 1993.

Roeder, Günther. *Ägyptische Bronzefiguren.* Berlin, 1956.

———. *Die ägyptische Götterwelt.* Zurich/Stuttgart, 1959.

Russmann, Edna R. *Egyptian Sculpture: Cairo and Luxor.* Austin, 1989.

———. *Le dieu égyptien Shaï dans la religion et onomastique.* Orientalia Lovaniensia Analecta 2. Louvain, 1975.

Saleh, Mohamed, and Hourig Sourouzian. *The Egyptian Museum, Cairo: Official Catalogue.* Cairo/Mainz, 1987.

Schmidt, Valdemar. *Sarkofager, Mumiekister, og Mumiehylstre i det Gamle Aegypten: Typologisk Atlas.* Copenhagen. 1919.

Seeber, Christine. *Untersuchungen zur Darstellung des Totengerichts im alten Ägypten.* Munich/Berlin, 1976.

Shaw, Ian, and Paul Nicholson. *British Museum Dictionary of Ancient Egypt.* London, 1995.

Spalinger, Anthony John. "The Concept of the Monarchy during the Saite Epoch—An Essay of Synthesis." *Orientalia* 47 (1978): 12–36.

Taylor, John. *Death and the Afterlife in Ancient Egypt.* Chicago, 2001.

Teeter, Emily. "Maat" (pp. 319–21) in *Oxford Encyclopedia,* vol. 2.

Trapani, Marcella. "Statue of Isis." In Alessandro Bongioanni and Maria Sole Croce, eds. *The Illustrated Guide to the Egyptian Museum in Cairo.* Cairo, 2001.

van Dijk, Jacobus. "Ptah" (pp. 74–76) in *Oxford Encyclopedia,* vol. 3.

von Känel, Frédérique. "Scorpions" (pp. 186–87) in *Oxford Encyclopedia,* vol. 3.

Ward, John. *The Sacred Beetle: A Popular Treatise on Egyptian Scarabs in Art and History.* London, 1902.

Zabkar, Louis V. *A Study of the Ba Concept in Ancient Egyptian Texts.* Chicago, 1968.

Abydos, 33
Ahhotep, 8, 60, 61
 coffin for, 66, 108–109, 109
 fan of, 106
 fly pendants of, 106, 107
 mirror of, 107
 vulture bracelet of, 108
Ahmose, 2, 8, 60, 61
Ahmose, 9
akh, 29
Akhenaten, 35, 39. See also Amenhotep IV
 erasing inscriptions, 82, 87
 worshiping Aten, 141
Akhmenu Monument, 16
Altenmüller, Hartwig, 113
Amarna Period, 71, 141
Amduat, 3, 17, 28, 39–48
 compared to the Book of Gates, 31
 figures from in tombs, 165–211
 in tomb of Amenhotep II, 40, 41, 46, 47
 in tomb of Seti I, 40, 41, 43, 44
 in tomb of Thutmose III, 40, 42, 43, 44, 45, 47,
 112
 in the tomb of Thutmose IV, 38–39
Amenemhab, 14
Amenemhat III, 172
Amenemhat, 17
Amenemhat, 15
Amenemhat, son of Hapu, 19, 55–56, 73n12
 burial of, 143
 statue as a scribe, 98–99, 98–100
Amenhotep-Huy, 66–67, 71
 pyramidion of, 194, 195, 196–198, 199
 shabti of, 142, 143
Amenhotep II, 17
 Amduat depicted in tomb of, 40, 41, 46, 47
 ankh, 110
 boat from tomb of, 76–78, 76–79
 djed pillar, 111
 relief sculpture of, 18
 Sennefer and Sentnay, 95, 96
 statue in Karnak Temple, 60, 61
 tomb of, 35
Amenhotep III, 2, 19–20
 Colossi of Memnon, 55
 crocodiles, 219
 funerary figures, 71
 overbite in family portraits, 80
 portrait statue of, 63
 statue of mummiform deity, 165
 using scarabs as commemorative objects, 210
Amenhotep IV, 20, 71.
 See also Akhenaten

Amulet plaque of Maat, 114–115
Amun/Amun-Re, 10, 214–215
 Akhenaten against, 141
 begetting queen Hatshepsut, 9
 and Mut, 134
 in "Nine gold gods" statues, 118
 offering table of Thutmose III, 86
 part of Theban triad of deities, 169
 relief of, 88
 relief of Thutmose III facing, 87
 in solar barque, 131
 sphinx of Thutmose III in temple of, 81–82
 stele of, 206
ankh, 110
Ankhnesneferibre, 201
Annals of Thutmose III, 12
Anthropoid coffin of Paduamen, 158–161, 159
Anubis, 10, 108, 215
 on canopic chest of Queen Nedjmet, 163–164
 as guardian of the body, 191
 hounds and jackals game, 158
 on model sarcophagus, 204
 on pyramidion of Amenhotep-Huy, 195
 on ushebti box of Djed-Maat-iuesankh, 207, 208
Anupet, 215
Apis bulls, 173
Apophis, 28, 31
 hindering the sun god's journey, 44
 turtle manifestation, 158
Apries, 177
atef crown, 169
Aten, 141
Atum, 2, 80
 connected with Re and Horakhty, 195.
 See also Re
 as snake or eel, 192
 temple in Heliopolis, 218
Ay, 101

ba, 3, 29
 in burial, 73
 contact with the sunlit world, 204
 in the journey to the netherworld, 43
 journeying into the west, 207
Bab El-Gusus, 158
baboon, 200
Barta, Winfried, 110
Bastet-Sakhmet (goddess), 174
Bead net and gold mask of Hekaemsaef, 136
Beautiful Festival of the Valley, 10, 88, 89
beauty, 55–56
Benaty, 206
Benermerut, 15
Bes, 117, 122, 155

Beyond, 28–29, 214. *See also* Journey
 to the netherworld
 described in the Amduat, 42
 inhabitants rejoicing in, 30
Block statues, 209. *See also* cubic statues, 209
Block with relief of Nebnefer, *184–186*
Boat from tomb of Amenhotep II, 76–79
Book of Caverns, 31–32
Book of Gates, 29–30, 31, 36
 Sakhmet in, 219
 on shrines containing deceased awaiting
 rejuvenation, 71
 Tatjenen in, 219
Book of Heaven, *32*
Book of the Celestial Cow, 32–33, 216, 218
Book of the Dead, 3, 29
 on coffins, 68
 depicting joys of paradise, 31
 judgment of the dead, 33
 on sarcophagus of Khonsu, 153
 scarabs in, 210
 in tombs, 58
 ushebti objects, 72–73, 143
Book of the Earth, *32*
Book of the Secret Chamber, 3. *See also* Amduat
Book of the Two Ways, 27–28
Books of the Netherworld, 28, 29. *See also* Amduat
 Horus and Sokar, 216
 king joining Re on underworld journey, 218
 punishment and destruction of deceased, 30–31
 as tomb decoration, 39
Bracelet with gold couchant lions, *105*
Bracelet with the eye of Horus, 128–129, *129*
bronze, 178, 187
Bronze cat, *190*, 191
building program of Thutmose III, 15
burial rites, 57–59

canopic jars/boxes, 69–70, *125*, *163–164*
cats, 190–191
Chair from tomb of Yuya and Tuya, *122–123*
Chest with jackal reclining on lid, 70
Clappers, *155*, 162
clothing, 44–45, 115
cobras, 109. *See also* serpents; uraeus/uraei
Coffin Texts, 1, 27–28, 184
coffins, 66–69
 Isis-em-akhbit, *133–134*
 model for *shabti*, *142–143*
 Paduamen, 158–160, *159–161*
 Queen Ahhotep, *108–109*
 with *wedjat* eye, *203*
collars, *104*, 168
Colossal head of Ramesses II usurped from
 Senusret I, *94–95*

Colossal statues of Ramesses II, 20
Colossi of Memnon, 55
 as cult statues, 19
 marking the site of Amenhotep III's mortuary
 precinct, 98, 100
cowry shells, 102
creation myths, 172
crocodiles, 184, 188, 191
cubic statues, 209. *See also* block statues, 209

Daressy, Georges, 136
Deir el-Bahari, 3, 35
 coffin of Isis-em-akhbit, 133
 Djeser Akhet Temple, 88, 89
 funerary temple of Queen Hatshepsut, 8, *9*, *10*
 inscriptions of Hatshepsut, 8
Deir el-Medina, 67, 143, 144, 201
Den, 1
Dira Abu el-Naga, 108
Djed-Maat-iuesankh (Singer of Amun), *52*, *54–55*,
 72, 207–208
djed pillars, 69, 86, 111
 on canopic chest of Queen Nedjmet, 163
 Ptah, 129
Djehuty (general), 13, 183
Djehuty, 200. *See also* Thoth
Djeser Akhet Temple, 2, 88, 89
Djoser, 34
Double snake coffin, *192–193*
Duamutef, 70, 124, 125

Early Dynastic Period, 221
Early Roman Period, 223
Edfu, 183
Egypt, map of, *xv*

Falcon, *187*
Falcon collar of Princess Neferuptah, *104*
Falcon-headed crocodile, *188*
Falcon with king, *171–172*
False door of Puyemre, *138*, *139*
Fans, 106
Fertility, 215, 217
Figure of Sakhmet, *173*
figurines, 70–73
Finger stalls, *132–133*
First Intermediate Period, 7, 221
Fly pendants of Queen Ahhotep, *106*, 106–107
Four Sons of Horus, 70, 114
 on canopic jars, 125
 on a model sarcophagus, 204
 on sarcophagus of Khonsu, 153
 on *wedjat* eye plaque, *124*
Fragment of an obelisk, 85–86

frogs, 157
Funerary banquet scene from tomb of
 Suemniwet, *10*
Funerary figure of the Adjutant Hat, *141*
Funerary mask of Wenudjebauendjed, 126, *127*
Funerary sandals, *115*
furniture, 147, 149

games, *156*, *157–158*
Gardiner, Alan, 110
Geb, 215, 216
geese, *206*, 215
gemstones, 60, 103
Girdle of Mereret, *102*
Glass vessels, *140*
gods and deities, 165–211. *See also under*
 individual names
gold, 60, 116, 118
 in burial rituals, 132
 representing the sun, 126
Gold covered handle and base of a fan of
 Queen Ahhotep, *106*
Gold pectoral with solar boat, *24*, *26–27*, *131*
granodiorite, 92, 165
Great Sphinx at Giza, *57*, 73n3
griffins, 211

Hapy, 70, 124
 on canopic jar, 125
 on offering table of Khety, 140
Harendotes ("Horus the Avenger of His Father"),
 216
Harper's Songs, 30
Harpocrates ("Horus the Child"), 216
Harsiese, 209
Harsomtus ("Horus the Uniter of the
 Two Lands"), 216
Hat, Adjutant, *141*
Hathor, 10, 33, 215–216
 accompanying Sobek, 184
 compared to Isis, 126, 170
 in gold pectoral with solar boat, *131*
 guiding Re through the underworld, 40
 musical associations with, 155
 in "Nine gold gods" statues, 117, 118
 pendant, *116*
 sistrum, *117*
 on statue of Paakhref, 209
 as winged goddess, 179
Hatshepsut, 2, 8–11
 Deir el-Bahari Temple, 3, 35
 obelisk of, 10, *11*
 portraiture of, 62
 presenting herself as offspring of Amun-Re, 214

Senemut and Nefrure, statue of, *90*
statues of, 83
Thutmose I, statues of, 81
Head of Thutmose I, 80–81
Headrest, *135*
Heddjet, 183
Heka, 31
Hekaemsaef, 65, 114, 136–137
Heket, 157
Heliopolis, 2, 98, 218
Henket-Ankh Temple, 16
Henutwedjbu, coffin of, 66, *67*
Herihor, 164
Herodotus, 191
Herwer, 188
Hetemyt ("Place of Destruction"), 30
hieroglyphics, 56–57
Horakhty, 195. *See also* Re
Horemakhet-Khepri-Re-Atum, 19
Horemheb, 35, 37
 detail from tomb, *36*
 rebuilding temple to Amun-Re, 82
 succeeding Ay to throne, 101
Hornakht, 125
Horus, 1, 30, 216
 eye of, 46, 124, 128–129
 falcon, *187*
 as falcon-headed crocodile, 188
 Four Sons of, 70 (*See also* Four Sons of Horus)
 Hathor, relationship to, 116, 216
 hidden by mother Isis, 69, 126
 with Isis his mother, *178*
 name of king, 85
 on pyramidion of Amenhotep-Huy, 195
 quarreling with brother, 42
 and scorpions, 183
 son of Osiris and Isis, 170
 wedjat eye of, *203*
Hounds and jackals playing set, 157–158, *158*
Hu, 214
Huy, 143. *See also* Amenhotep Huy
Hyksos, 7, 9

ibises, 189, 220
Ii-neferti, 144, 149, 150
Imhotep, 34, 100
Imperial administration of Thutmose III, 13–15
Imsety, 70, 124, 125
Ineni, 8
Instruction for Merikare, 29
Iret, 183
Isis-em-akhbit, 65, 68–69, *133–134*

Isis, 28, 117–118, 216–217
 with Horus child, *178*
 on Isis-em-akhbit's coffin, 69
 as masculine statue, 166
 on model sarcophagus, 204
 necklace with pendant in the form of, *126*
 in the netherworld, 44
 in pectoral of Psusennes I, 130
 as protector, 125, 153
 on Queen Ahhotep's coffin, 109
 as Renenutet, 211
 reviving Osiris, 169
 statues of, *xvi, 65, 170*
 as tree goddess, 39
 as uraeus serpent, 46
 as winged goddess, 179
Isis Heddjet, 183
Ivory frog, *157*

Jackals, 158, *191*
jewelry, 102–108, *150*
Journey to the netherworld, 27–31
 Amduat, description of, 39–48
 Litany of Re, 48
 tombs of kings prepared for, 33–39
Jubilation relief, *162*
Judgment of the Dead, 30
 Anubis' role in, 215
 in the Book of Caverns, 31
 by Osiris, 44, 218
 Thoth and Maat, *189*
 Thoth in, 200

ka, 19, 29
 in funerary chapels, 93
 in statues, 60
Kadesh, 12, 20
Kamose, 106
Karnak, 11, 19, 20
Karnak Temple, 2
 Akhmenu Monument, 16
 Amun-Re worshiped at, 206, 214
 Festival Temple of Thutmose III, 112
 high officials putting statuary in, 95
 inscriptions of Hatshepsut, 8
 Isis-em-akhbit's role in, 69
 Paduamen serving in, 158
 Ramesses II's early complex at, 95
 Thutmose III statue from, 83
Kebehsenuef, 70, 124, 125
Khabekhnet, 71–72, *143*
 jewelry box for, 150
 ushebti box of, *145–146*

Khaemwaset, 21
Khafre, 57
Khentyamentiu. *See also* Osiris, 217
khepresh crown, 87
Khepri, *43, 44, 210*, 218
Khety, 139–140
Khnum, 217
Khnumet, 103
Khonsu, son of Sennedjem, 106, 134, 169
Khonsu, 67, 146
 sarcophagus of, *ii–iii, 151–154*
 statuette of, 144
Khufu, 58
Khufu Pyramid, 34
King facing Amun, *87*

lapis lazuli, 60, 116
Late Period, 223
Leopard of Thutmose III, *113*
lions, 105
Litany of Re, 48–50
 buried with Thutmose III, 17, 38
 in tomb of Thutmose III, 38, *39*
Loret, Victor, 110
lotus blossoms, 131, 174
Loyalist Teachings, 22
Luxor
 artisans in, 144
 monuments of Amenhotep III, 19
 monuments of Ramesses II, 20
Luxor Temple, 11, 88

maat, 37
 accompanying the sun god, 41
 judgment of the dead, 33
 as moral and ethical principle, 180
Maat, *36, 180–181*
 amulet plaque, *114–115*
 on coffin of Paduamen, 158
 in gold pectoral with solar boat, *131*
 as personification of cosmic order, 218
 and Thoth, *189*
 as winged goddess, 179
Mariette, Auguste, 108, 168
Maspero, Gaston, 144
mastaba, 34
materials, 59–60, 86
 bronze, 178, 187
 gold, 118
 granodiorite, 92, 165
 lapis lazuli, 116
 quartzite, 98
 red granite, 59, 86
 wood, 149

Medinet Habu Temple, 11, *21*, 35
 Decade Festival, 88
 sarcophagus lid of Nitocris, 201, 203
Medjaseshet,182
Megiddo, 12
Mehen, *44*
Mehytenweskhet, 201
Memphis, 15
 as center of Ptah worship, 172
 as center of Sokar worship, 219
 colossi of Ramesses II, 21, 95
 djed pillars, 111
 ruled over by Amenhotep-Huy, 195
Menkaure, 34
Menkheperre, 83. *See also* Thutmose III
Menkheperre-seneb, 14, 15
Menkheperre (son of Thutmose III), 17
Mentuhotep (king), 34
Mentuhotep, 95
Merenptah, 21, 31
Mereret, 102
Merneith, 1
Merytre Hatshepsut,17, 91
Middle Kingdom, 7, 222
 jewelry in, 103
 pyramid tradition in, 38
 military campaigns of Thutmose III, 12–13
Min, 214
Mirror of Queen Ahhotep, *107*
mirrors, 110
Mitanni, 13
Model tools for *ushebti*s, *120*
Montu, 79, 214
Morgan, Jacques de, 102, 103, 105
mummification, 29, 57–58
 animals, 191
 canopic jars, 69
 incision plaques, *124*
Mummy bed of Sennedjem, *148–149*
Mummy on bier, *204–205*
music, 155, 162
Mut, 133–134, 169
Mutnofret, 95

Nakhtmin,101
naos shrines, 163
Narmer, 1
Nebetta, 17
Nebnakht, *56*, 92–93
Nebnefer, 184–185
Necklace of Princess Khnumet, *103*
Necklace with pendant in the form of Isis, *126*

Nectanebo, 171–178
Nedjmet, 70, 163–164
Nefer-peret, 91–92
Nefertari, 95
Nefertem, 130, 139, *174*
Neferuptah, 104
Neferweben, 14
Nefrure, 9, *90*
negative confessions, 33, 189
Nehmetawy, 200
Neith, 125, 153, 210, 217
Nekhbet, 1, 108, 158
Nemesis, 211
Nensemekhtuef, 155
Nephthys, 216
 as depicted on Queen Ahhotep's coffin, 109
 on model sarcophagus, 204
 in pectoral of Psusennes I, *130*
 as protector, 125, 153
 reviving Osiris, 169
 as uraeus serpent, 46
 as winged goddess, 179
netherworld, 27–31. *See also* Journey to the
 netherworld
New Kingdom, 7, 222
 Anubis on canopic chests, 163–164
 finger and toe stalls, *132*
 funerary figures, 71
 kings and society, 2, 76
 obelisks in, 86
 placement of statues of wives and husbands,
 101
 senet game in, 156
 Sennefer and Sentnay, 95
 sun's journey through the underworld, 128
 *ushebti*s, 143
Nine gold gods, 117–118, *118*
Nitocris, 69, 169, *201–202*, 203
Nomes, 169
Nubia, 15
Nun, 31, 32, 44
 as female deity, 184
 rejuvenation of sun, 47
Nut, 31, 32, 217
 on coffin of Paduamen, 158
 helping the deceased, 50
 prayer to, 142
 rejuvenation of sun, 47
 as winged goddess, 179

Obelisk fragment, *85*, 85–86
offering bearer, *137*, 137–138
Offering chapels in tombs, 139. *See also* Tombs
 of nobles

Offering table of Khety, *139*, 140
Offering table of Thutmose III, *4, 6–7, 86–87*
offerings to the dead, 138
Old Kingdom, 7, 221
Opening of the mouth ritual, *36–37*, 130
Opet Festival, 19
Osiris, 2, 28, 217–218
 association with the dead, 137
 in the Book of Caverns, 32
 on canopic chest of Queen Nedjmet, 163
 on coffin of Paduamen, 158
 colored green, 67
 as crocodile, 188
 deceased presenting himself as, 50
 djed pillars, *111*
 and Isis, 126, 216–217
 journey through the netherworld, 45, 46
 judgment of the dead, 44, 189
 in Litany of Re, 49
 murder of, 30
 passivity of, 42
 protected by Mehen, *44*
 with Ptah and Sokar, 109
 Re, the sun god, 43–44, 217, 218
 resurrecting, *176–177*
 as ruler of the dark world, 27, 41
 with Sokar, 195, 199
 statue of, *65, 169*
 on stele of a woman, *182*
Osorkon II, 70, 125

Paakhref, *65*, 209
Paduamen, 68, 158–161
papyrus umbels, 106, 107
Patek, 118
peasantry, 22
Pectoral of Psusennes I, *130*
Pectoral of Sheshonk II, *128*
Pendant in the form of a Hathoric head, *116*
Pendant of the god Ptah in his shrine, *129*,
 129–130
Perunefer, 15
Petrie, Flinders, 114
Philae Temple, 178
Pi-Ramessu, 21
Pliny the Elder, 157
Plutarch, 169, 218
Predynastic Period, 221
priests, 113. *See also under* individual names
Psamtik I, 65
 daughter Nitocris, 69, 169, 201
 statue of Isis, *170*

237

Psusennes I, 70, 126
 pectoral of, *130*
 toe stalls with rings, *132*
Ptah, 60, 111
 in "Nine gold gods" statues, 117
 in pendant, *129,* 129–130
 Sakhmet as consort, 169
 and Sokar, 219
 son Nefertem, 174
 statue of, 172–173, *173*
 temple of, 2
 worshiped in Memphis, 15
Ptahmose, 14
Ptolemaic Period, 172, 223
Punt expedition, 10
Puyemre, 139
Pyramid Texts, 27, *28,* 34
 Hathor in, 216
 Isis in, 216
 king conceived by Sakhmet, 169
 Re in, 218
Pyramidion of Amenhotep-Huy, *194,* 195,
 196–198, 199
pyramids, 33–34. *See also* Tombs of royalty

quartzite, 98

Ramesses II, 11, 20–21
 Amenhotep-Huy serving, 195
 colossal head of, *94,* 95
 Khabekhnet serving, 146
 layout of sarcophagus, 37
 obelisk of, 85–86
 re-carving statue of Senusret I, 64–65
 shape of eyes, 165
Ramesses III, 21, 37
Ramesses IV, 21, 37
Ramesses VI, 32, 37
Ramesses XI, 164
Ramesseum, *20,* 34
Ramessid Period, 20–21, 222
rams, 206
Re-Horakhty, 2, 218
Re (royal herald), 204
Re, 2, 218
 in Book of Heaven, 32
 in the Book of the Celestial Cow, 33
 connected with Horakhty and Atum, 195
 Four Sons of Horus, 124
 Hathor, daughter of, 216
 journey to the netherworld, 31, 40–48
 and Khnum, 217
 in Litany of Re, 49
 as Osiris, 177

pharaoh equated with, 48
 on pyramidion of Amenhotep-Huy, 199
 Sakhmet, daughter of, 169
 as Sobek, 219
 and Tatjenen, 219
 and Thoth, 200
Recumbent jackals, *191*
Red Chapel in Karnak, 11
red granite, 59, 86
Rekhmire, 14, 79, 139
Relief of Amun, 88
Relief of the Sea People, 20, *21*
Relief with two snake deities and griffin, *211*
Renenutet, 211
rituals
 for burial, 57–59
 jubilation relief, *162*
 *sistrum*s used in, 117
Royal barque of Thutmose III, *89*

Saite Period, 65, 201
Sakhmet, 46, 129, 219
 figure of, *172*
 seated statue of, *168,* 168–169
 seated statuette of, *175*
 son Nefertem, 174
Sakkara, 162
sarcophagus, 66
 of Khonsu, *ii–iii, 151–154*
 lid of Nitocris, 201–202, *203*
scarabs, *210*
 image of Amenhotep II on, 18
 as image of hope, 40
 Khepri, *43*
 in pectoral of Psusennes I, *130*
 in pectoral of Sheshonk II, *128*
 as sun god, *48*
Scene of the vizier, *14*
Scorpion stone, *183*
Seated statue of the goddess Sakhmet,
 "mistress of fear," *168,* 168–169
Seated statuette of Sakhmet, *175*
Second Intermediate Period, 7, 222
Sed festivals, 2
Selket
 in the netherworld, 44
 as protector, 125, 153
 scorpions, 183
Senenmut, 9, *90,* 139
senet, 153, 156
Sennedjem, 67, 71
 funerary figure of, *144*
 jewelry box from tomb, *150*
 mummy bed of, *148–149*

stool, *147*
 triangle level of, *148*
 ushebti of Khabekhnet, *143*
Sennefer and Sentnay, 95–97, *96–97*
Sennefer, 60, 63, 95–96, *96–97*
Sentnay, 60, 95–96, *96–97*
Senusret I, 62
 hymns in honor of, 2
 image re-carved by Ramesses II, 64–65, 95
Senusret II, 34, 103
Senusret III, 2, 102
Senyseneb, 139
Serapeum, 173
serpents
 Apophis, 28
 double snake coffin, *192–193*
 identified with Upper and Lower Egypt, 57
 Mehen, 44
 protection to corpse, 149
 relief with two snake deities and griffin, *211*
 as world encircler, 47
Seth, 28
 Isis protecting her son from, 126
 killing Osiris, 169
 in the netherworld, 44
 quarreling with brother, 42
 tearing out one of Horus' eyes, 203
Seti I, 20, 21
 Amduat depicted in tomb of, 39, 40, *41, 43, 44*
 Litany of Re, 48
 restoring inscriptions, 82
 Sennedjem serving, 144
 tomb of, *36–37,* 38
Setnakht, 21
shabtis, 70–71, *142,* 142–143. *See also ushebtis,*
 shawabtis
shawabtis, 70, 71–72. *See also shawabtis, ushebtis*
Sheikh Abada, 165
Shepenwepet II, 201
Sheritre, 93
Sheshonk I, 128, 131
Sheshonk II, 128
Sheshonk, 116
shrines containing deceased awaiting
 rejuvenation, *71*
Sia, 31, 214
sistrum, 117, 184
Sit-Amun, 122
Sitiah, 17
snakes. *See* serpents
Snefru, 34
Sobek, 44, 117, 219
 as falcon-headed crocodile, 188
 on relief of Nebnefer, 184

Sokar, 16, 42, 219
 associated with Ptah, 172
 combining with Osiris, 111, 195, 199
 journeying through the netherworld, 46
 union with the sun god, 43
sphinxes, 57
 Great Sphinx at Giza, 57, 73n3
 of Thutmose III, *viii, 81–82*
 Thutmose IV's "dream stele," 18–19
statuary, 60, 165
Statue of Isis, *xvi, 170*
Statue of mummiform deity, *165–167*
Statue of Osiris, *169*
Statue of Paakhref, *209*
Statue of Ptah, *172–173*
Statue of Senemut and Nefrure, *90*
Statuette of Nefertem, *174*
Stele of a woman, *182*
Stele of Amun-Re, *206*
Stele of Nebnakht and family, *92, 92–93*
Stelophore of Nefer-peret, *91, 91–92*
Stool from Sennedjem's tomb, *147*
Suemniwet, *10, 58, 59*
Suhet, 66
Sun god. *See* Re
Symbolism
 colors, 214
 lions, 105
 of materials, 59–60

Tamaket, 153
Tanis, 130, 131
 burial site of, 85
 sarcophagus lid of Nitocris, 203
Tao II, 108
Tatjenen, 129, 172, 219
Taweret, 122
Tetisheri, 8
Thebes, 57–58, 68
 deities important to, 169
 god Montu, 79
 as religious center, 7–8
 Sennefer and Sentnay, 95
Third Intermediate Period, 222
Thoth, 33, 42, 220
 as baboon, *200*
 of coffin of Paduamen, 158
 and Maat, *189*
 on sarcophagus of Khonsu, 153
Thutmose I, 7, 9
 head of, *61–62, 80, 80–81*
 tomb built for, 10–11
Thutmose II, 9

Thutmose III, 1
 Amduat depicted in tomb of, *40, 42, 43, 44, 45, 47*
 being suckled by tree goddess, *30*
 calling himself "son of Amun," 2
 Festival Hall of, 14, 15
 gods depicted on tomb of, 214
 Hatshepsut disappearing from records of, 11
 leopard of, *113*
 lineage of, 7–8
 Litany of Re, 17, 38, 39, 48
 offering table, *4, 6–7, 86–87*
 picture of goddess Nut on sarcophagus of, 32
 reign of, 12–17
 relief of Amun, *88*
 relief of king facing Amun, *87*
 royal barque of, *89*
 sphinx of, *viii, 62, 63, 81, 81–82*
 statues of, *8, 62, 63, 82, 82–84, 84*
 Stelophore of Nefer-peret, *91*
 tomb of, 38–39
 wearing *atef* crown, 16, 17
 wood statue of, *111–112, 112*
Thutmose IV, 18–19
 Giza stele of, *19*
 herald of, 204
 paintings in tomb of, 35
Tiye, 20, 119, 120
Tjanen, 14
Toe stalls with rings, *132*
Tomb statue of Nakhtmin's wife, *100, 100–101*
tombs of nobles, 135–164
tombs of royalty, 33–39
 building and furnishing of, 58
 objects in, 102–134
tools, 120, 148
toys, 157
Tree Goddess, *30, 39. See also* Isis
Triangle level of Sennedjem, *148*
turquoise, 60
Tutankhamun, 35, 39
 chest with jackal, *70*
 funerary sandals, *115*
 head of, *64*
 pectorals of, *130*
Tuya, 119–122
tyet knots, 86, 110

Unas, 34, 169
uraeus/uraei, 83, 117
 on goddess Maat, *180–181*
 on pectoral of Sheshonk II, *128*
 on Princess Nefrure, *90*
 on Ramesses II's obelisk, *85*

 on relief of Thutmose III, *87*
 worn by Isis, *178*
Useramun, 39, 48
Usermaatre, 165
ushebtis, 70, 72, 226
 of the Adjutant Hat, *64*
 during the Amarna Period, 141
 box of Djed-Maat-iuesankh, *52, 54–55, 207–208*
 box of Khabekhnet, *145–146*
 boxes for, *121*
 in chest of Queen Nedjmet, 163
 of Khabekhnet, *143*
 model tools for, *120*
 in tombs of nobles, 135
 of Yuya, *119*

Valley of the Kings, 38
 burial of Ramesses II and sons, 21
 burial of Thutmose III, 112
 hierarchy of, 35
viziers, 14, 180
Vulture bracelet of Queen Ahhotep, *108*
vultures, 108, 109

Wadjet, 1
 as Nefertem's mother, 174
 on Paduamen's coffin, 158
Water procession, *58*
wedjat eye, 92, 93, 124
 on bracelet of Sheshonk II, *129*
 pair of, *203*
Wenudjebauendjed, 126
Wepwawet, 191, 215, 217
Wernes, *41*
Westendorf, Wolfhart, 110
Wet, 66
White crown of Upper Egypt, 128
Winged goddess, *179*
wood, 149
working classes, 21–22
writing and art, 56–57

Yuya, 119–122

Illustration Credits

Cover

Photographs by J. D. Dallet

Prologue

Map p. xv by Laris Karklis

Thutmose III and the Glory of the New Kingdom

Figs. 1, 8, 12 by Tammy Krygier; figs. 2, 3, 7, 11, 13 by James VanRensselaer; figs. 4, 5, 6, 9, 10 by Betsy M. Bryan

Exploring the Beyond

Fig. 1 by Betsy M. Bryan; figs. 10, 18 by Erik Hornung; fig. 5 by Frank Teichmann; figs. 2–4, 6–9, 11–17, 19–21 by Andreas Brodbeck; fig. 22 by J. D. Dallet

Art for the Afterlife

Figs. 2, 3, 5, 8, 19, 20 by Betsy M. Bryan; fig. 4 by James VanRensselaer; fig. 7 by James Romano; fig. 12 courtesy Cleveland Museum of Art; fig. 14 courtesy Metropolitan Museum of Art; fig. 18 courtesy Cleveland Museum of Art

Catalogue

Cat. nos. 2, 3, 5, 7, 8, 9, 12, 13, 17, 18, 19, 21, 22, 23, 25–35, 38, 40, 41, 42, 44–52, 54, 55, 56, 61, 62, 63, 64, 65, 68, 69, 70, 71, 74, 75, 77, 82, 83, 85, 87, 89, 90, 91, 93, 95, 98, 99, 100, 101, 103, 104, 105, 106, 107 by J. D. Dallet; cat. nos. 6, 14, 16, 57, 58, 59, 60 by Jürgen Liepe; cat. nos. 1, 4, 10, 11, 15, 20, 24, 36–37, 39, 53, 66, 67, 72, 73, 76, 78, 79, 80, 81, 84, 86, 88, 92, 94, 96, 97, 102 by James VanRensselaer

Facing the Gods

Geb, p. 215 by Betsy M. Bryan

Epilogue

Pages 241–243, fig. 6 by Rob Shelley; fig. 3 by Theodor Abt; figs. 4, 5 by Andreas Brodbeck

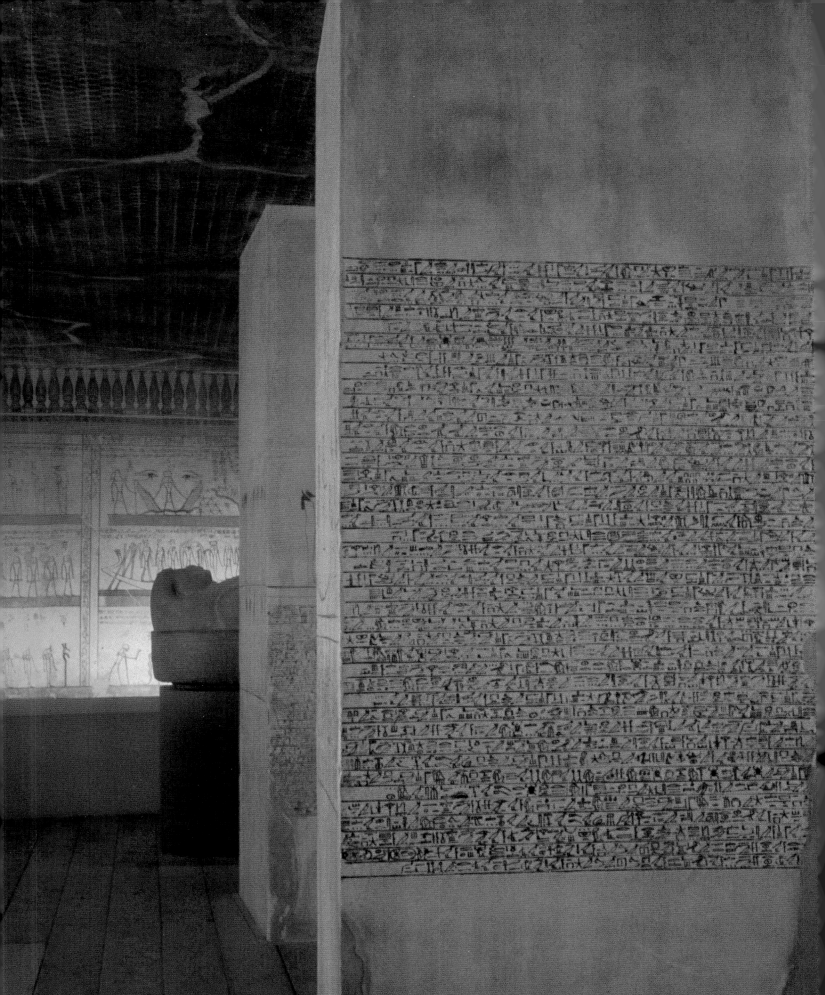

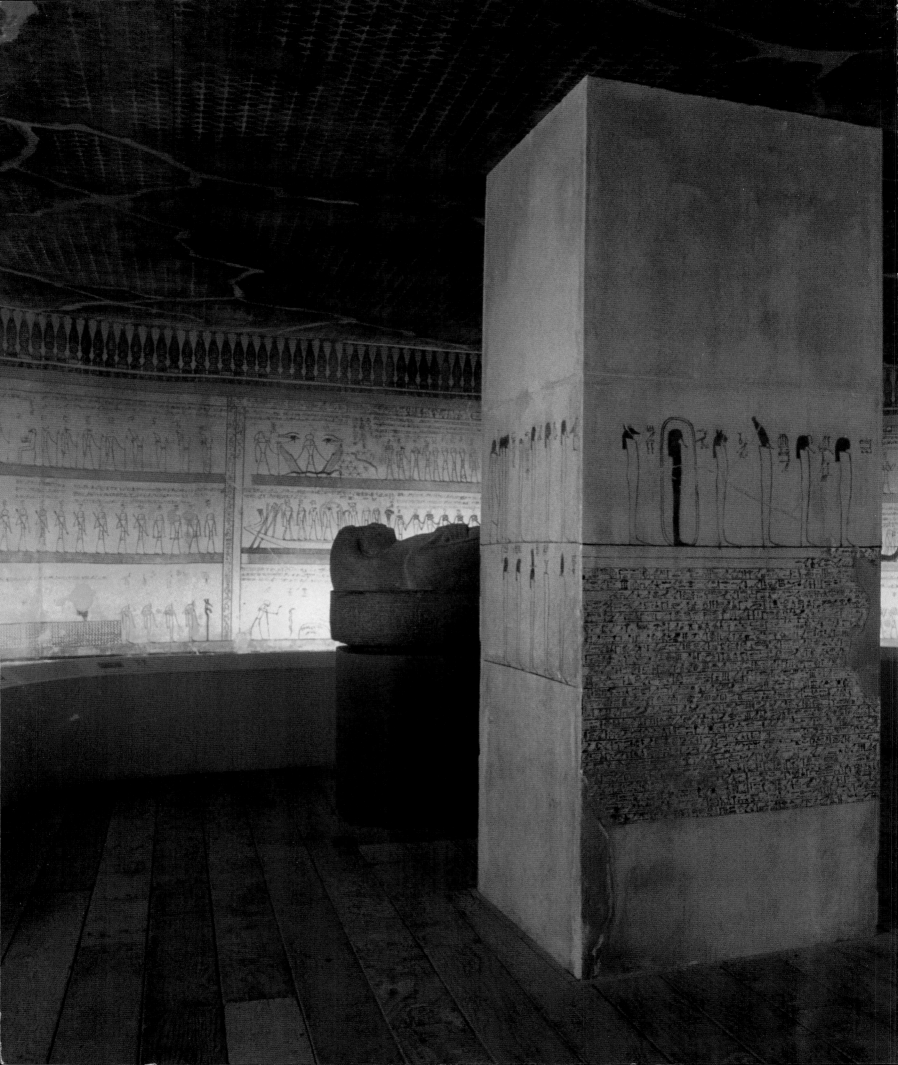

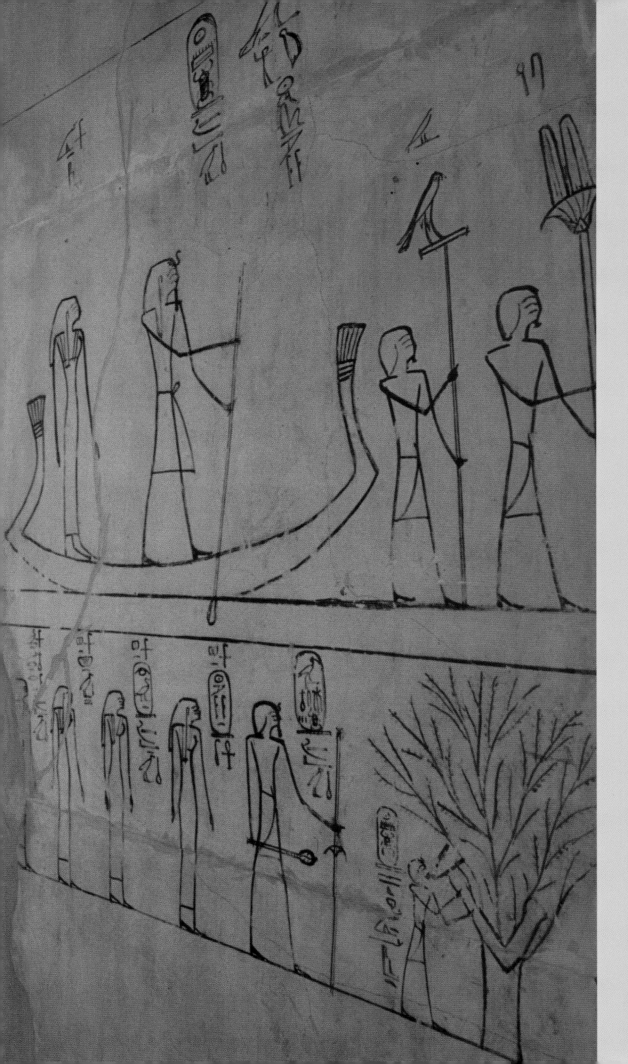

Epilogue

Theodor Abt

1 *Sennefer and Sentnay,* Eighteenth Dynasty, 1427 – 1390 BCE, granodiorite. The Egyptian Museum, Cairo (cat. 14).

2 *Goddess Maat,* Third Intermediate Period, c. 800 – 700 BCE, lapis lazuli and gold. The Egyptian Museum, Cairo (cat. 88).

3 Sun god's night journey.

• Of all the pharaonic monuments, the royal tombs of the Valley of the Kings near Luxor in Upper Egypt are especially attractive for visitors. These tombs, some of them up to 100 meters in length, were chiseled deep into the rock of this remote desert valley solely, as we know, with the aid of hardened copper. Many of the wonderfully decorated walls, corridors, and burial chambers within still retain their magnificent color.

Based on our knowledge of the world-famous treasures of the tomb of King Tutankhamun — the only tomb found virtually intact — we can imagine what amazing treasures once lay hidden inside the tombs of more commanding pharaohs buried here. They must have been filled with the most exquisite and beautifully crafted funerary architecture, sculptures, and gold, their walls and corridors decorated with inscriptions from top to bottom. It was a stroke of good fortune for humankind that the site of the tomb of Tutankhamun remained practically undisturbed for nearly thirty-five hundred years. Discovered by Howard Carter in 1922 as a result of his untiring persistence, the tomb and its treasures permit us to form an impression of the funerary practices and paraphernalia at that time. However, our modern utilitarian mindset has difficulty grasping that this huge, labor-intensive endeavor, which began with the carving of these tombs from rock, was never intended to be seen again by the living. It was truly a work for the world beyond, a world hidden to all but the dead pharaoh.

As all the monuments, statues, and images testify, pharaonic culture was strongly imbued with a concern for the afterlife. Very few archaeological traces remain from the daily life of old Egypt; indeed, the Egyptians at that time did not focus their main interest in life on earth. The relative importance they placed on preparation for the world beyond is visible in their language: they called their house on earth "resthouse" while their tomb was called "the house for eternity."

When today we enter the burial chamber of a royal tomb, like the one of Thutmose III that has been rebuilt as a facsimile for this exhibition, we are taken by surprise. The mysterious images on the wall — animal-headed humans, snakes with two or more heads, a single eye — do indeed appear to be from another world. Where else but in the landscape of dreams might we find images so alien to our reality yet so compelling? Perhaps it is that these images unconsciously remind us of a dimension of our soul that has largely faded away from the modern enlightened worldview. What we see in pharaonic culture that may at first seem alien to us is actually a reflection of the Egyptians' belief in the potential for human spiritual development — an aim that is shared by all of the world's great religions.

The purpose of these images and texts in the royal tombs was to guide the deceased pharaoh in achieving immortality. A visit to such a tomb reminds us that the quest for eternal life has always been a concern for humans. The realization that this quest might have a personal meaning for us triggers our appetite to learn more about the roots and values of a culture that directed most of its surplus energy and resources into preparation for the afterlife.

One of the roots of this culture is evident in the geographic situation of Egypt. Nature protects the fertile land along the Nile on all sides: the natural barrier in the north is the Mediterranean; in the east, the Red Sea and the Sinai peninsula; in the west, the Libyan desert; and in the south, the first cataract at Aswan (see map, page xv). This natural protection allowed ancient Egyptians to defend their crops and wealth with minimal effort. This distinction sets apart the Nile culture from other early superior civilizations such as those in Mesopotamia or the Indus Valley. Thus, instead of being preoccupied with defending its wealth, pharaonic Egypt was able to turn its surplus energy and time to a more introverted

1

search relating to the spiritual dimension of life, including questions about the guiding principles and basic laws of nature that humans need to respect and about the afterlife.

As the first enduring form of higher civilization, pharaonic culture had a deep concern for its own constant renewal. The ancient Egyptians never put aside, but actually paid great heed to, the cultural achievements of their ancestors. Such respect for the organic growth of culture derives from the insight that conscious cultural achievements cannot be maintained without constant acts of renewal. This effort toward renewal is probably the reason pharaonic culture continued over a period of over three thousand years, mainly in peace, interrupted only by short periods of disorder.

The key to renewal or regeneration is linked to the feminine, so it is not surprising that ancient Egypt had a deep respect for the female principle, and accordingly for women in general. This remarkable feature can be seen, for instance, in the way both pharaonic and ordinary couples were represented at that time: a husband and wife were very often drawn the same size and with the same attention to detail (fig. 1). In the Amduat, the ancient guidebook through the afterlife, the female principle resides in the twelve goddesses of the hours who lead the sun god Re safely through the afterlife. These twelve goddesses are different appearances of Hathor, the goddess of rejuvenation, renewal, and love.

Another fascinating aspect of pharaonic culture is the belief in a divine cosmic order, balanced and just, symbolized by the goddess Maat (fig. 2). Maat was to be respected by all humans on earth, including the pharaoh. Today we recognize in this concept respect for the divine aspect of Mother Nature. To our knowledge, the concept of Maat is the first formulation of humankind's sustainable relationship with nature and its laws. The individual is responsible for living his or her life in accordance with the cosmic order so as to sustain a harmonious society.

Quest for Immortality and the Amduat

For the ancient Egyptians there was more to human life than mere biological existence. In the early days of Egyptian civilization, the pharaoh represented the divine on earth. The oldest religious texts in the world — the Pyramid texts — recount how the pharaoh became immortal after his death. In a later period, this "quest for immortality" increasingly came to be shared by the nobles, and eventually, in the late period of pharaonic culture, this quest became a common goal for all. An increased cognizance in Western civilization about the eternal aspect of human existence has its roots in this culture, where human beings developed a growing awareness of the potential of a spiritual dimension to their lives, witnessing the growth of something inside that would never perish.

The Books of the Netherworld were seen as guides to achieve the goal of immortality. The Amduat, the "Book of the Hidden Chamber," is the oldest Egyptian book of the netherworld from the New Kingdom, dating back some thirty-five hundred years. It describes the renewal of the sun god Re, who every day becomes old and weak when sinking in the west at evening time, yet rises in the morning rejuvenated, and accounts for what happens during the sun god's night journey (fig. 3). The twelve-hour journey through the night is also related to the annual renewal that is experienced in Egypt during the Nile flood, which takes twelve cycles of the moon plus five days.

In the Amduat, humans meet another world after death, a world with a range of favorable as well as destructive forces. These forces related to the past, to the ancestral world, much as, according to modern biology, the human body harbors within itself the traces of its past evolution. In the same way as our bodies, brains, and minds are the result of a gradual evolution, the human psyche is developed and shaped by the experiences of our ancestors. The traces of these experiences are not directly visible but remain latent in our common unconscious, manifesting themselves over time in typically human representations and myths.

The hideous Apophis snake, for instance, which in the seventh hour of the Amduat attempts to stop the sun god in his journey of renewal, might be seen to be still at work (fig. 4). Our world, "the sun of our time," is badly in need of a collective renewal. But there seems to be an inhibiting force that seeks to prevent such a renewal. We could call this "Apophis force" our collective distrust in the regulating forces of nature, which are symbolized in the Amduat by the goddess Isis. Her feminine force might indeed overcome the destructive Apophis snake and allow culture to be renewed.

This view of the supernatural realm or the inner world, as depicted by the ancient Egyptians, is in danger of being lost to us as a result of our lack of reflection. Indeed, all these images and visions

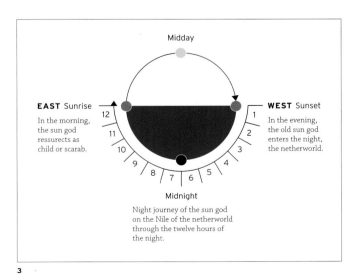

Midday

EAST Sunrise

In the morning, the sun god ressurects as child or scarab.

WEST Sunset

In the evening, the old sun god enters the night, the netherworld.

Midnight

Night journey of the sun god on the Nile of the netherworld through the twelve hours of the night.

4 Detail, the sun god and Osiris being protected by the Mehen serpent during the seventh hour of the Amduat, in the tomb of Thutmose III. Eighteenth Dynasty, 1479–1425 BCE; painted plaster. Valley of the Kings tomb no. KV 34.

5 Photograph showing the 1980s condition of the tree goddess painting on a pillar in the burial chamber of Thutmose III. Eighteenth Dynasty, 1479–425 BCE; painted plaster, Valley of the Kings, tomb no. KV 34.

6 Facsimile showing condition of painting in 2002.

4

of the inner world are, if taken literally, strange superstitions, of course. But if instead they are understood on a *symbolic level,* then we realize that the one sun god and the many divinities of the Amduat are realities of the human psyche. There is, for instance, a mysterious relationship between the sun god and the ego. The sun god in his barque is like the prototype of an individual who is self-contained and functioning in a right and proper manner. The pharaoh tries to follow his father, the sun god, on his journey through the twelve hours of the dark beyond and thus leads the way for his people. He is a role model, ready to pass through darkness and uncertainty in order to resurrect in the morning. In the later period of pharaonic culture, everyone wanted to sail as the pharaoh did in the "barque of the millions" and hence acquire immortality.

The Amduat could be considered the first "scientific publication" of humankind. Describing and mapping the unconscious realm is familiar from descriptions of shamans in tribal cultures, high religions, and depth psychology. The Amduat states that the mystery of rejuvenation can occur if an individual consciousness relies on the knowledge of the myth of the sun god. Consequently, by accompanying the sun god through the netherworld, the reader of the Amduat becomes familiar with the contents and the "geography" of the different hours, the names of the gods, and so on. He or she learns from symbolic images how to cope with the dangerous and destructive forces that consciousness meets on its journey of renewal. The individual is thus given a chance to pass through the same process of renewal and in so doing will be mentally reborn to a feeling of being connected to something eternal even during his lifetime. That is why the Amduat says repeatedly in different wordings: "This knowledge is good for the person on earth, a remedy — a million times proven."

Conservation and Protection

It is a simple fact that we protect something only once we recognize its value. Despite the majesty of the Valley of the Kings, the royal tombs of Egypt are not themselves immune to the threat presented by an ever-growing number of visitors. This book accompanies an exhibition of the same name, one initiated by the Swiss-based Society of Friends of the Royal Tombs of Egypt. The educational aim of the exhibition is to raise worldwide awareness not only of the unique treasures and value of the royal tombs of Egypt but also of their need for protection (figs. 5, 6). Listed by UNESCO as part of the world's cultural heritage, the royal tombs of Egypt are among the sites that in unison we agree must be preserved and restored for future generations. To this worthy end, a portion of the revenues from *The Quest for Immortality* will be set aside in a fund mediated by the International Foundation for the Preservation of the Royal Tombs of Egypt, allowing each visitor to the exhibition, each reader of this book, to contribute to the powerful endurance of these royal tombs and treasures.

5 **6**

246